# JACQUES LOUIS DAVID

THE
MET

THE METROPOLITAN MUSEUM OF ART, NEW YORK

DISTRIBUTED BY YALE UNIVERSITY PRESS,
NEW HAVEN AND LONDON

# JACQUES LOUIS DAVID
## RADICAL DRAFTSMAN

Edited by Perrin Stein

# CONTENTS

## The Long Meditation
Perrin Stein

15

## Elders, Contemporaries, and Pupils: David's Drawings in Context
Philippe Bordes

35

## Catalogue
Perrin Stein, Daniella Berman, Philippe Bordes, Mehdi Korchane,
Benjamin Peronnet, Louis-Antoine Prat, and Juliette Trey

66

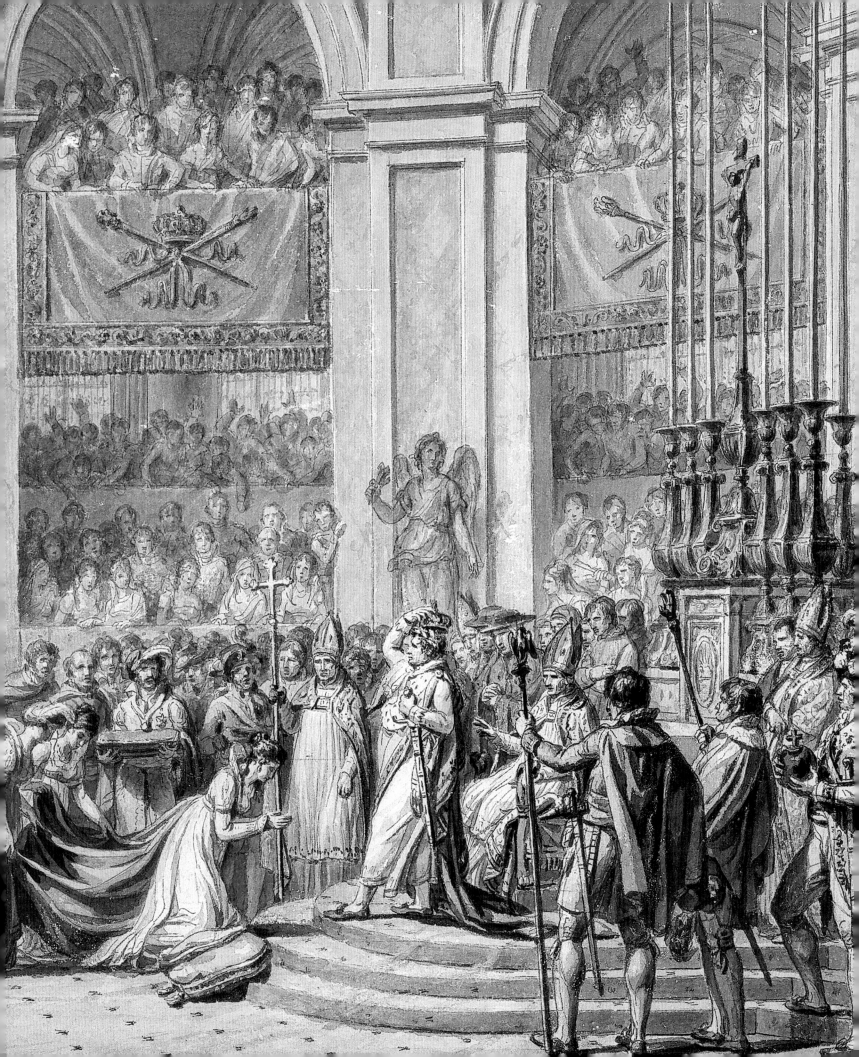

# DIRECTOR'S FOREWORD

The complex relationship between art and politics is rarely more on display than in the life and work of Jacques Louis David, who rebelled against the entrenched styles and powerful institutions that had circumscribed his early career as an artist. During the dramatic upheavals of the revolutionary era, when the French people were transformed from subjects to citizens, David was instrumental in crafting a vision of this new society, animated by new principles and requiring new forms of expression. The years that followed would bring additional peaks and valleys—imprisonment; appointment as first painter to the emperor; exile—spurring further reinvention. From his birth in Paris in 1748 to his death in Brussels in 1825, David not only navigated vast artistic and political divides but also produced iconic images that have shaped our view of these periods and events.

Why, then, for such a towering figure in the history of European art, have there been no exhibitions focusing on his drawings? For one, David's works on paper do not offer up prettiness or displays of facility. Rather, they are born of utility, and in their execution emphasize clarity and force. One enters the realm of David's drawings not for easy aesthetic pleasure but for companionship on a challenging but ultimately rewarding journey through his creative process. We emerge with fascinating insights into his life and work. But while the endpoints of David's artistic enterprise—that is, the canvases—dazzled in the limelight of public display, the drawings stayed behind in his studio. They bear the physical evidence of trial and error, labor and epiphany. They were rarely sold during the artist's lifetime, kept instead in sketchbooks, albums, and portfolios. As such, they

were available to the many students who benefited from David's tutelage and seeded the flowering of French art well into the nineteenth century.

To tell these stories, it was necessary to reunite many sheets dispersed across collections and repositories around the world, and for this we are indebted to the generosity of a great number of lenders, both public and private. All are acknowledged, with our sincerest thanks, on page 11. Many of the most recognizable works, including *The Combat of Diomedes* and *The Oath of the Tennis Court*, have never before been exhibited in the United States. Others, including the *Allegory of the Revolution in Nantes* and newly identified studies for *The Death of Socrates* and *The Lictors Bringing Brutus the Bodies of His Sons*, have come to light in recent years and are exhibited here for the first time. A number of oil sketches, including some fresh discoveries, are presented as an integral part of the artist's preparatory process. The result, we trust, will be even greater than the sum of the parts.

The exhibition and this catalogue that accompanies it were conceived and organized by Perrin Stein, Curator in the Department of Drawings and Prints. We are grateful to the scholars who have enriched this publication with their contributions. In addition, we are immensely thankful to the Eugene V. and Clare E. Thaw Charitable Trust for its phenomenal support of this exhibition. We are also grateful for the generosity of the Margaret and Richard Riney Family Foundation and The Schiff Foundation. We owe our appreciation to the Drue E. Heinz Fund for helping us bring this publication to realization, as well as to the Tavolozza Foundation and Mireille and Hubert Goldschmidt for their wonderful gifts and dedication to this project.

Max Hollein
Marina Kellen French Director
The Metropolitan Museum of Art, New York

# PREFACE AND ACKNOWLEDGMENTS

The word *radical*, which appears in the title of this book, makes frequent appearance in art historical writings on Jacques Louis David. It embodies the notion of a bold, transformative vision, one capable of dismantling boundaries, conventions, and hierarchies. This figurative use of the word to mean fundamental change or reform only emerged at the end of the eighteenth century, in the context of British politics. Its origins, as well as its current use in mathematics and botany, lie in the late Latin *radicalis*, meaning root. Radical in this sense is an equally apt descriptor for David's drawings, for they are the root, or the base, from which the rest of his work grows.

To study David's drawings, and to trace the origins of his ideas, is to know that his innovations and his creativity, no matter how radical, sprang from an engagement with the past, a dialogue always playing in his mind. However, if channeling the classical past was the means by which he was able to create works that captured the aspirations and suffering of a nation, and of humanity more broadly, our understanding of these works is complicated by their unfixed nature, shifting over time, and by the unstable vantage points of victor and vanquished.

Take as an example the figure of Lucius Junius Brutus, founder of the first Roman Republic, whose brooding countenance David had first studied in a chalk drawing after an antique marble bust in Rome (see fig. 95). Over the years he would ruminate on the story of Brutus, plumbing its psychological depths, until Brutus reemerged on his canvas in 1789 as the central figure in a wrenching drama of a father who sacrificed his sons for his principles. The picture was painted for the king of France but exhibited to the public after the fall of the Bastille, when it was celebrated for its antimonarchical message at a time of revolutionary fervor. So embraced was Brutus in the early days of the new French Republic, when his filicide was cast as stoic heroism, that the bust David had once drawn in situ was looted from the Capitoline Hill in Rome and placed by the podium in the National Convention in Paris, where it stood watch over some of the grimmest days of the Terror. Brutus thus became an avatar, a recurring presence in David's life, its significance fluid and malleable.

In this book, we have tried to grapple with how David's work existed amid such shifting historical tides. To illuminate both the ruptures and the continuities, the catalogue is organized into chronological sections, each introduced by a brief overview, situating David's biography in historical context. In place of individual entries for each drawing, the reader will find narratives on groups of related works, with a focus on the development of ideas. An opening essay focuses on the mutable status of David's drawings as physical objects, from artifacts of studio practice, to objects of exchange and markers of social connection, to commercial commodities and, ultimately, bearers of legacy. In the essay that follows, Philippe Bordes takes on the myth of David's singularity, exploring the artistic context for his drawings. To better define his achievement, as well as his debts, Bordes goes beyond the well-worn view of David as a genius whose brilliance left his contemporaries in the shadows and examines the ways in which his approach to drawing was both connected to and distinct from that of his teachers, rivals, and students.

My desire to share with the museum-going public my fascination with David's drawings and the insight they offer into his inner workings, both intellectual and psychological, owes much to my exposure to his work, which I have been fortunate to have had throughout my career, first as an assistant curator at the J. Paul Getty Museum, Los Angeles, and then, for the past twenty-seven years, at The Metropolitan Museum of Art. This book benefits immensely from the work of the many great scholars who have studied David's corpus, not least Pierre Rosenberg and Louis-Antoine Prat, whose catalogue raisonné of the artist's drawings, published in 2002, provides its essential foundation. I would also like to extend my thanks to the authors who contributed to this volume, named on page 13, each of whose work has been instrumental to our understanding of David.

The emergence of a worldwide pandemic midway through the preparation of this exhibition and catalogue impacted many lives and halted many plans. For this project's survival at The Met, I am truly grateful to Daniel H. Weiss, President and Chief Executive Officer, and Max Hollein, Marina Kellen French Director. Quincy Houghton, Deputy Director for Exhibitions, recognized the point of the exhibition from the moment it was proposed and has been a solid and steady presence throughout its development, guiding it through the headwinds of 2020 with the assistance of her able staff, including former Senior Administrator for Exhibitions and International Affairs Martha Deese, Exhibitions Project Manager Christine McDermott, former Touring Exhibitions Project Manager Rachel Ferrante, and Associate Exhibitions Project Manager Marci King. Exhibition Design Manager Daniel Kershaw and Graphic Designer Tiffany Kim are responsible for the handsome installation and presentation of the works in the galleries. The wall texts were expertly edited by Jennifer Bantz, Manager of Editorial Interpretation. In the Registrar's Office, Aislinn Hyde, Assistant Registrar, succeeded Nina Maruca in coordinating the loans. I am grateful to both of them for their organizational skills and good judgment, and I extend my thanks to the many individuals and institutions, enumerated on page 11, who loaned drawings to the exhibition. Their generosity made this project possible.

In the Department of Drawings and Prints, I am grateful to be part of a most helpful and supportive team, led by Nadine M. Orenstein, Drue Heinz Curator in Charge, and including Carmen Bambach, Marica F. and Jan T. Vilcek Curator, Samantha N. Craig, Ashley E. Dunn, Jennifer Farrell, David Del Gaizo, Clara Goldman, Ricky Luna, Mark McDonald, Constance McPhee, Allison Rudnick, Femke Speelberg, and Elizabeth Zanis. I was especially fortunate to have the unflappable assistance of Collections Manager Arielle S. Llupa. In the Department of European Paintings, I am grateful to my colleagues past and present: former John Pope-Hennessy Chairman Keith Christiansen, whose boundless admiration for *The Death of Socrates* provided the germ of the idea for this show; and Curator Emerita Katharine Baetjer and Associate Curators Asher E. Miller and David E. Pullins, all of whom share my fervor for the artist, his methods, and his milieu. For their expertise and advice, I thank my colleagues in the Department of Paper Conservation: Marjorie Shelley, Sherman Fairchild Conservator in Charge; Conservators Yana van Dyke, and Rachel Mustalish; and Associate Conservators Rebecca Capua and Marina Ruiz-Molina. I have also learned so much from my opportunities to examine works alongside Sherman Fairchild Chair of Paintings Conservation Michael Gallagher and Conservators Charlotte Hale and Dorothy Mahon.

For the editing and production of this catalogue, I am extremely grateful for the talents and dedication of my colleagues in the Publications and Editorial Department: Mark Polizzotti, Publisher and Editor in Chief, as well as Associate Publishers Peter Antony and Michael Sittenfeld. It was a pleasure to work with Marcie M. Muscat, who edited the catalogue with great skill and aplomb; Lauren Knighton, who ably managed its production; Josephine Rodriguez-Massop, who acquired the images; Margaret Aspinwall, who edited the provenances, endnotes, and bibliography; and Laura Lindgren, who devised the book's elegant design. The translations of French texts were done by John Goodman. The staff of Thomas J. Watson Library were also incredibly helpful during a time when access was difficult.

I have been buoyed by the enthusiasm and support of Jason Herrick, Chief Philanthropy Officer, and Katherine Lester Thompson, Deputy Chief Development Officer of Individual Giving, who helped find support for the show. It has benefited immeasurably from the generosity of the Eugene V. and Clare E. Thaw Charitable Trust, as well as the Margaret and Richard Riney Family Foundation and The Schiff Foundation. This publication is made possible by the Drue E. Heinz Fund. For their additional gifts, the Tavolozza Foundation and Mireille and Hubert Goldschmidt have my sincere gratitude. For

their help in publicizing and disseminating the content of the exhibition, I thank Jennifer Isakowitz and Egle Zygas in External Affairs and Skyla Choi, Melissa Bell, and their colleagues in the Digital Department.

And to the many friends and colleagues, both at The Met and beyond, who helped in ways large and small, I would like to extend my heartfelt thanks: Sébastien Allard; Stijn Alsteens; Dita Amory; Olivier Azzola; Colin B. Bailey; Andrea Bayer; Augustin, Louis, Matthieu, and Patrick de Bayser; Joseph A. Becherer; Emily Beeny; Katrin Bellinger; Daniella Berman; Nathalie Besson-Amiot; Rhea Sylvia Blok; Jonathan Bober; Pierre Bonnaure; Thierry Boucher; Peter Bowron; Pierre Branda; Julian Brooks; Lisa Cain; Silvia A. Centeno; Alvin L. Clark Jr.; Jay Clarke; Eric Coatalem; Adeline Collange-Perugi; Dominique Cordellier; Stéphane Deurbergue; Barbara Dossi; Valentine Dubard; Anne Esnault; Côme Fabre; Guillaume Faroult; Kaywin Feldman; Carina Fryklund; Stephen A. Geiger; Bruno Girveau; George R. Goldner; Margaret Morgan Grasselli; William M. Griswold; Valérie Guillaume; Cordélia Hattori; Rena M. Hoisington; Mary Tavener Holmes; Diana Howard; Valérie Huss; Hélène Jagot; Christophe Janet; Sophie Join-Lambert; Nicolas Joly; Guillaume Kazerouni; Mehdi Korchane; Anne Labourdette; Frédéric Lacaille; Ewa Lajer-Burcharth; Cyril Lécosse; Casey Lee; Sidonie Lemeux-Fraitot; Thierry Lentz; Christophe Leribault; David Leventhal; Sophie Lévy; Laurence Lhinares; José de Los Llanos; Elisabeth Maisonnier; Louis Marchesano; Claire Martin; Jean-Luc Martinez; Emmanuel and Laurie Marty de Cambiaire; Rémi Mathis; Tamar Mayer; Suzanne Folds McCullagh; Christof Metzger; Hélène Meyer; Mary Miller; Elyse Nelson; Benjamin Peronnet; Emily J. Peters; Susanna Pettersson; Catherine Pimbert; Timothy Potts; Louis-Antoine Prat; Daniel Prytz; Richard Rand; Marcia Reed; Céline Rincé-Vaslin; Laura Ritter; Côme Rombout; James Rondeau; Pierre Rosenberg; Gregory Rubinstein; Elizabeth Rudy; Kevin Salatino; Marie-Pierre Salé; Britany Salisbury; Xavier Salmon; Laurent Salomé; Joseph Scheier-Dolberg; Klaus Albrecht Schröder; Nicolas Schwed; David Simonneau; Cheryl K. Snay; Reba F. Snyder; Freyda Spira; Marcia Steele; Naoko Takahatake; Jennifer Tonkovich; Guy Tosatto; Juliette Trey; Isabelle Varloteaux; Linda Wolk-Simon.

Perrin Stein
Curator, Department of Drawings and Prints,
The Metropolitan Museum of Art, New York

# LENDERS TO THE EXHIBITION

Art Institute of Chicago
Cleveland Museum of Art
Ecole Polytechnique, Palaiseau
Fondation Napoléon, Paris
J. Paul Getty Museum, Los Angeles
Getty Research Institute, Los Angeles
Graphische Sammlung, Albertina, Vienna
Xike Jiulu, Shanghai
James Mackinnon, England
Morgan Library and Museum, New York
Victoria Munroe, New York
Musée Carnavalet, Paris
Musée d'Arts de Nantes
Musée de Grenoble
Musée de la Chartreuse, Douai

Musée des Beaux-Arts, Angers
Musée des Beaux-Arts, Tours
Musée du Grand Siècle, Saint-Cloud, Département des
    Hauts-de-Seine
Musée du Louvre, Paris
Musée National des Châteaux de Versailles et de Trianon
National Gallery of Art, Washington, D.C.
Nationalmuseum, Stockholm
Roberta J. M. Olson and Alexander B. V. Johnson
Palais des Beaux-Arts, Lille
Petit Palais, Musée des Beaux-Arts de la Ville de Paris
Véronique and Louis-Antoine Prat Collection, Paris
Snite Museum of Art, University of Notre Dame
and
Numerous private collectors who wish to remain
anonymous

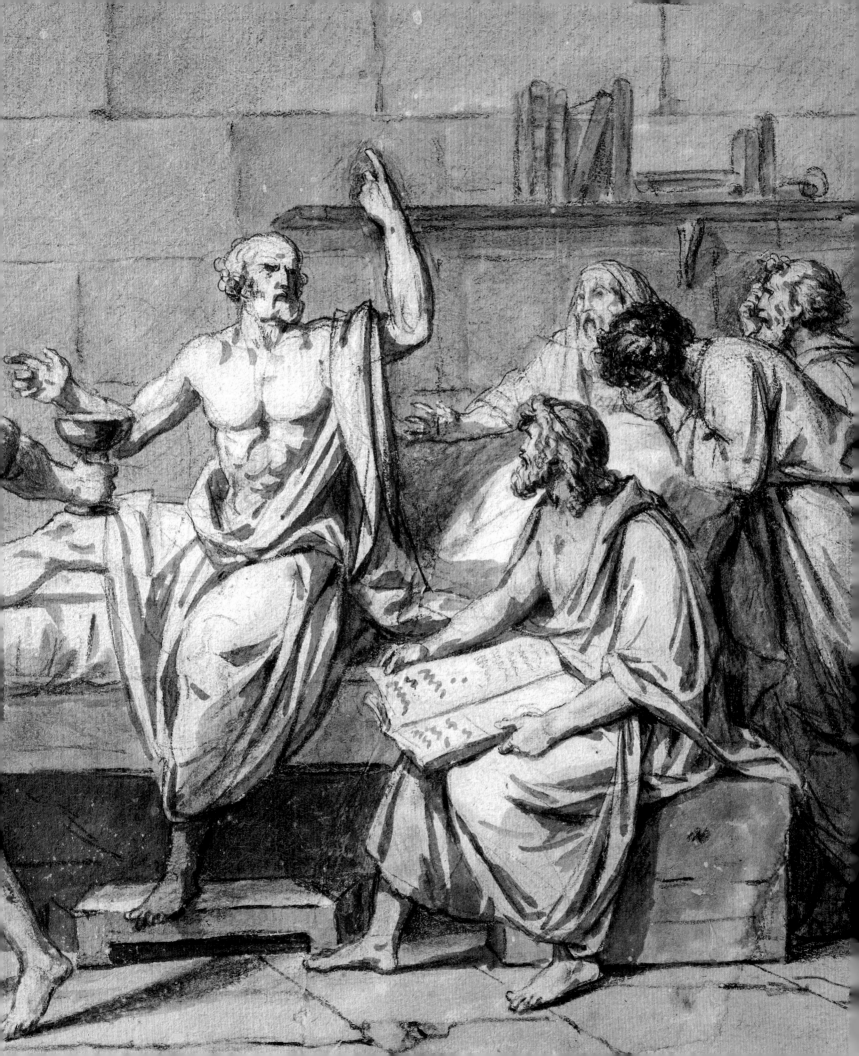

# CONTRIBUTORS TO THE CATALOGUE

PS Perrin Stein is Curator in the Department of Drawings and Prints, The Metropolitan Museum of Art, New York.

DB Daniella Berman is a PhD candidate at the Institute of Fine Arts, New York University.

PB Philippe Bordes is Professor Emeritus of Art History, Université Lyon 2.

MK Mehdi Korchane is Director, Cabinet des Arts Graphiques, Musée des Beaux-Arts d'Orléans.

BP Benjamin Peronnet is an independent scholar and dealer of old master drawings in Paris.

LAP Louis-Antoine Prat is an art historian and President of the Société des Amis du Louvre.

JT Juliette Trey is Deputy Director of Study and Research, Institut National d'Histoire de l'Art, Paris.

# NOTE TO THE READER

For reasons of space, references to previous exhibitions and publications in the catalogue entries are selected, not exhaustive. For works published in Pierre Rosenberg and Louis-Antoine Prat's 2002 catalogue raisonné of David's drawings (Rosenberg and Prat 2002; see Bibliography), a complete list of previous publications can be found there. Full citations for references that appear in abbreviated form in the entries and endnotes can be found in the Bibliography.

Further research needs to be done on David's drawing materials. "Black chalk" is used to indicate a range of related media. The color of the paper is assumed to be white or off-white unless otherwise noted. Height precedes width in dimensions.

Collectors' marks, stamped or inscribed on the drawings, are identified, where possible, by their Lugt numbers, a reference to *Les marques de collections de dessins & d'estampes* by Frits Lugt, first published in Amsterdam in 1921 but available in its most up-to-date version online at http://www.marquesdecollections.fr.

For albums and sketchbooks, overall dimensions are given for the volumes, but only selected drawings are illustrated. For a full enumeration of their contents, with dimensions, titles, and images of each individual drawing therein, see Rosenberg and Prat 2002.

The entries by Mehdi Korchane, Benjamin Peronnet, Louis-Antoine Prat, and Juliette Trey were translated from the French by John Goodman. In the texts by Perrin Stein, Philippe Bordes, and Daniella Berman, the transcriptions of inscriptions and translations from the French are all the authors' own, except where otherwise noted. The original French is cited in the endnotes.

# The Long Meditation

## Perrin Stein

Jacques Louis David's most famous paintings, iconic masterpieces in the history of Western art, exist in a spotlight that can render them static. It is the premise of both this volume and the exhibition it accompanies that our understanding of David's achievement is deeper and more nuanced when we pull back the curtain and examine the process by which he developed and refined these ideas. His canvases were not the product of epiphanies but, rather, represented hard-won triumphs. As he himself put it, in a letter of 1820, "What constitutes a masterpiece? It is, I think, a combination of thought and indefatigable perseverance on the artist's part, as he tries to bring his work to completion, while not letting the feeling of his first idea go cold."[1] The essays and entries in this volume propose that not only the brilliance of the first idea, but much of David's thought and perseverance, as well, found its expression on paper.

David's career spanned a tumultuous period of French history, and his continued success was based on his ability to adapt and reinvent himself, even as governments rose and fell. The artistic shifts over his lifetime were dramatic, as well; a champion of Neoclassicism in his early career, battling the last vestiges of the Rococo, he lived to witness the rise of Romanticism in his later years, a movement spawned, in many ways, by his students and their pupils. His drawings, in contrast to the paintings that built his fame, were not intended for the public eye. They functioned as a space for experimentation while at the same time serving as threads of continuity across divides. It is through his drawings that the enduring themes of David's work can be traced most clearly from spark to ember, from the preoccupations revealed in the sketchbooks he filled as a student in Rome to the memories that haunted his final years in exile.

Although his drawings have much to tell us, we should remember that David was first and foremost a painter. Drawings were for him a quotidian necessity, at times exploratory or personal, but rarely the goal, the finished product. They represent the thought process that underpins what Keith Christiansen described, in discussing The Met's painting *The Death of Socrates*, as the "incomparable finality of the choreography."[2] The story that follows, therefore, is less about individual drawings as works of art than it is about drawing as a practice and a tool, as an unfailing source of inspiration and renewal. But even if they came into being as ideas, incidental to his larger ambitions as a painter, David's drawings nevertheless lived on as material objects—markers of artistic debt, social connection, and legacy.

Jacques Louis David, *Leonidas at Thermopylae* (cat. 75, detail)

## The Social Currency of Drawings

Notorious for demanding astronomical prices for his paintings, David was never comfortable monetizing his drawings. They were made neither to showcase his skill and virtuosity, nor to be admired, framed behind glass or in a collector's portfolio. They embody, in their very technique, a disregard for beauty, finish, and salability (for more on which, see Philippe Bordes's essay in this volume). Only two were ever shown publicly, on the walls of the academy's biennial Salons: *Frieze in the Antique Style* (cat. 18) in 1783, as a pronouncement of his newly classicizing style, and *The Oath of the Tennis Court* (cat. 53) in 1791, to raise money to finance a monumental painting. Of the more than two thousand drawings by his hand, the vast majority were conceived in terms of their utility: to record motifs and work out compositions. They remained in his studio in portfolios and albums, which functioned as a collective resource for him and his students—a source of authenticity and a springboard for creativity—but also as a record of struggle and triumph.

If David resisted the commodification of drawings as luxury objects, he did not shy away from exploiting their social and political capital. When they left his studio, it was typically to affirm personal ties through the ritual of gift giving, to express gratitude to students and collaborators, and to cultivate potential patrons or favors. Such exchanges were often memorialized in inscriptions on the mount or on the drawing itself, applied by either giver or recipient. The practice began during David's first stay in Rome, as a student, or *pensionnaire*, at the Académie de France, where exchanging such tokens of friendship was an established part of the culture. The *Reclining Male Nude* (cat. 4), presented to Jean Augustin Renard, an architect in training at the academy, bears on its mount the prominent caption, "ACADEMIE DONNEE PAR DAVID A SON CAMARADE RENARD / A / ROME," and has been passed down in the recipient's family for over two hundred years. Certain composition drawings from this period wound up with wealthy collectors—*The Combat of Diomedes* (cat. 15) with the Duke of Sachsen-Teschen, and *Belisarius Begging for Alms* (cat. 16) with the marquis de Clermont d'Amboise, the French ambassador to Naples, although we cannot be sure whether they were sold or presented as gifts.

Most often, David's gifts of drawings went to fellow artists, primarily his current and former students. His drapery study for the figure of Crito in *The Death of Socrates* (cat. 34) is inscribed "à son ami chaudet," referring to the sculptor Antoine Denis Chaudet, whom David likely met on his second stay in Rome, and who would later base a sculpture on it (figs. 1, 2).[3] To another sculptor, Jean Guillaume Moitte, David would present his composition study for *Paris and Helen* (cat. 39). Other examples commemorate the assistance that David relied on to execute his most ambitious paintings. To Jean-Baptiste Joseph Wicar, who had accompanied him on his second trip to Rome to complete *The Oath of the Horatii*, David gave the compositional study for that painting, today in the Palais des Beaux-Arts, Lille (cat. 21). Stage designer Ignace Eugène Marie Degotti and fellow painter Angélique Mongez, both of whom assisted David with the daunting challenges of perspective and composition posed by *The Coronation*, were rewarded with studies (for example, cat. 67).[4] Other sheets were bestowed in the spirit of pedagogy, as with the *Two Studies of the Head of a Young Man Crowned with a Laurel Wreath* (cat. 12), which, according to the sheet's recipient, David's former student and later biographer, Etienne Jean Delécluze, was meant to illustrate how unembellished antiquity could be made modern by adding expression.[5] Highly finished drawings offered as marks of esteem

to former students include the painterly study for *Alexander, Apelles, and Campaspe*, sent from Brussels to Antoine Jean Gros, who, in David's absence, was managing his studio in Paris;[6] and the careful pen-and-wash study for *Cupid and Psyche* (cat. 77), presented to Louis Nicolas Philippe Auguste de Forbin, who had become the second director of the Louvre following Napoleon's fall from power.

This pattern was broken during the revolutionary period and the years that followed, when David's gifts of drawings tended to go to friends and colleagues who were united by their fervent pro-republican sentiment and participation in the newly minted government. To the archaeologist Alexandre Lenoir, David gave the study for the allegorical *Triumph of the French People* (cat. 55); to the sculptor Jean Joseph Espercieux, a finished study for *The Intervention of the Sabine Women*;[7] and to François Omer Granet, a cooper from Marseille who sat alongside David in the National Convention, a study of the bust of Brutus (see fig. 95).[8] Most poignant were the profile portraits recording the stoic fortitude of his fellow former Jacobin deputies during the anxious days of their imprisonment, presented as gifts to their subjects, presumably upon their release (cats. 58–63).

The exchange of drawings as a mark of artistic kinship or gratitude was also on display on David's own walls, where, aside from a few of his own works (see, for example, cats. 5, 53, 68), the framed drawings spoke to bonds of studio affiliation, where the personal and the commercial are often difficult to disassociate. Inventories made after

Figs. 1, 2. Left: Jacques Louis David, *Crito* (cat. 34); right: Antoine Denis Chaudet (1763–1810), *Belisarius and His Guide*, 1794. Bronze, H. 18 in. (47.5 cm). The Metropolitan Museum of Art, New York, Rogers Fund and Edith Perry Chapman Fund, 2004 (2004.113a, b)

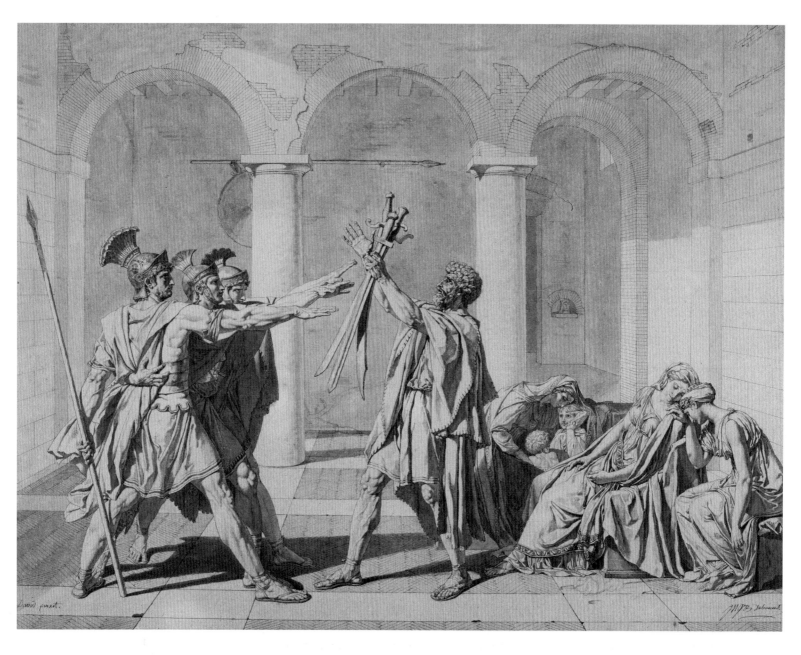

Fig. 3. Jean Auguste Dominique Ingres (1780–1867), *The Oath of the Horatii, after David*, ca. 1797–1801. Pen and black ink, brush and gray wash, over graphite, heightened with white, 21 × 27⅜ in. (53.4 × 69.5 cm). Musée du Louvre, Paris (RF 5272)

his death list numerous drawings by students, of which fourteen were described as "under glass," including works by François Xavier Fabre ("*La Mort de Socrate*"),[9] Jean Germain Drouais ("*Andromaque*"), and Jean Auguste Dominique Ingres ("*Bélisaire*" and "*des Horaces*"), as well as others by Albert Paul Bourgeois, Jean Broc, Louis Crignier, and Michel Ghislain Stapleaux; many of them apparently were made after or inspired by compositions or vignettes from David's most famous paintings.[10] Notably, they are represented neither in their own styles nor by their subsequent successes but, rather, caught like ants in amber, in emulation of their master.[11] Ingres's large wash copy of *The Oath of the Horatii* (fig. 3) was presumably done as a model for a printmaker, as were the large-scale, precisely rendered studies of figures from David's most famous history paintings, such as the *Study after Camilla* (fig. 4) by Jean-Baptiste Peytavin. Anne Louis Girodet signaled his admiration for

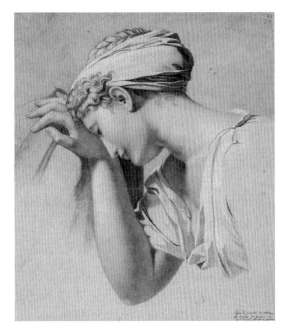
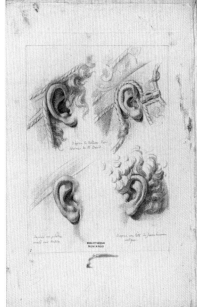
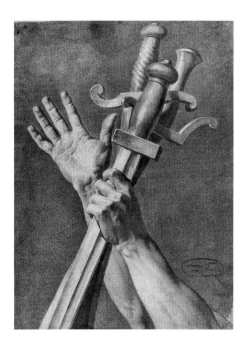

the work of his master by featuring tiny details of David's paintings, for instance, the ears of two of the Horatii (fig. 5), alongside similar exemplars lifted from antique statues in a set of drawings, later engraved as part a pedagogical suite of prints, the *Cahier de principes* (1826).[12] Not all of these quotations of details were intended for the print market; works such as the recently discovered vignette copy *Hands of Horatius* (fig. 6) by Jean-Baptiste Debret, a young relative who was part of the entourage David took to Rome to support him as he completed *The Oath of the Horatii*, may simply have been intended as a graphic declaration of allegiance.[13]

## FROM STUDIO TO AUCTION BLOCK

While David could control the destiny of his drawings during his lifetime, his death in 1825 and the subsequent dispersal of his works set into motion an effort to consolidate and burnish his legacy. Posthumous inventories list works spread between his wife's apartment, his son Eugène's apartment, and his former student Gros's studio.[14] Eugène traveled to Brussels to collect the contents of his father's studio and was given his heart in a silver box, but the Belgian government would not release the body for burial in France.[15] The sale of David's estate took place over several days beginning on April 17, 1826. The author of the catalogue, Alexis Nicolas Pérignon, after describing the paintings, spoke of the drawings in terms of the insight they offered into the master's working process:

> it will be easy to follow step by step, in these studies, the progress of the one who raised the [French] school rather suddenly from a mannered and languid style to a rigor and a purity worthy of the great masters of Italy.[16]

In advance of the sale, Eugène and David's other son, Jules, labored to organize and present the drawings. On every drawing, loose or framed, on over a thousand studies

Fig. 4. Jean-Baptiste Peytavin (1767–1855), *Study after Camilla*, ca. 1800. Charcoal, stumped, white chalk, 19½ × 16⅞ in. (49.5 × 43 cm). Cabinet d'Arts Graphiques des Musées d'Art et d'Histoire, Geneva (0-0999)

Fig. 5. Anne Louis Girodet (1767–1824), leaf 7 (ear studies) from his *Album de Principes de Dessin*, ca. 1789–90. Red chalk, over graphite, 11⅝ × 8½ in. (29.5 × 21.5 cm). Médiathèque de Montargis, on deposit at the Musée Girodet, Montargis (D. 77-1)

Fig. 6. Jean-Baptiste Debret (1768–1848), *Hands of Horatius*, ca. 1791–1802. Red chalk, 16¾ × 22⅝ in. (42.5 × 57.5 cm). Present whereabouts unknown

Fig. 7. Detail of cat. 5 showing the paraphs of Eugène David and Jules David

affixed to album pages, and on every individual sheet in twenty-five sketchbooks, they placed their initials (fig. 7). The sale catalogue assured prospective buyers that these paraphs, as they were called, guaranteed the authorship of each work, and that everything sold would "forever keep its authenticity."[17] It seems clear today, however, that in their zeal to safeguard the integrity of their father's oeuvre, Jules and Eugène swept in a number of sheets, presumably by friends or students, that had been kept in his studio among David's own works.[18]

To make the two huge volumes of collected studies, most dating to the artist's early years in Rome, more commercially viable, they were broken up and reassembled as twelve smaller but still sizable albums, each featuring a broad range of types and subjects and comprising, in the words of Pérignon, a "precious repository of David's various studies and inspirations, demonstrating in a precise manner the route he took to reach the great goal he had proposed: the regeneration of the [French] school."[19] Despite this paean, none of the twelve albums was sold. The Musée Central des Arts, as the Louvre was then known, bought only a drawing of Homer asleep, drawn while David was imprisoned in 1794; a wash study for *Leonidas at Thermopylae* (cat. 76) dated 1813; and a handful of landscape drawings from the artist's youth.[20] Indeed, the Louvre's lukewarm interest in the sale was only one of many indicators of the anxiety around David's legacy, as his homeland was forced to grapple with an oeuvre that reflected his great stature as an artist but also the weight of his past as a revolutionary, a regicide, and a supporter of Napoleon in opposition to the Bourbon Restoration.[21]

## BUILDING A REPOSITORY

A full appraisal of Pérignon's claim of the essential place of drawing in David's enterprise has been in development for over a century. In 1880 Eugène David's son Jules David-Chassagnolle completed a study of his grandfather's life and works, which, though monumental, reflected only a partial knowledge of the drawings, emphasizing those that had stayed in the family.[22] More recently, Arlette Sérullaz devoted her career to the study of David's drawings, resulting in the groundbreaking catalogue, coauthored with Antoine Schnapper, for the monographic exhibition held in 1989–90 at the Musée du Louvre, Paris, and the Château de Versailles, as well as the deeply researched catalogue of David's drawings in the collection of the Louvre, published in 1991.[23] However, it was only with the 2002 catalogue raisonné by Pierre Rosenberg and Louis-Antoine Prat that the full range of David's graphic production was presented in chronological sequence, paving the way for a better understanding of his stylistic development and the role of drawings in his artistic process. Sheets that have come to light since 2002 have been published regularly in articles by Rosenberg, Prat, and Benjamin Peronnet.[24]

David's earliest student works show facility but no indication of the sterling career to come. His initial training took place in Paris in the early 1770s, when the last gasp of the Rococo style existed alongside a painterly neo-Baroque and an early form of antiquarian-influenced Neoclassicism. Calls to revitalize the French school held out Nicolas Poussin as the archetype of French classicism. It was David's five years at the Académie de France in Rome that provided the catalyst for his transformation. Certain early sheets, for instance, the charming red chalk *Young Woman of Frascati* (cat. 5) and the operatic *Combat of Diomedes* (cat. 15), suggest a young artist still in the sway of his immediate predecessors.

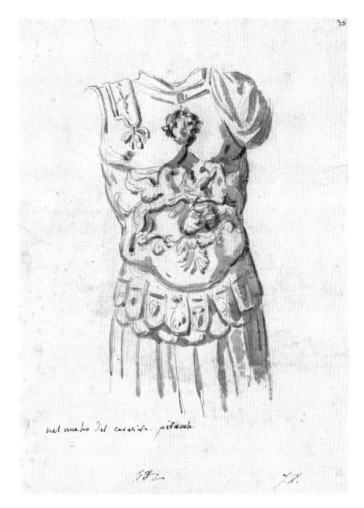

He would soon adopt a more schematic style emphasizing clarity over facility, forswearing the red chalk of Hubert Robert, the brown wash of Jean Honoré Fragonard, and the watercolor of Charles Joseph Natoire. Black chalk quickly became his medium of choice, with gray washes sometimes added later for legibility. Antique statues were rendered in quick sketches, without pedestal or setting; paintings by earlier masters were roughly blocked in with broad dabs of wash. More care was given to the finish of landscape drawings, which were lightly sketched in black chalk en plein air, often with later additions of gray washes. In the end, they would be of little use to a history painter who favored indoor settings, but their controlled application of wash, monochrome palettes, and attention to underlying geometry prefigured his aesthetic sensibility as a draftsman.[25]

Once back in Paris, David cut apart his Italian sketchbooks and reassembled the thousand or so sketches into two large albums, the arrangement of which followed a personalized taxonomy governed, above all, by pragmatism. As he pasted his drawings onto album pages according to theme, he had to choose, with each two-sided sketchbook drawing, which design might come in handy and which to sacrifice. A study of a Roman cuirass bearing a head of Medusa (fig. 8), for instance, was deemed more likely to prove useful than a rapid copy on the verso after another painter's Madonna and Child (fig. 9), and was therefore pasted into the album faceup.[26] On one level, these sketches

Fig. 8. Jacques Louis David, *Cuirass with Head of Medusa and Griffons*, from Roman album no. 8 (leaf 17), ca. 1775–80. Brush and gray wash, over black chalk, 8⅜ × 5⅞ in. (21.2 × 15 cm). Morgan Library and Museum, New York (see cat. 7)

Fig. 9. Jacques Louis David, *Madonna and Child*, from Roman album no. 8 (verso of a drawing on leaf 17), ca. 1775–80. Black chalk, 8⅜ × 5⅞ in. (21.2 × 15 cm). Morgan Library and Museum, New York (see cat. 7)

provided the prototypes that would become the building blocks of his Neoclassical style. More than that, however, it can be argued that the mechanical steps required to create the albums—copying and tracing, cutting and pasting, deconstructing and reconstructing—imprinted themselves on David's working method, one in which fragments were mobile, transmutable signifiers and similar modes of assembly, reassembly, and iteration were employed in the development of compositions.

## DRAWING AS EXPLORATION

Throughout his career, David mined the trove of visual data in his Roman albums for inspiration and to infuse his paintings with classical forms and details, but they were not his sole source: their use was mediated by his engagement with literary and theatrical interpretations of ancient narratives, as Mark Ledbury has demonstrated.[27] His visual ruminations might consider alternate moments in a story, often giving form to episodes not previously depicted or even those not specifically described by authors. From the compositions David explored on paper but did not carry over onto canvas, we can see that he was frequently drawn to graphic scenes of familial violence, but he consistently abandoned the development of such subjects, moving them offstage, as it were, and opting instead for psychologically powerful tableaux of prelude and aftermath.[28]

The period following his return from Rome—the year 1782 in particular—was a time of intense ideation. David spun out concepts for paintings as he prepared to gain membership in the Académie Royale de Peinture et de Sculpture, the institution that had earlier thwarted his ambitions (see "Early Training, 1764–80"). Some ideas would be worked up and others jettisoned, although certain of the latter category would be revived and developed later in the decade. That even the unused compositional studies were considered to have value apart from whether or not their ideas found their way to canvas can be seen in the 1822 list of works in the handwriting of David's wife, Marguerite Charlotte, which includes a category for "compositions drawn but not executed."[29]

For the iconic paintings of the 1780s—*The Oath of the Horatii*, *The Death of Socrates*, *Paris and Helen*, *The Lictors Bringing Brutus the Bodies of His Sons*—the evidence of the drawings shows that the path to each composition was long, involving in each case an extended sequence of steps following the same order of operations. First, on small sheets with figures or figural groups lightly sketched in black chalk, the poses of the protagonists began to take form, often in an echo of the classical prototypes David had seen in Rome. Next to come into focus was the architectural setting, most often an interior, where the scene would be staged. Once the initial spatial framework was devised, a series of drawings experimented with the placement and poses of the figures; nude studies sometimes preceded clothed studies to ensure correctness of anatomy and form. Iterative versions tinkered with setting, poses, and possibilities for swapping out furniture and still-life details. To knit together these elements, compositional studies were executed carefully in pen and a broad range of gray washes, to experiment with light effects (see cats. 38, 39, 43, 44). The scheme was then transferred onto another sheet, with oil paint added over the ink drawing to try out a potential palette for the painting (fig. 10; see also cats. 22, 40, 47). Only at this late stage were models posed and the fall of their drapery subtly modeled in black and white chalk on large sheets. To transfer the designs to canvas, a grid, known as squaring, was drawn over the drapery studies,

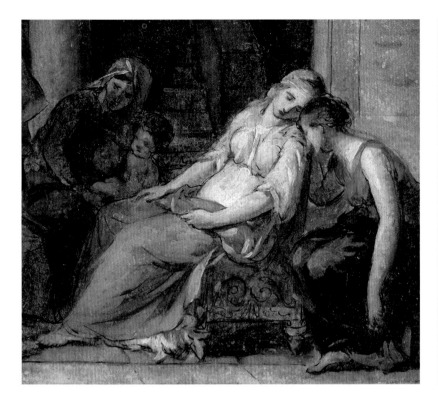

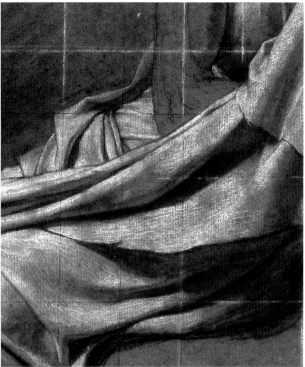

Fig. 10. Jacques Louis David, oil sketch for the *The Oath of the Horatii* (cat. 22, detail)

Fig. 11, Jacques Louis David, *Seated Woman Lamenting* (cat. 48, detail)

sometimes using a mix of black and white chalk lines, placed so as to achieve maximum visibility (fig. 11).

Whether by conscious choice or serendipity, certain "unfinished" sheets present distinct phases of a composition's genesis splayed across a single sheet, as with *The Triumph of the French People* (cat. 55 and fig. 12). The left side features a broad range of techniques and finishes, from preliminary ideas for figures, lightly sketched in black chalk, to the sword-bearing attackers, one nude and the other clothed. The right side, meanwhile, is highly finished, with delicately modulated washes, highlights in white gouache, and exquisitely rendered details of ornament. The sheet reads as a primer for the stages and methods of drawing. In cases like the study for *The Execution of the Sons of Brutus* in the Morgan Library and Museum, New York (see fig. 96), the disparity in handling likely indicates that David considered the poses of the two consuls drawn in pen and wash at right more resolved than the multifigure scene of execution summarily indicated in chalk to the left. Such a high degree of variation on a single sheet is a manifestation of a working process that considered compositional elements to be movable parts of a yet-to-be resolved whole.

## THE CHALLENGES OF CONTEMPORANEITY

The French Revolution brought an abrupt shift to David's subject matter, as circumstances led him to pivot from ancient history to modern history in the making, unfolding in real time. His drawings, however, reveal significant continuity in terms of working process, which is unsurprising in cases where he adopted allegory as a means of portraying revolutionary events. For example, in *The Triumph of the French People*, mentioned above, the two attackers were based on a source recently identified by Philippe Bordes (see p. 41):

Fig. 12. Jacques Louis David, *The Triumph of the French People* (cat. 55, detail)

Fig. 13. Jean Germain Drouais (1763–1788), *Copy of a Roman Relief*, ca. 1784–88. Black chalk, 4⅝ × 8⅛ in. (11.6 × 20.7). Musée des Beaux-Arts, Rennes (INV. 74.73.18)

a mid-sixteenth-century relief in the courtyard of Palazzo Spada in Rome, presumably copied by David in a study, now lost, but echoed in a copy of the same relief by his student Jean Germain Drouais (fig. 13).[30] David's academic training also allowed him to graft the well-engrained forms and themes of Roman history onto contemporary events, thereby endowing his compatriots with a lofty pedigree and promoting the legitimacy of the new republican power structure. By continuing his practice of sketching figures nude before adding clothing, he could more readily link his contemporaries with their classical progenitors, an association one sees in the addition of ancient helmets and swords in a sketchbook study for *The Oath of the Tennis Court* (fig. 14).[31] But in contrast to *The Oath of the Horatii*, the cast of characters was now both vast and specific, and arranging them to convey the urgency of the moment while retaining legibility became a complex puzzle. In *Two Studies of Dubois-Crancé and Robespierre* (fig. 15), we see a distillation of David's

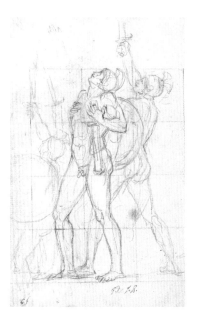
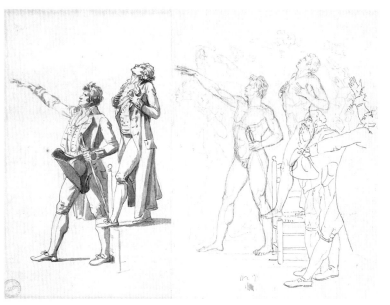

larger process. The pose of the Roman soldier in the sketchbook study is adopted for the figure of Maximilien Robespierre: on the right, sketched nude in black chalk, and on the left, in contemporary dress, with ink and wash added to signal the resolution of the study. On the right, the nude figures are overlaid with a pen-and-ink tracing carrying over two figures from another study, a method of determining the relative placement of these groups in the final composition (fig. 16).

In addition to sheets like this one that integrate areas of tracing, there are also intriguing mentions of tracings in David's estate sale, for example, "an album of chalk studies and tracings for the composition of the Oath of the Tennis Court."[32] The artist surely used tracing in earlier instances, as well. The contours of the figures in the iterative composition studies for *The Lictors Bringing Brutus the Bodies of His Sons* (cats. 43–44) align so exactly that, even if the placement of the figures has shifted, one assumes that they were carried over sheet-to-sheet with a mechanical aid, at least for the initial underdrawing. In addition to tracing, David also employed scissors to experiment with revisions and rearrangements. As a method of making changes or corrections, elements drawn on separate sheets were cut out and pasted onto existing drawings, as seen in the hat worn by the *Representative of the French People* (cat. 56), the figure of Jean Sylvain Bailly, gesturing from atop a desk, in *The Oath of the Tennis Court* (cat. 53), and the erasure of a figure in a group at left in a sheet of fourteen studies (cat. 51). More dramatically, in the *Allegory of the Revolution in Nantes* (cat. 49), the protagonist on the ramp and the entire portion of the composition behind him were cut from another sheet and pieced together with the main support (fig. 17).

Despite David's commitment to the revolutionary cause and the energy he poured into artistic projects intended to lend glory and authority to the young French Republic, the fast pace of historical developments meant that few came to fruition. After two periods of incarceration related to his Jacobin sympathies and the unsettled decade of Napoleon's rise to power, he was ready to put his talents to the service of the emperor, whose ability to award major commissions would once more allow David to fulfill his

Fig. 14. Jacques Louis David, *A Group of Soldiers*, from a sketchbook with studies for *The Oath of the Tennis Court* (carnet 3; cat. 50), 1790–91. Black chalk, squared in red chalk, 7 9/16 × 5 1/16 in. (19.2 × 12.8 cm). Musée National des Châteaux de Versailles et de Trianon, Versailles (VMS 114 / MV 7800, fol. 53 recto)

Fig. 15. Jacques Louis David, *Two Studies of Dubois-Crancé and Robespierre for "The Oath of the Tennis Court"* (cat. 52)

Fig. 16. Jacques Louis David, *The Oath of the Tennis Court* (cat. 53, detail)

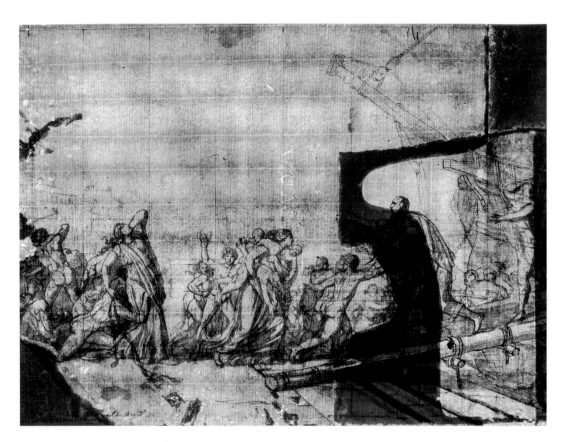

potential as a painter in search of his own glories. The commission to produce four vast canvases to celebrate Napoleon's ascension to the imperial throne, of which two were ultimately completed (see cats. 67–73), presented new challenges. Like *The Oath of the Tennis Court*, *The Coronation* depicted an actual event and specific individuals, but unlike the patriotic scrum of the tennis court, for which David looked to Roman warriors for prototypes, the ceremony staged in the cathedral of Notre-Dame sought to convey Napoleon's sovereignty in terms of royal precedent. Medieval pageantry, with its taste for bejeweled accessories, was effectively fused with Empire style as the architects Charles Percier and Pierre François Léonard Fontaine decorated the interior of the cathedral for the festivities. To record this highly orchestrated scene, David relied on his established practice of assembling and rearranging fragments, but the process was considerably more complex, as he needed to invite attendees to his studio to draw their portraits, and their arrangement within the space had to reflect the realities of social and court hierarchies.[33] Because perspective was never his strong suit, David invited the stage designer Degotti to assist him by drawing the architectural setting that would provide the armature for his composition. A study at the Musée du Louvre (cat. 67 and fig. 18) may be an instance of one such collaborative work; its combination of techniques—from precisely rendered architecture and furniture to ghostly, lightly sketched figures in black chalk, to other figures more clearly delineated in pen and ink, presumably those whose poses and placement were more settled. In addition to the possibility of two hands at work, the technique suggests a temporal layering, corresponding not to one moment but to a sequence of stages.

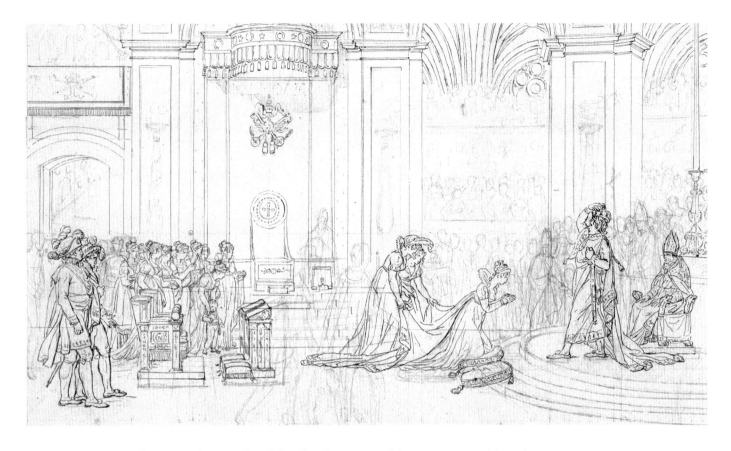

Drawings provide a record not only of the development of the two compositions in the suite, but also of the interference of the emperor and his entourage in demanding late-stage alterations. In the case of *The Distribution of the Eagles* (cats. 71–73), an allegorical figure of Victory was suppressed from the scene, and Empress Josephine was excised from the viewing area, the latter change necessitated by the emperor's recent divorce from her and remarriage to Marie Louise, Duchess of Parma. New evidence of these various stages of creation has emerged with the discovery of an oil sketch on paper (cat. 73), another work with temporal layers, beginning with a quick compositional sketch in black chalk, with squaring and soldiers drawn nude, overlaid with an oil sketch, with sections later scraped out and repainted.[34] Oil sketches had been a regular part of David's working process in the 1780s (see cats. 22, 40, 47),[35] but with the emergence of this Napoleonic-era example, it is now clear that the technique remained part of his repertoire into the nineteenth century. Over this stretch of time, his style evolved from what were essentially pen-and-ink drawings with dabs of oil paint indicating ideas for color (see fig. 10) to a larger format that allowed for a freer application of paint, with jewel-like tones and scumbled highlights showcasing the brilliance of Napoleon's army against the gray sky. In palette and painterly quality, it reminds us not of the late Rococo but, rather, of the warm tones, density, and feverish application of paint that characterize the oil sketches of certain of David's students and other painters sharing this proto-Romantic sensibility.

Fig. 18. Jacques Louis David, *The Coronation* (cat. 67, detail)

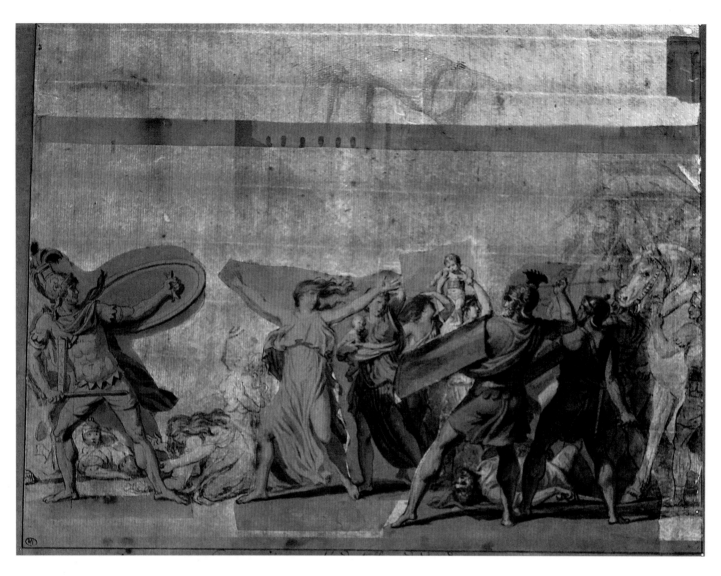

Fig. 19. Jacques Louis David, *The Intervention of the Sabine Women*, 1794. Black chalk, pen and black ink, brush and gray wash, heightened with white, 10⅛ × 13⅜ in. (25.7 × 34 cm). Musée du Louvre, Paris (RF 5200), detail of transmitted-light image

## ANTIQUITY REDUX

When not occupied with Napoleonic commissions, David returned to subjects drawn from ancient history, but in contrast to his sober and distilled compositions of the 1780s, *The Intervention of the Sabine Women* and *Leonidas at Thermopylae* are dramatic multifigure works of intense complexity. Unchanged, however, was his iterative way of thinking through compositional problems. He continued to produce constellations of studies, arranging and rearranging component elements. What evolved was the physical means by which it was achieved. Squaring and tracing were still used as tools to transfer elements from sheet to sheet, but rather than starting afresh each time, he increasingly used scissors to cut out figures and reposition them on new supports, as one can see in a transmitted-light image of a compositional study for the *Sabines* in the Musée du Louvre (fig. 19). As noted, cutting and pasting pieces of paper to make alterations to discrete parts of a composition was an established part of David's repertoire (see, for example, fig. 17), but in the planning of the *Sabines*, the practice expanded to the point where the studies can be described as collages.[36]

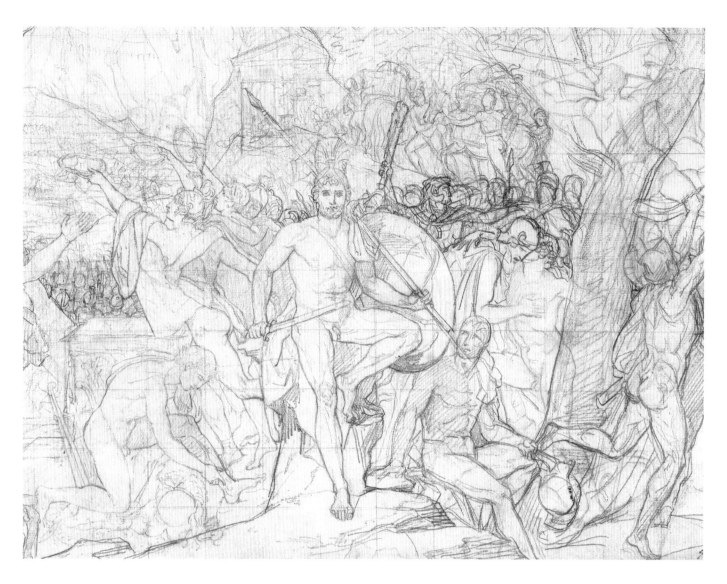

Even in cases without collage, one sees instances of the same iterative methodology at work. For example, in a study for *Leonidas* in The Metropolitan Museum of Art (fig. 20), the pose of Leonidas and of the kneeling figure to his left are indicated mostly through deliberate contours, apparently transferred from earlier drawings, while other elements are drawn in a loose, freehand manner. Pierre Théodore Suau, one of David's students of the Napoleonic era, attested that David would sometimes become so frustrated that he would rework sections of the canvas to the point where few of the original figures remained.[37] Indeed, this constant revision of the work in progress was a communal project, for which students were solicited for ideas, used as models, and assisted with the transfer of designs onto the canvas. For David, this deliberative process, played out across numerous sheets of paper, was not a weakness but a necessity, even a point of pride. In 1824, one year before his death, when the Didots, esteemed publishers of luxury books, desired to add a work by David to their collection, he wrote them from Brussels, offering a drawing he had left behind in his Paris studio, "the second composition for my Leonidas, where you can see the changes that further reflection suggested to me."[38] For David, the

Fig. 20. Jacques Louis David, *Leonidas at Thermopylae* (cat. 75, detail)

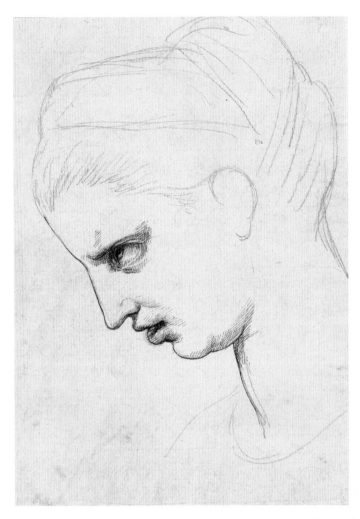

Fig. 21. Jacques Louis David, *Head of a Woman*, from Roman album no. 8 (verso of a drawing on leaf 20), ca. 1775–80. Pen and brown ink, over black chalk, 8⅜ × 5⅞ in. (21.2 × 15 cm). Morgan Library and Museum, New York (RP 884; see cat. 7)

value of the drawing was defined not by its beauty or performative facility, but by its role in a larger, cerebral process.

## MEMORY AND EXPRESSION

David's corpus of drawings is not limited to compositional studies for his paintings; he drew portraits and head studies throughout his life. They were not, for the most part, connected to his painted portraits but, rather, reflect a variety of motivations. Some had a clear purpose, like the delicate sketch of Empress Josephine's bowed head for *The Coronation* (cat. 69), or the densely hatched portrait of the revolutionary martyr Jean Paul Marat, made as a model for a commemorative print (cat. 54). Others resist easy explanation. What are we to make, for instance, of the woman with the sullen stare in the recently revealed verso of a sheet pasted into one of the Roman albums (fig. 21)?[39] Is she copied from a work of art? Expressive heads would become a major preoccupation during David's years in Brussels, where he settled following his exile from France (see cats. 78–81), but they can also be found throughout his oeuvre, often calling to mind the types of characters that populate history paintings. Certain quick ink studies are quotations from his own work; several record heads from *The Intervention of the Sabine Women*.[40] In *A Bust of a Young Man in a Phrygian Cap and a Young Woman with Her Head Bowed* (fig. 22), for instance, two such quotations are presented as unrelated fragments on a single sheet. Works in this category suggest themselves as mementos and appear to have been given as gifts to students.[41] They echo the large-scale copies after details that David's students made, under his supervision, as models for printmakers. An etching by Noel Bertrand after a drawing by David's student Eugène Bourgeois depicts the same young horseman with his capped head turned (fig. 23) and forms part of a larger series of nearly lifesize excerpts from the *Sabines*.

With their dramatic expressions and their hats, turbans, or veils, many others of David's pen-and-ink studies of heads likewise suggest themselves to be *ricordi* of details from history paintings. Without identified sources, however, we read them as disembodied studies of expression, and there are few benchmarks by which to date them.[42] A recently discovered drawing, *Heads of a Faun and a Reclining Woman* (fig. 24), is a case in point, similar in technique to the ink heads drawn after the *Sabines* in the 1790s, but compositionally closer to the drawings of his Brussels period. A faun, here paired with a sleeping woman, as one often sees, is unexpected for David but calls to mind a letter of 1818 in which Antoine Jean Gros, to soften the criticism elicited by his former master's *Cupid and Psyche* (fig. 140), referred to the male protagonist as "faun-like."[43]

David was at his least self-conscious when drawing bust-length black chalk portraits of his friends and family. These works glow with a disarming naturalism (see cat. 83),

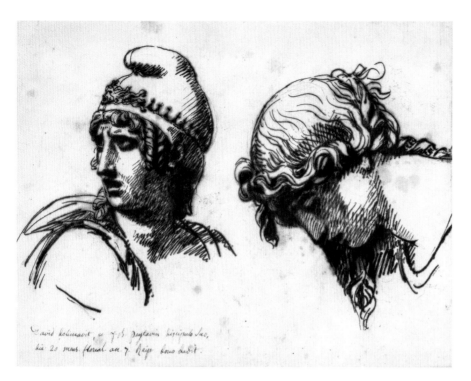

David delineavit... (handwritten inscription)

TÊTE D'ÉTUDE D'ÉCUYER

a quality accentuated by his habit of inscribing them as "d'après nature," or drawn "from life." During his decade in Brussels, he also produced an abundance of portraits drawn "de souvenir," or "from memory," either of absent family members (cat. 82) or of members of Napoleon's court for a painted replica of *The Coronation*.[44] These, too, he annotated, indicating not only an acute awareness of these two modes—drawing from life and drawing from memory—but also an urge to record this distinction for posterity.

Memory, along with its ability to filter and distort, played an increasingly prominent role in David's drawings practice in exile. He began a series of cropped figures— single figures as well as groups—in a roughly applied, greasy black chalk, works he himself referred to as "caprices," or follies (cats. 78–81). Their effect, though, is more haunting than whimsical. One recognizes the protagonists of his most celebrated works, the *Sabines* and *Leonidas* (see fig. 147 and cat. 78), yet their groupings reveal no logic. They retain the fraught emotional state of those on whom they are modeled but have been pried free from a conventional narrative structure.[45] Without settings or backgrounds, they have a new flatness that, along with their corkscrews of curly black hair, give them a kind of primitive aesthetic, resembling Greek vase painting.[46] The more sculptural notion of antiquity found in David's earlier work had been underpinned by the many studies of ancient statues pasted into his Roman albums, resources that he had left behind in his studio in Paris when he went to Brussels. In a kind of coda or bookend, the dialogues with the ancient past that were the building blocks of his early successes become dialogues with his own past. It was, in a way, the logical endpoint for a lifelong habit of considering figures as mobile components, to be traced, cut out, and repositioned, that they would ultimately be liberated from narrative altogether.

Fig. 22. Jacques Louis David, *Bust of a Young Man in a Phrygian Cap and a Young Woman with Her Head Bowed*, 1799. Pen and brown ink, over graphite, 6¼ × 8 in. (15.9 × 20.4 cm). Statens Museum for Kunst, Copenhagen (KKS 1978-75)

Fig. 23. Noel Bertrand (1784–1852), after Eugène Bourgeois (1791–1818), *Study of the Head of a Horseman*, 1813. Etching, 23⅜ × 18⅜ in. (59.5 × 46.7 cm). MAH–Musée d'Art et d'Histoire, Geneva, on deposit at the Société des Arts, Geneva (SDA 000050)

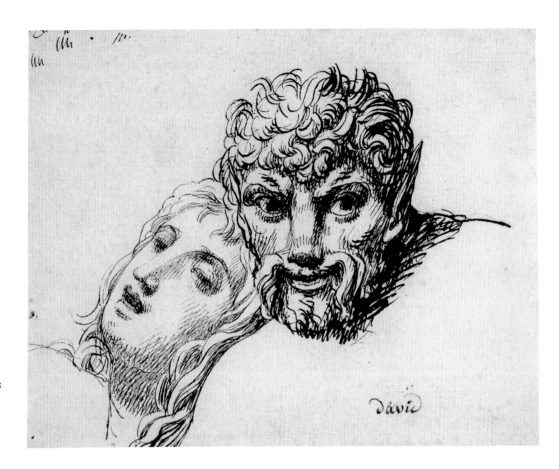

Fig. 24. Jacques Louis David, *Heads of a Faun and a Reclining Woman*, ca. 1793–95. Pen and brown ink, 6⅛ × 7⅝ in. (15.5 × 19.5 cm). Art market, Paris

## DRAWING AND LEGACY

Pérignon's language in the catalogue of David's estate sale shows an awareness that the artist's death had ushered in a new era in which his drawings would be transformed from tools of his workshop to components of his legacy. David's reputation, moreover, would be defined for posterity by the measure of both his own work and that of the many artists he had trained—in effect, his school. In the words once more of Pérignon:

> the various studies of the great master who trained so many famous artists, will be, in this [auction], an object of the greatest interest; it will be easy to follow step by step, in these studies, the progress of the one who raised the school rather suddenly from a mannered and languid style to a rigor and a purity.[47]

David himself had articulated the fundamental role of drawing in a letter of 1812, proclaiming, "invention is the essential part of painting . . . and must be long meditated in advance . . . which involves a great many studies, drawings, and sketches before [a work] can be brought to completion."[48] This practice, this long meditation, of ideas explored on paper, was well known to David's students, who themselves had been witnesses and assistants. Many had cherished examples of their master's drawings in their own collections. They were rarely large, finished works but more often sketches and excerpted motifs that would have recalled for them the camaraderie of the studio and the close bonds they forged there, as well as their connection to some of the

greatest masterpieces of French painting, many
of which were by that time hanging on the walls
of the Louvre.[49]

For many years after his death, David's
students gathered for annual reunion dinners
at the Restaurant des Vendanges de Bourgogne.
Jean-Baptiste Debret, the distant relative who
had accompanied David to Rome in 1784 to
complete *The Oath of the Horatii*, had returned to
Paris in 1831 from a long stint in Brazil, and he
began marking these occasions by presenting
to each attendee a lithograph after one of
David's drawings, each bearing the dedication,
"Aux Elèves de David."[50] The only undated one
(fig. 25), and likely the first of the series, made
in 1835,[51] was after a small red chalk sketch of
the wife and daughters of Brutus, nude, executed
in the course of resolving their poses for the
painting (see cat. 46). The drawing, which resur-
faced in 2007, bears the marks of having been
folded, perhaps even to be sent in a letter to one
of the former students in attendance. Debret
highlighted the sheet's exploratory function,
taking care to mark with the lithographic crayon
not only the final contours of the figures but
also the pentimenti and the places with visible
underdrawing, as in the thighs of the fainting
girl. It is notable that the first drawing Debret
chose to replicate was slight, a quick notation
of an idea. It was Debret's conscious choice, no doubt, to focus, for the purposes of this
dinner, not on David's public fame but on the private space of the studio.

Why, then, almost two hundred years later, devote an exhibition to David's drawings,
a category of work that the artist kept stubbornly within a private realm? The answer lies
in the very reason he was averse to selling them, and why his students treasured them:
they pull back the curtain to reveal the process—the thought and perseverance—behind
David's public production. For David, drawings were the opposite of finished works;
they were vehicles of exploration, and as such, they illuminate the birth of ideas and the
trajectory of themes. These themes, as we will see, were carried over from era to era, at
each successive turn newly inflected, probed, revisited, and reborn. Throughout a career
marked by repeated ruptures, the path to regeneration always began with recourse to
his albums, sketchbooks, and portfolios, allowing past and present to remain in never-
ending dialogue. Across shifting social and political divides, drawings were the thread
linking David's evolving personas: the academic rebel; the rising star; the revolutionary
firebrand; the stoic prisoner; the first painter to the emperor; and finally, the exile.

EBA 12132

J.B. Debret.

Lith. de Thierry frères.

Aux Elèves de David.

Fig. 25. Jean-Baptiste Debret,
*The Wife and Daughters of Brutus*,
1835 (?). Lithograph, 14⅛ × 10¾ in.
(36 × 27.4 cm). Ecole Nationale
Supérieure des Beaux-Arts, Paris
(Est. 10851)

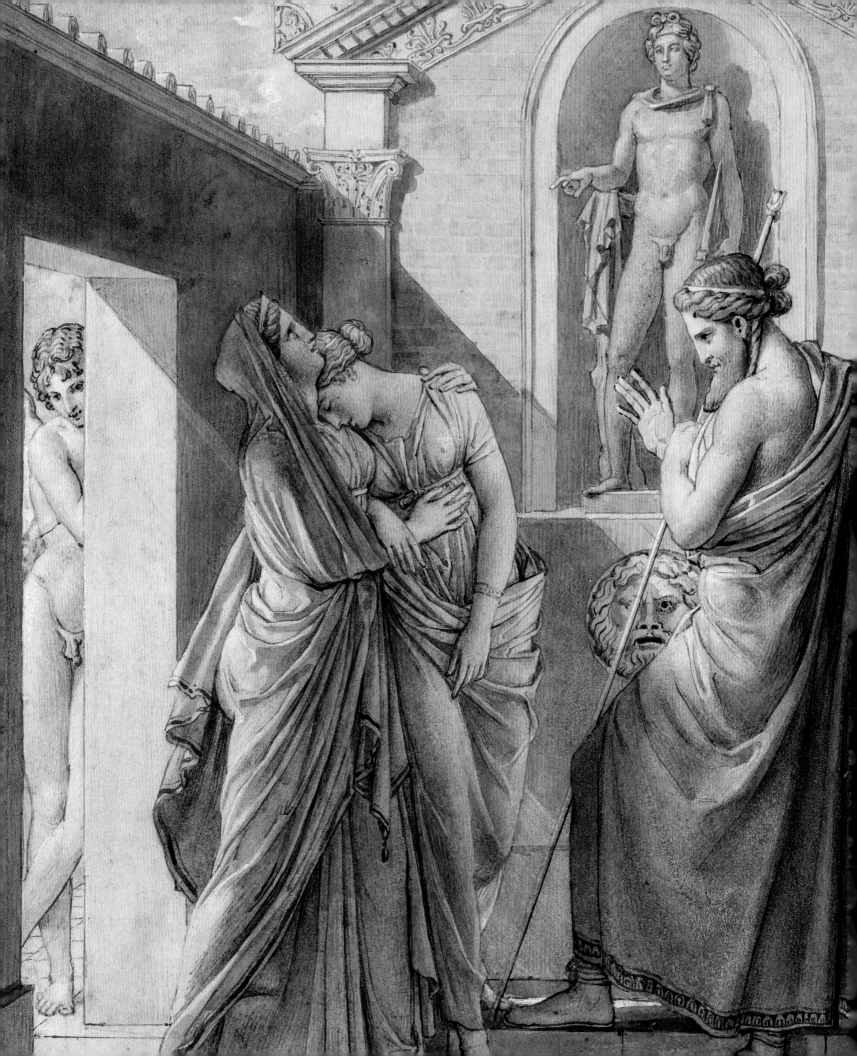

# Elders, Contemporaries, and Pupils: David's Drawings in Context

## Philippe Bordes

Jacques Louis David was unyielding in his drive to establish himself as the foremost history painter of his time, an eminence that contemporaries across Europe had endorsed by 1789. His showpiece exhibition of *The Intervention of the Sabine Women* in 1800 caused his celebrity to resonate from the palatial residences to the garrets of Paris: "his reputation has moved from floor to floor, to the poorest social classes where a number of individuals go without a 36 sous meal for the pleasure of seeing it."[1] *The Coronation of Napoleon* in 1808 enjoyed the same broad appeal across the capital, while his partisans in the art world proclaimed that, henceforth, the "school of David" was synonymous with the French school. Although during a good part of the nineteenth century his focus on antiquity was deemed boring, appreciation of his art has grown steadily since the mid-twentieth century and upheld his position in the pantheon of great artists.

A competitive spirit gripped David in the 1780s, pushing him to target openly those he considered to be his most able rivals. Two had a head start in catching the eye of the public at the biennial Salon, the decisive promotional venue to which David just managed to be admitted in 1781: François André Vincent first showed his work there in 1777, and Joseph Benoît Suvée two years later. Jean-Baptiste Regnault joined the competition only in 1783, and Pierre Peyron in 1785. David proved somewhat more collegial in the autumn of 1789 when he banded with a group of dissident artists fighting to reform the Académie Royale de Peinture et de Sculpture. He did so, however, as their implicit leader, for no one involved could claim his level of celebrity. He personally held the academy to account for the setbacks encountered in his rise to fame. Prompt to employ his reputation to show support for the Revolution and wield influence, he became for likeminded politicians the undisputed counsel on cultural reforms under the new constitutional regime. During these tumultuous years, however, because of his uncompromising personality, undeferential behavior, and political opinions, which few former members of the academy shared, he found himself more isolated than ever from other artists. In December 1792, three months after being elected deputy to the National Convention—basically, to serve as a party hack for Maximilien Robespierre and the Jacobins—David urged a former pupil who had stirred up republican sentiment while on a study trip in Rome to return to Paris: "Come back, my friend, for I have no more friends."[2]

François Gérard, *The Father of Psyche Consulting the Oracle of Apollo* (fig. 43, detail)

It is tempting to project onto David's artistic practice the social isolation that was provoked by his grating personality and aggravated by his Jacobin sympathies, which at heart he would never disavow. Doing so chimes with the romantic narrative often applied to major figures whose early history stresses emancipation and self-fashioning. In such narratives, superiority tends to be constructed by distancing the artist from their contemporaries, who are profiled as secondary players. But isolating heroic figures from the shared creative impulses of their time distorts perception of their singularity and, in David's case, ignores the particularly rich artistic scene of his historical moment. As is well known, his career was harnessed to tremendous sociopolitical changes in France: the collapse of the court, aristocratic networks, and the academy that structured artistic professions during his rise to fame; a dizzying succession of political regimes; and a breakdown of social barriers. The course that he managed to steer from the ancien régime to the Restoration was erratic and unpredictable, with few secure guideposts. During the half-century of his activity, he was confronted with the broad range of artistic options that typically characterize transitional periods, and his own resources were not always enough to allow him to find his way. Indeed, he paid close attention to the practice of his elders, his contemporaries, and the generations of pupils who became his rivals, a scrutiny that could be critical and even damning, but also at times admiring and imitative.

As mentioned, David was on his own when he stepped out of the confines of the studio and onto the stage of republican politics. He also stood out among artists by developing sidelines for making money. Along with the entrance fees to his exhibitions, he collected dues from several generations of students eager for his comments on their work. He spent time performing a slew of other activities, such as penning letters, speeches, reports, and leaflets, attending meetings and juries, negotiating with engravers and clients, and managing financial investments and real estate. But in one way or another, all of these occupations converged to benefit his artistic reputation and independence.

David proceeded with a practical mind largely unhindered by the kinds of doctrinal concerns whose defense tormented his pupil Jean Auguste Dominique Ingres. The idea of David as a pragmatic artist may seem paradoxical, given his reputation as the painter who regenerated the French school by restoring the authority of the antique. But as the highly diverse and often idiosyncratic work of his pupils proves, he had no set principles to inculcate, other than to keep an eye on nature. The reported advice he proffered to students is always frustratingly vague. The one time he felt his artistic legacy threatened and an urgency to take a firm stand was in April 1800, when he perceived maneuvers to restore an academy. He was convinced it would be disastrous for the arts. In an emotional letter to the minister of the interior, he drew a self-portrait: "an artist with a passion for the progress of the arts, still all riled up from the countless battles he has fought for twenty years, and who would die of despair if he were again to see bad taste in painting rear its haughty head."[3] A return to a manner of painting dictated by aristocratic pleasure was the red line he would not let the regenerated French school cross.

The life and art of David, admired as the most accomplished painter of his day, are illuminated by a vast amount of contemporary documents and commentary. The personalities and pursuits of his contemporaries remain relatively shadowy and lacunar, which

begins to explain why his graphic corpus has often been treated as a rewarding object of study in itself. The aim of this essay is to propose a comparative account of his draftsmanship, focusing on practices that single him out and others that were common to the artists of his time. The notion of context applied here, as always, is a selective construct. Emphasis is placed on artists whose activities played out within David's horizon and on the institutional conditions of artistic production. The drawings invoked for the sake of argument, chosen from the more than two thousand by David that have been catalogued, and from the untold number produced by the hundreds of his contemporaries who have received the attention of art historians and collectors, are inevitably a personal selection, but hopefully one that incites readers to look further afield and to set up their own cast of characters around the period's dominating figure.[4]

## COMING TO TERMS WITH THE MEDIUM

A heightened appreciation for drawings among eighteenth-century collectors was buoyed by a redefinition of their status with regard to painting. Antoine Joseph Dézallier d'Argenville encapsulated their new appeal: "When painting, an artist corrects himself and represses the full ardor of his genius; in making a drawing, he throws down the fire of his first idea, he loses himself within himself; he shows himself just as he is."[5] Drawing was freed from its perceived subservience to painting as primarily a step in the creative process, a dependence that gave the practice a taint of artisanship. In the eyes of knowledgeable connoisseurs, a candidly drawn composition characterized the artist's genius more truthfully than a finished canvas.

There are indications that David was reluctant to go along with this notion of the medium as a support for self-revelation. The vitality of his drawings results not from a sense of release but from the confident yet tense application of line and wash that brings the figures to life. He never took his cue from those pupils, like Philippe Auguste Hennequin and Antoine Jean Gros, whose graphic productions allow for an unbridled frenzy. David let his emotions take over during the Revolution and the result was disastrous: a cumulative year in prison and a close call with the guillotine. However, in the studio he was careful to repress any hint of hotheadedness; whatever instrument he was using, he sought to display a sense of mastery. Only in a few drawings meant to remain private does he appear to loosen control, as when he attempts to sort out the figural intricacies of the *Sabines* (cats. 64–66) and *Leonidas* (cats. 75–76), resulting in studies overwhelmed by a dense web of confusing lines.

The revealing spontaneity that charmed Dézallier d'Argenville is not absent from David's drawings, but it is never a gratuitous exercise in *sprezzatura*. He left a large number of sheets with compositions at different stages of completion, thus making explicit their utilitarian purpose. But his practice of pasting pieces of paper over one another to attain a desired result (cat. 49), testing a wash directly on the margins of a composition (cat. 51), or covering a splendid drapery study with an overlay of heavy-handed squaring (cat. 48) gave his natural proficiency an air of rough-hewn fabrication. By comparison, Peyron treats a group of figures found in his version of *The Death of Socrates* (fig. 26) as a complete and autonomous drawing, with no clear hint of its status as a preparatory study or as an excerpt from the finished composition. For collectors who visited the Salon, careful execution, with its aura of mastery and dedication, continued to enhance the

Fig. 26. Pierre Peyron (1744–1814), *Study for "The Death of Socrates,"* ca. 1787. Black chalk, brown ink, brown wash, heightened with white gouache, on brown paper, 14⅜ × 15⅞ in. (36.5 × 40.3 cm). J. Paul Getty Museum, Los Angeles (2010.8)

salability of drawings. David's indifference to the work-in-progress aspect of his sheets might find an explanation in the sums paid for his paintings, which stunned contemporaries and which few other artists could command. His creative experimentation with the graphic medium when preparing his paintings was a luxury, especially after the Revolution, when branded modes of draftsmanship were reassuring for collectors. It meant that he was not tied down by a prescribed program or by repetition of a successful manner. Though there are series in his corpus, they always belong to specific moments in his career (for example, cats. 58–63). There is no equivalent to the signature sheets produced over an extended period by other artists, like the *académies* on blue paper by Pierre Paul Prud'hon, undertaken for his own pleasure and the instruction of his students (fig. 27), or the refined stipple portraits by Jean-Baptiste Isabey that were much in demand (fig. 28).

David chose to present himself only as a painter, and he no doubt had low esteem for those who adopted drawing as their principal medium of visual expression, such as Charles Nicolas Cochin II, Louis de Carmontelle, André Pujos,[6] and Jean Michel Moreau the Younger. He underscored this point by proudly signing his letters "Peintre du Roy" after his admission to the academy (and at least up to March 1790), and later, during the Empire, "Premier Peintre de Sa Majesté l'Empereur." The painter's palette was the

Fig. 27. Pierre Paul Prud'hon (1758–1823), *Standing Male Académie*, ca. 1810–20. Black and white chalk, stumped, on blue paper, 24⅛ × 14¼ in. (61.4 × 36.2 cm). Petit Palais, Musée des Beaux-Arts de la Ville de Paris (PPD 245[2])

Fig. 28. Jean-Baptiste Isabey (1767–1855), *Portrait of a Young Woman Seated in a Landscape*, 1793. Black chalk, graphite, heightened with white chalk, 21 × 15¾ in. (53.5 × 40 cm). British Museum, London (2007.7060.1)

professional emblem he adopted for his coat-of-arms when elevated to chevalier of the Empire in 1808. His observation that his last achievement would be *Mars Disarmed by Venus and the Graces* (Musées Royaux des Beaux-Arts de Belgique, Brussels), finished the year before he died and at a scale that he had abandoned a decade earlier, was the ultimate affirmation of this identity. Nonetheless, he could not ignore the ever-greater attention his contemporaries were paying to drawings.

From the mid-eighteenth century, artists began in earnest to produce drawings for the market that were unrelated to their paintings. During the years leading to David's success in 1774 in obtaining the academy's Grand Prix and the royal pension in Rome, the most media-savvy painters—François Boucher, who was an important collector of master drawings; Jean-Baptiste Greuze; and Jean Honoré Fragonard—were reaping the greatest commercial benefits of this new practice.[7] It was not long before some members of the academy sent a set of their own drawings to the Salon, among whom Jean Jacques Lagrenée the Younger was the most emboldened. In 1777 he exhibited a mixed lot of sixteen drawings, including a pair from the "Cabinet de M. le Comte de Puységur," a reference to the patronage of an illustrious noble family meant to impress prospective buyers. The selection suggests a commercial venture with something for every taste and purse: projects for a ceiling decoration; four frieze compositions; religious subjects, including two "petits dessins sur papier bleu" (small drawings on blue paper); and an antique scene that David, away in Rome, could only read about, *The Sabine Women Running to Place Themselves Between the Sabines and the Romans*.[8] In 1785, the painter Jean Bardin

exhibited six drawings of a variety of secular and religious subjects, all presumably finished compositions, that also addressed a buying public: one was lent by a private collector, two were related to major paintings familiar to the Salon public, and the three others probably were shown to encourage picture commissions.[9] David, not wanting to pursue the same direction, sent only two drawings to the Salon in the course of his career: *Frieze in the Antique Style*, in 1783 (cat. 18), and *The Oath of the Tennis Court*, in 1791 (cat. 53). Significantly, however, these works rank among his most carefully executed compositions. There was a commercial motive for exhibiting the latter, as an incentive for visitors to subscribe to the print and thus help finance the painting that David projected on a grand scale for the National Assembly. More importantly, both drawings share the programmatic sophistication of his paintings. Each constitutes an artistic manifesto: the first, of the virile classical vision David was promoting during the 1780s, and the second, of the conventions of history painting applied to the representation of the narrative of the Revolution.

## THE LURE OF ANTIQUITY

The large number of studies that David made, in sketchbooks and on loose sheets, of statues, reliefs, and vases, or after the reproductions printed during the second half of the eighteenth century by his contemporaries, "drunk on antiquity" as Ezra Pound would say,[10] indicate that he surrendered to a broad cultural phenomenon, conveniently labeled *Neoclassicism*, when he made this program his own. During David's first visit to Rome, where he was won over by what he saw, it was a high-minded vogue spurred on by emulation within an international milieu of artists whose aim was to restore the dignity of art and topple the reign of what partisans called, contemptuously, the *manière française*—an allusion to the Rococo culture that French artists recruited by the courts of Europe around midcentury were accused of having disseminated. Of course, in their studies after the antique, each practitioner applied a vision and a graphic style that were always, to an extent, personal. Among David's contemporaries, the creative distance with regard to the antique model could range from aiming for an exact description to endowing the marble with lifelike animation, and even further to offering only a barely recognizable interpretation. The choice of models was no less revealing of personality and purpose: the relief compositions on Roman sarcophagi naturally attracted painters, while sculptors might be more attentive to freestanding statues. Vase painting could quench a yearning for the primitive and the hieratic, while Hellenistic marbles responded to a penchant for movement and emotion. Some artists focused on canonical statues to create a "paper museum," whereas others let their curiosity wander aimlessly, their choice of models dictated by circumstance and opportunity. During David's coming of age, the new appreciation for classical antiquity, like most conversions at first, was a liberating experience and inspired a range of graphic expression that was surprisingly diverse.

In Paris during the period of his youthful admiration for Boucher and Fragonard, David had been led to believe that allegiance to the antique was incompatible with invention and the expression of feeling. His autobiographical notes and the recollections of his entourage all insist on the transformative experience of his direct confrontation with the antiquities of Rome and Naples and on his methodical practice

of sketching to imbue himself with the spirit of the classical corpus. He began in earnest during his years as a *pensionnaire* at the Académie de France in Rome (1775–80) and pursued this exercise even on his second stay, as he wrote to his master, Joseph Marie Vien: "I work during the day on my picture [*The Oath of the Horatii*] and in the evening I draw after the antique."[11] Some contemporaries found it expedient to focus more on the masters who appeared to have acquired an understanding of the visual rhetoric of the ancients: Jean Antoine Julien, called Julien de Parme, was subjugated by the degree to which Anton Raphael Mengs had assimilated the concise Roman fresco compositions of the Villa Negroni, while Peyron venerated the narrative genius of Nicolas Poussin, collected prints of his work, and came close to producing pastiches of his paintings.[12] David made studies directly from statues in order to absorb the balance of a pose and the rhythm of falling drapery; from reliefs he distilled the expressive power of individual figures and the graceful interaction of bodies within groups. He was particularly clever in picking out promising motifs that he later recycled in his own compositions. In that respect, he was more concerned with the spirit of the antique than with the documentary obsessions of scholarly antiquaries. For example, a frieze from the mid-sixteenth century caught his eye high up in the courtyard of the Palazzo Spada, as it managed to reconcile extreme violence and classical harmony. The stucco relief illustrating a *Wild Animal Hunt* with two muscular nudes chasing a lion later served for a group he revolutionized into two sans-culottes savaging a monarch (cat. 55).[13]

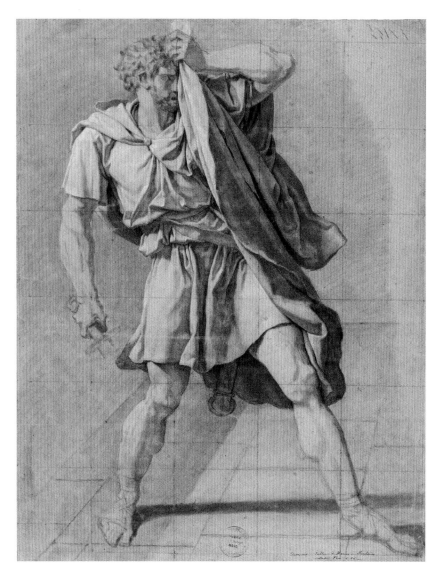

Fig. 29. Jean Germain Drouais (1763–1788), *Study for "Marius at Minturnae,"* 1785–86. Black and white chalk, stumped, 23 × 18⅛ in. (58.5 × 46 cm). Ecole Nationale Supérieure des Beaux-Arts, Paris (EBA 861)

Jean Germain Drouais, David's first pupil to win the Prix de Rome, in 1784, who assisted him in painting *The Oath of the Horatii* (Musée du Louvre, Paris; see fig. 75), imitated his master's assiduity and filled his sketchbooks and albums with drawings of many of the same statues and reliefs.[14] Like David, in his student exercises Drouais sought to capture the underlying structure of antique models, but with greater detachment. When elaborating his *Marius at Minturnae* (Musée du Louvre; see fig. 97), painted in 1786 just one year after *The Oath of the Horatii*, Drouais followed the practice of his master and studied individual figures, but his anxious hand stiffened the linear folds of the drapery, resulting in a marmoreal presence (fig. 29). Critics would eventually find this sculptural vision exceedingly lifeless and contrary to the nature of the pictorial medium. A recently rediscovered drawing by David relates to *Caius Gracchus Leaving*

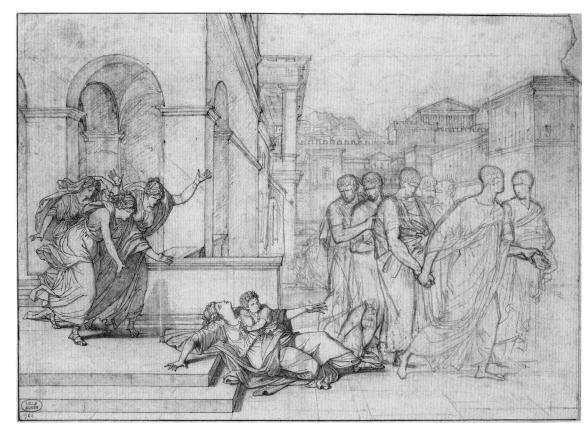

Fig. 30. Jean Germain Drouais, *Study for "Caius Gracchus Leaving His House, Surrounded by Friends, to Calm the Sedition in Which He Will Perish,"* 1787. Graphite, pen and black ink, 11¾ × 16⅞ in. (29.9 × 42.8 cm). Palais des Beaux-Arts, Lille (Pl. 1325)

Fig. 31. Jacques Louis David, *Study for "Caius Gracchus Leaving His House, Surrounded by Friends, to Calm the Sedition in Which He Will Perish"* (after Jean Germain Drouais), 1787–88. Graphite, light brown ink and wash, 4½ × 7⅜ in. (11.5 × 18.7 cm). Private collection

*His House, Surrounded by Friends, to Calm the Sedition in Which He Will Perish*, the painting in progress by his pupil before his fatal illness (fig. 30).[15] David reworked the group comprising the afflicted wife of the imperiled hero and the couple's child (fig. 31). An annotation explains that the main female figure, given her social status in the composition's narrative, should be more decorously posed.[16] The critique illustrates a conceptual imperative anchored in David's eighteenth-century academic and Enlightenment culture that was beyond the reach of most followers and imitators.

Concurrently, David's devotion to nature steered clear of a purist trend in the *retour à l'antique* that Suvée, a successful rival whom David scapegoated, was among the first to explore. Around 1800, the tendency gave rise to the archaizing program of a group of pupils, known as the Primitifs, whose radical formalism in the name of the antique challenged David. And yet, even though their bravado exasperated him and led to their expulsion from the studio, he was receptive to their ideas. As he went through the steps to create *The Intervention of the Sabine Women*, he let his pen and pencil work out the composition with full confidence in his training (cats. 64–66), but when taking up the brush he made concessions to an unprecedented idealism that overrode the vigorous naturalism he had until then espoused.

On account of his early death, it is impossible to know how Drouais would have matured and whether or not he would have found an independent course, like his fellow pupil Anne Louis Girodet, who openly strived to clear his work from any recall of David's manner. A paradoxical result of the impact of David's heroic style of the 1780s on this generation of aspiring artists was to lessen the need for the methodical study after the antique that his own personal epiphany had required. The recently published Italian sketchbooks of Gros are telling in this regard. Traveling across the peninsula from 1793 to 1801, initially to get away from the turmoil in Paris, he occasionally studied famous antiques and artworks by canonical masters, some of the same that were drawn by David, Drouais, Prud'hon, and many others; however, his curiosity was disorderly and open-minded, inclusive of little-known Italian artists and contemporary productions that appealed to him as much as did the ancient marbles.[17]

## The Impact of the Museum

The terms of the treaties imposed after Bonaparte's successful military campaigns in Italy during the Directory modified how artists accessed and studied antiquities. The French victories brought to Paris a number of the most famous works from Italian, and especially Roman papal, collections as the spoils of war. The procession of carriages bearing this bounty was ceremoniously received on July 27, 1798, the fourth anniversary of the fall of Robespierre. Their permanent exhibition on the ground floor of the Louvre incited artists to rely for their inspiration on a relatively small and particularly famous set of statues. As a consequence of this access, some artists believed that the formative Italian tour could be dispensed with, especially in times of economic hardship. But as opponents of the transfer of the antiquities to Paris had forewarned, once cut off from their cultural context, the statues lost much of their aura and instead became objects of calculating study.

The reproductive prints after antiques in major collections produced by French draftsmen and engravers after 1789 contributed further to this move away from interpretation in front of antique models. The drawings of the Medici cameos and reliefs in

the Uffizi and Pitti palaces of Florence that Jean-Baptiste Joseph Wicar, an early pupil of David, provided in connection with a monumental publishing enterprise financed by one of the master's wealthy patrons, Philippe Laurent de Joubert, are carefully finished renderings of seemingly lifeless figures.[18] Classical-minded critics showered praise on Wicar, who had been "raised from childhood with a love of the antique and the principles of the great masters" and "preserved early on from the contagion of French taste in the school of M. David."[19] The increasing authority of this documentary aesthetic, a power grab by the antiquarians in charge of the museum collections, doused the historical imaginary that had inspired the rediscovery of the classical past for David's generation. The publication of the four volumes of *Le musée français* between 1803 and 1809 capped this change.[20] It included about eighty prints of antique statues, after drawings by a host of younger draftsmen who were no doubt happy to have found such work, among them Ingres and several other lesser-known pupils of David. The broken limbs of the marble figures are scrupulously reproduced, but surface imperfections are smoothed over with hard precision. And unlike the approach taken by David, who breathed life into them and suppressed the pedestals in his studies after statuary, in these representations of museum collections, the bases of the statues are present. The stage was thus set for the Romantic generation to see in this petrification of the antique, carried over into history painting, a manifestation of decadence with its origins in David's influence.

While the new museum setting altered artists' perception of antiquities on its ground floor, it concurrently encouraged greater consideration of drawings as works of art on the main floor above. On August 15, 1797, the Musée Central des Arts, known today as the Musée du Louvre, exhibited nearly three hundred old master drawings, formerly hidden away in the royal collection, for the most part. With only minor changes, this presentation of works remained on view for nearly five years. In January 1794, David had presented a report to the National Convention incriminating the faulty governance of the museum and demanding a greater concern for the instruction of artists and the public. He stressed that all in the audience, "and me more than anyone," ignored "the immense collection of drawings by the greatest masters" that were willfully hidden from view.[21] The unprecedented access to such a broad range of works on paper in 1797 surely made Parisian artists, and David in particular, more alert to the medium as an instrument by which to fortify their reputations.

One reviewer of the exhibition for a progressive journal seized the occasion to advocate for the superiority of drawing over painting. Indeed, for him, the exhibition was a momentous revelation:

> From this simple crayon, one likes to imagine the sort and harmony of colors and visual effects the painter must have given his painting; one looks for the sensations left in his memory by the sight of the broad strokes of nature, and there one finds them with a frankness fully intact. This is because they have not been recast, weakened and denatured by some extraneous meddling, produced all too often by the habit of applying rules; because they have not been deadened by the stubborn pretension of a chore that often only serves to blunt its salient characteristics; and finally because they have not been subjected to the tyrannical caprice of a rich

Fig. 32. Constant Bourgeois (1767–1841), *Exhibition of Drawings in the Galerie d'Apollon of the Louvre*, ca. 1802. Pen and black ink, brown wash, 13¼ × 17⅜ in. (33.6 × 44 cm). Musée du Louvre, Paris (RF 29455)

amateur who takes over, for the glory of giving directions, just as he commands the form of his waistcoat or his shoe.

Yes, [drawing] is where the Artist is often superior to himself, but always himself, and only himself.

Oh you, who intend to study painting, go often to this gallery; go and collect the most secret notions of your art; the portfolio of your masters is right before your eyes; the secrets of their compositions are given away to you; the Republic has conquered for you down to their first thoughts."[22]

David would have been sympathetic to the call to set aside rules and abide only some general principles, but he hardly would have gone along with the implicit reversal of the traditional hierarchy of mediums as the measure of artistic merit, the perspective favorable to drawing already intimated by Dézallier d'Argenville. The view expressed by the reviewer signals an emergent Romantic sensibility that establishes the artist's personality as the key factor of his work. Another facet of this paradigmatic shift is the affirmed superiority of the museum over the master's studio as a school for painters and the ideal of a creative autonomy freed from the transactional conditions of patronage and support. Though the Louvre exhibition in 1797 in no way undercut the prestige of painting, magnificently on show nearby in the Grande Galerie, it reinforced the appreciation of drawings as the most unmediated expression of the artist's genius.

The accompanying catalogue vaunts the "original drawings, cartoons, gouaches, pastels, enamels and miniatures . . . exhibited for the first time in the Galerie d'Apollon," and museum administrators expressed regret that the collection had until then been "inaccessible to the public and to artists, who were grief-stricken to be deprived of such a potent means of study."[23] The choice of a palatial setting (fig. 32), decorated with magnificent tables, porcelain vases, and tapestries, partook of the initiatives pursued by the Directory, the five-man executive board in power since October 1795, to bolster its authority by restoring the princely trappings of government spurned under Robespierre's rule. Framed and mounted under glass, the selected sheets were judged to be the most important works of each master in the national collection. Most prominently on display was the Italian school, with nearly two hundred drawings; those of the Northern schools were limited to under ninety.

Of the 115 drawings of the French school, only three represented the second half of the eighteenth century: a minutely detailed subject from ancient history by Cochin, a richly inked bacchanale (more exactly, *The Education of Bacchus*) by Louis Félix de La Rue, and a picturesque seacoast scene by Alexis Nicolas Pérignon, dated 1777.[24] This modest and peculiar selection ignored the masters of the period and put a strain on the museum's policy of functioning as a pantheon for deceased artists. Nonetheless, the exhibition introduced artists to the opulent new home that might one day enshrine their drawings. For David, who upheld his republican ideals, the museum created an alternative destiny for drawings that had generally been either passed on to assistants and pupils, allowing them to prolong the commercial success of the master, or increasingly, as the studio replaced the workshop, sold to private collectors, a prospect that inevitably brought with it the whiff of aristocratic privilege.

## Capital Drawings

Early in his career, David was responsive to the tastes of those who collected what Johannes Wilde has designated "presentation drawings"—that is, accomplished works without the visual traces of study and experimentation. A deliberate sense of compositional harmony, thoughtfully controlled execution, and, often, a sizable format constituted the key identifying qualities of such drawings, and the hyperbolic language used in the eighteenth-century saleroom to describe them—*dessin capital*—encouraged their production.[25] David's large-scale and elaborately composed *Combat of Diomedes* (1776; cat. 15) and *Funeral of Patroclus* (ca. 1778; Musée du Louvre) exemplify his respect for this standard of his time.

While a *pensionnaire* in Rome, David still dreamed of his upcoming integration into the community of elder artists and aristocratic patrons who ran the academy, not yet fully aware that, once back in Paris, he would feel alienated by their entrenched conservatism and hierarchical obsessions. Upon his arrival in Rome, he sought manifestly to emulate the *Battles of Alexander the Great* of Charles Le Brun, a touchstone for the French school widely known through the set of engravings by Gérard Audran, which to this day remain a decorative fixture in many *hôtels particuliers* and châteaux. He may have found a more recent stimulus in the graphic work of the contemporary sculptor Augustin Pajou, who was less inhibited than the painters of the academy in providing his historical imagination with a vast stage. In 1771, Pajou exhibited a powerful drawing of *The Roman Army*

Fig. 33. Augustin Pajou (1730–1809), *The Roman Army under Camillus Assaulting the Temple of Juno at Veii*, 1771. Black chalk, pen and brown ink, brown and gray wash, heightened with white, on two joined sheets, 20⅝ × 37¾ in. (52.5 × 96 cm). Private collection

*under Camillus Assaulting the Temple of Juno at Veii* (fig. 33), which he then had engraved with a complaisant dedication to the administrative overseer of the academy. At the time he produced his two Homeric drawings, David no doubt found appealing the kind of unbounded drama deployed by Pajou, described by James David Draper as "orchestrated, almost in a wide-angle, cinematic sense."[26] It was a manner of drawing that David mastered by relying on and showing off all he had learned up to that point. However, as he came to better understand the qualities of restraint found in the antique and in the works of eminent painters, especially Raphael, Poussin, and Mengs, he suppressed this predilection for compositional grandstanding.

That David's early Homeric compositions are not hemmed in by architectural elements may have been purposeful: perspective was not his forte. The architecture in the background of his prize-winning composition of *Antiochus and Stratonice* (see fig. 52) in 1774 is illogical and perfunctory, though more stable than the swirling decor he had imagined the previous year for *The Death of Seneca* (Petit Palais, Paris). In 1782, when the subject of *The Elder Horatius Defending His Son after the Death of Camilla* retained his attention and inspired several studies, the depiction of a simple flight of stairs viewed from a high angle was visibly a challenge. He soon made the most of the shallow, boxlike spaces borrowed from Poussin, which were easier to handle. Later, for his most ambitious compositions—those which called for a vast interior setting—he relied on the help of stage designers, a collaborative process that accounts for the web of perspectival lines traced on some of his drawings (see, for example, cat. 67). This professional assistance did not

ELDERS, CONTEMPORARIES, AND PUPILS: DAVID'S DRAWINGS IN CONTEXT    47

Fig. 34. Guillaume Guillon Lethière (1760–1832), *Brutus Condemning His Sons to Death*, ca. 1788. Black chalk, brown and gray wash, 14 × 24½ in. (35.6 × 62.2 cm). Sterling and Francine Clark Art Institute, Williamstown, Mass. (2018.1.2)

always preclude fault-finding by critics, such as the anonymous pamphleteer unhappy with the depiction of the nave and choir of Notre-Dame Cathedral in *The Coronation* (Musée du Louvre; see fig. 126), filled with more than a hundred figures: "No air, no impact, no perspective."[27]

Whereas for David the horizontal format implied the shallow space of sculptural relief, several other artists adopted the wide-angle composition to give depth to historical narratives teeming with figures. These are generally executed on the scale of presentation drawings and enriched with *péripeties*—groupings marginal to the main action that Poussin developed to introduce diachronic nuances in his compositions. It was a practice that David rejected after his conversion to the antique. In the 1790s, much to the dismay of critics who held fast to academic principles, some artists even experimented with a mode of composition without a determined focal point, a novelty they justified by pointing to the narrative modes of the ancients.[28]

Once David's powerful history paintings of the 1780s had set a new benchmark for the French school, they were widely imitated. For a term, many painters were impressed and adopted the closed stage and focused composition of this model. It was clearly a comfort zone for some, while others found this claustrophobic vision needlessly restrained and unpleasant. They aspired to situate their episodes from ancient history in vast and bustling urban spaces. Arguably, the forum rather than the domestic space dear to David was more in tune with the political urgency of the consultations and debate going on in every corner of society, years before the Revolution converted the

outpouring of words into action. David's study for *The Execution of the Sons of Brutus* (see fig. 96) called for an elaborate historical stage, a vast esplanade able to accommodate the Roman population assembled to witness the punishment of the traitors to the Republic. He may have been wary of the demands of such a composition, and also reticent to join those artists who increasingly curried public attention with explicit scenes of violence and bloodshed. Left unfinished, the sheet is a testimony to his decision to back away from this iconography and to imagine instead the execution's tragic consequences for the family of the consul.

A pupil of Gabriel François Doyen, the history painter who best understood and upheld the narrative conventions of the Baroque masters, had no such misgivings. Guillaume Guillon Lethière built his reputation on a surprisingly similar composition of *Brutus Condemning His Sons to Death*—more precisely, the gruesome beheading in progress—a project that appears to have been a lifeline to keep his career afloat for a quarter of a century. His earliest studies date from the late 1780s, while a *pensionnaire* in Rome. A finished sketch he claimed to have painted in 1788 was exhibited in 1795 and again in 1801; a large print of the composition, in 1798; and at last, in 1812, the huge canvas, now hanging in the Louvre, that does away with the controversial figure of the executioner holding aloft the head of one of the sons. In an early study for the composition that has recently come to light (fig. 34), Lethière's loose brushwork is alien to David's careful application of wash, which gives volume and weight to his figures. The latter artist, who by the 1780s valued sharpness and precision, would have judged slovenly this fluid manner that recalls some late drawings by Jean-Baptiste Greuze and gives priority to

Fig. 35. Jean Simon Berthélemy (1743–1811), *Manlius Torquatus Condemning His Son to Death*, 1774. Black chalk, gray wash, heightened with white gouache, on blue paper, 16⅛ × 22⅞ in. (41.2 × 58.1 cm). Private collection

Fig. 36. Pierre Peyron, *Study for "Athenian Youths and Girls Drawing Lots to Determine Those to Be Sacrificed to the Minotaur,"* ca. 1796. Pen and brown and black ink, brown wash, red chalk, on blue paper, 18 × 33⅜ in. (45.7 × 85.3 cm). Musée du Louvre, Paris (RFML.AG. 2018.41.1)

expediency and overall effect. The fusion of all the elements of the composition into an organic whole was a heritage of midcentury practice. It also characterizes a large drawing of *Manlius Torquatus Condemning His Son to Death* by Jean Simon Berthélemy, dated 1774 (fig. 35), generously swathed in strokes of black crayon and white gouache. More than ten years later, in 1785, Berthélemy sent to the Salon a painting of this example of harsh military discipline, today in the Musée des Beaux-Arts in Tours. Though transformed under the influence of David's heroic manner, Berthélemy was nonetheless criticized for "indulging himself in his facility," a remark even more suited to the earlier drawing.[29]

Peyron illustrated a full range of grief and pathos in his perversely patriotic *Athenian Youths and Girls Drawing Lots to Determine Those to Be Sacrificed to the Minotaur* (fig. 36), a subject he began to compose in Rome in 1777 and reworked for more than two decades.[30] The drawing illustrated dates from about 1796, when Peyron revised his composition to satisfy an engraver eager to reproduce it. Like Poussin, he preferred painting cabinet-size pictures and never managed to carry out this project on the grand scale of royal commissions, the accepted measure of superior talent upheld by David's Salon blitz during the 1780s.[31] Whereas the draped figures in Peyron's design form graceful interlocking groups, he reveals some shortcomings when he purports to study them in the nude. This step to ensure the veracity of the pose was standard practice for David and Vincent (fig. 37), but generally bypassed by Peyron. His virtuosity resided instead in the intricate draping of his figures, a penchant that early on his professors found fussy.[32] His graphic manner appears relatively brittle and cautious, lacking the energy released by Lethière.

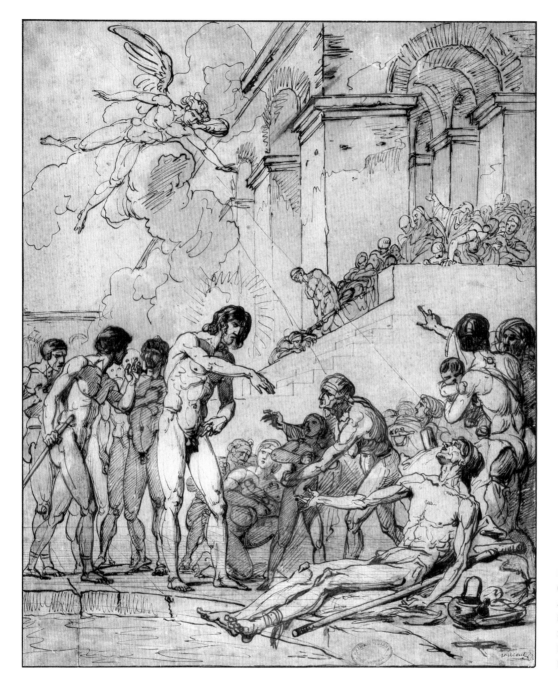

Fig. 37. François André Vincent (1746–1816), *Christ Healing the Sick*, ca. 1779–82. Pen and black ink, brown wash, over black chalk, 21¾ × 17¾ in. (55.2 × 45.2 cm). National Gallery of Victoria, Melbourne (1278.933-3)

Vast civic themes were particularly attractive to Jean Pierre Saint-Ours, only four years younger than David and also a pupil of Vien. In 1780, he was awarded the Grand Prix for painting and traveled to Rome to complete his studies, at his own expense, since, as a foreigner, the Geneva-born laureate was denied the royal pension. Before he left Paris, Saint-Ours composed a subject with political resonances found in Plutarch's biographies of great men, *Titus Quinctius Flamininus Granting Liberty to Greece at the Isthmian Games* (fig. 38). The victorious Roman consul was admired by Johann Joachim Winckelmann for his magnanimity toward the Greeks he had vanquished, as Francis Haskell has pointed out.[33] Saint-Ours imagines the reaction to the official gesture: effusions of joy and gratitude

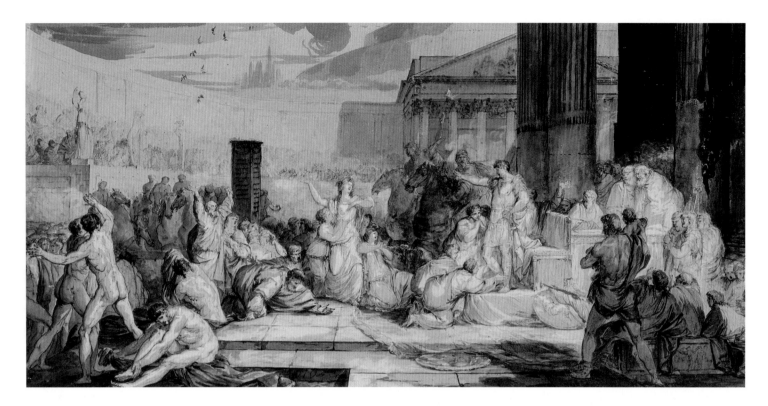

animate the mixed crowd, framed by the nude athletes on the left and the robed dignitaries on the right. He employs a fine pen to sketch in his composition with nervously applied scratches; highlights in white gouache lend a sense of form; and selectively applied areas of wash that embrown the sheet provide a degree of depth and spatial coherence.

Designers for the theater and opera were naturally inclined to adopt these extensive settings for full-fledged drama. Most daring was Louis Jean Desprez, who created extravagant drawings in this vein. Haunted by the darkest moments in ancient history, he relished recreating visions of antique cities engulfed in smoke and flames as sites of massacre and horror. A composition Desprez replicated several times during the years 1785–95 was particularly successful with collectors. It is directly inspired by Diodorus of Sicily's macabre details of the siege of the Greek city of Akragas (later Agrigentum) directed by the Carthaginian army of Hannibal Mago (fig. 39).[34] At one point, as the assailants were destroying the tombs in front of the city walls in order to construct assault ramps, lightning struck a particularly important monument. This event was interpreted as an ill omen by the Punic army, which was then being decimated by a mysterious malady. Above a field of unearthed skeletons and cadavers, Desprez represents the Carthaginians overcome by natural forces run amok and crumbling constructions, a geometry of chaos that is an ironic reminder of his success in 1776 for the Prix de Rome in architecture. The closest David ever came to admitting a hint of mayhem in his work was during the years 1790–91, when he attempted to characterize the disruptive force of a revolution in the making. In the project for the allegory commissioned by the city of Nantes in 1790, frenzied citizens hurry to find refuge on a docked ship, but their disorderliness is carefully calculated across the composition (cat. 49). In the famous drawing for *The Oath of the Tennis Court* (cat. 53), the lives of the assembled deputies are also endangered by the threat of an

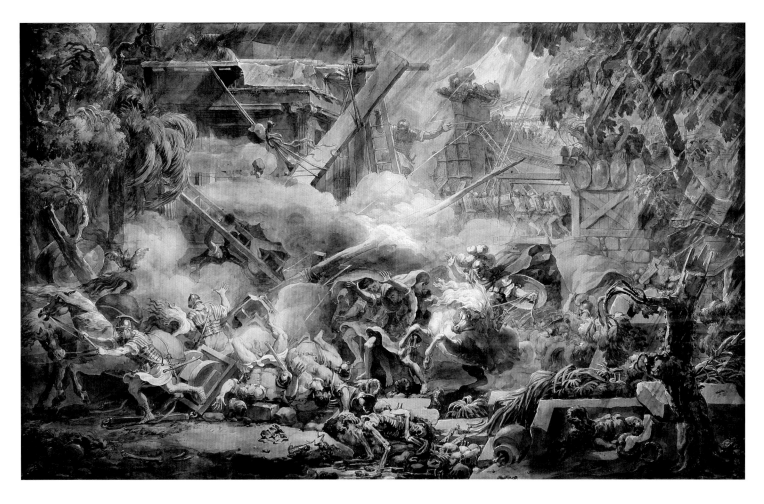

Fig. 39. Louis Jean Desprez (1743–1804), *The Siege of Agrigentum by the Carthagnians*, ca. 1785–95. Black chalk, pen and gray ink and wash, watercolor, heightened with white, 23⅛ × 38⅞ in. (59 × 99 cm). Musée du Louvre, Paris (RF 54234)

imminent massacre, but the repeated gesture that expresses their shared purpose creates a powerful image of resistance and unity. The billowing curtains suggest nature's response to the action of the deputies, but the lightning made to strike the royal chapel of Versailles in the background is indeed timid, and rather ineffective in comparison to the way Desprez unleashes the destructive ire of the gods.

Throughout his life David manifested a deep interest in the theater and opera, but he was less interested in the increasingly melodramatic effects he saw onstage than in the new historical decorum of the costumes, an evolution owing in part to his paintings. He was also receptive to the music, which helped "warm" his brush and his soul, as he wrote to the composer Jean François Lesueur of his enthusiasm for *Ossian, ou Les bardes* in 1804.[35] He does not appear to have furnished drawings for the stage, despite the solicitations he received from actors such as Joseph Talma and playwrights such as Antoine Vincent Arnault, who sought the same degree of historical verisimilitude in their productions that they admired in the artist's vision of ancient Rome. The history painter Berthélemy, who, as mentioned above, shared the limelight with David at the Salon of 1785, also developed a fruitful parallel career as a designer of costumes for the opera from about 1787 to 1807, including those for Lesueur's *Ossian* (fig. 40). More than fifty drawings are preserved, many lightly colored, revealing a historicist sensibility capable of imagining a broad diversity of cultures.[36]

Fig. 40. Jean Simon Berthélemy, *Costume Studies for "Ossian, ou Les bardes" (Ossian as Bard and as Hunter, Hydala as Bard)*, ca. 1804. Graphite and watercolor, 9½ × 15⅞ in. (24.2 × 39.8 cm). Bibliothèque Nationale de France, Paris

## NEW DEMANDS, NEW PRACTICES

David's academic training and public success during the thirty-year period leading up to the Revolution cemented his concern that his work on paper should serve his ambition as a history painter. His drawings manifest a range of subjects, formats, and techniques that demonstrate the extent of his ease with the medium. However, one cannot help but feel that his aspirations as a painter bridled his graphic practice. He rescinded this position under the pressure of the moment, when in September 1793 the Committee of Public Safety ordered him to organize a visual response to the British caricatures, notably those by the hard-hitting James Gillray, that depicted the French as a repulsively uncivilized nation. The following March, David submitted to the committee two unsigned prints as his designs, whose forced naiveté suggests a high-minded artist's discomfort with the genre of caricature (fig. 41). Since no sketch in connection with these compositions is known, it cannot be ruled out that he relied on the assistance of a pupil. By contrast, the designs for a suite of official costumes that he executed under the same auspices are easily recognized as his own (cats. 56–57).

The welcome support that artists received under the revolutionary and imperial regimes came with the duty to service their aims. David was no doubt aware that the public recognition and positions of influence he so eagerly sought entailed demands on his talent far removed from the imaginary of antiquity and mythology that inspired him most. From this perspective, *Allegory of the Revolution in Nantes* and *The Oath of the Tennis Court*, as has often been noted, were bids to preserve his long-ingrained practice as a history painter while accommodating the call for artists to confront directly their own times. Once named "First Painter to His Majesty Emperor Napoleon," he put aside *Leonidas at Thermopylae*, the subject from ancient history that he wanted to pair with the *Sabines*, to work on the commissioned suite of four immense coronation scenes, two of which he managed to finish between 1804 and 1810 (see figs. 126, 135). As court artist, he

EXPLICATION

N.º 1. *George-Roi d'Angleterre, commande en personne l'élite de son Armée Royal-Cruche N.º 2. Il est conduit par son Ministre Pitt ou Milor Dindon N.º 3 qui le tient par le Nez pour mieux lui prouver son attachement. L'avant-Garde de la Royal Armée N.º 4 reçoit un échec à la porte de la Ville N.º 5 qui est occasioné par la colique de quelques Sans-Culottes placés au haut de la Porte N.º 6. L'avant-Garde dans sa défaite brise les cruches, dont il ne sort que toutes sortes de Bêtes venimeuses N.º 7 qui est l'esprit qui les animes. Fox ou Milord Oie N.º 8 ferme la marche monté sur sa Trompette Angloise et qui témoin de l'échec sonne un rappel en arrière par prudence. Artillerie Angloise nouvelle N.º 9 qui a la vertu d'éteindre les incendies et de délaïer les fortifications.*

also had the traditional responsibility of approving and occasionally correcting designs of all sorts, for wall hangings, ceremonial furniture, and even playing cards.[37] Though David and most of the art critics of his time upheld the moral superiority of history painting, artists were increasingly distracted from this genre in the society reconfigured by the Revolution.[38]

David employed his painted portraits to further his reputation at the Salon, but his drawings in this genre remained for him a private affair. Those already mentioned of fellow prisoners (cats. 58–63) are the ones executed with the most care, while those of friends and family, produced especially during the Empire and his years of exile in Brussels, are more casual and even intimate (cats. 82–84). Generally conceived as gifts, these portraits were instrumental in sustaining his network of partisans after the devastating blows to his reputation in the aftermath of his blind allegiance to Robespierre. Content with this limited output, he remained indifferent to the extraordinary rise in demand for small-scale portraits during his lifetime. Ordinary citizens came to feel

Fig. 41. Anonymous printmaker after Jacques Louis David, *George III Leading an Army of Jugs*, 1794. Etching with watercolor, 11¹³⁄₁₆ × 19⅝ in. (30 × 49.8 cm). The Metropolitan Museum of Art, New York, Purchase, Ellen Peckham Gift, 2015 (2015.456)

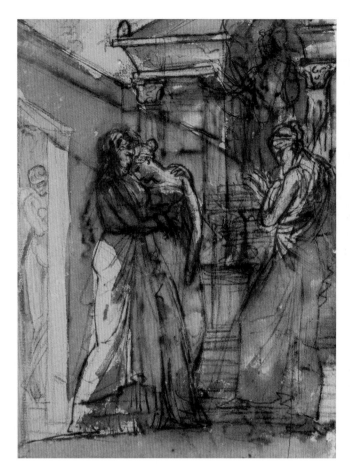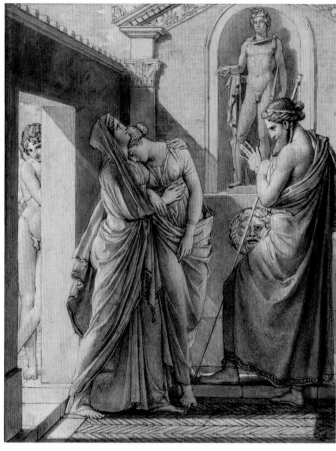

Fig. 42. François Gérard
(1770–1837), *The Father
of Psyche Consulting the
Oracle of Apollo*, ca. 1796.
Black chalk, pen and brown
ink, wash, 7¼ × 5½ in.
(18.4 × 14 cm). Private
collection

Fig. 43. François Gérard,
*The Father of Psyche
Consulting the Oracle of
Apollo*, ca. 1796. Pen and
brown and gray ink, brown
and gray wash, heightened
with white gouache, over
black chalk, 7⅜ × 5¾ in.
(18.9 × 14.6 cm). J. Paul
Getty Museum, Los Angeles
(92.GA.108)

deeply that their lived experiences mattered, an awareness encouraged by the writings of
Jean Jacques Rousseau and political philosophers like Emmanuel Joseph Sieyès, whose
influential pamphlet, "What Is the Third Estate?," contributed to the advent of the
Revolution. This shift in public attitude stimulated a market for miniatures, mechani-
cally executed physionotraces, and drawings in all kinds of formats, often embellished
with verses and ornamental surrounds.[39] That this field was overtly commercial probably
added to David's recoil from any participation. In 1789, the demand for portraits of the
mostly unknown representatives of the nation, and later of the generals who repelled its
enemies and ensured its defense, provided work for a great number of draftsmen, includ-
ing David's pupils Gros and Isabey. Indeed, after Thermidor, Isabey emerged with his
drawings and miniatures as one of the most sought-after artists by the fashionable society
of the capital. Blessed with a fine figure and exceptional social skills, he went on during
the Empire to endear himself to a new clientele, the members of Napoleon's family
and entourage.

Prominent artists earlier in the eighteenth century such as Boucher and Fragonard
had willingly furnished editors with drawings intended to be engraved as book illustra-
tions. But unlike his fellow history painters Peyron and Prud'hon, David never put his
talent at the service of any editorial ventures, a recalcitrance explained by a number of
factors. Throughout his career, his success meant that he was almost never in need of
work and income. He may have thought it belittling to have his compositions reproduced

in the format of book illustrations, and he did not enjoy collaborating with engravers, whom he viewed as parasites living off the work of creative artists.[40] When the editor Pierre Didot, about 1790, pressed David to contribute to his luxury publishing projects, arguing for the need to set book illustration on a par with his revolution in painting, the master transferred the commission to his pupils Gérard and Girodet.[41] For more than a decade, Gérard furnished a great number of drawings for Didot's editions, including four for Jean de La Fontaine's *Les Amours de Psyché et Cupidon*, which he then sent in a single frame to the Salon in 1796, an initiative suggestive of his esteem for such work. Two sheets roughly the same size for one of the subjects, *The Father of Psyche Consulting the Oracle of Apollo* (figs. 42, 43), show how he responded to the task. In the first study the architectural space is defined by the four well-positioned figures: Psyche; her mother, in whose arms she seeks comfort upon learning from the oracle that she will wed a monster; her surprised father; and, somewhat in hiding, Cupid the schemer.[42] However, the application of wash to render the chiaroscuro is still hesitant. The second drawing, the final state of the composition that was presumably exhibited, is highly finished, ready to be reproduced by the engraver. Gérard's controlled execution, rich detailing, and sensuous technique—two shades of ink and wash; white gouache highlights—create a graphic manner consonant with the sense of smooth perfection that was the hallmark of his paintings at the time. Girodet, who also produced some highly finished drawings for Didot, underscored the artistic merit of such work that David most likely judged to be miscalculated exertions:

> Drawings have the shortcoming of being only drawings, even though they require the same vision and almost the same amount of study as a picture, when one has the nerve to aim for style and character; the only difference is the process of execution. The artist who is successful in these sorts of drawings can only be a history painter, or a sculptor who can rightfully expect to achieve success in his own field.[43]

During the Empire and when in exile, David drew several historical compositions unrelated to paintings whose formats recall his pupils' illustrations for Didot (see, for example, cat. 74). However, no doubt intentionally, they lack the detailed precision required for reproduction by an engraver.

## Color

There are few traces of color in David's graphic oeuvre. Once he settled on his mature manner of painting, one that conservative critics found exceedingly dark, he abandoned red chalk and gouache, aiming for a comparable gravitas of style in his drawings obtained by a slimmed-down technique, most often graphite, black chalk, pen, and wash. Among the draftsmen of his generation, some, like Vincent, never totally gave up red chalk. In general, they admitted gouache highlights only sparingly, though an exception was Bardin, whose historical subjects demonstrate a remarkable mastery of this sensuous, creamy medium, with a wealth of gossamer touches that veil the figures in a web of flickering light (fig. 44). It was left up to younger artists, most forcefully Théodore Géricault, to discover in bold applications of white gouache a means to accentuate the dramatic presence of his figures.

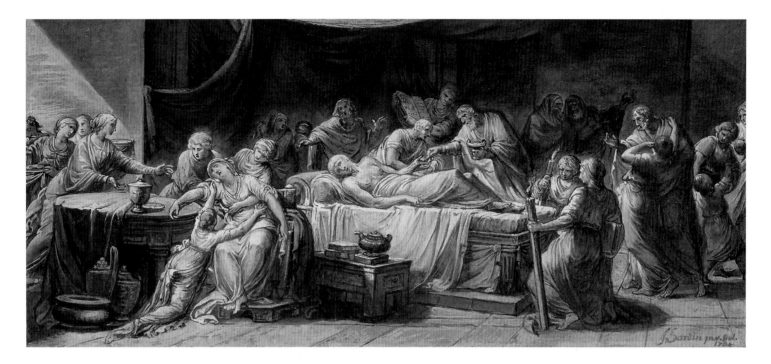

Fig. 44. Jean Bardin (1732–1809), *Study for "Extreme Unction,"* 1783. Black chalk, brown wash, heightened with white gouache, 6⅞ × 15⅞ in. (17.5 × 40.2 cm). Private collection

Nonetheless, David flirted occasionally with coloristic effects, as when he designed the official costumes for the republican administration. In need of a way to specify the aspect of the fabric, he preferred the visual appeal of watercolor rather than simply making written annotations (cats. 56–57). In order to fix the color harmonies of a composition before its reworking on canvas, he invented a hybrid technique of sketching whereby the drawn lines are not overridden by the loaded brush, as if he wanted to keep this pictorial shift in check (cats. 22, 47).

David was hardly alone in avoiding the play of color, inevitably linked to the manner of drawing most appreciated during the reign of Louis XV. The popularity of the *dessins aux trois couleurs*, executed in black crayon, red chalk, and white chalk, was such that it led to the development of print techniques capable of reproducing them. The fashion for the framed *gravure en couleurs*, a term that covers several distinct techniques,[44] further suggests that this pictorial conception of drawing enjoyed wide appeal at the time. In the decades preceding the French Revolution, however, the fascination of history painters for the marble debris of antiquity revived a long-felt mistrust of the unruly nature of color among the constituents of the work of art.[45] Cochin, in his *Lettres à un jeune artiste* of 1774, expressed alarm over the effects of this proscription, having seen in recent years a number of *pensionnaires* set out for Rome "full of warmth" ("pleins de chaleur") and come back "completely cold-blooded" ("entièrement refroidis").[46]

Over the course of David's lifetime, color-mindedness as an element of everyday experience was freed from the shackles of aristocratic privilege. Heightened attention was given to skin color, a subject discussed previously mostly in terms of fashion and aesthetics. However, racial considerations were increasingly present during a period traversed by the abolition of slavery by the National Convention in 1794 and its reestablishment by the first consul in 1802. Between those dates, the presence at the Salon of authoritative paintings that celebrated the restored humanity of Black men and women attests to the

engagement of several artists with color in such terms. Following Bonaparte's Egyptian military campaign of 1799–1800, depictions of the diverse populations of the eastern Mediterranean confronted painters with similar concerns. Another fallout from this adventure was a much deeper curiosity among artists and costume designers for the richness of oriental costumes and motifs.

The obsession with classically inspired whiteness finally abated during the Empire, as women donned deep-colored velvets. Officers paraded like peacocks, and despite the trend toward more sober uniforms, colorful garnishes, bouquets of insignias and ribbons, and glittery metal-thread embroideries endured. As is well known, even before the proclamation of the Republic in 1792, citizens eager to manifest their support for the Revolution adopted the patriotic combination of red, white, and blue on a variety of supports, an identification not lost on British caricaturists. Though the latter persisted in associating Napoleon with these colors, the pageantry of empire adopted the chromatic splendor of monarchy—deep reds and greens—and a great deal of gilt. The minds of royalists were also filled with colors. Considering the republican and imperial regimes to be illegitimate, they evoked them with a different palette: the metallic gray of the guillotine's blade, the blood red of its victims, and the fiery hues of Dante's *Inferno*. All were the rich colors of a modernity that emerged in the paintings of the period but rarely in the drawings.

The fall of Robespierre in the summer of 1794 put an end to the Terror, the code word contemporaries used to evoke the months of indiscriminate and bloody repression for which he was deemed responsible. But the widely felt sense of liberation from anxiety and duress did not translate into an outburst of color on paper in artists' studios. Crayons, inks, and washes, though offering only a restricted range of shades, remained the most convenient and accessible graphic technique at the time. Coloration still recalled the commercial spirit of the ancien régime and of the lower-brow taste for popular

Fig. 45. François André Vincent, *An Archer and a Gardener, after Figures from the "Months of Lucas" Gobelins Tapestries*, ca. 1780–90. Pen and brown ink, watercolor, over black chalk, 11⅜ × 17⅜ in. (29 × 44 cm). British Museum, London (2010,7085.2)

Fig. 46. Benjamin Zix (1772–1811), *Nuptial Cortege of Napoleon and Marie Louise in the Grande Galerie of the Louvre* (2 parts of 4), ca. 1811–13. Graphite, pen and black ink, watercolor, left: 9 × 35⅜ in. (23 × 90 cm); right: 9 × 32¼ in. (23 × 82 cm). Musée du Louvre, Paris (RF 54935, RF 54936)

imagery, as well as the dryness of scientific illustration, informative but fundamentally inexpressive. Among the painters of David's generation, Vincent was not put off by the documentary practice of coloring, for it served his historical curiosity (fig. 45). Benjamin Zix, one the main visual chroniclers of the Empire, laid out on four sheets totaling more than three meters in length the *Nuptial Cortege of Napoleon and Marie Louise in the Grande Galerie of the Louvre* (fig. 46). Here, color was required because it was to be reproduced by the painters of the imperial porcelain factory at Sèvres on a colossal commemorative vase, a project that did not survive the Bourbon Restoration. Under the influence of English and Swiss artists, watercolor became more common, but it required a specific training and implied adopting a pictorial aesthetic when drawing that many painters found unfamiliar and even threatening. It was especially attractive when depicting natural landscape and during the Empire for capturing the energy of battle scenes.

The younger generation who flooded the Salon with artwork during the Directory and the Consulate, however deeply they continued to admire the antique, were less concerned than their masters in rejecting the decorative charm valued during the eighteenth century. On the contrary, the insouciant art of the ancien régime tended to exercise their curiosity. Under the cover of satire, the *Journal des arts* published an animated back-and-forth during the months of December 1801 and January 1802 that gave voice to a provocative celebration of the merits of eighteenth-century painting and jokingly treated the "innovations" of Vien and David as bad taste ("mauvais goût")—the supreme insult, which up to that point had only been applied by critics to the art of Carle Vanloo, Boucher, and their epigones.[47] Surprisingly, it was not David's pupil Gros, credited with reviving the Venetian and Rubensian tradition of coloristic painting about 1800, who pushed a parallel restoration in drawing but, rather, Girodet and Ingres. The first gave some robust pastel strokes to a series of studies for *The Revolt at Cairo* (Musée National des Châteaux de Versailles et de Trianon, Versailles) that he exhibited in 1810 (fig. 47), while the latter turned to watercolor to replicate the moody nocturnal atmosphere of his *Dream of Ossian*, painted in 1813 for the Napoleonic palace of Montecavallo in Rome (fig. 48). In a willful repudiation of their master's graphic "chromoclasm,"[48] they let their imagination wander into the realm of painting when putting their ideas down on paper.

David does not seem to have ever taken up pastel, generally considered the domain of society portraitists. After enjoying a heyday owing to Maurice Quentin de La Tour and Jean-Baptiste Perronneau, the technique was derided later in the century for its impermanence and associated with female practice and taste. The hybrid nature of pastel, underscored by its designation as "crayon painting," was a source of discomfort for artists like David for whom oil painting remained the sole measure of eminence. Nonetheless, more open-minded contemporaries achieved excellence in pastel portraits. Among the most prolific practitioners were two women, Adélaïde Labille-Guiard and Elisabeth Vigée Le Brun, along with two men, Joseph Ducreux and Prud'hon.[49]

## DRAWING AND ITS DISCONTENTS

David's manner of drawing and the reported principles of his teaching both belie Stendhal's retrospection on the artist's influence, published in his review of the Romantic Salon of 1824. The author of a history of painting in Italy and future novelist claimed that, during the thirty years of the master's "tyrannical government" of the arts, the public had been led to believe that artistic taste and genius relied on the acquisition of the *"exact science* of drawing."[50] In fact, the degree of finish that David preferred was rather a *juste milieu* between the poles exemplified by Gérard's two illustrations for La Fontaine's *Les Amours de Psyché et Cupidon*, discussed above. Notational drawings abound in his sketchbooks, but when he developed a composition, he was driven by a superior respect for the intelligibility of nature and rarely maintained much informality. Nor did the prevailing practice of drawing after the model in the studio signify a call for precision and detail. One of the young men studying with him during the Empire reported that David "wants nothing to do with finished drawings."[51] This requisite was not the result of some shortcoming, for when David directed his hand to render close details, he was exceptionally proficient. His antipathy toward finish was a self-imposed aesthetic position. The cautionary note in the catalogue of the Salon of 1791, warning the public that the figures of the deputies in *The Oath of the Tennis Court* were not meant to be resemblant, was a preemptive measure to permit revisions in a time when political reputations rose and fell quickly. But David's intent was perhaps also to incite the public to focus on the visual interpretation of the event as a carrier of historical meaning, rather than to amuse itself, as with so

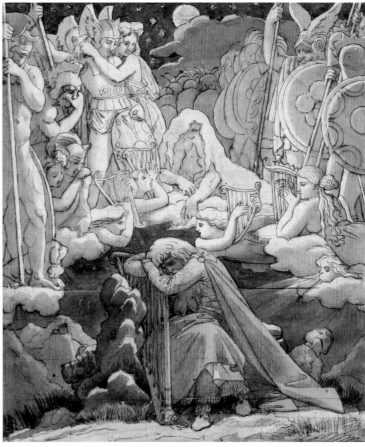

Fig. 47. Anne Louis Girodet (1767–1824), *A French Dragoon, Study for "The Revolt at Cairo,"* ca. 1809. Pastel and conté crayon, stumped, on gold-colored dyed laid paper, 23⅜ × 18½ in. (59.4 × 47 cm). The Metropolitan Museum of Art, New York, Purchase, Lila Acheson Wallace, David T. Schiff, Jean A. Bonna, and Guy Wildenstein Gifts, 2011 (2011.86)

Fig. 48. Jean Auguste Dominique Ingres (1780–1867), *Study for "The Dream of Ossian,"* ca. 1812. Pen and brown ink, watercolor, squared with graphite, 12 × 11⅞ in. (30.5 × 30.2 cm). Véronique and Louis-Antoine Prat Collection, Paris

many revolutionary prints, in picking out the portraits of notable participants. Throughout his life, David was receptive to eighteenth-century academic principles, which had been deeply branded on him during his formative years and were undiminished by his conversion to the antique. For him, expressive freedom in drawing as an end in itself, independent of painting, was always at risk of becoming an artistic libertinage, and inversely, an overly worked composition deprived the viewer of his or her creative involvement, that is, the pleasure of imagining how it might be finished.[52]

The post-revolutionary generation's fascination with meticulously rendered drawings was strong and can be attributed to a number of factors. Some have already been mentioned: the understandable desire of certain pupils, in particular Girodet, Isabey, and Ingres, to distance themselves from their master and develop their own manner, and an admiration for the antique that translated into the pursuit of formal perfection. Girodet's drapery studies (fig. 49) take their cue from those by David (for example, cat. 66), but their virtuosity makes a claim for their complete self-sufficiency and a status far superior to that of working drawings.

The vital need to reach a broader audience and to collaborate with commercial interests in order to survive professionally also had an impact on graphic practice. The delicate refinement of the stipple technique captivated the same public that, thirsting for change after the Terror, came to admire as living deities the so-called Merveilleuses, such as Madame Tallien and Madame Récamier. On the eve of the Revolution, Girodet

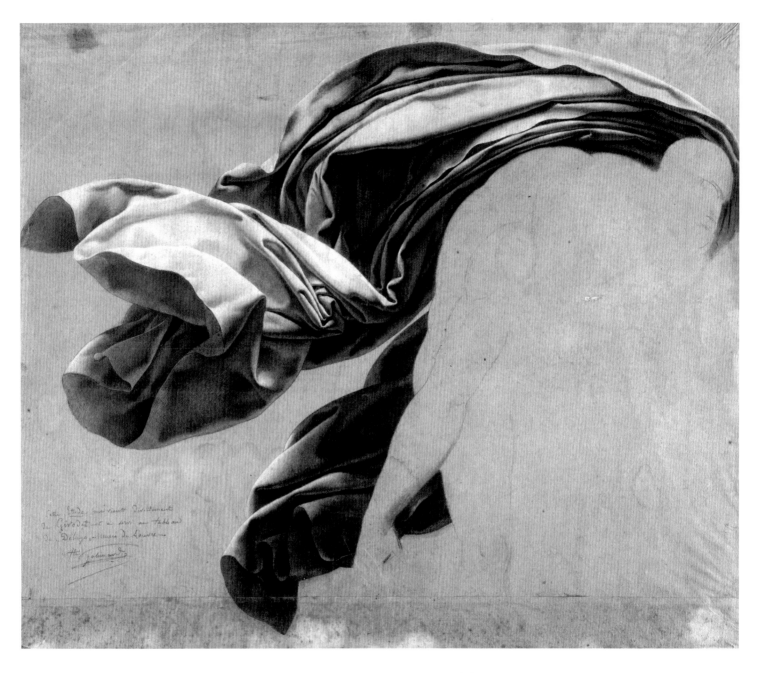

Fig 49. Anne Louis Girodet, *Drapery Study for "A Deluge,"* ca. 1805–6. Black and white chalk, on beige paper, 18⅞ × 22⅛ in. (47.8 × 56 cm). Musée d'Arts de Nantes (1523)

was already under the influence of fashionable English stipple prints—and the chivalric subject matter associated with them—when he composed *Bayard Refusing the Presents of His Hostess, in Brescia* (fig. 50). Around 1800, delicately rendered drawings by Isabey and several lesser-known draftsmen, often employing a stipple technique, were immensely popular with the Salon public. Isabey sent to the Salon of 1804 a very large drawing filled with doll-like figures, illustrating the Bonapartes' visit to a famous textile factory in Rouen (fig. 51). When he exhibited the pendant two years later, Pierre Chaussard, a republican critic close to David, could not contain himself and snapped against this pretentious attempt to rival painting: "drawing will only ever be the cold and lifeless part of painting."[53]

Fig. 50. Anne Louis Girodet, *Bayard Refusing the Presents of His Hostess, in Brescia*, ca. 1789. Black and brown chalk, stumped, pen and brown ink, heightened with white gouache, 14⅜ × 20¼ in. (36.4 × 51.3 cm). Art Institute of Chicago (1990.495)

Fig. 51. Jean-Baptiste Isabey, *Bonaparte, First Consul, Visits the Manufacture of the Brothers Sévène in Rouen, November 1802*, 1804. Graphite, black chalk, heightened with white gouache, 48⅞ × 69¼ in. (124 × 176 cm). Musée du Louvre, Paris, on deposit at the Musée National des Châteaux de Versailles et de Trianon, Versailles (INV. DESS 27233 / MV 2574)

Though David was on good terms with Isabey, an imperial court artist like himself, he no doubt found distasteful the formal elegance that his pupil and so many other artists had banked on to achieve success. By catering to the taste of new elites, their productions were redolent of the frivolous luxury objects that he had condemned in 1793 when developing his vision of a republican art.[54] The deliberate gruffness he manifests in his graphic works, especially those he executed in exile after 1815, may have been a reaction to these society drawings. They also suggest a fundamental unease with the graphic medium.

It was during the eighteenth century that collectors and amateurs began framing their drawings and treating them as objects of decoration.[55] It is significant that David was not inclined to collect original compositions by his contemporaries, a common practice resulting from friendly exchanges among peers and gifts of gratitude from pupils. The inventories and estate-sale catalogues of most major painters of the period list sketches and drawings by contemporaries procured in this way. However, none figured at the sale organized after David's death and, according to the inventories of his residences, none was hung on the walls, which were decorated instead with reproductions after his own work and those of his most famous pupils.[56]

David's uneasiness with the appreciation of drawings as a marker of social prestige and with their commercial circuits, along with a sense of remoteness toward his established colleagues, were feelings that would have been understood by Géricault, a painter of great promise and a bold draftsman who made the trip to Brussels in 1820 to pay homage to the exiled glory of the French school. Géricault was performing the Enlightenment ritual of paying a visit to the *grand homme*, and David was surely flattered. It is not known whether the latter, who never ceased urging Gros to devote his brush to ancient history, made a similar plea to the painter of *The Raft of the Medusa* (Musée du Louvre) exhibited at the Salon the year before. Géricault is reported to have lamented on his deathbed, in 1824, "If only I had done five pictures, but I have done nothing, absolutely nothing," and to have belittled his huge canvas, "The Medusa. Bah! a vignette!"[57] Although David and Géricault both engaged brilliantly with contemporary subjects on a grand scale, academic doctrine continued to haunt them as the touchstone of artistic self-esteem. Especially for the elderly painter in whom this heritage of the ancien régime was ingrained, far more deeply than for his visitor born in 1791, the graphic arts were the humble servant of painting, and mostly a private activity. Such an attitude, however, did not prevent David, across the broad range of graphic techniques he adopted, from inventing a vibrant personal manner that set him apart from contemporaries, young and old, and continues to impress today.

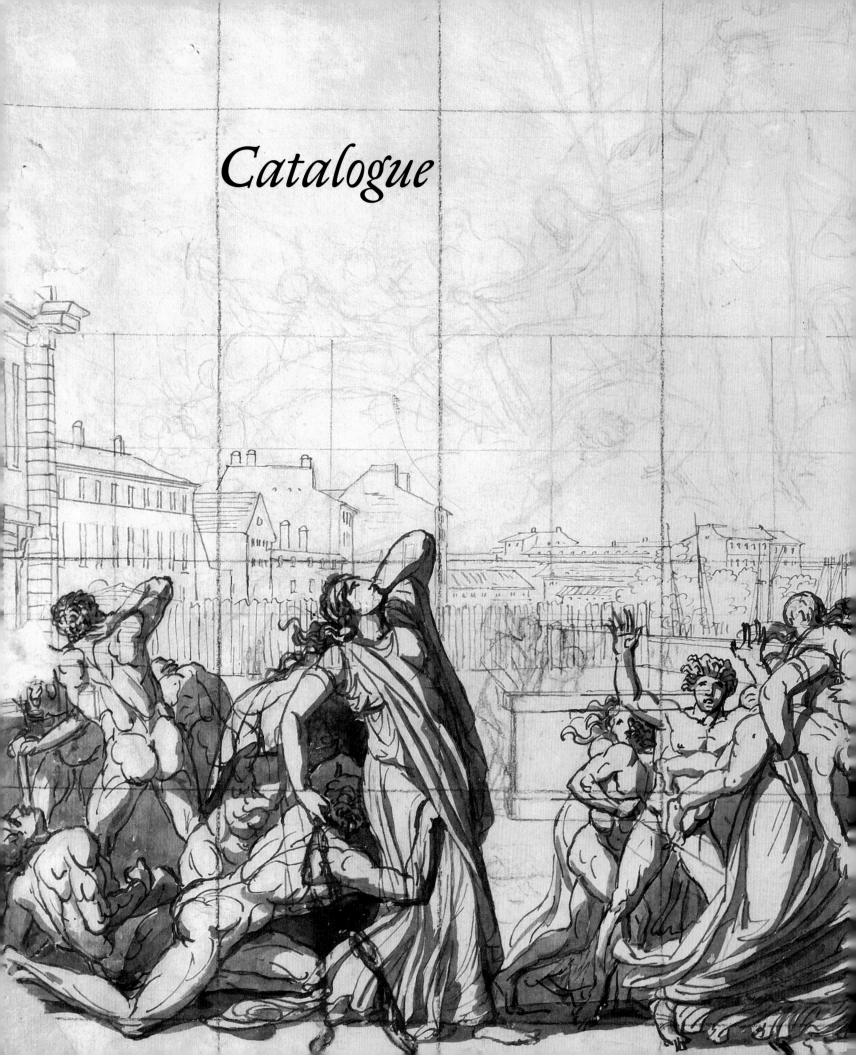

Catalogue

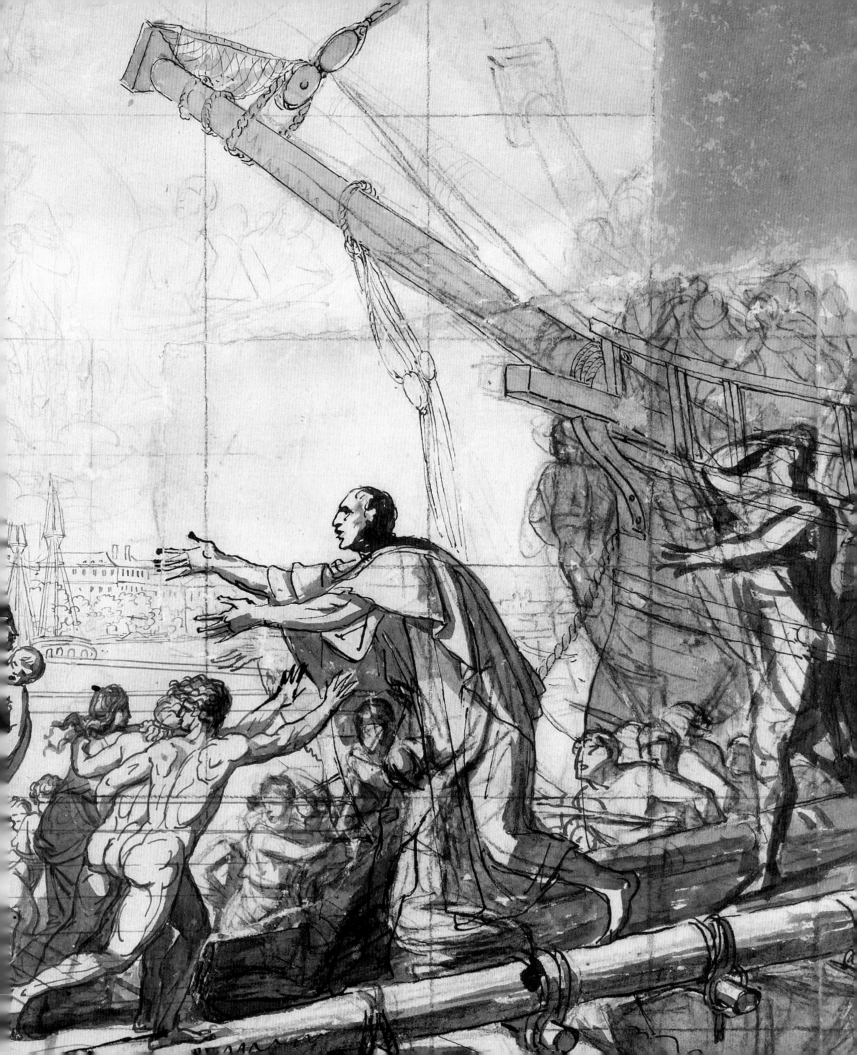

# Early Training, 1764–80

Jacques Louis David was born in Paris in 1748, the only child of Maurice David, a merchant of iron building materials, and Marie Geneviève Buron, whose extended family included many builders and architects, as well as François Boucher, first painter to the king. David was nine years old when his father was killed in a duel, according to family accounts. His mother left the capital for the town of Evreux, in Normandy, leaving her son in the care of two maternal uncles, the architects François Buron and Jacques François Desmaisons. They saw to it that he received a classical education, first at the Collège de Beauvais and then at the Collège des Quatre-Nations, but David resisted their plans for him to pursue a professional career in law, medicine, or architecture. About drawing, however, he was passionate, and his artistic aspirations would find support with another father figure, Michel Jean Sedaine, perpetual secretary to the Académie Royale d'Architecture and a dramatist known for his *opéras comiques*.

On the advice of Boucher, David entered the studio of Joseph Marie Vien in 1764, and by 1766 was officially listed as his student in the registers of the Académie Royale de Peinture et de Sculpture. Vien was a successful history painter influenced by the rise of antiquarianism in the second quarter of the eighteenth century, a trend spurred by recent excavations at Herculaneum (1737) and Pompeii (1748). Vien's work in the fashionable *goût grec*, or "Greek" style, which grafted classical themes and motifs onto a Rococo aesthetic, presaged later, more severe forms of Neoclassicism. His other students at the time included Pierre Peyron, Jean Joseph Taillasson, François André Vincent, and Jean-Baptiste Regnault.

Founded in 1648, the Académie Royale was the preeminent arts institution in France. With the support of royal patronage, it controlled the teaching of art, mounted biennial exhibitions (Salons) in the Louvre, and steered royal commissions to its members. The training of prospective painters followed a well-established course of study centered on the practice of drawing. To master the depiction of the male nude, students first made copies after the work of their masters, then after plaster casts of antique sculptures, and, finally, after live models. Lessons in history, anatomy, and perspective rounded out the curriculum. Advanced students competed for the annual Grand Prix de Rome, which entailed painting first an oil sketch and then a finished canvas of a composition of one's own invention, based on an assigned subject from ancient history or mythology. Winners of the prize were granted several years of study at the Académie de France in Rome, where they would absorb the lessons of antiquity and of earlier masters in preparation, it was assumed, for brilliant careers back in Paris as members of the Académie Royale.

But this path did not unfold easily for David. His early efforts were fraught with disappointment and hardly foretold his future role as leader of the French school. He entered the competition for the Prix de Rome for the first time in 1771, against the advice of his teacher, who did not feel that he was ready. His submission, *The Combat between Minerva and Mars* (Musée du Louvre, Paris), was judged inferior to that of Joseph Benoît Suvée, and the following year his *Apollo and Diana Attacking the Children of Niobe* (Dallas Museum of Art) came in behind the entries of Pierre Charles Jombert (Ecole Nationale Supérieure des Beaux-Arts, Paris) and Anicet Charles Gabriel Lemonnier (Musée des Beaux-Arts, Rouen). This second defeat led David to lock himself in his room, threatening suicide by starvation. Yet, by 1773 he was competing again. His *Death of Seneca* (Petit Palais, Paris) fell short of Pierre Peyron's submission (location unknown), but in 1774, on his fourth attempt, David finally succeeded with his *Antiochus and Stratonice* (fig. 52).

These early efforts contain few clues to his future artistic development, but they do provide clear evidence of David's independent streak. His first three attempts at

Fig. 52. Jacques Louis David, *Antiochus and Stratonice*, 1774. Oil on canvas, 47¼ × 61 in. (120 × 155 cm). Ecole Nationale Supérieure des Beaux-Arts, Paris (PRP 18)

the Prix de Rome did not emulate the style of his master. They had more in common with the florid, neo-Baroque tenor of painters like Gabriel François Doyen, whose altarpiece the *Miracle of Saint Geneviève* hung opposite, and in stylistic contrast to, Vien's *Saint Denis Preaching in Gaul* in the church of Saint-Roch. David's fourth, winning entry was decidedly less operatic. In *Antiochus*, he hewed more closely to the example of Nicolas Poussin, the seventeenth-century painter most venerated by senior members of the arts establishment, opting for a more

planar composition, more stolid figures, and a more sober manner of evoking the ancient world. This experience of repeated failure at the hands of the powerful Académie Royale doubtless sowed the seeds of certain rivalries and resentments, but it must also have ingrained in the aspiring young painter a belief in the rewards of tenacity.

David finally left for Italy in October 1775 in the entourage of his teacher, who had just been appointed director of the Académie de France. They arrived in Rome about a month later and settled into the Palazzo

Mancini, where the Académie de France had been housed since 1725. Before departing from Paris, David had reportedly declared, "the antique will not seduce me,"[1] but by the time he arrived in the Eternal City he was, by his own recollection, "ashamed of his ignorance."[2] Indeed, there is little in David's student work in Paris to predict the artistic revolution he would lead upon his return from Italy; his true formation took place over the course of his five years as a *pensionnaire* in Rome.

The instruction of the young sculptors, architects, and painters in training at the Académie de France had become fairly relaxed under the laissez-faire leadership of the previous director, Charles Joseph Natoire. Vien's charge was to bring new discipline to the students' daily regimen. In concert with the director of the Bâtiments du Roi, Charles Claude de Flahaut, comte d'Angiviller, he enforced a schedule of drawing after the live model and required each *pensionnaire* to send drawings and paintings as part of regular shipments (*envois*) to Paris, so that d'Angiviller and the professors of the Académie Royale could judge their progress. In 1776, he also instituted the practice of staging a yearly exhibition of the students' work in Rome before the shipments left for Paris.

In this structured environment, the academy asserted control over the work and daily routines of the *pensionnaires*. But this did not prevent David from assiduously continuing his education beyond the walls of the Palazzo Mancini, making the city his studio and assimilating its many wonders, by carrying sketchbooks and chalk and recording all he found admirable and instructive. And there was no shortage of inspiration. Churches and palaces were filled with great works of the Renaissance and Baroque, and new antiquities were being unearthed with regularity. The fervor for archaeology and classical art was also manifested in a bounty of publications and illustrated treatises, including, among others, Bernard de Montfaucon's *L'antiquité expliquée* (*Antiquity Explained*; Paris, 1719–24), Giovanni Battista Piranesi's *Le antichità romane* (*Roman Antiquities*; Rome, 1756), Johann Joachim Winckelmann's *Geschichte der Kunst des Altertums* (*History of Ancient Art*; Dresden, 1764), and Pierre d'Hancarville's *Collection of Etruscan, Greek, and Roman Antiquities from the Cabinet of the Honble. Wm. Hamilton*

(Naples, 1766–67). Reflecting this pan-European interest in Roman antiquities was the broad range of nationalities of the many young painters and sculptors working and studying in Italy. David's five-year stay would have put him in contact with Anton Raphael Mengs, Gavin Hamilton, Henry Fuseli, and Johan Tobias Sergel, to name just a few.

The drawings from this period tell two parallel stories. Some, like the two recently discovered red chalk *académies* (cats. 3–4) and the large-scale compositional studies for *The Combat of Diomedes* (cat. 15) and *The Funeral of Patroclus* (Musée du Louvre, Paris), both inspired by the *Iliad*, reflect the directives of the institution and David's efforts to shine in the eyes of the academicians back in Paris. But what truly allow us to chart his growth and ambition are the smaller studies—well over a thousand in number—in his sketchbooks, made not to impress others but for his own personal use. Emphatic and legible, but with little attention to detail or polish, the sketchbook drawings are incisive records of ancient sculpture, Renaissance and Baroque paintings, and the Roman urban landscape. David then carefully cut and pasted these sketches onto larger sheets in albums according to a precise system of classification (cats. 6–14). It is this act of reorganization, as much as the drawings themselves, that reveals the utility David envisioned for them. Yet, while the construction of the albums offers invaluable insight into David's working method, it also confounds attempts to establish an internal chronology for this large assemblage of studies made during his five formative years in Rome, a period when the artist was working diligently to hone his skills as a draftsman. Annotations occasionally indicate the location where he made a drawing but almost never record the date.

That his style transformed dramatically during his time in Italy is eminently clear from works securely dated to the end of his stay. In 1779, required to make a painted copy for the king, David chose Valentin de Boulogne's *Last Supper*, a Caravaggesque work with a balanced arrangement of figures and strong contrasts of light and dark (then in the Palazzo Mattei, now in the Galleria Nazionale d'Arte Antica, Palazzo Barberini, Rome). It was around the same time that he was developing ideas for history subjects in his drawings for *Belisarius Begging for Alms* (cat. 16) and *The Spartan Mother* (cat. 17), both

works evincing a sensibility more akin to Poussin than to Boucher.

Just as it had been in Paris, David's progress was at times slowed by periods of discouragement. Vien's correspondence with d'Angiviller reveals a concern with David's apparent bouts with depression and anxiety in the summer and fall of 1779. A study trip to Naples suggested by Vien seems to have had its intended salubrious effect, and by the fall, David was again working productively. He painted a large altarpiece of *Saint Roch Interceding with the Virgin for the Plague Victims* for a hospital chapel in Marseille (now Musée des Beaux-Arts, Marseille), a commission passed to him by Vien. In its theatrical lighting and chaotic piling up of figures in a condensed space, we see the work of an artist who gained much from his studies in Italy—from Baroque masters as well as from the antique—but who was not yet fully formed. By the summer of 1780, David was on his way back to Paris. Anxious to seek success in the French capital, he carried with him a prodigious number of drawings, evidence of his having acquired not only a mastery of technique but also a vast repertoire of motifs and sources that would inform and enrich his work throughout his life.   PS

## 1. *Seated Male Nude in Three-Quarter View, with Right Arm Extended to the Left*

Ca. 1774–75
Black chalk, stumped, heightened with white
21¼ × 16⅜ in. (54 × 41.6 cm)
Marks: lower left, in black ink, collection mark of the Musée de la Chartreuse (not in Lugt); lower right, blind stamp of the Musée de la Chartreuse (Lugt 3167); paraph of Eugène David (Lugt 839)
Musée de la Chartreuse, Douai (INV. 466)

PROVENANCE: David estate sale, Paris, April 17, 1826, and following days (two *académies* are recorded in an annotated copy of the catalogue,[1] pp. 2 and 4 [to Coutan]); acquired at that sale by Théophile Bra (1797–1863); his gift to the Musée de la Chartreuse, 1852

REFERENCES: Arlette Sérullaz in *David e Roma* 1981, cat. 5, p. 71; Rosenberg and Prat 2002, vol. 1, no. 1, p. 28

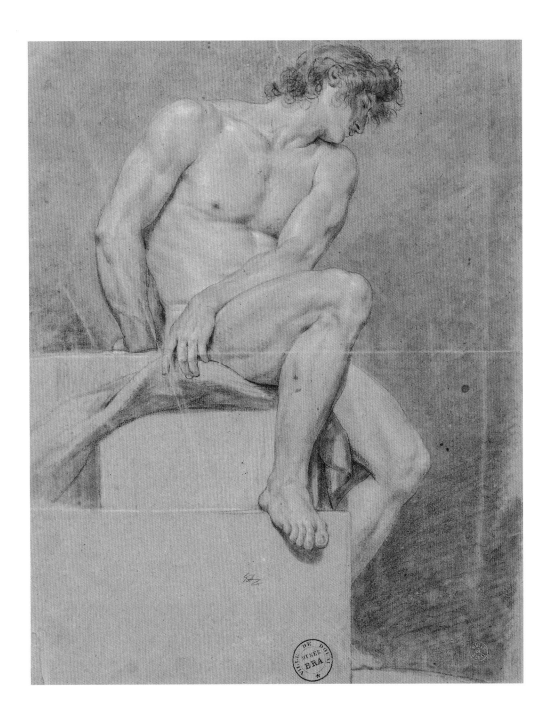

## 2. *Seated Male Nude in Three-Quarter View, Head Turned to the Right, with Bent Right Leg Resting on a Platform*

Ca. 1774–75
Black chalk, stumped, heightened with white
20⅞ × 17⁵⁄₁₆ in. (53 × 44 cm)
Marks: bottom center, paraph of Eugène David (Lugt 839); in black ink, collection mark of the Musée de la Chartreuse (not in Lugt); lower right, blind stamp of the Musée de la Chartreuse (Lugt 3167)
Musée de la Chartreuse, Douai (INV. 467)

PROVENANCE: See cat. 1

REFERENCES: Arlette Sérullaz in *David e Roma* 1981, p. 71; Arlette Sérullaz in Schnapper and Sérullaz 1989, cat. 27, p. 85; Rosenberg and Prat 2002, vol. 1, no. 2, p. 28; Nicolas Sainte Fare Garnot in *Jacques-Louis David* 2005, cat. 21, p. 72

These two *académies*, now in the Musée de la Chartreuse in Douai, belong to the very small corpus of known examples by David. While the exercise of drawing the nude male model was central to both the training and practice of history painters, only a half dozen or so such sheets by David's hand have come to light, despite his having been a prolific draftsman. Three other *académies* have survived fortuitously as remnants on the versos of large compositions, David having opted to reuse the sheets on which he had drawn these studies (fig. 53).[2] Completing this small group are a drawing in black chalk in poor condition, on the art market in 2009,[3] and two *académies* in red chalk that resurfaced only in 2013 and 2015 (cats. 3–4). The catalogue of the posthumous sale of David's work, which commenced in Paris on April 17, 1826, does not list any *académies* (with the exception of two painted ones).[4] The handwritten annotations in a copy of the sale catalogue in the Institut National d'Histoire de l'Art in Paris, which list the uncatalogued lots, mention only two *académies*, probably drawings.[5] Jules David-Chassagnolle, in his biography of the artist (his grandfather), writes only of "*académies* drawn during his studies in the studio of Vien and at the Académie Royale de Peinture et de Sculpture," without providing further specifics.[6] A few other *académies* inscribed "David" exist, but they were rejected by Pierre Rosenberg and Louis-Antoine Prat; dated 1763 and 1764, their style and state of conservation make it difficult to attribute them to the artist with any certainty.[7] However, a drawing of a seated man in profile that is now in the library of the University of Warsaw might belong to this corpus; its medium (black and red chalk) and dimensions correspond to the only drawn *académie* sold in David's lifetime, in 1778.[8]

After studying at the Collège des Quatre-Nations, David, then aged sixteen, became a student of Joseph Marie Vien, to whom he had been introduced by his relative François Boucher. It was likely in 1765 that David began his studies at the Académie Royale, where he would have begun preparing for the Prix de Rome competition. He would finally win the prize in 1774, after having failed to obtain it on three previous attempts.[9] Explaining the belatedness of this recognition, Pierre Jean-Baptiste Chaussard wrote, "As he applied himself only when competing for prizes, several years passed

Fig. 53. Jacques Louis David, *Académie*, ca. 1775–76. Red chalk and red wash, traces of charcoal, sheet 29⅞ × 13⅛ in. (75.8 × 33.2 cm), fragment with *académie*, 23⅞ × 13⅛ in. (60.5 × 33.2 cm). Musée du Louvre, Paris (RF 4004 verso)

before he obtained first place."[10] Even if this suggests that David, as a student, was less than assiduous in his attendance at drawing sessions after the model, he can scarcely have avoided executing such *académies*, the very foundation of academic pedagogy, between 1766 and 1774. Moreover, on September 30, 1769, he obtained a third-place medal in the institution's quarterly drawing competition.[11]

In any case, the small number of known *académies* by David complicates the dating of the present studies. These two sheets have the same provenance; together with five other drawings, they were acquired at the 1826 sale by the sculptor Théophile Bra, who bequeathed them to the museum in Douai in 1852, along with the rest of his collection of drawings, prints, and books, as well as the works remaining in his workshop.[12] In terms of style, Arlette Sérullaz has connected these *académies*, executed in black chalk, to the one in red chalk on the verso of the large compositional study for *The Funeral of Patroclus*, dating them on this basis to 1775–80, during David's first Roman sojourn.[13] While Rosenberg and

Prat have emphasized the facility of execution in these two drawings, they nonetheless view them as student exercises, placing them "during the period that precedes the prix de Rome victory," that is, between 1770 and 1774.[14]

The pose adopted by the models, both of whom sit on wooden platforms covered with drapery and avert their faces or tilt them downward, is consistent with a formula encountered in drawings executed by students at the Académie, whether in Paris or in Rome, between 1772 and 1789.[15] Despite their stylistic similarities (the handling of the hair is especially close), the two sheets might have been executed a few days or perhaps weeks apart; at the Académie, the same pose was retained for three successive days.[16] There are, however, differences between them, notably in the positioning of the model's limbs and in their approach to the studio props, which are rendered literally in one (cat. 2) but transformed into a rock with drapery in the other (cat. 1). The use of black chalk, stumped and heightened with white, supports a

date before the Roman trip; the only three *académies* that can be dated more or less securely to David's first sojourn there are all, as noted above, in red chalk. Finally, even if the technique and degree of finish of the Douai *académies* distinguish them from the incomplete red chalk drawing on the verso of the Louvre *Funeral of Patroclus*,[17] it is worth noting that the pose of the model in the latter is almost identical to the one seen in one of the Douai drawings (cat. 2); only the heights of the right knees and the directions of the gazes vary. It seems likely, then, that David continued to study this pose shortly after his arrival in Rome. While the Douai drawings align in broad terms with an academic tradition characterized by the repeated use of certain poses and props, the quality of their execution here, which reveals considerable mastery in the depiction of anatomy and volume, as well as the proximity of the pose to that of the *académie* on the verso of the Louvre *Funeral of Patroclus*, all lend support to a more precise dating of 1774–75, shortly before David's departure for Rome.   JT

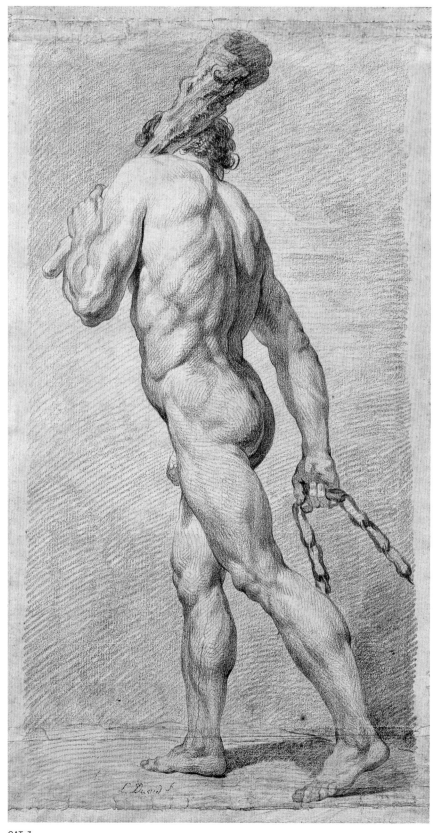

CAT. 3

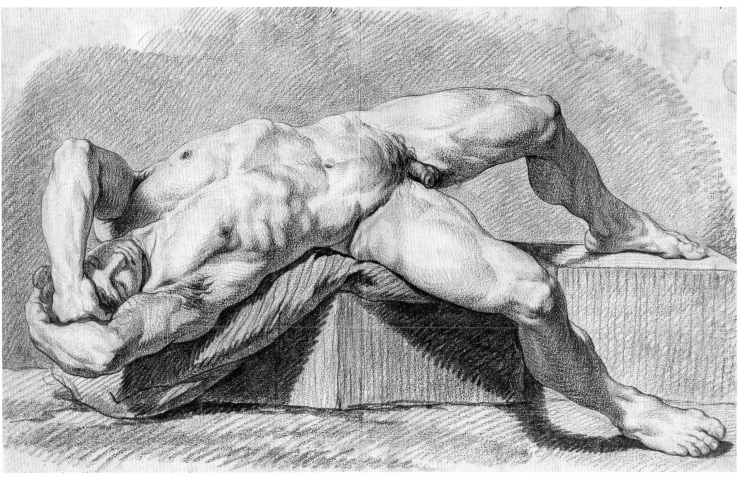

CAT. 4

## 3. *Male Nude as Hercules*

Before 1772–75
Red chalk
26⅜ × 14¹⁄₁₆ in. (67 × 35.7 cm)
Inscriptions: lower left, in red chalk, signed "L. David f."
Private collection, Switzerland

PROVENANCE: Sale, Campo & Campo, Antwerp, December 3, 2013,
lot 53; acquired by Galerie Nathalie Motte Masselink; sold in 2021 to
the present owner

REFERENCES: Motte Masselink 2016; Prat 2016b, pp. 110, 221, fig. 1

## 4. *Reclining Male Nude*

Ca. 1775–77
Red chalk
15⅜ × 24¾ in. (39 × 62.8 cm)
Inscriptions: lower left, in pen and brown ink, signed "J. L. David in
Roma pensionnaire du Roy"; bottom center of mount, in pen and
brown ink, "ACADEMIE DONNEE PAR DAVID A SON CAMARADE RENARD / A / ROME"
Private collection, France

PROVENANCE: Gift of the artist to Jean Augustin Renard (1744–1807);
by descent to the present owner, France

REFERENCES: Willk-Brocard and Gady 2015, no. 91, p. 33; Prat 2016b,
pp. 110, 221, fig. 2

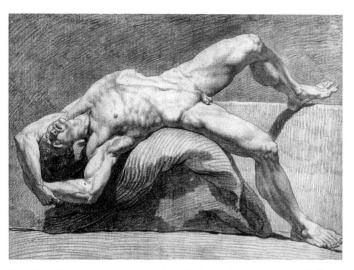

Fig. 54. Unknown French artist, *Académie*, 18th century. Red chalk, 15⅜ × 22 in. (39 × 56 cm). Private collection

After winning the Grand Prix of the Académie Royale de Peinture et de Sculpture in 1774, David went to Rome to study at the Académie de France, as provided by the rules of the competition. He resided in the Palazzo Mancini, the seat of the academy, from November 1775 until August 1780. His contact with fellow *pensionnaires* and his exposure to works of art in the city are thought to have precipitated changes in his approach to drawing and painting. However, these changes seem to have come about relatively late, for they apparently were connected to advice imparted by the sculptor Jacques Lamarie, who arrived in Rome in 1778, and to David's trip to Naples in the summer of 1779.[1] Nevertheless, from the time of his arrival the painter "studied like a beginner, writing to his friends that his sole occupation was drawing the écorché by Houdon, and that afterward, he would proceed to the one by Michelangelo" (see also cats. 6–14).[2] Indeed, in his own estimation, he was "ashamed of his ignorance."[3] Alexandre Lenoir further noted that, "like a schoolboy he set about drawing, for a whole year, eyes, ears, mouths, feet and hands and was content to execute complete figures [*ensembles*] after the most beautiful statues. Anatomy was another of his preferred areas of study."[4]

A few painted *académies* executed by David in Italy are known, such exercises being among the works that *pensionnaires* in Rome were obliged to send to Paris.[5] Antonio Canova noted "various academies by David" at the exhibition of students' work at Palazzo Mancini in November 1779.[6] Drawings executed in Rome by the winners of the Grand Prix, now in the Ecole des Beaux-Arts, Paris, also indicate that drawing after the live model was a part of these young artists' training.[7] The corpus of drawings executed by David in Rome already included three *académies*, two of them fragmentary, on the versos of preparatory studies for *The Funeral of Patroclus*.[8] Pierre Rosenberg and Louis-Antoine Prat date all three to about 1775–76. In 2015, the publication of the reclining male nude shown here (cat. 4) added a new example to the small group of Roman *académies* by David, this one fully finished and selected for preservation, rather than flipped over and reused.[9]

The first owner of the sheet was Jean Augustin Renard, who won the Prix de Rome for architecture in 1773 and resided at Palazzo Mancini from 1774 to the end of 1777. In 1775, 1776, and 1777, then, he rubbed shoulders there with David, who gave him this sheet, as noted on the mount.[10] The use of red chalk, a medium that is easy to handle but which precludes correction, as it cannot be erased, is rare in David's work after his time in Rome, further confirming the dating. The drawing is likewise wholly consistent with the technique and format of *académies* executed during this period: the studio props (wooden platform, mattress) are familiar, and the model adopts one of the four most frequently used poses in the eighteenth century, reclining so as to create a diagonal that tenses the muscles.[11] A red chalk drawing of a figure in an almost identical pose, executed by an unidentified artist, was sold in 2016 (fig. 54); the two sheets share so many features that they might have been made during the same posing session.[12] The drawing shown here, preserved by Renard's descendants, was thus in all likelihood a student exercise that David presented to one of his comrades at Palazzo Mancini, a common practice among students.

The figure of Hercules shown from behind (cat. 3), which resurfaced in 2013, is more difficult to situate within the chronology of David's *académies*. Nathalie Motte Masselink has connected it to a print by Jean-Baptiste de Poilly, after a drawing by François Verdier, that was published in the late seventeenth century.[13] However, even if David's work exhibits echoes of Verdier's Hercules, it cannot be a copy of the print; there are too

many differences in the props, shadows, and position of the model. On the basis of the red chalk medium, which David used almost exclusively in Rome, as well as comparison with the studies of feet he executed there, Motte Masselink has dated the drawing to 1775–80, during the artist's first Roman sojourn. She also specifies that the paper has an Auvergnat watermark, which suggests that David could have brought the sheet with him to Italy from Paris. She further notes the similarity in stance of David's Hercules to that of the figure holding the cup of hemlock in a preparatory drawing for *The Death of Socrates*, dating from 1782 and now in a private collection (see cat. 31).[14] However, cat. 3 contains awkward passages of a kind not encountered in the drawing presented to Renard (cat. 4), or even in the *académies* in black chalk now in Douai (cats. 1–2). The hatch marks form a rectangle around the figure of Hercules and are spaced regularly around the torso, while in the reclining nude they are more vigorously applied and constitute a dense network, the upper edge of which approximates the silhouette of the model below. The handling of the shadows and anatomical modeling also seem less masterful in the Hercules, notably at the level of the lower stomach and the right arm, where the shadows are sharp and distinct. Finally, the anatomy of the model, with its exaggerated musculature and awkwardly short right leg, is poorly proportioned. All of this suggests that the sheet predates the other *académie*. Considering its French watermark, it may have been executed in Paris, or perhaps at the very beginning of the first Roman sojourn, if one accepts the hypothesis that the artist brought some large sheets with him from Paris to Rome. The use of red chalk, specific to David's activity in Rome, further supports the latter theory. The distant echo of this pose in the compositional study for *The Death of Socrates* could be explained by the practice of conserving *académies* in the atelier as a source of inspiration.

The inclusion of Hercules's club and the chain are relatively unusual for this period, when draftsmen tended to avoid mythological allusions in favor of the frank representation of studio props, especially ropes and batons.[15] However, at least two drawings executed by academy students in 1772 feature a pose close to that of David's Hercules and include a club over the model's shoulder.[16] Clearly, the prop was not entirely unknown in drawing sessions at the Académie Royale during this decade.   JT

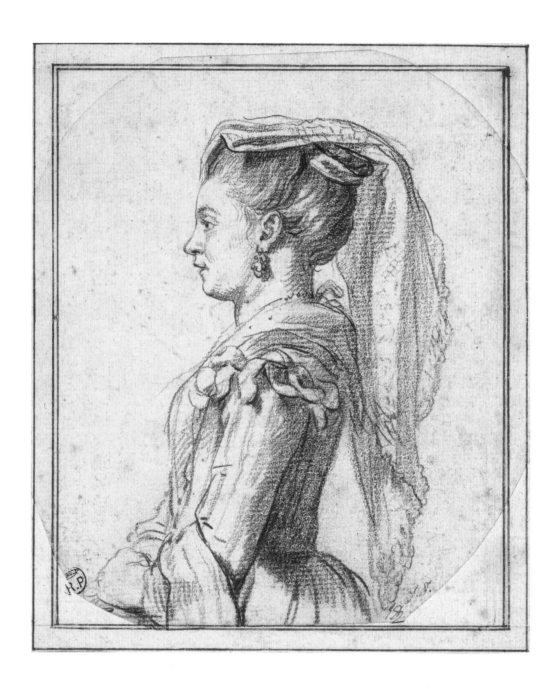

## 5. *A Young Woman of Frascati*

Ca. 1775–76
Red chalk, framing lines in pen and brown ink, irregularly cut
6 × 5⅜ in. (15.3 × 13.7 cm)
Marks: lower right, paraphs of Eugène David (Lugt 839) and Jules David (Lugt 1437); lower left, in black ink, collector's mark of baron Roger Portalis (Lugt 2232)
The Metropolitan Museum of Art, New York, Gift of Mrs. Charles Wrightsman, 2012 (2012.150.2)

PROVENANCE: Included in David's posthumous inventory, February 27, 1826, as part of no. 78; David estate sale, Paris, April 17, 1826, and following days, lot 59, to M. Guéret; baron Roger Portalis (1873–1912), Paris; sale, Hôtel des Ventes du Vieux Palais, Rouen, October 20, 1996, lot 64 (no catalogue); private collection, France; sale, Sotheby's, New York, January 23, 2001, lot 317; Katrin Bellinger Kunsthandel, Munich; acquired by Jayne Wrightsman, 2001; her gift to the Metropolitan Museum, 2012

REFERENCES: J. L. J. David 1880, p. 653; D. Wildenstein and G. Wildenstein 1973, no. 2042, item 78, p. 238, and no. 2062, item 59, p. 245; Rosenberg and Prat, 2002, vol. 1, no. 9, p. 34; Perrin Stein in Fahy 2005, cat. 71, pp. 262–64

It must not have been long after his arrival in Rome that David tried his hand at a tradition venerated among French artists visiting Italy: drawing young Italian women in regional dress. He would have been aware of precedents by Nicolas Vleughels, Jean Barbault, and Jean-Baptiste Greuze, if not from the works themselves, then from the engravings made after them, which featured full-length figures, detailed costumes, and identifying captions.[1] Suites of such prints formed pictorial compendiums, an intra-European form of exoticism that described, catalogued, and found charm in the foreign.

It was Jean Honoré Fragonard who finally jettisoned this formulaic approach when he visited Rome the year before David's arrival and made sketches after a variety of local inhabitants—sometimes in chalk, sometimes in wash, often with François André Vincent working at his side.[2] He presented his subjects not as mannequins for picturesque costume but as vivid individuals, seen through the lens of genre or portraiture. Fragonard's *A Neapolitan Woman* (fig. 55), for example, drawn in 1774, suggests the empathy he brought to these studies.[3]

Within this context, David's *A Young Woman of Frascati* is a hybrid of norms and novelty. Like Barbault's *Frascatane* (fig. 56),[4] the subject is shown standing and in strict profile, with a long headscarf falling to a point behind her back and a tight-waisted, striped dress embellished with ribbons at the shoulder. David's version differs from Barbault's, however, in that she is presented at half-length and bathed in natural light, her fresh features and upswept hair outshining the details of her costume. If the naturalism suggests an awareness of Fragonard's and Vincent's recent plein-air studies of Italian women, then the compositional format has a different pedigree: it reflects the fashion for portrait drawings in profile, inspired by antique coins and cameos, that had been popularized in Paris by Charles Nicolas Cochin II in the years before David's departure.[5] This debt is further highlighted by the original shape of the support, imperfectly cut to suggest a medallion format.

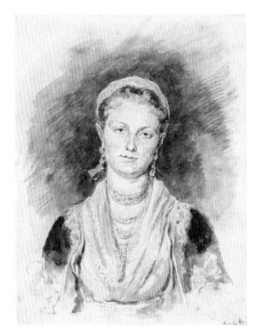

Fig. 55. Jean Honoré Fragonard (1732–1806), *A Neapolitan Woman*, 1774. Brown wash over black chalk, 14½ × 11⅛ in. (36.7 × 28.2 cm). Morgan Library and Museum, New York (2001.60)

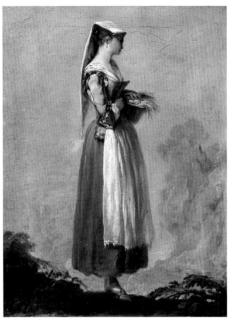

Fig. 56. Jean Barbault (1718–1762), *Frascatane*, ca. 1750. Oil on canvas, 9⅝ × 7⅜ in. (24.5 × 18.8 cm). Private collection

Immediately following this work in their 2002 catalogue raisonné of David's drawings, Pierre Rosenberg and Louis-Antoine Prat published two very preliminary sketches in black chalk of a woman in similar attire, standing and facing to the right.[6] The attribution of those sheets was questioned in 2004 by Philippe Bordes, who instead put forward the idea of the Italian artist Giovanni David.[7] Despite the apocryphal signatures, the style of these two sheets is distant from that of The Met's drawing seen here, and the woman's pose hews more closely to Barbault's treatment of the subject, known through multiple versions.[8]

David kept the drawing his entire life; it appeared five decades later in both the *inventaire après décès* and his estate sale, at which time the subject was described as "une paysanne des environs de Frascati." In contrast to the practice that flourished during Vleughels's directorship of the Académie de France in Rome, David does not seem to have made this drawing of a woman in regional dress as part of a larger series. As such, it appears to be a unicum in his oeuvre, but the fact that he cherished it is clear, for it was among a handful of drawings he chose to frame and hang on his walls.[9] PS

CAT. 6, LEAF 11

## 6. *Roman Album No. 4*

Assembled 1826; most drawings 1775–80
Album of 21 leaves (initially 23; leaves 1 and 15 absent) and a flyleaf, with 82 drawings (including one drawn directly on leaf 3 and 21 tracings) affixed to 14 greenish leaves and 7 white leaves; bound in brown leather
Overall 20⅝ × 13¾ in. (52.4 × 35 cm); greenish leaves 19⅛ × 12⅞ in. (48.6 × 32.8 cm); white leaves 19¾ × 13⅛ in. (50.2 × 33.5 cm)
Inscriptions: on the flyleaf, in pen and brown ink, "N⁰ 4 / Contenant vingt trois feuillets sur lesquels sont collés ou dessinés / soixante douze dessins et vingt calques / Vérifié et reconnu exact . . ."
National Gallery of Art, Washington, D.C., Patrons' Permanent Fund, 1998 (1998.105.1)

PROVENANCE: David estate sale, Paris, April 17, 1826, and following days, part of lot 66, unsold; second David estate sale, Paris, March 11, 1835, part of lot 16; Galerie de Bayser, Paris; acquired by the National Gallery of Art, Washington, D.C., 1998

REFERENCES: Rosenberg and Prat 2002, vol. 1, nos. 589–670, pp. 477–507

CAT. 7, LEAF 2

## 7. *Roman Album No. 8*

Assembled 1826; most drawings 1775–80

Album of 23 leaves (originally 24; leaf 14 absent) and a flyleaf, with
101 drawings (including one that is loose, one executed directly
on leaf 17 verso, and 19 tracings) affixed to 19 greenish leaves and
4 white leaves; bound in brown leather

Overall 20⅛ × 13⅝ in. (51 × 34.5 cm); greenish leaves 19⅛ × 13⅛ in.
(48.5 × 33.4 cm); white leaves 19¾ × 13⅛ in. (50.2 × 33.3 cm)

Inscriptions: on the flyleaf, in pen and brown ink, "N⁰ 8 / Contenant
vingt quatre feuillets sur lesquels sont collés ou dessinés / quatre
vingt trois [written above "sept," which is crossed out] Croquis dix
neuf calques . . ."

Morgan Library and Museum, New York, Purchased as the Gift of
S. Parker Gilbert and Eugene Victor Thaw (1998.1)

PROVENANCE: David estate sale, Paris, April 17, 1826, and following
days, part of lot 66, unsold; second David estate sale, Paris, March 11,
1835, part of lot 16; acquired by baron Louis-Charles Jeanin (1812–
1902), David's grandson; by descent in the family; Galerie de Bayser,
Paris; acquired by the Morgan Library and Museum, 1998

REFERENCES: Rosenberg and Prat 2002, vol. 1, nos. 818–918, pp. 584–622

CAT. 8, LEAF 1

## 8. *Roman Album No. 11*

Assembled 1826; most drawings 1775–80
Album of 26 leaves and a flyleaf, with 99 drawings (including 17
tracings) affixed to 20 greenish leaves and 6 white leaves; bound in
brown leather
Overall 20½ × 13⅝ in. (52 × 34.7 cm); greenish leaves 19⅛ × 13 in.
(48.5 × 33 cm); white leaves 20 × 13⅛ in. (50.8 × 33.5 cm)
Inscriptions: on the flyleaf, in pen and brown ink, "N⁰· 11 / Contenant
vingt six feuillets sur lesquels sont dessinés ou collés quatre vingt
huit / croquis et quinze calques . . ."
Getty Research Institute, Los Angeles (940049)

PROVENANCE: David estate sale, Paris, April 17, 1826, and following
days, part of lot 66, unsold; second David estate sale, Paris, March 11,
1835, part of lot 16; André Chassagnolle, Paris; Jules David-
Chassagnolle (1829–1886), Paris, 1882; comtesse J. Murat (according
to an inscription on leaf 10; presumably Thérèse Bianchi, comtesse
Murat); sale, Sotheby's, Monte Carlo, February 22, 1986, lot 106;
Stephan Mazoh, New York; Rolf Weinberg, Zurich; Getty Research
Institute, 1994

REFERENCES: Rosenberg and Prat 2002, vol. 1, nos. 1103–1202,
pp. 709–45

## 9. *Alpine Landscape with a Horse-Drawn Carriage Traversing a Pass*

From Roman Album no. 10, leaf 17
Ca. 1775–80
Black chalk, traces of white heightening
6 × 8⅜ in. (15.4 × 21.2 cm)
Marks: lower right, paraphs of Eugène David (Lugt 839) and Jules David (Lugt 1437)
Morgan Library and Museum, New York, Purchased on the Sunny Crawford von Bülow Fund, 1978 (1991.6)

PROVENANCE: David estate sale, Paris, April 17, 1826, and following days, part of lot 66, unsold; second David estate sale, Paris, March 11, 1835, part of lot 16; sale, Hôtel des Ventes de la Bourse, Paris, April 4–5, 1836, part of lot 164; Jules David-Chassagnolle (1829–1886), Paris; marquis and marquise de Ludre-Frolois, Paris; her sale, Galerie Charpentier, Paris, March 15, 1956, part of lot 11, unsold; their daughters, marquise du Lau d'Allemans and comtesse de Chaumont-Quitry, Versailles; sold by them in 1958 as part of album no. 10 to Germain Seligman of Jacques Seligmann & Co., New York, where the album was dismembered and its drawings sold individually; this sheet acquired by Dr. Leon Greenstein, Peekskill, New York, 1960; sale, Christie's, London, January 10, 1990, lot 157; Galerie Haboldt, Paris; acquired by the Morgan Library and Museum, 1991

REFERENCES: *Dessins anciens* 1991, cat. 6, pp. 18–19; Denison 1995, cat. 21, pp. 50–51; Rosenberg and Prat 2002, vol. 1, no. 1080, p. 700

## 10. *Statue of a Standing Woman*

From Roman Album no. 6, leaf 5
Ca. 1775–80
Red chalk with brush and brown wash
8⅜ × 5⅝ in. (21.3 × 14.3 cm)
Inscriptions and marks: lower left, in pen and black ink, "[pal]azzo giustiniani"; lower left and lower right, paraphs of Eugène David (Lugt 839) and Jules David (Lugt 1437)
National Gallery of Art, Washington, D.C., Ailsa Mellon Bruce Fund (1980.21.2)

PROVENANCE: David estate sale, Paris, April 17, 1826, and following days, part of lot 66, unsold; second David estate sale, Paris, March 11, 1835, part of lot 16; sale, Hôtel des Ventes de la Bourse, Paris, April 4–5, 1836, part of lot 164; Galerie Paul Prouté, Paris, 1978; Galerie de Bayser, Paris, 1979; acquired by the National Gallery of Art, Washington, D.C., 1980

REFERENCES: *Dessins originaux* 1978, part of cat. 58; *Louis David* 1979, cat. 14, n.p.; Rosenberg and Prat 2002, vol. 1, no. 682, p. 517

## 11. *Statue of a Standing Woman (Anchyrroe)*

From Roman Album no. 6, leaf 5
Ca. 1775–80
Pen and black ink, brush and gray wash, over black chalk
8⅜ × 5⅜ in. (21.2 × 13.7 cm)
Marks: lower left and lower right, paraphs of Eugène David (Lugt 839) and Jules David (Lugt 1437)
National Gallery of Art, Washington, D.C., Ailsa Mellon Bruce Fund (1980.21.1)

PROVENANCE: David estate sale, Paris, April 17, 1826, and following days, part of lot 66, unsold; second David estate sale, Paris, March 11, 1835, part of lot 16; sale, Hôtel des Ventes de la Bourse, Paris, April 4–5, 1836, part of lot 164; Galerie Paul Prouté, Paris, 1978; Galerie de Bayser, Paris, 1979; acquired by the National Gallery of Art, Washington, D.C., 1980

REFERENCES: *Dessins originaux* 1978, part of cat. 58; *Louis David* 1979, cat. 18, n.p.; Rosenberg and Prat 2002, vol. 1, no. 687, p. 519

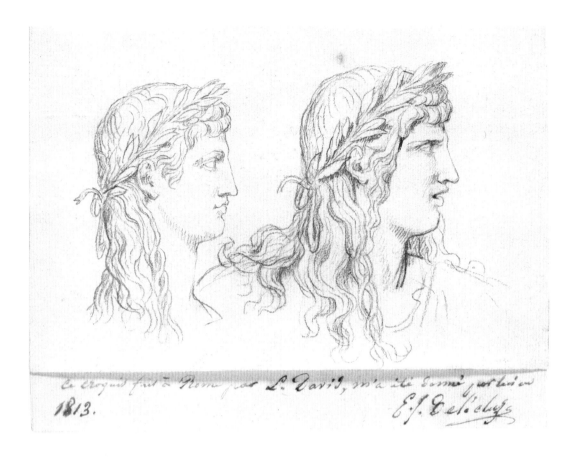

## 12. *Two Studies of the Head of a Young Man Crowned with a Laurel Wreath*

Ca. 1775–80
Black chalk
4⅝ × 7⅛ in. (11.8 × 18.1 cm)
Inscriptions: below the drawing, on an attached strip of paper, in pen and brown ink, "Ce croquis fait à Rome par L. David, m'a été donné par lui en / 1813. E. J. Delécluze"
National Gallery of Art, Washington, D.C., Bequest of William B. Jordan and Robert Dean Brownlee, 2019 (2019.45.9)

PROVENANCE: Etienne Jean Delécluze (1781–1863), Paris; Albert Vaudoyer, Paris; Galerie Jean-François et Philippe Heim, Paris, 1990; sale, Sotheby's, New York, January 12, 1994, lot 212; William B. Jordan and Robert Dean Brownlee, Dallas; their bequest to the National Gallery of Art, Washington, D.C., 2019

REFERENCES: Delécluze 1855, p. 112; Arlette Sérullaz in Schnapper and Sérullaz 1989, pp. 68–69, fig. 35; Heim and Chambadal 1990, p. 8; Rosenberg and Prat 2002, vol. 1, no. 13, p. 38

## 13. *View of the Campidoglio in Rome*

Ca. 1775–80
Brush and gray wash over black chalk
5⅛ × 7½ in. (13 × 19 cm)
Inscriptions and marks: lower right, in pen and black ink, "capitole.";
lower left, paraphs of Eugène David (Lugt 839) and Jules David (Lugt 1437)
Roberta J. M. Olson and Alexander B. V. Johnson

PROVENANCE: Galerie de Bayser, Paris; acquired by the present owner, 2006

REFERENCES: Rosenberg 2017a, p. 51, fig. 11

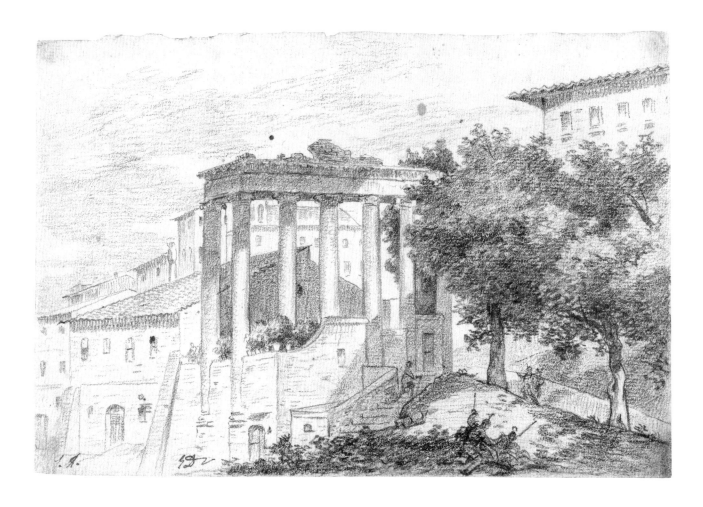

## 14. *View of the Roman Forum from the Temple of Saturn*

Ca. 1775–80
Black chalk
5¼ × 7¾ in. (13.2 × 19.7 cm)
Marks: lower left, paraphs of Eugène David (Lugt 839) and Jules David
(Lugt 1437)
Roberta J. M. Olson and Alexander B. V. Johnson

PROVENANCE: Galerie Terrades, Paris; acquired by the present owner, 2006

REFERENCES: Rosenberg 2017a, p. 51

## The Albums

On April 17, 1826, at the sale that took place after David's death, lot 66 comprised "twelve large books of sketches consisting of studies after ancient bas-reliefs, figures after the antique, landscapes, almost all of Italy, and tracings"; they remained unsold.[1] A few months later, in the estate inventory of David's widow, Marguerite Charlotte Pécoul, dated June 27, 1826, they were described as "twelve large books containing drawings & tracings, studies [made] by M. David in Italy."[2] The inventory also specifies the number of leaves, drawings, and tracings in each album. Nine years later, on March 11, 1835, the twelve albums reappeared at the artist's second posthumous sale, this time offered individually, though described under a single lot number. Two of them were acquired by the Louvre, while the others were apparently purchased by descendants of the artist.[3]

Ten of the albums are now known: eight survive more or less intact, two have been dismembered and dispersed, and two remain untraced.[4] According to the 1826 inventory of Madame David's estate, the complete set of twelve then contained approximately 972 drawings and 164 tracings, for a total of 1,136 drawings attached to 276 leaves. The ten albums known today contain 850 drawings (140 of which are tracings) on approximately 216 leaves. To this total must be added at least 80 drawings (6 of them tracings) that definitely derive from this corpus but lack a clear link to any specific album.[5] The 1826 sale catalogue already listed several lots of drawings removed from the albums, often identifiable as such because they consisted of between four and seven drawings affixed to a single sheet.[6] In addition, some of the drawings affixed to the leaves have been revealed in modern times to have drawings on their versos. Examples can be found in the albums now in the collections of the Musée du Louvre, Paris, the Nationalmuseum, Stockholm, and, most recently, the Morgan Library and Museum, New York (see, for example, figs. 9, 21).[7]

The surviving albums all have similar dimensions, about 20 3/8 by 13 5/8 inches (51.8 by 34.5 centimeters). Their cardboard covers and flyleaves are inscribed with the number assigned to them in the series and, in most cases, a precise indication of the number of leaves and drawings they contain, as well as brief descriptions of certain modifications they had undergone. The surviving albums of the set have between 21 and 26 leaves, measuring roughly 19 by 13 inches (48.4 by 33 centimeters) when the paper is white or 19 3/4 by 13 1/8 inches (50.8 by 33.5 centimeters) when it has a greenish tint (the color of the papers is discussed in further detail below).

Most leaves are numbered twice. The indications at lower right specify the leaf numbers within the album (the numbers are consecutive), while a second numerical inscription at upper right gives the number of drawings attached to each leaf, for example, "62 quatre dessins," or "[leaf] 62 [with] four drawings." These inscriptions make it possible to compare the structure of the original albums with their present state. We are indebted to Arlette Sérullaz and Lina Propeck for solving the mystery of these notations by organizing all of the leaves known at the time in accordance with this numbering system (albums 4, 5, 8, and 11 had not yet resurfaced at the time of their study).[8] This ordering enabled them to establish a single ensemble. Originally, before the fabrication of the twelve albums, the leaves succeeded one another as indicated by this numbering system. The leaves from the first half of the sequence have a greenish tint while those from the second half are white, which suggests that, initially, they comprised two thicker albums that might be called the "original" ones.[9] At present, the last-known leaf from the first original album is the one numbered 194 (now in album no. 1), while the first leaf from the second original album is numbered 196 (leaf 10 in album no. 9) and the last, 284 (leaf 21 in album no. 3).[10]

Reconstitution of the original albums revealed a logic behind the initial arrangement of the drawings.[11] The first original album consisted of eight sections, organized in the following sequence: single male figures (leaves 1 to 19; see fig. 57); single female figures (20 to 65); two figures, most of them paired (67 to 95); groups, often copied from old master paintings (101 to 128; see cat. 7); landscapes (131 to 168; see cat. 6); heads (169 to 175); animals (177 to 183); and antiquities (184 to 193; see cat. 8). The arrangement on every leaf is meticulous, nearly all presenting four carefully spaced drawings. Only three leaves have drawings attached to the verso as well as the recto.

The organization of the second original album was less rigorous. The rectos of leaves 196 to 200 displayed

Fig. 57. Jacques Louis David, leaf 7 (seated male figures), Roman album no. 11 (cat. 8)

Fig. 58. Jacques Louis David, leaf 13 verso (copies after paintings, sculptures, and prints), Roman album no. 11 (cat. 8)

copies of works in the Vatican by Raphael and his students, while their versos were laid out with a larger number of drawings (as many as ten), mostly copies of illustrations in Bernard de Montfaucon's *L'antiquité expliquée* (*Antiquity Explained*; Paris, 1719–24); paintings in the Orléans collection; or ancient statuary, including a few drawn at Fontainebleau (fig. 58). Drawings of antiquities followed on leaves 201 to 225, but thereafter the logic and coherence of the sequencing and layouts becomes increasingly attenuated. Leaves 226 to 235 were devoted to landscapes, while leaves 241 to 282 consisted exclusively of tracings of plates in Pierre d'Hancarville's *Collection of Etruscan, Greek, and Roman Antiquities from the Cabinet of the Honble. Wm. Hamilton* (Naples, 1766–67).[12]

The album eventually came to a close with a leaf featuring two studies for David's projected *Death of General Dampierre*, followed by two leaves with drawings related to the *Sabines* (see, for example, cat. 65).[13] Clearly, the order of the leaves in this second album was more a matter of incremental addition than of any logical scheme.

With respect to their date of assembly, the first original album was put together from drawings executed in Rome between 1775 and 1780, during David's first sojourn in the city. The artist probably assembled it, over a relatively brief time span, shortly after his return to Paris, and definitely before his second trip to Italy, in 1785. The second original album is rather different. Some of its drawings date from the first Roman sojourn,

Fig. 59. Jacques Louis David, leaf 13 recto (detail, after *Marius at Minturnae*), Roman album no. 11 (cat. 8)

but others were made after David's return to Paris in 1780. Several are copies of works seen by him during a trip to Flanders with the painter Piat Joseph Sauvage during the final months of 1781.[14] The inclusion of studies for *Andromache Mourning the Death of Hector* on some of the early leaves indicates that it could not have been assembled before 1782.[15] The presence of a 1785 study for the *Paris and Helen* on the verso of leaf 274 indicates that the series of d'Hancarville tracings, which brought the second original album to a provisional close, had been integrated previously.[16] David continued to add to this album until about 1795, which explains its relative disarray and less unified content. On leaf 200, for example, we find a study by David (fig. 59) for the *Marius at Minturnae* executed by his student Jean Germain Drouais between 1784 and 1786.[17] Furthermore, as already mentioned, the last two leaves consisted of preparatory drawings for *The Death of General Dampierre*, an unrealized painting that David began in 1793, and for the *Sabines*, a composition on which he began work in 1795.[18]

Why and when were the two original albums broken up and transformed? They are not described in

the estate inventory of February 25, 1826, which does, however, list some "large books" ("gros livres") that might correspond to them. A document dated March 2, 1826, records that "the binding of twelve volumes of drawings, in folio" had cost "sixty-six francs,"[19] which surely must refer to the cardboard coverings of the twelve albums subsequently included in the estate sale of April 17, 1826. It seems logical to assume that the numbering of the original leaf sequence dates from very shortly before the original albums were disassembled, more or less the same moment that David's two sons, Jules and Eugène, inscribed their paraphs on each drawing. This dismemberment disregarded the artist's guiding principles of organization, which, as a result, we will never be able to understand fully. The act was doubtless carried out for financial reasons: the artist's heirs thought that they would reap a greater return from the sale of twelve albums, each containing an array of drawings that encompassed the various categories included in the originals, than from the sale of two cumbersome albums that were awkward to handle and perhaps somewhat monotonous. They also removed a few leaves entirely that were then offered individually at the April 1826 sale.[20]

It has long been assumed that the composition and assembly of the twelve albums was ad hoc and that the selection of their leaves was relatively haphazard. This was not, in fact, the case. Close study of the later albums reveals that many of their consecutive leaves initially constituted a single sheet folded in half. The original albums were assembled from these larger sheets, folded and arranged in gatherings generally consisting of six leaves or recto-verso pages. Thus, leaf 1 was on the same sheet as leaf 6, leaf 2 on the same sheet as leaf 5, leaf 3 on the same sheet as leaf 4, and so forth. When David's heirs dismantled the original albums, they decided not to divide these large sheets, which guaranteed the new leaf sequences a certain rhythm—although one that is sometimes interrupted by the absence of a sheet that was removed for retention by the heirs or for sale in discrete lots. A distinction should also be drawn in this regard between the first original album, in which the pattern of six leaves per gathering was more or less consistent, and the second, in which the gatherings comprised two sheets and thus had four leaves each.

## The Drawings

The drawings in the albums can be divided into three basic categories: depictions of ancient sculpture and artifacts, copies of old master paintings, and landscapes. The first category accounts for roughly two-thirds of the drawings, the second slightly less than twenty percent, and the last, fifteen percent. These calculations do not include the tracings, most of which were made after illustrations in d'Hancarville.

For the drawings after antiquities, David visited several collections in Rome: the Medici collection in the Villa Medici, before most of its holdings were moved to Florence; the papal collections in the Vatican; the Giustiniani, Albani, and Borghese collections, the latter now in the Musée du Louvre; the Negroni and Farnese collections, before the departure of the latter for Naples; and the Altemps collection.[21] He also copied works in the collections of two contemporary artists, Giovanni Battista Piranesi and Anton Raphael Mengs, as well as in Palazzo Mancini, then home to the Académie de France, which possessed a large collection of plaster casts. David often inscribed on the sheet the location of the depicted objects. He used both statues and bas-reliefs as models, sometimes choosing to draw them in their entirety and other times to represent only a detail.

The copies after old master paintings hold the most surprises.[22] Most were drawn in Rome, but some were executed during his return trip to Paris, in Florence, Bologna, Venice, Milan, and Turin. Of the ninety drawings after paintings, forty-three are copies of complete compositions and forty-seven represent details. Of the latter, twenty-five depict figural groups, six are of individual figures, and fourteen are of heads; the remaining two drawings represent, respectively, a landscape and a decorative object, namely, an incense burner depicted in a fresco painted by Carlo Magnone after a cartoon by Andrea Sacchi.[23] Although Raphael is the artist most heavily represented and many of the drawings are recognizably after seventeenth-century Bolognese masters or Poussin, several of the names are less expected. There are some whose works are remote from David's supposed interests, for example, Paolo Veronese, Giovanni Battista Gaulli, and Pier Francesco Mola; more importantly, many, for example, Bonaventura Lamberti and Giovanni Maria Morandi,[24] were considered unfashionable and were rarely copied by artists sojourning in Rome. When visiting Roman churches, David seems to have been particularly interested in works by artists active in the city during the last third of the sixteenth century, for example, the Zuccari, Giovanni Baglione, Michiel Coxcie, and Giovanni da San Giovanni. David did not hesitate to visit churches off the usual tourist track, to cross the thresholds of infrequently visited monuments, or to copy works rarely drawn by other artists. At the church of Santo Spirito in Sassia, for example, situated in the Borgo and doubtless visited en route to the Vatican, he copied a *Deposition* by Pompeo Cesura (see cat. 7, bottom center).[25]

It is also interesting to note what David chose to copy and what he passed up. Surprisingly, the church in which he made the most copies, at least among the drawings now known to us, is San Marcello al Corso, a fact likely due to the church's proximity to Palazzo Mancini, the two buildings, both situated on the via del Corso, are just over a hundred yards from one another. Here, David sketched paintings by Taddeo Zuccaro and Giovanni Battista Ricci,[26] but he opted not to copy those by Perino del Vaga and Francesco Salviati.

Anthony van Dyck and Peter Paul Rubens must also be mentioned here: the former because of an equestrian portrait that David drew in Turin, which would later serve, in 1780, as a source of inspiration for his *Portrait of Stanislas Potocki*; and the latter, for paintings that David saw during his trip to Flanders, undertaken in part to acquire works for the French royal collections.[27] During this same trip, David drew a painting by his Flemish contemporary André Corneille Lens, the only known drawing by David after a work by a living artist.[28] Among other surprises, it is worth mentioning that he copied details from a drawing by Laurent de La Hyre, *The Early Christian Community* from the History of Saint Stephen cycle, now in the Louvre, but still in the church of Saint-Etienne-du-Mont when David drew from it.[29]

Most of the landscape drawings represent the city of Rome and the surrounding countryside, although there are also views of Gaeta, on the route to Naples;[30] Palazzone, near Florence;[31] Milan; and of mountains that have not yet been precisely identified (see, for example, cat. 9). In his views of Rome, David favored closely framed compositions with only a few buildings over

Fig. 60. Jacques Louis David, leaf 13 (landscapes), Roman album no. 4 (cat. 6)

grand panoramic views. Even when these scenes include celebrated monuments, he tended to linger over the bulky forms of humble dwellings and anonymous farm buildings. He liked to use gray wash to depict the play of light and shade over arches and colonnades. At least one "landscape" is in fact taken from a painting, in this case by Domenichino (fig. 60, lower right).[32] As David sometimes indicated in his inscriptions, certain drawings were made "d'après nature," or "from life," in particular those of animals—cows and mules but also, in one instance, a lion that he sketched in Paris.[33]

The color of the paper used for the drawings—not to be confused with that of the leaves on which they were mounted—varies, ranging from white, the predominant color, to a bluish tint (but only in the second original album). Some of the drawings are on greenish paper and, more rarely, beige paper. Most were done in black chalk. Although sometimes left as they were, regardless of their degree of finish, many drawings were reworked in pen and brown or black ink, often heightened with

wash, usually gray. Some drawings are in red chalk, occasionally augmented with wash. It appears that, in general, these ink-and-wash refinements were added in the evening, after David's return to Palazzo Mancini. For example, on a copy recently identified as after a fresco by Giovanni Battista Ricci, a *Presentation of the Virgin* some thirty feet above the choir of San Marcello al Corso, the wash additions altered the direction of the light (fig. 61); if David had added the wash while still working in the church, he would probably have honored the placement of the light source in Ricci's original scheme.[34] A few drawings, all landscapes from the second original album, were even completed in wash after having been glued onto the pages of the album (as some brushstrokes extend beyond the support and onto the leaf), and thus after David's return to France (see, for example, fig. 60).[35]

A recent examination of the watermarks in the Roman albums has revealed that when the latter are visible, they most often display the Orfini arms, namely, a

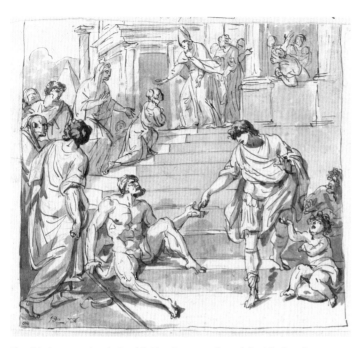

Fig. 61. Jacques Louis David, *The Presentation of the Virgin, after Giovanni Battista Ricci*, ca. 1775–80. From Roman album no. 9, leaf 2. Pen and black ink, brush and gray wash, over black chalk, 9⅜ × 11⅛ in. (23.7 × 28.3 cm). Musée du Louvre, Paris (INV. 26131)

circle containing a pigeon displayed above three mounts, sometimes with the letter F above the circle.[36] To be more precise, most of the drawings show half of this watermark, with either the pigeon or the three mounts.[37] When David oriented his sketchbook horizontally, usually to draw a landscape or a frieze composition with several figures, the half-watermark is situated at upper center; when he oriented it vertically to draw one or two figures, the half-watermark is at left center. This indicates that he originally used sketchbooks made from sheets that had been folded in half before being bound.

Other clues of the order and orientation of the sheets in the original sketchbooks can be found in the pen-and-ink annotations that appear on fifteen drawings from the Roman albums, evidence of a prior numbering system. All of them are on the same paper and, when left uncut, have similar dimensions (roughly 8⅜ by 6⅛ inches, or

Fig. 62. Jacques Louis David, *Two Draped Women*, dated 1780. From Roman album no. 9, leaf 8. Pen and black ink, brush and gray wash, over black chalk, 6 × 8¼ in. (15.2 × 21 cm). Musée du Louvre, Paris (INV. 26142 bis)

21.3 by 15.3 centimeters). The lowest such number is 15, inscribed on a drawing of an antique statue then in "ville panphile [*sic*]," while the highest is 48, on a landscape with the Pyramid of Cestius.[38] Certain of the drawings with consecutive numbers depict works from the same collection (24 and 25 show works from Villa Albani; 29 and 30, from the residence of Mengs; 37 and 38, from the "museum du cavalier Piranese"), which makes it possible to outline a rough chronology of David's peregrinations during his use of this sketchbook.[39] It is to be hoped that the reappearance of more drawings from the Roman albums will enable a gradual reconstitution of this sketchbook, which David likely used toward the end of his first Roman sojourn.

At present, it is difficult to establish a precise chronology of the Roman album drawings, owing in part to the fact that David's reworkings in pen and wash are not always contemporary with the initial drawings in black chalk. We can nonetheless lay down a few benchmarks. A landscape bearing the inscription "gayette" must have been executed at Gaeta during David's trip to Naples in July–August 1779. The copies of works in Florence, Bologna, Venice, and Brescia as well as a view of Milan were doubtless executed during David's return trip to Paris between July and September 1780. A copy of a relief in the Vatican collections is inscribed, "the last such study sketch made in Rome on 17 July 1780, and I departed the 18th," [40] while a copy of another relief in the Vatican is inscribed, "completed in an inn / while returning from Rome. 1780" (fig. 62).[41]

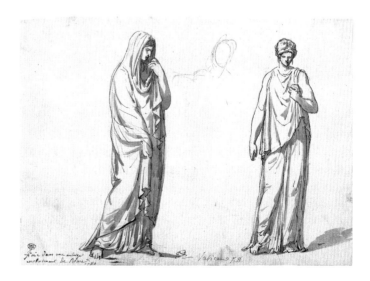

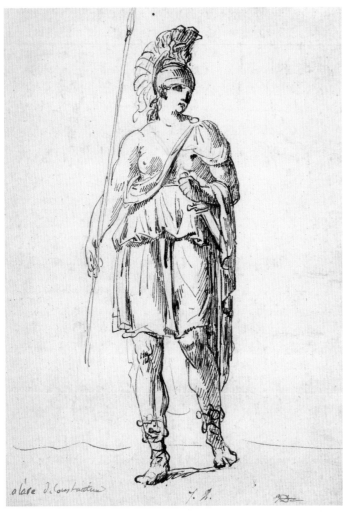

Fig. 63. Jacques Louis David, *Athena*, ca. 1775–80. Pen and black ink, 8¼ × 5⅞ in. (21 × 14.8 cm). Private collection

It is tempting to date to the beginning of the Roman sojourn an entire group of drawings of antiquities, executed in an oily black chalk in a technique that is somewhat loose but quite finished.[42] A group of copies after old master paintings, also sketched in black chalk, whose style and subject matter bring to mind Fragonard's drawings for the *Panopticon italiano*, may likewise date from the same time.[43] A similar case could be made for a group of landscape drawings executed in black chalk only,[44] like the study depicting the temple of Saturn in the Roman Forum (cat. 14).[45]

To when, however, should we date a group of drawings executed in pen and black ink and distinguished by their use of tight hatching (for example, fig. 63)?[46] It could

be that they were made in the first years of the sojourn, given the similarity of their technique to that of a large drawing, dated 1777, of an ancient relief in the Musée d'Art et d'Archéologie in Senlis.[47] Alternatively, they may date to 1779–80, when David was en route home to Paris, since their technique is not very different from that used to create the view of Gaeta and the landscape executed in Palazzone, as well as some mountainous landscapes executed in pen and brown ink also realized, in all likelihood, during David's return trip.[48]

Similarly, when should we date the landscapes contained in the second original album, for example, the ones now on leaf 13 of album no. 4 (see fig. 60)? In both style and motif, they differ somewhat from the ones in the first original album. The wash in these drawings is applied with greater freedom, and the pen marks are less dominant; the compositions, moreover, are characterized by a more pronounced geometricization of form and a more dramatic contrast of light and shade. In these respects, they more closely resemble the landscapes in a sketchbook used by David during his second Roman sojourn, when he was working on *The Oath of the Horatii*.[49]

As Pierre Rosenberg and Louis-Antoine Prat were the first to point out, some of the album drawings are not from David's hand.[50] The tracings of illustrations in d'Hancarville, which have a mechanical quality, are clearly not by David. Neither are the roughly sixty copies in black chalk characterized by a heavy-handed technique and boxy, geometric forms, sometimes bearing inscriptions that are not in David's hand. Given that a number of these drawings depict ancient statuary (as well as a few paintings) in the Giustiniani collection, Rosenberg dubbed their unknown author the "Giustiniani Master" (see, for example, fig. 64). David reworked some of them with gray wash.[51] A few are on paper with the same watermark of the Orfini arms found on paper used by him.[52] In all likelihood, the Giustiniani Master was a fellow student at the Académie de France who was well known to David.

Other copies after the antique, particularly those depicting objects, are likewise not by David, and the attribution to him of two large views of Rome, one in album no. 11 (Getty Research Institute; cat. 8), the other in album no. 5 (Musée du Louvre), is also dubious.[53] Also not by his hand are three compositional studies, one

Fig. 64. The "Giustiniani Master," *Four Sketches after the Antique,*
1775–80. From David's Roman album no. 11 (cat. 8), leaf 12

representing *Virgil Reading from the Aeneid* and the other
two, *The Death of Tatius.*[54] The latter was the designated
subject for the Prix de Rome in 1788, when the winner
was Etienne Barthélémy Garnier. Inscriptions on the
*Tatius* drawings indicate that their author was a student
of David's who was seeking his master's advice on some
compositional changes. Two of his students competed
that year, Girodet and Jacques Augustin Catherine Pajou.
As the composition of the painting by Girodet, now
in the Musée des Beaux-Arts, Angers, is, in fact, quite
unlike these two drawings, Rosenberg has proposed their
attribution to Pajou.

The drawings in the Roman albums served David as
a repertoire of forms from which he drew for much of

his career. He put some of the drawings to use even prior
to the fabrication of the two original albums. Thus *The
Funeral of Patroclus,*[55] *Belisarius Begging for Alms* (cat. 16), and,
especially, the *Frieze in the Antique Style* (cat. 18) all borrow
from the drawings after ancient sculpture that David exe-
cuted in Rome. Once the albums had been assembled,
his borrowings were of a greater variety.

The poses of individual figures, and even of entire
groups, in paintings by David sometimes derive directly
from one or several drawings in the Roman albums.
Thus, when he was developing the composition of the
*Paris and Helen,* his point of departure for the figure of
Paris was a drawing of a statue of a faun leaning on a tree
trunk on leaf 15 of the original albums, which prompted
him to draw his first compositional sketch directly
onto the facing page, the original leaf 14 verso.[56] In all
likelihood he shortly thereafter sketched another com-
positional study, on leaf 274 verso, which was opposite
leaf 275 recto, whose layout includes a large tracing after
a d'Hancarville plate representing a seated Paris and a
standing Helen (see cats. 36, 37).[57]

A drawing on leaf 78 of the original albums (cat. 8,
top) shows two horizontal registers of reclining women
taken from the cover of a sarcophagus, now in the
Vatican, carved with scenes from the Massacre of the
Niobids.[58] David adapted one of the figures in the lower
register, notably by reversing it, for his drawing of *The
Elder Horatius Defending His Son after the Death of Camilla,* now
in the Louvre, which dates from about 1782.[59] In a first
idea for *Andromache Mourning the Death of Hector,* attached to
the original leaf 222,[60] he used the entire group.

The copy of the painting by Lens, already mentioned,
was used by David to develop his composition represent-
ing *The Death of Artemisia,*[61] but he subsequently reworked
the pose of Artemisia into that of Andromache. Some of
the borrowings are less literal. The drawing of a statue of
a seated man with joined hands on leaf 7 of the original
albums was perhaps the point of departure for the figure
of Plato in *The Death of Socrates.*[62]

The album drawings were especially useful in the
development of backgrounds and as a stock of models
for decorative accessories. The source for the setting of
*The Oath of the Horatii,* with its triple arcade, was doubtless
a drawing on leaf 139 depicting the courtyard of the
Palazzo Vecchio in Florence.[63] An ancient statue of

Minerva formerly in the Palazzo Farnese, depicted in a drawing on the original leaf 20,[64] appears at right, on a pedestal, in the drawing of *The Ghost of Septimius Severus Appearing to Caracalla* in the Horvitz collection.[65]

Ultimately, it was in the depictions of furnishings and clothing that David's borrowings are most apparent and most numerous. The dead warrior's helmet in *Andromache* was lifted directly from a drawing after the antique on leaf 218.[66] Moreover, David repeated this motif, in slightly altered form, in a sketch executed directly on the same leaf.[67] A chair drawn on the verso of the original leaf 203 directly inspired the one on which Andromache sits in the painting.[68]

David's complex creative process allowed him to slip seamlessly from mythology to history, from the model that inspired him to the original composition, digesting and obscuring his many sources along the way. The drawings in the Roman albums served as points of departure in the elaboration of his compositions. The farther this process advanced, the more attenuated became the connections with the albums.

The Roman albums were an essential source of inspiration for all of David's large pre-Revolution compositions. They subsequently played a less significant role, in particular for the preparation of paintings depicting events from contemporary history, notably *The Oath of the Tennis Court* and *The Coronation*. David turned to the albums once again while developing the *Sabines*, but no direct borrowings from them have yet been identified in the *Leonidas*. By contrast, his 1813 drawing of *Alexander, Apelles, and Campaspe*, now in the Pébereau collection, incorporates several elements from them, for example, the lyre, the chair upon which it rests, and the bust in the background, two drawings of which figured in the albums.[69] Moreover, the painting on which Apelles is working in the drawing is not a depiction of Campaspe but, rather, of the departure of Orestes and Iphigenia from Tauris, shown in a composition that duplicates that of a drawing from the original leaf 83.[70]

The Roman albums played a lesser role in David's subsequent production, and he probably did not take them with him when he went into exile in Brussels.[71] However, very few artists went as far as David in assembling such a repertoire of forms. To be sure, many artists returned from Rome with a corpus of drawings of ancient models, one that later played a role in the elaboration of their work, but none made this resource so fundamental to their creative process. The thematic reorganization of the drawings of antiquities and the addition of drawings after old master paintings as well as landscapes make David's Roman albums a unique and fascinating artifact, one that has yet to reveal all of its secrets.   BP

## 15. *The Combat of Diomedes*

1776
Pen and black ink, brush and gray wash, black chalk, heightened with
white, on three joined sheets of gray-blue paper
42½ × 80½ in. (108 × 204.4 cm)
Inscriptions and marks: lower right, in pen and black ink, signed
and dated "L. David f. Roma 1776"; blind stamp of Duke Albert von
Sachsen-Teschen (Lugt 174)
Graphische Sammlung, Albertina, Vienna (17428)

PROVENANCE: Duke Albert von Sachsen-Teschen (1732–1822)

REFERENCES: Hofmann 1958; Arlette Sérullaz in *David e Roma* 1981,
cat. 14, pp. 79–80; Arlette Sérullaz in Schnapper and Sérullaz 1989,
cat. 29, pp. 90–91; Rosenberg and Prat 2002, vol. 1, no. 12, pp. 36–37;
Guillaume Faroult in Faroult, Leribault, and Scherf 2010, pp. 300–301,
fig. 140 (under cat. 90); Prat 2011, p. 28, fig. 38; Ekelhart 2017, cats. 67,
68, pp. 154–55, 166–69

Upon his arrival in Rome, Joseph Marie Vien, as the
new director of the Académie de France, was tasked with
implementing and enforcing detailed new regulations
issued by Charles Claude de Flahaut, comte d'Angiviller,
director of the Bâtiments du Roi. These rules required
the *pensionnaires* to produce an original composition each
year, in addition to studies from life and copies after
earlier masters. The rationale, according to the official
wording, was that, "in this way, it will be possible to
judge the progress of their genius."[1] The present sheet,
dated 1776, now in Vienna, exemplifies this type of
composition and speaks to David's boundless ambition at
the outset of his Roman sojourn.

On a sheet stretching more than six feet in length,
David presents a roiling battlefield, filled to bursting
with ancient warriors, gods, and horse-drawn chariots.
The violence of the subject finds stylistic echo in the
dramatic contrasts of tone and the fervor of the brush-
work, especially the white heightening, put down with
a loaded brush to highlight the muscles, weapons, and
armor of the soldiers. Its immense scale and large cast
of characters have led many to compare *The Combat
of Diomedes* to the famous panoramic battle scenes of
David's Baroque and Mannerist predecessors Giulio
Romano, Pietro da Cortona, and Charles Le Brun,[2]
while the painterly technique and strong sense of

Fig. 65. Carle Vanloo (1705–1765), *The Sacrifice of Iphigenia*, ca. 1755. Pen and brown ink, brush and brown, blue, red, and pale yellow wash, heightened with white, over traces of black chalk, on brown-washed paper, 28⅛ × 35⅜ in. (71.4 × 89.9 cm). The Metropolitan Museum of Art, New York, Rogers Fund, 1953 (53.121)

movement have been associated with the French Rococo painters Jean Honoré Fragonard, Gabriel François Doyen, and Jean-Baptiste Deshays.[3] In terms specifically of the drawing technique, the sheet perhaps most closely resembles the manner of Carle Vanloo, whose large drawing of *The Sacrifice of Iphigenia* (fig. 65) was sold at auction by the artist's widow a few months before David left for Rome.[4]

The choice of subject likewise bears the imprint of recent French precedents.[5] Indeed, it relates directly to the last history subject painted by Vien on the eve of his, and David's, departure from Paris: *Venus, Wounded by Diomedes, Is Saved by Iris* (fig. 66). In Vien's treatment of the subject, exhibited at the Salon of 1775, the composition focuses not on the clamor of battle but, rather, on Venus, Mars, and Iris, their putti, and the horses. In the

scene's orchestration, Vien followed closely the suggestions made by his friend the comte de Caylus in his *Tableaux tirés de l'Iliade, de l'Odyssée d'Homere et de l'Eneide de Virgile* (Paris, 1757), a book intended to guide painters in selecting from these classical sources moments suitable for depiction.[6] But if Vien's choice of subject was fresh in David's mind, he eschewed the distilled clarity of Caylus's vignettes, opting instead to combine several different episodes of Diomedes's exploits from book 5 of the *Iliad* into a single, operatic fray. In Homer's account, Diomedes was one of the most valiant Greek warriors of the Trojan War, favored and guided by Athena, whose balance of strength and wisdom he shared. With her help, he was one of the few mortals to successfully battle immortals, wounding Aphrodite's son Aeneas and even injuring the goddess herself. This is the episode high-

Fig. 66. Joseph Marie Vien (1716–1809), *Venus, Wounded by Diomedes, Is Saved by Iris*, 1775. Oil on canvas, 63¾ × 81¾ in. (161.9 × 207.7 cm). Columbus Museum of Art (1986.007)

lighted at the center of David's composition, as Diomedes lunges toward Aphrodite and the wounded Aeneas.

*Diomedes* is thus a testament to David's vast ambition in the first year of his Roman studies, still early on his path to developing a personal style. While one imagines he made the drawing with an eye to its reception in Paris, it is not clear if it was ever included in the *envois*. It does appear, however, in the earliest inventories of the drawings owned by Duke Albert von Sachsen-Teschen, whose collection forms the basis of the holdings of

the Albertina Museum, Vienna.[7] The duke and his wife, Marie-Christine, visited the Eternal City in the spring of 1776, and the correspondence between Vien, d'Angiviller, and other members of the French diplomatic community in Rome makes frequent mention of their travels and the art they acquired.[8] They would also buy works of art during a visit to Paris in 1786, but the most straightforward theory is that the duke and duchess acquired the drawing directly from David the year it was made.[9]  PS

## 16. *Belisarius Begging for Alms*

1779
Pen and black ink, brush and gray wash, heightened with white gouache, on faded blue paper
18¾ × 14⅛ in. (47.5 × 36 cm)
Inscriptions: lower right, in black ink, signed and dated "J [in another hand and another ink] L. David inven / et delineavit / 1779 Napo . . ."
Ecole Polytechnique, Palaiseau (B.7)

PROVENANCE: Acquired from the artist by Jean-Baptiste Charles François, marquis de Clermont d'Amboise (1728–1792); seized as émigré property at the Hôtel de Clermont d'Amboise, June 6, 1793; placed at the Dépôt National on rue de Beaune (Hôtel de Nesles); Ecole Centrale des Travaux Publics (Hôtel de Lassay), 1794; Ecole Polytechnique, Palaiseau, 1795 (classified an *objet historique* by the Minister of Public Instruction and Fine Arts, June 30, 1908)

REFERENCES: Boime 1980, pp. 88, 99–100 n. 44, pl. 49; Régis Michel, p. 95, and Arlette Sérullaz, pp. 117, 120, in *David e Roma* 1981; Arlette Sérullaz in Schnapper and Sérullaz 1989, cat. 48, pp. 134–35; Sandt 1993, pp. 122, 131, 136 n. 19; *L'Ecole Polytechnique* 1998, cat. D7, pp. 218–19; Rosenberg and Prat 2002, vol. 1, no. 31, pp. 51–52; Prat 2011, pp. 30–31, fig. 44; Korchane 2016, cat. 4, pp. 36–40, 156

The painting *Belisarius Begging for Alms* (fig. 67)—according to Antoine Schnapper, the first Neoclassical painting, and now an iconic work in the collection of the Palais des Beaux-Arts, Lille—was warmly received at the Salon of 1781. Inspired by the eponymous novel by Jean François Marmontel (*Bélisaire*, 1767), it conveys a pitiless fate and the ingratitude of the great, for Belisarius was a general who, despite securing many victories for the glory of Emperor Justinian, was repeatedly disgraced by him— and yet, he continued to be recalled to duty whenever the Byzantine Empire was under threat. According to an improbable tradition, at the end of his life Belisarius had become blind and been reduced to beggary, depending on the assistance of a child, here shown holding out his elder's helmet to solicit obols from passersby. The subject was fashionable; Pierre Peyron and François André Vincent had previously taken it up.[1]

The date on the drawing clearly indicates that it was conceived during David's sojourn in Naples (July 22– August 20, 1779). The composition, which is monumental in character, seduces through the rigor of its construction, the elegance of the female figure (whose drapery is more enveloping in the painting), and the power of the white highlights that animate the central group. Only one figure study for the sheet is known, a sketch of a male nude,[2] corresponding to the soldier at left, who is stunned by the state to which his former general has been reduced.

David must have produced a repetition of this compositional study, a practice he would employ with other subjects until roughly 1789, shortly after presenting the Palaiseau sheet as a gift to Jean-Baptiste Charles François, marquis de Clermont d'Amboise and ambassador at the court of Naples from 1775 to 1784. The replica,[3] executed in the same technique but on gray-blue paper that is now considerably less yellowed, differs little from the Palaiseau drawing, the most notable variant being the treatment of the background landscape at left, which is less detailed. David also replaced the beautiful undulating highlight in white gouache on the young woman's veil with a vertical accent that is less effective.

By comparison with the painting, which is almost square, the Palaiseau sheet is proportionally higher, which made it possible for David to insert a statue between the two furthermost columns. The buildings in the background are less developed here than in the painting, where David has added a pedimented building and an obelisk, visible beyond the enclosing wall.   LAP

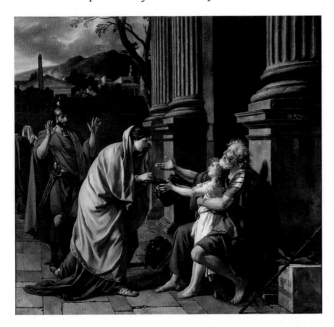

Fig. 67. Jacques Louis David, *Belisarius Begging for Alms*, 1781. Oil on canvas, 113⅜ × 122⅞ in. (288 × 312 cm). Palais des Beaux-Arts, Lille (P. 436)

## 17. *The Spartan Mother*

1779
Pen and black and brown ink, brush and gray wash, over black chalk,
heightened with white gouache
13¾ × 9⅞ in. (34.8 × 25 cm)
Inscriptions and marks: lower right, in pen and brown ink, signed and
dated "David f. et inv. in / Napoli / 1779"; collector's mark of baron
Dominique Vivant Denon (Lugt 779)
Private collection

PROVENANCE: Baron Dominique Vivant Denon (1747–1825); his estate
sale, Paris, May 1–19, 1826, lot 855, to Durand; Alexandre Morel sale,
Paris, April 12–16, 1830, lot 43; anonymous sale, Paris, December 29–
30, 1830, lot 81; Van den Zande sale, Paris, April 30, 1885, lot 2957;
Paris art market; private collection

REFERENCES: Rosenberg and Prat 2002, vol. 1, p. 51 (cited as lost in
no. 31); Prat 2011, p. 30; Prat 2016a, pp. 290–93

The 2002 catalogue raisonné of David's drawings docu-
ments drawings undoubtedly by the artist's own hand
but known at that time only through enigmatic textual
mentions. One of the most promising of the latter refers
to a characteristically moralizing *exemplum virtutis* depict-
ing a Spartan mother holding her son's shield as he is
about to depart for war. She instructs him to return *dessus
ou dessous*, that is, "above or below [it]" (sometimes trans-
lated as, "with shield in hand or lying under it")—or,
in other words, victorious and borne home in triumph,
or having died the glorious death of a hero. The story is
recounted by Plutarch in the "Apothegmata Laconica"
(Sayings of the Spartans) from his *Moralia*.

There are no less than four descriptions of this
drawing in nineteenth-century sale catalogues, each
of which points to its importance. The earliest was
occasioned by the Denon sale, which took place in 1826,
only days after David's posthumous estate sale. In the
catalogue it is described as "A drawing in pen and India
ink, representing the mother of a Spartan soldier giving
him his shield and telling him to return either on it or
under it. This drawing was made in Naples in 1779." It
was sold to Durand for 98 francs. The sheet resurfaced
in the Alexandre Morel sale (April 12–16, 1830), when it

was said to represent "the Spartan woman" ("la femme
du Spartiate"), and then reappeared at an anonymous
sale later that year (December 29–30, 1830), when it was
described as "The Spartan woman giving a lesson to her
son." Finally, at the Van den Zande sale (April 30, 1885),
the subject was described as "A Spartan woman presents
a shield to her son who is departing for war, recommend-
ing that he return on it or under it. Magnificent pen
drawing with India ink wash; it is signed David f. et inv.
in Napoli 1779."

Another David drawing bearing the same date and
place of execution, a compositional study for *Belisarius
Begging for Alms* (cat. 16), was made for the marquis de
Clermont d'Amboise, French ambassador to the King-
dom of Naples. The present sheet, which is somewhat
more concise in conception, and features shorter figures,
is remarkable not only for its legibility and concentration,
but also for its retention of Baroque elements. For exam-
ple, the dynamic swags of drapery at the top of the sheet
stand in contrast to the stoic fortitude of the maternal
figure, while the treatment of the horse and equerry in
the background brings to mind one of the artist's earliest
large drawings, *The Funeral of Patroclus*, generally dated to
1778, the year preceding David's sojourn in Naples.[1]  LAP

## 18. *Frieze in the Antique Style: Death of a Hero*

1780
Pen and black ink, brush and gray wash, black chalk, heightened with white gouache, with framing lines in pen and brown ink, on three joined sheets of faded blue paper and a fourth strip added at right
10½ × 29³⁄₁₆ in. (26.6 × 74.2 cm)
Inscriptions: lower left, in black chalk, signed and dated "L. David, fecit. 1780 roma"
Musée de Grenoble (MG 2615)

PROVENANCE: The painter Bouquet;[1] his collection sale, Paris, January 26, 1797, lot 30; acquired by Jean-Baptiste Pierre Le Brun (1748–1813); Guillaume Jean Constantin (1755–1816); his estate sale,

March 3, 1817, lot 508 bis, to Delpech; Antoine Jean, baron Gros (1771–1835); his estate sale, November 23, 1835, lot 174; acquired by Jean Dominique Larrey (1766–1842);[2] Perrier collection, Grenoble, 1880;[3] Aristide and Isaure Rey; their bequest to the Musée de Grenoble, 1931

REFERENCES: Salon 1783, no. 164, p. 34; Howard 1975; Arlette Sérullaz in Schnapper and Sérullaz 1989, cat. 38, pp. 103–5; Johnson 1993, pp. 50–58; Rosenberg and Prat 2002, vol. 1, no. 34, pp. 55–57; *Jacques-Louis David* 2005, cat. 19, pp. 68–69; Guillaume Kazerouni in Kazerouni 2011, cat. 112, pp. 203–7; Prat 2011, pp. 30–31, fig. 46

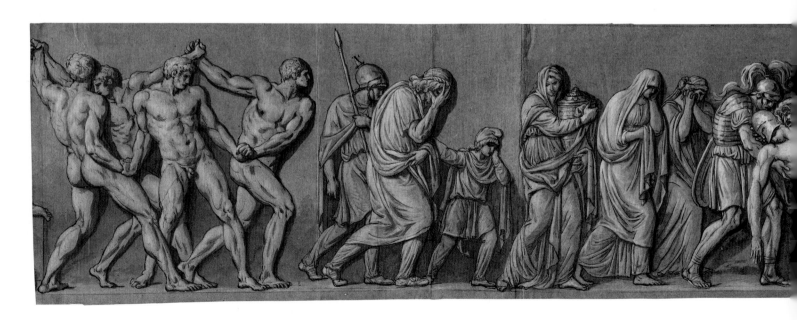

In the final months of his stay at the Académie de France in Rome, David drew a frieze depicting the death and funeral procession of an ancient warrior. Drawn in the *all'antica* style, the drawing was originally more than seven feet long and comprised eight sheets of paper. At some point between 1783 and 1797, it was cut into two unequal pieces. The Grenoble portion, seen here, with a strip added at the right and Lachesis's two amputated feet redrawn by another hand, presents a balanced, autonomous composition. A violent vignette of a classical warrior raising his sword to slay his fallen adversary is flanked by two groups of mythological figures who coolly observe and control the human drama. At left, a steely Athena sits with her lance in one hand and her shield in the other, while a similarly impassive Hercules stands ready to crown the victor. At right, the three Fates, with their flowing locks and twisting poses, form a more dynamic grouping. Clotho, who spins the thread of life, appears agitated as Atropos prepares to sever it. Meanwhile, Lachesis indolently looks on. The drawing of a funerary procession that originally formed the right-hand portion of the composition is today in the Crocker Art Museum, Sacramento (fig. 68).[4]

Drawings and monochrome paintings imitating ancient bas-reliefs had been popular in Italian art since the Renaissance, and they saw a surge in popularity in France in the second half of the eighteenth century.[5] In David's oeuvre, however, the frieze drawing, with its large scale and trompe-l'oeil technique, is a unicum. He would have been well aware of the style from Polidoro da Caravaggio's *all'antica* paintings he had seen in Rome,[6] as well as from works in this vein by his own contemporaries, notably the allegorical frescoes for the newly constructed Ecole de Chirurgie in Paris, executed by Esprit Antoine Gibelin just prior to David's departure for Italy. The frescoes were destroyed in 1796 but are known through engravings and the surviving preparatory drawing (fig. 69).[7] While a *pensionnaire* in Rome, David would also have seen the drawing that Pierre Peyron made, at the request of Joseph Marie Vien, after an ancient cameo (fig. 70).[8] He likewise would have been familiar with the classicizing reliefs of the sculpture *pensionnaires*, especially those of his friend Antoine Léonard Dupasquier, who was at that time working on a commission for a pair of reliefs featuring deathbed scenes.[9]

Yet, in contrast to the examples cited above, the function of David's ambitious sheet—neither a study nor a copy—is unclear. Efforts to identify the combatants have proved inconclusive, and Dorothy Johnson is likely correct in characterizing the subject as archetypal,

Fig. 68. Jacques Louis David, *Funeral of a Hero*, 1778. Pen and black ink, brush and gray wash, heightened with white gouache, over black chalk, on blue laid paper, 10 5/16 × 59 5/8 in. (26.2 × 151.5 cm). Crocker Art Museum, E. B. Crocker Collection, Sacramento (1871.408)

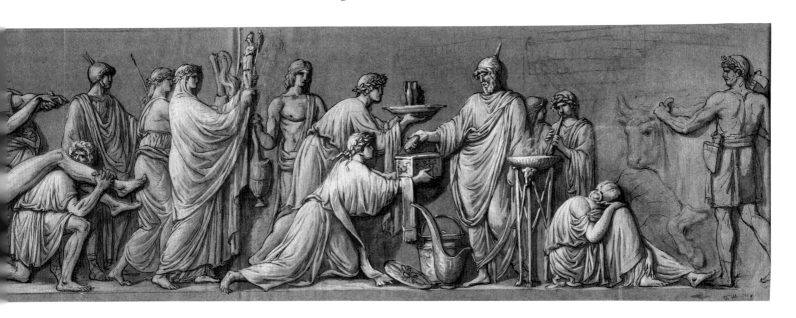

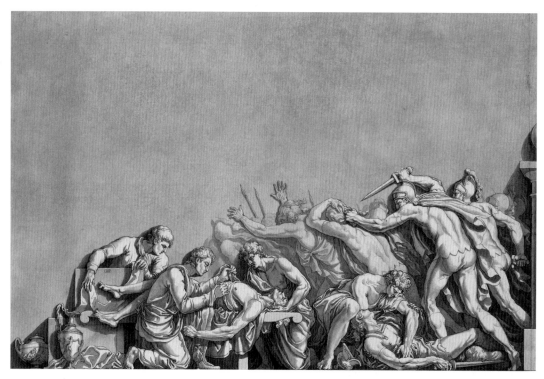

Fig. 69. Esprit Antoine Gibelin (1739–1813), *Louis XVI as the Benefactor of Surgery* (detail), ca. 1771–74. Pen and black ink, brush and gray wash, over black chalk, 15⅜ × 75³⁄₁₆ in. (39 × 191 cm). The Metropolitan Museum of Art, New York, Purchase, Joseph McCrindle Foundation Gift, 2018 (2018.832)

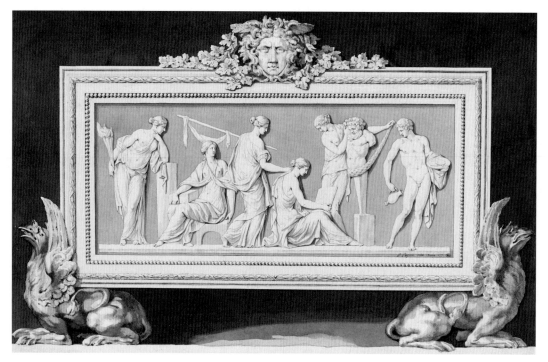

Fig. 70. Pierre Peyron (1744–1814), *Cameo Representing an Offering to Pan*, 1777. Pen and black ink, brush and gray and sepia wash, 15⅞ × 25½ in. (40.4 × 64.8 cm). Musée du Louvre, Paris (INV. 32355)

symbolic of all fallen warriors.[10] Its purpose may have been performative, a vehicle to showcase the mastery of technique that David had achieved by the end of his Roman studies. The figures are vigorously delineated in ink and modeled in white gouache. A careful application of gray wash furthers the trompe-l'oeil effect of shallow relief. But for a sheet of such exceptionally large format, the pentimenti are surprisingly prominent, showing hesitation and alterations in the armor of the warriors and in the placement of Clotho and of Athena's stool and lance.[11]

Was the frieze intended, as some have suggested, as a manifesto—a summing up of what David had gained from his five years of study of the antique and a pronouncement of the classical aesthetic that would now guide his work? If so, why did it not feature among his submissions to the Salon of 1781, a large group of works he made or designed in Rome?[12] By exhibiting the frieze in 1783, David may have intended to highlight its relationship to his reception piece, *Andromache Mourning the Death of Hector* (see fig. 83), which reprises the central vignette of the Grenoble sheet (with clothed warriors) as a relief on Hector's bed (fig. 71).[13] As with the stylistic juxtaposition that is the subject of *Two Studies of the Head of a Young Man Crowned with a Laurel Wreath* (cat. 12), the pairing of frieze and reception piece would have illustrated the absorption of the antique and its translation into the modern idiom.

Fig. 71. Jacques Louis David, *Andromache Mourning the Death of Hector* (fig. 83, detail)

Finally, what was the motivation behind the cutting of the frieze in two? It may have been a wholly pragmatic decision, made to facilitate display. It may also reflect a desire to move away from the conflation of narrative episodes, as seen in his Roman compositions such as *The Combat of Diomedes* (cat. 15), in favor of temporal unity.   PS

# Building a Reputation, 1780–89

The decade that marked David's remarkable ascent from aspiring history painter to undisputed leader of the French school coincided with the final decade of the ancien régime. While these two story lines—the burgeoning success of the young painter on the one hand, and the building societal pressures that would result in the overthrow of the monarchy on the other—unfolded in tandem, they would eventually intertwine. But at the outset, when David had just returned from Italy, his focus was on establishing his career.

Aged thirty-one when he returned to Paris in September 1780, David was clear-eyed that the sole path to success and patronage as a history painter entailed gaining membership to the Académie Royale. He had studied in Rome for five years but likely still felt the shadow of his earlier, repeated failures to win the Prix de Rome, and he clearly did not consider Jean-Baptiste Marie Pierre, first painter to the king, a supporter. He had hoped to have his altarpiece *Saint Roch Interceding with the Virgin for the Plague Victims* (Musée des Beaux-Arts, Marseille), painted at the end of his Roman sojourn, accepted as his *morceau d'agrément*, the first step in full membership to the Académie, but Pierre insisted that he submit a work painted in Paris.[1] In the end, David was accepted as *agréé* in the following year, on August 24, 1781, with the presentation of *Belisarius Begging for Alms* (Palais des Beaux-Arts, Lille; see fig. 67), a composition based on drawings he had made at the end of his Roman period (see cat. 16). With its sober subject and monumental figures aligned with the picture plane, *Belisarius* was both a nod to the precedent of Poussin and a harbinger of the true Neoclassical style. Weeks later it would hang, along with a dozen or so other canvases, as part of the artist's impressive debut at the Salon of 1781, where it was received favorably by critics and the public alike. Later that year, he journeyed to Flanders, where he made drawings after Rubens and other Flemish artists that he would eventually add to his Italian albums.

The artist returned to France in early 1782, and on May 16 of that year married Marguerite Charlotte Pécoul, a young woman of seventeen whose father was the supervisor of royal buildings. The marriage brought David financial security and useful social connections. The couple would have four children: Charles Louis Jules, François Eugène, and twin girls, Félicité Emilie and Pauline Jeanne. In these same years, David set up a studio and began to take on students. Through his role as a teacher, he would develop lasting friendships and expand significantly his impact on French art. Among his earliest pupils were Jean Germain Drouais, Philippe Auguste Hennequin, and Jean-Baptiste Joseph Wicar. By the middle of the decade, François Xavier Fabre, Anne Louis Girodet, François Gérard, and Antoine Jean Gros were all working in his studio, assisting with his commissions and absorbing his style. He also instructed female students, like Marie Guillemine Benoist,[2] although in 1787 Charles Claude de Flahaut, comte d'Angiviller, the powerful arts administrator under Louis XVI, forbade their presence in David's studio in the Louvre.[3]

David became a full member of the Académie Royale on August 23, 1783, with the approval of his *morceau de réception, Andromache Mourning the Death of Hector* (Ecole Nationale Supérieure des Beaux-Arts, Paris, on deposit at the Musée du Louvre, Paris; see fig. 83). Like the *Belisarius*, it was a monumental history painting that recounted a powerful story with only a small cast of characters. To establish the overall scheme of the painting, at once wrenching and noble in effect, David made an extended sequence of drawings, experimenting with every component of the composition (cats. 27–28). This use of drawing to innovate, tinker, and meditate would become an increasingly entrenched practice for David. It is clear, too, that he was committed to the authenticity of every classicizing detail, from the figural poses to the armor to the decorative arts. This veracity had its foundation in the hundreds of sketches after antiquities that he had

made in Rome (see cats. 6–14). The practice of mining the Roman albums for useful sources and details was also one that would continue throughout his career.

With his reception piece finished and accepted, David turned his attention back to an earlier royal commission for a history painting based on the ancient legend of the Horatii. He had been deliberating for several years over which episode of the story to depict (cats. 19–20), deciding in the end to avoid the tragic fallout of the battle in favor of the patriotic oath that preceded it (cats. 21–24)—a subject not previously depicted in art. The painting, he felt, would best be executed in Rome, so after waiting a few months for Marguerite Charlotte to give birth to their second child, and for his star pupil, Drouais, to win the Prix de Rome, he set off again for Italy. In addition to his wife and Drouais, his entourage included two other students: Wicar and Jean-Baptiste Debret. In Rome David and Drouais applied themselves with fervor to the project. Surviving sketchbooks and drawings from the period show that every detail of the picture was considered and planned on paper, and that a renewed exposure to Roman architecture and antiquities infused the classicizing tenor of the painting. *The Oath of the Horatii* (Musée du Louvre; see fig. 75) was completed in time to be exhibited in Rome during the summer of 1785, when artists and dignitaries of all stripes flocked to see it. Word of this acclaim, coupled with the painting's slightly late arrival to the Salon of 1785, only fed the anticipation of Parisian audiences (fig. 72).

*The Oath of the Horatii*, with its moral and visual clarity, was a resounding success at the Salon, and the moment marked undeniably David's status as a rising star of the French school. As Thomas Crow has described, David built and burnished his fame with savvy calculation and daring, balancing a measured defiance against the Académie and royal patronage with an enterprising use of public space to gain favor with a broader, and ultimately more powerful, public.[4] His rapid success also had the effect of exposing alliances and factions within the French arts establishment. And yet, if this strategy fomented antagonism between David and certain senior academicians, it also inspired camaraderie and resistance among his students. Indeed, David's role as a teacher and the respect he earned from his pupils led to his being put forward in 1787 as a possible director of the Académie de France in Rome, although he was eventually deemed too young and inexperienced for the post. The Salon of that year brought another public success with the exhibition of *The Death of Socrates* (cat. 35), which, unlike the *Horatii*, was a commission from a private patron. David had been sketching ideas for the composition as early as 1782, so we can assume that the subject was his suggestion. It gave him the opportunity to compete head-on with Pierre Peyron, an old rival, who sent an oil sketch of the subject to the same Salon. David's version, with its austere setting and dramatic cohesion, was seen as the clear winner.

By 1787 the artist was also already immersed in the process of developing the composition that would become *The Lictors Bringing Brutus the Bodies of His Sons* (Musée du Louvre; see fig. 98). Like the *Horatii*, the painting began as a royal commission, but David chose to depict a different episode than what had been initially requested. What he finally arrived at, after a great number of drawings (cats. 41–48), was a scene neither specifically described in a text nor ever before painted by an artist, but one that plumbed the psychological depths of the story, a tableau that crystallized the tension between familial bonds and patriotic duty. David was immersed in the preparation of the *Brutus* when he received the news, in early 1788, that Drouais had succumbed to smallpox in Rome. The untimely death of his talented and favored student had a profound impact on David. In a eulogy published in the *Mercure de France* in 1788,[5] he famously lamented, "I have lost my emulation."

The triumphs and losses of David's studio took place amid a broader societal instability in the years leading

Coup d'œil exact de l'arrangement des Peintures au Salon du Louvre, en 1785.
Gravé de mémoire, et terminé durant le temps de l'exposition.

A Paris, chez Bornet, Peintre en miniature, Rue Guénégaud N.° 24.

Fig. 72. Pietro Antonio Martini (1738–1797), *View of the Salon of 1785*, 1785. Etching, image 10⅞ × 19⅛ in.
(27.6 × 48.6 cm). The Metropolitan Museum of Art, New York, Purchase, A. Hyatt Mayor Purchase Fund,
Marjorie Phelps Starr Bequest, 2009 (2009.472)

up to the French Revolution. By 1787 mounting fiscal problems and proposals to levy taxes on the privileged classes brought different interests into conflict. Unrest continued to spread through the spring of 1788, when King Louis XVI appointed a new finance minister, Jacques Necker, and promised to convene the Estates General, a long-dormant body that combined representation of the nobility, the clergy, and the Third Estate (a large category of commoners that included many successful members of the bourgeoisie). Tensions built as the deputies to the Estates General were elected,

leading to the founding of the National Assembly on June 17, 1789. The Bastille, a medieval fortress that served as an armory and prison, and which was seen as a symbol of royal tyranny, was seized by crowds about a month later, on July 14. On August 4 the feudal system was abolished, and within a few weeks, the National Assembly would issue the Declaration of the Rights of Man and of the Citizen, proclaiming rights of liberty and equality.

Against this tense backdrop, the Salon of 1789 opened its doors on August 15. The decision of which works

to include had been a politically delicate task. In the *livret*, the booklet describing the works on view, it was noted that *The Lictors Bringing Brutus the Bodies of His Sons* was painted for the king, although the canvas did not appear on the walls until the final days of the exhibition. The erotic and jewel-like *Paris and Helen*, painted for the king's brother the comte d'Artois, was included, but with no mention of its unpopular owner (cats. 36–40). As for the magnificent full-length portrait of the scientific couple Antoine Laurent and Marie Anne Lavoisier (The Metropolitan Museum of Art, New York), it was deemed best not to include it at all, given that Monsieur Lavoisier had been a recent focus of public ire (see "Navigating the Revolution, 1789–99").[6]

While there is no specific evidence of David's political leanings in the years that preceded the Revolution, there can be no doubt that he embraced the cause, supporting change at first within the Académie Royale, and then within the larger society, becoming a member of the National Convention in 1792 and voting in favor of regicide in 1793. Many of his paintings predating the Revolution feature the themes of civic virtue and sacrifice that had been embraced following the overthrow of the monarchy. Certain of his drawings (see cat. 44) even contain evidence (with the later addition of inscriptions and Phrygian caps) of the changing lens through which these subjects were perceived. Indeed, the *Brutus*, which had been made for the king in the waning days of the monarchy, would later be adopted as a symbol of the young French Republic. The artistic transformation that David led in the decade following his return from Rome, as newly minted icons of the Neoclassical style appeared at each biennial Salon, would turn out to be only the first of many, over a career of remarkable transformations.   PS

# THE DEATH OF CAMILLA

## 19. *The Death of Camilla*

Ca. 1781
Black chalk, brush and gray wash
14⁷⁄₁₆ × 15⁹⁄₁₆ in. (36.7 × 39.5 cm)
Marks: lower left (verso), in blue ink, collector's mark of Alice Kaplan (Lugt 3061)
The Metropolitan Museum of Art, New York, Gift of Joan K. Davidson, in memory of her mother, Alice M. Kaplan, 1998 (1998.203)

PROVENANCE: Gilbert Pelham, New York, 1973; Mrs. Alice M. Kaplan (1903–1995), New York; given by her daughter to the Metropolitan Museum, 1998

REFERENCES: Bantel 1981, cat. 42, pp. 98–99; Perrin Stein in Stein and Holmes 1999, cat. 88, pp. 202–3; Stein 1999; Rosenberg and Prat 2002, vol. 1, no. 49, p. 68

## 20. *The Death of Camilla*

1781
Pen and black ink, brush and gray wash, black chalk
10¹³⁄₁₆ × 15¼ in. (27.5 × 38.7 cm)
Inscriptions and marks: lower left, in black chalk, partly rubbed out, "L. David fecit / 1781"; collector's mark of Duke Albert von Sachsen-Teschen (Lugt 174)
Graphische Sammlung, Albertina, Vienna (12676)

PROVENANCE: Duke Albert von Sachsen-Teschen (1732–1822)

REFERENCES: Calvet 1968, pp. 37–42, 82 pl. 23; Arlette Sérullaz in *The Age of Neoclassicism* 1972, cat. 551, p. 328; Arlette Sérullaz in *Horace de Corneille* 1987, cat. 52, p. 138; Crow 1995, pp. 38–41; Cornelia Reiter in *Angelika Kauffmann e Roma* 1998, cat. 125, p. 90; Rosenberg and Prat 2002, vol. 1, no. 48, p. 67; Ekelhart 2007, no. 69, pp. 156–59; Korchane 2012, cat. 19, p. 170

Shortly after gaining acceptance to the Académie Royal in August 1781 on the basis of his *Belisarius Begging for Alms*, David received his first commission from the Bâtiments du Roi, intended for exhibition at the Salon of 1783. The painting, to be in a format of 10 by 10 *pieds* (roughly, 12³⁄₄ square feet), was to represent "Horatius, victorious over the three Curiatii, condemned to death for having murdered his sister Camilla, defended by his father, at the moment when the lictors produce him for punishment and absolved by the People touched by this spectacle and by the great service he had just rendered to his Country."[1] David never executed a painting of this subject, but he devoted several study drawings to the story of the Horatii and the Curiatii before finally painting *The Oath of the Horatii* (Musée du Louvre, Paris).

Exhibited at the Salon of 1785, this canvas depicts an episode prior to the combat of the Horatii and the Curiatii, and thus before Horatius's victory (see fig. 75).

Of all the drawings that David devoted to this subject, three (cats. 19–20 and fig. 73) refer to an episode that is not mentioned in the documents of the Bâtiments du Roi—that is, the death of Camilla, who was killed by her own brother, Horatius, when he witnessed her pained reaction to his victory against the Curiatii, during which he had killed her fiancé. As recounted by Livy (*History of Rome*, 1.26), "the triumphant soldier was so enraged by his sister's outburst of grief in the midst of his own triumph and the public rejoicing that he drew his sword and stabbed the girl." Livy relates how the war that pitted Romans against Albans was resolved when the heads of each army entrusted the outcome of the conflict to a combat between three brothers from each of the clans, the Horatii and the Curiatii. Closer to David's own time, a history of Rome by Charles Rollin, published between 1738 and 1748,[2] mentions the death of Camilla, as does the tragedy *Horace* by Pierre Corneille, written about a century earlier (1640). We do not know what source David used, but if the testimony of Alexandre Péron is to be believed, David attended a performance of Corneille's play at the theater of the Comédiens Ordinaires du Roi toward the end of 1782.[3] On this premise, he could have begun work on a depiction of the defense of Horatius by his father (after the murder of Camilla) before settling on the oath as his theme. However, the 1781 commission indicates that David was already thinking about a subject relating to the struggle between the two clans. As noted by Arlette Calvet (later Sérullaz), the drawings that represent Horatius killing his sister would then precede the other compositions pertaining to this theme, namely, *The Oath of the Horatii* and *The Elder Horatius Defending His Son after the Death of Camilla* (Musée du Louvre),[4] and thus would date from 1781 or 1782.

The three *Camilla* drawings have roughly the same dimensions, but their states of completion differ markedly. The sketch in black chalk on the verso of a drawing for *The Death of Socrates*, dated 1782 (fig. 73), might be earlier than the other two drawings, now in New York (cat. 19) and Vienna (cat. 20). In that case, David would have kept the sheet and used it again roughly a year later for the *Socrates* composition in black chalk and wash on

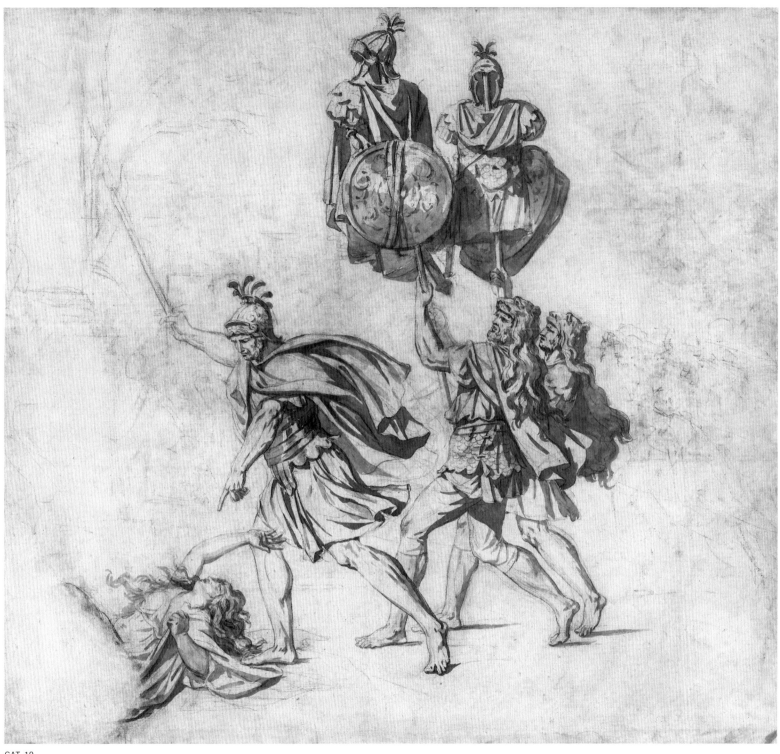

CAT. 19

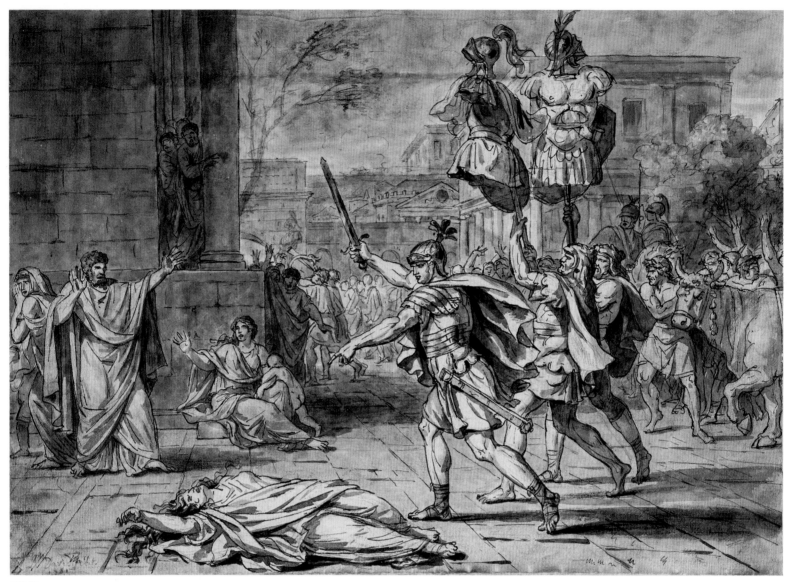

CAT. 20

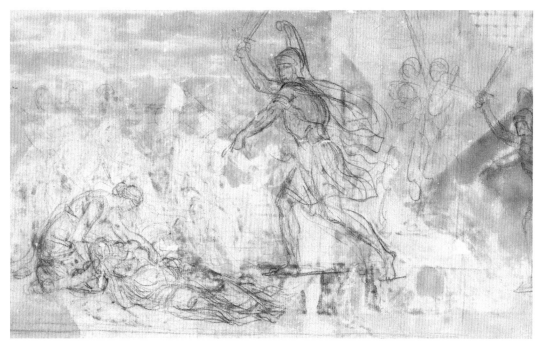

Fig. 73. Jacques Louis David, *The Death of Camilla*, ca. 1781. Black chalk, 9¼ × 14¾ in. (23.5 × 37.5 cm). Private collection (cat. 31, verso)

the recto (see cat. 31). The pose of Horatius, with his right arm brandishing a sword and his left extended downward toward Camilla, who is shown lying on the ground, is already present here, though the New York and Vienna drawings display minor differences in the pose and in the position of the sword. The trophy bearers and the man leading an ox, visible to the right in both the New York and Vienna sheets, are not present in the verso sketch, which instead shows a woman kneeling over Camilla, a figure absent from the other two drawings. Camilla's pose in the verso sketch is retained in the Vienna composition but reversed in the New York sheet—to rather awkward effect, as was noted by Louis-Antoine Prat.[5] This latter, unfinished drawing, in which David worked the central group at a somewhat larger scale than in the two other studies, rendered the trophies borne in triumph with greater realism and experimented with reversing the reclining figure of Camilla, might be slightly later than the composition in Vienna.

No other drawings by David for *The Death of Camilla* are presently known. The figure of Camilla lying on the ground does, however, reappear in the composition that

David worked on next, the abovementioned *Elder Horatius Defending His Son*. It seems that David also executed a painted sketch of *The Death of Camilla*; Johann Heinrich Wilhelm Tischbein mentions it in his memoir,[6] and such a work figured in the Charles de Wailly sale of November 24, 1788.[7] The lack of precision in these two sources, together with the fact that no such oil sketch has yet resurfaced, precludes discussion of its relation to the known drawings of the subject. However, it was reportedly executed "in Rome," which is to say either before David's return to Paris in 1780 or during his second Roman sojourn, in 1784–85.

The *Camilla* drawings contain visual echoes of works by David executed in 1780 and 1781. Arlette Sérullaz was the first to point out the connections with *Belisarius Begging for Alms*, the composition on which the artist began work in 1779 and exhibited at the Salon of 1781 (see fig. 67). She notes in particular the motif of the tree behind the columns, which is reversed in the Vienna drawing in relation to the canvas in Lille, and the gesture of arms raised to express shock, which one sees in the figure of the soldier in *Belisarius* and finds again on the left side of the Vienna composition.[8] The warrior brandishing

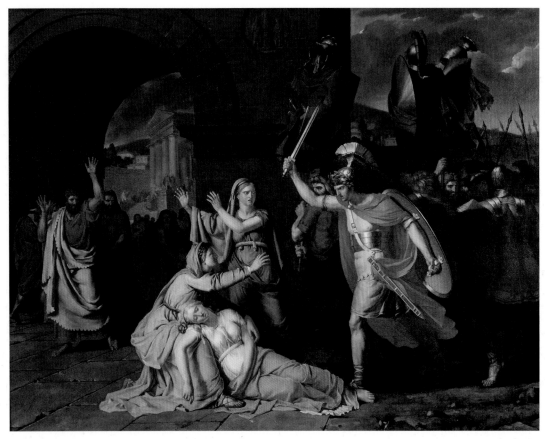

Fig. 74. Anne Louis Girodet (1767–1824), *The Death of Camilla*, 1785. Oil on canvas, 43¾ × 58¼ in. (111 × 148 cm).
Musée Girodet, Montargis (874.10)

his sword in the "antique" frieze drawn by David in Rome in 1780 (cat. 18) also anticipates the figure of Horatius in the *Camilla* studies, who likewise extends his left arm toward his victim.

Although David never executed *The Death of Camilla* as a finished painting, "Horatius killing Camilla" was the assigned theme for the Prix de Rome competition at the Académie Royale in 1785, with a direct reference to Rollin's text.[9] Anne Louis Girodet, a student of David's, produced a painted version at the time, despite his not taking part in the competition (fig. 74). It features many elements close to those found in his teacher's drawings, notably a woman kneeling over Camilla; a similarly positioned group comprising Horatius followed by men bearing trophies; and a figure of a man with raised arms at left.   JT

# THE OATH OF THE HORATII

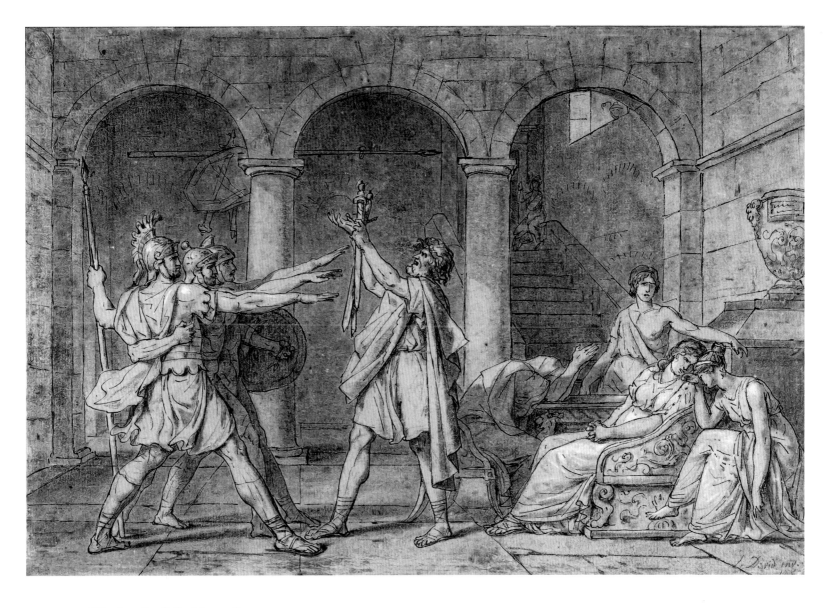

## 21. *The Oath of the Horatii*

Ca. 1782
Pen and black ink, brush and gray wash, heightened with white, over black chalk
9 × 13⅛ in. (22.9 × 33.3 cm)
Inscriptions and marks: lower right, in pen and brown ink, signed "L. David inv."; below it (in another hand?), dated "1782"; upper left, collector's mark of Jean-Baptiste Joseph Wicar (Lugt 2568)
Palais des Beaux-Arts, Lille (P. 1194)

PROVENANCE: Jean-Baptiste Joseph Wicar (1762–1834); bequeathed to the Société des Sciences, de l'Agriculture et des Arts de Lille, 1834; transferred to the Palais des Beaux-Arts, Lille, 1891

REFERENCES: *Autour de David* 1983, cat. 15, p. 46; Arlette Sérullaz in *Horace de Corneille* 1987, cat. 89, p. 102; Arlette Sérullaz in Schnapper and Sérullaz 1989, cat. 71, p. 171; Humphrey Wine in *Tradition and Revolution in French Art* 1993, cat. 36, p. 111; Dominique de Font-Réaulx in Dassas et al. 2002, cat. 17, p. 110; Rosenberg and Prat 2002, vol. 1, no. 51, p. 70; Nicolas Sainte Fare Garnot in *Jacques-Louis David* 2005, cat. 22, p. 74

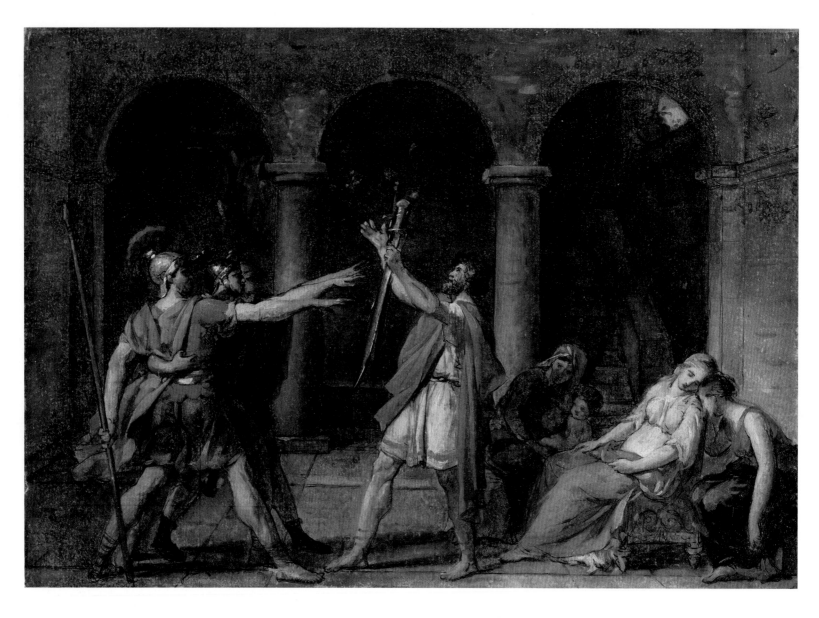

## 22. *The Oath of the Horatii*

1784–85
Oil over pen and black ink, squared in black chalk, on paper laid down
on canvas
10⅜ × 14¾ in. (26.5 × 37.5 cm)
Musée du Louvre, Paris (RF 47)

PROVENANCE: Acquired by the Musée du Louvre from Mme Vincent,
August 1873

REFERENCES: Hautecoeur 1954, no. 5, p. 71; Sterling and Adhémar
1959, no. 537, pl. 169; Compin and Roquebert 1986, p. 186; Régis
Michel in *David e Roma* 1981, cat. 36, p. 143; Philippe Durey in
*Triomphe et mort du héros* 1988, cat. 118, pp. 384–85; Arlette Sérullaz
in Schnapper and Sérullaz 1989, cat. 68, p. 168; Herman Mildenberger
in Schulze 1994, no. 190, p. 294; Cornelia Reiter in *Angelika Kauffmann
e Roma* 1998, cat. 127, p. 91; Nicolas Sainte Fare Garnot in *Jacques-
Louis David* 2005, cat. 23, p. 76; David Bindman in Bückling and Mongi-
Vollmer 2013, cat. 37, pp. 160–63

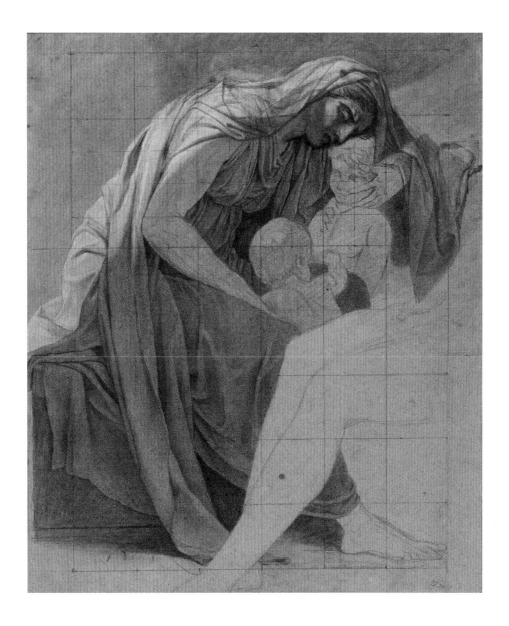

## 23. *The Nurse and the Children of the Horatii*

1785
Black chalk, stumped, heightened with white, squared in black chalk, on beige paper
21½ × 17¾ in. (54.5 × 45 cm)
Marks: lower right, paraph of Eugène David (Lugt 839)
Musée des Beaux-Arts, Angers (MBA 846.2)

PROVENANCE: David estate sale, Paris, April 17, 1826, and following days, probably part of lot 102; Pierre Jean David d'Angers (1788–1856); his gift to the Musée des Beaux-Arts, Angers, 1846

REFERENCES: D. Wildenstein and G. Wildenstein 1973, no. 2090, p. 250; Arlette Sérullaz in Schnapper and Sérullaz 1989, cat. 74, p. 174; Cornelia Reiter in *Angelika Kauffmann e Roma* 1998, cat. 126, p. 90; Patrick Le Nouëne in *Desseins d'artistes* 2000, cat. 33, p. 81; Rosenberg and Prat 2002, vol. 1, no. 71, p. 89; Nicolas Sainte Fare Garnot in *Jacques-Louis David* 2005, cat. 25, p. 28

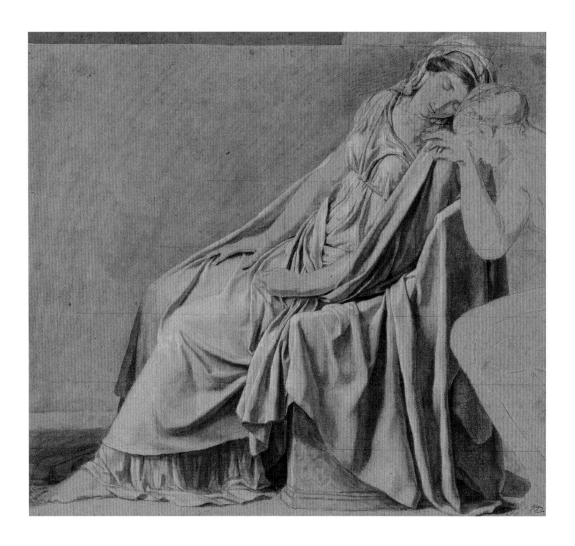

## 24. *Sabina*

1785
Black chalk, stumped, heightened with white, squared in black chalk,
on several joined pieces of beige paper
18¼ × 20⅛ in. (46.5 × 51 cm)
Musée des Beaux-Arts, Angers (MBA 846.1)

PROVENANCE: David estate sale, Paris, April 17, 1826, and following
days, probably part of lot 102; Pierre Jean David d'Angers (1788–1856);
his gift to the Musée des Beaux-Arts, Angers, 1846

REFERENCES: D. Wildenstein and G. Wildenstein 1973, no. 2090, p. 250;
Régis Michel in *David e Roma* 1981, cat. 34, pp. 139–40, 142; Arlette
Sérullaz in *Horace de Corneille* 1987, cat. 98, p. 106; Arlette Sérullaz
in Schnapper and Sérullaz 1989, cat. 73, p. 174; Rosenberg and Prat
2002, vol. 1, no. 72, p. 90; Nicolas Sainte Fare Garnot in *Jacques-Louis
David* 2005, cat. 25, p. 80

Relying on the archives of the Bâtiments du Roi and skeptical of the account of Alexandre Péron, Régis Michel and Arlette Sérullaz retraced the protracted genesis of *The Oath of the Horatii* between 1781 and 1785, when the painting was exhibited at the Salon (fig. 75).[1] After having considered depicting Horatius victorious over the Curiatii, sometime around New Year's 1784–85, David seems to have changed the subject of his painting to the "Oath of the Horatii in the presence of their father"; however, he had not yet ruled out "Horatius condemned to death for the murder of his sister and defended by his father"— at least according to a list from January 1784 indicating "Different subjects proposed by the artists for execution for the next Salon in 1785" (see cats. 19–20).[2] For this, his

first royal commission, David returned to Rome, where, from November 1784 to early August 1785, he worked on the "Oath of the Horatii between the Hands of Their Father,"[3] the title used at the Salon of 1785. Péron specifies that David wanted to represent "the moment that must have preceded the combat [and] during which Horatius the father, gathering his sons within his household, made them swear an oath to obtain victory or die,"[4] a scene that does not figure in any of the literary sources that the painter might have consulted.

Several possible visual sources have, however, been identified. Having returned to Rome for the first time since his student sojourn of 1775–80, David crisscrossed the city, sketchbook in hand, in search of models for his painting.[5] In the Sala di Costantino in the Vatican, he copied the heads of a group of prelates surrounding Pope Sylvester in the *Donation of Constantine* fresco by Giulio Romano and Gianfrancesco Penni, which he then adapted for the young Horatii brothers swearing their oath.[6] David also found motifs in the work of Nicolas Poussin: two of his sketches for the group of tearful women,[7] situated at right in the final composition, rework a figure in the elder artist's *Death of Germanicus* (1627; Minneapolis Institute of Art), while the arms on the wall in the compositional drawing in Lille (cat. 21) appear to echo those in Poussin's *Testament of Eudamidas* (1644–48; Statens Museum for Kunst, Copenhagen).[8] According to Péron, David had found the pose of the eldest son, and by extension, the germ of the composition, in that of a lictor at lower left in Poussin's *Rape of the Sabine Women*, where the figure's spear is located—as in the Lille drawing—behind his left leg.[9] The oaths painted by Gavin Hamilton and Jacques Antoine Beaufort, by contrast, probably were not among the sources for *The Oath of the Horatii*.[10] David indeed copied both canvases, but no earlier than 1790, in connection with preparatory work for *The Oath of the Tennis Court* (see cats. 50–53).[11]

From his first compositional studies for *The Oath of the Horatii*,[12] David created an opposition between two

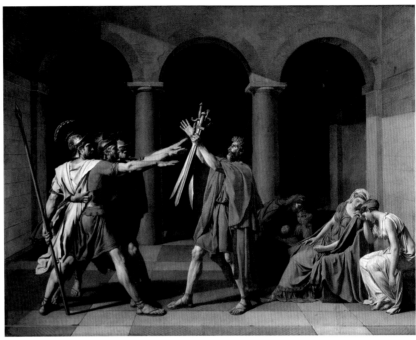

Fig. 75. Jacques Louis David, *The Oath of the Horatii*, 1785. Oil on canvas, 129⅞ × 167⅜ in. (330 × 425 cm). Musée du Louvre, Paris (INV. 3692)

groups, one consisting of the three Horatii brothers and their father swearing the oath, at left, and another consisting of their mother, distraught sister, and sister-in-law, at right. As Régis Michel observed, "an opposition is established between the world of feminine affliction (a series of drooping arabesques) and the masculine universe of energy, based on taut verticals (spears, swords, limbs, muscles)."[13] The compositional study now in Lille (cat. 21) and the painted sketch now in the Louvre (cat. 22) enable us to follow David's final adjustments to the male group. In the Lille drawing, the arrangement of these figures is not yet resolved with respect to their appearance in the final painting: the spear held by the eldest son is situated on the far side of his left leg and mantle, and the arm that wields it is raised. Moreover, the furthermost brother holds an oval shield with his left arm. In the painted sketch, the poses of all these figures correspond to those in the finished painting: the spear, now gripped at a lower point, passes in front of the left leg of the eldest brother, whose mantle is larger; and the shield held by the third figure has disappeared. The background of three archways—beyond which, at left, hang a spear, a shield, and scabbards

Fig. 76. Jacques Louis David, *The Oath of the Horatii*, from sketchbook (carnet) 2, 1784. Black chalk, 5¼ × 7⅝ in. (13.3 × 18.9 cm). Musée du Louvre, Paris (RF 4506, fol. 21 verso)

that echo those in Poussin's *Eudamidas*; and, at right, an ascending stairway—survives in the finished painting almost unchanged.

Antoine Schnapper and Louis-Antoine Prat are inclined to accept the date of 1782 inscribed on the Lille drawing.[14] By the end of that year, David would have settled on a composition, at least its left portion, before reworking it a year later, around New Year's 1783–84, and again after his arrival in Rome. An early date for this drawing makes it possible to reconstruct the evolution of the right portion of the composition, which changed considerably between the Lille drawing and the final work. The group of Sabina and Camilla, at right, is almost settled; only the position of Sabina's head and the placement of her hands, which are joined in her lap in the Lille sheet, have been adjusted somewhat in the painted sketch in the Louvre. David apparently altered this figure in Rome, after October 1784, as indicated by a rough sketch showing Horatius's wife with her head tilted at a slightly lower angle and her hands on either side of her body.[15] In the painted sketch, David also

added a mantle covering Sabina's legs and some drapery that, in the final painting, almost completely obscures her chair.

Decor and accessories figure prominently in the Lille drawing, notably, an ornate vase rising above the group at far right, Sabina's heavy chair, and a console table on which the mother of the three brothers leans and joins her hands in prayer. All these elements have disappeared in the Louvre sketch, with the exception of Sabina's chair. An intermediary sketch (fig. 76), executed in Rome, shows that David was still uncertain about how many of these accessories to retain; in it, we see, behind Sabina and Camilla, a bowl on a pedestal and, immediately above, a niche in the wall.[16] In Rome, David also reworked the group at right: he suppressed the male adolescent standing behind the women in the Lille drawing whose presence evened out the number of figures in each group (two times four) but muddled the binary opposition that structures the composition. By contrast, he added two young children huddled around the figure of the mother, transforming her into a nurse, as can be seen in the painted sketch as well as in several drawings in the Roman sketchbook.[17] Nonetheless, as early as 1782, if one accepts this date for the Lille drawing, David had settled on the idea of a bent-over figure with her back to the elder Horatius, thereby creating a semicircular motif that simultaneously functions as a visual link and establishes an opposition between the group of men, rising toward the sky, and the group of women, slumping toward the ground. In Rome, then, the composition evolved toward purification of the decor and a gradual elimination of accessories.

The painted sketch marks an important step in this quest to simplify the composition by making it more compact, and thus more powerful. The arrangement of the figures is almost identical to that in the final painting, save for a few differences. Some are minimal, like the right hand of the elder Horatius, whose palm faces

upward in the Lille drawing and still has an intermediary position in the painted sketch, but whose fingers rise upward in the canvas; or the right arm of Camilla, still hidden behind Sabina in the painted sketch but shifted forward and fully visible in the final work. The change in the pose of the nurse, her face turned toward the viewer in the painted sketch but in profile in the canvas, is more striking, and again consistent with the Roman sketchbook. The painted sketch does not, then, correspond to the final stage of elaboration but to an intermediary one, contemporary with David's final studies in the sketchbook.[18]

The painted sketch made it possible, above all, for David to explore color relationships. Some years later he would use the same method for his *Brutus*, exhibited at the Salon of 1789, for which he prepared a painted sketch (see cat. 47) using the same technique and at roughly the same size as the one he made for the *Horatii*, and which likewise presents very few compositional differences from the final canvas (Musée du Louvre; see fig. 98). The chromatic range adopted by David for the *Horatii* sketch is warmer than that of the finished canvas, and the colors used for the clothing are different. In the final work he accentuated the presence of blue in the costumes and focused his palette around blue, red, and white, with touches of gray and brown. In the sketch, both the father and Sabina wear white, which concentrates the light in the center of the composition, but in the final canvas David relegated white to either side of the composition, in the mantle of the eldest son and the robe of Camilla. The two groups thus echo one another in a more balanced way, with the white passages functioning as framing elements. The painted sketch also allowed David to assess the prominence of the background and the furnishings. In the final canvas he darkened the space beyond the archways so as to make the figures stand out more forcefully. Sabina's chair, quite visible in the sketch, largely disappears under drapery in the completed work, while the opening in the wall beside the stairway is reduced to a small triangle of sky. David also modified the expanse of wall visible beyond the arch above the group of women. In addition to facilitating color adjustments, then, the painted sketch made it easier for David to edit out elements of the preparatory studies that he now deemed excessive.

"M. Debret, history painter, relative and student of David," who accompanied David to Rome in 1784, and whose account is related by Alexandre Péron, clarifies one of the final stages of the artist's work on *The Oath of the Horatii*, after his arrival in Rome: "his first concern was to arrange all the draperies with the very particular taste that he possessed to such a high degree. Drouais drew them on paper for subsequent transfer to the canvas."[19] At least five drawings, executed in black chalk heightened with white, sometimes with gray wash, now in the Musée Bonnat-Helleu in Bayonne and the Musée des Beaux-Arts in Angers, can be associated with this text. They are all detailed studies of isolated figures: the father, the three Horatii brothers, the nurse (cat. 23), Sabina (cat. 24), and Camilla.[20] They might represent a collaboration between David and his student Jean Germain Drouais, for Drouais executed a study for his *Marius at Minturnae* that is very close to this series (see fig. 29), while David continued to make such studies in Drouais's absence for his *Socrates* and the *Brutus*.[21] The drawings present some minor differences from the Salon painting, for example, in the position of the arms and hands of the two children. David (with Drouais?) rendered the details of these figures with great precision, even a few areas that do not appear in the canvas, for example, the leftmost portion of the nurse's drapery and her right foot, ultimately obscured by the father's mantle and Sabina's clothing, respectively. Nonetheless, it should be noted that the left leg of the nurse and the lower bodies of the children, effectively invisible in the final composition, are not shown in the study. Here, as in the sheet dedicated to Camilla, David renders the foremost figure only in contour, by way of indicating the areas that would eventually be blocked from view by the placement of other figures. Finally, in the finished canvas Camilla is situated closer to Sabina, such that her legs obscure more of the drapery covering Sabina's chair.

The drapery studies were not the final stage of the artist's meticulous preparatory work. At the end of the sketchbook containing his Roman studies for the painting, David himself describes how he used the drawings.[22] Once the drapery studies had been transferred to canvas, with the aid of the squaring technique, he continued to work after the live model, playing with the height of his models and his canvas.   JT

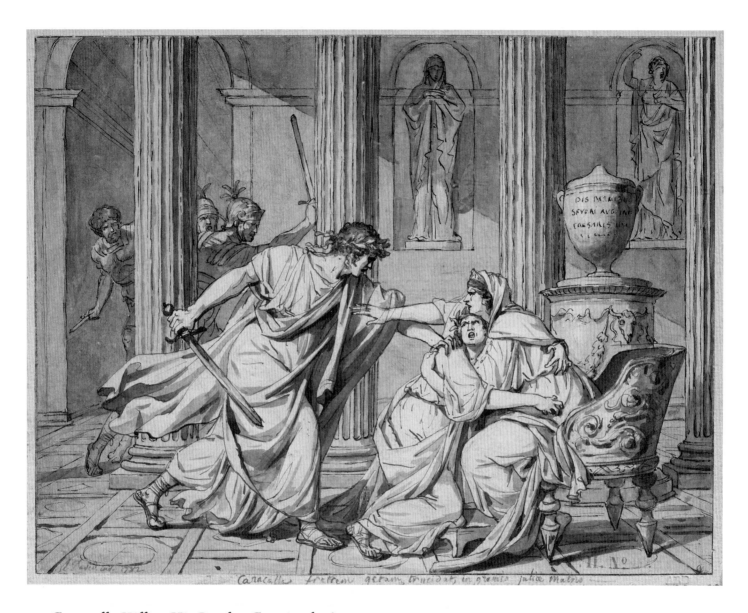

## 25. *Caracalla Killing His Brother Geta in the Arms of His Mother*

1782
Pen and black ink, brush and gray wash, heightened with white, over black chalk
8¾ × 11½ in. (22.3 × 29.2 cm)
Inscriptions and marks: lower left, in pen and brown ink, signed and dated "L. David. inv. 1782"; on the urn, in pen and black ink, "DIS MANIBUS / SEVERI AUG. IMP / CAESARIS."; below the image, on the mount, in black chalk, in another hand, "Caracalla fratrem getam trucidat, in gremio juliæ matris"; lower right, blind stamp of the mountmaker "ARD" (Lugt 172); collector's mark of Prosper Flury-Hérard (Lugt 1015), with the number "233" in pen and brown ink; stamp of the Musée du Louvre (Lugt 1886a)
Musée du Louvre, Paris (RF 49923)

PROVENANCE: Prosper Flury-Hérard (1804–1873), Paris;[1] his sale, Hôtel Drouot, Paris, May 13–15, 1861, lot 106, to Pelletier; Martial Pelletier collection sale, Hôtel Drouot, Paris, April 29–May 4, 1867, lot 1269; sale, Jacques Tajan, Hôtel George V, Paris, December 12, 1995, lot 116; purchased by the Société des Amis du Louvre for the Musée du Louvre

REFERENCES: Arlette Sérullaz in Rosenberg 1997, cat. 380, p. 300; Bailey 2002, p. 128, fig. 114; Rosenberg and Prat 2002, vol. 1, no. 55, p. 76; Ledbury 2004; Ledbury 2005; Wood 2010; Christophe Leribault in Faroult, Leribault, and Scherf 2011, cat. 98, p. 177; Prat 2011, pp. 34–35, fig. 53; Brugerolles 2016, p. 178, fig. 1, under cat. 60

## 26. *The Ghost of Septimius Severus Appearing to Caracalla after the Murder of His Brother Geta*

Ca. 1783
Pen and gray and brown ink, brush and gray wash, over black chalk, heightened with touches of white, with strips of paper added along the upper and lower margins
9½ × 12⅟₁₆ in. (24.2 × 30.6 cm)
Inscriptions: lower right, in pen and gray ink, signed and dated "j.L. David. inv. et fecit"
Private collection, New York

PROVENANCE: Probably Anne Louis Girodet-Trioson (1767–1824), Paris; his estate sale, Paris, April 11–25, 1825, lot 481; probably L. J. A. Coutan (d. 1830), Paris; his collection sale, March 9–10, 1829, lot 93; possibly Aristide Dumont, Paris; his estate sale, Paris, February 13–16, 1854, lot 120; probably Théodore Dumesnil, 1884; private collection, France; sale, Sotheby's, New York, January 24, 2007, lot 78; private collection, New York

REFERENCES: Probably Association des artistes 1884, cat. 55, p. 28 (as collection T. Dumesnil); Faroult, Leribault, and Scherf 2011, p. 177; Prat 2011, p. 35; Prat 2016a, pp. 293, 295, fig. 4 (listed erroneously as in The Metropolitan Museum of Art)

The year 1782 was a critical one in David's career. His *Belisarius Begging for Alms* (Palais des Beaux-Arts, Lille; see fig. 67) had been well received in the Salon of the previous summer and had earned him acceptance into the Académie Royale. His next task was to prepare a reception piece, and the numerous surviving compositional studies from this period suggest that he was actively brainstorming a subject, one that would showcase the benefits he had derived from his Italian sojourn and broadcast his ambitions as a history painter. For the subject he ultimately chose, *Andromache Mourning the Death of Hector*, an extended sequence of studies sheds light on the genesis of the composition, even while he was simultaneously weighing alternate possibilities (see cats. 27–28). Of the many subjects from ancient history that he explored on paper in the early 1780s, some became the basis for paintings, some evolved into other episodes, some were put aside and taken up again years later, and some were never painted at all.

Into the category of abandoned projects falls the story of Caracalla, a dark tale of a tyrannical ruler from the late Roman Republic. The emperor Septimius Severus, upon his death, had designated both of his sons, Geta and Caracalla, as successors, despite the fact that the latter had tried to kill him. Caracalla, desiring to rule alone, murdered his brother in the arms of his mother, Julia Domna. For this act of fratricide, he would later be berated by the ghost of his father. Mark Ledbury has demonstrated that David's literary source was Jacques Roergas de Serviez's *Les impératrices romaines* (Paris, 1724), a vivid account of the lives of certain Roman empresses. A manuscript page of reading notes in David's hand, published by Ledbury in 2005, suggests that David had contemplated four scenes from Serviez's account.[2] To date, four versions of *Caracalla Killing His Brother Geta* and two of *The Ghost of Septimius Severus Appearing to Caracalla* have come to light.[3]

Caracalla was a surprising choice for David, especially as it would have been associated with Jean-Baptiste Greuze's failed attempt in 1769 to be admitted to the Académie as a history painter.[4] Alternatively, David may have intended the violent episode he put forth in a drawing now in the Musée du Louvre, Paris (cat. 25), as a pointed corrective to Greuze's static domestic drama of a father reprimanding a sulking son. Even more unexpected was the undeniable debt, first pointed out by Pierre Rosenberg, that David's composition owed to

Fig. 77. Jean Antoine Julien, called Julien de Parme (1736–1799), *Caracalla Killing His Brother Geta*, 1775. Oil on canvas, 88¾ × 113⅝ in. (225.5 × 288.5 cm). Musée Granet, Aix-en-Provence (860.1.365)

a painting of the same subject by Jean Antoine Julien, called Julien de Parme (fig. 77), a Swiss-born artist who worked for private patrons in Paris from 1773 but was not a member of the Académie Royale.[5] David would have seen Julien's painting in the home of Louis Gabriel, marquis de Véri, whose collection favored works by living French artists and whose doors were open to young practitioners beginning around 1779.[6] David's initial sketch for the *Caracalla* composition, a chalk drawing in Rotterdam,[7] relies heavily on Julien's conception of the scene, from the figural grouping to Caracalla's dagger to the curtained backdrop. In the Louvre's more worked-up version, David has exchanged Caracalla's dagger for a sword and omitted the curtain, although he carries over the background wall featuring statues set in niches, separated by columns. While he adopted the overall composition from Julien, David took care to update the style to a more Neoclassical manner by imposing a stricter planarity on the central group and by combing through the examples sketched in his Roman albums to ensure that Julia's chair and the statues in the niches accurately reflected antique models.[8] Another intermediary step, after studying Julien's picture and making a quick chalk sketch, must have been a close reading of Serviez. David's handwritten notes focus on the passage describing the

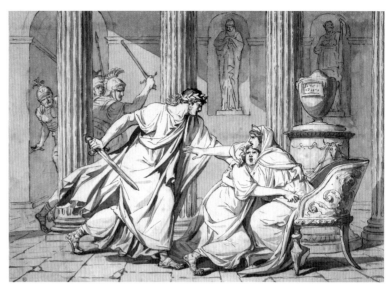

Fig. 78. Jacques Louis David, *Caracalla Killing His Brother Geta*, ca. 1782. Pen and black ink, brush and gray wash, 9¾ × 11⅞ in. (24.9 × 30.2 cm). New Orleans Museum of Art (86.177)

Fig. 79. Jacques Louis David, *The Murder of Geta*, ca. 1782. Pen and black ink, brush and gray wash, over black chalk, 8⅞ × 12¼ in. (22.8 × 31.2 cm). Ecole Nationale Supérieure des Beaux-Arts, Paris (EBA 736)

urn, destined to hold his ashes, that Septimius showed his sons. By introducing the urn into the scene of the murder, David invokes the spirit of the dead father as both a witness to the crime and a chastising symbolic presence, as Ledbury has observed.[9]

The chronology of David's three wash versions of the subject has been a matter of debate.[10] Based on the residual signs of process, the Louvre sheet, dated 1782, would appear to be the earliest, with the lines of Caracalla's cape cutting through his mother's wrist, and the horizontal lines of the architecture visible through the niche statues. The sheet now in New Orleans (fig. 78) would logically come second, with these areas of overlap anticipated, and therefore avoided. The quick and schematic rendering noted by Philippe Bordes is the result of the artist's lack of hesitation in executing a largely resolved composition.[11] In a drawing in the Ecole Nationale Supérieure des Beaux-Arts (fig. 79), proposed here as the final sheet in the sequence, the cropping of the soldier behind Caracalla is less awkward; the soldier on the left is given a helmet; and, most importantly, David has given Caracalla a beard and a knitted brow to conform more closely to previous portrayals of him, both French and ancient.[12]

Two studies have come to light in recent years for a later episode in the story, in which Caracalla falls prey to remorse and is confronted by the ghost of his father, brandishing a sword and threatening to kill him in retribution for the murder of Geta. As often happens in cases like this, the provenance of the two sheets is difficult to untangle. It would appear that one of the two, now in a private collection in New York (cat. 26), is more likely to have been the one in the Girodet and Coutan sales. The other sheet, now in the Horvitz collection (fig. 80), does not, however, appear to be the one described in the Dumont sale as being "on colored paper." The Dumont sheet may represent a third, untraced version of the theme. The order of execution of the two drawings is also unclear. Pierre Rosenberg and Louis-Antoine Prat raised the question of whether the Horvitz sheet might have been traced from another drawing, an idea supported by Bordes, who cited the framing lines, the *mise-en-page*, and the use of wove paper.[13] But whether or not David employed tracing (a technique that was part of his studio practice), the composition of the Horvitz drawing must precede that of the present version, sold at Sotheby's in 2007. Added strips at top and bottom have given the composition more breathing room, and the architectural space has been completely altered with the addition of a sharply receding arched corridor. This feature, along with the newly off-center vanishing point, makes

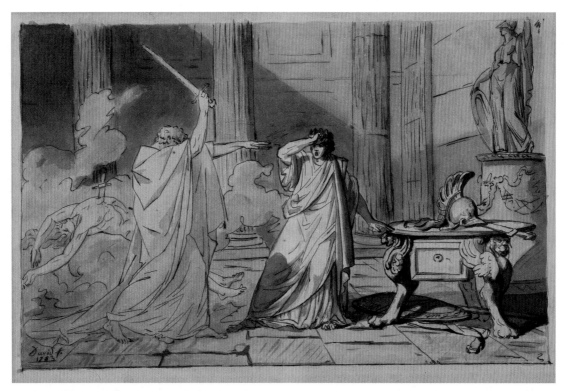

Fig. 80. Jacques Louis David, *The Ghost of Lucius Septimius Severus Appearing to Caracalla*, 1783. Pen and brown ink, brush and blue-gray wash, over traces of black chalk, on tan wove paper, 12⅜ × 17½ in. (31.6 × 44.6 cm). Edgewater House, Horvitz Collection (D-F-471)

Caracalla's terrified expression the composition's focal point, a fear also conveyed by the physicality of his recoil and emphasized by the way he uses the table to support his weight. To balance the pale insubstantiality of the vengeful figure of Septimius and the naked corpse of Geta, David has reintroduced on the left the stool from the initial chalk study for the murder scene.[14]

While the depiction of fantastical and otherworldly subjects were finding favor around this time with the Swiss painter Henry Fuseli and others, apparitions are unusual in David's oeuvre. Ledbury has convincingly proposed that the catalyst may have been David's relationship with the largely forgotten playwright Jean François Ducis. Ducis's productions often relied heavily on Shakespeare, and in 1782 he was drafting an adaptation of *Macbeth* for the French stage, grappling with how to incarnate the figure of Banquo's ghost. David's engagement with theater was at that point already firmly established, and the parallels between Macbeth and Caracalla—both characters confronted by a ghost after

seizing the throne and then tormented by remorse—lend credence to Ledbury's theory.[15]

Despite this prolonged engagement, David did not, as far as we know, commit to canvas any episodes from the life of Caracalla. As with *The Death of Camilla* (cats. 19–20), he was drawn to brutal subjects from antiquity but, in the end, deemed them unsuitable for painting, opting to move the violence offstage, as it were. He would continue to explore themes of duty, loss, and betrayal, but only obliquely, preferring instead scenes of prelude or aftermath. Nonetheless, the impact of these drawings in David's studio should not be underestimated. Their presence can be felt in visual echoes in David's own work. The protective pose of Julia in the Louvre drawing, for instance, prefigures other strong maternal figures in David's oeuvre: Andromache, Vitellia (the wife of Brutus), and even, many years later, in the Sabine women. Violence, horror, and fantasy ultimately would find more forthright expression in the work of his students, not least Anne Louis Girodet, who owned this drawing of the ghost of Septimius.[16]   PS

# ANDROMACHE MOURNING THE DEATH OF HECTOR

## 27. *Andromache Mourning the Death of Hector*

Ca. 1782
Black chalk, touches of pen and brown ink
9⅞ × 11⅝ in. (25.1 × 29.5 cm)
Marks: lower right, paraph of Jules David (Lugt 1437); lower left, paraph of Eugène David (Lugt 839); in black ink, collection mark of Véronique and Louis-Antoine Prat (Lugt 3617)
Véronique and Louis-Antoine Prat Collection, Paris

PROVENANCE: David estate sale, Paris, April 17, 1826, and following days (not in catalogue, but possibly the sheet indicated in an annotated copy of the catalogue[1]); purchased by Amédée Constantin, Paris; his "cessation de commerce" sale, Paillet, Paris, March 29, 1830, lot 331; possibly M. and Mme Le Tourneur; their estate sale, Coutellier, Paris, February 7–9, 1831 (listed on p. 40 of the catalogue among the unnumbered framed drawings as "un dessin, par David. Andromaque déplorant la mort d'Hector"); possibly the estate sale of the architect Kraft, Paris, April 21, 1836, lot 52; Galerie Prouté, Paris, 1980; acquired by Véronique and Louis-Antoine Prat, Paris

REFERENCES: Arlette Sérullaz in Schnapper and Sérullaz 1989, cat. 58, p.150; Rosenberg and Prat 2002, vol. 1, no. 60, p. 80; Prat 2011, pp. 35–36, fig. 56; Pierre Rosenberg in Rosenberg 2017b, cat. 47, pp. 136–37

## 28. *Andromache Mourning the Death of Hector*

1782
Pen and black ink, brush and gray wash, over black chalk, on two joined pieces of paper
11⁷⁄₁₆ × 9¹¹⁄₁₆ in. (29 × 24.6 cm)
Inscriptions: lower left, in pen and brown ink, signed and dated "L. David f. et. inv. 1782"
Petit Palais, Musée des Beaux-Arts de la Ville de Paris (PP D 1801)

PROVENANCE: M. N. R[evil]; his collection sale, Hôtel de Ventes Mobilières, Paris, March 29–April 2, 1842, lot 66; René Soret; his estate sale, Hôtel des Commissaires-Priseurs, Paris, May 15–16, 1863, lot 37; Benjamin Fillon; his estate sale, Hôtel Drouot, Paris, March 20–24, 1882, lot 571; sale, Sotheby's, London, July 25, 1922, lot 34 ("property of a gentleman"); Seymour de Ricci, 1924; in the collection of the Petit Palais, Paris, since 1946 (?)

REFERENCES: *David e Roma* 1981, cat. 31, pp. 129–32; Arlette Sérullaz in Schnapper and Sérullaz 1989, cat. 60, pp. 152–53; Jose-Luis de Los Llanos in *Fragonard et le dessin français* 1992, cat. 50, pp. 100–102; González-Palacios 1993; Rosenberg and Prat 2002, vol. 1, no. 63, p. 82; Prat 2011, p. 36, fig. 57; Isabelle Mayer-Michalon in Clark 2017, pp. 292–95, under cat. 116

The year 1782 was one of the most fertile in David's early career, when he frequently took up chalk, ink, and wash to quickly put to paper his many ideas for history paintings. To this moment can be dated the *premières pensées* for two of his most significant compositions, *The Oath of the Horatii* and *The Death of Socrates*. But this flurry of creative invention did not distract him from his primary goal of completing his reception piece, a step required for full membership in the Académie Royale. In late February,

Jean-Baptiste Marie Pierre, the director of the academy, informed the comte d'Angiviller, director of the Bâtiments du Roi, that David had resolved to work on his submission and had chosen the subject of Andromache crying with Astyanax over the body of Hector. D'Angiviller approved, and by March 29 an oil sketch was received, followed by a finished painting in August, described in the official Salon *livret* as "The Sorrows and Remorse of Andromache over the Body of Hector, Her Husband."[2]

Lamentation in classical literature was the female counterpart to male valor. Considered particularly tragic was the figure of Andromache in Homer's *Iliad*, whose husband, Hector, the prince of Troy, was slain in battle by Achilles, and whose young son Astyanax would soon be thrown from the city's ramparts, to thwart any future acts of revenge or claims to the throne. In choosing to depict the death of an ancient hero, David would have been steeped in precedent, from his classical education to the antiquities he saw in Rome; from the dramas of Racine to the canvases of Poussin.[3] Many studies in his Roman albums can be connected to the theme,[4] but their order and function are difficult to sort out. Some are copies after antique models, others may have sources that have not yet been identified, and still others may have been sketches of David's own ideas for a painting, made either in Italy or after his return.

One such enigmatic sheet is a large ink-and-wash drawing of an antique bed, or funeral bier, now in the British Museum, London (fig. 81), that was removed

Fig. 81. Jacques Louis David, *An Antique Bed with Scenes from the Life of Hector*, ca. 1775–83? Brush and gray wash, over black chalk, 8³⁄₈ × 15¹⁄₄ in. (21.3 × 38.7 cm). British Museum, London (2003,0429.9)

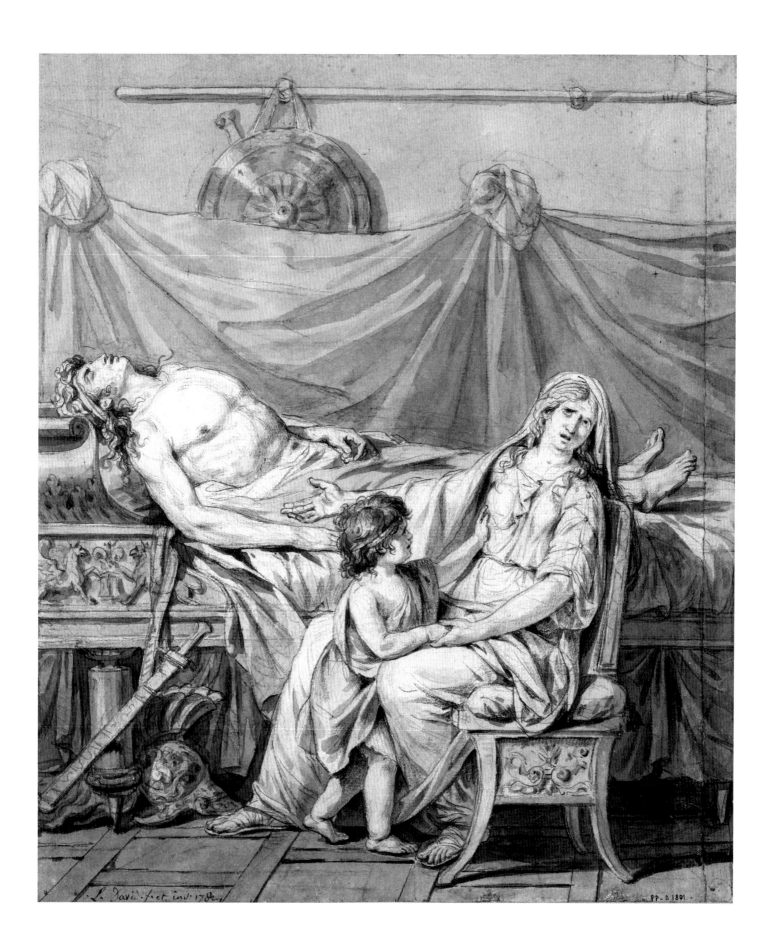

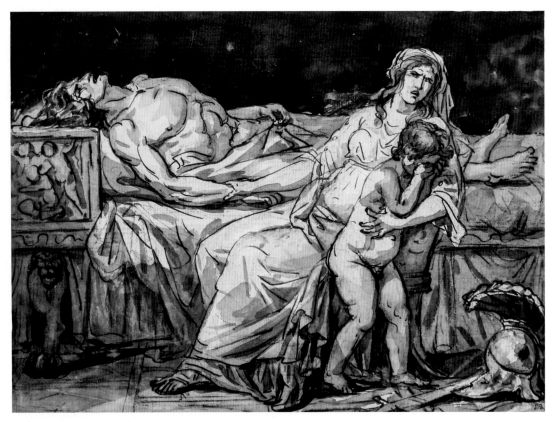

Fig. 82. Jacques Louis David, *Andromache Mourning the Death of Hector*, 1782. Pen and brown ink, brush and brown, gray, and black wash, heightened with white, over traces of black chalk, 7⅝ × 10¼ in. (19.4 × 26.2 cm). Private collection

from Roman album no. 6 in 1979. One would assume, from its inclusion in the album, that it was drawn in Italy after an antique source, and that it later inspired the artist to adopt the same form for Hector's deathbed. However, certain details of the London study—the relief depicting scenes from the life of Hector, the mattress and white bed linens, the quick indications in black chalk of a body laid out on the bed—suggest that David may have made it at a later date, with the composition of *Andromache Mourning the Death of Hector* already in mind, or even in progress.[5]

As for the figural groups, the Roman albums contain numerous examples of mourning women,[6] but it was perhaps in the sheet now in the collection of Véronique and Louis-Antoine Prat (cat. 27), where a female attendant holds up a baby to embrace the widow, that the theme definitively took the form of Andromache. The energy of the quickly drawn chalk lines aligns with the Baroque

tenor of the design, manifest in the oblique angle of the corpse and the sense of movement in the female figures, with their expressions of extreme grief. David's decision to pare the composition down to his three main protagonists seems to have come in a striking ink-and-wash study in a French private collection (fig. 82). In it, David carries over details such as Andromache's grip on her husband's wrist and the extension of her near leg, but he reinvents the scene as a grim tableau of familial grief, the planarity of Hector's pale body stark against the inky black background. The next drawing in the sequence of compositional development is a sheet in the Bibliothèque de la Grand'Rue, Mulhouse, an awkwardly rendered linear reprise of the figural group, in which the artist has switched the position of Andromache's legs and turned her right hand upward in an open-palmed gesture.[7]

A drawing now in the Petit Palais, Paris (cat. 28), represents the first fully rendered compositional study for

*Andromache.* From the numerous chalk pentimenti and the added strip of paper on the right, it is clear that David used ink and wash to give a finished appearance to what began as an exploratory study.[8] Shifts and refinements are evident throughout as David tweaked the placement of the figures, objects, and setting. He added signifiers of Hector's identity as a warrior (sword, shield, helmet) and went back through his Roman albums to give a gloss of antique authenticity to the furniture, weaponry, and ornament, although the shield and spear mounted on the back wall appear to quote directly from Poussin.[9] Most notable, however, is the reorientation of the composition into a vertical format, an idea he took even further in the finished painting (fig. 83), giving over the entire upper half of the canvas to a murky void. The darkness hangs like a weight over the family, amplified by Andromache's upward gaze.

Over the spring and summer of 1782, as David executed version after version of this painful tableau, preparing to present the finished oil first to the judges of the Académie, then to the broader public, it must have been hard to ignore the story's emotional resonance with his own childhood, especially once distilled into the triad of mother, son, and dead father.[10] Consciously or not, it was a heroic recasting of his personal tragedy, and Robert Rosenblum was surely correct in suggesting that this alignment of subject and biography must have fueled the intensity of the painting.[11] An additional point worth noting is that, in the long sequence of drawings that chart the development of David's composition, there is also an evolution in the treatment of Astyanax, who gains in maturity with each iteration. From the Prat sheet, where he is an infant in the arms of an attendant; to the intermediary sheets, where he is a bawling toddler with his fists pressed into his eyes; to the compositional study in the Petit Palais and another in the Horvitz collection,[12] where he stands between Andromache's knees and gazes up at her face;[13] to, finally, the finished canvas, where he wears sandals and a bright red cape, and his hand has moved away from his mother's breast and reaches for her face, his transformation is complete: from a baby needing to be consoled to a boy offering comfort.   PS

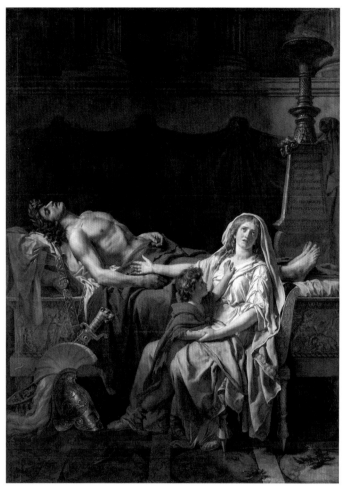

Fig. 83. Jacques Louis David, *Andromache Mourning the Death of Hector,* 1783. Oil on canvas, 108¼ × 79⅞ in. (275 × 203 cm). Ecole Nationale Supérieure des Beaux-Arts, Paris, on deposit at the Musée du Louvre, Paris (DL 1969-1)

## 29. *The Departure of Marcus Atilius Regulus for Carthage*

Ca. 1786
Pen and black ink, brush and gray and brown wash, heightened with
white, over traces of black chalk, on blue laid paper
12⅜ × 16⁵⁄₁₆ in. (31.5 × 41.4 cm)
Marks: lower left, paraph of Eugène David (Lugt 839); collector's mark
of Etienne (Auguste) Desperet (Lugt 721)
Art Institute of Chicago, Clarence Buckingham Collection (1976.58)

PROVENANCE: David estate sale, Paris, April 17, 1826, and following
days, lot 53, to M. Musigny; possibly William Mayor (d. 1874), London;
sale, Hôtel Drouot, Paris, November 21-22, 1859, lot 41, presumably
unsold; possibly sold, William Mayor, London, sale, Paris, May 2,
1863, lot 131;[1] Etienne (called Auguste) Desperet (1804-1865); his
estate sale, Paris, June 7-13, 1865, lot 537, to Le Blanc; Maurice-
Alfred Martin (1826-1895), baron de Beurnonville; his sale, Hôtel
Drouot, Paris, February 16-19, 1885, lot 291; sale, Paris, ca. 1970 (no
catalogue);[2] Henri Baderou, Paris; Shickman Galleries, New York;
acquired by the Art Institute of Chicago, 1976

REFERENCES: Schnapper 1982, pp. 89-90; Tedeschi 1985, no. 45,
pp. 106-7; Arlette Sérullaz in Schnapper and Sérullaz 1989, cat. 78,
pp. 182-83, 197; Rosenberg and Prat 2002, vol. 1, no. 77, pp. 92-93;
Prat 2011, p. 38, fig. 63

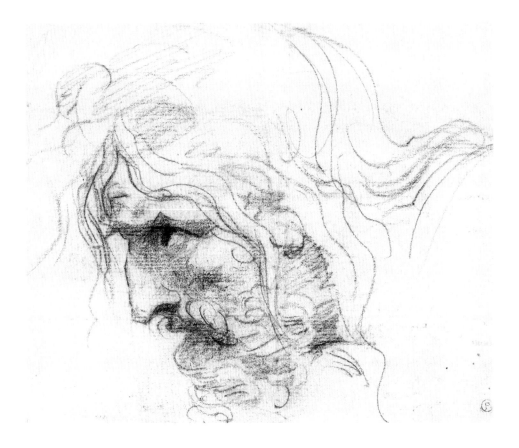

## 30. *Head of Marcus Atilius Regulus*

Ca. 1786
Black chalk
5³⁄₁₆ × 6⅛ in. (13.2 × 15.6 cm)
Marks: lower right, in black ink, collection mark of Véronique and
Louis-Antoine Prat (Lugt 3618)
Véronique and Louis-Antoine Prat Collection, Paris

PROVENANCE: Alvar González-Palacios; his collection sale, Sotheby's,
Paris, March 29, 2007, lot 17 (as by Jean-Baptiste Joseph Wicar);
acquired by Véronique and Louis-Antoine Prat, Paris

REFERENCES: Prat 2011, p. 38, fig. 64; Prat 2016a, p. 297, fig. 6; Conrad
Valmont in Rosenberg 2017b, cat. 49, pp. 140–41

The success of *The Oath of the Horatii* at the Salon of 1785 brought David another royal commission. The comte d'Angiviller, director of the Bâtiments du Roi, proposed two alternatives: David could depict either the story of the Roman general Coriolanus, who had defected and led the Volscian siege of Rome until the city's female inhabitants prevailed upon him to cease; or that of another Roman general, Marcus Atilius Regulus. The latter was captured by the Carthaginians in the First Punic War and released so that he might go to Rome to negotiate a peace, after which he rejected the entreaties of his family to remain and chose instead to honor the terms of his parole and return to Carthage, where he was tortured and killed.[3] Surviving drawings make clear that David explored both subjects,[4] although he ultimately executed neither and instead fulfilled the commission with a subject apparently of his own choosing, an episode from the life of Lucius Junius Brutus, founder of the first Roman Republic (see cats. 41–48).

The subject of the departure of Regulus was not a common one, but it had been treated by Laurent Pécheux about 1757 and reproduced as a print by Antoine de Marcenay de Ghuy in 1772 (fig. 84). Pécheux's shallow composition is set against an austere architectural

Fig. 84. Antoine de Marcenay de Ghuy (1724–1811), after Laurent Péchaux (1729–1821), *Regulus*, 1772. Etching, 11⅝ × 12⅜ in. (29.5 × 31.5 cm). The Metropolitan Museum of Art, New York, Gift of Georgiana W. Sargent, in memory of John Osborne Sargent, 1924 (24.63.1060)

Fig. 85. Jacques Louis David, *View of the Campidoglio in Rome with Ancient Figures*, ca. 1775–80. Pen and black ink, brush and gray wash, 5⅛ × 6¼ in. (12.9 × 16 cm). Private collection, France

backdrop, with Regulus striding purposefully forward as his family attempts to restrain him. David, on the other hand, envisioned the scene amid recognizable Roman buildings and landmarks. His compositional study, lost today, was catalogued in his estate sale under lot 40.[5] According to a description penned in 1860 by the critic Amédée Cantaloube, the drawing featured Regulus alongside the equestrian statue of Marcus Aurelius and a milliary column, before the Capitoline steps and the basilica of Santa Maria in Ara Coeli.[6] When the subject was assigned for the Prix de Rome competition in 1791, both top-prize winners, Charles Thévenin and Louis Lafitte, followed David's example and placed the drama in an urban setting, in the case of Thévenin, at the Roman port.[7]

A drawing that has recently come to light presents evidence that David may have conceived of this notion, of depicting this specific episode from ancient history set among recognizable Roman monuments, years earlier, while a student in Rome (fig. 85). This pen-and-wash study of the Capitoline Hill seen from an oblique angle differs from his typical Roman landscape drawings in its inclusion of ancient figures. The central pair of the group, a man striding to the left with a kneeling woman trying to restrain him, is a clear antecedent of the figures in the Chicago drawing, suggesting that, like many of the compositions he explored in the 1780s, *The Departure of Marcus Atilius Regulus* had long been percolating in the artist's mind.[8]

Despite the compositional study being lost to us, David's deep engagement with the central crux of the story is clear in the powerful figure study in the Art Institute of Chicago (cat. 29). Executed at a large scale on blue paper with extensive highlights in white gouache, the study imbues the figures with a sculptural quality. Regulus's muscular physique and active pose help him evade the lunging grasp of his daughter.[9] With his raised hand, he blocks her beseeching gaze. Other figures are lightly sketched in black chalk. The most legible is the fainting woman at right, presumably Regulus's wife. Her outstretched hand, clutching drapery, evokes the grieving and protective urges of other mothers in classical antiquity: Geta's mother (see cat. 25) and Brutus's wife (see cats. 42–47). As he did with many other ancient subjects

in this last decade of the ancien régime, David here pits female grief and emotion against male resolve and patriotic duty. However, unlike the compositions of *The Oath of the Horatii* and *The Lictors Bringing Brutus the Bodies of His Sons*, in which the male and female characters occupy distinct zones, the contrast of Regulus and his daughter is expressed not by juxtaposition but by physical struggle. The daughter is collapsed and clinging; like her counterparts in the *Horatii* and the *Brutus*, she registers anguish but will not prevent the violence.

A black chalk sketch of Regulus's head (cat. 30) was identified by Louis-Antoine Prat in 2007 when it appeared at auction under an attribution to one of David's students, Jean-Baptiste Joseph Wicar. Though small and rapidly done, it marks a further exploration of the protagonist's character and plight. His brow is heavy but no longer appears knitted in anger. His gaze, emphasized by the heavily applied chalk, is not cast down but trained fixedly ahead, expressing an unwavering determination and forward motion, as does the low placement of the head relative to his shoulders. Substituted for the flat light of the Chicago sheet, which gives the effect of an ancient relief, is a light source from above, casting large portions of Regulus's face into deep shadow.

Neither of the surviving studies for Regulus are typical of what we know of David's preparatory drawings of the 1780s. There are few sketches of heads for individual characters, despite the fact that the *tête d'expression* had been a focus of academic pedagogy during the years he competed for the Prix de Rome. More often, he would find inspiration in his drawings of Roman busts, such as the 1784–85 study of the Capitoline Brutus (see fig. 95), to whose appearance his own Brutus would hew closely.[10] The Chicago drawing likewise stands apart from the other figure studies he made for history paintings during

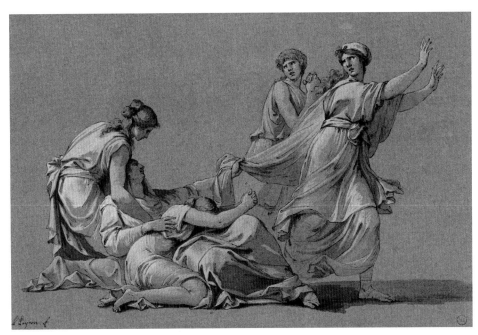

Fig. 86. Pierre Peyron (1744–1814), *The Young Athenians Drawing Lots for the Sacrifice to the Minotaur*, ca. 1778. Pen and black ink, brush and gray wash, heightened with white, on blue paper, 10¼ × 15¾ in. (26 × 40 cm). Musée Fabre, Montpellier (837.1.1148)

this decade, which focus on the detailed rendering of drapery of individual figures. Arlette Sérullaz drew a comparison with the figure studies of Pierre Peyron, which, like the Chicago sheet, were often of multiple figures, drawn at large scale on blue paper with white heightening (for example, fig. 86).[11] A precedent within David's own oeuvre can be found in the large scale and relief-like effect of the *Frieze in the Antique Style* (cat. 18), drawn at the end of his Roman sojourn and exhibited at the Salon of 1783.[12]

While the Regulus composition was ultimately a path not chosen, its theme of conflict between patriotic duty and familial attachments resonates strongly with David's other history subjects of this period and highlights the cross-pollination of ideas and compositions through exercises of drawing. In the *Brutus*, he would take the idea of male sacrifice and female anguish to a darker and more complex place, as the father figure sacrifices not himself, but his sons. The imprint of the Regulus drawings on the initial concepts for the Brutus composition is even more evident in the poses of his wife and daughter in the newly discovered study (see cat. 42). PS

# THE DEATH OF SOCRATES

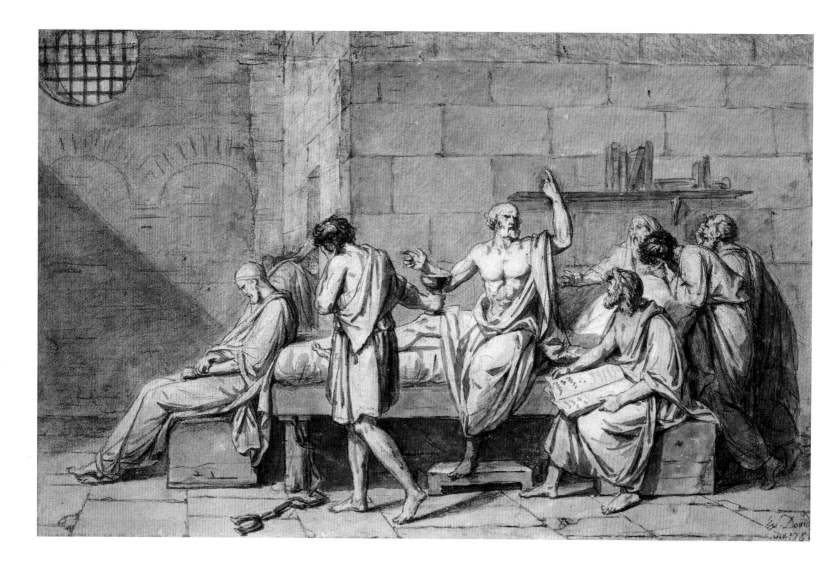

## 31. *The Death of Socrates*

1782
Black chalk, brush and gray wash, touches of pen and black and brown ink, with two irregularly shaped fragments of paper affixed to the sheet and a strip added along the upper margin
Verso: *Study for the Death of Camilla*
Black chalk
9¼ × 14¾ in. (23.5 × 37.5 cm)
Inscriptions: lower right, in black chalk, signed and dated "L. David / inv. 1782"
Private collection

PROVENANCE: Probably Henri Delaroche sale, Paris, April 24–26, 1821, lot 107; possibly Renée Bianchi, vicomtesse Fleury (1869–1948), 1940;[1] private collection, Paris, 1989; Galerie Eric Coatalem, Paris, 2014; private collection

REFERENCES: Nash 1973, pp. 76, 78, 216 n. 220; Bordes 1981, pp. 181–83, 184 n. 17; Arlette Sérullaz in Schnapper and Sérullaz 1989, cat. 76, pp. 178–79; Rosenberg and Prat 2002, vol. 1, no. 52, pp. 71–72; Crow 2006, pp. 95–97, fig. 74

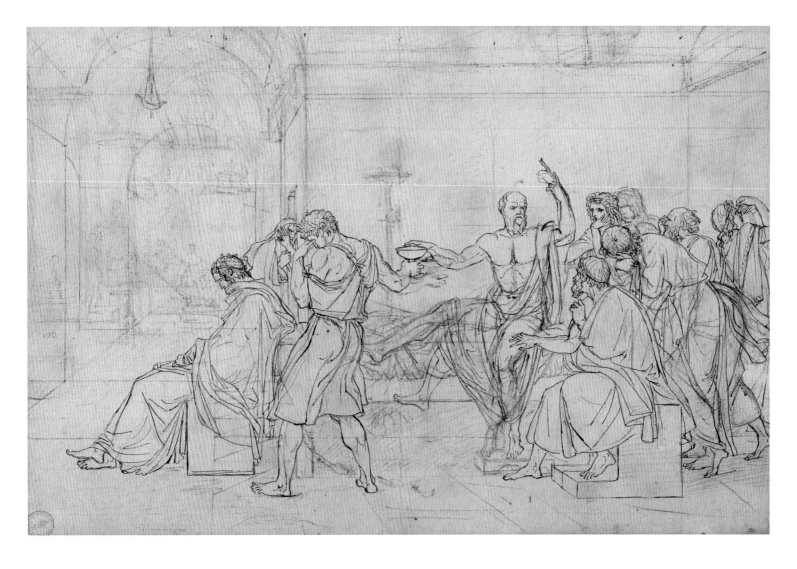

## 32. *The Death of Socrates*

Ca. 1786
Pen and black ink, over black chalk, touches of brown ink, squared in black chalk
11 × 16⅜ in. (27.9 × 41.6 cm)
Marks: lower left, in black ink, collector's mark of the Coutan-Hauguet family (Lugt 464)
The Metropolitan Museum of Art, New York, Purchase, Walter and Leonore Annenberg Acquisitions Endowment Fund and Mr. and Mrs. J. Tomilson Hill and Mr. and Mrs. Mark Fisch Gifts, 2015 (2015.149)

PROVENANCE: L. J. A. Coutan (d. 1830), Paris; his wife, Mme Coutan (d. 1838); their brother-in-law Ferdinand Hauguet (d. 1860); by descent to his son, Maurice-Jacques-Albert Hauguet; his wife, Mme Hauguet, née Schubert; her sister, Mme Gustave Milliet; estate sale, Coutan-Hauguet collection, Hôtel Drouot, Paris, December 16–17, 1889, lot 90 (as "Mort de Socrate. Première pensée avec variants, Dessin au crayon et à l'encre."); bought at that sale by Jules Froyez, Paris;[2] presumably his collection sale ("la collection de M. J. Fᶻ" and others), Hôtel Drouot, Paris, December 15, 1896, lot 44 ("première pensée, avec variants. Dessin à la plume et au crayon"; listing the Coutan-Hauguet provenance);[3] private collection, France; sale, Christie's, New York, January 29, 2015, lot 89; acquired by Katrin Bellinger Kunsthandel, Munich; acquired by the Metropolitan Museum, 2015

REFERENCES: Rosenberg and Prat 2002, vol. 2, no. M 49, p. 1221 (as known from an early mention); Prat 2016b, pp. 111–12, fig. 8; Baetjer 2019, pp. 311–12, fig. 106.9

## 33. *Seated Old Man (Plato) with a Young Man Standing Behind*

Ca. 1786–87
Black chalk, stumped, heightened with white chalk, squared in black chalk
20¹³⁄₁₆ × 14⁹⁄₁₆ in. (52.9 × 37 cm)
Marks: lower right, paraph of Eugène David (Lugt 839)
Musée des Beaux-Arts, Tours (INV. 922-306-2)

PROVENANCE: Presumably David estate sale, Paris, April 17, 1826, and following days, probably as part of lot 97; Jean-Baptiste Auguste Vinchon (1786–1855); given by his daughter-in-law Aline Vinchon to the Musée des Beaux-Arts, Tours, 1922

REFERENCES: Arlette Sérullaz in Schnapper and Sérullaz 1989, cat. 77, pp. 180–81; Rosenberg and Prat 2002, vol. 1, no. 82, p. 98; *Jacques-Louis David* 2005, cat. 29, pp. 88–89; Danielle Oger in Bassani Pacht et al. 2013, cat. 16, pp. 58–60

## 34. *Crito*

Ca. 1786–87
Black chalk, stumped, heightened with white chalk, squared in black chalk
21⅛ × 16⁵⁄₁₆ in. (53.6 × 41.4 cm)
Inscriptions: lower right, in graphite, in the artist's hand, "David à son ami chaudet"
The Metropolitan Museum of Art, New York, Rogers Fund, 1961 (61.161.1)

PROVENANCE: Antoine Denis Chaudet (1763–1810); Wildenstein & Co., London; acquired by the Metropolitan Museum, 1961

REFERENCES: Bean 1986, no. 90, pp. 87–89; Perrin Stein in Stein and Holmes 1999, cat. 90, pp. 208–20; Rosenberg and Prat 2002, vol. 1, no. 84, p. 99; Prat 2011, p. 39, fig. 65

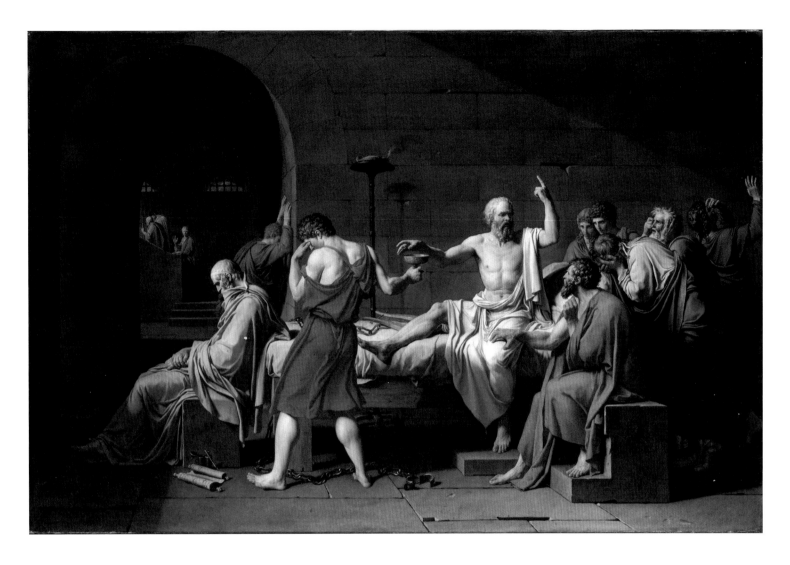

## 35. *The Death of Socrates*

1787
Oil on canvas
51 × 77¼ in. (129.5 × 196.2 cm)
Inscriptions: lower left, dated "M D CC LXXXVII"; on the stool, "L· D"; on the bench, "ΑΘΕΝΑΙΩΝ" (of the Athenians), and below it, "L. David."
The Metropolitan Museum of Art, New York, Catharine Lorillard Wolfe Collection, Wolfe Fund, 1931 (31.45)

PROVENANCE: Charles Louis Trudaine de Montigny (1764–1794), Paris; seized for the nation following Trudaine's imprisonment and execution in 1794, but later returned to the family; his sister-in-law, Louise Micault de Courbeton, Mme Trudaine de Montigny (d. 1802); her brother, Lubin Marie Vivant Micault de Courbeton (d. 1809); his cousin Armand Maximilien François Joseph Olivier de Saint-Georges, 5th marquis de Vérac (d. 1858); his widow, Euphémie de Noailles, marquise de Vérac (d. 1870); her son-in-law, Adolphe, comte de Rougé (d. 1871); his estate sale, Hôtel Drouot, Paris, April 8, 1872, lot 1, to Bianchi; Marius Bianchi (d. 1904), Paris; Mathilde Jeanin, Mme Marius Bianchi (1904–1913 or after); their daughters, Renée, vicomtesse Fleury (1869–1948), Thérèse, comtesse Murat (1870–1940), and Solange, marquise de Ludre-Frolois (d. 1949), until 1931, when sold through Walter Pach to the Metropolitan Museum, 1931

REFERENCES: Antoine Schnapper in *French Painting 1774–1830* 1975, cat. 32, pp. 82, 367–68; Crow 2006, pp. 95–99, fig. 72; Philippe Bordes in Jackall et al. 2017, pp. 106–8, 110, 112, 118 nn. 29, 30, 36, 42, fig. 5; Baetjer 2019, pp. 31, 306–17 no. 106 (citing earlier literature and previous exhibitions), 379

Commissioned in 1786 by one of the wealthy and privileged Trudaine brothers, most likely the elder, Charles Louis Trudaine de Montigny,[4] *The Death of Socrates* (cat. 35) has often been discussed within the framework of David's rivalry with Pierre Peyron and their public showdown on the walls of the Salon, from which David emerged triumphant.[5] However, a previously unknown early study (cat. 31), exhibited in 1989, introduced evidence of a genesis significantly more protracted and complex than previously thought. The date inscribed on the drawing, 1782, accepted by the majority of scholars,[6] places David's initial engagement with the subject in the fertile few years following his return from Rome, when he was casting about for subjects for his *morceau de réception*, or reception piece for the academy. During this period, he explored on paper ideas for a number of projects, including *The Oath of the Horatii* (cats. 21–24), the story of *Caracalla and Geta* (cats. 25–26), and *Andromache Mourning the Death of Hector* (cats. 27–28). Indeed, the first idea for *The Death of Socrates* has much in common with this group in its insistent planarity and dramatic distillation of narrative.

That David chose to portray this episode from antiquity is not surprising, as it had become a popular theme in France in the second half of the eighteenth century.[7] Etienne La Font de Saint-Yenne, an art critic writing about Michel François Dandré-Bardon's painting of the subject exhibited in the Salon of 1753, proclaimed it "moral and well-chosen."[8] In 1759, Denis Diderot suggested that the death of Socrates was a suitable topic for the stage, describing how it could be adapted into a "drame philosophique" in five acts,[9] and the subject was chosen by the Académie Royale for the Prix de Rome competition of 1762. As we will see, however, David's painting also bears the strong imprint of ancient sources, most notably, Plato's *Phaedo*.

The 1782 sheet, though predating the painting by five years, contains the essence of David's concept. The ancient Greek philosopher Socrates was imprisoned for the crime of impiety and for corrupting the youth of Athens. Rather than renounce his beliefs, he prepares to drink the poison hemlock. He pauses to address his gathered disciples, who variously express their distress; even the figure bearing the poison (whose pose carries an echo of one of David's Roman *académies*; see cat. 3)

averts his gaze.[10] The sheet itself is a layered construction, bearing traces of pentimenti and multiple alterations, representing a sequence of ideas and revisions. Initial thoughts were put down very quickly in roughly applied black chalk. Gray wash in a range of intensities was then used to add shadows and lend solidity to figures, drapery, and furniture. But even after he had modeled the forms with wash, David was evidently unhappy with two areas of the composition, issues he resolved by pasting irregular pieces of paper over these areas and redrawing them, a technique of revision he would return to throughout his career. A vertical rectangular piece was cut to cover the angled piece of wall extending from the top of the cupbearer's head to what was originally the upper margin of the sheet. In transmitted light (and bleeding through on the verso), one can see that the doorway cut into the stone wall was initially much wider. The second piece of pasted paper includes the entire figure of Crito, seated on a block to the right of Socrates (see detail on p. 12). The earlier version of this figure, again seen with transmitted light, was in a slightly different pose and of generally larger scale, perhaps considered out of proportion relative to the other figures. A strip of paper across the upper margin must have been a later addition, as the paper and the handling of the chalk are both visibly different.

A repetition of the 1782 study in Los Angeles emerged in 2013 and is now in the collection of the Metropolitan Museum (fig. 87). Although the execution of the sheet may have been by a member of David's studio,[11] the technique reflects David's use of tracing to produce iterations of compositions in development. Overlays of the digital images of the two sheets suggest that The Met's version was made in the artist's studio using tracing to establish the contours of the figures, a practice he continued to use over the course of his career. It was perhaps the sketchy nature of the Los Angeles sheet, with its numerous pentimenti and pasted-on pieces of paper, that suggested the need for a cleaner version.[12] Nonetheless, certain small adjustments can be observed. In The Met's sheet, Plato's right foot is now flexed, as it appears in the final painting;[13] the position of the chain (drawn freehand) has shifted; the tunic of the slave is higher; errors in the perspective of Socrates's footstool are corrected; and, generally, various blocks and pieces of furniture are given

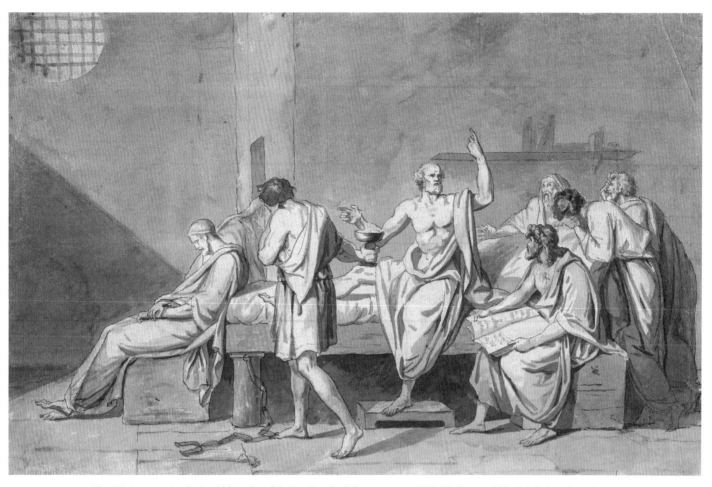

Fig. 87. Jacques Louis David (studio of?), *The Death of Socrates*, ca. 1782–86. Pen and black ink, brush and gray wash, over black chalk, lightly squared in black chalk, 9⅝ × 14⅞ in. (24.4 × 37.8 cm). The Metropolitan Museum of Art, New York, Purchase, The Elisha Whittelsey Collection, The Elisha Whittelsey Fund, 2013 (2013.59)

more strictly horizontal bases. It is also worth noting that there is faint chalk squaring on the New York version.

At this point, the project seems to have gone dormant, and would have remained an unexecuted idea if not for the return of the Trudaine brothers from Constantinople in the spring of 1786. David presumably made the acquaintance of Charles Louis Trudaine de Montigny and Charles Michel Trudaine de la Sablière through a mutual friend, the poet André Chénier. The sons of a powerful minister of finance, the brothers were well educated and well traveled, and, following the early deaths of their parents, had considerable wealth at their disposal. They were made *conseillers* in the Paris parliament at unusually young ages.[14] When they wished to commission a painting from David, a rising star in

the Académie, it was likely the painter who suggested the death of the Greek philosopher as an appropriate subject, for which he already had a fairly advanced idea. Shortly after receiving the commission, David apparently paid a visit to the Paris house of the Oratorian fathers and there consulted a scholar, Jean Félicissime Adry, who provided details of the age and appearance of many of the figures in the scene, as we learn from a surviving letter dated April 8, 1786.[15] One line in the letter suggests that David had brought a sketch of his work in progress to show Adry, and perhaps even left it with him.[16] They also seem to have discussed the necessity of including Plato in the scene, despite his not being present, as he was responsible for recording for posterity Socrates's last words, a role further emphasized in the

Fig. 88. Jacques Louis David, *View of the Entrance to a Palace*, from sketchbook (carnet) 2, ca. 1775–80. Black chalk, 5¼ × 7⅜ in. (13.5 × 18.8 cm). Musée du Louvre, Paris (RF 4506, fol. 47 verso)

painting by means of the pen, ink, and scroll placed by his feet.

That the four intervening years, from his first treatment of the subject in 1782 to his return to the theme in 1786, had been critical ones for David's artistic formation is clear in the study that first came to light in 2015, now likewise in the collection of The Met (cat. 32). In the rapid handling of the black chalk, we sense the rush of inspiration that clearly accompanied David's return to the composition. The sheet records, in its layers of reworkings, a sequence of alternative ideas for the architectural setting, as well as for the poses and placement of the figures, some of which are then redrawn in pen and ink. Most notable is the idea to pierce the unrelenting severity of the stone backdrop of the 1782 composition with a receding hallway at left, leading to a set of stairs. Alternate sketches for the placement of windows, arches, and columns can be seen below, drawn freehand in faint black chalk, but when he came to the idea of the arched hallway, David used a compass and a straightedge to work out the perspective.[17] The concept for the space seems to have come, either consciously or unconsciously, from a sketch of an unidentified building made on his second trip to Italy, in 1784–85 (fig. 88).[18] The device of the recessed stairs would allow David to visually conflate an earlier moment in the story—the departure of a group of figures, presumably Socrates's family—into his finished composition.[19] It was at this juncture that David looked to ancient prototypes, as he had in the Caracalla drawings (see cats. 25–26), for the appearance of his protagonist, giving Socrates facial features that would have made him easily recognizable.[20]

The Met sheet also makes clear that, when the painting was commissioned, David returned not only to his earlier drawings, but also to the words of Plato, finding through poses and accessories innovative ways to refer to his teachings. The description of Socrates's death is given in *Phaedo*, one of Plato's dialogues, even though Plato was not physically present in the prison at the time of the elder philosopher's death. Indeed, Plato would

have been a very young man at the time, not old, as he appears here. David expresses this disjunction through a conceit: he places Plato, an old man, seated at the foot of Socrates's bed, facing away, with his mouth covered and his eyes closed.[21] He is the storyteller from whose memory springs the scene taking place around him. This drawing renders legible David's subtle strategy to reinforce the primacy of Plato's role by constructing the architectural setting with an off-center vanishing point at the crown of his head.[22] The harnessing of perspective to narrative purpose is reinforced by the detailed perspective lines, keyed to the same vanishing point, that begin at the bottom margin, below the cupbearer's left foot, and help determine the diminishing scale of the paving stones.

David also shifts the placement of certain figures to incorporate elements from Plato's account. The cupbearer, in a more tense and muscular pose, is moved to the left, closer to Plato. By thus allowing the full length of the philosopher's outstretched leg to be visible in the center of the sheet, and by relocating the chain to just below it, David evokes Socrates's discourse on the relationship of pleasure to pain, spoken, as recounted in *Phaedo*, while he rubbed the ankle that had just been released from the manacle.[23] (In the final work, David further references the passage with touches of red paint on the ankle.) Likewise the ancient lyre, introduced here in a very schematic rendering partially obscured by Socrates's leg, evokes a metaphor in Plato's text that offers the lyre as an analogy for the relationship of the soul (music) to the body (instrument).[24] For as Socrates's gesture toward the heavens suggests, his final moments were spent expounding on his notions of the immortality of the soul. Yet even while he was establishing the architectural framework and inserting textual and visual references, David's clear obsession was with composing the visual center of the sheet, in part by resolving the poses of the two figures on either side of the central axis, with their splayed pentimenti of hands and limbs. Ultimately, however, his efforts were focused on hollowing out the center, thus drawing the viewer's gaze to the vignette that was the crux of the subject—that is, the passage of poison from one hand to another.[25]

Judging from the many differences between The Met's drawing and the canvas, we can be certain that there were additional compositional studies. The drawing that Klaus Holma saw in the home of the vicomtesse Fleury and described in 1940 as "very advanced and very detailed" may have been a pen-and-wash study of the type that has survived for many of David's paintings of the 1780s, and the small oil sketch with nine figures seized from the Trudaine residence in 1794 was likely a study comparable to those he made for the *Horatii* and the *Brutus*.[26]

Following the practice he established in Rome in early 1785, where he had gone to complete *The Oath of the Horatii*, David made large drapery studies for each major figure. That these studies were only made once the composition had been resolved is clear in the case of overlapping figures, as in a study in the Musée des Beaux-Arts, Tours, for the man leaning against the wall behind Plato (cat. 33). By blocking in the contours of Plato in the foreground, David modeled no more of the standing man's drapery than was necessary. He did, however, sketch in the man's nude lower body in chalk, even though it would be obstructed by the figure of Plato, no doubt to assure himself on the placement and scale of the figure.[27] In The Met's study for Crito (cat. 34), the wealthy Athenian disciple seated by Socrates's side, the artist employed a mix of black and white chalk with stumping (a technique that smudges and blends the chalk) to subtly model the fall and folds of drapery, lending a sense of grandeur and amplitude to the underlying figure, even if the head and visible appendages are blocked in with only minimal detail.[28] The sheet is squared in black chalk to facilitate the transfer to canvas, where the scale is slightly larger. Characteristically for the artist, the squaring does not extend evenly to the edges of the sheet but, rather, focuses only on the areas pegged for transfer. These studies are very close to the figures as they appear in the painting and generally have few pentimenti, with the exception here of Crito's footstool, which seems to have been extended after the drapery was drawn.

In total, David seems to have made seven drapery studies for *The Death of Socrates*. Five (presumably including the Tours sheet) remained in his studio until his death, and two were given away as gifts. A study for the figure of the cupbearer was given to a certain Jeuffroy (perhaps the printmaker Romain Vincent Jeuffroy) and last recorded in the Revil sale of 1842.[29] The study of

Fig. 89. Fe (iron) distribution map of *The Death of Socrates* (cat. 35), acquired by macro X-ray fluorescence (MA-XRF)

Crito is inscribed, "David à son ami chaudet," presumably in reference to the sculptor Antoine Denis Chaudet, whom David likely met on his second stay in Rome. Chaudet must have cherished the drawing, for we see a distinct echo of it in the side view of his 1794 bronze statuette *Belisarius and His Guide* (see fig. 2), based on a 1791 terracotta.[30]

Technical examination of the painting conducted in 2020 by Charlotte Hale, Conservator, and Silvia A. Centeno, Research Scientist, at The Metropolitan Museum of Art revealed that David continued to tinker with the elements that had occupied him most in his drawn studies, even after the composition had been brushed on canvas.[31] The barred oculus window that he had considered placing in various locations in cat. 32 was initially painted on the wall above and to the right

of Socrates (fig. 89), only to be painted out later, its former presence echoed by the metal ring that took its place.[32] Further, the steep angle of the stair railing, again, as seen in the drawing, was repainted, with the newel-post positioned higher. There even appears to have been an additional figure on the stairs (fig. 90).[33] Other changes made in the course of completing the picture include repositioning the chain, which had initially been sketched descending awkwardly from the cupbearer's left calf, now visible snaking behind Socrates's bed (fig. 91); painting over the buckle on the strap crossing the cupbearer's back;[34] removing a headband from the black-haired disciple on the right, presumably to omit distracting details; and making small adjustments to the contours and appendages of various figures. David also continued to fine-tune the "hand-

cup-hand" vignette at the center of the composition, shifting Socrates's arm slightly to the right. As he had in the *Belisarius* (cat. 16), David gives center stage to a charged and emblematic gesture. Socrates's hand hovering just above the cup's rim activates the scene's central void, a fulcrum read by some scholars as a tension between rationalism and homoerotic impulse.[35] More generally, we see a drama paused, balanced between the physical and the metaphysical, despair and hope, life and death.

The success of The Met's painting can be measured in part by the distance traveled between the first idea put to paper in 1782 and the many versions, known and lost, that came after. Together, they document David's engagement with the subject through texts, research of ancient prototypes, and the exploration of poses and placement. It was not by epiphany but by perseverance and experimentation that David orchestrated this finely calibrated tableau. The dichotomies inherent in his composition are enhanced by the polished execution and enamel-like surface of the canvas, with its poignant contrast between the cool palette of the gray stone and the naturalistic rendering of flesh. Five of the figures depicted avert or cover their eyes, while the eyes of the viewer are invited to linger on the veins, muscles, and expressions of human grief as they contemplate Socrates's discourse on the immortality of the soul.   PS

Fig. 90. Hg (mercury) distribution map (detail) of *The Death of Socrates* (cat. 35), acquired by macro X-ray fluorescence (MA-XRF)

Fig. 91. Infrared reflectogram (detail) of *The Death of Socrates* (cat. 35)

## 36. *Paris and Helen (Anonymous Tracing after d'Hancarville)*

Ca. 1775–80
Pen and brown ink, on tracing paper
10¼ × 15⅞ in. (26 × 40.2 cm)
Victoria Munroe, New York

PROVENANCE: David estate sale, Paris, April 17, 1826, and following days, part of lot 77, unsold; second David estate sale, Paris, March 11, 1835, part of lot 16; Galerie Paul Prouté, Paris, 1978, no. 58, as part of Roman album no. 6; Galerie de Bayser, Paris, 1979, no. 47 bis; Bromberg collection;[1] sale, Hôtel Drouot, Paris, December 16, 1985, part of lot 1; Véronique and Louis-Antoine Prat Collection, Paris; sale, Christie's, New York, January 30, 1998, part of lot 190; acquired at that sale by Victoria Munroe, New York

REFERENCES: *Fonds Nicolas Mignard* 1978, no. 58, as part of Roman album no. 6; *Louis David* 1979, no. 47 bis, n.p.; Rosenberg and Prat 2002, vol. 1, no. 730*, p. 538; Prat 2011, p. 27, fig. 35

## 37. *Paris and Helen*

Ca. 1782–86
Black chalk
9 × 11¾ in. (22.9 × 29.8 cm)
Marks: lower center, paraphs of Eugène David (Lugt 839) and Jules David (Lugt 1437); lower right, in black ink, collection mark of Véronique and Louis-Antoine Prat (Lugt 3617)
Victoria Munroe, New York

PROVENANCE: David estate sale, Paris, April 17, 1826, and following days, part of lot 77, unsold; second David estate sale, Paris, March 11, 1835, part of lot 16; Galerie Paul Prouté, Paris, 1978, no. 58, as part of Roman album no. 6; Galerie de Bayser, Paris, 1979, no. 47; Bromberg collection (per Christie's); sale, Hôtel Drouot, Paris, December 16, 1985, part of lot 1; Véronique and Louis-Antoine Prat Collection, Paris; sale, Christie's, New York, January 30, 1998, part of lot 190; acquired at that sale by Victoria Munroe, New York

REFERENCES: *Fonds Nicolas Mignard* 1978, no. 58, as part of Roman album no. 6; *Louis David* 1979, no. 47, n.p.; Arlette Sérullaz in Schnapper and Sérullaz 1989, cat. 81, pp. 188–89; Sérullaz 1991, pp. 20, 27–28, fig. 17; Rosenberg and Prat 2002, vol. 1, no. 729, p. 537; Prat 2011, p. 27, fig. 34

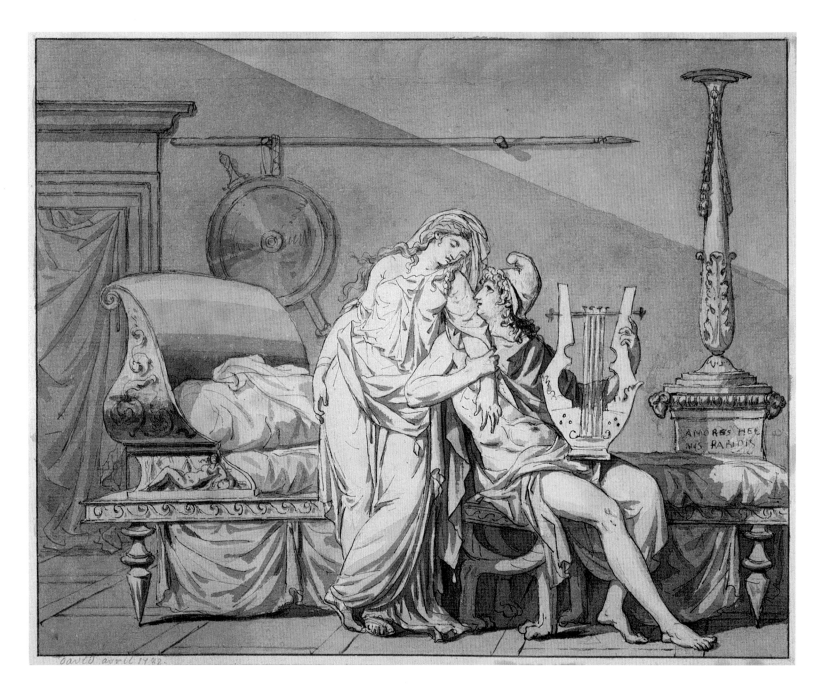

## 38. *Paris and Helen*

1782?
Pen and black ink, brush and gray wash, over black chalk
8¹¹⁄₁₆ × 10¹³⁄₁₆ in. (22.1 × 27.5 cm)
Inscriptions: on the candelabrum at right, in pen and black ink, "AMORES HEL / NIS PARIDIS"; lower left, in graphite, in another hand, "david avril 1782"
Private collection, New York

PROVENANCE: Possibly Flury-Herard, banker;[2] his sale, Delbergue-Cormont, Paris, May 13–15, 1861, lot 465 bis, acquired by Dreux;[3] possibly [H.] D[reux] sale, Delbergue, Paris, February 3–4, 1870, lot 28, acquired by Danyand;[4] art market, Paris, 2002; François Bigot; his estate sale, François Thion, Hôtel des Ventes, Evreux, May 9, 2010, lot 12; acquired at that sale by the present owners, New York

REFERENCES: Rosenberg and Prat 2002, vol. 2, no. 87 bis, p. 1279; Prat 2016b, pp. 111, 223, fig. 7

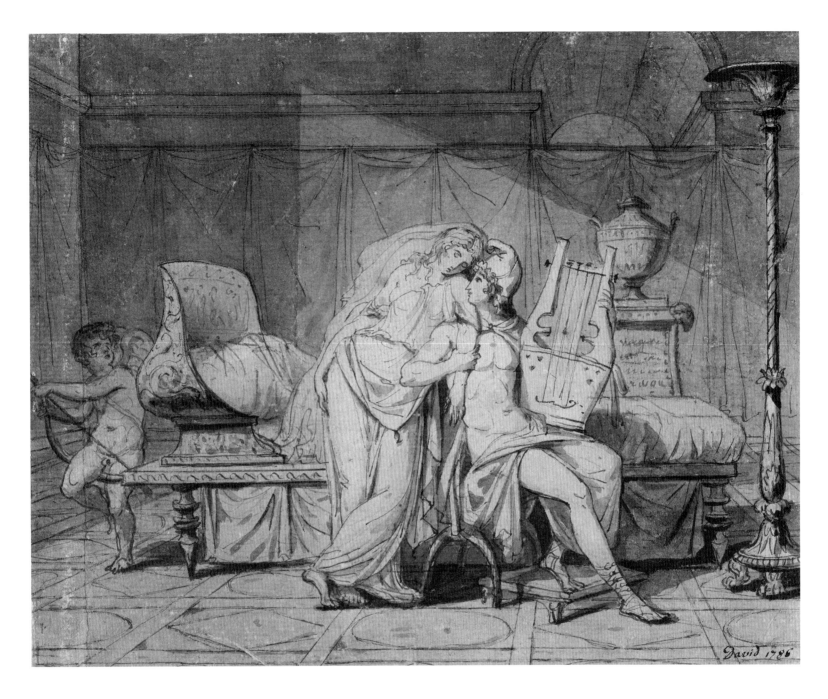

## 39. *Paris and Helen*

1786
Pen and brown and black ink, brush and gray wash, with a strip of paper added along the left margin
7³/₁₆ × 9 in. (18.3 × 22.9 cm)
Inscriptions: lower right, in pen and black ink, signed and dated "David 1786."
J. Paul Getty Museum, Los Angeles (83.GA.192)

PROVENANCE: Possibly Jean Guillaume Moitte (1756–1810); his estate sale, Paris, June 7–8, 1810, lot 20; acquired by (presumably Guillaume Jean) Constantin; possibly L. J. A. Coutan (d. 1830); his estate sale, April 19, 1830, lot 182; possibly the estate sale of baron D**** (Dubneville or Denon?), Petit, Paris, November 29–December 1, 1830, lot 70; possibly Prince d'Esl[ing]; his collection sale, Petit, Paris, March 4–5, 1833, lot 57 (as from the Coutan collection);[5] possibly A. Dumont (1790–1853), secretary of the Ecole des Beaux-Arts, Paris; his estate sale, Paris, February 13–16, 1854, lot 118 (as dated "1786"); private collection, sale, Hôtel Drouot, Paris, March 22, 1983, lot 2; acquired by the J. Paul Getty Museum, 1983

REFERENCES: Goldner 1988, no. 67, pp. 154–55; Arlette Sérullaz in Schnapper and Sérullaz 1989, no. 83, p. 189; Rosenberg and Prat 2002, vol. 1, no. 88, p. 102

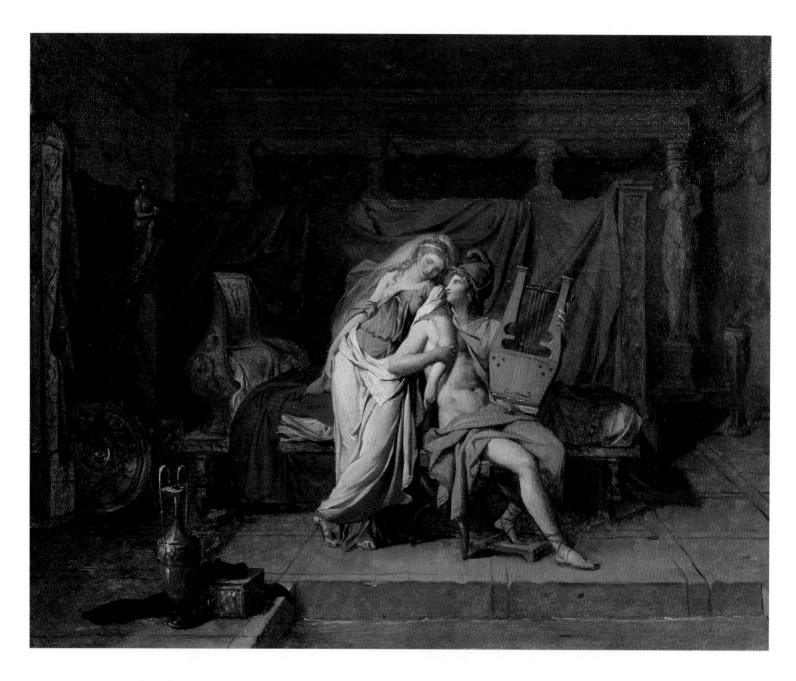

## 40. *Paris and Helen*

Ca. 1786–87
Oil on canvas
14⁹⁄₁₆ × 18½ in. (37 × 47 cm)
Private collection, New York

PROVENANCE: Comte de Cypierre;[6] Charles Meynier (1763–1832); his estate sale, November 26–December 4, 1832, lot 68 ("Fort belle esquisse, avec quelques changemens du tableau de Pâris et Hélène, qui est au Musée."); possibly Bertrand, Château du Doubs, and others, sale, Paillet, Paris, December 22–23, 1834, lot 49 ("Esquisse terminée du tableau de Pâris et Hélène que se voit dans la galerie du Musée; il y a quelques différences dans les draperies et le fond. C'est une des plus agréables productions de cet habile peintre."); possibly anonymous sale, Pressé, Paris, January 13, 1847, lot 57 ("Première pensée du tableau du Louvre. Esquisse de très-belle qualité."); Bourdier collection, until 1912; by descent to Verdé-Delisle, Paris, 1913; by descent in the family, Turquin, Paris, 2008;[7] acquired by the present owners, New York

REFERENCES: Florisoone 1948, cat. M.O.25, p. 52; Antoine Schnapper in Schnapper and Sérullaz 1989, pp. 184–89, fig. 62, under no. 79; Rosenberg and Prat 2002, vol. 1, p. 102, under no. 88; Nicolas Sainte Fare Garnot in *Jacques-Louis David* 2005, cat. 28, pp. 86–87, 158; Duchemin 2008, cat. 1, n.p.

The bound albums of studies that David brought back from Italy served him as an essential studio resource throughout the 1780s (see cats. 6–14). He had organized them according to utility, intermixing his own copies and studies with sketches by other hands, and with tracings made from published treatises on antiquities. Indeed, it was a pair of figures in a tracing (cat. 36) made from an illustration depicting an ancient vase in the collection of William Hamilton, the British ambassador to Naples,[8] that prompted David to make a quick sketch in black chalk (cat. 37) directly on the facing album page, swapping Paris's spear for a zither and resting Helen's arm on his shoulder. From this quick redrawing of the traced figures, David had only to reposition Paris to the opposite side of Helen and reverse his orientation to establish the figural grouping that would eventually anchor his painting of the subject.[9] Whether he was purposefully researching the theme or simply inspired

by a chance encounter while leafing through his albums, every step of the progression from Greek vase to finished canvas is made visible through David's preparatory studies.

Completed in 1788, *The Loves of Paris and Helen* (fig. 92) was a commission from King Louis XVI's younger brother Charles Philippe, comte d'Artois, later King Charles X. The painting was intended either for his residence at the Palais du Temple or for the Bagatelle, his recently constructed pleasure pavilion in the Bois de Boulogne.[10] Artist and patron seem to have known each other as early as 1782,[11] but it was likely in 1786 that d'Artois commissioned the painting, along with *Rinaldo and Armida* from François André Vincent, and possibly also *Mars and Venus* from François Guillaume Ménageot, all variations on the theme of love triumphant.[12]

The Trojan War, set off by the abduction of Helen, the wife of the Spartan king Menelaus, was a frequent

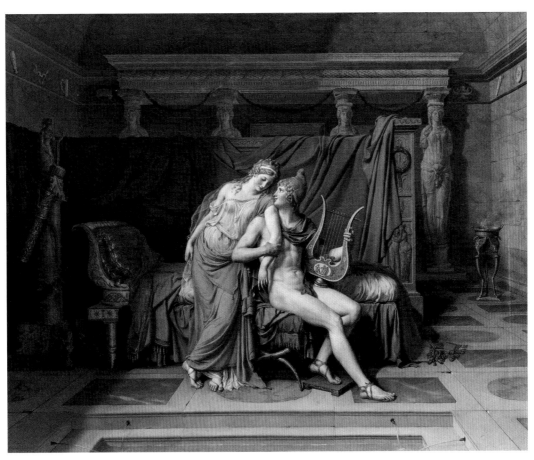

Fig. 92. Jacques Louis David, *The Loves of Paris and Helen*, 1788. Oil on canvas, 57⅞ × 70⅞ in. (147 × 180 cm). Musée du Louvre, Paris (INV. 3696)

Fig. 93. François Joseph Bélanger (1744–1818), *Bedroom of the Comte d'Artois at Bagatelle*, ca. 1777–78. Pen and ink, gray wash, watercolor, 14⅝ × 21¾ in. (37.1 × 55.2 cm). Bibliothèque Nationale de France, Paris

theme for painters in eighteenth-century France, but the subject of Paris and Helen in their nuptial chamber was without precedent in French painting.[13] Paris had been whisked from the battlefield and brought to his palace by his protectress, Venus. He is shown by David with his weapons cast aside—not a warrior, but a youthful lover besotted by the modest yet pliant Helen. The subject was a fitting one for the comte d'Artois, whose military forays had been similarly brief and unsuccessful, and who was better known for his romantic liaisons and elegant building projects.[14] Indeed, scholars have noted strong corollaries between Paris's chamber as depicted by David and the comte's bedroom at Bagatelle, designed by François Joseph Bélanger about 1777 (fig. 93).[15] Conceived as a gallant military tent, the decor was saturated with martial imagery, including swords and shields mounted on the fabric walls of the faux tent.

Should we conclude, based on these commonalities between patron and protagonist, that *The Loves of Paris and Helen* was specifically developed for the comte d'Artois, or is it possible that, as was the case with the Trudaine

brothers and *The Death of Socrates*, that the artist offered d'Artois a choice among several compositions that he had already begun to develop on paper (see pp. 144–45)? The sequence of preparatory works contains clues, but not a conclusive answer. Only a sheet in the J. Paul Getty Museum, Los Angeles (cat. 39), bearing a date of 1786, offers a solid guidepost. Two pen-and-wash drawings of larger dimensions but representing less advanced stages of the composition must precede it. As with the compositional studies for *The Death of Socrates*, David's initial scheme was spare: figures aligned with the picture plane against a bare wall embellished only with military attributes, as was also the case with his early ideas for *Andromache Mourning the Death of Hector* (cats. 27–28).[16] The version formerly in the Nathan collection (fig. 94) was dated about 1785–86 in the 2002 catalogue raisonné,[17] but the appearance of another iteration as that book was going to press, now in a New York private collection (cat. 38), bears the following, in graphite: "david avril 1782." While the inscription is not in the artist's hand, and the date may well be erroneous, it is a question that

merits consideration, especially as the complexity and details of the setting are significantly altered in the Getty drawing, allowing for the possibility that some time had elapsed between iterations.[18]

In the addenda to the 2002 catalogue raisonné, the New York sheet (cat. 38) was described as an autograph replica of the drawing previously in the Nathan collection. This thesis finds support in the calm precision of its technique and the fact that it is drawn directly on the paper that forms the mount, with the gold strips and band of pale green wash applied, giving the sheet the appearance of a presentation drawing. Other observations, however, argue in favor of a reverse chronology. Of the various differences between the two versions—the legs of Paris's stool, the volute on the headboard of the bed, the position and placement of Helen's left hand—it was invariably the details from the ex-Nathan sheet that are carried forward. Moreover, the pentimento in black chalk near the upper margin of the New York sheet reveals that the artist initially considered placing

the lance above the lintel of the doorway, reinforcing that sheet's anteriority. The composition would evolve considerably, but even in these early incarnations, the sparse interior displays a characteristic concern for authenticity, reflecting David's study of the copies he made after antiquities in Rome.[19]

The Getty sheet (cat. 39), dated 1786, with its freer and looser handling and overhaul of the room's architecture and decor, signals a new engagement with the subject, likely corresponding to the receipt of a commission. Most prominent among the changes is the introduction of a curtained backdrop (reminiscent of the comte d'Artois's bedroom at Bagatelle) and the addition of an impish cupid lurking behind the bed. David added a footstool, an archway, and an urn but neglected to carry over the cast-aside weapons.

The next step in the development of the composition was the execution of a small oil sketch, in which the lavish trappings continued to multiply (cat. 40). Here, David moved away from the severe planarity of his

Fig. 94. Jacques Louis David, *Paris and Helen*, ca. 1785–86. Pen and black ink, brush and gray wash, 8½ × 11⅛ in. (21.5 × 28.1 cm). Present whereabouts unknown

earliest designs, adding a pool in the foreground, with a ewer and box worked in precious metals alongside it, and expanding the depth of the room with the addition of the partially obscured row of columns beyond the curtained wall. The latter is a quotation from the Caryatid Tribune, designed by the sculptor Jean Goujon for the Louvre in the sixteenth century. For David, who typically sought out ancient prototypes, the reference is anachronistic but reflects a revival of interest in Goujon that coincided with the development of the Neoclassical style.[20] Other significant changes from the Getty study include the reappearance of military paraphernalia at left (displacing the cupid), as well as the addition of a perfume censer at right and a red blanket thrown across the bed.

The fact that the sketch functioned primarily as a preparatory study, rather than an autonomous work, is evident in the varied levels of finish throughout. The shadowy areas are thinly painted, while a creamy impasto draws attention to the luminous pair at the center, their delicate skin tones set off by the primary colors of the draperies. If its purpose was, in part, to explore the palette he would use in the final canvas, than it served it well, for David ultimately jettisoned the entire chromatic scheme, transposing virtually every hue with its opposite (Paris's Phrygian cap went from blue to red, the curtain behind him from red to blue, et cetera). On the other hand, the cool, diffuse frontal light of the sketch presages the effect of the finished canvas, and the touches of ochre impasto announce a new focus on gilt ornament and luxe accoutrements. Even twenty years later, Jacques Claude, comte Beugnot, would rhapsodize over his memory of the finished work, calling it "as sweet as the dawn itself."[21]

Illness prevented David from finishing the painting in time for the 1787 Salon, where it would have presented a striking complement to the austere and cerebral *Death of Socrates*. Finally completed the following year, *The Loves of Paris and Helen* (fig. 92), preserves the essence of the oil sketch. Thoroughly researched and scrupulously described, the painting presents antiquity in terms of eroticism and tactile luxury, with sumptuous textiles and elegantly wrought furnishings. The porcelain-like forms

of Paris and Helen, at once languorous and frozen, create a pyramid at the center of the composition. The zither of the preparatory studies has been exchanged for a more curvaceous lyre, and the bodies of the protagonists are further revealed through more transparent drapery. As befitting a patron so devoted to opulence, each object in the room, from quiver to pillow to footstool, is given an exquisite overlay of gilt ornament, and the figural motifs that embellish the surfaces are rife with allusions to love, from Leda and the Swan to the Judgment of Paris to Cupid and Psyche.

The delay that led to the painting not being exhibited until 1789 has undoubtedly colored modern interpretations of the picture. With the Salon of that year coming soon after the storming of the Bastille, it was deemed best to not list the owner, whose involvement in the events leading to the Revolution, as well as his much-derided profligacy and immorality, had led to his being among the first to flee France.[22] Against this backdrop, some have read the picture's "indolent sensuality" as an implicit condemnation of the ancien régime. For Thomas Crow, David's strategy to escape complicity lay in his original plan to juxtapose *Paris and Helen* with *The Death of Socrates*, with the philosopher's stoicism an unspoken rebuke.[23]

Yet, seen through the lens of drawing and process, the commonalities are as striking as the differences. As with *The Death of Socrates*, *Paris and Helen* grew out of an extended sequence of studies, evidence of sustained research, experimentation, and fine-tuning, begun years before the artist could have had foresight of the impending social upheavals. In the tranquility of the nuptial chamber, love is privileged, but not without costs and conflicts. One senses, in the flaccid pose of Helen and the weapons lurking in the shadows, the bittersweet layering of themes integral to Homer's *Iliad*. Their resplendent idyll may be the calm before the storm, but once set in motion, their love will ignite the Trojan War. David, characteristically preferring psychological complexity to the physicality of battle, leaves the violence offstage, just as he had in representing the death of Hector, a later episode in the *Iliad*, through the intimacy of loss in *Andromache Mourning the Death of Hector*.   PS

# THE LICTORS BRINGING BRUTUS THE BODIES OF HIS SONS

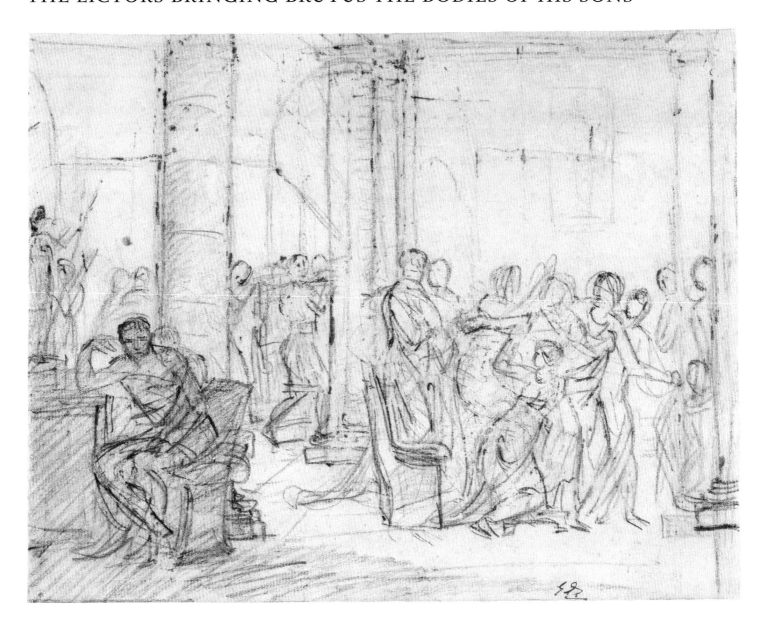

## 41. *The Lictors Bringing Brutus the Bodies of His Sons*

Ca. 1787
Black chalk, touches of brown ink
9⁷⁄₁₆ × 12⅛ in. (23.9 × 30.8 cm)
Marks: lower right, paraph of Eugène David (Lugt 839)
The Metropolitan Museum of Art, New York, Robert Lehman
Collection (1975.1.607)

PROVENANCE: Possibly David estate sale, Paris, April 17, 1826, and
following days; possibly to Eugène David (1784–1830); possibly to
his wife, Anne-Thérèse Chassagnolle (1800–1845); their son Jules

David-Chassagnolle (1829–1886); his wife, née Léonie-Marie de
Neufforge (1837–1893), Annecy; Mme Béraud (grandniece of Mme
Jules David-Chassagnolle); by descent to her grandniece Mme A. H.
Béraud; Galerie Les Tourettes, Basel; acquired by Robert Lehman,
1960; his bequest to the Metropolitan Museum, 1975

REFERENCES: Arlette Sérullaz in Schnapper and Sérullaz 1989, cat. 88,
pp. 203–4; Brettell et al. 2002, no. 1, pp. 2–5; Rosenberg and Prat
2002, vol. 1, no. 92, p. 105

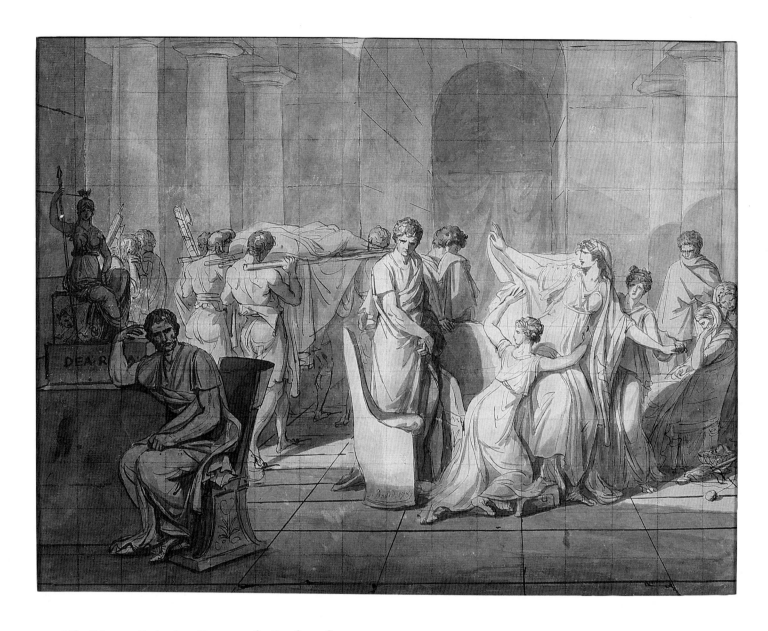

## 42. *The Lictors Bringing Brutus the Bodies of His Sons*

1787
Pen and black ink, brush and gray wash, squared in black chalk
12¼ × 16 in. (31 × 40.7 cm) (sight)
Inscriptions: on the chair at center, in pen and black ink, signed and dated "L. David. 1787"; on the pedestal of the statue, "DEA·R[obscured] A·"
Private collection, France

PROVENANCE: By descent in the family since the late nineteenth century; private collection, France

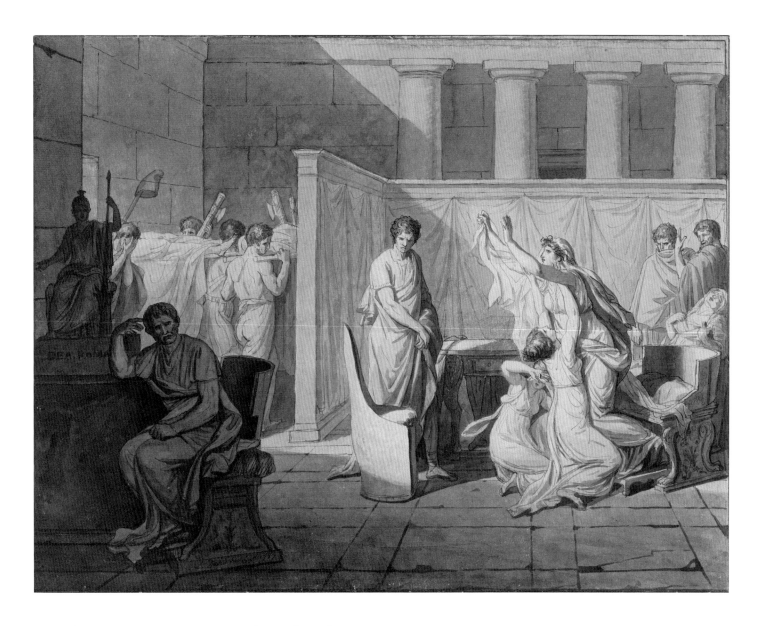

## 43. *The Lictors Bringing Brutus the Bodies of His Sons*

1787
Pen and black ink, brush and gray wash, over black chalk
12⅞ × 16⁹⁄₁₆ in. (32.7 × 42.1 cm)
Inscriptions: on the base of Brutus's chair, in pen and black ink, signed and dated "L. David faciebat 1787"; on the pedestal of the statue, in black ink, "DEA·ROMA"
J. Paul Getty Museum, Los Angeles (84.GA.8)

PROVENANCE: T. C. Bruun-Neergaard (1776–1824); his sale, Paris, August 29, 1814, lot 83; possibly D[emesse] sale, Paris, January 27–30, 1840, lot 77;[1] possibly estate sale of the painter Vauzelle, Paris, March 16–17, 1840, lot 11; possibly M. N. R[evil]; his collection sale, Hôtel de Ventes Mobilières, Paris, March 29–April 2, 1842, lot 67; possibly H. D[reux] sale, Hôtel Drouot, Paris, February 3–4, 1870, lot 27,[2] to Danyand;[3] Paul Mathey (1844–1929), Paris, 1913;[4] art market, Lausanne; acquired by the J. Paul Getty Museum, 1984

REFERENCES: Arlette Sérullaz in Schnapper and Sérullaz 1989, cat. 90, pp. 203, 205; Rosenberg and Prat 2002, vol. 1, no. 95, p. 107; Stein 2009, pp. 221–36, fig. 12

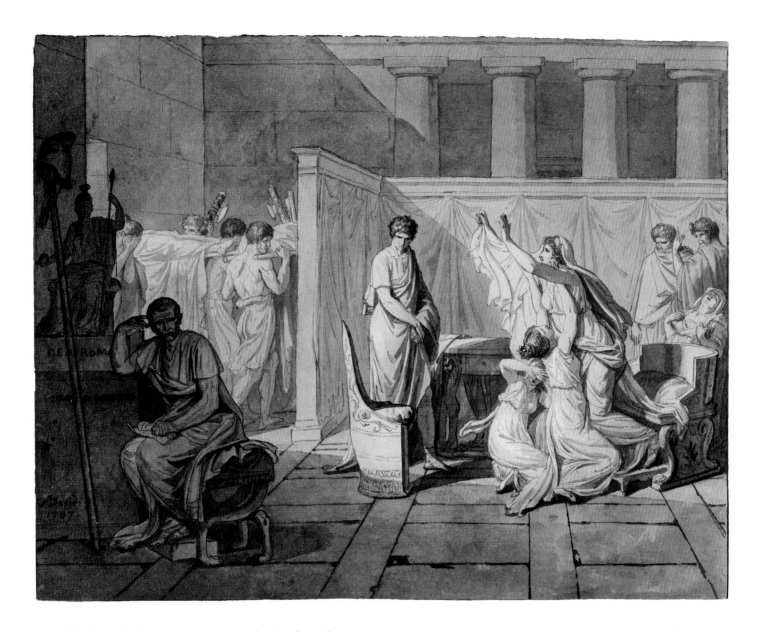

## 44. *The Lictors Bringing Brutus the Bodies of His Sons*

1787
Black chalk, pen and black and brown ink, brush and gray and brown wash, heightened with white gouache
13¹⁄₁₆ × 16⁹⁄₁₆ in. (33.2 × 42.1 cm)
Inscriptions: lower left, in pen and black ink, signed and dated "L David. / 1787."; on the plinth, in pen and black ink, "DEA ROMA," and below it, on the pedestal, in pen and brown ink, "FUGAT[obscured]S. REGIBUS."
The Metropolitan Museum of Art, New York, Purchase, Lila Acheson Wallace Gift, 2006 (2006.264)

PROVENANCE: Possibly D[emesse] sale, Paris, January 27–30, 1840, lot 77;[5] possibly estate sale of the painter Vauzelle, Paris, March 16–17, 1840, lot 11; possibly M. N. R[evil]; his collection sale, Hôtel de Ventes Mobilières, Paris, March 29–April 2, 1842, lot 67; possibly H. D[reux], sale, Hôtel Drouot, Paris, February 3–4, 1870, lot 27, to Danyand;[6] Paul Mathey (1844–1929), Paris, 1913;[7] sale, Delorme Collin du Bocage, Hôtel Drouot, Paris, December 7, 2005, lot 71; purchased by Katrin Bellinger Kunsthandel, Munich; acquired by the Metropolitan Museum, 2006

REFERENCES: Stein 2009, pp. 221–36, fig. 13; Prat 2016a, pp. 297–98, fig. 7

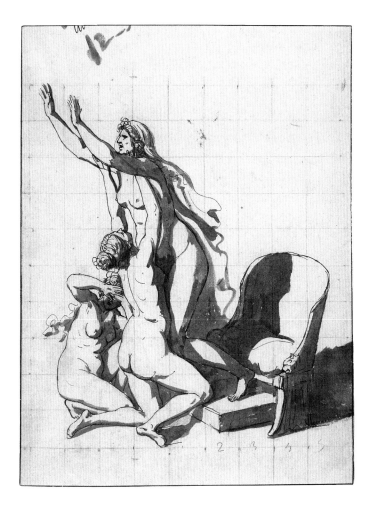

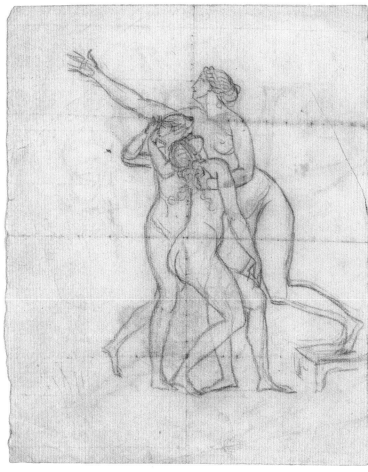

## 45. *The Wife and Daughters of Brutus*

Ca. 1787

Pen and black ink, brush and gray wash, touches of brush and brown wash, squared and (along lower margin) numbered in black chalk

Verso: *A Woman's Head in Profile, Wearing a Hat*

Graphite, traces of brush and gray wash, pen and brown ink

9 9/16 × 7 1/4 in. (24.3 × 18.4 cm)

Musée du Grand Siècle, Saint-Cloud, Département des Hauts-de-Seine, Donation Pierre Rosenberg

PROVENANCE: Anonymous sale, Hôtel Drouot, Paris, December 12–13, 1927, lot 38;[8] art market, Paris, 1991; Pierre Rosenberg, Paris; his gift to the Musée du Grand Siècle, 2020

REFERENCES: Rosenberg and Prat 2002, vol. 1, no. 96, p. 108

## 46. *The Wife and Daughters of Brutus*

Ca. 1788

Red chalk

Verso: *Study of a Male Nude*

Red chalk

9 1/16 × 7 5/16 in. (23 × 18.5 cm)

The Metropolitan Museum of Art, New York, Purchase, Robert Gordon Gift, 2007 (2007.450a, b)

PROVENANCE: Sale, Pierre Bergé & Associés, Brussels, May 23–24, 2007, lot 194; Wildenstein & Co., New York; acquired by the Metropolitan Museum, 2007

REFERENCES: Stein 2009, pp. 229–34, figs. 19, 20; Prat 2016a, pp. 298–99, fig. 8

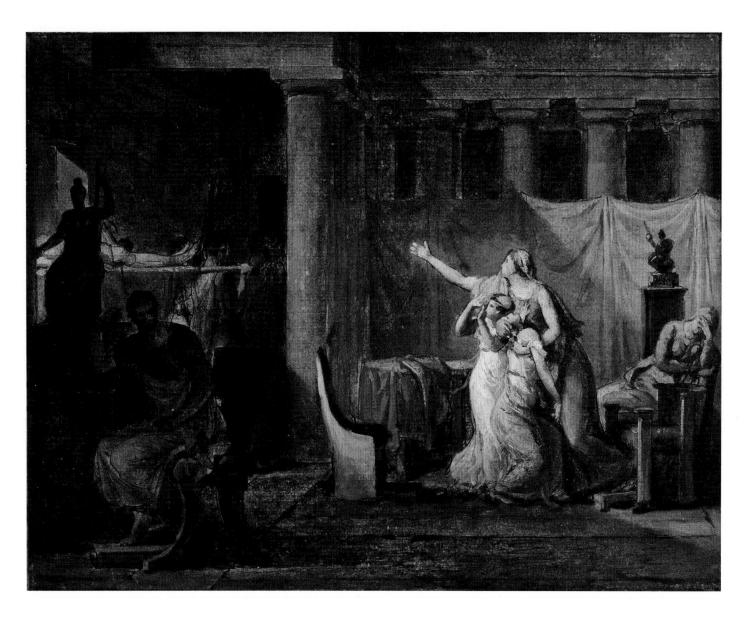

## 47. *The Lictors Bringing Brutus the Bodies of His Sons*

Ca. 1788
Oil over pen and black ink, squared in black chalk, on paper laid down on canvas
10¹³⁄₁₆ × 13¾ in. (27.5 × 35 cm)
Nationalmuseum, Stockholm (NM 2683)

PROVENANCE: Probably A. Didot sale, Constantin, Paris, December 27, 1796, lot 37; Villiers sale, J. B. P. Lebrun, Paris, March 30, 1812, lot 111, to Constantin; Empress Joséphine de Beauharnais; her son, Eugène de Beauharnais, later duc de Leuchtenberg (d. 1824), Munich; by descent in the family, until 1917; John Johnson, Stockholm; his gift to the Nationalmuseum, Stockholm, 1928

REFERENCES: Antoine Schnapper in Schnapper and Sérullaz 1989, cat. 86, pp. 200–201; Bordes 1996, cat. 21, pp. 43, 95; *Jacques-Louis David* 2005, cat. 30, pp. 90–91; Guillaume Faroult in Faroult, Leribault, and Scherf 2010, cat. 130, pp. 390–91

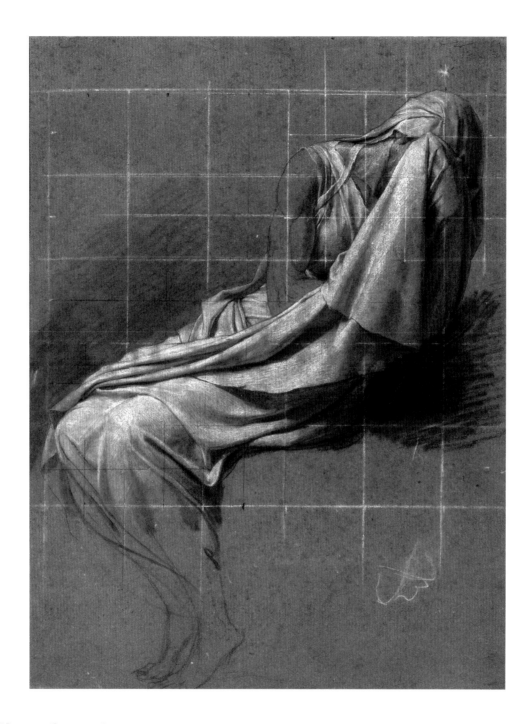

## 48. *Seated Woman Lamenting*

Ca. 1789
Black chalk, stumped, heightened with white chalk, squared in black and white chalk
22⁵⁄₁₆ × 17 in. (56.6 × 43.2 cm)
Musée des Beaux-Arts, Tours (INV. 922-306-3)

PROVENANCE: Presumably David estate sale, Paris, April 17, 1826, and following days, lot 104; Jean-Baptiste Auguste Vinchon (1789–1855);

given by his daughter-in-law Aline Vinchon to the Musée des Beaux-Arts, Tours, 1922

REFERENCES: Arlette Sérullaz in Schnapper and Sérullaz 1989, cat. 91, p. 206; Danielle Oger in Gilet 2001, cat. 27, pp. 100–101; Rosenberg and Prat 2002, vol. 1, no. 98, p. 110; Danielle Oger in Bassani Pacht et al. 2013, cat. 17, pp. 62–64

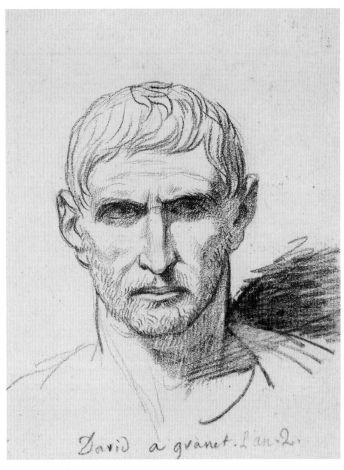

Fig. 95. Jacques Louis David, *Head of Brutus, after the Antique*, ca. 1784–85. Black chalk, 5½ × 4¼ in. (13.9 × 10.9 cm). British Museum, London (2000,0929.11)

*The Lictors Bringing Brutus the Bodies of His Sons* was David's final masterpiece of the ancien régime. His intense exploration of the subject, documented in more than fifteen surviving studies, had already begun in earnest by 1787. Commissioned and paid for by the Crown, the painting went on public view in the Salon of 1789, shortly after the fall of the Bastille, and became an immediate critical triumph. This renown only grew in the years that followed, as both David's painting and the historical figure of Brutus came to embody certain ideals of the revolutionary period. The picture attained a towering cultural stature that did not so much straddle a historical divide as be defined by it. But the shifting nature of the picture's reception and the ideals ascribed to it also cloud our vision of the artist's original intent. Ultimately, its transmutability was an essential feature of its success.

The precise origins of the project are unclear. David's brooding, psychological copy of the Capitoline bust of Brutus (fig. 95),[9] made on his second stay in Rome (1784–85), suggest that he was already intrigued by the subject at the time of the commission. Lucius Junius Brutus, outraged at the rape of Lucretia by a son of the brutal king Tarquin, led the overthrow of the monarchy and founded the first Roman Republic in 509 B.C., becoming one of its first consuls. When it came to light that his own sons, Titus and Tiberius, had conspired to restore the monarchy, he oversaw their punishment by death. This harsh episode, rarely depicted in earlier art, was the subject assigned to sculptors competing for the Prix de Rome in 1785, the year David returned to Paris, having just completed *The Oath of the Horatii* in Rome. The following year, the architect Antoine François Peyre mentioned in a letter to the archbishop-elector of Trier, Clement Wenceslaus, Duke of Saxony, that he had discussed with David a possible commission for a painting of Brutus condemning his sons.[10]

It must have been about the same time, 1785–86, that David made the study today in the Morgan Library and Museum, New York (fig. 96),[11] a sheet of unusually large dimensions on which David used black chalk to broadly sketch his ideas. In an outdoor space bounded by the geometry of classical architecture, executioners lead Brutus's sons to a stone block. One twists from their grip to gaze back imploringly at his father. Brutus is seen seated to the right, on an elevated platform, calm and unflinching, in contrast to Collatinus, his fellow consul, who averts his gaze and covers his face, presaging the pose of the nurse in the finished canvas. It is only this pair that David worked to a higher degree of finish in pen and wash. They would be carried over, in a sense, to the episode he ultimately chose to depict, in which the reactions of these two figures meld into the tortured resolve that marks the artist's later conception of Brutus in his home, receiving the bodies of Titus and Tiberius. As with David's early explorations of the Horatii story, he would gravitate away from the violence itself in favor of the underlying principles and psychological struggle.[12]

David would finally paint his *Brutus* for the king, but the commission followed an unconventional path. In May 1786, the comte d'Angiviller, director of the Bâtiments du Roi, commissioned from him a history

Fig. 96. Jacques Louis David, *The Execution of the Sons of Brutus*, ca. 1785–86. Pen and black ink, brush and gray wash, over black chalk, 16⅜ × 23 in. (41.6 × 58.4 cm). Morgan Library and Museum, New York, Thaw Collection (2010.109)

painting for the 1787 Salon, and the official records show that David suggested two alternate subjects: Coriolanus dissuaded from seeking vengeance against Rome, and the departure of Atilius Regulus for Carthage (see cats. 29–30). The latter subject is crossed out, suggesting that the former had been accepted.[13] A number of factors led to David not meeting this deadline, which was then extended for the Salon of 1789. In a telling indication of his attitude toward the institutions of the Académie Royale and Bâtiments du Roi, which commissioned work on behalf of the king, David had embarked on a new subject, rather than the one agreed upon—in the words of Fernand Engerand, "contrary to accepted practice and on his sole authority."[14] It would appear that the authorities only got wind of the change in 1789,[15] despite dated drawings attesting to the concept's already advanced state of development two years prior.

For the first half of 1787, David was presumably largely occupied with *The Death of Socrates* (cat. 35),

which was submitted late for that year's Salon. The autumn must have seen a flurry of activity around *Brutus*, for several of the highly finished composition studies are dated 1787. In the time since he had made the Morgan drawing, David had clearly decided that, instead of depicting a well-known episode from Brutus's life, he would opt for a more challenging scene without visual precedent, one of his own "pure invention," as he would describe it with pride in the summer of 1789 in a letter to his student Jean-Baptiste Joseph Wicar.[16] In his new composition, the public judgment and execution have occurred, and David conjures the domestic aftermath. Brutus is seated alone, cast in gloom. Behind him, the lictors bear his sons' corpses in a solemn cortege. Across the room, his wife, Vitellia, and daughters enact a tableau of grief and horror. The viewer contemplates the pain of a family riven by the conflict between loyalty to country and to kin, and the emptiness of loss.

The tripartite concept must have been fully formed in David's head before he put chalk to paper, for the earliest sketches contain the core elements of Brutus alone in the left foreground; a more dramatic group of figures, including his wife and daughters to the right; and the lictors carrying the corpses of the sons in the left background.[17] Through a series of rough compositional studies and figure sketches, and regular recourse, no doubt, to the studies of ancient statues in his Roman albums, David begins to flesh out his concept. The solitary figure of Brutus, placed daringly off-center and shrouded in darkness, undergoes a series of minor tweaks, while the grouping around his wife and the ways in which architecture is deployed to reinforce the psychological themes are both subject to broader experimentation.[18] The study in the Robert Lehman Collection at The Met (cat. 41) falls into this early group of *premières pensées*. Worked with speed and urgency, the figures are indicated with rough marks and little elaboration, to try out a general scheme. There are numerous pentimenti (for instance, in the head and shoulders of Brutus) and the indications of architectural elements in the upper part of the sheet are rudimentary, layered, and contradictory. As we saw in The Met's study for *The Death of Socrates* (cat. 32), the sheet reflects a period of time, not a single distinct moment, and retains the evidence of a sequence of ideas. The isolated additions of brown wash indicate, perhaps, a distinct moment of reflection, as the artist used staccato and intermittent touches, not to add detail or contours, but apparently to mark the placement and position of certain elements.

The appearance of a previously unknown drawing in a French private collection (cat. 42),[19] exhibited here for the first time, reveals that David was sufficiently satisfied with the Lehman composition to elaborate it into a fully worked-up compositional study in pen and wash and squaring. The archway and columns of the Lehman sketch are rearranged in a manner reminiscent of the recently completed *Death of Socrates*, with an arched hallway and a vanishing point placed off-center, to draw the eye to Brutus's wife.[20] She raises her shawl in a Niobe-like pose, a gesture emphasizing the futility of her maternal protectiveness.[21] Indicators of movement (the empty chairs, the flow of drapery) suggest the startled horror of her first glimpse of the corpses. Reinforcing this sense of intrusion into the feminine sphere is the detail of the discarded sewing basket on the floor, a single ball of yarn rolling into the foreground. This haunting motif, an expression of the quotidian upended by tragedy (also associated in classical mythology with the three Fates, who controlled human destiny), appears in no other study but does feature in the painting, abandoned and starkly lit atop the table. It is a vignette that exploits the power of the canvas's center, as David had done with the swords in *The Oath of the Horatii* and the goblet in *The Death of Socrates*. In this first wash study, David used a dark gray tone to meld Brutus and the statue of Minerva into a unified *repoussoir*. Her identity as the symbol of Rome is triply reinforced, by the artist's reliance on antique prototypes; by the Latin words "DEA ROMA," for "goddess of Rome," inscribed beneath her; and by the delicately rendered relief of Romulus and Remus, the mythological founders of Rome, suckled by the she-wolf.

Returning to the sequence of previously known studies, it is clear that there were two aspects of the private-collection sheet with which David was not satisfied, despite the fact that it was squared for transfer. One was the disturbing proximity of the headless bodies to the wife and daughters, and the other was the general conception of that figural grouping. For the former, he would reintroduce and experiment with architectural barriers, and for the latter, he began anew, making studies for their poses and relative positions. As was his frequent practice, he began by depicting the figures nude, presumably to ensure that the anatomy and proportions were correct before adding clothing. Such a sheet in the Musée du Grand Siècle, Saint-Cloud (cat. 45), shows the mother in the reverse position: instead of running away from her sons' bodies while twisting to see them, she now lunges out of her chair toward them, both arms raised. She seems oblivious to her daughters, one of whom reaches up for her, while the other, on the floor, twists but shields her eyes. Dark shadows suggest that they are to be placed in a strong light. Squared and numbered in black chalk, the design would have been carried over to another sheet, presumably the lost study known from an 1836 lithograph by Jean-Baptiste Debret, in which the poses are the same, but drapery has been added and the design of the chair changed.[22]

With this new grouping worked out, David now made two further compositional studies both, like cat. 42, dated 1787. The first, acquired by the J. Paul Getty Museum, Los Angeles, in 1984 (cat. 43), shows David's addition of an L-shaped partial wall, which mitigates the uncomfortable proximity of the dead bodies and places a physical divide between political and domestic realms. The standing man with downcast eyes is now alone at the center of the composition, and the group at the right is reconfigured, the two seated women replaced by an older nurse baring her chest in lamentation. In a practice not unusual for the artist, David made another finished compositional study shortly after, with only a few small changes. In that sheet, which came to light in 2005 and was acquired by The Met (cat. 44), the revisions center on the figure of Brutus. He is now seated on a lion-footed stool based on an ancient relief David copied in Rome,[23] and he clenches in his fist a piece of paper, undoubtedly intended to reference the treachery of his sons and his role in their punishment.

After his third, highly finished composition study, David was still not satisfied with his depiction of the mother-daughter group. Brutus's wife, in her all-consuming grief, neither sees nor attends to her daughters. They are physically unified but emotionally unconnected. David's solution, it would appear, came from an ancient relief of Silenus supporting a collapsing maenad.[24] David captured this new idea quickly in red chalk, an unusual medium for him, but perhaps it was all he had at hand when inspiration struck (cat. 46). In a faint like the ancient maenad's, Brutus's daughter is held up only by her mother's strong grip. The second daughter now stands, leaning into her mother, her view of her brothers partially blocked by her own hands. This solution encapsulates the mother's dual role, at once victim and protector. Working in apparent haste, David drew the overlapping figures whole, so they appear ghostly, with the mother's body visible through the daughter's.[25] We know nothing of the early provenance of the sheet, but the paper bears clear signs of having been folded into eighths, perhaps in order to be mailed in a letter.

But did this epiphany immediately follow the Los Angeles and New York drawings? It is entirely possible that David had put the project aside while he completed other pictures (the Lavoisier double portrait; *Paris and Helen*), as Philippe Bordes has suggested,[26] and returned to it, perhaps in 1788. If so, it may have been with a newly heavy heart. He had learned of the death of Jean Germain Drouais, his favorite student, in February of that year. The two had worked closely together in 1784–85 when David was in Rome to complete his *Oath of the Horatii*. David was strongly affected by Drouais's passing and lamented that he had "lost his emulation."[27] It is hard to imagine that the event did not color his relationship with the story of Brutus, the bereaved father. Beyond the resonance of a "father" losing a "son," the structure of Brutus's family, as David chose to depict it on canvas, with two older sons and two younger daughters, mirrored that of his own household. Indeed, the mirroring went in both directions, for at the same time that he was painting the *Brutus*, David was commissioning luxury reproductions of ancient Roman chairs from the *ebéniste* Georges Jacob.[28]

If there was, in fact, a hiatus following the extended exploration of 1787, then The Met's red chalk figure study and the subsequent drawings that incorporate these poses presumably would date to 1788. A quick black chalk composition study in the Musée Toulouse-Lautrec, Albi, moves the central male servant to the background, giving space to the newly powerful pose of Brutus's wife,[29] while the next study in the overall sequence, an oil sketch in the Nationalmuseum, Stockholm (cat. 47), omits him entirely. This sketch is a hybrid object, begun as a vigorous pen-and-ink drawing on paper, with dabs of colored oil paint added sparingly throughout, allowing the penwork and areas of black chalk squaring to remain visible. As with the colored sketch he made for the *Horatii* (cat. 22), the Stockholm sketch is thoroughly embedded in David's preparatory process; in it, he continued to refine the composition while at the same time exploring the potential impact of color choices.

Small in scale and radically pared down in its cast of characters, the sketch is perhaps David's darkest vision of the subject yet. Contrary to his normal practice of moving the most graphic violence offstage as he progressed toward his final composition, he here inserts the gruesome detail of the lictors holding aloft pikes bearing the heads of the two sons. As if to balance this ratcheted-up horror, he bathes the female figures in light from an unseen clerestory window, pulling the viewer's gaze to

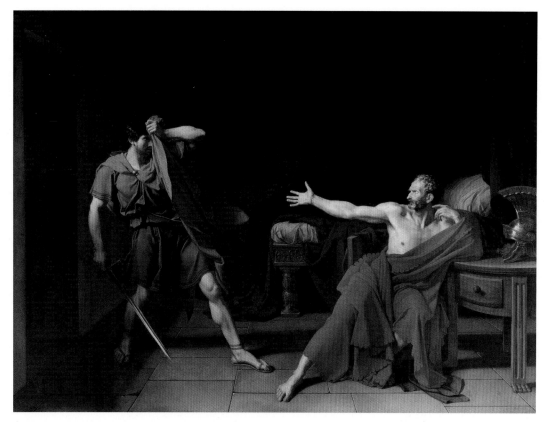

Fig. 97. Jean Germain Drouais (1763–1788), *Marius at Minturnae*, 1786. Oil on canvas, 106¾ × 143¾ in. (271 × 365 cm). Musée du Louvre, Paris (INV. 4143)

the illuminated bare arm of the mother. Her hand alone occupies the center of the composition, no longer lifting drapery but in an open-palmed gesture of plaintive rhetorical force. In choosing to orchestrate his scene around this focal point, David was also inserting a clear homage to his former student Drouais, whose *Marius at Minturnae* (fig. 97) had been designed in close consultation with his teacher (via correspondence) and exhibited in Paris to great acclaim in 1786.[30] It was an homage tinged with loss, however, as Marius's hand could halt death, while Brutus's wife's could only lament it.

Having thus stripped away many of the nonessential figures, David neared his final resolution. The only changes from the oil sketch in Stockholm to the finished canvas (fig. 98) were the subtraction of the heads on pikes and the statue behind the nurse and the reappearance of the sewing basket. There presumably exist additional drawings that have not come down to us. Likely, he would have made a finished compositional study in

ink and wash, comparable to the Los Angeles and New York drawings, as well as detailed drapery studies for each of the major figures or figural groups, as there are for *The Oath of the Horatii* and *The Death of Socrates*. In the case of the *Brutus*, only a single drapery study is known, that for the nurse, in the Musée des Beaux-Arts, Tours (cat. 48). With only her neck and upper arm exposed, her grief finds expression primarily through the arrangement of the drapery in which she hides her averted face. The beauty of the execution was less intentional than a function of the sheet's utility. Characteristically, David completed only those areas that would be visible in the painting, thus leaving her lower legs and feet only lightly sketched. The method of squaring, too, is idiosyncratic, with large squares over the part of the sheet he needed to transfer, and those squares divided into four smaller quadrants where the forms were most complex. He switched between black and white chalk as needed to ensure visibility of the lines.

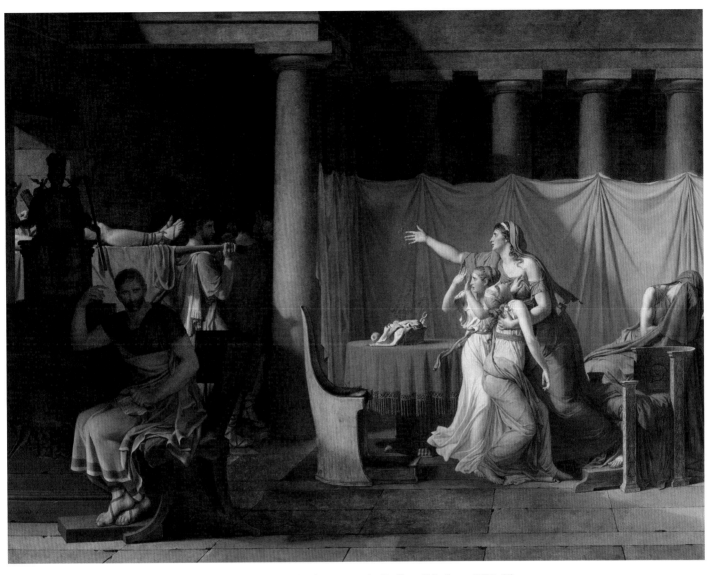

Fig. 98. Jacques Louis David, *The Lictors Bringing Brutus the Bodies of His Sons,* 1789. Oil on canvas, 127 × 166 in. (323 × 422 cm). Musée du Louvre, Paris (INV. 3693)

The nurse's restrained grief in the Tours study contrasts with her declamatory body language in the Los Angeles and New York drawings, where she bares her chest and tilts her head heavenward. She first appeared in this new pose in the Stockholm sketch, where she holds her hand over her face (in the Tours study, the hand is hidden behind drapery). The source can be found in one of David's sketches after (or inspired by) the antique that came to light in 2016 (fig. 99),[31] confirming that, at every stage of preparation, he returned to his Roman albums for inspiration. In this

case, annotations in the artist's hand across the top of the sheet, though not fully legible, indicate that he was thinking about the Brutus composition.[32] As late as June 1789, David was writing to Wicar in Florence, asking him to find an antique prototype for the hairstyle of Brutus's younger daughter and to send him a sketch.[33] The painting finally went on view as a late addition to the Salon in September of that year, and David wrote again to Wicar to report that he was "covered with praises," and that "[t]hey praise principally the conception (*la pensée*) and especially placing [Brutus]

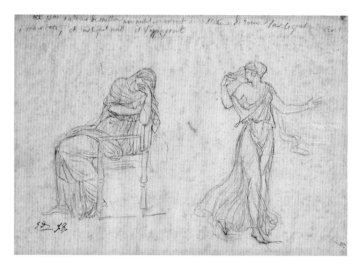

Fig. 99. Jacques Louis David, *Two Female Figures*, ca. 1775–80? Black chalk, 8¼ × 11¾ in. (21 × 30 cm). Present whereabouts unknown

in the shadow."[34] Indeed, much of the published Salon criticism highlights in particular the bold originality of placing the isolated protagonist in darkness, his agony and resolve playing out across his features.[35] David's letter to Wicar had described Brutus as a "man and father," acknowledging by this phrasing the inherent conflict in Brutus's public and domestic roles.[36]

The initial public display of *Brutus* in the final years of the ancien régime marked only the opening chapter in the reception of the painting, which went on to assume a cultlike status in the years that followed. Like two lines converging, the epochal shift in French politics from monarchy to republic by means of revolution all conferred a retroactive prescience on David's painting. When the picture was exhibited a second time, along with other of David's pre-revolutionary masterpieces, in the very different atmosphere of the Salon of 1791, this point was explicitly made by Charles Villette, a writer and supporter of Voltaire, who wrote in his critique that "burning patriotism directed [David's] thoughts long before the Revolution."[37]

As numerous scholars have demonstrated, the image of Brutus became ubiquitous during the revolutionary period, embodying the ideals of moral rectitude and civic virtue, only gradually fading from view following the fall of Robespierre.[38] Brutus, as a loyal patriot but also a filicide, was a complex hero, suited to unsettled times. No one would have been more attuned to Brutus's

metamorphosis from conflicted hero to revered emblem of the Revolution than David himself.

Physical evidence suggests that David may even have altered some of his pre-revolutionary studies to better align with post-revolutionary sentiment. As Bordes first suggested in 1996, the Phrygian cap born by lictors in the background of the Getty sheet (cat. 43) appears to have been added later, as the masonry of the wall is visible through it. Similarly, when The Met's version (cat. 44) came to light, John Goodman pointed out that the same may have been the case with both the Phrygian cap on the pole leaning against the wall at left, the word "liberté" inscribed in cursive on its strap, and the inscription on the plinth, "FUGAT . . . S. REGIBUS" (after the kings have fled).[39] These elements, presumably added to his 1787 studies after Louis XVI's flight to Varennes in June 1791, suggest that David sought to inflect his drawings with revolutionary meaning, retroactively adapting them to the changed political climate. David's revisionism speaks not only to Brutus's chameleon-like symbolism in a period when patriotism was subject to constant redefinition, but also to the semipublic role of drawings within David's circle, where they would have been seen and appreciated by many, and where their role clearly extended beyond their preparatory function.

These reworkings might also be viewed as a personal commentary. David, like the quasi-mythical figure of Brutus, had seen his star rise along with that of the Jacobins. As a member of the Committee of Public Safety during the Terror, presiding over executions in service to the young French Republic, might David have identified with the grim, but newly sympathetic, first consul of the Roman Republic? It is telling, perhaps, that in Year II of the revolutionary calendar (probably 1794), he inscribed the study he had made a decade earlier of the Capitoline Brutus as a gift to a fellow member of the National Convention, François Omer Granet.[40] While it remains difficult to judge how prescient David's 1787 conception of *Brutus* was, his later additions to his compositional studies, presumably made between the summers of 1791 and 1794, make clear how closely aligned to contemporary events he felt the subject to be during the revolutionary years, and how he wanted others to view it through that lens, as well.   PS

# Navigating the Revolution, 1789–99

Well established with a large studio, and having enjoyed consecutive successes at the Salons of 1785 and 1787 with, respectively, *The Oath of the Horatii* (Musée du Louvre, Paris; see fig. 75) and *The Death of Socrates* (cat. 35), David was among the foremost painters of the French school at the start of a decade of profound change. Rather than resting on his laurels, however, David deployed his reputation and skills throughout the revolutionary era in the service of certain political and ideological tenets. He did not seek simply to depict the Revolution but, through his artistic output, to animate his fellow citizens.

The revolutionary decade saw an extreme shift in the power dynamics and social structures of French society, with a transfer of authority from an aristocracy that had largely inherited its privileges to a bourgeoisie that had previously been afforded no political capital. During the first phase of the Revolution, reform was the goal. Several years of turmoil regarding the government's insolvency as a result of King Louis XVI's extravagant spending came to a head at a series of meetings in May and June 1789 of the Estates General, an assembly of representatives from each class of French subjects, namely the nobility, clergy, and middle class—or, the First, Second, and Third Estates. Clashes during these meetings led representatives of the Third Estate to organize a National Assembly, aimed at mobilizing support for equal representation for the middle class. The group convened at the tennis court of Versailles on June 20, 1789, vowing to remain in session until a constitution was drafted and reform had been achieved. Within a week, representatives of the clergy and forty-seven liberal nobles had joined them. Known as the Tennis Court Oath, their gesture signaled a fundamental change in the form of government: the formerly absolute monarch would now be kept in check by a constitution, creating a forum for the concerns of commoners.

While the newly formed National Assembly drafted a constitution at Versailles, Paris descended into chaos amid the breakdown of royal power. In an attempt to restore order, Louis XVI deployed troops to Paris, stoking fears of a military coup. In search of ammunition and weapons to fight the royal troops, popular insurgents stormed the infamous Bastille prison on July 14, 1789. Several weeks later, the assembly adopted the Declaration of the Rights of Man and of the Citizen, which granted universal rights for all men and abolished the feudal system. Despite proclaiming the assembly's commitment to replace the former regime with a system based on freedom of speech, popular sovereignty, a representative government, and equal opportunity, the declaration notably excluded women and enslaved peoples.

After a tumultuous few months, the Salon opened in late August where, according to its *livret*, only two exhibited works explicitly addressed the events of the Revolution: a sketch of the first meeting of the Estates General by Louis Durameau (now lost) and Hubert Robert's *The Bastille in the First Days of Its Demolition* (Musée Carnavalet, Paris), which focused on the dismantlement of the emblematic building that followed its storming, not the revolutionary act itself. David exhibited two important history paintings, *The Loves of Paris and Helen* and *The Lictors Bringing Brutus the Bodies of His Sons* (both Musée du Louvre; see figs. 92, 98). Although planned before the events of the Revolution took place and representing a scene from antiquity rather than a recent event, the *Brutus* was immediately understood by Salon visitors to relay a symbolic revolutionary message, owing to the politically charged moment of its display.

Out of caution, David's large-scale portrait of the scientist Antoine Laurent Lavoisier and his wife, Marie Anne, dated 1788 (The Metropolitan Museum of Art, New York), was removed from the Salon prior to its opening at the direction of the arts minister, the comte d'Angiviller. Lavoisier, director of the gunpowder and saltpeter administration at the time, had relocated stores of gunpowder in early August 1789. This move was

perceived as withholding the precious product from the people and had caused a riot. The removal of Lavoisier's potentially controversial portrait from the Salon was just one way that the politically fraught moment impacted the arts.

Many artists struggled to represent contemporary events, as their enduring implications were still unclear. At times, painters used allegorical subjects or ones taken from antiquity or mythology that could be inflected with political meaning. While in Nantes in 1790 to paint a commissioned portrait of the mayor, C. C. Danyel de Kervégan, David explored this approach in preparatory studies for a complex revolutionary scene that fused the contemporary setting of Nantes with allegorical figures (cat. 49). (Neither the portrait nor the allegorical painting was ultimately realized.) Upon his return to Paris, David accepted a number of portrait commissions, developing a sort of formula by repeatedly positioning his subjects seated in three-quarters view in front of a tonal background.[1] The loose and gestural paint handling of these portraits differs dramatically from that in David's earlier work, which has led many scholars to assume that they are unfinished, victims of history's vicissitudes. In fact, David was likely experimenting with a deliberately sketchlike style that had particular relevance for the contemporary moment, as seen in his first self-portrait (ca. 1790–91; Gallerie degli Uffizi, Florence).[2]

During the protracted process of drafting a constitution, several factions battled for power both within and outside the National Assembly. The Jacobin Club was one such group that argued for "extreme egalitarianism." Its membership included deputies from various departments across France, as well as others committed to protecting the Revolution's gains from possible aristocratic retaliation. By July 1790 the Society of Jacobins boasted 152 affiliate clubs across France and 1,200 members in its Parisian club, among them David and most of the major figures of the Revolution. In October 1790 Edmond Dubois-Crancé, a Jacobin deputy and close friend of David, put forward a proposition—edited by the artist himself—that the Tennis Court Oath be commemorated in a large-scale canvas. He suggested that the commission go to the "author of the *Brutus* and the *Horatii*, that French patriot whose genius anticipated the Revolution."[3] By undertaking the commission for *The Oath of the Tennis Court*,

David established himself as the artist of the Revolution. He also interceded to align the Académie Royale with Jacobin values by arguing for reforms to its program and structure that ultimately led to the Académie's dissolution in 1793. Notably, David helped establish the Commune des Arts Qui Ont le Dessin pour Base, a society of three hundred artists who sought to open the biennial Salon to all artists, rather than just academicians, and to establish open competitions for royal commissions. The Salon of 1791 was the first to be opened to non-academicians and academicians alike, and more than double the usual number of works were exhibited, among them David's drawing for *The Oath of the Tennis Court* (cat. 53). It was displayed below his *The Oath of the Horatii*, underscoring the connection between the virtuous heroes of antiquity and their contemporary counterparts.

Amid these and other reforms, two major political factions emerged, first among the Jacobins, and then across French society. Deputies of the more moderate of the two groups, known as the Girondins because many came from the Gironde, in the southwest, dominated the National Assembly and its subsequent governing body until June 1793. Professing an ideology of personal liberty, meritocracy, republicanism, and abolitionism, they advocated for a national government representative of all citizens. On the other hand, the Montagnards ("mountain people"), so called because they occupied the higher benches in both the Jacobin Club and the national legislature, were known for their democratic outlook. Seen as more radical in their thinking, the Montagnards drew most of their support from the capital; twenty-one of the twenty-four Parisian deputies sat (and voted) with the Montagnard faction.

The constitution adopted in September 1791 reflected moderate Girondin values and established a constitutional monarchy that allowed Louis XVI to retain many royal privileges. Such leniency was unacceptable to the Montagnards, particularly after the events of June 20, 1791, when the king abandoned Paris and fled to Varennes. Moreover, upon his capture, it was discovered that Louis intended to rescind his vow to uphold the constitution. Still, in early 1792, David made sketches for a potential portrait of Louis XVI showing the constitution to the dauphin.[4] Such a commission attests to the continued viability of a role for the monarch, a

role that would become increasingly perfunctory as the Montagnards gained power.

Increasing domestic unrest coupled with international wars (against Austria and Prussia in 1792, and England, Holland, and Spain in 1793) undermined Girondin authority. Months of violence and frustration culminated on August 10, 1792, when insurrectionists stormed the Tuileries Palace, suspended the monarchy, and took the royal family hostage. Aligned with the Montagnards, David was one of the new deputies elected to a reorganized governing body, known as the National Convention. On September 22, 1792, the Republic was proclaimed. Shortly thereafter, Louis XVI was put on trial, and on January 20, 1793, he was condemned to death by a majority vote of the deputies, David among them. The foundation of the Republic was a pivotal moment in French history and was recognized as such by contemporaries. In fact, the declaration of the Republic was the point of origin for a new calendar system, implemented in October 1793, that marked the so-called Years of Liberty.[5]

David became increasingly involved in politics during the second, more militant phase of the Revolution, even as many of his activities remained tied to the realm of the arts. In August 1793, David gave an impassioned speech condemning the institution of the Académie as elitist, hierarchical, and undemocratic—untenable values in the new regime. This intervention was the final pronouncement in advance of a vote that suspended all academies. Following the establishment of the Republic, David was elected first to the National Convention's Committee of General Security, a policing organization that sent many to the guillotine, and then to the Committee of Public Instruction, which was responsible for social and educational reforms. These prestigious committees reported to the Committee of Public Safety, which was established in 1793 and evolved into a dominant group of about a dozen men with full executive power. In these and other roles, David was responsible for organizing elaborate public festivals that animated the rhetoric and values of the Republic.[6] He consulted on institutional projects such as the Musée du Louvre, which opened its doors to the public in 1793, and the Musée des Monuments Français, which opened in 1795. Additionally, David was instrumental in the reorganiza-

tion of the 1793 Salon, a guide to which opened with the words, "The forms of the arts, like the political system, must change," signaling that art and politics were fundamentally intertwined.[7]

Following the murder of the deputy Louis Michel Le Peletier de Saint-Fargeau, killed for voting for the king's death, David was charged with organizing an elaborate funeral procession and painting an effigy. He presented a portrait of Le Peletier (now lost) to the National Convention in March 1793, accompanied by a discourse on the importance of civic-mindedness. A few months later, when the journalist Jean Paul Marat was assassinated (see cat. 54), David was similarly charged with organizing an opportunity for the people to mourn Marat and asked to paint a commemorative portrait of his friend and fellow deputy. Conceived as pendants, the two paintings were intended to hang above the tribunal at the National Convention. Upon completing *Marat at His Last Breath* (Musées Royaux des Beaux-Arts de Belgique, Brussels; see fig. 111), David requested permission to display the two paintings side by side for fifteen days at the Louvre, where the public could admire them. One visitor noted that "the forceful and skilled touch of an artist would have been insufficient; these works needed the ardent love of country that impassions that artist."[8] The display of these martyrs of the Revolution opened to the public on October 16, 1793, in the afternoon following Queen Marie Antoinette's execution by guillotine. In so doing, David offered citizens an immediate replacement for an iconic figure and reiterated the revolutionary ideals that he and his fellow deputies sought to elevate.

David continued to further his sociopolitical agendas through art: by orchestrating an artistic competition—known as the Concours de l'An II—aimed at inspiring patriotism; by designing costumes for various official posts of the new Republic (see cats. 56–57); and by creating political caricatures, primarily satirizing the English, with whom France was at war (see fig. 41). In these ways, much of David's work was part of the propaganda machine of a progressively unequivocal ideology as increasingly radical Montagnards consolidated power. The Committee of Public Safety, headed by David's friend Maximilien Robespierre, implemented increasingly draconian policies that allowed them to eliminate their political adversaries. Known as the Reign of Terror,

Fig. 100. Jacques Louis David, *The Death of Joseph Bara*, 1794. Oil on canvas, 47¼ × 61¹³⁄₁₆ in. (120 × 157 cm). Musée Calvet, Avignon (INV.146)

in the Hôtel des Fermes and then in the Luxembourg prison for five months, presumably awaiting execution. He penned a fervent self-defense to be read aloud at the National Convention emphasizing his role as an artist rather than a politician. David's requests, and pleas on his behalf by his many students, were ignored.

Shortly after his imprisonment, David asked that a student bring him paints, an easel, canvases, chalks, paper, books, and a mirror, so he could distract himself. Among the works he created was a self-portrait in which he represents himself as an artist, palette in hand (fig. 101). His direct gaze almost challenges the viewer, and contrasts with his disheveled appearance. By emphasizing his exclusive role as an artist rather than a political persona, David sought to exculpate himself from the accusations leveled against him. He also produced many drawings during his time in prison, gravitating toward subjects that reflected his condition, such as the outcast figure of Homer.[10]

On December 27, 1794, David was released, owing to the intervention of a well-positioned Montagnard (who had turned on Robespierre), François Boissy d'Anglas, and of his brother-in-law Pierre Sériziat, who interceded at the request of David's wife. This was somewhat unexpected, since the couple had separated in 1790 and formally divorced in 1793.[11] Nevertheless, Madame David took a keen interest in securing David's release, avoiding his seemingly imminent execution, and reestablishing his position as a prominent artist; the couple ultimately reunited in 1796. In gratitude for their intervention, David began paired portraits of Sériziat and his wife, Emilie, shown with their son, depicting them all in the latest fashion (both Musée du Louvre). David exhibited them at the Salon of 1795 as a way of advertising his prowess as a portraitist, which contributed to subsequent high-profile commissions. Notably, David did not exhibit at the Salon again until 1808.

Arrested for a second time on May 28, 1795, under renewed charges, David spent just over two months (until August 4, 1795) in the Collège des Quatre-Nations prison along with several other disgraced Jacobins. In a direct effort to exculpate himself in the eyes of the public, David wrote a "response" refuting the charges, which he had printed and posted around Paris. He claimed that the accusations were motivated by

this period was marked by mistrust, fear, betrayal, and great bloodshed; it is estimated that over three hundred thousand people were arrested and over fifteen thousand sentenced to death in just under a year.

While David was not a member of the Committee of Public Safety, his political responsibilities supported its work in various ways. In July 1794, for instance, he choreographed a pantheonization ceremony for Joseph Bara and Joseph Agricol Viala. These two child martyrs had been elevated from anonymity by Robespierre in an attempt to inspire citizens to willingly sacrifice for the nascent French Republic. As part of this project, David painted his most enigmatic canvas, *The Death of Joseph Bara* (fig. 100).[9] The project was abruptly aborted when Robespierre was overthrown on July 27, 1794, or the 9th of Thermidor, Year II, according to the new calendar system. Members of the National Convention and the public turned against Robespierre's uncompromising, dogmatic vision for France's future and his indifference to the human costs of achieving it. Robespierre's execution the following day ushered in a period known as the Thermidorian Reaction. Popular and even royalist revolts took place, and radical revolutionaries were marginalized, oftentimes violently. The Jacobin Club was closed, and many of Robespierre's fellow deputies, friends, and supporters—including David—were imprisoned. Arrested on August 2, 1794, David was detained first

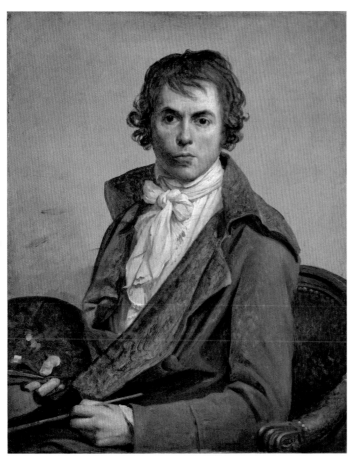

Fig. 101. Jacques Louis David, *Self-Portrait*, ca. 1794–95. Oil on canvas, 32 × 52 in. (81 × 64 cm). Musée du Louvre, Paris (INV. 3705)

this oligarchical reorganization, but their protests were silenced by the military, led by the young, successful general Napoleon Bonaparte. Bonaparte's star continued to rise through France's various military campaigns abroad during this period. In 1797 David met the lauded military hero and sketched his portrait in the hopes of a larger commission, which came shortly after Bonaparte overthrew the Directory on November 9, 1799, declaring himself first consul.

After his release from prison in 1795, David focused on his work as he sought to consolidate his professional position. He concentrated his efforts on a major canvas, which had already been on his mind during his first incarceration, selecting a classical Roman subject but drawing on ancient Greece for its aesthetics. In *The Intervention of the Sabine Women*, David explored the Directory's guiding principle of reconciliation (see cats. 64–66). He exhibited this large canvas in 1799, not at the Salon but in an installation nearby that sought to be an immersive experience, akin to those popular in England. To achieve this, David positioned a mirror across from the canvas, visually incorporating visitors into the scene. The painting remained installed until 1805. By that time France had ceased to be a Consulate and had become an Empire, led by the military hero Bonaparte turned Emperor Napoleon. David had tied his fortunes to this new leader.   DB

professional jealousies—again reiterating his role as an artist. As during his first prison term, David continued to work, exploring subjects that resonated with his own condition of victimhood or that responded to the pervading sentiment of regeneration and reconciliation. Especially notable were the medallion portraits that represented his fellow prisoners with dignity and empathy (cats. 58–63).

In late October 1795, the National Convention disbanded, having approved a new constitution and a new form of government, the Directory. Composed of five members who wielded executive power, the Directory was advised by two assemblies: the Council of Five Hundred and the Council of Ancients. This parliament would appoint the five directors. In an effort to promote internal cooperation, the Directory issued amnesty for all previous actions, thus allowing former political figures a fresh start. Both royalists and Jacobins objected to

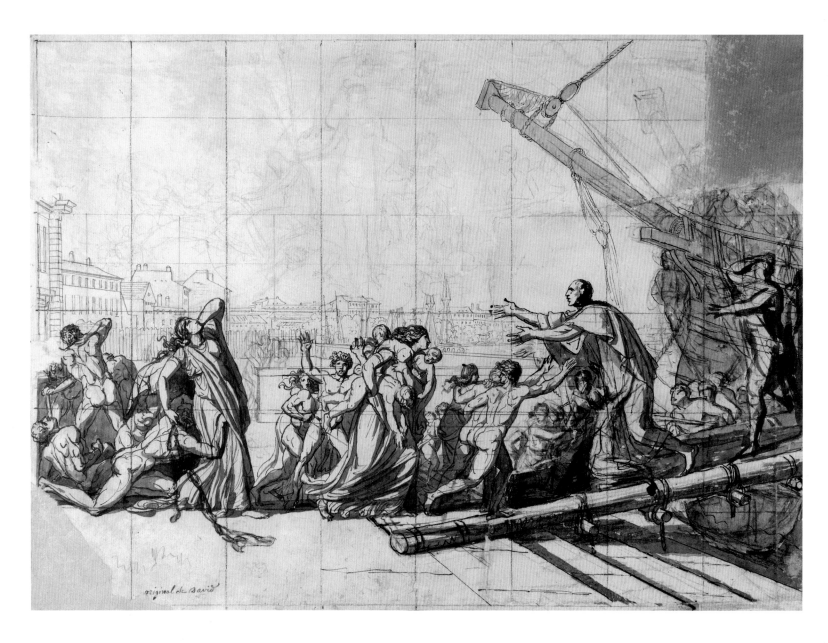

## 49. *Allegory of the Revolution in Nantes*

Ca. 1789–90
Pen and black ink, brush and gray wash, graphite, squared in graphite, on two joined and partially overlapping pieces of paper, with filled-in areas at the upper right and lower left corners
12 × 17¼ in. (30.4 × 43.9 cm)
Inscriptions: lower left, in pen and brown ink, in another hand, "original de David"; lower right, on an affixed fragment, in pen and brown ink, in another hand, "original / de / David"; on the verso, in graphite, "un sceptre de fer à la main / le despotisme Porté sur un pavois par l'envie / le préjugé / la Superstition fuyant à l'aspect de la Raison / représenté / par une seule figure ayant à elle seule / l'attribut /

les [corrected to des] 3 pouvoirs. La legislation par les ta[bles] / de la loix et le Stilet. Le pouvoir exécutif par la glaive le pouvoir judic[iaire] / par la Balance"[1]
Musée d'Arts de Nantes (11.2.1.D)

PROVENANCE: Galerie de Bayser, Paris, 2010; acquired by the Musée d'Arts de Nantes, 2011

REFERENCES: J. L. J. David 1880, p. 665; Bordes 1983, p. 30; Cosneau 1983, pp. 258, 263 n. 34; Prat 2016b, pp. 109–17, esp. pp. 111–12, 224 fig. 9

In June 2009, L'Institut National d'Histoire de l'Art (INHA) organized a symposium in memory of Antoine Schnapper, one of the most knowledgable of David scholars. My presentation, entitled "Additions to the Corpus of Drawings by David, I," concerned several sheets that had surfaced since the publication in 2002 of the catalogue raisonné of the artist's drawings, written by Pierre Rosenberg and myself. I concluded my remarks by emphasizing that such a catalogue could not be definitive but, rather, should be regarded as a work in progress, since additional drawings by so prolific a draftsman were sure to reappear. Events soon justified this statement, for precisely one year later, a Parisian gallery revealed the existence of a previously unknown drawing judiciously acquired by the Musée des Beaux-Arts in Nantes in 2011.

The reappearance of this important sheet was not a surprise, for several documents allude to it. Early publications by Camille Mellinet (1836) and Charles Saunier (1903), as well as a more recent article by Claude Cosneau (1983), have made it possible to clarify thorny questions surrounding the works that David, an ardent revolutionary at the time, had conceived and/or realized during his sojourn in Nantes in March and April 1790.[2] In 2002, my co-author and I posited a connection between certain drawing sheets and several folios in Louvre sketchbook (carnet) 4 with a projected *Allegory of the Revolution in Nantes*.[3] It is known that David began to develop such a composition in December 1789, before his visit to the city, for in a letter written to the Nantes architect Mathurin Crucy on December 9, he describes it as an evocation of a "France ripped apart by abuses," placing itself under the protection of the people of Brittany and "their mayor."[4] We also noted the presence in the former Chennevières collection of a drawing representing "The Aristocracy Pursuing Families of the Persecuted." The sheet is lost to view but known from articles written by Philippe de Chennevières about his collection, published in *L'Artiste* between 1894 and 1897, in which he even suggests that some of the drawings now understood to be connected with the Nantes project might pertain to this other composition.[5] Finally, the autograph inscription on the back of the present drawing lays out a third conception, one in which Despotism and Superstition are pursued by Reason and personifications of the three

powers—Executive, Legislative, and Judicial. Here, we are not far from a subject that David developed in two celebrated drawings that date from much later, between April and July 1794, representing *The Triumph of the French People* (see cat. 55).[6]

The Nantes drawing depicts a subject distinct from the others elaborated by David during the revolutionary moment, even if it, too, combines themes related to the deliverance from social slavery (and the chains symbolic of it): justice belatedly delivered, and what we might characterize as "consensus regained" in the face of the abuses of absolute power. Nonetheless, it is clear that several of the drawings in the Louvre sketchbook depict figures that have almost identical analogues in our Nantes drawing.[7] One depicting a nude male figure seen from behind (fig. 102) is after Michelangelo's *Conversion of Saint Paul* in the Pauline Chapel at the Vatican, though here it is copied by way of a reproductive print, and therefore reversed.[8] Shorn of clothing, the figure was incorporated, without alteration, at the far left of the Nantes drawing. David inscribed the sheet, "for the vigorous man who drinks the blood of a weakened laborer" ("faire le / fort qui / s'abreuve / du sang du / faible / d'un laboureur"), a sentiment clearly pertaining to the exploitation of the poor by the powerful, and a theme obviously related to those mentioned above.

On the verso of the same sketchbook folio, a nude woman holding chains in her right hand (fig. 103) is closely connected to the tall female figure at left in the Nantes drawing, now clothed but with her head similarly thrown back.[9] Perhaps also related to this figure is the drawing of a head on the recto of folio 6 (fig. 104).[10] Other pertinent studies in the same sketchbook include three running figures on folio 7 (fig. 105), who reappear in the Nantes composition, rushing toward the monumental figure disembarking from the ship;[11] and four male figures with upraised arms on the rectos and versos of folios 9, 10, and 11,[12] which seem to explore the pose of the nude man facing front with his right arm raised in the center middle ground of the Nantes sheet. The two children on folio 12 (fig. 106),[13] based on a figure in a print by Giorgio Ghisi after Giulio Romano's *Mocking of the Prisoners*, reappear just behind the running trio derived from folio 7. The monumental figure extending his arms in a gesture

Fig. 102. Jacques Louis David, *Figure of a Man, Seen from Behind, after Michelangelo*, ca. 1789–90. Black chalk, 7⅛ × 4½ in. (18.2 × 11.3 cm). Musée du Louvre, Paris (RF 36942, fol. 8 recto)

Fig. 103. Jacques Louis David, *Nude Woman, Holding a Chain*, ca. 1789–90. Black chalk, 7⅛ × 4½ in. (18.2 × 11.3 cm). Musée du Louvre, Paris (RF 36942, fol. 8 verso)

Fig. 104. Jacques Louis David, *Head of a Woman with Loose Hair and a Striding Figure*, ca. 1789–90. Black chalk, 7⅛ × 4½ in. (18.2 × 11.3 cm). Musée du Louvre, Paris (RF 36942, fol. 6 recto)

Fig. 105. Jacques Louis David, *Two Men and a Woman Running Toward the Right*, ca. 1789–90. Back chalk, 7⅛ × 4½ in. (18.2 × 11.3 cm). Musée du Louvre, Paris (RF 36942, fol. 7 recto)

of welcome was revised by the artist, who pasted a new piece of paper over the right-hand portion of the composition, leaving the hand of the earlier pose partially visible.[14] The ship from which he disembarks probably derives from the drawing of a docked vessel on folio 14 of the Louvre sketchbook,[15] though here David made it loom larger and recede more sharply. Finally, it seems likely that the nude male figures shown gesticulating and supporting one another on loose sheets now in the Musée Calvet in Avignon and the Pushkin State Museum of Fine Arts in Moscow also relate to the themes of liberation and solidarity, even if they have no direct analogues in our drawing.[16]

What does this drawing represent? The answer is far from clear. All the revolutionary allegories that David worked up into compositional drawings, namely, the abovementioned iterations of *The Triumph of the French People*, as well as *The Aristocracy Pursuing the Families of the Persecuted* (formerly Chennevières collection; now lost), or merely conceived in his head, such as the programs he

described in his December 1789 letter to Crucy and in his inscription on the back of our drawing, are organized around two diametrically opposed groups: the powerful and the oppressed, the rich and the poor, the monarchy and the people, executioners and their victims. Here, however, all of the figures seem to be "on the same side," assuming that the two prominent standing figures at left, one male and the other female, each raising a hand to their neck, are attempting to free themselves from metal collars or chains. As for the nude man on the ground at far left, it is possible that the figure glimpsed above his head and beyond the man shown from behind may be pulling upward on a chain wrapped around his neck in an attempt to free him.

This procession of unfortunates gradually liberating themselves advances in scattered groups toward the strange and imposing figure who approaches them from the docked ship, a man of impressive stature whose toga and short haircut bring to mind a Roman man of virtue. Could this be C. C. Danyel de Kervégan, the mayor of

Fig. 106. Jacques Louis David, *Two Young Children, Walking Toward the Right, after Giulio Romano*, ca. 1789–90. Black chalk, 7⅛ × 4½ in. (18.2 × 11.3 cm). Musée du Louvre, Paris (RF 36942, fol. 12 recto)

her attribute. To the left of her is a bearded, seated male figure, apparently recording the event on a tablet, while to the right a crowned figure—perhaps a personification of the city of Nantes—holds what appears to be a scroll. Still further left are trumpeters, perhaps celebrating the liberation of the people of Nantes, and a young man peering over the clouds at the unfolding spectacle. Farther right are scribes, who also record the scene. Together, they comprise an odd assembly, one that can be read in several different ways and includes figures later recycled by David, for example, the trumpeters, who resurface in studies for his *Leonidas at Thermopylae*.

What is clear, however, is that in David's most ambitious treatment of the theme of national unity, *The Oath of the Tennis Court*, a project the artist began to elaborate shortly after his sojourn in Nantes,[18] he would renounce all forms of allegory (see cat. 53). As such, it is at odds with the present composition, which is executed with an authority, a fervor, and a kind of naiveté that enable us to construe at least the general intention. The precise depiction of the ship's rigging and gangplank is consistent with David's tendency to anchor his work in reality; so, too, is the evocation of the city in the background, a sketch for which, featuring a palisade in front of several buildings and two small, standing figures, is visible on the verso of a fragment of paper affixed to the right side of the drawing.

It is regrettable that David never painted this composition, expressed here with an exceptionally confident handling of the quill pen, especially in the evocation of male musculature and in the way that the dark wash constructs forms in a manner recalling architectural draftsmanship. This conception is doubtless the one for which David, in a letter to the city of Nantes dated July 1, 1792, claimed to have devoted six months of his life to making "related sketches." In remuneration for this work, he laid claim to the considerable sum—characterized by him as "niggardly"—of a thousand écus.   LAP

Nantes, whose profile portrait David may have recorded in the head "à la Brutus" on folio 5 of the Louvre sketchbook?[17] Indeed, is this mayor the patriotic leader of Brittany who figures in David's letter of December 1789, and whose likeness the artist here decided to Romanize? Or are we dealing with an allegorical figure meant to evoke Reason, Liberty, Charity, or even Brutus himself? Admittedly, all these hypotheses are tenuous, especially given recent photographs that provide a clearer view of the upper portions of the drawing. They reveal an airborne allegory, lightly sketched in graphite and now difficult to read, which, despite its less emphatic technique, would have reinforced the overall theme of the composition. It seems to represent an orb or globe surmounted by a figure of Atlas, in front of which is a female nude with open arms who contemplates the scene below. In her right hand she holds two lit torches, which might allude to Truth and Liberty, but also bring to mind the Greek goddess Hecate, for such torches are

CAT. 50, FOL. 51 VERSO

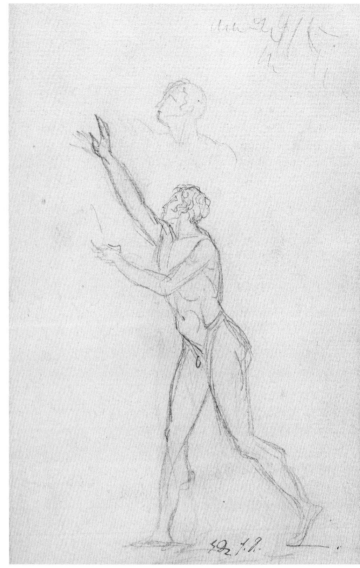

CAT. 50, FOL. 52 RECTO

## 50. *Sketchbook with Studies for "The Oath of the Tennis Court" (Carnet 3)*

1790–91
Sketchbook of 66 folios, with drawings in black chalk; bound in green board
7⁹⁄₁₆ × 5¹⁄₁₆ in. (19.2 × 12.8 cm)
Musée National des Châteaux de Versailles et de Trianon (VMS 114 / MV 7800)

PROVENANCE: David estate sale, April 17, 1826, and following days, probably lot 72 (but possibly lot 67 or 71); Mme David's posthumous inventory, June 27, 1826; anonymous sale, Karl and Faber, Munich, January 15, 1943, lot 1028; acquired by Otto Wertheimer (1878–1972) for the Musée National des Châteaux, 1951

REFERENCES: Antoine Schnapper in Schnapper and Sérullaz 1989, cat. 102, pp. 256–57; Trey and Baecque 2008, cat. 18, pp. 16, 19; Rosenberg and Prat 2002, vol. 2, carnet 3 (nos. 1368–1435), pp. 919–52; Prat 2011, p. 44, fig. 755

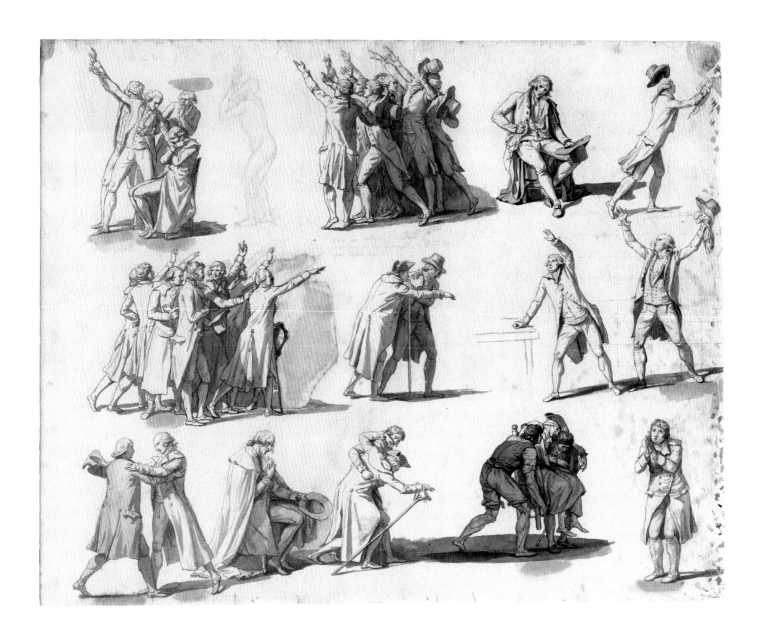

## 51. *Deputies and Groups of Deputies: Sheet of Fourteen Studies for "The Oath of the Tennis Court"*

Ca. 1790–91
Graphite, pen and black ink, brush and gray wash, squared in graphite, with fragments of paper affixed to the sheet
19⁵⁄₁₆ × 23⁵⁄₈ in. (49 × 60 cm)
Inscriptions, in graphite: under the group at upper left, "Martin d'Auch"; under the group at top center, "ceux qui arrivent peuvent encore avoir leurs chapeaux sur la tête par distraction"; under the figure at upper right, "arrives donc arrives donc"
Musée National des Châteaux de Versailles et de Trianon (INV. DESS 19 / MV 7124)

PROVENANCE: Saint-Albin (probably Marc-Achille [1857–1885], son of M. L. A. Jubinal and Hortense de Saint-Albin), 1880; sale, Saint-Albin and Jubinal, Hôtel Drouot, Paris, March 11–12 1886, lot 182; Paul-Arthur Chéramy (1840–1904); sale, Chéramy, Hôtel Drouot, Paris, April 14–16, 1913, lot 428, to Schoeller; gift of the Société des Amis de Versailles to the Musée National des Châteaux, 1913

REFERENCES: Antoine Schnapper in Schnapper and Sérullaz 1989, cat. 110, p. 266; Trey and Baecque 2008, cat. 19, p. 57; Rosenberg and Prat 2002, vol. 1, no. 111, pp. 122–23; Prat 2011, p. 45, fig. 76

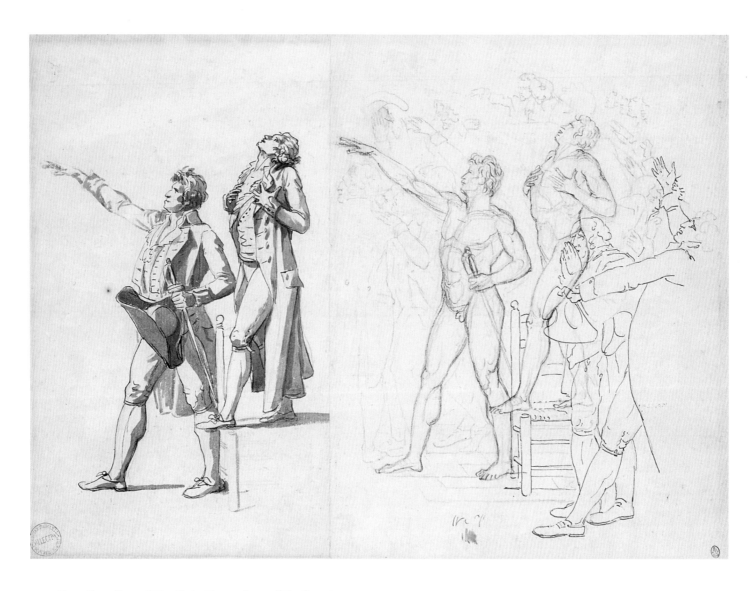

## 52. Two Studies of Dubois-Crancé and Robespierre for "The Oath of the Tennis Court"

Ca. 1790–91
Pen and black ink, brush and gray wash, over black chalk (left), pen and black ink over black chalk (right), on two joined sheets
9⁷⁄₁₆ × 12⁷⁄₈ in. (24 × 32.7 cm)
Marks: lower right, in black ink, collector's mark of Dominique Vivant Denon (Lugt 779); lower left, in black ink, collector's mark of the Coutan-Hauguet family (Lugt 464)
Private collection, France

PROVENANCE: Collection of Dominique Vivant Denon (1747–1825); his estate sale, May 1–19, 1826, part of lot 856 or 857; L. J. A. Coutan (d. 1830); his brother-in-law Ferdinand Hauguet (d. 1860); by descent in the family; Coutan-Hauguet sale, Hôtel Drouot, Paris, December 16–17, 1889, part of lot 92; anonymous sale, Hôtel Drouot, Paris, February 7, 1898, lot 28; private collection, Belgium; sale, Pierre Bergé & Associés, Brussels, May 23–24, 2007, lot 195; private collection, France

REFERENCES: Trey and Baecque 2008, cat. 20, p. 17; Prat 2011, p. 46; Prat 2016a, p. 300

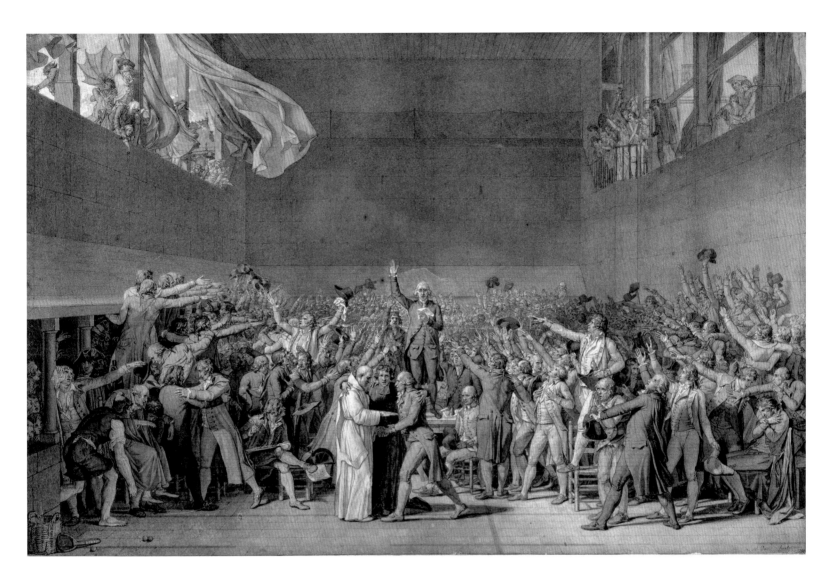

## 53. *The Oath of the Tennis Court*

1791
Pen and brown and black ink, brush and brown wash, heightened with
white, over black chalk, with two irregularly shaped fragments of
paper affixed to the sheet
26 × 39¹³⁄₁₆ in. (66 × 101.2 cm)
Inscriptions: lower right, in pen and brown ink, signed and dated
"J. L. David faciebat anno 1791"
Musée du Louvre, Paris, on deposit at the Musée National des
Châteaux de Versailles et de Trianon (INV. DESS 736 / MV 8409 /
MV RF 1914)

PROVENANCE: David estate sale, Paris, April 17, 1826, and following
days, lot 26; Eugène David (1784–1830), in his posthumous inventory
of February 14, 1830; his wife, Anne-Thérèse Chassagnolle (1800–
1845); their son Jules David-Chassagnolle (1829–1886); his bequest to
the Musée du Louvre, 1886, with a life interest to his wife, née Léonie-
Marie de Neufforge (1837–1893); entered the Musée du Louvre, 1893;
deposited at the Musée National des Châteaux

REFERENCES: Antoine Schnapper in Schnapper and Sérullaz 1989,
cat. 101, pp. 252–55; Trey and Baecque 2008, cat. 16, pp. 6–7, 48;
Rosenberg and Prat 2002, vol. 1, no. 118, pp. 129–31; Sérullaz and Prat
2005, no. 24, p. 75; Reichardt and Kohle 2008, p. 93, fig. 73; Bordes
2010, p. 62, fig. 19; Prat 2011, p. 43 fig. 72; Hout 2012, p. 149

In David's composition . . . we believe we are witnessing and taking part in this immortal scene which presaged the triumph of French liberty . . . this painting will be the history of our revolution, although the subject seems circumscribed in the first period. . . . All of Mr. David's works have been honored with public applause; but whatever fame this artist may have acquired previously was insufficient for [here] he honors his patriotism as much as his rare talents, and it serves as proof that passion for liberty enlarges the faculties of the soul and doubles the forces of genius.[1]

These accolades, for both David and his seminal composition *The Oath of the Tennis Court* (cat. 53), were published anonymously in June 1791, just after the drawing had been on view in the artist's studio in the Louvre.[2] This viewing opportunity, in advance of the drawing's public display in September 1791 at the Salon, stoked anticipation of David's monumental project that had inspired the poet André Chénier to publish a twenty-two-stanza ode entitled *The Tennis Court*, dedicated to David.[3] The anonymous commentary underscores the foundational importance of this 1789 event to the Revolution. Amid mounting frustration with Louis XVI and distrust of the existing legislative processes, members of the Third Estate—a broad swath of the French population representing those who were neither the clergy nor the nobility—found themselves unable to gather in their usual location,[4] and thus regrouped in the nearby indoor tennis court, from which the event takes its name. The 630 deputies pledged allegiance to the National Assembly, as they had begun calling themselves, and vowed to see to fruition a constitution that would serve to guide the monarchy. Marking the first time that citizens openly opposed the king, their actions were both radical and pivotal. However, the oath takers were not seeking, at that stage, to overthrow the monarchy, only to reform it. Such circumscribed aspirations would seem misguided by 1791, as suggested by the critic's comment that David's subject belonged to the Revolution's early phase.

During the months that followed, the event's significance became increasingly clear; the episode was recorded in several engravings, and a commemorative plaque was placed at the tennis court to mark its anni-

versary amid various celebrations during the spring and summer of 1790. Around this time, David, who had established his reputation with *The Oath of the Horatii* (see cats. 21–24), began to conceive of a project representing a contemporary oath swearing. According to a notation on the inside front cover of a sketchbook devoted to this project (cat. 50), David began using it on March 20, 1790.[5] Letters between his students from that summer suggest that he had embarked on a "painting of the Revolution."[6]

However, it was only on October 28, 1790, that David's friend and fellow deputy Edmond Dubois-Crancé proposed—at the artist's instigation—that the Jacobin Club commission David to create a large-scale painting of the oath to honor the National Assembly and inspire patriotic fervor. Dubois-Crancé suggested that the canvas could decorate the assembly's meeting space, thereby serving as a virtuous example and a reminder of the body's foundational act. The cost was to be covered by subscribers, who, in turn, would receive an engraving of the work. This proposition proved to be a dubious one in such uncertain times. After the politically charged reception of his *Brutus* in 1789 (see cats. 41–48), it is unsurprising that David was seeking an appropriately dignified subject through which to reinvent himself as the painter of the Revolution. As a history painter, David was trained to identify the moral and distill the universal truth from the scenes he represented, but how did one extract an enduring narrative from events that were still unfolding?

With an almost audible cacophony, David's completed drawing (cat. 53) depicts a boisterous scene of deputies extending their arms—and ostensibly their voices—in commitment to the oath that has just been read aloud by Jean Sylvain Bailly. Standing atop a desk with right arm outstretched and text in hand, Bailly is positioned at the very center of the composition, with all sightlines leading to him; diagonal parallel perspective lines in black chalk remain faintly visible in some areas. Turning his back to his fellow deputies, Bailly looks out at the viewer, inviting us to join the scene. David depicted the rest of his cast of characters following the same theatrical device, as though they are lined up at the edge of a proscenium, making the figures and their gestures legible from a single vantage point. Given the anticipated placement

of the large-scale painting in the meeting space of the National Assembly, these compositional choices would juxtapose the actual representatives with their painted counterparts, effectively inviting viewers to complete the circle around Bailly and pledge their own loyalty to the assembly. Bailly's importance to the scene is reiterated by the fact that David redrew this figure, perhaps changing his pose or expression, on a separate piece of paper that is affixed to the main sheet, having studied Bailly's features repeatedly in the Versailles sketchbook.

The particulars of the event mandated the inclusion of a multitude of figures, which in turn required a careful negotiation of space and a distillation of gestures to ensure legibility. To achieve this, David, despite claiming to be uninterested in incorporating individual likenesses into the drawing, selected some fifty individuals whose features would be sufficiently delineated so as to be recognizable to contemporaries.[7] Some were key figures who had played prominent roles in the episode, including Bailly at center and Martin d'Auch, the sole deputy who refused to swear the oath, at far right. Others were included for their political standing or narrative potential, for instance, the three religious figures at center, who emphasize the overall unity of the assembly. David studied this embrace between a Protestant minister, a Catholic priest, and a berobed Carthusian monk repeatedly; like the figure of Bailly, the group was drawn on a separate piece of paper affixed to the main sheet.

The composition's upper register is pure artistic invention, enabling David to accentuate the event's significance and imbue the scene with dynamism. The billowing curtain at left emphasizes the instantaneity of the moment, which, along with the compression of space, communicates a sense of urgency. The storm raging outside acts as a metaphor for the chaotic state of the French nation. Though not actually visible from the tennis court, the royal chapel of the château at Versailles can be seen through the windows at left of David's composition. Adding to the immediacy of the scene, lightning strikes the roof of the chapel, just between the cross and the royal coat of arms, a symbolic harbinger of the rupture in the divine authority invested in the monarchy. Such details were not mere afterthoughts included to animate the composition but, rather, integral to the significance of the scene and the meaning of the work.

Fig. 107. Jacques Louis David, *Annotated Study of the Tennis Court Interior for "The Oath of the Tennis Court"* (cat. 50, fol. 34 verso)

In reality, the tennis court's parapet was inaccessible, but David's composition envisions the space filled with commoners, young and old, who bear witness to the event. In this way, David engaged with contemporary discourses that called for civic education and emphasized the importance of witnesses, including artists, to document the Revolution's history. David included two figures who record the event. In the upper right balcony, a behatted man turns his back to the scene to use the wall as a support for his writing; close examination reveals that the top of this page reads *L'ami du peuple*, the revolutionary journal published by Jean Paul Marat, which did not, however, exist at the time of the oath (see cat. 54). By including this detail, anachronistic to 1789, David updated his representation to reflect the important figures of the Revolution in 1791. In the foreground, shown seated with quill in hand to record the oath, is Bertrand Barère de Vieuzac, whose real-life account of the event served as source material not only for David, but also for other, future interpretations of the episode.[8]

David distilled these narratives and selected his figures after exploring various aspects of the composition across a multitude of drawings. Not having been present at the event itself, David studied details that would lend his representation credibility, such as the tennis court's interior (fig. 107). The Versailles sketchbook also records various ideas, some as notations resembling stage directions, alongside many black chalk drawings

Fig. 108. Jacques Louis David, *Study of Two Figures by a Table for "The Oath of the Tennis Court"* (cat. 50, fol. 5 verso)

of individuals and figural groups. He often focused on a pose or gesture by sketching a figure nude, with carefully articulated musculature, and then repeating the same figure clothed. In seeking to distinguish some figures from the crowd, David sometimes introduced props to create greater visual interest and legibility. For example, Pierre Louis Prieur de la Marne, who in the final composition stands on a chair with his arms dramatically outstretched, appears in an almost identical pose in a sketch (cat. 50, at left). Elsewhere in the sketchbook, David investigated figures' relationships to one another or to objects, as on one page that shows two men variably positioned adjacent to a table, with one figure's head tilted and arm gesturing downward, and with shifting leg placement, among other alterations (fig. 108). The initial iterations remain visible, creating a proto-stop-motion effect. Variations and experimentation—of pose and dress; of the size and shape of groups—abound; the rare profile portrait is sketched over an unrelated nude figure posed with outstretched arms, and the occasional clothed deputy is squared for transfer. The sketchbook also highlights David's nonlinear process, with consecutive pages used in different orientations or multiple overlapping drawings in distinct directions on the same page.

In an unusual sheet with fourteen studies (cat. 51), David applied a gray wash for pictorial effect and to explore the interplay of light and shadows on individual

figures and groups. Rather than putting the distinct groups into dialogue, David studied each one independently, considering the directionality of the bodies and attending to the gestures, costumes, and corporeal relationships. Many of these vignettes—such as the embracing pair at bottom left or the resistant d'Auch at top left—can be found, in whole or in part, in the finished drawing, with slight modifications. David worked meticulously, as evidenced by the multiperson cluster at left in the middle register, where he removed one member at the front of the group by adding scraps of paper deliberately cut to silhouette the remaining figures. Here, David used the collage method, deployed in the finished drawing and elsewhere,[9] to edit his own work (see also cats. 31, 49 and figs. 122, 123). Similarly, graphite inscriptions shed light on David's thought process, as he included justifications for his characters' actions and ascribed intentionality to their gestures. For example, an annotation under the group at the center of the upper register reads, "those arriving might have, in their distraction, forgotten to remove their hats." Such indicators, as well as the use of a consistent light source to illuminate these groups, suggest that David already had a sense of the overall composition, worked out on other sheets likely similar to the sole extant large-scale compositional study of the scene (fig. 109).[10] Just a few centimeters narrower than the finished drawing, this preparatory sheet demonstrates another facet of David's practice. The architecture of the tennis court was laid in first, likely by a collaborator,[11] who focused on depicting the fullness of the space and creating a stage upon which David could place his figural groups. A similar process was deployed in the final drawing, although the space is more compressed; the architectural framework—precisely drawn building elements and parallel lines indicating floorboards, in black chalk—can be seen beneath the figures and other elements that were drawn on top. Whether depicted clothed or nude, in ink or black chalk, few figures in the Cambridge sheet appear in the same position as in the finished drawing, suggesting that, while the study served as an important intermediary step, David continued to explore the narrative potential of individual gestures and poses elsewhere, breaking down the mass of figures and focusing on select personages.

Among the latter, Dubois-Crancé and Maximilien Robespierre are prominent in the finished drawing,

Fig. 109. Jacques Louis David, *Study for "The Oath of the Tennis Court*," ca. 1790. Brown and black ink and graphite, squared in graphite, 26¹⁄₁₆ × 39 in. (66.2 × 99 cm). Harvard Art Museums/Fogg Museum, Cambridge, Mass. (1943.799)

owing to their political cachet in 1791 and their personal friendship with the artist. David draws attention to them through dramatic gestures: Dubois-Crancé's elongated right arm extends to pledge his allegiance, while Robespierre throws his head back and rips his shirt open in patriotic passion. An interesting study (cat. 52) reveals David's process in developing their final poses. In the right portion of the sheet, David depicts both men nude, with schematic features, in black chalk. At left, the ink-and-wash figures are clothed in contemporary garments and have individuated characteristics but maintain the same poses. In both cases, Robespierre stands atop a chair, reinforcing David's practice of using such props to organize the visual field and distinguish certain individuals from the mass of bodies.

The sheet is composed of two pages, possibly excised from sketchbooks. It is unknown when they were pasted together, but the intervention was likely staged by the drawing's first owner, David's student Dominique Vivant Denon,[12] who was responsible for engraving David's composition in 1794. The resulting back-and-forth between the idealized male nude and the particulars of contemporary individuals haunted David's process as he navigated between the principles of heroic history painting and the practical constraints of depicting contemporary events. While the juxtaposition of studies on this sheet tempts us to envision a progression from the nude form to the clothed figure, David's process was more complicated. He repeatedly revised his composition to make his complex narrative more legible. Compared to the

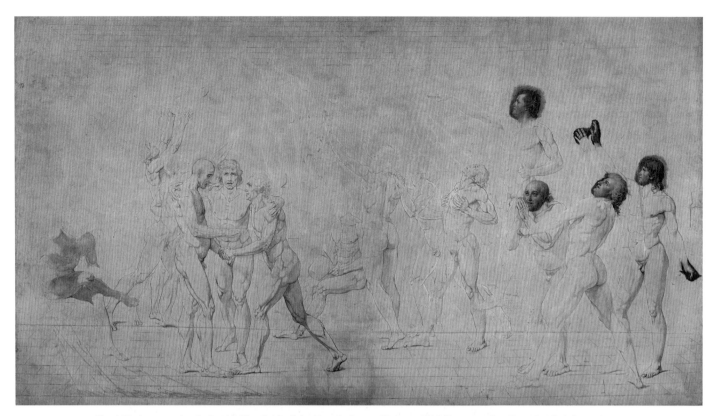

Fig. 110. Jacques Louis David, *The Oath of the Tennis Court, 20 June 1789* (fragment), 1791–92. Oil, ink wash, black chalk, and traces of white chalk on canvas, 146¾ × 592¾ in. (370 × 654 cm). Musée National des Châteaux de Versailles et de Trianon, Versailles (INV. DESS 26182 / MV 5841)

preparatory drawings owned by Denon, the positions of Dubois-Crancé and Robespierre are reversed in the final drawing; Dubois-Crancé is placed on the chair, while Robespierre stands with his feet firmly planted on the floor, belying his imminent rise to prominence.

David displayed the finished drawing for *The Oath of the Tennis Court* at the Salon of 1791; it was the second, and final, drawing David would ever show publicly, under-scoring the largely functional role of drawings in the artist's practice.[13] It was displayed, no doubt intention-ally, directly below David's *Oath of the Horatii*, reinforcing the parallels between the revered ancient oath and its contemporary cognate. One anonymous critic admired the "figures [that] breathed of love of country, of virtue, and of liberty."[14] Despite such praise, David's project became a specious undertaking as featured protagonists of his representation fell from favor: by the time of the 1791 Salon, Mirabeau was posthumously disgraced, Dubois-Crancé became increasingly disengaged from

politics, and Bailly was seen as a counter-revolutionary (and was guillotined in 1793). Changing political tides posed a problem for the relevance of David's subject matter but did not prevent him from embarking on a large-scale canvas, known today only as a fragment (fig. 110).[15] In addition to studying the likenesses of different deputies for his monumental painting, David returned to his drawing practice and to the heroic nude as he embarked on his fully conceptualized project. Rather than transferring the finished drawing whole to the canvas, the painting fragment reveals that David returned to drawing, outlining his figures in white chalk on the canvas before using gray wash to delineate the bodies and brown wash to model the forms. Much of the friable white chalk has dissipated over time, but ghostly outlines of figures such as Bailly remain, reminders of this monumental unrealized project, of the importance of drawing to David's practice, and of the shifting fortunes of the Revolution's protagonists.   DB

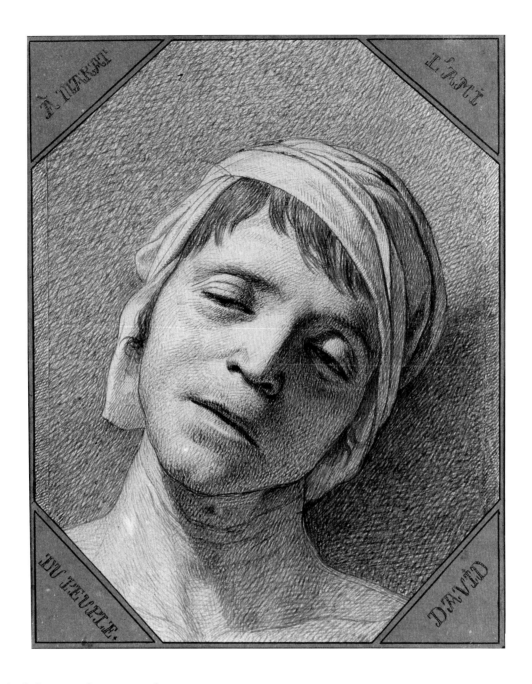

## 54. *The Head of the Dead Jean Paul Marat*

1793

Pen and brown and black ink, over black chalk, with strips of paper added along the left and right margins and corners cut, pasted down on board

10⅝ × 8¼ in. (27 × 21 cm); with mount 13¼ × 11 in. (33.8 × 28 cm)

Inscriptions: in the four corners, in pen and black ink, "À MARAT / L'AMI / DU PEUPLE / DAVID"

Musée National des Châteaux de Versailles et de Trianon (INV. DESS 855 / MV 5288)

PROVENANCE: David estate sale, Paris, April 17, 1826, and following days, lot 55; Eugène David (1784–1830); his son Jules David-Chassagnolle (1829–1886); his bequest to the Musée de Versailles, 1886, with a life interest to his wife, née Léonie-Marie de Neufforge (1837–1893); entered the Musée de Versailles, 1893

REFERENCES: Antoine Schnapper in Schnapper and Sérullaz 1989, cat. 119, p. 286; Rosenberg and Prat 2002, vol. 1, no. 121, p. 133; Prat 2011, p. 47

Fig. 111. Jacques Louis David, *Marat at His Last Breath*, 1793. Oil on canvas, 65 × 50⅜ in. (165 × 128 cm). Musées Royaux des Beaux-Arts de Belgique, Brussels (3260)

David executed this haunting representation of the journalist and political activist Jean Paul Marat shortly after Marat's assassination on July 13, 1793. For this posthumous drawing of his friend and fellow deputy, David used dense, staccato pen-and-ink lines to model the shadows of the face and head, which emphasize the effects of gravity on Marat's tilted, turbaned head,[1] seen particularly in his drooping left cheek and eye. Marat's slightly open eyes seem to survey the viewer from under heavy lids, and his parted lips seem poised to speak, further underscoring the figure's liminal status between life and death. Lighter pen marks spaced farther apart to reveal the cream paper capture how the light hits Marat's face from the left. The network of closely crosshatched marks in the background creates an effect

of resonance or reverberation,[2] accentuating the feeling of transition.

A deputy of the radical Montagnard faction, Marat publicly championed freedom of the press and the people's causes.[3] He cultivated a lifestyle of austerity, truth, and virtue, insisting that polite manners were a form of corruption and a refusal to please was, in turn, aligned with integrity. His radical publication *L'ami du peuple* aimed to expose traitors and conspiratorial plots and warn the people of danger, regardless of its source, all while striving toward the ideal of a popular democracy.[4] Persecuted for his criticism of government policies, Marat was seen as an instigator of violence against moderates and royalists, and he was demonized in particular by the Girondin faction. His murderer, Charlotte Corday, was a royalist sympathizer acting under the influence of an impassioned speech denouncing Marat, given by a Girondin in Caen. A polarizing figure for his relentless commitment to his political ideals, Marat adopted the title of his journal as a sobriquet and became known as "the friend of the people."[5]

When word of Marat's assassination reached the National Convention, his fellow deputies called for David to paint a commemorative portrait as a pendant to his portrait of the first martyr of the Revolution, Louis Michel Le Peletier de Saint-Fargeau, who had been murdered on January 20, 1793, on the eve of the execution of King Louis XVI, for having voted for the death of the monarch.[6] Both paintings were to be displayed behind the tribunal at the National Convention, to remind the deputies of the sacrifices made for the young Republic. Completed in October 1793,[7] David's painting, *Marat at His Last Breath* (fig. 111), like the drawing, emphasizes the transition between life and death. David eschews the narrative details of the event, focusing instead on creating an iconic image of a martyr and centering the viewer's attention on the features of Marat himself. The aesthetic severity of both drawing and painting, particularly in the background, might be seen as a reflection of Marat's core values of austerity and truthfulness.

While much is known about the circumstances of the painting's creation, scholars continue to debate the particulars of the present drawing. David used Marat's sobriquet as an epithet, cutting the four corners of the sheet to make room for an inscription that reads "To

Marat, the friend of the People, David."[8] This physical alteration augments the intensity and intimacy of the image, creating the illusion of space closing in around the martyr's head. This compression of space and the off-centeredness of Marat's head is preserved by the artist even as the sheet was slightly enlarged on the sides through the addition of two thin strips of paper. The tight "weave" of the pen marks suggests that David created the study of Marat's head as an autonomous image, intended to be disseminated as a print. It was engraved in 1794 by Jacques Louis Copia (fig. 112), who added the caption "Ne pouvant me corrompre, ils m'ont assassiné" (Unable to corrupt me, they assassinated me).[9] Copia's addition is notable, as it is written in the first person, making Marat the presumed speaker.[10] This further animates the image, as if reviving the martyr.

David claimed to have seen Marat on the eve of his murder, "in an attitude that was striking."[11] Both David's drawing and painting were likely informed by this last visit. The drawing was first sketched in black chalk and then elaborated in at least two campaigns in pen and ink,[12] suggesting close study in front of the corpse. David would have had such an opportunity to study Marat's features during the funeral, which he himself organized.[13] Marat's body was theatrically displayed in the church of the Cordeliers from July 14 to 16, so that French citizens could come pay their respects. The drawing served to memorialize Marat and, through its inscription, to link the radical martyr's name to that of the artist.    DB

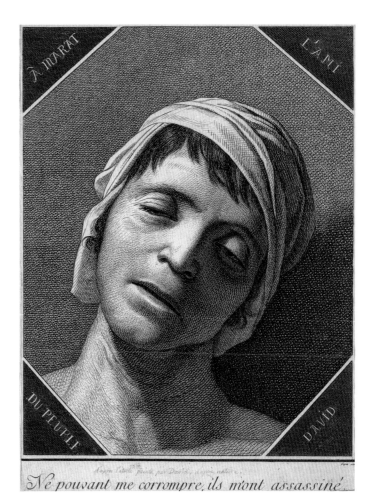

Fig. 112. Jacques Louis Copia (1764–1799), after Jacques Louis David, *Marat as He Was at the Moment of His Death,* 1794. Etching and engraving, 10⅞ × 8½ in. (27.5 × 21.5 cm). Bibliothèque Nationale de France, Paris

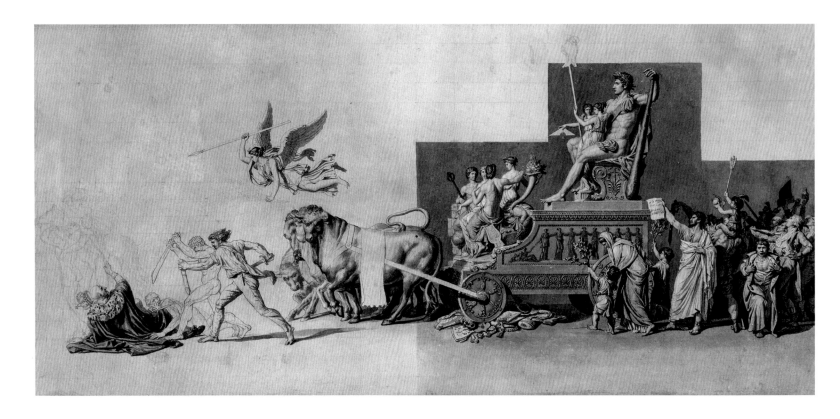

## 55. *The Triumph of the French People*

1794
Pen and brown and black ink, brush and gray wash, heightened with white, over graphite and black chalk, squared and partially numbered (1–3 at lower left; 1–6 above the figural group at left) in graphite, with one irregularly shaped fragment of paper affixed to the sheet
12⅞ × 28⅜ in. (32.7 × 72 cm)
Inscriptions: on the scroll held by Brutus, in pen and black ink, "À la mort que l'on mène mes fils"
Musée Carnavalet, Paris (D 4852)

PROVENANCE: Alexandre Lenoir (1762–1839); his estate sale, Paris, February 5–6, 1838, lot 40; Albert Lenoir (1801–1891); his son Alfred Lenoir and, in 1913, his wife, Mme Alfred Lenoir; possibly anonymous sale, Hôtel Drouot, Paris, June 20, 1922, lot 9 ("projet pour un décor de théâtre"); gift of M. Boitte to the Musée Carnavalet, 1923

REFERENCES: Renée Davray-Piékolek in *La Révolution française* 1983, cat. 23, pp. 34–35; Antoine Schnapper in Schnapper and Sérullaz 1989, cat. 124, pp. 294–95; Rosenberg and Prat 2002, vol. 1, no. 129, p. 145; Nicolas Sainte Fare Garnot in *Jacques-Louis David* 2005, cat. 43, pp. 118–19; Reichardt and Kohle 2008, p. 173, fig. 136; Prat 2011, p. 49, fig. 87; Ledbury 2014, p. 61, fig. 3.3

Writing in 1835, the first owner of this drawing, Alexandre Lenoir, noted that it was fully embedded in, and a product of, the political environment of its day, describing it as representing "the revolutionary system of 1793."[1] Indeed, in *The Triumph of the French People*, David aspired to create a new language for the Revolution, incorporating classicizing elements and experimenting with allegory. The composition offers insight into both the evolution of revolutionary ideology and the artistic problem of representing contemporary heroes.

Lenoir claimed that the drawing was a commission for a theater curtain at the Opéra in Paris.[2] It may have been connected to the 1794 premiere of *The Reunion of the Tenth of August; or, The Inauguration of the French Republic*, but this relationship remains tenuous.[3] While the drawing's horizontal format would make it a strange choice for a stage curtain, which would typically be a vertical composition, the work's theatricality is unmistakable. This unfinished drawing for an unrealized project is in dialogue with other initiatives that furthered the ideological

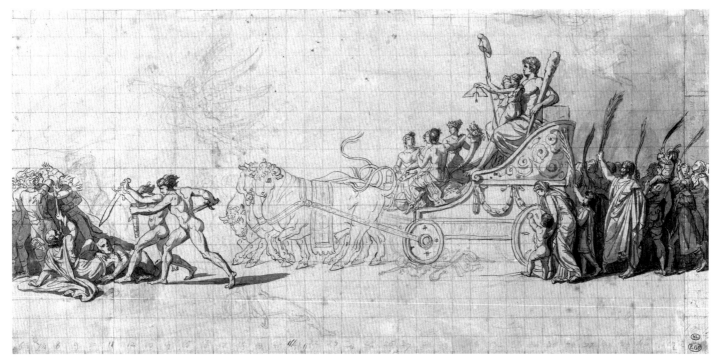

Fig. 113. Jacques Louis David, *The Triumph of the French People*, 1794. Graphite, pen and black ink, gray wash, on four joined sheets of paper, squared and numbered in graphite, 8½ × 17⁷⁄₁₆ in. (21.5 × 44.3 cm). Musée du Louvre, Paris (RF 71)

program of the Montagnard faction,[4] including the numerous festival parades organized by David, as well as a proposed colossal public statue bearing inscriptions of revolutionary values.[5]

At the center of the procession is a chariot bearing female personifications of Liberty and Equality, as well as Hercules, who symbolizes the French people. Below them are seated allegories of Commerce, Abundance, Sciences, and Arts. Drawn by bulls, the chariot crushes attributes of despotism as it advances. Further ahead, two sword-wielding men attack a king and his entourage of fleeing figures.[6] The cowering figure with an ermine-lined cloak and toppling crown is an allegory of monarchy rather than a representation of Louis XVI. The juxtaposition of nude figures with those wearing antique drapery or contemporary garb reveals David's efforts to integrate classical ideas and contemporary referents. Heroic figures from both antiquity and recent history follow the chariot. The inclusion of modern martyrs was paramount to David's search for a visual language that addressed the momentous and chaotic nature of the

Revolution. In this, David was responding to various contemporary representations of triumphal processions, and in particular to a drawing by his teacher, Joseph Marie Vien (fig. 114).[7] While Vien's allegorical *Triumph of the Republic* adheres to the classical tradition, David updates the mode by fusing the modern with the antique, the heroic with the historic.

By comparing the Carnavalet sheet to an earlier version of the same subject (fig. 113), we can trace the evolution of David's project. The central group is largely the same, although changes reveal an increasingly militant rhetoric: a helmetlike Phrygian cap replaces the liberty cap atop Liberty's pike,[8] and the winged Fame transforms into a menacing Victory. In the earlier drawing, more attention is devoted to the group of royalists at left dressed in contemporary clothing. In the later drawing, David concentrates on the monarch, whose garments are carefully articulated in black ink, while the others are nude and sketched only lightly in black chalk.

Many of the same characters follow the chariot in both drawings, but their presentations differ between

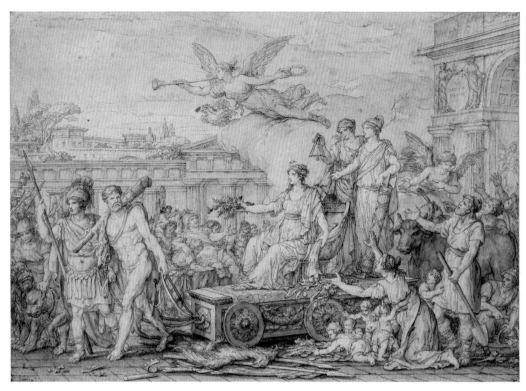

Fig. 114. Joseph Marie Vien (1716–1809), *The Triumph of the Republic* (*The Triumph of the Constitution of 1793*), 1794. Pen and black ink, gray and brown wash, heightened with white, over black chalk, squared, 13⅜ × 18⅞ in. (34 × 48 cm). Musée du Louvre, Paris (RF 38804)

the two versions. In the later drawing, David imbues the ancient heroes with new significance and expands the canon of modern martyrs. With the rise of praise for the patriotic mothers of child martyrs in 1794, Cornelia had become a popular emblem of motherly love, and David lavished attention on the figures of Cornelia and her two sons by the rear wheels of the chariot, even redrawing the boy holding a laurel branch on a separate sheet pasted onto the composition. For his representations of Brutus and William Tell, David drew from contemporary theatrical representations that recast ancient and historical heroes in revolutionary terms.[9] Appearing in a dramatic pose, Brutus holds a paper inscribed with the words that condemn his sons to death. Its phrasing is taken from act 5, scene 7, of Voltaire's eponymous play, which had been revived in 1793 by order of the National Convention. Modern martyrs follow: Louis Michel Le Peletier de Saint-Fargeau and Jean Paul Marat (see cat. 54) are joined by five well-known contemporaries who were likewise killed for their politics, all displaying their

wounds in dramatic gestures.[10] David emphasized their connection to antiquity and their vital relationship to the French people (Hercules) by uniting this portion of the composition through the application of a gray wash, which brings the figures into greater relief and further emphasizes the friezelike quality of the stoic procession.

Only Marat faces outward, thereby breaking rank and the theatrical convention of the fourth wall. Kneeling and baring his chest, he addresses the viewer directly, serving as the entry point to the scene. David emphasized Marat's importance to the project by taking care to reinforce the lines of his vest and bleeding wound; for this David used a different ink, which has now faded to brown. Such a direct appeal to the audience was a vital component of revolutionary rhetoric, which David excelled at integrating into his art and that his conditioned compatriots readily recognized. In the Carnavalet drawing, this mode of address accentuates the theatricality of David's most extensive use of allegory as he attempted to fuse the classical and the contemporary.   DB

# DESIGNS FOR REPUBLICAN COSTUMES

## 56. *Representative of the French People on Duty*

1794
Pen and brown ink, watercolor; toque drawn on a separate piece of paper, cut out and affixed to the sheet
12⁷⁄₁₆ × 8⅝ in. (31.6 × 21.9 cm)
Inscriptions and marks: on the decorative strips applied to the clasp of the cloak, in brush and black ink, "PEUPLE FRANCAIS / EGALITE LIBERTE"; on the papers held by the figure, "Rapport / sur les / Costumes / français"; lower right, in pen and ink, paraphs of Eugène David (Lugt 839) and Jules David (Lugt 1437)
Musée Carnavalet, Paris (D 7059)

PROVENANCE: David estate sale, April 17, 1826, and following days, part of lot 54, apparently unsold or purchased by the artist's family; David's daughter Emilie (1786–1863), wife of Claude Marie Meunier;[1] "Monsieur de Saint-Albin," probably Philippe de Corbeau de Saint-Albin (1822–1879), by 1880; his daughter, Hortense de Corbeau de Saint-Albin (1824–1885), wife of Achille Jubinal; sale ("par suite de décès"), collections Saint-A[lbin] and J[ubinal], March 11–12, 1886, lot 183; presumably acquired at that sale, along with lot 184, *Le citoyen français dans son intérieur* (D 7058), by or for the Musée Carnavalet

REFERENCES: J. L. J. David 1880, pp. 657–58; Association des artistes 1884, cat. 153, p. 27; Arlette Sérullaz in Schnapper and Sérullaz 1989, cat. 125, p. 296; Rosenberg and Prat 2002, vol. 1, no. 137, p. 152

## 57. *A Seated Judge*

1794
Pen and black ink, watercolor
11¹³⁄₁₆ × 7⅞ in (30 × 20 cm)
Inscriptions and marks: on the toque, "LA LOI"; lower right, in pen and ink, paraphs of Eugène David (Lugt 839) and Jules David (Lugt 1437)
Musée National des Châteaux de Versailles et de Trianon (INV. DESS 831 / MV 5292)

PROVENANCE: David estate sale, April 17, 1826, and following days, part of lot 54; apparently unsold or purchased by the artist's family; Eugène David (1784–1830); his son Jules David-Chassagnolle (1829–1886); his bequest to the Musée de Versailles, 1886, with a life interest to his wife, née Léonie-Marie de Neufforge (1837–1893); entered the Musée de Versailles, 1893

REFERENCES: J. L. J. David 1880, p. 658; Association des artistes 1884, cat. 154, p. 27; Florisoone 1948, cat. M.V.105 (3), p. 115; Arlette Sérullaz in Schnapper and Sérullaz 1989, cat. 125, p. 298; Rosenberg and Prat 2002, vol. 1, no. 138, p. 153

A suite of eight designs for costumes executed by David in the spring of 1794, together with one costume design for the consular government, formed a single lot when put up at auction by his heirs in 1826.[2] Six sheets—among them, cats. 56 and 57—are today divided between the Musée Carnavalet, Paris, and the Musée National des Châteaux de Versailles et de Trianon, Versailles. A suite of etchings by Dominique Vivant Denon after David's designs includes the two missing projects, while two other drawings, not etched by Denon, also relate to the suite.[3] Concurrently, David designed the uniform for the pupils of the Ecole de Mars, a military academy established in June 1794 on the outskirts of Paris.[4] Such preoccupations were not totally new for him, since he had earlier helped the actor François Joseph Talma with his stage wardrobe. Deploying the creative mind of a history painter, David took what were basically fashion plates and infused them with the plenitude of an imagined republican order, offering in a time of civil war a utopian vision that aimed to surmount social differences and conflict.

When the Estates General convened in May 1789, acrimony was sparked by the intended contrast between the flamboyant dress of the high clergy and nobility and the sober black outfits prescribed to the commoners representing the Third Estate. On October 15, 1789, the National Assembly decreed that costume and seating during ceremonies would no longer be based on social privilege. The discussion of whether government officials should be undistinguished from the citizens they represented or whether their authority needed to be signaled by distinctive attributes continued until the Consulate.[5] The centrality of costume during the Revolution is further substantiated by the fortune of the term "sans-culotte," initially a condescending reference to artisans and dayworkers who wore loose pants rather than aristocratic breeches. By 1791, the slur was proudly appropriated by the popular forces that had allowed the "chariot of the Revolution" to advance (see cat. 55).

On April 4, 1793, the Committee of Public Safety, the heart of the revolutionary government, specified that, "until a costume for the national representatives is decreed," a set of markers—notably, a sash tied around the waist and three feathers on the hat forming the colors of the Republic—would be used to identify and confer authority on the deputies sent on mission in ever greater numbers to keep an eye on local situations and military operations.[6] One year later, simply accessorizing the officials in this way would not satisfy David.

Criticism of contemporary French dress as impractical and constrictive compared to the flowing attire of the ancients had been voiced for several decades. David reportedly designed a republican costume in the autumn of 1792, after his election to the National Convention, but the real impetus to enact a change occurred one year later, with the adoption of the republican calendar. Its references to the gifts of nature and the ideals of the regime, in place of Christian feasts and saintly narratives, led to an imagining of other radical transformations of daily life. The Société Populaire et Républicaine des Arts brought up the subject in March 1794, and the topic gained momentum the following month. Someone from the Société contacted David, who sat on the Committee of Public Instruction, and reported back on April 5 that he encouraged them to pursue their discussions.[7] These went on for several months; some projects were presented; and a text to alert public opinion was sent to the press. But on June 7, an informed member announced that the matter should be put aside, "because the cloths are cut for someone presently making them according to the ideas and drawings of the representative David."[8]

David's political clout was at its zenith during these months. The Committee of Public Safety welcomed his proposal to devise new designs for standardized republican costumes, casting aside the freedom of dress that the Convention had guaranteed on October 29, 1793. David drew the "costume of the representative of the people on mission to the armies of the French Republic" by April 25, 1794, when he received money for a tailor to create the garment.[9] This initial drawing was very likely the one today in the Bibliothèque Nationale de France that belonged to Denon—a gift?—and was not part of the lot in the 1826 sale (fig. 115). When developing the full suite, David drew a second project, known only through Denon's etching, with the pose modified to enhance the figure's outward authority.[10] On May 14, to formalize his personal initiative already underway, the committee invited David "to present his views and projects on the means to improve the current national costume and adapt it to republican morals

and the character of the Revolution."[11] By that date, the drawings were probably done, for a mere ten days later he was authorized to have printed and colored "the various projects for a national costume, be it legislative, on duty and on mission to the armies, or judicial, be it civil or military [*crossed out*: be it the costume of female citizens]," a precise list suggesting that his compositions were shown to the committee on this occasion.[12] The question of whether to reform women's dress came up repeatedly in the discussions of the Société: some members claimed it needed to be "regenerated," but others considered it already to be "closer to the [republican] costume than our own," which is perhaps the reason the matter was dropped.[13]

The eclectic nature of David's designs, with their nods to antiquity, the Middle Ages, and the Renaissance, is unified by an exceptionally vibrant and confident execution, indicative of his enthusiasm. *Representative of the French People on Duty* (cat. 56) holds aloft the "Report on French Costume" David had been asked to submit but never delivered. Pierre Rosenberg and Louis-Antoine Prat surmise that this drawing, one of the most colorful of the suite, may have been the cover piece. During this period, so as to control the political semantics of his designs, David often adopted explicit labeling, such as that present here on the clasp of the cloak. He thus inscribed "LIBERTY / EQUALITY" on the double harness across the chest of the citizen-soldier in *Military Dress* and covered with tattoo-like slogans a projected monumental statue of the French people.[14] The sheaf of wheat tucked behind the cockade pinned to the toque of the *Representative*, in place of the tricolor feathers worn on mission to the armies, attests to the preoccupation at the time with food shortages, a subsistence crisis that persisted despite the measures taken by the National Convention on November 15, 1793, dictating the kind of bread that bakers were to produce.

Shortly before David was invited to design the suite of costumes, the Committee of Public Instruction had asked him to review a demand by a local Paris tribunal to do away with the judge's costume.[15] The commission, in the end, did include dress for a judicial official, but David's design for the *Judge* (cat. 57) was apparently a latecomer to the etched series, and not part of the set of seven that Denon asked to be paid for on September 24,

Fig. 115. Jacques Louis David, *Representative of the People on Mission to the Armies*, 1794. Pen and black ink, watercolor, 11¾ × 8 in. (30 × 20.2 cm). Bibliothèque Nationale de France, Paris

Fig. 116. Pierre Narcisse Guérin (1774–1833), *A Judge of the Criminal Court*, 1798–99 (Year VII). Pen and gray ink, watercolor, over traces of graphite, 11⅞ × 7⅝ in. (30.2 × 19.3 cm). The Metropolitan Museum of Art, New York, Harry G. Sperling Fund, 2006 (2006.67)

1794, after the overthrow of Robespierre ended support for the codification of dress.[16] Though Denon's etching leaves blank the space allotted for the title, the figure is easily identified as a judge by the toque, inscribed "LA LOI" (the law). An older, and presumably wiser, figure than the other officials in the set, most of whom are surprisingly young, he is depicted in a seated pose that conveys authority and steadfastness. The armchair, present in several works, was a studio prop fabricated by Georges Jacob (see cat. 74). There are reminiscences of David's *Brutus* (see cats. 41–48), though the French republican manifests none of the moral suffering of his Roman forebear. David's conception contrasts especially with the candor and youthful fragility of the judge drawn by Pierre Narcisse Guérin in 1798–99, and with the refinement of the latter's draftsmanship (fig. 116). Even softened by touches of violet, blue, and white, this most formidable figure of David's suite belongs to the moment when the expedited justice and cruel repression of the revolutionary tribunal was entering its most grievous phase.   PB

## 58. *Portrait of a Revolutionary*

1795
Pen and black ink, over traces of black chalk, with touches of brush and brown and gray wash
Diam. 7 3/16 in. (18.3 cm)
Inscriptions: on the etiquette on the back of the old frame, in pen and brown ink, "Dessiné par / Louis David, En / moins de vingt minutes / Et Sur les genous, dans les / Prisons des 4 nations, le 3. / messidor an 3 d. L. R."
Private collection, New York

PROVENANCE: Mlle Isabelle de Boys, second half of the nineteenth century; by descent in the family; sale, Piasa, Drouot Richelieu, Paris, March 31, 2011, lot 172, unsold; private collection, New York

REFERENCES: Rosenberg and Prat 2002, vol. 1, no. 147, p. 165; Prat 2011, p. 53

## 59. *Portrait of Jeanbon Saint-André*

1795
Pen and black ink, brush and black and gray wash, heightened with pale yellow wash and white gouache, over graphite
Diam. 7 1/8 in. (18.2 cm)
Inscriptions, in pen and black ink: bottom center, signed "L. DAVID"; on the mount, "Donum amicitiae. Amoris solatium. David faciebat in vinculis anno R. p. 3 [1795] messidoris 20"; on the back of the frame, "appartenant à / Mr Jean-bon St André / à Montaubon."
Art Institute of Chicago, Helen Regenstein Collection (1973.153)

PROVENANCE: André Jeanbon Saint-André (1749–1813), Montauban (according to an inscription on the back of the frame); Thuet de Caussade (?);[1] marquis de Biron (ca. 1860–1939); his sale, Galerie Georges Petit, Paris, June 9–11, 1914, lot 12; purchased by Oscar Stettiner; Gabriel Cognacq (1880–1951), 1939; his estate sale, Hôtel Drouot, Paris, June 11–13, 1952, lot 49; Sacha Guitry (1885–1957), Paris, by 1954; his sale, Hôtel Drouot, Paris, November 24, 1972, lot 22; purchased by Henri Baderou (1910–1991); Jacques Seligmann & Co., New York; acquired by the Art Institute of Chicago, 1973

REFERENCES: Arlette Sérullaz in Schnapper and Sérullaz 1989, cat. 138, p. 309; Lajer-Burcharth 1994, p. 224 fig. 39a, pp. 226–28, 236–37, 241; Lajer-Burcharth 1999, p. 89 fig. 39, pp. 100–105, 108, 114–15, 117–19, 321 n. 48; Rosenberg and Prat 2002, vol. 1, no. 148, p. 166; Prat 2011, pp. 53–54, fig. 94

## 60. *Portrait of a Man*

1795
Pen and black ink, brush and gray wash, over traces of black chalk
Diam. 7⁵⁄₁₆ in. (18.5 cm)
Inscriptions: lower right, in pen and brown ink, signed "L. David"; on
the back of the old frame, "Mirabeau représentant du people à la
Convention nationale peint à l'encre de Chine par son collègue David,
dans la prison des quatre-nations à Paris le 28 messidor l'an de la
Rep. française unie et indivisible."
Private collection, New York

PROVENANCE: Sale, Koller, Zurich, May 20–21, 1977, lot 5094; private
collection, Switzerland; private collection, New York

REFERENCES: Bordes 1983, p. 184; Lajer-Burcharth 1999, pp. 89, 94
fig. 44, pp. 100-101, 115, 118, 320–21 nn. 45, 48; Rosenberg and Prat
2002, vol. 1, no. 149, p. 167; Prat 2011, p. 54

## 61. *Portrait of Bernard de Saintes*

1795
Pen and black ink, brush and gray wash, heightened with white
gouache, over black chalk
Diam. 7⅛ in. (18.2 cm)
Inscriptions: lower right, in pen and black ink, signed "L. DAVID"; on
the back of the mount, in pen and brown ink, "Bernard, de Saintes
représentant du people français à la Convention Nationale, peint par
son collègue David avec de l'encre de la chine, dans la maison d'arrêt
des Quatre-Nations à Paris le 6 Thermidor an III de la République"; in
black chalk, "14"; on the etiquette on the back of the mount, "André
Antoine Bernard né le 21 juin 1751 à Corme Royal, avocat au Présidial
de Saintes Député à l'assemblée legislative le 29 août 1791, à la
Convention Nationale le 14 7.bre 1792. Mort à Funchal, ile Madere en
1818. Enfermé a la prison des quatre-nations du 28 mai 1795 au 26
octobre. Le peintre David détenu avec lui fit ce portrait."
J. Paul Getty Museum, Los Angeles (95.GB.37)

PROVENANCE: André Antoine Bernard des Jeuzines, called Bernard de
Saintes (1751–1818); by descent in his family; Mr. Mignet (per Hazlitt);
sale, Château du Pinier, Charente-Maritime, July 10–11, 1927, lot 89;
sale, Groupe Gersaint, Pavilion Josephine, Strasbourg, June 20,
1989, lot 10; Hazlitt-Gooden and Fox, Ltd., London, 1990; Leonardo
Mondadori, Italy; acquired by the J. Paul Getty Museum, 1995

REFERENCES: Lajer-Burcharth 1994, pp. 224 fig. 39b, 226–28, 241;
Lajer-Burcharth 1999, pp. 89–91, fig. 40, pp. 100, 102–4, 115–17, 119,
321 n. 48; Turner 2001, no. 63, pp. 179–81; Rosenberg and Prat 2002,
vol. 1, no. 150, p. 168; Prat 2011, p. 54, fig. 95

## 62. *Portrait of Barbau du Barran*

1795
Pen and black ink, brush and gray wash, over traces of black chalk
Diam. 7⅜ in. (18.7 cm)
Inscriptions: lower left, in pen and black ink, signed "L. David"
Private collection, New York

PROVENANCE: Joseph Nicolas Barbau du Barran (1761–1816); by descent in his family; sale, Strasbourg, November 17, 1989, lot 207; Banque Nationale de Paris, Finacor-Art collection, 1991; sale, Christie's, New York, January 28, 1999, lot 171; W. M. Brady & Co., New York; private collection, New York

REFERENCES: Lajer-Burcharth 1994, pp. 226, 240; Lajer-Burcharth 1999, pp. 89, 91 fig. 41, pp. 100, 108–9, 115, 117; Rosenberg and Prat 2002, vol. 1, no. 151, p. 169; Prat 2011, p. 54

## 63. *Portrait of Thirius de Pautrizel*

1795
Pen and gray ink, brush and gray wash, over black chalk, heightened with white gouache
Diam. 7⁹⁄₁₆ in. (19.2 cm)
Inscriptions: lower right, in pen and black ink, signed "L. David"; on the mount, in pen and brown ink, "THIRUS DE PAUTRIZEL – Capitaine de Cavallerie en 1785, Représentant de la NATION FRANÇAISE en 1794 et 1795."
National Gallery of Art, Washington, D.C., Gift of Walter H. and Leonore Annenberg, in Honor of the 50th Anniversary of the National Gallery of Art (1990.47.2)

PROVENANCE: George Gairac, Paris; Wildenstein & Co., New York, 1957 to at least 1961; Curtis O. Baer (1898–1976), New Rochelle, N.Y.; by descent to his son and daughter-in-law, Dr. and Mrs. George M. Baer, Atlanta; acquired by the National Gallery of Art, Washington, D.C., 1990

REFERENCES: Zafran 1985, cat. 66, p. 117; Arlette Sérullaz in Schnapper and Sérullaz 1989, cat. 134, p. 303; Lajer-Burcharth 1994, pp. 226, 240 n. 15; Lajer-Burcharth 1999, pp. 89, 92 fig. 42, pp. 100–101, 103–4, 116–17; Rosenberg and Prat 2002, vol. 1, no. 152, p. 170; Grasselli 2009, cat. 113, pp. 262–63, 291; Prat 2011, p. 54

The arrest of Maximilien Robespierre on 9 Thermidor, Year II (July 27, 1794), followed by his execution the next day, set off a period of upheaval and peril for the Jacobin deputies who had been his close allies during the Terror. As a staunch supporter of the new Republic, who had organized its festivals, designed its costumes, and glorified its martyrs, David was among those targeted by the Thermidorian Reaction, as this time of recrimination was known. He was imprisoned twice: first, during the summer and fall of 1794, in the Hôtel des Fermes, before being moved to the Hôtel du Luxembourg, and then again, in 1795, following the uprising on 1 Prairial, Year III (May 20, 1795), at the former Collège des Quatre-Nations. Throughout both periods of incarceration, he continued to paint and draw, and it is through these works, his "prison opus," to use the term of Ewa Lajer-Burcharth,[2] that we can take the measure of his response to this personal and political crisis.

It was during his second imprisonment that David carried out his most singular and haunting achievement as a draftsman: a series of portraits of his fellow prisoners in the form of circular medallions. Shown bust-length and in profile, the sitters are recorded in exquisite and clear-eyed detail, stripped of extraneity. The series displays a supreme control over the pen-and-ink line and nuanced gradations of wash rarely seen in David's graphic oeuvre. Although only about half of the sitters have been firmly identified, it is assumed that they all represent fellow Jacobin deputies of the National Convention, called Montagnards ("mountain people") in reference to the high seats allocated to them in the convention hall. In prison they seem to have formed a fraternal community, living in proximity to each other, taking meals together, and pleading their cases to the authorities. By the autumn this group of former dignitaries, responsible for dispatching many of their fellow citizens to the guillotine during the Terror, would all be released, but that outcome was far from certain at the time the portraits were made.[3]

As recently as 1989, when the major David retrospective was mounted at the Musée du Louvre, Paris, and the Château de Versailles, the portrait medallions had

not yet been recognized as a series. Only the *Portrait of Jeanbon Saint-André* (cat. 59) and the *Portrait of Bernard de Saintes* (cat. 61), which had just appeared at auction in Strasbourg, had inscriptions linking them to the artist's incarceration at Quatre-Nations.[4] It was Lajer-Burcharth, first in her 1992 dissertation, then in later publications, who expanded the group with works that had recently come to light and others that had been incorrectly dated, to propose the portrait medallions as a larger, and largely coherent, enterprise.[5] In their catalogue raisonné of 2002, Pierre Rosenberg and Louis-Antoine Prat added to the eight published by Lajer-Burcharth in 1999 a portrait of an unidentified revolutionary with a *cocarde tricolore* (a symbol of the French Republic) pinned to his hat (cat. 58). Executed in pen and ink and modeled with hatching rather than wash, it stands apart from the rest of the group in terms of technique, but an inscription on an etiquette pasted on the back of the mount states explicitly that it was drawn by David in less than twenty minutes, on his knees, in Quatre-Nations on 3 Messidor, Year III (June 21, 1795). The date positions it, to the best of our present knowledge, as the earliest of the prison

Fig. 117. Jacques Louis David, *Portrait of Philippe Lebas*, ca. 1793–94. Pen and brown ink, Diam. of original sheet 6 in. (15.2 cm). Private collection

Fig. 118. Louis Lafitte (1770–1828), *Portrait of a Man,* 1793. Conté crayon, heightened with white chalk, Diam. 9¾ in. (24.8 cm). The Metropolitan Museum of Art, New York, Purchase, Guy Wildenstein Gift, 2012 (2012.42)

portraits, presumably executed before the idea of a series had solidified and a visual uniformity been imposed. The sheet also offers a stylistic bridge to a recently discovered, earlier portrait roundel in a similar technique depicting Philippe Lebas (fig. 117), a deputy to the National Convention and close friend of Robespierre's who committed suicide on the day of Robespierre's execution.[6]

Of the nine portraits known today, considered to represent a "fraternal suite,"[7] four (cats. 59, 61–63) are identified with certainty. Four others (not the same ones) bear specific dates.[8] They are all about 7 to 7½ inches (18–19 centimeters) in diameter and are, for the most part, signed. Seven are on similar circular mounts, with a green-wash border and gold filet. Five sitters face right and four face left. Three wear hats and four cross their arms. Subtle distinctions hint at their psychological states. In one instance (cat. 62), the sitter is set against a stone wall, evoking confinement, while another sitter (cat. 60) has a cloudy sky as his backdrop, suggesting freedom and boundless space.

The sitters are all presumed to be Montagnards, thirteen of whom were imprisoned at the same time as David. Among the four whose identities are certain, André Jeanbon Saint-André (cat. 59), André Antoine Bernard des Jeuzines, called Bernard de Saintes (cat. 61), and Joseph Nicolas Barbau du Barran (cat. 62) were all arrested on the same day as David. When they were taken to Quatre-Nations, they joined the already incarcerated Jean-Baptiste Louis Thirius de Pautrizel (cat. 63), who had been detained three days earlier.[9] They came from different walks of life: Jeanbon Saint-André had been a Huguenot pastor, Bernard de Saintes and Barbau du Barran had been lawyers, and Thirius de Pautrizel, according to the inscription on the mount, had been a captain in the French cavalry.[10] Scholars have proposed identities for some of the other portraits, based on their resemblance to individuals whose names are present on lists of known prisoners, although the long-held belief that the *Portrait of a Man, Called Saint-Estève Père* was the artist's self-portrait has come into question in recent years.[11]

By opting for precisely rendered profile portraits in circular compositions, David adopted a format rich in precedents and associations.[12] With its origins in the coins and medals of the classical world, the portrait medallion saw a revival in the eighteenth century, led initially by the antiquarian taste that flourished in the 1740s and persisted, in evolving forms, in the decades that followed. Medallions were popular as cast or carved reliefs and were also a common format for portrait engravings. Limiting ourselves to drawings, we can cite the impact of the prolific Charles Nicolas Cochin II, whose carefully controlled chalk portraits captured many of the luminaries of his day in profile against blank backgrounds, endowing their likenesses with a timeless dignity. Profiles were not conducive to narrative or nuance but, rather, suggested a calm, empirical observation, which appealed to Enlightenment sensibilities. Augustin de Saint-Aubin, like Cochin a draftsman and printmaker, continued in this popular vein, often highlighting Rococo fashions and adding touches of watercolor. Louis Roland Trinquesse, who preferred red chalk, saw the portrait medallion as suitable for male sitters.[13] Jean Honoré Fragonard adopted the format for an informal series of family portraits around 1786–88.

Like portrait miniatures, Fragonard's diminutive medallions conjure up an intimate and sentimental function.[14] Pre-revolutionary examples in David's own oeuvre hewed closely to these precedents. *A Young Woman of Frascati* (cat. 5) used the profile format to focus on the picturesque attire of the sitter, and he also occasionally drew black chalk portraits of stylish women in the form of medallions in the early 1780s.[15]

If the sitters depicted by Cochin and Saint-Aubin during the ancien régime had often been highly placed and accomplished individuals or the friends and intimates of the artist, a far broader swath of society came to embrace the portrait medallion in the early years of the revolutionary era. Several series of engraved portraits were commissioned to portray the representatives to the newly elected body of the National Assembly.[16] The format, strongly associated with ancient Rome, would have been considered apt for capturing and disseminating the effigies of these officials. Egalitarian in their unembellished uniformity, profile portraits had also recently become more accessible through the physionotrace, a mechanical device that democratized the process of accurately capturing a silhouette.[17] For Philippe Bordes, the shedding of the social pretensions of the portraits of Cochin and Saint-Aubin opened the door to a new immediacy of presence in the revolutionary period, eventually putting portraiture on the path to greater naturalism.[18] These qualities begin to emerge in works predating David's prison portraits, as can be seen, for instance, in a pen-and-wash portrait roundel drawn by Louis Lafitte, a *pensionnaire* in Rome in 1793, representing perhaps a friend or fellow student (fig. 118).[19]

By contrast, many of the portraits created by imprisoned artists during the Terror had made a more direct emotional appeal. Hubert Robert's output during his incarceration presented the quotidian life of the prisoner through interior scenes, akin to genre subjects. In the case of his self-portraits, he showed himself working diligently, his cell converted to a studio, drawings tacked to the walls.[20] In a wrenching set of painted portraits, David's one-time rival Joseph Benoît Suvée portrayed several of David's former friends and patrons in frontal and three-quarter poses.[21] Among them was Charles Louis Trudaine de Montigny (fig. 119), whose appeal for mercy David had rejected, and who would be beheaded not

Fig. 119. Joseph Benoît Suvée (1743–1807), *Portrait of Charles Louis Trudaine de Montigny*, 1794. Oil on canvas, 23⅝ × 19⅛ in. (60 × 48.5 cm). Musée des Beaux-Arts, Tours (INV. 2012-1-1)

long after he sat for Suvée. Ironically, they were bound together by Trudaine's commission of *The Death of Socrates* (cat. 35), a painting lauding a principled man about to die in prison.

Thus, David, by choosing the form of the profile medallion to portray his fellow fallen Montagnards, was consciously harking back to portraits that glorified revolutionary heroes and "representatives of the people," as deputies to the National Convention were called, thereby asserting their claim to these titles and the legitimacy they conferred. As such, the medallion portraits are aligned with the letters and written defenses produced by the imprisoned deputies to plead their innocence—or, in the case of David, to argue for his potential future usefulness as an artist.[22] However, as Lajer-Burcharth has described, there is an inherent destabilizing tension between the "historicizing decorum" of the medallion format and the psychological specificity with which each sitter is rendered.[23] Fear and defiance alike register in the tightly crossed arms, the dark shadows cast by the brims

of hats, the gazes averted from the viewer and focused into the void beyond the picture frame. Meanwhile, every fold and crease of their clothing, every dangling button and off-center cravat, is delineated with minute exactitude and serves as a poignant reminder of the sitter's prior status. In this context, the closely cropped, circular format, ostensibly a mode of glorification based on antique prototypes, acts simultaneously as a form of claustrophobic confinement, underscoring the captivity of the sitters.

Ultimately, the Montagnards imprisoned at Quatre-Nations were all released, and David must have presented the drawings as gifts to the sitters, as several turned up in the possessions of their descendants.[24] Some of the mounts bear inscriptions that were likely added in their early days of liberty. The inscription on the sheet in the Art Institute of Chicago (cat. 59), for instance, reads, in Latin, "Gift of friendship. Solace of love. Made by David in chains."[25]

Chains, it should be said, make appearances throughout David's oeuvre, sliding back and forth between the metaphorical and the actual. In a student *académie* (cat. 3), a standing male nude drags a heavy chain in his right hand, anticipating the pose of the cupbearer in the first version of *The Death of Socrates* (cat. 31). The prominence of the chain and shackles in *The Death of Socrates* (cat. 35) serves to highlight the prisoner's nobility of spirit, a theme that reappears in the work of David's students, for instance, Jean Germain Drouais's *Marius at Minturnae* (see fig. 97).[26] In a drawing made shortly after the Revolution for a commission from the city of Nantes (cat. 49), broken chains symbolize freedom from oppres-

sion. And late in life, during his exile in Brussels, David was clearly still haunted by the motif of the prisoner, represented in a sketch (cat. 81) as a generic figure, and identified only by the chain and lamp, emblems of captivity and darkness.

At the same time, the words *chains* ("chaines" or, in Latin, "vinculis," as inscribed on the mount of the Chicago sheet) and links ("liens") have double meanings, signifying not only bondage but also social bonds.[27] Liberty, the opposite of captivity, was of course the symbol of the young Republic. It was the word David chose to inscribe, likely after the early events of the Revolution, on the strap of the Phrygian cap on one of his studies for *Brutus* (cat. 44). David himself uses these words metaphorically in the *Réponse* he wrote in prison. To describe his connection to the students he had trained, he wrote,

The students that I teach, these young artists, in whom I will see myself reborn, have expressed to me that filial piety binds the student to his teacher by chains as strong as blood ties, since they are linked to the noblest sentiments of the human heart.[28]

Bonds and bondage are thus inexorably interconnected in David's images of his fraternity of fellow imprisoned deputies, where we see play out in the sitters' expressions a battle between resilience and anxiety, pride and contrition. For David, the conditions of confinement gave rise to a novel variant on the portrait roundel—contained and highly finished. They appeal to posterity while also laying bare the uncertainty of the moment.   PS

# THE INTERVENTION OF THE SABINE WOMEN

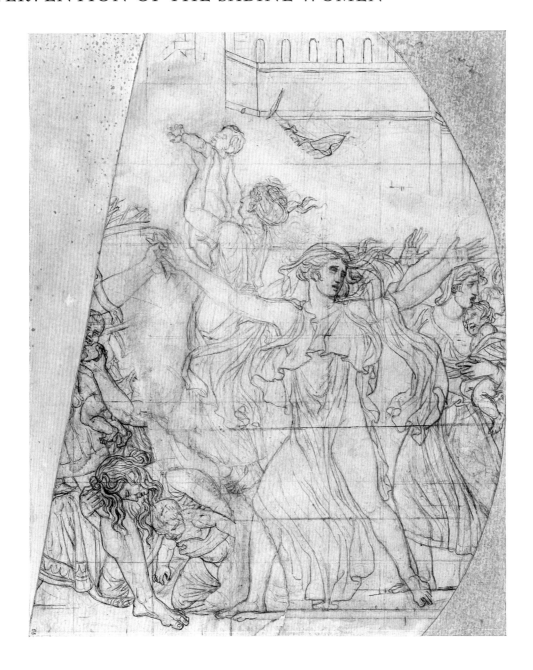

## 64. *Hersilia Surrounded by the Sabine Women and Their Children*

Ca. 1795
Black chalk, reworked in areas in pen and brown ink, squared in black chalk, irregularly cut
11¹⁵⁄₁₆ × 9¹⁄₁₆ in. (30.3 × 23 cm)
Marks: lower left, in black ink, collector's mark of marquis Philippe de Chennevières (Lugt 2073)
Palais des Beaux-Arts, Lille (W. 3494)

PROVENANCE: Collection sale of Diaz le fils (per Chennevières); marquis Philippe de Chennevières (1820–1899); his second sale, Hôtel Drouot, Paris, April 4–7, 1900, part of lot 591; sale, Hôtel Drouot, Paris, February 9, 1972, lot 13; acquired by the Palais des Beaux-Arts, Lille

REFERENCES: Arlette Sérullaz in Schnapper and Sérullaz 1989, cat. 153, pp. 348–49; Ann H. Sievers in Sievers, Muehlig, and Rich 2000, pp. 118–19, fig. 4, under cat. 27; Rosenberg and Prat 2002, vol. 1, no. 164, p. 180; Prat and Lhinares 2007, cat. 1336, p. 555; Mayer 2018, pp. 241–42, fig. 9

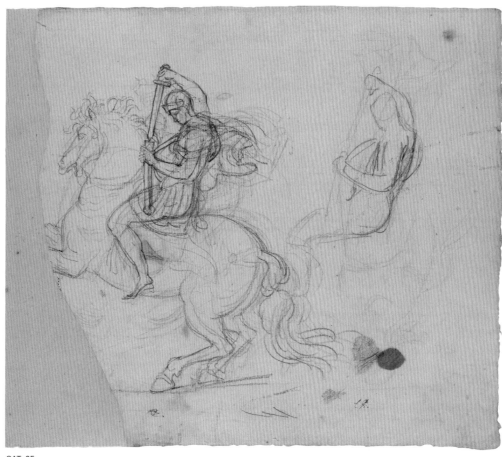

CAT. 65

## 65. *Warrior on Horseback, Sheathing His Sword*

Ca. 1796
Black chalk
9¹³⁄₁₆ × 11⁵⁄₁₆ in. (25 × 28.8 cm)
Marks: lower right, paraph of Jules David (Lugt 1437); lower left, paraph of Eugène David (Lugt 839)
Nationalmuseum, Stockholm (NM 111/1969)

PROVENANCE: As part of Roman album no. 3: David estate sale, Paris, April 17, 1826, and following days, part of lot 66, unsold; to David's wife, Marguerite Charlotte David, née Pécoul (1764–1826); second David estate sale, Paris, March 11, 1835, part of lot 16; acquired by baron Louis-Charles Jeanin (1812–1902), David's grandson; by descent to the marquis and marquise (baron Jeanin's granddaughter) de Ludre-Frolois; her sale, Galerie Charpentier, Paris, March 15, 1956, part of lot 11, unsold; their daughters, marquise du Lau d'Allemans and comtesse de Chaumont-Quitry, Versailles; acquired by Germain Seligman of Jacques Seligmann & Co., New York, 1958; acquired by the Nationalmuseum, Stockholm, 1969, after which the album was dismembered and the drawings mounted separately

REFERENCES: Rosenberg and Prat 2002, vol. 1, no. 576, p. 470

## 66. *Kneeling Sabine, Lifting a Nude Infant*

Ca. 1796–97
Graphite, black chalk, stumped, heightened with white, squared in graphite
20¹³⁄₁₆ × 16⁵⁄₈ in. (52.8 × 42.3 cm)
Marks: lower right, paraph of Eugène David (Lugt 839); collection mark (not in Lugt) and blind stamp (Lugt 3167) of the Musée de la Chartreuse
Musée de la Chartreuse, Douai (INV. 462)

PROVENANCE: David estate sale, April 17, 1826, and following days, part of lot 98; acquired at that sale by Théophile Bra (1797–1863); his gift to the Musée de la Chartreuse, 1852

REFERENCES: Arlette Sérullaz in Schnapper and Sérullaz 1989, cat. 156, pp. 352–53; Rosenberg and Prat 2002, vol. 1, no. 170, p. 184; *Jacques-Louis David* 2005, cat. 47, pp. 124–25

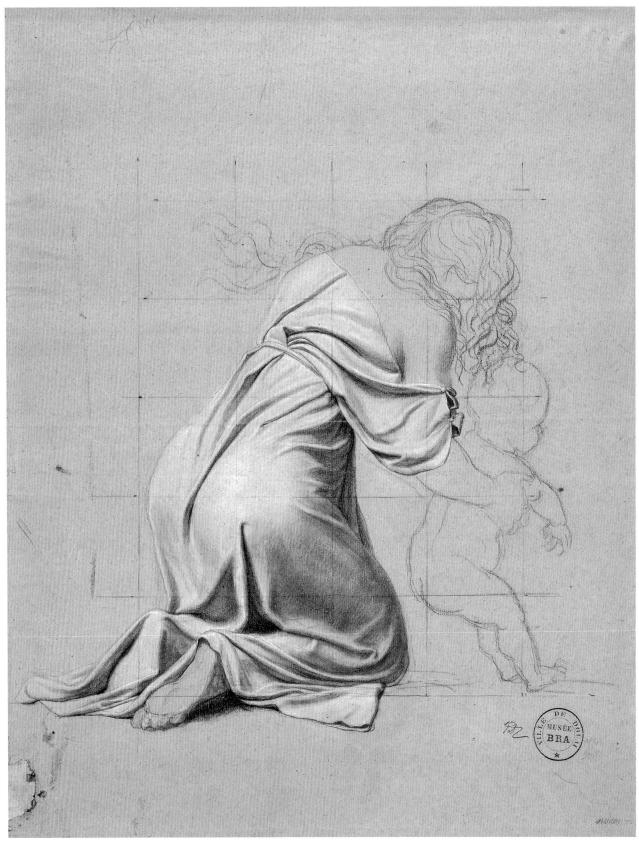

CAT. 66

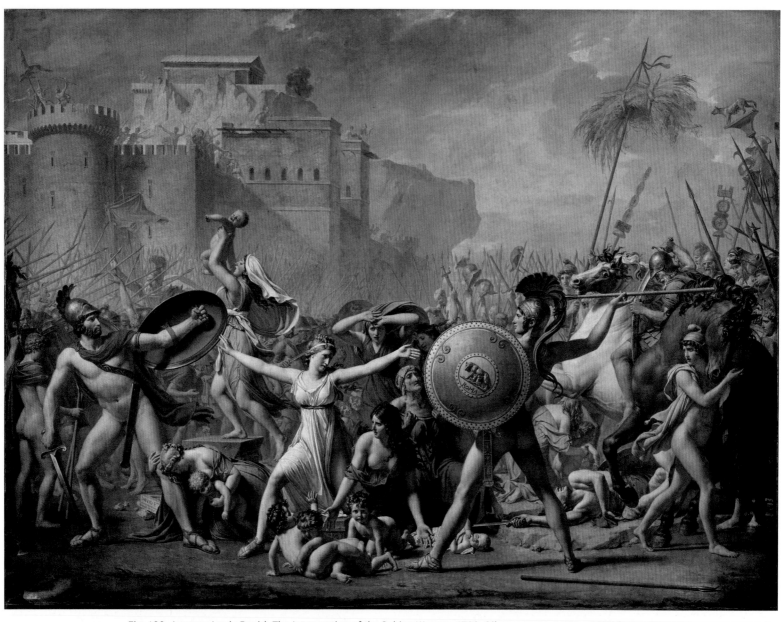

Fig. 120. Jacques Louis David, *The Intervention of the Sabine Women*, 1799. Oil on canvas, 151⅝ × 205½ in. (385 × 522 cm). Musée du Louvre, Paris (INV. 3691)

Few of David's great masterpieces have elicited such a broad range of interpretive perspectives as *The Intervention of the Sabine Women* (fig. 120), his first ambitious history painting of the post-revolutionary period. Inscribed on the canvas is the date "1799," a year marking the end of a creative process that began in a prison cell in 1794, after the fall of Robespierre; accelerated after David's release in 1795; and continued throughout the Directory. The picture finally went on public view, with state support and to clamoring crowds, in December 1799, barely a month after Napoleon had declared himself first consul. The drawn studies that chronicle this creative process are of special significance, as the intentions of the artist must certainly have evolved, and the subject taken on new inflections, over the course of a tumultuous five years during which an unsettled society sought its footing.

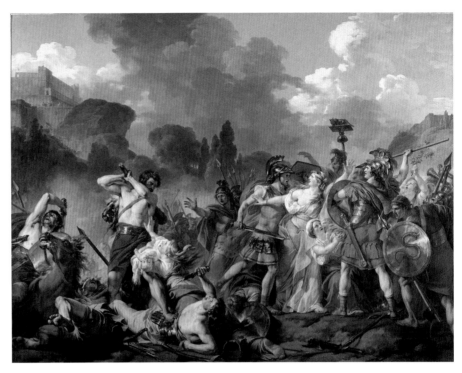

Fig. 121. François André Vincent (1746–1816), *The Intervention of the Sabine Women*, 1781. Oil on canvas, 128 × 166½ in. (325 × 423 cm). Musée des Beaux-Arts, Angers (2013.22.53)

The subject, much less common than the abduction of the Sabine women, focuses on the reconciliation of warring tribes, a theme that would have had obvious appeal in the wake of the Terror, a raw moment when a society riven by violence needed to find a way forward. For David, who had built his reputation as a history painter in the 1780s but then put his skills to the service of the young French Republic—commemorating contemporary events, memorializing martyrs, designing festivals and costumes—*The Intervention of the Sabine Women* signaled a return both to the genre that had first brought him fame and to the founding myth of ancient Rome, which would prove a lifelong interest.

Three years after the abduction of their daughters and sisters, the Sabine men attacked Rome in retaliation.[1] A white-clad Hersilia, daughter of the Sabine king, occupies the center of David's composition. She lunges forward, her pale arms extended in a gesture that immobilizes the leaders of the two warring tribes: at left, her father, Tatius, and at right, her husband, Romulus, the legendary co-founder of Rome. After three years, the Sabine women have married Roman husbands and borne their children.

David shows them rushing onto the battlefield to thrust their babies before the soldiers as proof of their familial bonds.[2] In response to Hersilia's emotional entreaty, the men are overcome with pity, dropping their bloody daggers, resheathing their swords, and removing their helmets. But the peace taking hold has not yet permeated the battlefield. Behind the foreground tableau, the fighting rages on, indicated by a bristling band of spears in the midground and violent combat atop the ramparts of Rome in the distance. Just beyond looms the Tarpeian Rock, named for Tarpeia, who opened the city gates to the Sabines, betraying her city for the promise of wealth.

It was in the Luxembourg prison, without a commission and with his future uncertain, that David began sketching ideas for *The Intervention of the Sabine Women*. We have direct accounts of the intermittent and extended genesis of David's painting from two of his former pupils, Pierre Maximilien Delafontaine and Etienne Jean Delécluze.[3] Supplied with drawing and painting materials but deprived of liberty,[4] it would seem that the germ of the composition came from David's memory of a picture exhibited by his contemporary and rival, François André

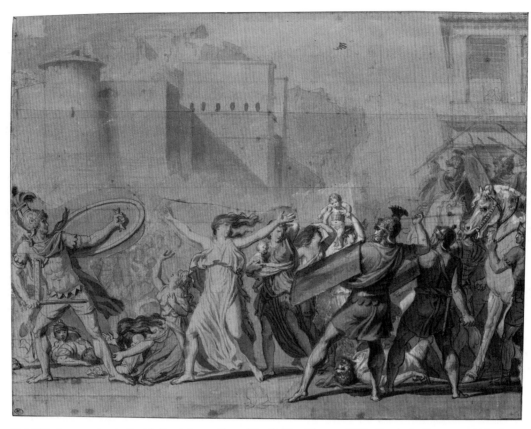

Fig. 122. Jacques Louis David, *The Intervention of the Sabine Women*, 1794. Black chalk, pen and black ink, brush and gray wash, heightened with white, 10⅛ × 13⅜ in. (25.7 × 34 cm). Musée du Louvre, Paris (RF 5200)

Vincent, at the Salon of 1781 (fig. 121).[5] Vincent's version of the subject, bright and operatic, is far removed from the neutral palette and frozen action of David's canvas, but one can see that certain elements, deconstructed and then reconstructed anew, made their way into David's composition: the Tarpeian Rock and ramparts in the background; the device of a single baby gazing tranquilly at the viewer; and, most critically, the central grouping of Tatius, Hersilia, and Romulus, who, if separated and repositioned farther apart, would prefigure their arrangement in David's version.

Indeed, the arrangement of the protagonists and secondary figures would be David's central obsession after his release from prison as he fine-tuned his composition through multiple iterations. The earliest known compositional study (fig. 122) is constructed from studies of individual figures and figural groups cut out and pasted down onto a new support.[6] David presumably did so to

work out their exact placement relative to one another, as has been discussed previously by scholars, including Antoine Schnapper in 1989 and Ewa Lajer-Burcharth, who, in 1991, used the phrase "cut-and-paste" to describe this working method.[7] It was a technique that David turned to throughout his oeuvre, deployed in a range of ways and for various reasons. It may have been the act of cutting close to a thousand sketches from his Roman sketchbooks and reassembling them onto new supports that made David comfortable taking scissors to his own creations. He also used cut-and-pasted pieces of paper to alter figures, details, and areas of compositions beginning in the early 1780s and continuing through the revolutionary period, as seen in works such as his *première pensée* (initial idea) for *The Death of Socrates* (cat. 31), his composition study for the *Allegory of the Revolution in Nantes* (cat. 49), and his studies for *The Oath of the Tennis Court* (cats. 50–53).[8] But working in prison, perhaps with limited supplies of

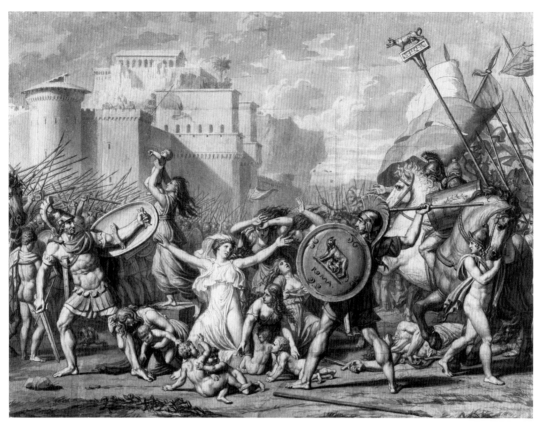

Fig. 123. Jacques Louis David, *The Intervention of the Sabine Women*, 1795. Pen and black and brown ink, brush and gray wash, heightened with white, over black chalk, 18¾ × 25¹⁄₁₆ in. (47.6 × 63.6 cm). Musée du Louvre, Paris (INV. 26183)

paper, David deployed what had previously been a sparer, more infrequent use of collage to create an entire stage of the present design's evolution. The steps and scale of the process are elucidated by the transmitted-light images published and analyzed by Tamar Mayer in 2018.[9]

In the study he made in prison, David, like Vincent, presents the male warriors clothed, a choice he would later renounce in favor of the greater authenticity of classical nudity.[10] He arrayed his figures in a bas-relief-like plane and surrounded Hersilia with a chorus of young mothers. However, the traditionally held idea, following an inscription on the mount by the sheet's first owner, that the drawing is the artist's *première pensée* is demonstrably inaccurate, as it is assembled from pieces cut from earlier drawings.[11] Still, accepting that its theme and strategy were established during his imprisonment, David's quest for perfecting the composition would go on for years. One of his main preoccupations was the group of women who

surround Hersilia. For their disheveled appearances and poses of grief and distress, David looked to precedents in Italian Renaissance painting, as made clear in the small sketches that fill his sketchbooks.[12] From these prototypes he would assemble Hersilia's supporting cast, who would encircle her in the final canvas, wedged in like tightly fitting puzzle pieces. His testing out of these groupings can be seen in linear studies such as *Hersilia Surrounded by the Sabine Women and Their Children* in Lille (cat. 64), itself a fragment of what was once a larger work. The drawing is squared in black chalk to facilitate transfer, but there are variable levels of finish within the sheet itself. Certain figures may have been transferred from earlier studies, their poses already established; others, like the woman lifting her baby aloft, is sketched freehand, with evidence of pentimenti. Some forms have their contours firmly delineated in ink, while others are left simply in chalk. The date proposed in the 2002 catalogue

raisonné—"probably mid-1796"—cannot be right if the Louvre's second composition study (fig. 123) dates to late 1795,[13] for this one must precede it. The woman holding a baby at the right edge of the sheet, carried over from the first Louvre study (fig. 122), will be dropped in the second, as will be the partially effaced woman at center left whose baby is cropped by the trimming of the sheet. Retained but altered will be the woman who, in the Lille sheet, stands atop a block to lift her baby but is not yet shown in motion (in the process of stepping up). The shape of the sheet is difficult to explain. The prominent tear at bottom center appears accidental, and the angled and curved trimming of the sides has no apparent compositional logic.[14]

The Lille study must date to the fall of 1795, when David, released from his second imprisonment began preparing the picture in earnest. According to his student Delafontaine, it was during this period that he assisted his master by researching engravings in the Bibliothèque Nationale and by helping him prepare a "large drawing" (often assumed to be the large compositional study in the Louvre, fig. 123) by tracing certain figures and sketching in others under David's watch, a process done with care in order to transfer the design to canvas.[15] This description of developing the complex, multifigured composition through a process of iteration—carrying over individual parts from previous studies and redrawing others—aligns with evidence seen in many other surviving studies, although not necessarily the second Louvre sheet, which was assembled, like the earlier version done in prison (fig. 122), from studies cut and pasted from existing sheets. In February 1796, David was granted temporary use of a studio in the Louvre in order to execute the *Sabines*.[16] When the German writer Friedrich Johann Lorenz Meyer visited in April, he described the composition as being already sketched in on the canvas, and Delécluze recalled that in October of that year, the figures of Tatius and the woman kneeling at his feet were already painted in.[17] However, the exact sequence of events remains murky, as there are numerous significant differences between the second Louvre study and the painting, suggesting either that there is a lost intermediary compositional study or that many changes were made in the course of completing the canvas.[18]

In the brochure distributed to viewers when the painting was exhibited, David would not only quote the plaintive entreaties of the Sabine women from Plutarch's *Life of Romulus*, but also catalogue the "signs of peace" visible in the actions of the warriors.[19] One of these, "the cavalry general putting his sword back in his scabbard," appeared late in the design process. The initial idea for this figure was sketched on a page of one of his Roman albums in two quickly executed reprises (cat. 65).[20]

Finally, as the last stage of drawn preparatory works, David made large-scale, delicately rendered drapery studies, as he had for his history paintings in the 1780s (see cats. 23, 24, 48). None is known for the male protagonists, whom David had decided by this point to depict nude or with very minimal drapery,[21] but four survive for female figures, including the *Kneeling Sabine, Lifting a Nude Infant* in Douai (cat. 66). The figure appears in the painting but is not included in any surviving compositional study, so it must have been a fairly late addition.[22] Tales of beautiful society women vying to pose for certain figures have become part of the picture's legend, and, indeed, the filmy draperies worn by David's Sabines and the unstructured white gowns fashionable during the Directory are not unrelated.[23] Although the *Sabines* project may have represented the last instance of David making this type of drapery study, the practice certainly influenced his students. Sérullaz described them as anticipating the suppleness of Ingres's studies for Stratonice,[24] and one also thinks of the tactile appeal of the blended studies of Girodet.

After a five-year pause from history painting, the preparation of the *Sabines* had David returning to many of his past habits: choosing classical subjects with contemporary resonance; looking to earlier art for inspiration; using drawings to refine figural poses and groups through multiple iterations; and, finally, making drapery studies from life. It must have been the dramatically multiplied cast of characters, however, that pushed the artist to expand his use of cutting apart and rearranging the components of his composition as he sought to solve ever-more complicated spatial puzzles. In 1897 Philippe de Chennevières, who owned the Lille study, penned an apt characterization of David's working process: "During the course of the laborious preparation of his large painting, David never stopped rotating and flipping, compressing and rearranging each group, especially the principal ones."[25]  PS

# The Napoleonic Era, 1799–1816

In December 1799, after five years of work, David's massive canvas depicting *The Intervention of the Sabine Women* went on view in the Louvre, where it would be seen by hordes of paying visitors. The critic Pierre Chaussard, a champion of the artist, laid out in clear terms the picture's metaphorical message of national reconciliation following a period of strife.[1] If the exhibition signaled redemption for an artist who had been a regicide and an ally of Robespierre, it occurred against a dramatically altered landscape. The subject of the *Sabines* had been conceived in a jail cell, then executed with the help of students over the span of the Directory, before being unveiled to the public shortly after Napoleon Bonaparte, a young Corsican-born general, had effected a coup d'état, installing himself as first consul and submitting a new constitution.

Without the advantage of lineage or wealth, Bonaparte had gained power by rising through the military ranks, racking up battlefield and diplomatic victories. Ambitious and confident, he fashioned himself heir to the Republic. In a symbolic gesture meant to make this association clear, he asked David in 1800 to have the bronze Capitoline bust of the first Roman consul, Brutus, spolia from his recent Italian campaign, brought to his study at the Tuileries Palace. Bonaparte would increasingly see the arts as a way to build and consolidate power, carefully crafting and burnishing his image. Dominique Vivant Denon, the first director of the Louvre, rechristened the museum the Musée Napoléon in 1802 as the collection swelled with masterpieces looted during the French army's foreign conquests. As his political persona evolved, Bonaparte would gradually adopt the pomp and luxury of earlier monarchical regimes to message his own power.

Whatever David's true feelings on the shifting political tides, it must have been evident to him that the path to glory would, going forward, lead through Bonaparte's favor and patronage. His first major contribution to the project of lionizing France's new leader was *Bonaparte Crossing the Alps* (fig. 124), a large equestrian portrait of the first consul commissioned in 1800 by King Charles IV of Spain to court favor with the new regime. An emblem of élan and confidence, it showed the young general atop a rearing horse, wrapped in a swirl of glittering military regalia as he led the army across the Saint Bernard Pass in May 1800. For all its golden-lit magnificence, it was essentially a demonstration of David's ability to mine established visual forms and motifs in order to transform current events into iconic images. In fact, David had not witnessed the event, the sitter had not posed for him, and the animal that bore Bonaparte across the Alps was not a dappled horse with flowing mane but, rather, a mule. Over the next few years, David would paint at least four replicas of the picture for Bonaparte, all with slight variations, to be sent to different locations. His achievement was recognized in 1803 when he was awarded the Legion of Honor, a distinction Bonaparte had established the year before.

Bonaparte's quest for power marched on. In 1802 he declared himself "consul for life." A new constitution was adopted, and in 1804 a civil code—later referred to as the Code Napoléon—was enacted into law, formalizing many civil and property rights that had come into being at the time of the Revolution, when the grip of feudal, ecclesiastical, and royal control was broken. The ascendency of the bourgeois upper middle class was thus affirmed. In May 1804, Bonaparte would be named emperor, and henceforth be known simply as Napoleon.

The transformation of the French state into an Empire was marked by a number of opulent events and ceremonies. David, who had yearned for official recognition of his artistic preeminence, was given the important assignment of recording these events in a suite of four immense canvases, a commission apparently awarded verbally by Napoleon himself. The coronation took place in the cathedral of Notre-Dame on December 2, with

the pope and a vast array of dignitaries in attendance. With costumes and decor designed by David's former student Jean-Baptiste Isabey and the architectural team of Charles Percier and Pierre François Léonard Fontaine, the Gothic setting was given a temporary veneer of the glittering Empire style. The assembly of attendees, the majority of whom would be individually recorded with care by David, amounted to a cataloguing of the newly minted imperial nobility. The authority of the emperor occupied the apex of a reordered social hierarchy.

In recognition of the importance of the commission, which, as much as the grandeur of the events themselves, would commemorate the legitimacy of the new regime for posterity, David was named first painter to the emperor on December 18. He soon started planning the composition and making sketches for the many portraits that would be needed (see cats. 67–70), but work on the canvas presumably began only after he was given studio space in the secularized church of Cluny in late 1805, having been forced to vacate his studio in the Louvre earlier that year. David went on to complete the picture over the next two years, lavishing care on each individual portrait. Along the way, one significant change was made. David, who witnessed the event, initially recorded Napoleon audaciously crowning himself. This pose, recorded in various drawings, was eventually painted over by David, probably in August 1806, but can be seen today in pentimenti visible on the painted surface.[2] In altering the focal point of the composition, he opted for a less provocative moment—Napoleon placing a crown on the head of the kneeling Empress Josephine, just after he had crowned himself.

After a military campaign requiring a lengthy absence from the capital, Napoleon visited David's studio in January 1808 and praised the finished painting, especially its illusionistic, panorama-like effect. *The Coronation* (Musée du Louvre, Paris) went on public view in 1808, first in late winter in the Louvre (fig. 125), and for a second time in autumn of that year at the Salon. According to David's recollections, he and the emperor discussed the eventual installation of the series in a dedicated gallery in the Louvre that, David ventured, might be called "la galerie du Sacre," but which Napoleon countered should be known as "la galerie de David."[3] Both men clearly saw the painting as a means to enshrine his own reputation.

The same summer, a decree would elevate all members of the Legion of Honor to the imperial nobility, conferring on David the title of chevalier of the Empire, but these successes did not smooth the path ahead; troubles with the series continued with haggling over prices. David had planned to follow the first painting with one of Napoleon and Josephine arriving at the hôtel de ville, a composition he had already planned in 1805,[4] but he was instructed instead to work on *The Distribution of the Eagles* (see fig. 135), a military subject preferred by Napoleon.

By late 1808, David had already devised the composition.[5] It was a subject more challenging than that of the coronation, but one with more latitude for invention. On December 5, 1804, three days after the ceremony in Notre-Dame, an elaborate demonstration of the military's allegiance to Napoleon was staged on the Champ-de-Mars against the architectural backdrop designed by Percier and Fontaine for the facade of the Ecole Militaire. New flags featuring the imperial insignia of the eagle were distributed to representatives of the Grande Armée, who swore their oath to the emperor before departing on a new campaign in the Pyrenees. As was his practice, David experimented with different configurations for the scene and made many sketches of figures and figural groups (cats. 71–73). However, before the painting went on public view in 1810, Napoleon requested two changes. First, he asked that the winged figure of Victory scattering laurels over the troops be suppressed, a request in keeping with his preference for painters to treat contemporary events without allegory. Second, in light of Napoleon's recent divorce from Josephine, who had failed to produce an heir, and subsequent marriage to Marie Louise of Austria, Duchess of Parma, David was instructed to paint out Josephine and her ladies-in-waiting. The anachronisms necessitated by the divorce may have been one of the factors leading the imperial administration to abandon, after the completion of just two, the suite of four paintings originally envisioned to commemorate Napoleon's ascent to the imperial throne.

It was likewise in 1810 that the large Concours Décennal, or decennial competition, was organized to award prizes and to celebrate achievements in the arts in the Empire's first decade.[6] The judges were drawn from the ranks of the *classe de beaux-arts* division of the Institut National des Sciences et des Arts, an academic institution

Fig. 124. Jacques Louis David, *Bonaparte Crossing the Alps*, 1800–1801. Oil on canvas, 102⅜ × 87 (260 × 221 cm). Château de Malmaison, Rueil-Malmaison (M.M.49.7.1)

of which David had been a member since 1795, and the categories for painting reflected Napoleon's stated preference for contemporary (i.e., Napoleonic) history over ancient history. As an entry with a subject of national history, David submitted his *Coronation*, and for the category of history painting, the *Sabines*. The debate over which pictures deserved prizes was so vitriolic that ultimately none was awarded, but the exhibition made clear just how fractured and diverse the field of painting had become in the first decade of the nineteenth century.

The purity of David's classicizing style had defined an earlier era, but the shifting aesthetics of this post-revolutionary period encompassed a broad range of styles, from Neoclassicism to early Romanticism, and were led, more often than not, by his students. Antoine Jean Gros, known for his talent at conveying the grim

dramas of distant battlefields in his distinctive hot colors and brushy technique, was the recipient of numerous state commissions, including *Napoleon Visiting the Victims of the Plague at Jaffa* (1804; Musée du Louvre). Anne Louis Girodet was admired for his originality, distilling in *The Deluge* (1806; Musée du Louvre), for instance, a tingling horror that needed no biblical reference. David's own manner was inspired by these new directions, but it was at times outstripped by the younger generation's embrace of violence, horror, and fantasy, and by its attraction to new sources: the mists of legend and the exoticized dress and cultures of foreign lands. All the while, his rivals of the ancien régime, François André Vincent and Jean-Baptiste Regnault, continued to teach and work, at times adopting a Troubadour style that found inspiration in the French medieval era, as did many of his own

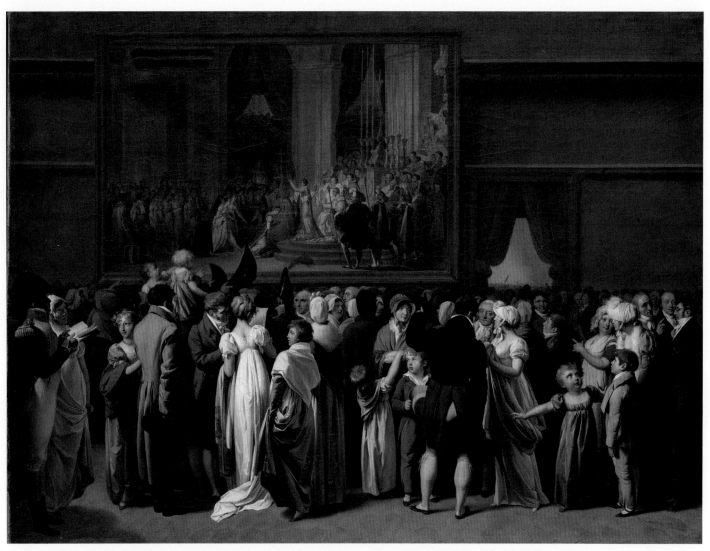

Fig. 125. Louis Léopold Boilly (1761–1845), *The Public Viewing David's "Coronation" at the Louvre*, 1810. Oil on canvas, 24¼ × 32½ in. (61.6 × 82.6 cm). The Metropolitan Museum of Art, New York, Gift of Mrs. Charles Wrightsman, 2012 (2012.156)

students, including Jean Auguste Dominique Ingres and Pierre Révoil. Others, like Isabey, François Gérard, and Pierre Paul Prud'hon, were adept at serving the needs of a fashionable new clientele and found favor with Empress Josephine.

If the demand for subjects of national—that is, Napoleonic—history dominated official commissions, private patrons occasionally offered David the opportunity to return to the classical themes that had brought him fame before the Revolution. In 1809 he completed *Sappho, Phaon, and Cupid* for the Russian prince Nicolay

Yusupov.[7] As with other commissions for foreign patrons, dating back to his student years in Rome, such works maintained his reputation and social network across the Continent. This languid vision of ancient lovers in a gilded interior is reminiscent of David's pre-revolutionary *Paris and Helen* (see cats. 36–40), but also harkens back to the cool, eroticized antiquity of his former master, Joseph Marie Vien, who died the same year, in 1809. This category of ancient subject matter, centered on tales of love and attraction, had been termed by David "le genre agréable." It proved a rich vein for his students as well.

Pierre Narcisse Guérin, for instance, painted his *Morpheus and Iris* (State Hermitage Museum, Saint Petersburg) for the same Russian patron two years later. David planned other works in this genre in the years that followed, creating finished compositional studies for *Cupid and Psyche* (cat. 77) and *Alexander, Apelles, and Campaspe*.[8]

After it became clear that the planned suite of four coronation paintings would not proceed beyond *The Distribution of the Eagles*, David struggled in his relationships with Denon and his superior, Pierre Daru, the two major gatekeepers of imperial commissions.[9] His relationship with Napoleon remained respectful, if distant, and his aspirations for a top role in arts administration never materialized. Military campaigns took Napoleon away from the capital for extended periods, and his new wife, Marie Louise, found the work of Prud'hon and Isabey more suited to her needs.

David filled the gap in official work, as he had in the post-Thermidor period, by painting portraits, sometimes on commission, including one of Napoleon in his study for a Scottish lord,[10] but more often of friends and family. For the most part, however, he would return his attention to *Leonidas at Thermopylae* (Musée du Louvre; see fig. 139), an ambitious history painting he had begun contemplating about 1798, as he was finishing the *Sabines*. Conceived as a pendant, but intended to be more authentically "Greek," the subject treated King Leonidas of Sparta, who in 480 B.C., led his small army to die in battle at Thermopylae, in an effort to prevent the advance of the Persian army of King Xerxes. A military defeat, however noble, had not been to the taste of the young general Bonaparte, who had discouraged David when he saw the drawings in 1798.[11] David, on the other hand, continued to find subjects of patriotic sacrifice resonant and returned to the project in 1811, completing it in 1814, fifteen years

after its conception. During this late, immersive stage of the process, the composition was repeatedly changed and reworked, as evident in the many surviving preparatory studies (see cats. 75–76). It was a period when David was quite invested in his role as a teacher and involved his students in the execution of his works, whether by painting sections or posing for certain figures.

By the time the picture went on view in David's Cluny studio in October 1814, the mood in the French capital had come to reflect the foreboding quality of the *Leonidas*. Napoleon had abdicated in April after a string of military losses and gone into exile on the island of Elba, off the coast of Italy. The Bourbon monarchy was restored with the ascension of Louis XVIII. Efforts were made to erase the traces of the Republic and the Empire, but, in whipsaw fashion, Napoleon would return in March of the following year for a period known as the Hundred Days. During this brief return to power, Napoleon would visit David's studio to view the *Leonidas* and award the painter an elevated rank. The artist's psychological evocation of patriotic men embarking on an ill-fated mission, an image described by Philippe Bordes as "the sublimation of defeat,"[12] must have struck the general-turned-emperor differently than when he first saw the studies for the picture fifteen years earlier.

Napoleon would abdicate a second time after being decisively defeated at the Battle of Waterloo on June 18, exiled this time to the more distant island of Saint Helena in the South Atlantic. A second restoration in July left David in an untenable position. He had not only voted for the regicide of Louis XVI but also, during the Hundred Days, rallied with Napoleon against the king's brother, Louis XVIII. By January 1816 David was banished by the Bourbon government and would live out his last decade in exile in Brussels.  PS

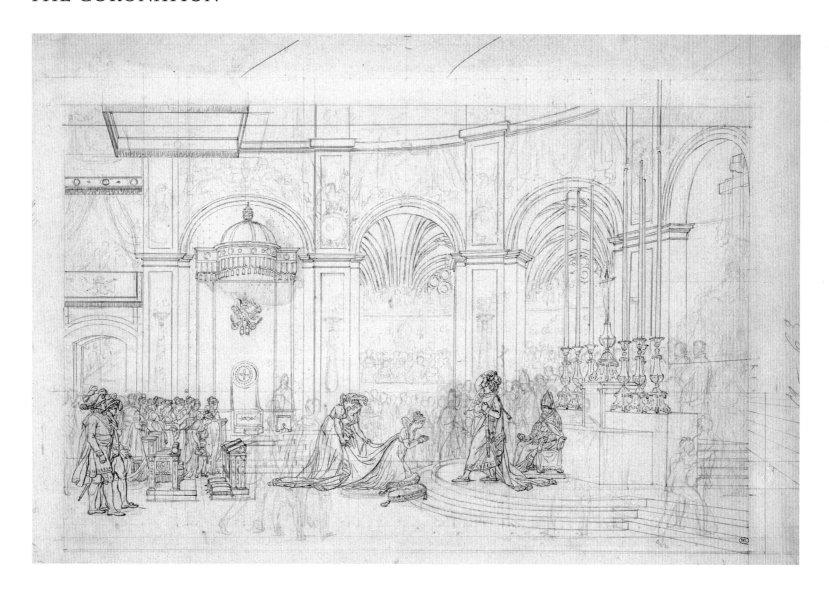

## 67. *The Coronation*

Ca. 1804–5
Graphite, with areas reworked in pen and black and brown ink
13⁹⁄₁₆ × 19⅛ in. (34.5 × 48.5 cm)
Inscriptions: right margin, in graphite, in another hand, "52–63"
Musée du Louvre, Paris (RF 4378)

PROVENANCE: Ignace Eugène Marie Degotti (1759?–1824); Emile Wattier (1800–1868); anonymous sale, Hôtel Drouot, Paris, January 27–29, 1863, lot 646; M. Cottenet; his estate sale, Hôtel Drouot, Paris, May 16–18, 1881 (not listed in the catalogue, but included in the sale, per Jules David-Chassagnolle[1]); M. Millet; acquired through the intermediary M. Sortais by the Musée du Louvre, 1917

REFERENCES: Florisoone 1948, cat. 35, pp. 33–34; Sérullaz 1991, no. 207, pp. 166–67; Rosenberg and Prat 2002, vol. 1, no. 199, pp. 209–10; Bordes 2004, p. 127; Laveissière 2004, cat. 27, pp. 94–96

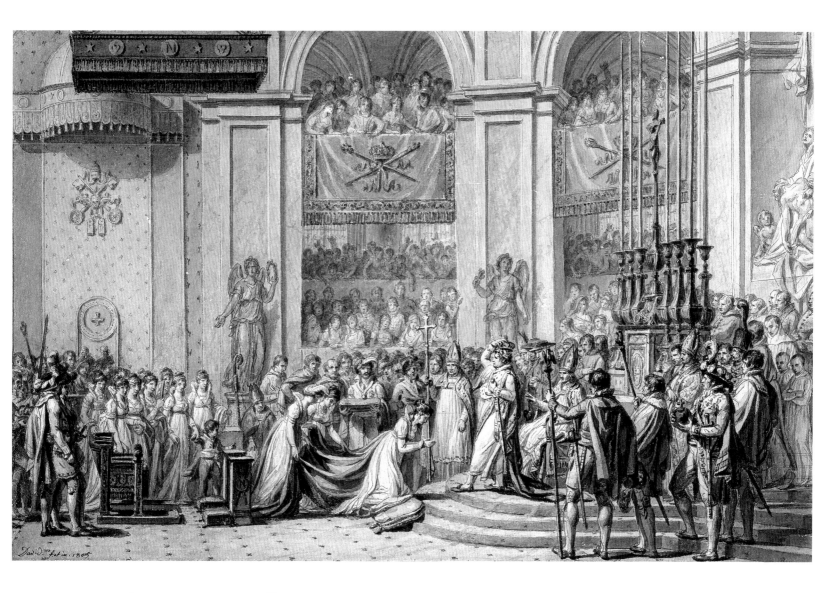

## 68. *Napoleon Crowning Himself*

1805
Pen and black ink, brush and gray wash
10³⁄₁₆ × 15¹⁵⁄₁₆ in. (25.8 × 40.5 cm)
Inscriptions: lower left, in pen and black ink, signed and dated "David
f. et in. 1805"
Fondation Napoléon, Paris (INV. 291)

PROVENANCE: David estate sale, Paris, April 17, 1826, and following
days, possibly lot 31, to Imbert; possibly René Soret estate sale, Hôtel
Drouot, Paris, May 15–16, 1863, lot 36; private collection; acquired by
the Fondation Napoléon, 1994

REFERENCES: Sérullaz 1991, pp. 166–67, under cat. 207; González-
Palacios 1993, pp. 948, 961–62 n. 25; Rosenberg and Prat 2002, vol. 1,
no. 201, p. 212; Laveissière 2004, pp. 94–96, fig. 39; Bordes 2005b,
pp. 94–95, fig. 27, under cat. 5

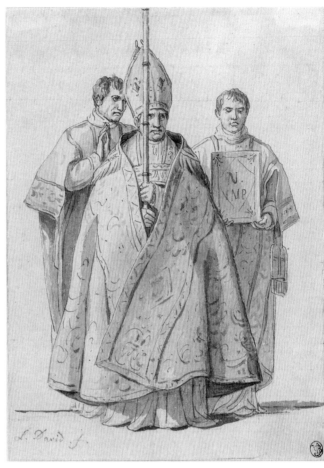

## 69. *The Empress Josephine*

Ca. 1804–5
Black chalk
8⁵⁄₁₆ × 6³⁄₈ in. (21.1 × 16.2 cm)
Inscriptions: upper right, in pen and brown ink, in the artist's hand, "l'imperatrice josephine / dessinée D'après / nature / par David"; at lower right, "donné à mon fils / Eugène / David."
Musée National des Châteaux de Versailles et de Trianon (INV. DESS 907 / MV 5289)

PROVENANCE: Eugène David (1784–1830); his son Jules David-Chassagnolle (1829–1886); his bequest to the Musée de Versailles, 1886, with a life interest to his wife, née Léonie-Marie de Neufforge (1837–1893); entered the Musée de Versailles, 1893

REFERENCES: Florisoone 1948, cat. 37, p. 34; Arlette Sérullaz in Schnapper and Sérrulaz 1989, cat. 175, p. 427; Rosenberg and Prat 2002, vol. 1, no. 195, p. 204; Bordes 2004, p. 126; Laveissière 2004, cat. 28, pp. 81, 97

## 70. *Study of a Bishop and Two Clerics*

Ca. 1806
Pen and gray ink, brush and gray wash, over black chalk, squared in black chalk
9¹⁄₁₆ × 6⁵⁄₁₆ in. (23 × 16 cm)
Inscriptions and marks: lower left, in black chalk, signed "L. David. f."; on the book's cover, in pen and gray ink, "N. / IMP"; lower right, in black ink, collector's mark of Alfred Beurdeley (Lugt 421)
Private collection, United States

PROVENANCE:[2] Alfred Beurdeley (1847–1919); his estate sale, Galerie Georges Petit, Paris, November 30–December 2, 1920, lot 109; private collection, Paris; Paul Rosenberg & Co., New York; purchased by Dr. Martin S. Weseley (1932–2017), New York, then Naples, Fla., 1980; sale, Sotheby's, London, July 4, 2018, lot 99, unsold; private collection, United States

REFERENCES: Rosenberg and Prat 2002, vol. 1, no. 207, p. 218

If Napoleon and David had a relationship that was at times uneasy, the pomp and circumstance of the events surrounding the imperial coronation and the desire to commemorate them in a grand manner provided the ideal synergy of the needs of the former and skills of the latter. To transform himself from consul to emperor, Napoleon orchestrated an opulent ceremony at the cathedral of Notre-Dame in Paris on December 2, 1804. He sought to express the legitimacy of his rule by invoking the precedent not of the recently overthrown Bourbon monarchy, but rather of the warrior king Charlemagne, the first ruler of the Holy Roman Empire. In order to present his authority as divinely sanctioned, Napoleon arranged to have Pope Pius VII travel to Paris to take part in the event. The Roman Catholic Church had only recently been reintegrated into French society with the Concordat of 1801, and delicate negotiations were required for every detail of the event's choreography. Ultimately, the pope would anoint Napoleon and Josephine, but Napoleon would then crown himself before placing a second crown on the bowed head of the kneeling empress.

Beyond the symbolism of the papal delegation, the various categories of guests and onlookers provided a clear taxonomy of the newly formed social structure built around the imperial court.[3] Relatives of Napoleon and Josephine formed a large imperial family, accompanied by their various chamberlains and ladies-in-waiting, all bedecked in jewels and glittering embroidery. Also present were high-ranking members of the French clergy, diplomats, and foreign ambassadors, as well as artists and luminaries of various fields, including David himself, his most successful pupils, and his former master, Joseph Marie Vien. Every detail, from the textiles adorning the walls to the costumes and jewelry of the attendees, was designed for the occasion by the team of Jean-Baptiste Isabey, Charles Percier, and Pierre François Léonard Fontaine. But for all the effort that went into the production, it was witnessed by only a select group of invited guests. For the event to broadcast its message effectively to the widest possible public, as intended, it would need to be memorialized on a grand scale, a task for which Napoleon chose David, who, in addition to being the acknowledged leader of the French school, had experience in the range of genres that such a hybrid

work would require: portraiture, history painting, and the recording of contemporary events. The canvas was to be of an immense scale—approximately twenty feet high and thirty feet wide—and was envisioned as the first in a suite of four pictures depicting key moments from the celebrations organized around the coronation. The prestige of the commission was further signaled on December 18, when Napoleon named David first painter.

David was present for the ceremony, viewing it from a loge with a sketchbook in hand. Years later, in his autobiography, he would boast of the accuracy of his painting, recounting how he had taken copious notes and made sketches on the spot of the entire scene, as well as of individual groups.[4] In emphasizing the empirical nature of the picture, David was being somewhat disingenuous. The execution of *The Coronation* (fig. 126) was a complex production stretched over three years, and evidence in the form of drawings, letters, and contemporary accounts all points to a process that was less about absolute fidelity than it was about crafting and manipulating a scene for maximum visual and political effect. David understood that the picture's essential purpose, like that of the ceremony itself, was to buttress Napoleon's claim to authority using a language borrowed from a monarchical past.

Work on the painting did not, in fact, begin until December 21, 1805, when David was able to move into his new studio in the secularized church of Cluny, a setting spacious enough to accommodate a canvas of such massive dimensions. The surviving drawings make clear, however, that considerable progress had taken place during the intervening year. Sketchbooks in Paris and in Cambridge, Massachusetts, are filled with chalk studies of full-length figures, nude and clothed; quick studies of the heads of the many individuals who were to be included, and studies after illuminated manuscripts in the Bibliothèque Impériale, evidence of David's research into medieval and ecclesiastical motifs with which to infuse his scene.[5]

During this year of planning on paper, and continuing into the execution-on-canvas phase, David benefited from the assistance of others. On April 6, 1805, he wrote to Ignace Eugène Marie Degotti, a set designer for the Paris Opéra, requesting his help with the architectural elements of the four pictures.[6] David's student Angélique

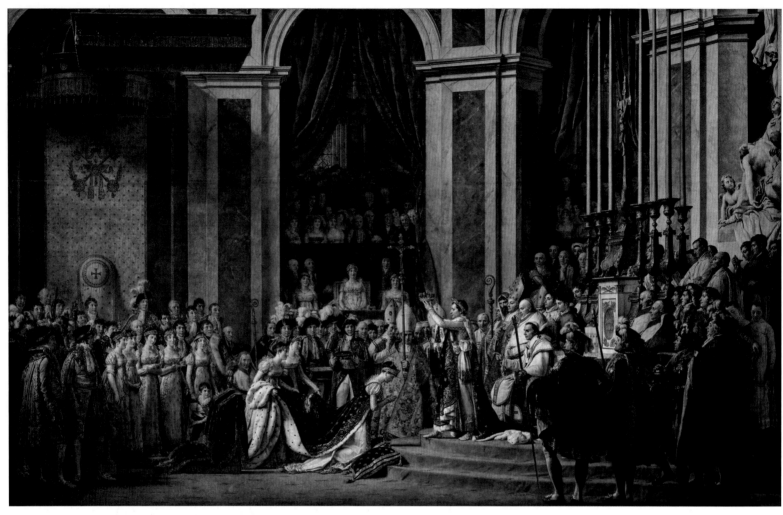

Fig. 126. Jacques Louis David, *The Coronation*, 1807. Oil on canvas, 244½ × 382¼ in. (621 × 971 cm). Musée du Louvre, Paris (INV. 3699)

Mongez (who appears just behind his daughter in the painting) assisted him in the arrangement of figures by making and coloring small full-length "dolls" that could be placed in a scale model of the interior of Notre-Dame that David had built inside a box for this purpose. He did so presumably in emulation of Nicolas Poussin, whose practice of designing compositions with the aid of clay figures arranged in a box was well known, or perhaps inspired by Isabey, who in advance of the ceremony is purported to have dressed small figurines made as children's toys in paper costumes, to show Napoleon the planned configuration of attendees.[7] For help in transferring the drawings to canvas and in the painting of certain areas, David relied on several of

his pupils, including, it would seem, Georges Rouget, Albert Paul Bourgeois, and Jérôme Martin Langlois, and possibly others.[8]

In addition to the written record, the surviving drawings shed considerable light on the three-year genesis of the painting. Preparatory drawings were made before, during, and after the coronation ceremony and document David's research into the interior space and overall composition, as well as the individual figures, their placement, their poses, and their features. Many bear signs of the processes of collaboration and transfer, with visible squaring in chalk or, in the case of two life-size cartoons of Napoleon in Lille, pouncing along the contours of the figures.[9]

Only three drawings of the entire composition survive, although there likely would have been more. Sylvain Laveissière was surely correct in seeing a wash drawing in a private collection (fig. 127) as the earliest of the three.[10] In composition it is close to the plate depicting the pope anointing Napoleon and Josephine (fig. 128) in the *Livre du sacre*, a luxury publication commissioned by the emperor in March 1805 featuring forty engravings documenting the events and costumes of the coronation ceremonies after designs by Isabey, Percier, and Fontaine.[11] The architectural elements are cropped in the same place, although David has enlarged the scale of the figures. For Pierre Rosenberg and Louis-Antoine Prat, the figures, with their featureless faces, have a doll-like quality, an observation linked to the fact that the sheet's first owner was Angélique Mongez, who had assisted David in populating his scale model with figurines. The hazy imprecision of the architecture in this first version suggests that it was made before April 6, 1805, when David hired Degotti to assist with the architectural elements of the picture.[12]

A study in the Louvre (cat. 67), often referred to as the "Degotti drawing" in honor of its first owner, would appear to be early evidence of this collaboration.[13] The sheet has been seen since 1980 as the product of two hands, with the areas lightly sketched in black chalk by David and the architectural and decorative elements carefully rendered in pen and ink by Degotti.[14] A trickier question is the order and dating of the various layers of work. Did the perspectival framework of the scene dictate the placement of the figures, as Laveissière claimed, leading him to date the sheet to April 1805 or after? An alternate scenario would have David making the quick chalk sketch either during or not long after the ceremony on December 2, with the architecture superimposed onto the *première pensée* months later, after Degotti joined the team.[15] Supporting the latter premise is the fact that the ornament details in chalk are rarely contained by the architectural forms they embellish, as can be seen in the eagle-topped trophies that fill and overflow the pilasters in the spandrels between the arches. The majority of these architectural embellishments would ultimately be omitted in favor of a more spare backdrop that would better serve as a foil to the glittering assembly of notables. And if the pen-and-ink architecture indeed

Fig. 127. Jacques Louis David, *The Coronation*, 1805. Pen and brown ink, with brush and brown wash, 6⁷⁄₁₆ × 10⁷⁄₈ in. (16.3 × 27.6 cm). Private collection, Paris

Fig. 128. R[émi]. Delvaux (1748?–1823), after Jean-Baptiste Isabey (1767–1855) and Pierre François Léonard Fontaine (1762–1853), "Les Onctions," hand-colored engraving (pl. iv) in *Le sacre de S. M. l'Empereur Napoléon dans l'église métropolitaine de Paris . . .* (Paris, 1807). Bibliothèque Nationale de France, Paris

constituted a second phase, the ink lines reinforcing certain figures must be later still. The inked figural groups represent a significantly more advanced stage in the development of the composition than the ones quickly indicated in black chalk, especially the boys going up the steps on the right, shown nude, as was David's habit in his initial attempts to work out poses. This thesis of a three-step sequence is also supported by

Fig. 129. Jacques Louis David, *Two Studies of a Crossbearer Accompanied by a Cardinal Carrying a Sacred Book*, 1805–6. Graphite, 9⁵⁄₁₆ × 7¹⁄₁₆ in. (23.7 × 17.9 cm). Harvard Art Museums/Fogg Museum, Cambridge, Mass. (1943.1815.12, fol. 34)

the way in which the architecture's straightedge lines violate certain figures, for instance, the line passing over the pope's face.

The second wash composition drawing, now in the collection of the Fondation Napoléon, Paris (cat. 68), postdates the collaborative David–Degotti sheet, as it follows closely the solid, three-dimensional rendering of the columns and arches around the main altar in the latter, even while cropping the scene on all four sides and vertically compressing the different levels of the loges to include as many identifiable portraits as possible. Making their first and final appearance in this iteration are two statues of angels mounted on pedestals,[16] placed so they appear to preside over the central vignette.

Painterly in execution, the Fondation Napoléon sheet, with its springy ink lines and washes in a great range of tones, applied via a dabbing technique, anticipates the rich and glittering effect of the painting. But was it, as characterized by Laveissière, a "presentation drawing"?[17] Dated 1805, the Fondation Napoléon sheet was presumably made after April of that year, as it follows Degotti's architectural framework seen in the Louvre study, but before David moved into his new studio on December 21 to begin work on the canvas. On October 9, during this period of planning on paper, David wrote to Degotti, describing how students were transferring drawings to canvas, adding, "I shall reposition the figures that might not work but I can do that only by seeing everything together."[18] Indeed, after this study, David went on to execute an oil sketch on panel with changes to the costumes of certain figures and the addition of the heavy curtains that would be carried over into the finished version.[19]

A great number of drawings were also made to record the features and poses of the many attendees. Their status, as recognizable portraits, was an essential part of the picture's overall message, for the ceremony was intended to confer a legitimacy that extended beyond the imperial couple, to encompass a broader social order. The majority of sitters came to the artist's studio to pose for their portraits, but in the case of certain dignitaries, David traveled to them.[20] Among these portraits is the quickly executed black chalk study of Josephine today in Versailles (cat. 69). Her bowed head casts her features into shadow, conveying the passivity of her role, while the illumination of her pale neck and cheek accentuate the dark tendril falling from her diadem. The inscription in the artist's hand notes that it was drawn "from life," an affirmation of the sheet's uninflected naturalism. Laveissière has argued that the drawing was made not during the ceremony but on a visit to the Tuileries Palace, as the empress wears a simples dress rather than the ermine-lined velvet cape, elaborate lace collar, and jewelry that she wore in Notre-Dame.[21] In contrast to her youthful glow and unblemished appearance in the painting, itself reflecting the heavy makeup she wore for the ceremony, she appears in the Versailles sheet closer to her true age of forty-one.

David also devoted considerable thought to the group of three bishops at the center of the composition, not

because of their identities, one presumes, but because of their compositional importance as the backdrop to the imperial couple. Philippe Bordes has theorized the bishop holding the cross as a stand-in for the artist, in proximity to the emperor and rivaling him in splendor.[22] That the representation of this ecclesiastical group did not, in the artist's mind, require identifiable individuals is clear in his studies, where he experimented with each figure's rank and placement.[23] On a page in the above-mentioned Cambridge sketchbook (fig. 129), he initially sketched the group as a pair, not a trio, once with the crossbearer in front, and once with him behind. In the Louvre sketchbook, the group comprises three figures, all bishops.[24] A more finished study of the group reemerged in 2018 (cat. 70). It stands apart from the many other figure studies related to *The Coronation* in its pen-and-wash technique, used to carefully delineate the costumes and the fall of light in a manner reminiscent of David's designs for revolutionary-period costumes (cats. 56–57). Squaring in black chalk suggests that the grouping was transferred to canvas.

Over the three-year development of the picture, this central zone was the politically fraught locus of compositional change, as the theme of imperial legitimacy achieved through military prowess gradually evolved to adopt the established language of dynastic rule—an evolution also coinciding with the growing popularity of the Troubadour style and its elevation of chivalry. In a clearly visible pentimento behind Napoleon, one can see the earlier pose of him placing the crown atop his own head. Despite this evidence of a major revision late in the process, the impetus, sequence, and timing of the changes are not fully clear. From a letter of March 25, 1806, we learn that, having painted the sumptuous ornamentation of the crossbearer's vestment, David felt it necessary to repaint his face and asked Degotti to pose for it.[25] If we hypothesize that the pen-and-wash study (cat. 70) slightly precedes this repainting, then both likely were done shortly before Napoleon's pose was altered, a change that Laveissière and Bordes both date to August 1806.[26] To portray this new action, of crowning Josephine, it was necessary to shift the figure of Napoleon slightly forward, thus partially obscuring the bishop on the right, whose missal, inscribed "N. / IMP" (for *Napoléon, imperator*) in the drawing, is blank in the painting. The diagonal gaze and slightly angled head of the crossbearer would also need to be adjusted; in the painting he is seen straight on, his eyes directed upward, toward the glittering crown.[27]

The final result features hundreds of portraits wedged into a scene of formal pomp and regalia, "flooded in an ocean of light," as Jean Claude, comte Beugnot described the effect in a letter to David.[28] When Napoleon, after being absent from the capital on extended military campaigns, visited David's studio on January 4, 1808, he is said to have marveled, "[t]his is not a painting; one walks into this picture."[29] Indeed, David's talents at orchestrating public spectacles and at commemorating them on canvas had effectively merged in this immense evocation of an official ceremony, soon to be on display for a broader populace, as the genre painter Louis Léopold Boilly would depict as a memorable scene within a scene (see fig. 125). Over the next two years, the picture went on public display three times, first, in February and March, at the Louvre (then called the Musée Napoléon), then in October at the Salon of 1808, and finally in August 1810 for the exhibition of the Concours Décennal. By then, the celebration of David's artistic achievement had outlasted the reign of his female protagonist: Napoleon had divorced Josephine, who had failed to produce an heir, and married Marie Louise of Austria in April 1810.

It was no secret that an accomplishment of this scale had been, as noted, a collaborative effort, with David receiving considerable help in the planning and execution of the canvas from various friends, colleagues, and students. In the end, the drawings that had served as studio tools became tokens of appreciation. From their early provenance, it would appear that the Louvre sheet (cat. 67) was given as a gift to Degotti, and the 1805 study now in a private collection (fig. 127) to Mongez. David apparently displayed the Fondation Napoléon compositional study (cat. 68) framed in his own apartment, and gave the study of Josephine (cat. 69) as a gift to his son Eugène, who had fought in Napoleon's army.    PS

CAT. 71, FOL. 10 RECTO

## 71. *Sketchbook with Studies for "The Distribution of the Eagles" (Carnet 10)*

Ca. 1809
Sketchbook of 65 folios, with 33 mounted drawings, most in black chalk, some in pen and black ink
9¹⁵⁄₁₆ × 8³⁄₁₆ × 7/8 in. (25.3 × 20.8 × 2.2 cm)
Art Institute of Chicago, Helen Regenstein Collection (1961.393.1)

PROVENANCE: David estate sale, Paris, April 17, 1826, and following days, probably lot 77; Prince Napoleon Bonaparte (1822–1893), nephew of Emperor Napoleon; acquired by Hippolyte Destailleur (1822–1893), 1877; his sale, Hôtel Drouot, Paris, May 26–27, 1893, lot 29, to "Morgand"; F. Martinet sale, Hôtel Drouot, Paris, April 25, 1896, lot 92; David David-Weill (1871–1952); Wildenstein & Co., New York; acquired by the Art Institute of Chicago, 1961

REFERENCES: Arlette Sérullaz in Schnapper and Sérullaz 1989, cat. 192, pp. 462–64; Rosenberg and Prat 2002, vol. 2, carnet 10 (nos. 1733–76), pp. 1092–1110; Bordes 2005b, cat. 11, pp. 109–12

## 72. *Sapper-Grenadier of the Imperial Guard*

Ca. 1809
Black chalk, squared in black chalk
9¹³⁄₁₆ × 7¹¹⁄₁₆ in. (24.9 × 19.2 cm)
Inscriptions and marks: upper right, in pen and brown ink, "15"; lower left, in graphite, in the artist's hand, "de Songis (?)"; lower right, paraph of Eugène David (Lugt 839)
Musée National des Châteaux de Versailles et de Trianon (INV. DESS 419 / MV 7690)

PROVENANCE: Originally part of sketchbook (carnet) 10 (see cat. 71); detached prior to 1877; Otto Wertheimer (1878–1972), Paris, from whom acquired by the Musée National des Châteaux, 1949

REFERENCES: Schnapper 1982, pp. 257, 259; Arlette Sérullaz in Schnapper and Sérullaz 1989, cat. 201, p. 471; Rosenberg and Prat 2002, vol. 1, no. 296, p. 280; Bordes 2005b, cat. 10, pp. 103–8

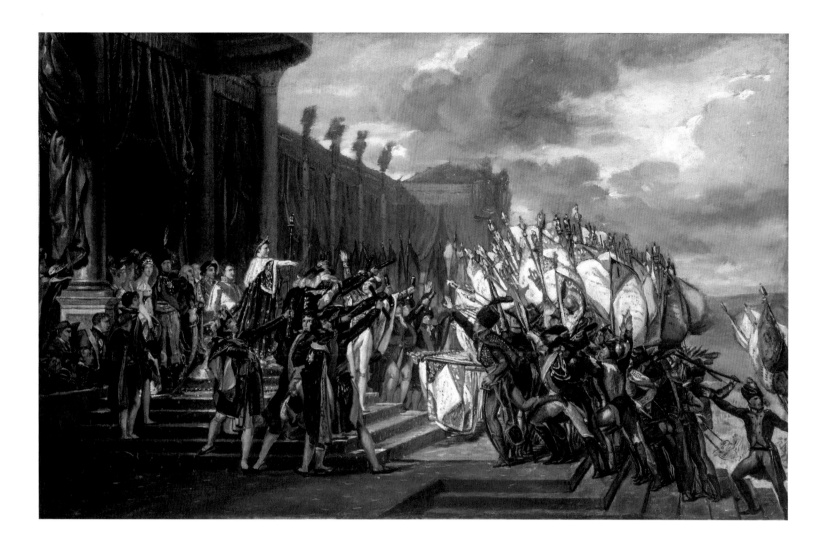

## 73. *The Distribution of the Eagles*

Ca. 1809–10
Oil over black chalk, on paper laid down on canvas
21¼ × 33½ in. (54 × 85.2 cm)
Xike Jiulu, Shanghai

PROVENANCE: Private collection, France; anonymous sale, Millon, Hôtel Drouot, Paris, March 22, 2017, lot 53 (as "French school, nineteenth century, entourage of Jacques Louis David"); art market, Paris; private collector, London; private collector (per Christie's); sale, Christie's, New York, May 1, 2019, lot 45; purchased by the present owner, Shanghai

During the three years he devoted to *The Coronation* (see cats. 67–70), David was also making steady progress on what he intended to be the second canvas in the four-part Coronation suite: *Napoleon and Josephine Arriving at the Hôtel de Ville*.[1] That composition had already been sketched onto the canvas when Napoleon, upon visiting the Salon on October 22, 1808, ordered David to change course and "set to work immediately on the one he prefers, the distribution of the imperial flags on the Champ-de-Mars."[2] Presumably, the subject of military allegiance and patriotic fervor was more aligned with Napoleon's current priorities, as he was readying the Grande Armée for a difficult campaign across the Pyrenees.

The picture was to depict an outdoor ceremony that took place on December 5, 1804, three days after the coronation, when the troops enacted an oath of loyalty to Napoleon and exchanged the flags from the republican campaigns for new regimental banners referred to as imperial "eagles."[3] The event was staged on the Champ-de-Mars, a large open space in front of the Ecole Militaire, which, like the interior of Notre-Dame, had been sumptuously decked out by Charles Percier and Pierre François Léonard Fontaine. A temporary portico had been added to the school's facade, with a grand set of stairs leading to the imperial dais and colonnaded wings draped in gold-fringed fabric and bedecked with sculpted eagles, gilt figures of Victory, military trophies, and tricolor banners.

In contrast to its sunny portrayal in paint and print, the event itself took place under a steady fall of rain and sleet. It does not seem that David himself was in attendance.[4] While his absence ultimately allowed him latitude for invention, his correspondence and sketchbooks demonstrate nonetheless his efforts to assemble authentic details after the fact. His initial compositional sketches show him engaged with the variables of vantage point and framing. From the outset, it was clear that, in order to bring Napoleon, the ceremony's protagonist, close

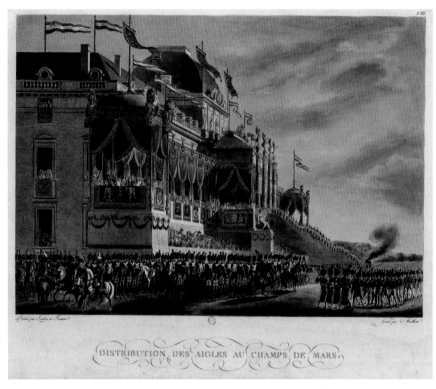

Fig. 130. Georges Malbeste (1754–1843), after Jean-Baptiste Isabey (1767–1855) and Pierre François Léonard Fontaine (1762–1853), "The Distribution of the Eagles," hand-colored engraving (pl. viii) in *Le sacre de S. M. l'Empereur Napoléon dans l'église métropolitaine de Paris . . .* (Paris, 1807). Bibliothèque Nationale de France, Paris

enough to the picture plane, he would have to assume an aerial perspective, thereby eliminating much of the expansive scene visible in the print after Fontaine and Jean-Baptiste Isabey (fig. 130) and erasing all glimpse of Ange Jacques Gabriel's building. In the *première pensée* in the Chalençon collection, Napoleon is a diminutive figure dwarfed by colossal columns amid a roiling mass of soldiers.[5] In a subsequent sketch in the Musée du Louvre, David shrinks the columns and moves Napoleon to the left, allowing more space for the steps on the right.[6] His plans were firmly established by December 1808, as can be seen in a finished study in the Louvre in which he has added to the sky at upper right a winged figure of Victory, showering laurels on the troops below (fig. 131).[7] By early 1809, the design had been transferred to the canvas, with Ignace Eugène Marie Degotti sketching in the architectural elements, as he had done for *The Coronation*, and David again making use of a scale model in a box and small dolls to plan the arrangement of figures.[8]

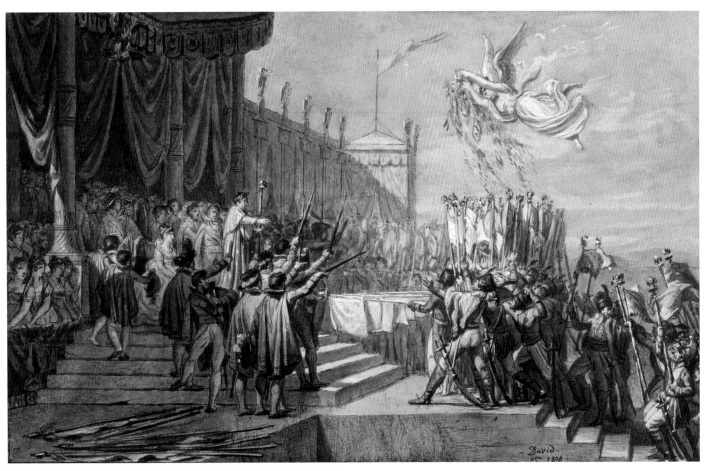

Fig. 131. Jacques Louis David, *The Distribution of the Eagles*, 1808. Pen and black ink, brush and gray wash, heightened with white, over graphite, 7⅛ × 11½ in. (18.2 × 29.1 cm). Musée du Louvre, Paris (RF 1915)

With the overall scheme worked out, David turned his attention to studies of the individual figures, from Napoleon, members of his court, and various dignitaries to the marshals on the steps just below the emperor and the throng of anonymous soldiers surging up the stairs. The sketchbook in the Art Institute of Chicago (cat. 71) seems to have been largely devoted to such studies, although the structure of the book underwent a number of alterations in the nineteenth century, with some sheets removed (see, for example, cat. 72) and other, unrelated drawings pasted in.[9] The individual sketches display a range of finish and finality and show David working out details of pose and costume. In some cases, the drawing is squared to facilitate transfer, either to another sheet or, perhaps, to the canvas.[10] There are also multiple iterations of certain figures, including two studies of

the seated Empress Josephine. In the one inscribed to indicate that it was drawn from life (cat. 71), she is seated in a swan armchair, likely indicating, as Philippe Bordes has observed, that the drawing was made at Malmaison.[11] Here, unlike her portrayal in *The Coronation*, Josephine appears to be her true age—forty-one on the day of the ceremony, and probably forty-six by the time David made this drawing. Observed with sympathy and incisively rendered, the sheet also records a new conception for her pose. In the Louvre compositional drawing (fig. 131), she was envisioned in profile, an attentive onlooker to the ceremony, but in the Chicago studies, she gazes directly at the viewer.

David made many discrete studies for the dense pack of soldiers in the right half of the composition. Some, following academic practice,[12] were nude, others were

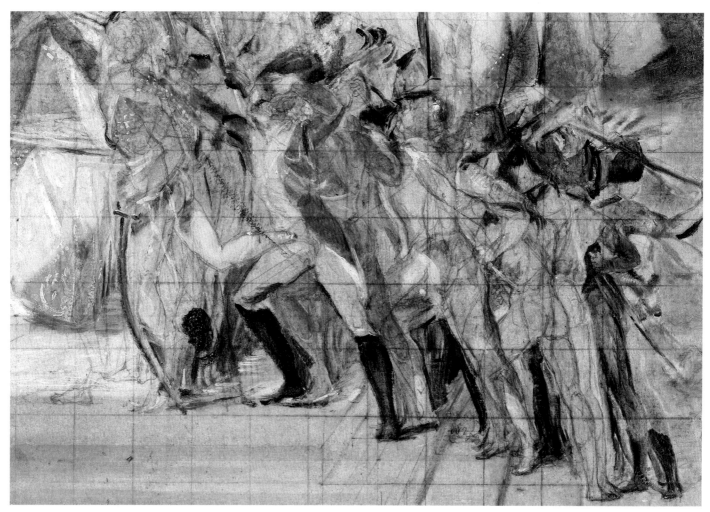

Fig. 132. Infrared image (detail) of cat. 73

clothed, and in some cases, this sequence of steps was layered one atop the other. For instance, in the *Sapper-Grenadier of the Imperial Guard* (cat. 72)—a loose sheet that was removed from the Chicago sketchbook in the nineteenth century—one can see the chalk sketch of the nude figure below the semitransparent rendering of his uniform. On the canvas, this figure plays an important role, anchoring the lower right corner of the composition, while at the same time his gesture and backward glance suggest that he is leading a larger group. As a *sapeur*, his role involved carrying an axe (more prominent in an earlier conception of his pose[13]) to destroy enemy fortifications. He wears a distinctive bearskin hat, and his regiment, the Grenadiers, is identified by the insignia on his belt buckle.

Male bodies molded into expressions of shared patriotism, especially the gestures of oath taking, are a recurring theme in David's oeuvre, from the Roman legend of *The Oath of the Horatii* (cats. 21–24), painted during the ancien régime, to the revolutionary *Oath of the Tennis Court* (cats. 50–53). Indeed, it was the common visual language of works like these that led Pierre Rosenberg and Louis-Antoine Prat to observe that the studies in David's sketchbooks "possess the strange ability to glide from one work to another."[14]

But if the soldiers' poses echoed the classical past, then the attire and all related military paraphernalia was up-to-the-minute and described in gleaming, tactile detail. In May 1809 David wrote to the minister of war, Jean Gérard Lacuée, comte de Cessac, requesting the

Fig. 133. Infrared image (detail) of cat. 73

Fig. 134. X-radiograph (detail) of cat. 73

uniforms and accessories he needed to complete the painting.[15] As trees obscure the view of a forest, this documentary impetus would ultimately bring new challenges, as action and accuracy were effectively at odds in such a large, multifigure scene. Nor was David the only artist grappling with such issues; it was a time when major commissions sought to glorify contemporary military exploits, calling for what was essentially a novel, hybrid form of painting that combined the scale and grandeur of history painting with the detailed likenesses and costumes associated with portraiture. His student Anne Louis Girodet, for one, would exhibit in the same Salon *The Revolt at Cairo*, a picture constructed through a similar process, albeit with an infusion of exoticism.[16] Like the *Eagles*, the result was at once cinematic and static, a kind of freeze-frame chaos.

After having invested considerable effort in resolving the details of the complex composition, David was forced to make a number of major changes. One concerned the figure of Victory, seen in the 1808 study (fig. 131) strewing laurels on the soldiers below. Allegories, although commonplace in the ancien régime and a favored replacement for royal iconography in the early years of the Republic (see cat. 49), were viewed much more critically during the Napoleonic era, especially in the context of military scenes.[17] From an inscription under a chalk study for Victory in one of the sketchbooks, we know that the suppression of the figure was directed by the emperor himself—and much to the chagrin of David, who considered it an indispensable compositional element.[18] The artist thought the figure was needed to justify the upward gazes and gestures of the marshals, galvanized by this celestial harbinger of triumph.

On October 8, 1810, just one month before the Salon was to open, Dominique Vivant Denon, the director of museums, raised another issue. Since the event had taken place, Napoleon had divorced Josephine, who had failed to bear him a child, and had married Marie Louise of Austria. Would it not, then, be advisable, Denon queried in a letter to the grand marshal, Géraud Christophe Michel Duroc, to excise Josephine from the painting? Napoleon's approval of Denon's suggestion set off a flurry of changes: Josephine's removal also necessitated the replacement of her ladies-in-waiting with various other figures at the left side of the canvas

Fig. 135. Jacques Louis David, *The Distribution of the Eagles (The Army Takes an Oath to the Emperor after the Distribution of Eagles, 5 December 1804)*, 1810. Oil on canvas, 20 × 31 ft. (610 × 975 cm). Musée National des Châteaux de Versailles et de Trianon, Versailles (MV 2278)

and a reworking of the pose of her son, Eugène de Beauharnais, resulting in a bizarrely extended right leg.[19] For Valérie Bajou, the aesthetic damage and erosion of visual logic engendered by these politically motivated changes constituted a mutilation of David's canvas.[20]

The recent discovery of a previously unknown oil sketch (cat. 73), published here for the first time, sheds considerable light on these late changes. Indeed, the new sketch adds three late compositional iterations to the three earlier studies previously known, if one considers, in addition to the image on the surface, the two underlying layers, visible in X-radiograph and infrared images. The latter reveal black chalk underdrawing with careful squaring, the straightedge laying-in of the architectural elements, and the initial nude studies (some retained and some abandoned) for the soldiers running up the stairs

(fig. 132). In the first oil-paint layer, David clothed the formerly nude figures in military garb and included the figures of Victory, in the sky (fig. 133), and, visible most clearly in the X-radiograph, Empress Josephine, seated behind Napoleon (fig. 134). She is seen not in profile, as in the Louvre compositional study (fig. 131), but with her gaze turned to the viewer, adopting the pose of the study in the Chicago sketchbook (cat. 71).

These first two layers reflect a number of changes that postdate the December 1808 composition study and must therefore date to 1809, perhaps to February, when David had Degotti sketch the architectural elements onto the canvas.[21] When David was told, in October 1810, just before the picture was to go on view, that he had to scrape out Josephine and her entourage, he presumably went back to his oil sketch to try out the necessary

changes before executing them on the larger canvas. This span of time—about a year and a half—between February 1809 and October 1810 would also explain the significant number of differences between the sketch and the finished painting (fig. 135). To enumerate just a few: the red and green carpets on the stairs were abbreviated, exposing a number of steps; a tricolor banner flutters atop the pavilion, perhaps to fill the void left by the removal of Victory; the flags in the center middle ground, behind the balletic duc de Lannes in his bright white pants, have been suppressed, while others have been added on the left, just behind Eugène de Beauharnais; the angle of the regimental banners held by the front row of charging soldiers has been lowered; and the sculpted eagles glinting atop each pole are significantly more formed and detailed. The uniforms of individual soldiers also underwent major changes, no doubt reflecting the loans of models David had requested in May 1809.[22] While the overall palette of the sketch closely anticipates that of the painting,[23] the colors of the clothing of particular soldiers on the right were often swapped out, recalling the chromatic relationship of sketch to finished painting in the case of *Paris and Helen* (cats. 36–40). A very late addition to the scheme was the exoticized figure of the ambassador from the Ottoman Empire, set against the base of the left-most column, who does not appear in the oil sketch.[24]

Beyond the light it sheds on the evolution of the *Eagles*, the discovery of the oil sketch upends accepted wisdom on David's working process during the Napoleonic era. In the 1770s and 1780s, David habitually made oil sketches while planning his history paintings (see cats. 22, 40, 47). However, none dating from after the Revolution was known, and it had been assumed that he gave up the practice.[25] With two decades separating the

Fig. 136. Anne Louis Girodet (1767–1824), *Sketch for "The Revolt at Cairo,"* ca. 1810. Oil and ink on paper, laid down on canvas, 12⅛ × 17¾ in. (30.8 × 45.1 cm). Art Institute of Chicago (1999.384)

oil sketch for the *Brutus* (cat. 47) and the newly discovered sketch for the *Eagles*, it is hardly surprising to see a stylistic leap. The *Brutus* oil sketch, for instance, as well as the one made for the *Horatii* about three years earlier (cat. 22), are smaller in scale and have a more restrained sensibility, giving the impression of ink drawings with oil paint added to test color choices and lighting.[26] By contrast, the *Eagles* sketch is larger and more painterly, with quick dabs and ribbons of impasto, all conveying the heat and movement of military ardor. While it may differ in feel from his sketches of the 1780s, the study sits comfortably in the context of the preparatory oil sketches made by many of David's students at this precise moment, for instance, Girodet's sketch for *The Revolt at Cairo* (fig. 136), a contemporaneous work that would hang with the *Eagles* in the Salon of 1810. Indeed, for a younger generation moving in the direction of Romanticism, the vibrant colors and fluid brushstrokes of such sketches held great appeal.   PS

## 74. *Venus, Wounded by Diomedes, Appeals to Jupiter*

1812
Pen and black ink, brush and gray wash, heightened with white, over
black chalk
9⁷⁄₁₆ × 7³⁄₁₆ in. (23.9 × 18.2 cm)
Inscriptions: on the plinth, in pen and black ink, signed and dated
"L. David. 1812"
Musée du Louvre, Paris (RF 1918)

PROVENANCE: David estate sale, Paris, April 17, 1826, and following
days, lot 29; purchased at that sale by Eugène David (1784–1830); his
son Jules David-Chassagnolle (1829–1886); his bequest to the Musée
du Louvre, 1886, with a life interest to his wife, née Léonie-Marie de
Neufforge (1837–1893); entered the Musée du Louvre, 1893

REFERENCES: Arlette Sérullaz in Schnapper and Sérullaz 1989,
cat. 211, pp. 374, 482–83; Sérullaz 1991, no. 215, pp. 171–72;
Rosenberg and Prat 2002, vol. 1, no. 306, p. 289; Bordes 2005b, cat. 29,
pp. 67–68, 215–19

After the aborted commission for a suite of four corona-
tion pictures and the contested prizes of the Concours
Décennal, David found himself, at the outset of the
century's second decade, the bearer of the title "first
painter," but lacking the commissions and influence
that would typically accompany it. In a bid to claim
the benefits he felt were his due, on September 2, 1812,
he penned a formal letter to Jean-Baptiste de Nompère
de Champagny, duc de Cadore, intendant general of the
Crown, asserting his authority to direct the decoration
of imperial palaces. He stated that he would choose
the subjects for any needed paintings or ceilings and
would either execute them himself or assign them
to other painters, of whose talents he was well aware,
as they had come out of his studio. He went on to
describe how, in order to be "worthy of the majesty of
the place," the preparation required "a large quantity of
drawings and sketches," to make the overall decoration
coherent.[1] Arlette Sérullaz considered the possibility
that the present drawing and another depicting *The
Departure of Hector*, also dated 1812, were arms of the same
campaign—proposals, in effect, for the decoration of
the Louvre and examples of the types of studies David
mentioned in his letter.[2] Philippe Bordes has suggested
that they alternatively could have been ideas—possibly
designs for tapestries—for the Grand Cabinet of the
Tuileries Palace, a room being redecorated that same year
under the supervision of the architect Pierre François
Léonard Fontaine.[3]

In the end, David's efforts to gain control over impe-
rial commissions were rebuffed, and neither composition
was painted. However, the finished drawings offer a win-
dow onto the evolution of his style, in relation both to

his earlier work and to the work of a younger generation
of painters who had become rivals. For a sense of the dis-
tance traveled, one need only compare the Louvre sheet
to the Le Brun-esque melee in the Albertina's *Combat of
Diomedes* (cat. 15). In the latter drawing, executed in 1776,
David had shoehorned multiple episodes of the Trojan
War into a crowded battlefield. The Louvre drawing,
from 1812, is quieter and more contained. After being
injured by Diomedes while trying to protect her son, the
Trojan hero Aeneas, Venus ascended Mount Olympus
to show her wound to Jupiter and beseech his help. Her
pose of humble supplication stands in contrast to the
cool and judgmental demeanor of Juno and Minerva.
Jupiter's expression is hidden in David's drawing, but in
Homer's text (*Iliad*, book 5), he chides the goddess of
love for meddling outside her domain. Visible just below
the clouds, reduced to a distant landscape, are the cities
and plains where the earthly battles had played out.

If David's drawing of the wounded Venus was indeed
intended to become a painting for the Louvre or the
Tuileries, the visual echo of a subject painted by his
rival Pierre Paul Prud'hon for the ceiling of the Salle de
Diane (fig. 137) was surely intentional.[4] In contrast to the
ethereal lightness of Prud'hon's scene, appropriate to its
overhead placement, David's composition is more solid
and grounded. Another image of Jupiter enthroned with
a supplicant female deity to which David's drawing is fre-
quently compared is the *Jupiter and Thetis* (Musée Granet,
Aix-en-Provence) by his former student Ingres, exhibited
at the Salon of 1811.[5] In addition to the parallel subject
matter, both artists seem to have looked to the designs of
John Flaxman for inspiration. For his figure of Jupiter,
Ingres adopted the frontal pose of one plate, while David

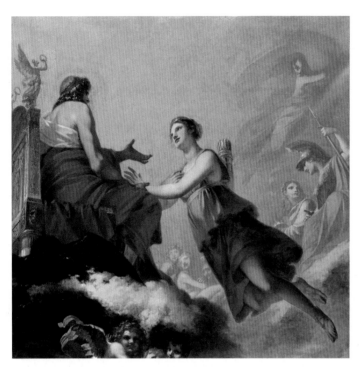

Fig. 137. Pierre Paul Prud'hon (1758–1823), *Diana Imploring Jupiter Not to Subject Her to the Laws of Hymen*, commissioned 1801. Oil on canvas, 96 × 115¾ in. (244 × 294 cm). Musée du Louvre, Paris (INV. 20115)

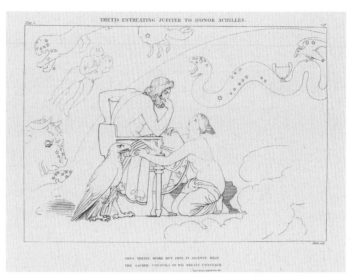

Fig. 138. William Blake (1757–1827), after John Flaxman (1755–1826), *Thetis Entreating Jupiter to Honor Achilles*, 1805. Etching and stipple engraving, 9⅞ × 14 in. (25.2 × 35.5 cm). British Museum, London (1973,U.1189.9)

preferred the profile view used in *Thetis Entreating Jupiter to Honor Achilles* (fig. 138).[6]

New power structures governing state support of the arts as well as shifting tastes created a situation for David that must have been both galling and frustrating, even as the growing ranks of former students forging so many divergent and successful paths burnished his legacy as a teacher. As a history painter returning to subjects of classical mythology in the late years of the Empire, David's ideas did not always progress beyond paper but were nonetheless appreciated as fully conceived and highly finished compositions. Both *Venus, Wounded by Diomedes* and *The Departure of Hector* were acquired at the artist's estate sale by his son Eugène, who apparently displayed them framed under glass until his own death in 1830.[7]   PS

# LEONIDAS AT THERMOPYLAE

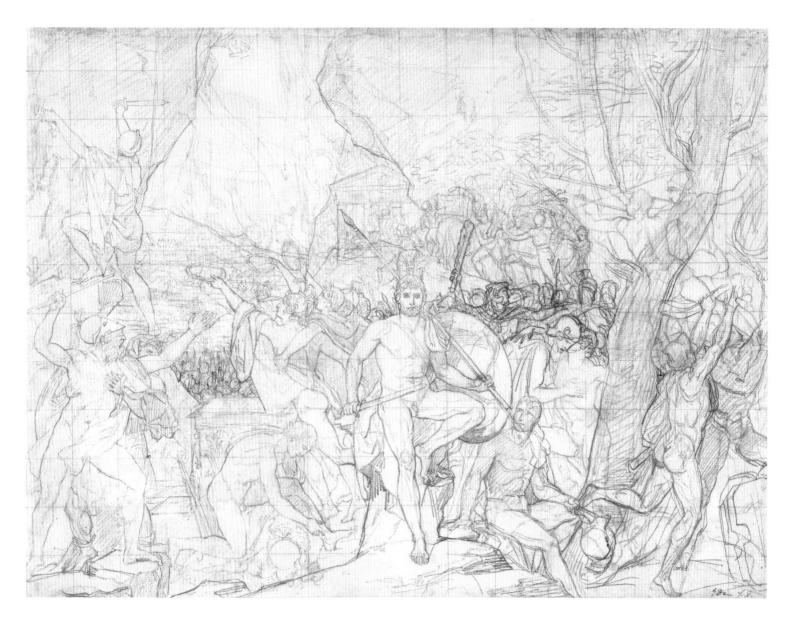

## 75. *Leonidas at Thermopylae*

Ca. 1812–13
Black chalk, squared in black chalk
16 × 21⅝ in. (40.6 × 54.9 cm)
Marks: lower right, paraphs of Eugène David (Lugt 839) and Jules David (Lugt 1437)
The Metropolitan Museum of Art, New York, Rogers Fund, 1963 (63.1)

PROVENANCE: Possibly included in the David estate sale, Paris, April 17, 1826, and following days, part of lot 92; Jean Oberlé (1900–1961), Paris (per Wildenstein & Co.); Henri Baderou (1910–1991), Paris; Wildenstein & Co., New York; acquired by the Metropolitan Museum, 1963

REFERENCES: Nash 1978; Bean 1986, no. 93, pp. 90–91; Arlette Sérullaz in Schnapper and Sérullaz 1989, cat. 219, pp. 493–95, 504–5; Rosenberg and Prat 2002, vol. 1, no. 317, p. 299; Bordes 2005b, cat. 25, pp. 196–204; Padiyar 2007a, pp. 27–28, 42–43, fig. 9; Prat 2011, pp. 61–63, fig. 112

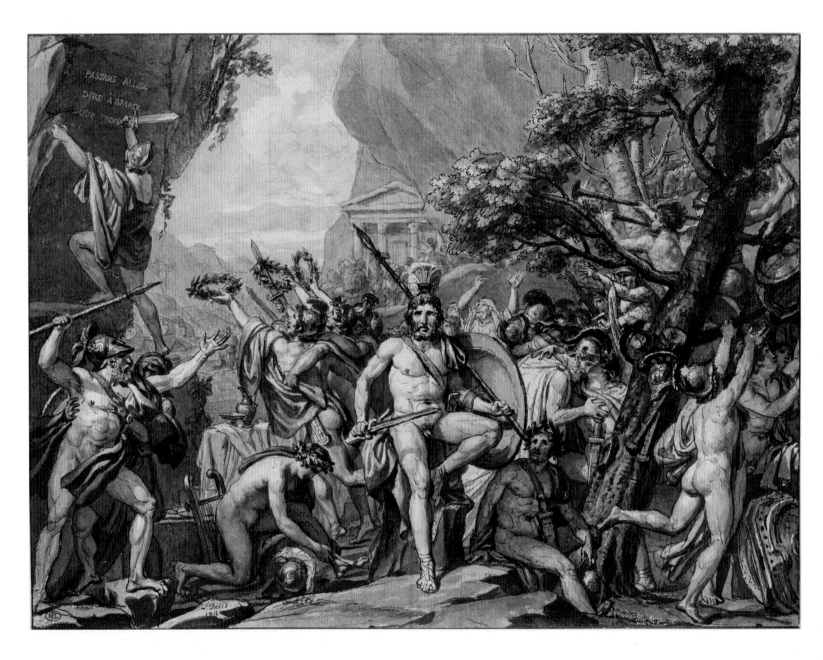

## 76. *Leonidas at Thermopylae*

1813
Pen and black ink, brush and gray and black wash, heightened with
white gouache, over black chalk, lightly squared in black chalk
8⁵⁄₁₆ × 11⅛ in. (21.1 × 28.1 cm)
Inscriptions: lower left, in pen and black ink, signed and dated "L.
David / 1813"; upper left, in white gouache, "PASSAN[N reversed] S ALLEZ /
DIRE À SPARTE / QUE TROIS."
Musée du Louvre, Paris (INV. 26080)

PROVENANCE: David estate sale, Paris, April 17, 1826, and following
days, lot 27; acquired at that sale by the Musée du Louvre

REFERENCES: Nash 1978; Arlette Sérullaz in Schnapper and Sérullaz
1989, cat. 220, pp. 495, 506–7; Sérullaz 1991, no. 221, pp. 174–75;
Rosenberg and Prat 2002, vol. 1, no. 316, p. 298; Bordes 2005b, cat. 26,
pp. 196–204; Prat 2011, pp. 61–63, fig. 111

About 1798, as he was completing the *Sabines* (cats. 64–66), David began work on a pendant. This second painting would have a Hellenistic subject, to balance the Roman legend of the Sabines, and feature the Spartan king Leonidas, a figure who had been revered by the Jacobins.[1] In 480 B.C., Leonidas and his three hundred soldiers all lost their lives at Thermopylae, where they were vastly outnumbered by the Persian army of Xerxes. In a subversion of the conventions of battle painting, David shows no bloodshed, highlighting instead the resolve, brotherhood, and patriotism of the Spartan warriors who, hearing the sentinels signal the approach of the enemy, knew "they would dine with Pluto that evening" (fig. 139).[2]

The young Bonaparte was dismissive of the project when he visited David's studio in 1800. According to Etienne Jean Delécluze, a student of David's at the time, the general disparaged the subject, saying, "you are wrong, David, to put your energy into portraying the vanquished."[3] These words must have stung, for not only would David revive the project in the waning years of the Empire, when the mood had grown dark in the French capital and military defeats were mounting for Napoleon, but he also would publish a lofty explanation of the subject when the painting first went on public view, echoing the act of the soldier who carves their epitaph into the stone, memorializing in advance "the most brilliant victory" that their deaths would represent.[4] Delécluze's recollections suggest that this decision to depict the preparations and farewells that preceded that battle reflected David's admiration for the artists of antiquity, who invariably chose to represent the moment just before or after a crisis.[5] Here, like Socrates in prison (see cats. 31–35), the Spartans appear calm in the face of certain death, assured of their own immortality.

From the earliest exploratory sketches, which date to about 1798, the gestation of the composition spanned fifteen years and can be traced through five known compositional studies and about 130 studies of figures and figural groups, although their order and dating are far from clear.[6] A few constants were present from the outset: an inhospitable rocky backdrop, a compressed jumble of mostly nude male warriors, and, at front and center, seemingly oblivious to the tumult swirling around him, the static figure of Leonidas. Even as David

experimented with different poses, the general retained a statuesque stillness, lost in contemplation of his soldiers' impending sacrifice.

With the drying up of Napoleonic commissions following the completion of *The Distribution of the Eagles* in 1810, David returned to the dormant project, as he often did in such cases, with a flurry of new ideas, which he captured on paper in a succession of sketches. This period of radical revision took place while progress on the canvas was already far along, and was chronicled by his student Pierre Théodore Suau, who wrote to his father on July 28, 1813, that so much had been scraped out and repainted that few of the original figures remained.[7]

A large study in The Met's collection (cat. 75) illustrates the extent of the transformations that marked this final stage in the picture's development. The artist's evolving ideas appear as layers of black chalk, from a paler initial sketch to emphatic revisions in a darker shade. Although the sheet may have been executed in two temporally distinct phases, Steven Nash was likely correct when he described it in 1978 as an intentional "palimpsest."[8] The different stages of work are distinguished not only by the contrast in the tone of the marks but in their handling, as well. Many of the figures at center and to the left are delineated with unwavering contour lines and bear the hallmarks of having been traced or carefully transferred from previously worked-out designs. In the middle ground and to the right, the figures are rendered in a more animated technique, sketched with evident speed, with loose, repeated contours and unarticulated extremities. We are reminded, in the way that certain elements have been carried over from previous iterations, of the collaged sheets used to develop the *Sabines* composition, where David cut and pasted figure studies in order to fine-tune their placement in the composition (see fig. 19).[9] The same dichotomy of handling in The Met's *Leonidas* is evident in the fragment in Lille, a study for the central figures of the Sabines (cat. 64), which combines traced portions with fresh freehand drawing, employing the same collagelike method of working, but produced without actual scissors.[10]

The Louvre drawing (cat. 76) is in many ways the opposite of The Met's sheet: smaller; highly finished

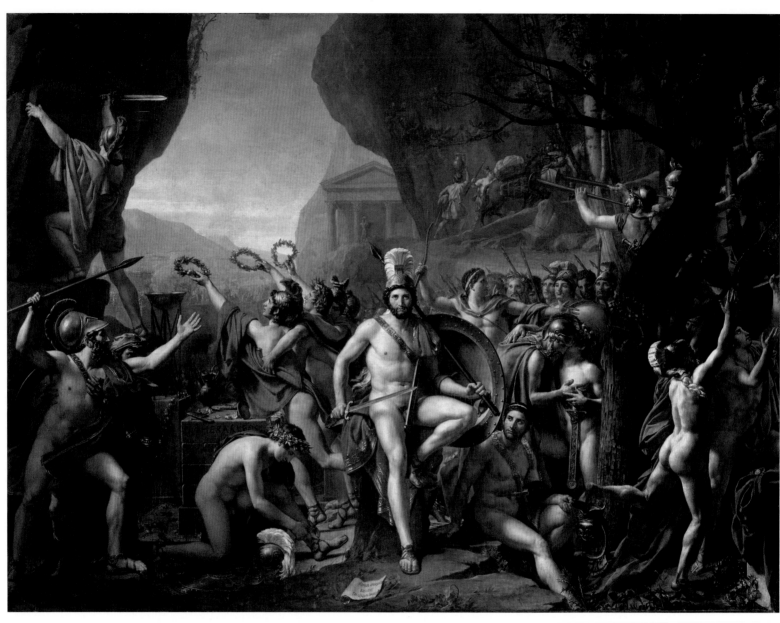

Fig. 139. Jacques Louis David, *Leonidas at Thermopylae*, 1814. Oil on canvas, 155½ × 209 in. (395 × 531 cm). Musée du Louvre, Paris (INV. 3690)

in ink, wash, and gouache; and signed and dated. The Spartan warriors, perhaps owing in part to the change in media, feel more like they are modeled from lumpy clay than based on a Winckelmannian ideal of polished antique marbles. Although it bears evidence of squaring and pentimenti (the length of Leonidas's spear, for example), the sheet has more of the plodding solidity of a presentation drawing than the rush of inspiration that, in The Met's drawing, battles with clarity. Each study has a different mix of commonalities and differences with the painted canvas, leaving the question of anteriority up for debate. A compositional study closer to the final work may once have existed, but the surviving drawings make clear that the process of completing the painting was marked by dissatisfaction and extensive reworking. Moreover, the resolution of the composition on paper did not precede the execution of the canvas but occurred in tandem, the drawn iterations forming a critical dialogue with the painted work in progress. Knowing the extensive involvement of David's students, one can imagine the drawings as the fulcrum of studio debate and discussion.

In addition to this protracted formal evolution, the meaning the picture had for both its maker and its viewers clearly underwent revision, as well. When David first began planning the picture, in the last years of the eighteenth century, the subject may have embodied, according to Satish Padiyar, a coded reference to Jacobin struggle,[11] but when it was revived in the late years of the Empire, it had taken on a pessimistic air. Napoleon had invaded Russia in 1812, suffered losses, and been forced to retreat. David's own son Eugène was injured on the French army's German campaign in 1813, the same year that David executed the Louvre's presentation drawing. The prospect of victory for Napoleon's army, which David had once planned to invoke with an allegorical figure in *The Distribution of the Eagles* (see fig. 131), had faded. But even though the drawings for *Leonidas* map David's intermittent engagement with the subject and the shifting nuances of meaning, they also lay bare the underlying themes in his oeuvre that run like deep currents through multiple political upheavals: patriotism, brotherhood, and the electrical charge of common purpose, as seen in *The Oath of the Horatii*, *The Oath of the Tennis Court*, and *The Distribution of the Eagles*. Unlike the binary outcomes of the battlefield, patriotic sacrifice represented for Leonidas, as it had for the contemporary martyrs that David had memorialized during the Revolution, a path to eternal glory.   PS

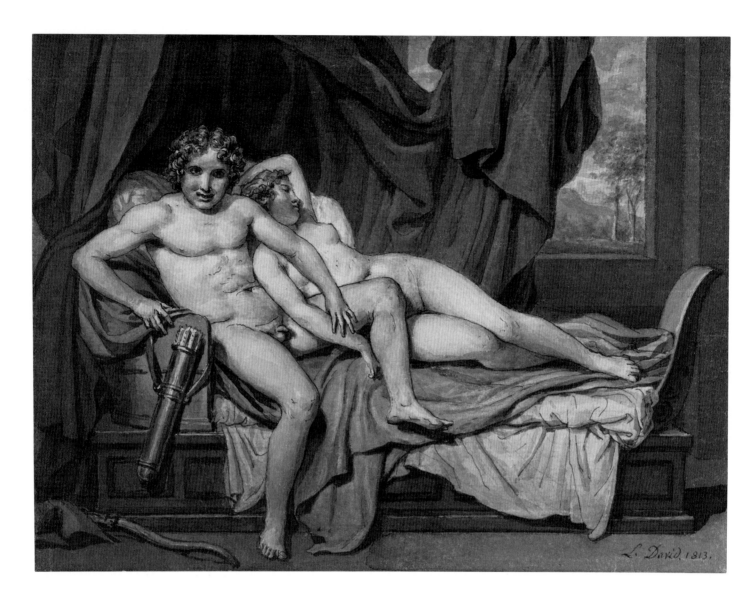

## 77. *Cupid and Psyche*

1813
Pen and black ink, brush and gray wash, heightened with white gouache, over black chalk
6⁹⁄₁₆ × 8¹³⁄₁₆ in. (16.7 × 22.4 cm)
Inscriptions: lower right, in pen and brown ink, signed and dated "L. David. 1813"
Cleveland Museum of Art, Andrew R. and Martha Holden Jennings Fund (2002.91)

PROVENANCE: Given by the artist to Louis Nicolas Philippe Auguste de Forbin (1777–1841);[1] private collection, France (?); sale, Hôtel Drouot, Paris, November 7, 1973, lot 107 (with incorrect attribution); art market; Heim Gallery, London; Arnoldi-Livie Gallery, Munich; David Carritt, London; Eugene V. Thaw, New York; Ed Hill, El Paso, Tex.; Elizabeth Eddy, Ohio; Richard L. Feigen & Co., New York, ca. 1980; Paul Weiss, New York; Richard L. Feigen & Co., New York, by 1994;[2] acquired by the Cleveland Museum of Art, 2002

REFERENCES: Rosenberg and Prat 2002, vol. 1, no. 319, p. 301; Bordes 2005b, cat. 30, pp. 220–24; Lampe 2007, pp. 108–21, fig. 43

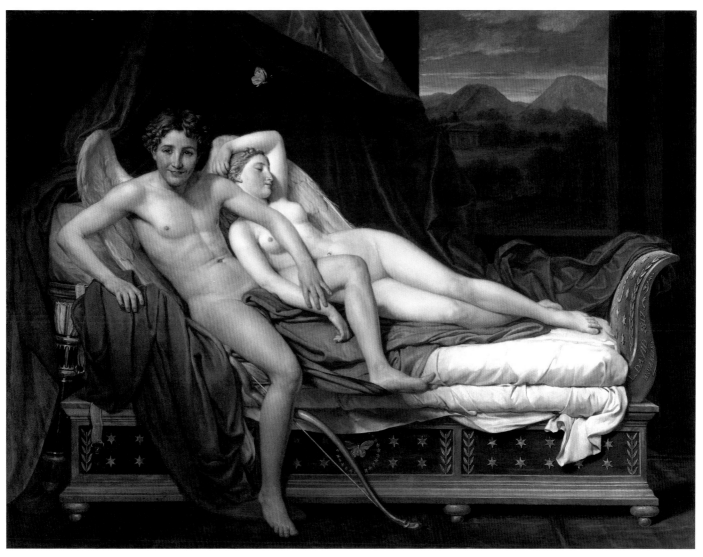

Fig. 140. Jacques Louis David, *Cupid and Psyche*, 1817. Oil on canvas, 72½ × 95⅛ in. (184.2 × 241.6 cm). Cleveland Museum of Art (1962.37)

On April 23, 1813, Pierre Théodore Suau, a pupil in David's studio, wrote to his father that his master was planning a work depicting Cupid and Psyche,[3] a fact confirmed by the date borne by the present composition study, acquired in 2002 by the Cleveland Museum of Art.[4] The concept may have been set, but it would be four more years until the canvas was completed. Banished from his homeland in early 1816 following the restoration of the Bourbon monarchy, David brought with him to Brussels the sketched-in canvas, which he completed by the following August (fig. 140).[5] The painting was sent back to Paris, where it was exhibited in the fall

of 1817 before entering the collection of Count Giovanni Battista Sommariva.[6]

The story of Cupid and Psyche was central to Apuleius's second-century novel *The Metamorphoses*. Psyche's beauty had aroused the jealousy of Venus, who directed her son Cupid to punish her rival. He instead fell in love, spiriting the mortal away to an isolated palace, where he visited her at night but stole away each morning before dawn to conceal his identity. After a series of ordeals, Psyche eventually gained immortality, and she and Cupid married. The myth offered many episodes attractive to artists.[7] David himself had copied the Capitoline marble of the

embracing lovers during his first Roman stay,[8] and he later embedded the image as a relief on a stone column in his *The Loves of Paris and Helen* (see fig. 92). Around 1795, in a considerably changed world, he chose to explore a darker moment in the tale, painting Psyche nude, abandoned, and anguished by the edge of the sea.[9]

When he returned to the subject of Psyche in 1813, David recorded his initial ideas as five quick vignettes in a sketchbook,[10] all featuring entangled lovers on a bed, embracing and gazing at one another. In one, Cupid is clearly trying to make his exit, but it is only in the finished composition drawing that David takes the more unconventional step of pairing the sleeping, postcoital Psyche with the fully awake Cupid, who gazes directly at the viewer with a complicit smirk as he prepares to extricate himself from the weight of his slumbering partner. David's wife, writing from Brussels to the painter Jean Antoine Théodore Giroust in the spring of 1817, as the painting was nearing completion, heralded the novelty of the moment in the story David chose to depict.[11] The Cleveland *modello* also differs from the early sketches in its planar composition and austerity. Aside from the landscape partially visible through the window, there is little in the decor to attract the eye and, with the exception of the bow and quiver, there are no attributes by which to identify the protagonists; Cupid has even lost his wings.

As Issa Lampe has pointed out, the composition initially brushed onto the canvas followed the Cleveland sheet, but significant changes were made in Brussels. In its completed state, the bed is embossed with Empire ornament, Cupid's wings are restored, and Psyche's symbol—a butterfly—floats above her head.[12] The figure of Cupid, based on a seventeen-year-old boy who modeled for the artist,[13] is rendered with a degree of naturalism that quickly became a flashpoint of criticism, recalling the reception of Edme Bouchardon's marble version of Cupid in 1750 (fig. 141).[14] Antoine Jean Gros, a loyal former student, diplomatically described his head as

Fig. 141. Edme Bouchardon (1698–1762), *Cupid Carving His Bow*, 1750. Marble. H. 68¼ in. (173 cm). Musée du Louvre, Paris (MR 1761)

"faun-like," while more recent critics have used descriptors like "monstrous" and "repellant."[15] Pearly Psyche, on the other hand, clearly descends from the Venetian nudes of Giorgione and Titian and the antique *Sleeping Ariadne* in the Vatican.[16] Cupid's aesthetic was jarring not only in juxtaposition to Psyche but also in its rejection of *le beau idéal*, a notion of polished classical beauty that had been promoted by the German art historian Johann Joachim Winckelmann and embraced by David in works as recent as *Leonidas* (cats. 75–76).[17]

Parsing David's intent in this strange picture is made more challenging by the fact that the preparatory study and finished painting straddle the chasm represented by the artist's banishment. Infrared images suggest that several elements, including the glimmering Empire-style decoration on the bed, were added late in the process, presumably in Brussels.[18] Seen through this lens, the picture, with its symbolism of death and transcendence, is reworked, in Lampe's reading, into "a memorial to Napoleon's Empire," its protagonist, like David, finding his way out.[19]  PS

# Reinvention in Exile, 1816–25

When news of Napoleon's defeat at Waterloo, on June 18, 1815, reached Paris, David knew his position would be precarious under the restored Bourbon monarchy,[1] given his history as a regicide and his close relationship with Napoleon during both the Empire and the Hundred Days. David opted to leave Paris in this transitional period, traveling in Switzerland and eastern France, sketching the countryside and likely considering emigration.[2] Upon his return to Paris, David was sentenced to banishment from France by the conservative Bourbon government, along with many others who were politically active during the Revolution. Out of respect for his exceptional talent, David was given the opportunity to renounce his past actions and remain in France, but he refused.[3] On January 27, 1816, David and his wife arrived in Brussels.

Upon his exile, David was solicited repeatedly by the king of Prussia to establish a new museum and academy of art in Berlin, an overture he rejected. He also refused a commission to paint the Duke of Wellington, signaling his continued allegiance to France and disdain for her political enemies. Of the latter offer, David wrote, "I have not waited seventy years to defile my brush. I would rather cut off my hand than paint an Englishman."[4] This powerful response was fueled by Wellington's role in setting punitive measures for France through the Treaty of Paris.[5] David's sense of patriotism was likely reinforced by his ongoing relationship with other French expatriates exiled in Brussels. Among them were individuals who refused to renounce the Revolution's republican ideals, such as Emmanuel Joseph Sieyès and Dominique Vincent Ramel de Nogaret.[6] David painted Sieyès's portrait in 1817 (Harvard Art Museums/Fogg Museum, Cambridge, Mass.) and Ramel's in 1820 (private collection, New York), choosing to depict both sitters not as they were in exile but, rather, with a more youthful aspect, when they were at the height of their—and, to their minds, France's—eminence.

Exile, however, did not mean isolation, as many artists made the pilgrimage to see David, and his children were free to visit him. For David, Brussels was "a period of tranquility."[7] He spent time with both young and established Belgian painters, including former students François Joseph Navez, Joseph Paelinck, and Joseph Denis Odevaere. This community inspired David to continue painting, initially portraits, and then allegorical subjects. In the meantime, his students in Paris entreated authorities to allow David to return. Their February 1816 petition—signed by forty-seven artists—emphasized that "David, in his old age, exists now only for the arts," reiterating that he posed no threat to the current monarchy and underscoring his importance for France's reputation.[8] David's devoted students, in particular Antoine Jean Gros, repeatedly, if unsuccessfully, lobbied for David's repatriation. At David's request, Gros took over David's studio in July 1816 and continued to manage David's arts-related affairs in Paris. Both were committed to preserving David's presence at the center of the French art world.

Given the political nature of David's earlier works—or, the way they had been politicized—and the artist's lived experience, it is unsurprising that, during these years, David eschewed contemporary subjects for those taken from ancient history and mythology. In the artist's words, they were the only subjects that "offer[ed] refuge from the passions of men."[9] These subjects and his Brussels milieu invigorated David, who wrote to Gros while working on *Cupid and Psyche* (cat. 77): "I work as if I were only thirty years old; I love my art as I loved it when I was sixteen, and I will die, my friend, brush in hand. No power, however malevolent, can take it from me; it makes me forget everything."[10] Upon its completion, the painting was publicly displayed in the Brussels museum to benefit the hospices of Saint Gertrude and of the Ursulines. This strategic move garnered David additional attention and was one of several gestures the artist made

to perform his gratitude to his new homeland. Similarly, David exhibited *The Farewell of Telemachus and Eucharis* (1818; J. Paul Getty Museum, Los Angeles) and *The Anger of Achilles* (1819; Kimbell Art Museum, Fort Worth), with proceeds going to the same charitable organization. Unlike other contemporary treatments of such subjects from antiquity,[11] David distilled his compositions to the main protagonists, emphasizing the intimacy and intensity of the narrative through close cropping. In the case of *The Anger of Achilles* (see fig. 146), David selected the subject (and dimensions) that had recently been assigned for the Prix de Rome competition. In this way, he engaged with the Parisian art scene, maintaining his influence on a new generation of artists. He exchanged frequent letters with many of his students, remaining well informed about important commissions and their reception. And even though David's Brussels-period paintings were inaccessible to the majority of French audiences, their compositions would have been known through reproductive prints in circulation.[12]

In Brussels, consistent with his practice of revisiting earlier ideas, David completed a panel on the subject of *Alexander, Apelles, and Campaspe*, for which he had produced an elaborate drawing in 1813.[13] The dynamics between a powerful leader and his revered and adored painter undoubtedly resonated with David, who had been lauded as Napoleon's Apelles by admirers. This association was reiterated in a portrait of David by his former student Jérôme Martin Langlois—the only representation of David drawing. In it, David is depicted with a *porte-crayon* in hand, drawing the figures of Alexander and Apelles in white chalk.[14]

Earlier in David's career, drawings were often functional, allowing David to record Roman artifacts or vistas, work out figures' relationships to each other for a complex composition, or decide what aspects of a given narrative to focus on, or they were part of a larger project, such as the revolutionary-era costume designs (cats. 56–57). This utilitarian aspect of drawing in David's practice is evidenced by the fact that he only exhibited two drawings publicly: *Frieze in the Antique Style* (cat. 18) and *The Oath of the Tennis Court* (cat. 53). In exile, drawing took on a new role in David's artistic practice, as both an independent mode of art making and a method of engaging with the heroes of past projects, restaging them in new configurations.

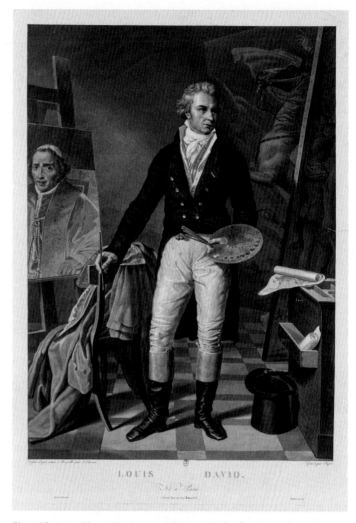

Fig. 142. Jean Pierre Marie Jazet (1788–1871), after Joseph Denis Odevaere (1775–1830), *Portrait of Jacques Louis David*, 1822. Engraving, 30 × 22 in. (76 × 56 cm). Bibliothèque Nationale de France, Paris

He also explored the potential of black chalk, a medium that had become fashionable before and during the Revolution; Jean-Baptiste Isabey executed David's portrait in this manner in 1789.[15] For David, working in black chalk proved to be fertile ground for new artistic experimentation. Known to frequent the theater and opera in Brussels, David likely drew inspiration from these performances for subjects as well as form. Their influence can be gleaned in the drama of David's late works and the composition of characters in unlikely—at times, stiff—groupings of his black chalk drawings.[16]

David's *The Fortune Teller* (1824; Fine Arts Museums of San Francisco) translates his tightly cropped drawn

compositions onto the canvas, using a painterly technique distinct from the highly polished surfaces of many of his Brussels pictures.[17] A meditation on life's vicissitudes, the painting might be said to reveal the aging, ailing artist's musings on his own (mis)fortunes at a time when he was increasingly preoccupied with how posterity would remember him. In addition to coauthoring (if not ghostwriting) his biographies,[18] David intervened in the iconographic program of his depiction by Odevaere. An 1820 preparatory sketch shows David in his studio surrounded by important examples of his post-revolutionary accomplishments in both portraiture and history painting.[19] Odevaere's drawing served as the model for a large-scale engraving by Jean Pierre Marie Jazet (fig. 142) The engraving is remarkable for its blatant avoidance of the corporeal realities of the eighty-four-year-old artist's physique, including the infamous protrusion on David's left cheek.[20] Instead, a slender, dapper man, dressed in riding boots, holds a palette and brush while surrounded by David's *Portrait of Pius VII* (1805; Musée du Louvre, Paris), *Bonaparte Crossing the Alps* (1800–1801; see fig. 124), *The Intervention of the Sabine Women* (1799; see fig. 120), and drawings for *Leonidas at Thermopylae* (1814; see cats. 75–76). Completed in 1822, the engraving tied David's legacy to his Napoleonic-era production,[21] and was an integral part of his conscious image crafting in his final years.

The pinnacle of these efforts was the meticulously choreographed public display of David's final painting *Mars Disarmed by Venus and the Graces* (1824; Musées Royaux des Beaux-Arts de Belgique, Brussels) from May 1824 to March 1825. Organized by his family and friends, doubtless with David's input, the exhibition marked the artist's return to France—at least of his art, if not of his person. Intended as a final proclamation by the leader of the French school to both artists and the French public, the exhibition in a private hall near the Louvre displayed David's final painting alongside his earlier history paintings and provided didactics to carefully underscore his devotion to artistic achievement.[22] The emphasis on David's life being driven by art rather than politics was important for his students' continued efforts to secure permission for his return to France.[23]

Even upon David's death, on December 29, 1825, the issue of his repatriation remained politicized; though his family hoped to inter David in France, their request was denied in favor of local artists who wished to have him buried in Brussels, and who submitted plans to erect a monument to the great master. In the spring of 1826, Parisian viewers had the opportunity to reconsider David's oeuvre at two venues: the Louvre, in an installation of his work that emphasized his classicism; and the Galerie Lebrun, in advance of his first estate sale, which showcased the full range of David's oeuvre, including his drawings. As works that had been hidden from view since the fall of first Robespierre, and then Napoleon, reemerged for these two concurrent displays, the aesthetic and political aspects of David's oeuvre required renegotiation once again.   DB

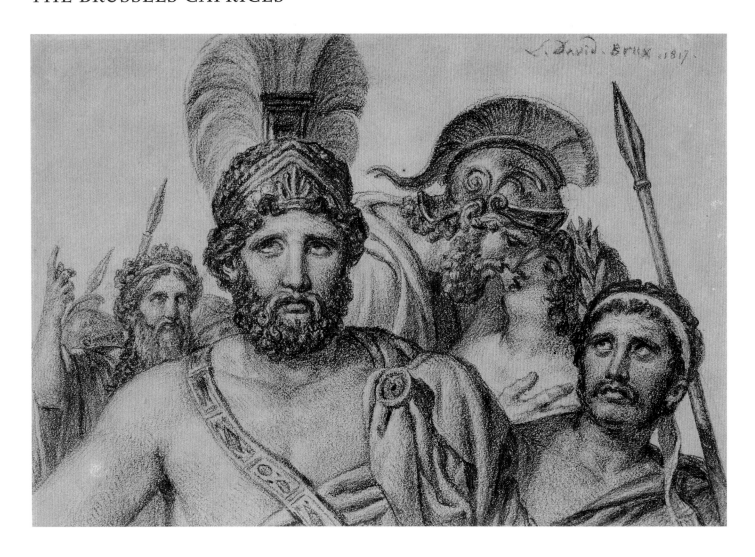

78. *Group of Figures Inspired by "Leonidas at Thermopylae"*

1817
Black chalk
5⅝₁₆ × 16¹¹⁄₁₆ in. (13 × 19.5 cm)
Inscriptions: upper right, in black chalk, signed and dated "L David. Brux. 1817"
James Mackinnon, England

PROVENANCE: N. R[evil] sale, Paris, March 29–April 2, 1842, lot 70; Solange Bianchi, marquise de Ludre-Frolois (d. 1949), great-granddaughter of Pauline Jeanne David (1786–1870), the artist's daughter, and Jean-Baptiste Jeanin; her sale, Galerie Charpentier, Paris, March 15, 1956, lot 9; private collection, Paris; sale, Libert-Castor, Hôtel Drouot, Paris, June 5, 1996, lot 21; acquired by the present owner

REFERENCES: Rosenberg and Prat 2002, vol. 1, no. 332, p. 311; Bordes 2005b, cat. 33, p. 239; Padiyar 2007b, pp. 306–7; Prat 2011, pp. 64–65; Crow 2018, pp. 135–37

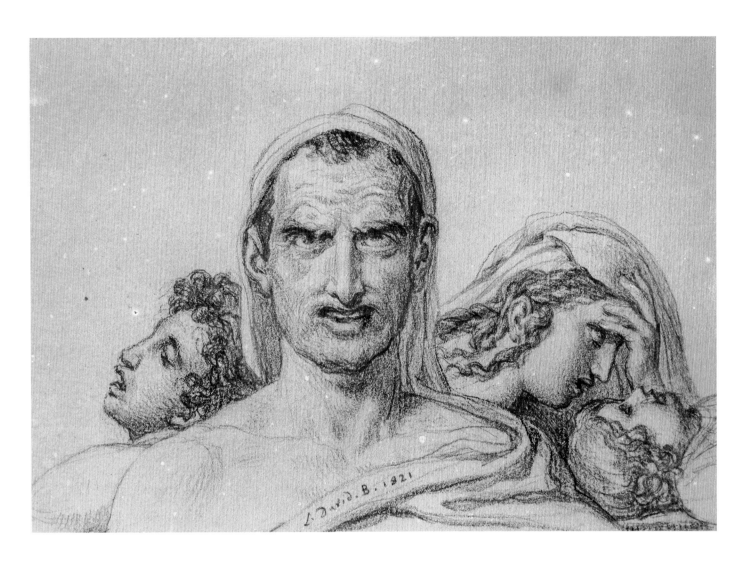

## 79. *Composition with Four Figures*

1821
Black chalk
5¼ × 7⅝ in. (13.3 × 19.5 cm)
Inscriptions: bottom center, in black chalk, signed and dated "L. David. B. 1821"
James Mackinnon, England

PROVENANCE: Acquired by the present owner from Galerie del Borgo, Paris, 1989

REFERENCES: Rosenberg and Prat 2002, vol. 1, no. 435, p. 375; Bordes 2005b, cat. 45, p. 288; Johnson 2007, pp. 163–64; Prat 2011, p. 65

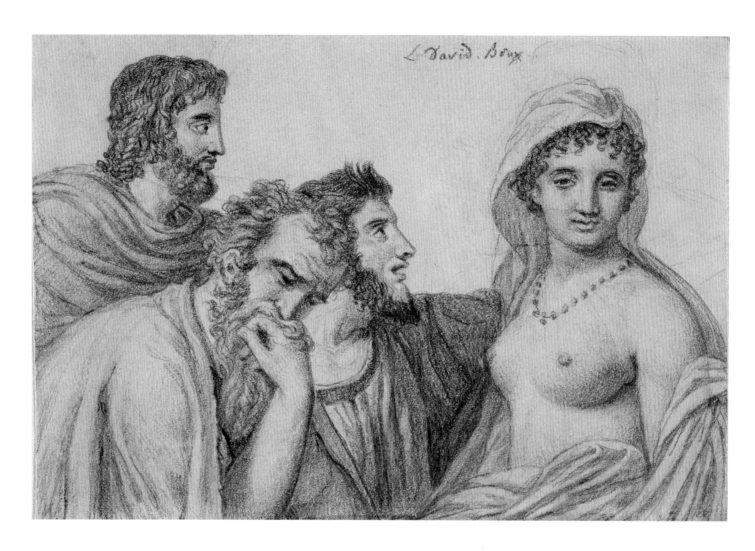

## 80. *Phryne Before Her Judges*

Ca. 1816–20
Black chalk
5⁵⁄₁₆ × 7¹³⁄₁₆ in. (13.5 × 19.9 cm)
Inscriptions: at upper right of center, in black chalk, signed "L. David Brux."
Cleveland Museum of Art, Gift in memory of Helen Borowitz (2013.249)

PROVENANCE: Adolphe Stein, Paris and London, 1977; Helen and Albert Borowitz, Cleveland; gift to the Cleveland Museum of Art

REFERENCES: Rosenberg and Prat 2002, vol. 1, no. 351, p. 326; Prat 2011, p. 65

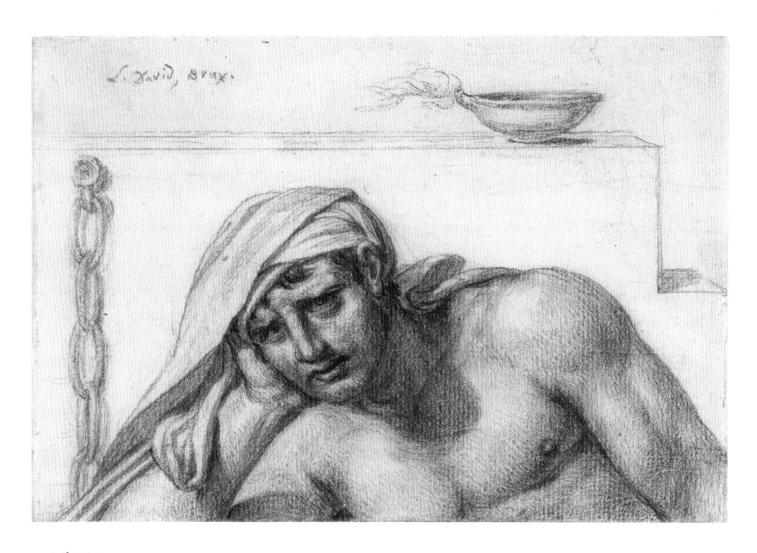

## 81. *The Prisoner*

Ca. 1816–1822
Black chalk
5¼ × 7⅜ in. (13.4 × 19.7 cm)
Inscriptions: upper left, in black chalk, signed "L. David, Brux."
Cleveland Museum of Art, Purchase from the J. H. Wade Fund
(1973.36)

PROVENANCE: Sale, Hôtel Drouot, Paris, February 9, 1972, lot 13 bis; Adolphe Stein, Paris and London, 1972–73; Eugene V. Thaw, New York, 1973; acquired by the Cleveland Museum of Art, 1973

REFERENCES: Coekelberghs and Loze 1985, cat. 148, p. 189; Arlette Sérullaz in Schnapper and Sérullaz 1989, cat. 245, p. 554; Johnson 1997, pp. 30–31; Rosenberg and Prat 2002, vol. 1, no. 393, p. 352; Bordes 2005b, cat. 43, p. 284; Padiyar 2007b, p. 310; Prat 2011, p. 65; Crow 2018, p. 139

It can no longer be said that the late work of David is neglected. The taxonomy and characteristics of this corpus are now well known, thanks to the 2002 catalogue raisonné of his drawings by Pierre Rosenberg and Louis-Antoine Prat. In the wake of that publication, the 2005 exhibition *Jacques-Louis David: Empire to Exile* at the J. Paul Getty Museum in Los Angeles and the Sterling and Francine Clark Art Institute in Williamstown, Massachusetts, under the direction of Philippe Bordes, as well as the associated symposium, drew newfound attention to the second half of David's career, thereby galvanizing research into his nineteenth-century production. The drawings from his Brussels period, formerly disparaged because of their idiosyncratic figural canon, their frequently unintelligible subjects, and their technique—considered slack by comparison with the artist's earlier work—have been reevaluated with the introduction of new sources and methodological approaches. In addition to portraits and preparatory studies for paintings, both consistent with David's usual practice, two new categories appear: single half-length figures, which amount to some fifty sheets, and compositions with multiple figures, again half-length but juxtaposed seemingly at random, of which there are some thirty sheets. The two groups have in common a focus on facial expression. This massive irruption of autonomous drawings by an artist for whom graphic art had always been subordinate to painting marks a major shift in David's creative economy. Although the works in these two groups do not seem to follow a program—their subjects are elusive and have no elaborative function—the discovery a few years ago of a letter from David to his student Joseph Denis Odevaere sheds light on their nature. Dated January 21, 1818, the letter contains a passage in which David uses the term "caprice" to designate the creative process that gave rise to these works:

> Since you left I've made thirty-two drawings that I've arranged in eight frames containing four drawings in each. These are croquis, caprices [*capricios*], if you like, I started off doing them without much real intent, I just threw down onto the paper the mad ideas [*folies*] that came into my head . . . but then my pride got involved and I made real drawings, I went back to them—well,

you can pass judgment on them when you return. However, I think I can say that this collection of drawings deserves a place among my works.[1]

Although this claim of irrationality would seem to curtail speculation about the logic of these inventions, it has not dispelled their unsettling effect, nor has it discouraged certain exegetes from seeking a hidden truth beyond this apparently conclusive explanation.

In her essay on the Brussels-period drawings, Dorothy Johnson begins by noting the role that David assigned to drawing throughout his career: it served as a repertory of forms and a laboratory for history painting, but rarely did he consider them an end in themselves. Her subsequent analysis goes on to describe several of the most significant works in this corpus, though she acknowledges the aporia that will inevitably result from any attempt to elucidate caprices, which, save for a small number with identifiable subjects, are by definition meant to elude such explanation.[2] Satish Padiyar takes quite a different methodological approach in his study of *Mars Disarmed by Venus and the Graces*, in which he uses psychoanalytic theory to examine the full semiotic potential of the Brussels drawings, aiming not merely to make sense of them but to uncover their true meaning. In shackling the one-time revolutionary painter and subsequent exile to a tragic vision of the world, Padiyar considers only those compositions with exaggerated facial expressions, divining in them "hysterical repetitions of a collective trauma of Terror."[3] This stance is, however, inconsistent with David's claims that he had found contentment, both in work and in life, in his new country.[4]

More recently, Thomas Crow discussed the Brussels caprices in his analysis of the trajectory of artistic modernity in post-Napoleonic Europe, specifically with respect to the disruption of the traditional narrative order in depictions of historical subjects.[5] Although he proposes a dialogue between David's experiments and those of his student François Joseph Navez, Crow, like Johnson and Padiyar before him, nonetheless isolates the artist from the European chessboard that is the focus of his book by observing him in the "laboratory of Brussels."

Before the reappearance of David's "caprices" letter, Philippe Bordes took a more objective tack by seeking to

provide a richer sense of context for the late drawings.[6] Eschewing analysis of the artist's inner state of mind, Bordes instead identifies points of reference within the artistic and visual culture of David's time that resonate with his "cropped figures."[7] He suggests a similarity between the graphic qualities of these drawings, notably, their thick, granular marks, and the aesthetic of nascent lithography. Moreover, he does well to consider the whole of this production—the single-figure drawings are usually neglected in favor of the multifigure compositions, despite being greater in number—given David's interest in all aspects of the theater at a time when French criticism was reflecting on the limits of theatrical imitation in history painting.

The break with the traditional tenet of *ut pictura poesis* (as in poetry, so in painting) in the caprices composed of historical figure types has been interpreted as a symptom of the rupture of exile. In fact, these caprices did not appear ex nihilo; there are precedents in David's work that make it possible to trace the genetics of this art of disjunction. Rosenberg and Prat have stressed the similarities between the "cropped-figure" sheets and the expressive heads in pen and brown ink that he produced from the 1780s until at least 1799; the latest examples are related to *The Intervention of the Sabine Women*, but most of these drawings lack any connection to a known composition.[8] Their technique, especially the use of hatched shadows, links them to the *Head of a Victim of the Plague*,[9] a reprise of a detail from *Saint Roch Interceding with the Virgin for the Plague Victims*, painted in Rome in 1780 (now Musée des Beaux-Arts, Marseille). Our inability, in our present state of knowledge, to relate these earlier drawings to any known project renders them akin to pieces of an unfinished puzzle. In fact, David assembled some of these pen-and-ink head studies on the only one of these sheets to bring together several figures (fig. 143): a turbaned man, first studied individually in a drawing now in Amiens,[10] appears together with two other figures to form a group united by the same emotion, though one whose source eludes us, thereby generating the same sense of narrative opacity encountered in the late compositions. We see the same thing in a sheet dating from 1821, now in the Horvitz collection, in which he reuses the head of a bedridden woman drawn in isolation in 1815 into a three-figure composition.[11]

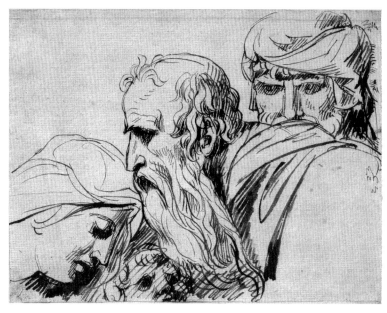

Fig. 143. Jacques Louis David, *Study of Juxtaposed Heads*, 1780s. Pen and brown ink (1 of 4 drawings affixed to a single sheet), overall 14⅝ × 13 in. (37 × 33 cm). Musée de Grenoble (MG 220; D. 150)

Fragmentary compositions of this kind can be related to an artistic practice that was commonplace at the time: the production of study sheets covered with diverse motifs, independent yet coexisting. A number of the Brussels sheets on which heads are juxtaposed without any overall compositional rationale bring to mind such exercises, the intended function of which could have been mnemonic (collections of models), preparatory (refining compositional details), or exploratory (formal experimentation). A precocious example of this practice can be found in certain sheets in Roman album no. 7 (Musée du Louvre, Paris), in which studies of various herms in the gardens of the Villa Medici are arrayed across the sheet, without interacting.[12] The care with which these drawings are executed gives them exceptional presence, as do their dimensions—equal to those of the Brussels drawings, and large relative to the supporting sketchbook pages. David's avowal, in his letter of January 1818, that he embarked on the caprices without any particular aim or intent connects them to these earlier studies, at least to the ones lacking specific motivation, a status confirmed by the humble nature of the supports he used in Brussels—that is, paper meant "for writing and printing."[13]

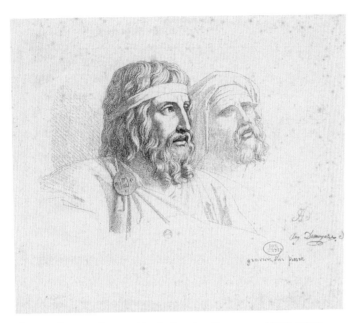

Fig. 144. Auguste Gaspard Louis Boucher Desnoyers (1779–1857), *Two Merovingian Chiefs*, ca. 1817. Lithograph, 6¾ × 10½ in. (17 × 26.7 cm). Bibliothèque Nationale de France, Paris

The similarity noted by Bordes between David's use of black chalk in these drawings and the aesthetic of lithography also applies to their fragmented visual syntax. Just as the facility of etching fostered the development in the eighteenth century of study plates in the form of caprices,[14] experimentation with the new reproductive medium, which Godefroy Engelmann brought to France in 1815, gave rise the following year to the practice of creating "test" plates. Several of the latter consist of head studies, such as that of Phryne by Jean-Baptiste Regnault, based on his painting *Socrates Wresting Alcibiades from the Bosom of Sensuality* (1812 Salon; location unknown); or the one based on *Two Merovingian Chiefs* by Auguste Gaspard Louis Boucher Desnoyers (fig. 144), which affects an archaic simplicity not unlike that cultivated by David in his last years. Before the invention of lithography, stipple engraving, which can faithfully mimic the appearance of drawing, had already made it possible for painters to disseminate details from their works. One such engraving by Edward Scriven (fig. 145), made about 1814, provides a key to David's experiments in Brussels. The print is composed of figures excerpted from Benjamin West's *Moses Receiving the Law on Mount Sinai* (1784; Palace of Westminster, London). Separated

from its original context, the group lacks cohesion and has no meaning apart from the distinctive expressions of its disparately oriented figures. Moreover, the absence of a caption severed its connection with the source composition, thereby fostering subjective readings of the image. David's caprices are functionally dependent on the same combination of fragmentary structure and lack of title. *Composition with Four Figures* (cat. 79) is an especially striking example in this regard, for here, three heads effectively merge into a single composite figure. The profile of the swooning young man at left and that of the woman turned toward the right, leaning over a reclining infant, seem almost of a piece with the bust of an older man shown full-face, his features distorted by deep sorrow. The disjunctive effect stems from the multidirectionality of the compact group; the two lateral figures, facing in opposite directions, seem to pull away from one another. In addition to being an attribute of psychological crisis for the man and an ornament with ancient associations for the woman, the drapery over their heads tends to abstract the representation from the present and situates it in the timeless realm of allegory.[15] The date of 1821 led Bordes to suggest that the drawing is an evocation of the suffering of the Greek people at the start of their war for independence.[16] On the other hand, David abstained, despite the consistency with which he signed his compositions, from inscribing a title here, thereby underscoring the importance to him of leaving these drawings unnamed.

The small number of figures is another measure of the creative journey that culminated in these drawings. It followed from the reduced format of the paper supports David was using, a spatial constraint that he exploited to develop his new visual rhetoric of figural truncation and narrative contraction. This limitation proved such a creative stimulus that he never varied the small format, save to experiment with the new idiom in oil on canvas, in *The Anger of Achilles* (fig. 146). The drawing of *Phryne before Her Judges* (cat. 80), the only one apart from the free variations on the *Leonidas at Thermopylae* (cat. 78) and the *Sabines* (fig. 147) with recognizable iconography, resulted from the same approach. The story of this hetaera, or Greek courtesan, accused of impiety but subsequently absolved by the judges on account of her beauty is condensed into a pileup of bodies that renders impracticable,

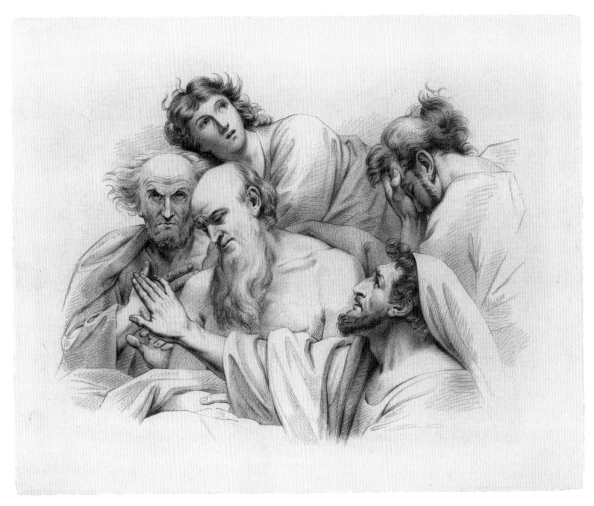

Fig. 145. Edward Scriven (1775–1841), *Moses Receiving the Law on Mount Sinai, after Benjamin West*, ca. 1814. Stipple engraving, 13¾ × 17 in. (34.8 × 43.2 cm). British Museum, London (1843,0513.32)

save for a single forearm, the depiction of extended limbs, elements that often served as vectors of expression in David's earlier history paintings. Despite his prior acknowledgment of the difficulty of assembling cropped figures "without having previously drawn complete ensembles of overall movement,"[17] he now dispensed with this method (there are no known preparatory drawings for these compositions), cultivating instead the discordant effects of improvisation.

The variations on the *Leonidas* and the *Sabines* also depart from the resolutely indeterminate iconography typical of these drawings, following a strategy other than disjunction. In the previously cited letter to Odevaere, David explains how he eventually glimpsed in these fantasies, drawn inattentively at first, a real creative method;

doubtless he would have placed these two "historical" compositions among the drawings that he called "real."[18] Here he recast, through radical simplification, two major paintings still in Paris that he had conceived as pendants, complementary visual parables about recent French history. The first, completed in 1814, pictures the last stand, both heroic and desperate, of the Spartan leader Leonidas and his three hundred men against the Persian army in 480 B.C. (see fig. 139). The second, on view at the Louvre from 1799 to 1805 in an exhibition for which admission was charged, depicts a foundational episode in the history of Rome from the eighth century B.C.: the intervention of the Sabine women in the battle between their Sabine fathers and their Roman husbands, in order to end the hostilities between them (see fig. 120).

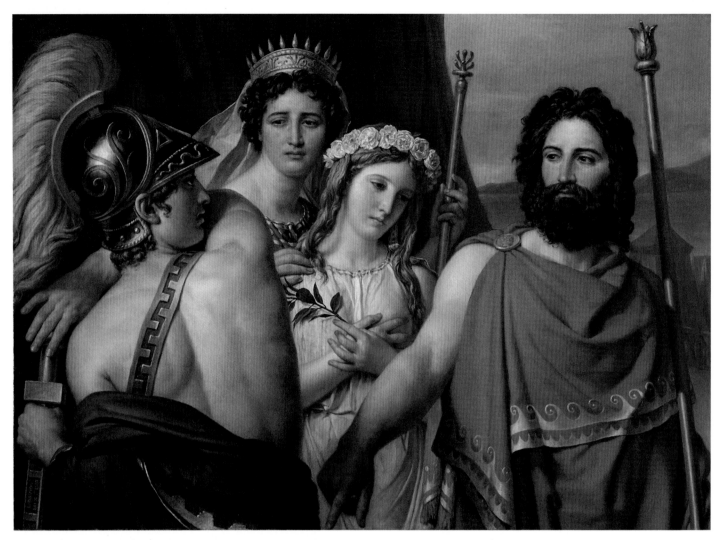

Fig. 146. Jacques Louis David, *The Anger of Achilles*, 1819. Oil on canvas, 41⁷⁄₁₆ × 57¹⁄₁₆ in. (105.3 × 145 cm). Kimbell Art Museum, Fort Worth (AP 1980.07)

David condensed the two works according to the Caravaggesque compositional model in which a few half-length figures occupy entirely a fictive visual field devoid of spatial references. The allegorical casts of these condensed narratives reflect the painter's introspective mindset at a moment of particular irony—that is, when the French monarchy, having exiled him, was negotiating the acquisition of these same two masterpieces.[19] However, the *Leonidas* and *Sabines* variations, dated 1817 and 1818 respectively, were likely neither composed together nor programmatically related.

Further confirmation that self-citation was a frequent practice in David's Brussels-period drawings is provided

by *The Prisoner* (cat. 81), in which the cropped male figure is a near repetition of the turbaned plague victim stretched across the foreground of the *Saint Roch* altarpiece. It stands out among these sheets for its inclusion of accessories and indications of setting; it is also unique in its creation of a unified space, as opposed to a fragmentary scene meant to be completed in the mind's eye, for the suspended chain and low wall clearly evoke the cramped quarters of a prison cell. Rosenberg and Prat suggest that the figure alludes to Napoleon, who died a prisoner on the island of Saint Helena in 1821, while Bordes discerns an air of resistance in the prisoner's expression that is reinforced by his muscular body. It

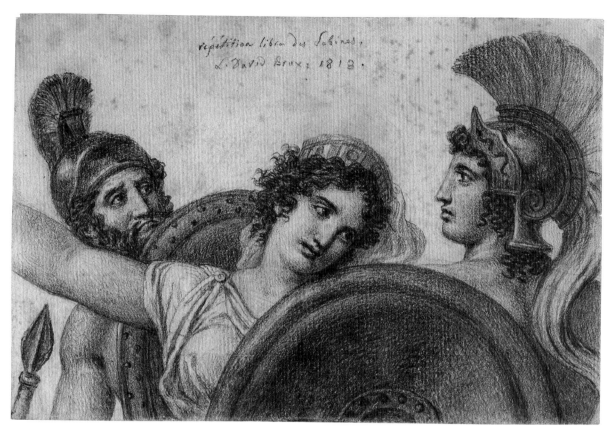

Fig. 147. Jacques Louis David, *Variation on "The Intervention of the Sabine Women,"* 1818. Black chalk, 5¼ × 7⅞ in. (13.4 × 20 cm). Peabody Collection, Maryland Commission on Artistic Property of the Maryland State Archives, on long-term loan to the Baltimore Museum of Art (MSA SC 4680-13-0081)

must be admitted, however, that the overall economy of the image lends little weight to a political reading.

The more rational compositional approach encountered in a few of the Brussels drawings marks them as exceptions within the corpus. While homogeneous in style and having in common their disjunctive method, David's caprices have no inspirational through line; rather, they are the fruit of momentary impulse. The artist's isolation in Brussels was doubtless conducive to this recreational practice, which academic theory condemned as unduly eccentric:

In the arts, *caprice* designates any invention or form that lacks necessity, that has not been suggested by nature, that cannot be justified by need and

is repudiated by decorum; it is the taste of any production that is alien to the principles of art and that, lacking a sound foundation, cannot endure.[20]

The interest of David's caprices resides precisely in this divergence from the rules of imitation that had governed his earlier production. Phantasmic constructions whose fragmentary components spur the imagination, these drawings invite us to go beyond their lack of sense and complete their images in our own minds. In this regard, they align with the Romantic notion that a work of art should not be a centered and integral whole but, rather, a fragmentary and personal representation of the world.   MK

# THE FINAL PORTRAITS

## 82. *Portrait of Baroness Pauline Jeanin*

Ca. 1816
Black chalk
7¹¹⁄₁₆ × 6 ½ in. (19.5 × 16.5 cm)
Inscriptions: bottom center, in black chalk, signed "fait de souvenir / David"
Private collection

PROVENANCE: Sale, Millon & Associés, Paris, December 14, 2016, lot 22; acquired at that sale by the present owner

## 83. *Portrait of Pauline Jeanin, née David, and Her Daughter Emilie*

1821
Black chalk
5¹¹⁄₁₆ × 7⅞ in. (14.4 × 20 cm)
Inscriptions: bottom center, in black chalk, signed and dated "Le 12 juin 1821 L. David Bruxelles."
Snite Museum of Art, University of Notre Dame, Gift of Mr. John D. Reilly (1996.070.004)

PROVENANCE: Pauline Jeanne David (1786–1870); her son baron Louis-Charles Jeanin (1812–1902); acquired on the New York art market by John D. Reilly, 1986; his gift to the Snite Museum of Art, 1996

REFERENCES: Arlette Sérullaz in Schnapper and Sérullaz 1989, cat. 45, p. 533; Spiro and Coffman 1993, no. 45, p. 40; Rosenberg and Prat 2002, vol. 1, no. 437, p. 376; Bordes 2005b, cat. 55, p. 324; Spiro 2005, p. 168

## 84. *Eugène David and His Wife, Anne-Thérèse*

1825
Black chalk, heightened with white
9¾ × 8³⁄₁₆ in. (24.8 × 20.8 cm)
Inscriptions: lower right, in black chalk, signed and dated "L. David 1825 / brux."; on the back of the old mount, in pen and brown ink, in the hand of Eugène David, "dernier dessin de mon pauvre père / E. David"
Véronique and Louis-Antoine Prat Collection, Paris

PROVENANCE: Eugène David (1784–1830); by descent in the family; Galerie de Bayser, Paris; acquired by Véronique and Louis-Antoine Prat, 1994

REFERENCES: Sérullaz 1991, p. 47; Rosenberg 1995, cat. 67, p. 168; Rosenberg and Prat 2002, vol. 1, no. 451, p. 387; Rosenberg 2004, cat. 61, p. 208; Bordes 2005b, pp. 324 fig. 108, 326 n. 3; Raissis 2010, cat. 10, pp. 23, 190; Prat 2011, p. 67, fig. 128; Pierre Rosenberg in Rosenberg 2017b, cat. 50, pp. 142–43; Rosenberg 2020, cat. 77, pp. 133, 291

CAT. 82

CAT. 83

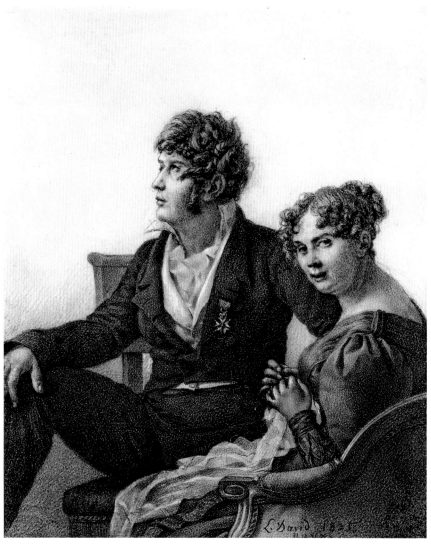

CAT. 84

The portrait drawing is a marginal category in David's body of work. Here, as with history painting, he maintained the same self-imposed limits on the practice of drawing: for him, the crayon was a vector of thought—an instrument in service to the creative process—not a means of independent artistic consummation. His view that drawing was purely utilitarian and unsuited to the production of finished works was at odds with both the widespread vogue for portraits in black chalk, initiated by Jean-Baptiste Isabey during the Directory, and the graphite portraits perfected by Ingres over the first decade of the nineteenth century (see pp. 60–61). During the revolutionary period, however, circumstances led David to capture the physiognomies of his contemporaries in

crayon and pen and ink, with various objectives. Beyond the gripping funerary portrait of Marat (cat. 54), drawn with vigorous pen strokes in 1793 to serve as the model for an engraving, it was David's imprisonment at the Collège des Quatre-Nations in the summer of 1795 that led him to further exercise his hand. There, he produced medallion portraits of his fellow detainees, all former deputies to the National Convention like himself, that demonstrate his superior gift for graphic analysis (see cats. 58–63). When he undertook the large group portraits *The Oath of the Tennis Court*, *The Coronation*, and *The Distribution of the Eagles*, he again turned to drawing, to fix the features of individuals who could not spare the time for extended posing sessions, for example,

Emperor Napoleon, Empress Josephine (see cat. 69), and Napoleon's mother for *The Coronation*. He did, however, always prefer to paint portraits directly after nature, the better to "imprint the resemblance."[1]

Dashed off quickly with a black crayon whose sharpened tip enabled the execution of vigorous contours, David's few portrait drawings made as finished works of art during the Empire period depict individuals close to the artist, notably, Angélique Mongez, Alexandre Lenoir, and Adélaïde Binard.[2] After 1816, when David's exile upended his relationship to drawing to such an extent that its practice began to occupy much of his time, portraits in black crayon remained rare but nonetheless reflective of his new circumstances. No longer serving propagandistic aims or meant as gestures of friendship, they now sprang from memory. The task of producing a replica of *The Coronation* (1822; Musée National des Châteaux de Versailles et de Trianon, Versailles) presented David with the challenge of recollection, which he met with the crayon. The canvas on which he had roughed out the composition had been sent from Paris, but in order to paint those who were no longer before his eyes, he had to draw their features "from memory."[3]

Memories of his family must have offered David solace from the rigors of exile, as can be surmised from at least two intimate portraits inspired by absent paintings: likenesses of his father-in-law, Charles Pierre Pécoul, painted in 1784 and redrawn "from memory, 22 years after his death," which is to say, in 1816 (fig. 148);[4] and of his daughter Pauline (cat. 82), which likewise bears an inscription that it was "done from memory." These works differ from the individual portraits of his twin daughters and their husbands that David had painted in Paris between 1810 and 1812,[5] which he made not to surround himself with images of family but to present as gifts, examples of a talent that he had always put to the service of his country. The drawn likeness of Pauline reproduces the painted portrait that David began in 1810 but, for reasons unknown, left unfinished (fig. 149), like that of her sister, Emilie. The only departure from the canvas is the addition of a necklace and earrings, a reference to her former status as lady-in-waiting at the imperial court.[6] The face is drawn with light strokes that recall the vibrant facture of the unfinished painting and point to an early date, shortly after David and his wife moved to

Fig. 148. Jacques Louis David, *Portrait of Charles Pierre Pécoul, David's Father-in-Law*, 1816. Black chalk, 4⅛ × 3 in. (10.5 × 7.5 cm). Private collection

Brussels, when they no longer had access to the original canvas but greatly missed their daughter. In its handling, this drawing differs considerably from that of Pauline and her own daughter (cat. 83), executed in the spring of 1821, when Pauline visited Brussels to care for her parents as they both convalesced from illnesses.[7] Philippe Bordes has persuasively situated this drawing in the wake of the double portrait of Zénaïde and Charlotte Bonaparte (J. Paul Getty Museum, Los Angeles), painted the same year, drawing attention to the fact that both painting and drawing depict a moment of affectionate complicity.[8] Despite the grainy quality of the black crayon, typical of his late work, David instilled this snapshot of family life with truth.

These last drawings of members of David's family bear witness to the artist's declining health and speak to both the attentiveness of his children when they came to Brussels to care for him and the degree to which their presence stimulated his hand. A case in point is the portrait of Eugène with his wife, Anne-Thérèse (cat. 84), which bears an inscription in Eugène's hand declaring it the "last drawing by my poor father." Just as the structure of the portrait of Pauline and her daughter indicates the artist's physical proximity to them, the oblique posture and orientation of Eugène's and Anne-Thérèse's bodies betray the position from which the draftsman worked: it is that of a patient observing his caregivers from his sickbed. The artist, who was struck by a carriage in February 1824, long kept his intimates in the dark about

Fig. 149. Jacques Louis David, *Portrait of Pauline Jeanne David, Baroness Jeanin*, 1810. Oil on canvas, 28¾ × 23⅝ in. (73 × 60 cm). Oskar Reinhart Collection "Am Römerholz," Winterthur, Switzerland

the seriousness of the accident, from which he never fully recovered. According to David's student François Joseph Navez, the situation was particularly dire in April 1825. Eugène was so concerned about his father's health that he left Paris for Brussels that May; he was still there in July, when the artist's condition was so worrying that news of his impending death reached as far as Rome. It makes sense, then, that this drawing would have been executed in August, when David was partially recovered, as opposed to the critical month of July, the dating proposed by Arlette Sérullaz.[9]

In any case, the naive quality of this double portrait is not necessarily an indication of weakened faculties. While the incongruous absence of Eugène's left leg, underlined by Rosenberg and Prat, could certainly be seen as an

indicator of that, it can be explained in the light of the artist's invalid state, and appears as a transference of his own infirmity. In further development of his late style, David worked the black crayon more thoroughly here than in most of the Brussels drawings, loading the sheet with its medium so as to render, with unaccustomed precision, details of clothing and furniture. This high degree of finish was perhaps a manifestation of the attenuated stretches of time that the diminished artist had at his disposal. As Bordes has noted, the attention to psychology here is also striking.[10] To convey Eugène's inconstant and distracted character,[11] David depicted him at an oblique angle, lost in thought, while the watchful gaze and active hands of Anne-Thérèse express her practicality and rootedness in reality.   MK

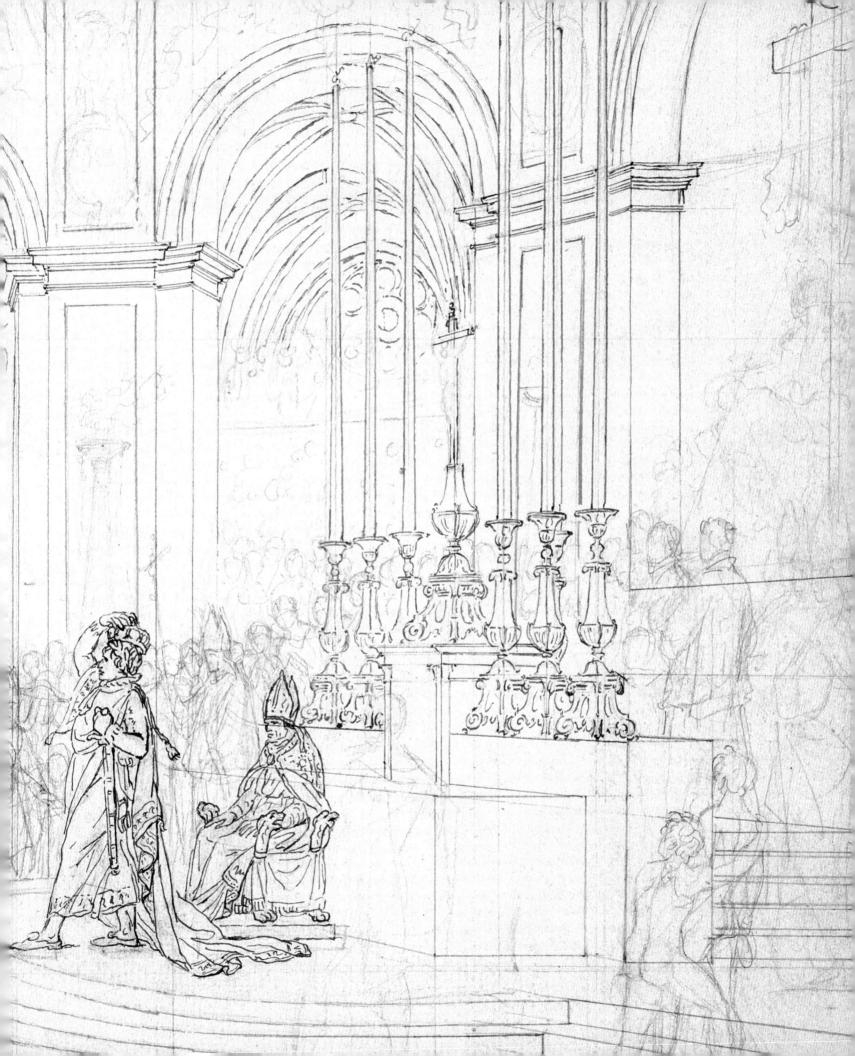

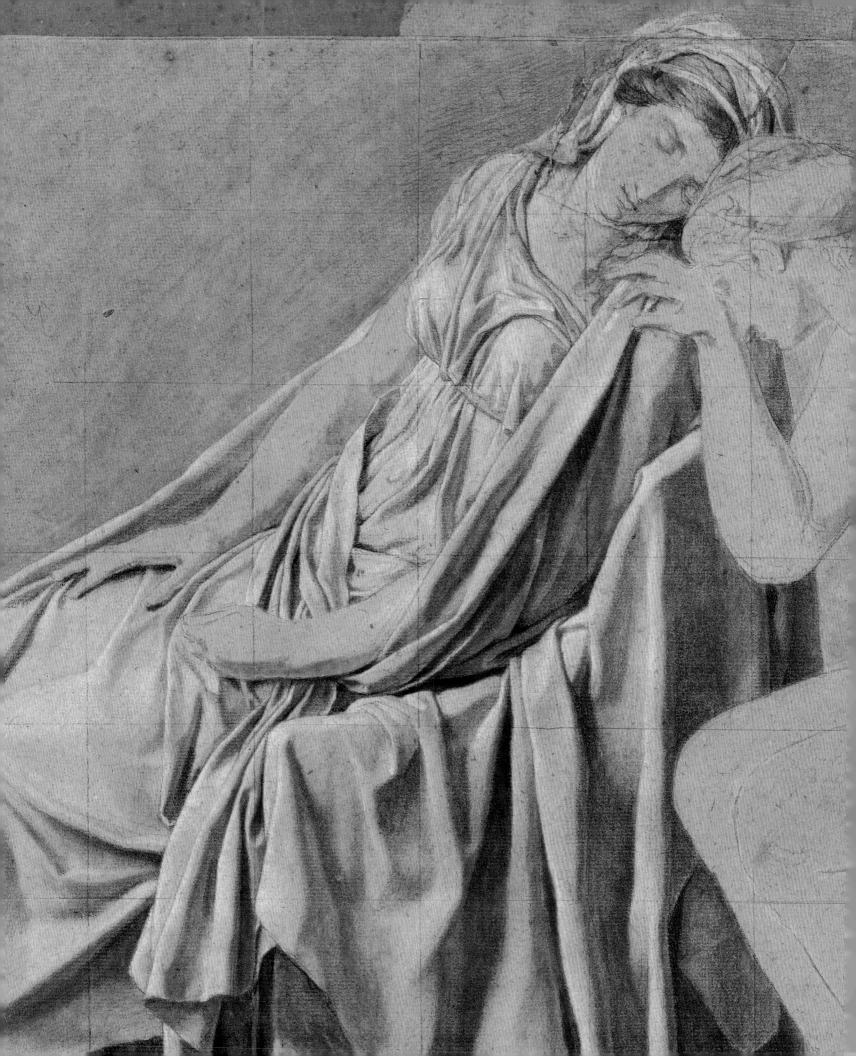

# Notes

THE LONG MEDITATION (pages 15–33)

1. David's letter was to Jacques Nicolas Paillot de Montabert, a former pupil who was writing a treatise on painting. This excerpt is quoted and translated by Mark Ledbury in Ledbury 2007, p. xiii.

2. Christiansen 2020, p. 39.

3. See Draper 2007.

4. See Rosenberg and Prat 2002, vol. 1, nos. 191, 198, 200, pp. 202, 208, 211.

5. In this case, the sheet was annotated by Delécluze, who would later provide the story that accompanied it. See Rosenberg and Prat 2002, vol. 1, no. 13, p. 38.

6. Ibid., vol. 1, no. 319 bis, pp. 302–3. For an account of the gift and the note of appreciation sent with it, see J. L. J. David 1880, p. 569.

7. Rosenberg and Prat 2002, vol. 1, no. 146, p. 161.

8. Stein 2005, cat. 65, pp. 160–61.

9. David was painting *The Death of Socrates* (cat. 35) while Fabre was in his studio, but Fabre would himself treat the subject years later. See Pellicer and Hilaire 2008, cats. 108–10, pp. 244–50.

10. D. Wildenstein and G. Wildenstein 1973, nos. 2041, 2042, 2052, pp. 237–38, 243. Some of these drawings remain untraced, but copies made by students in David's studio have surfaced. For example, Ingres's copy after Leonardo's *La Belle Ferronnière* (Musée du Louvre, Paris), listed in the February 25, 1826, inventory (ibid., p. 237), is today in the Barber Institute of Fine Arts, Birmingham, U.K. (37.3). A copy in black chalk after the figure of Hersilia in the *Sabines* by Benjamin Eugène Bourgeois (1791–1818) was with the Galerie de Bayser in 2021; see their online catalogue *Dessins de figures: October 2021*, https://www.paperturn-view.com/?pid =MTk190215&p-55.

11. The use of the word "emulation" in this context is an intentional reference to both the book of that title by Thomas Crow (1995) and the quote that inspired it—that is, David's lament on the premature death of his favored student, Jean Germain Drouais: "I have lost my emulation."

12. Boutet-Loyer 1983, cat. 106, n.p.

13. Another example of a quoted excerpt would be François Xavier Fabre's *Head of Andromache, after David* in the Musée Fabre, Montpellier (837-1-609); see Pellicer and Hilaire 2008, cat. 2, p. 96. For a copy of the same head, left similarly unfinished along the lower margin, see Prat 2011, pp. 37–38, fig. 59.

14. D. Wildenstein and G. Wildenstein 1973, nos. 2041–43, 2052, pp. 236–39, 243.

15. For documents related to David's burial and the family's unsuccessful efforts to repatriate his body, see D. Wildenstein and G. Wildenstein 1973, nos. 2010, 2014, 2016, 2018, 2025, 2030, 2037, 2038, pp. 233–36.

16. "il sera facile de suivre pas à pas, dans ces études, la marche de celui qui a élevé l'école presque subitement d'un style maniéré et languissant à une sévérité et à une pureté dignes des grands maîtres d'Italie"; David estate sale catalogue 1826, p. 3.

17. "Des cachets et des paraphes mis par MM. David fils, à chaque tableau, esquisse, dessin ou étude, en garantissent l'originalité;

et l'on aura, par ce moyen, l'avantage que chaque objet sortant de cette vente mémorable, conservera, dans tous les temps, son authenticité"; ibid., pp. 3–4.

18. As the Roman albums were created with the pragmatic goal of collecting material for potential future use, David occasionally would add drawings or tracings by other hands, which in Rosenberg and Prat 2002 are indicated by an asterisk next to the catalogue number (see also fig. 64 in the present volume). There are also autonomous sheets that bear the paraphs of his sons but whose attributions have come to be viewed as suspect. An example would be the *Study for a Costume* in the Musée National des Châteaux de Versailles et de Trianon (INV. DESS 304 / MV 5294 / RF 1926), which Philippe Bordes included in the 2005 exhibition *Jacques-Louis David: Empire to Exile* but later began to doubt; see Bordes 2007, pp. 345–46. That there would be an intermingling of student drawings among his own is not surprising. Etienne Jean Delécluze, in his memoir of his time in David's studio, recounted that David found two of his student's drawings in a portfolio. David returned to Delécluze the one that he had used to develop the painting *Leonidas at Thermopylae*, saying, "it will be a reminder both of your studies and of your master's manner of working." The other, he kept, stating that it had been given as a gift; see Rosenberg 2000, p. 139.

19. "Ces livres de croqis sont pour ainsi dire le dépôt précieux des diverses études, et des inspirations de M. David, et démontrent d'une manière précise la route qu'il a prise pour arriver au grand but qu'il s'était proposé, celui de régénérer l'école"; see David estate sale catalogue 1826, pp. 16–17, under lot 66.

20. See Sérullaz 1991, p. 49.

21. See Harkett 2007.

22. J. L. J. David 1880.

23. Schnapper and Sérullaz 1989; Sérullaz 1991.

24. Rosenberg and Prat 2002. For drawings that have come to light since 2002, see Rosenberg and Peronnet 2003; Prat 2016a; Prat 2016b; and Rosenberg 2017a. Previously unpublished works in the present catalogue include cats. 42, 73, 82, and figs. 9, 21, 24, 63, 85.

25. Ottani Cavina 2005; Bell 2017.

26. For the cuirass (fig. 8), see Rosenberg and Prat 2002, vol. 1, no. 884, p. 613. The Madonna and Child on the verso (fig. 9) was revealed recently thanks to the assistance of Reba Snyder, Paper Conservator, Morgan Library and Museum, New York.

27. Ledbury 2005.

28. The resonance of these themes is not surprising, given the fact that David's own childhood was rent asunder at age nine when his father was killed in a duel and he was left to be raised by two maternal uncles (see "Early Training, 1764–80" in the present volume).

29. Bordes 2004, pp. 124, 127–28 n. 15.

30. Ramade 1985, cat. 178, p. 100.

31. It is also the possible that these figures were drawn, or redrawn, at a later date, when the artist was preparing the *Leonidas* composition, as suggested in Rosenberg and Prat (2002, vol. 2, no. 1421 recto, p. 945), but the sketchbook has similar nude sketches (for

instance, on the facing page) for poses in *The Oath of the Tennis Court*, so one can at least deduce that David perceived a fluidity between the two. The concept of morphing seamlessly from one form to another is referred to in French as *glisser*, which translates as "to slip" or "to glide."

32. "Un livre d'études au crayon et de calques pour la composition du serment du jeu de Paume"; David estate sale catalogue 1826, lot 67. Other mentions in David's estate sale catalogue that seem to link tracings with the compositional process are lot 90, "Un petit livre où sont tracés des compositions et croquis," and lot 96, "Deux calques, compositions différentes pour le sujet de Caracalla tuant son frère Jetta." See also Mayer 2018, pp. 244–46, which considers two tracings in the Musée des Beaux-Arts et d'Archéologie, Besançon, in connection with the development of the *Sabines* composition.

33. Laveissière 2004.

34. The underlying layers are visible with X-radiograph and infrared imagery; see figs. 132–34 in the present volume.

35. In addition to the well-known oil sketches on paper for *The Oath of the Horatii* (cat. 22) and *The Lictors Bringing Brutus the Bodies of His Sons* (cat. 47), an oil sketch on canvas for *Paris and Helen* (cat. 40) has come to light in recent years, and others may have been lost. For instance, Juliette Trey, in her entry in this volume for *The Death of Camilla* (cats. 19–20), points to evidence that a painted sketch of that subject once existed.

36. See Mayer 2018. The transmitted-light images reproduced in Mayer's article and here as fig. 17 were taken in the Musée du Louvre's conservation studio by Valentine Dubard, whom I thank for so generously sharing them.

37. Nash 1978, p. 111.

38. "j'ai à Paris . . . une suite de compositions dessinées, une entre autres la seconde composition de mon Léonidas aux thermopyles, on y voit les changemens que de nouvelles réflexions m'ont suggérées"; quoted in Schnapper and Sérullaz 1989, p. 630.

39. The drawing was recently revealed on the verso of *Mountainous Landscape*, thanks to the assistance of Reba Snyder at the Morgan Library and Museum. For the recto, see Rosenberg and Prat 2002, vol. 1, no. 898, p. 618.

40. In addition to those noted in Rosenberg and Prat 2002 (vol. 1, nos. 171, 172, 177, pp. 180, 190), one might also add the sketch of a bearded man in a cap at the upper left of a sheet of joined studies, which appears to relate to a figure at the extreme right in the *Sabines*; see Rosenberg and Prat 2002, vol. 1, no. 38, p. 61.

41. *A Bust of a Young Man in a Phrygian Cap and a Young Woman with Her Head Bowed* (fig. 22), for example, was given to Jean-Baptiste Peytavin; see Rosenberg and Prat 2002, vol. 1, no. 177, p. 190. For Peytavin's study after the head of Camilla in *The Oath of the Horatii*, see fig. 4 in this volume.

42. Philippe Bordes, in his review of Rosenberg and Prat 2002, took issue with the dating of many of these sheets; see Bordes 2004, pp. 125–26.

43. "d'un caractère un peu faunesque"; quoted in J. L. J. David 1880, p. 546.

44. For a group of drawings associated with the second version of *The Coronation* and dated by Rosenberg and Prat to about 1817–20, see Rosenberg and Prat 2002, vol. 1, nos. 358–85, pp. 332–47. According to a letter dated March 12, 1808, sold at auction in 2021

(Hôtel Drouot, Paris, March 16, 2021, lot 11), the repetition was commissioned by a Peter Whiteside, citizen of the United States.

45. For the discovery of an unexpected source for the heads in the 1819 *Scene of Mourning* in the Fine Arts Museums of San Francisco (1974.2.11), see Kairis 2005. Yet, even with the identification of this source, the heads remain extracted fragments, rearranged without setting or legible narrative.

46. The appeal of the archaic aesthetic of Greek vase painting was fueled by a number of print publications, including some by David's friend Aubin Louis Millin de Grandmaison. See Bordes 2005b, pp. 274–75.

47. "Enfin, les études diverses du grand maître qui a formé tant d'artistes célèbres, vont être, dans cette exposition, un objet du plus haut intérêt; il sera facile de suivre pas à pas, dans ces études, la marche de celui qui a élevé l'école presque subitement d'un style maniéré et languissant à une sévérité et à une pureté"; David estate sale catalogue 1826, p. 3.

48. D. Wildenstein and G. Wildenstein 1973, no. 1658, p. 192.

49. For drawings by David listed in the estate sales of his students, see Rosenberg and Prat 2002, vol. 2, pp. 1226, 1229–30.

50. For Debret's lithographs, see Bordes 1981. Bordes's article was the first to draw attention to the importance of these prints. At the time of its writing, the author knew of only two incomplete sets. Since then a third set, comprising eleven lithographs, left to the Ecole Nationale Supérieure des Beaux-Arts, Paris (Est. 10846–56) by Jacques-Edouard Gatteaux, has come to light. For the ongoing ties of certain artists formed in David's studio, see also Ramade 2016.

51. Of the eleven prints in the series now held at the Ecole Nationale Supérieure des Beaux-Arts (see note 50 above), ten bear a date ranging from 1836 to 1845. As pairs of related drawings were issued in sequence, and the first dated print, depicting an untraced drawing of the wife and daughters of Brutus, clothed, is dated 1836, it seems likely that Est. 10851 (illustrated here as fig. 25) was made first, in 1835, before Debret began inscribing the date.

ELDERS, CONTEMPORARIES, AND PUPILS (pages 35–65)
My thanks go to Perrin Stein for her critical suggestions and assistance in accessing certain sources during the successive lockdowns in France; to Frédéric Jimeno for discussing the work of Jean Bardin; and to Côme Rombout for help in the archived documentation of the prodigious catalogue of David's drawings by Pierre Rosenberg and Louis-Antoine Prat.

1. "Sa réputation est passée d'étage en étage jusqu'aux dernières classes de la société dont quantité d'individus supriment un dîner de 36 s[ous] pour jouir de sa vue"; the engraver Adrien Pierre Godefroy to "C[itoy]^en Le Houé," a friend living near Rouen, "15 pluviôse" [probably February 4, 1800], Archives de l'Académie de Rouen, C28; document kindly furnished by Aude Gobet.

2. David to François Jean-Baptiste Topino-Lebrun, December 24, 1792: "Venez, mon ami, car je n'ai plus d'amis"; letter (original untraced) published in J. L. J. David 1880, p. 122.

3. David to Jean-Antoine Chaptal, April 1, 1801: "un artiste passionné pour le progrès des arts, encore tout échauffé des combats sans nombre qu'il a essuyés depuis vingt années, et qui mourrait de désespoir s'il voyait de nouveau le mauvais goût de peinture relever sa tête orgueilleuse"; D. Wildenstein and G. Wildenstein 1973, no. 1371, p. 159.

4. To add to the limited cast invoked in this essay, see, for example, the drawings by Jean Joseph Taillasson, Jean Guillaume Moitte, Jacques Réattu, and François Xavier Fabre in Couilleaux et al. 2019; and those by Jacques Gamelin, Armand Charles Caraffe, Auguste Félix Fortin, and Charles Meynier in Rosenberg 2020.

5. "Un artiste en, peignant un tableau, se corrige, & réprime la fougue de son genie; en faisant un dessin, il jette le premier feu de sa pensée; il s'abandonne à lui-même; il se montre tel qu'il est"; Dézallier d'Argenville 1762, vol. 1, pp. xxxii–xxxiii; see C. Michel 2004, p. 30.

6. Though Pujos remains today the least known of the four, his portraits of celebrities enjoyed considerable popularity in his lifetime; see his obituary in *L'année littéraire*, 1788, vol. 7, pp. 210–16.

7. C. Michel 2004, p. 27.

8. *Explication des peintures, sculptures et gravures de messieurs de l'Académie royale, dont l'Exposition a été ordonnée, suivant l'intention de Sa Majesté, par M. le Comte de La Billarderie d'Angiviller . . .* (Paris: Imprimerie de la Veuve Hérissant, 1777), nos. 37–48, p. 12. Some entries comprise several drawings.

9. Salon 1785, nos. 150–54, p. 37. Entry no. 151 is for two drawings.

10. Of course, since Pound's generation had only disregard for Neoclassicism, he used this expression in 1934 to evoke the Renaissance; see Ezra Pound, *ABC of Reading* (New York: New Directions, 1960), p. 72.

11. David to Joseph Marie Vien, December 13, 178[4]: "Je travaille le jour à mon tableau et le soir je dessine d'après l'antique"; "Une lettre de Louis David" 1907, p. 326. The transcription of the letter in D. Wildenstein and G. Wildenstein 1973, no. 132, pp. 16–17, is faulty and incomplete.

12. For a discussion of these stylistic options against a backdrop of national rivalries, see Bordes 2019.

13. Rosenberg and Prat 2002, vol. 1, no. 128, p. 143 (*Le Triomphe du Peuple français*); vol. 2, no. M117, p. 1224 (a lost drawing for this group). For the same group drawn by Drouais, see Ramade 1985, no. 178, p. 100; see also fig. 13 in this volume.

14. Ramade 1985.

15. For more on this project, see Crow 2006, pp. 73–75.

16. The drawing was sold at Swann Auction Galleries, New York, May 21, 2020, lot 30. The annotation by David reads: "Je crois que cette figure la [se]ra plus noble au moins, elle n[']a pas l'air d[']une suivante ou d[']une femme du peuple et elle composera mieux avec le stilleaubate [*sic*] qui est derriere a la droite [*sic*, gauche*] [;] il faudra relever le mouvement des suivantes qui arrivent mais tout cela n[']est rien" (I believe this figure will at least have more nobility, she does not look like a lady's maid or a woman of the people and she will fit better with the stylobate on the [left]; you will have to straighten up how the servants rush in but overall this is nothing). Before his death, Drouais was able to follow his master's advice and revise his composition, as it appears from the 1788 engraving by Tommaso Piroli after a lost drawing; Ramade 1985, p. 64, fig. 1.

17. Angelucci 2019; see the review by Philippe Bordes (2020).

18. A number of Wicar's drawings for this publication are in the collection of the Palais des Beaux-Arts, Lille. The four volumes of *Tableaux, statues, bas-reliefs et camées, de la Galerie de Florence, et du Palais Pitti, dessinés par M. Wicar, peintre, et gravés sous la direction de M. Lacombe, peintre; avec les explications, par M. Mongez l'aîné, . . .*, were

19. published in 1789–1807, except for the last four installments, which appeared in 1821; Savettieri 2007.

19. "Nourri dès l'enfance dans l'amour de l'Antique & les principes des grands Maîtres; préservé de bonne heure de la contagion du goût François dans l'Ecole de M. David"; review of the first two installments of the *Galerie de Florence* by Antoine Chrysostome Quatremère de Quincy, *Mercure de France*, September 19, 1789, p. 64.

20. *Le musée français* 1803–9. For an excellent study of the project, launched in 1791 with a focus on the royal collection, see McKee 1995.

21. *Convention nationale* 1794, p. 6; D. Wildenstein and G. Wildenstein 1973, no. 783, p. 83.

22. "On aime à deviner, par ce simple crayon, l'attente et l'harmonie des couleurs et des effets que le peintre a dû donner à son tableau; on cherche les sensations qu'avait laissée [*sic*] dans son souvenir la vue des grands traits de la nature, et on les y retrouve dans toute leur franchise. C'est qu'elles n'ont pas été refondues, affaiblies et dénaturées par des conseils étrangers, que ne donne que trop souvent l'habitude des règles; c'est qu'elles n'ont pas été refroidies par l'opiniâtre prétention d'un travail qui ne sert souvent qu'à en émousser les traits, c'est qu'enfin elles n'ont pas été tyrannisées par le caprice d'un riche amateur qui s'en empare, pour avoir la gloire de les diriger de la même manière qu'il ordonne la forme de son habit ou de sa chaussure. / Oui, c'est là que l'Artiste est souvent supérieur à lui-même, mais toujours lui, et rien que lui. / O vous, qui vous destinez à l'étude de la peinture, allez souvent dans cette galerie; allez y recueillir les plus secrètes notions de votre art; le portefeuille de vos maîtres est sous vos yeux; les secrets de leurs compositions vous sont abandonnés; la République a conquis pour vous jusqu'à leur première pensée"; Chazot, "Exposition de Dessins de différentes écoles," *La décade philosophique, littéraire et politique*, no. 36 (30 Fructidor, Year V [September 16, 1797]), pp. 560–61. The author was possibly Claude François Chazot, a former draftsman ("dessinateur de fabrique"; "dessinateur en fleurs") who had worked for manufacturers in Lyon and whose political activity in Paris during the Revolution is detailed in Viola 2012, pp. 132–34.

23. "inaccessible au public et aux artistes, qui souffraient avec peine de se voir sevrés d'un si puissant moyen d'étude"; *Notice des dessins* 1797, p. i; see also *L'an V* 1988.

24. *Notice des dessins* 1797, cats. 313 (Cochin), 339 (La Rue), 385 (Pérignon), pp. 78, 81, 89.

25. "Un dessein *Capital*, est un dessein qui renferme une composition de quelque importance, & qui pourroit faire la matière d'un tableau. L'esquisse d'un pied, d'un bras, d'une tête, d'une figure même, à moins que cette figure n'exprime une action sensible & remarquable, ne peut être appellée dessin *Capital*. Les Curieux font grand cas des desseins *Capitaux*" (A capital drawing is a drawing that consists of a composition of some importance, and that could furnish the elements for a picture. The sketch of a foot, an arm, a head, even of a figure, unless this figure expresses a strong and remarkable action, cannot be termed a *capital* drawing. Knowledgeable amateurs are most fond of capital drawings); Marsy 1746, vol. 1, pp. 95–96.

26. On Pajou's drawing, see Draper and Scherf 1997, cat. 74, pp. 194–96; on the print, cat. 75, pp. 196–97.

27. "point d'air, point d'effet, point de perspective"; *Arlequin au Muséum, ou critique en vaudeville des tableaux du Salon; douzième année, no. 2* (Paris: Imprimerie de Brasseur aîné, 1808), p. 10.

28. The best example is *The Consternation of the Family of Priam after the Death of Hector* by Etienne Barthélémy Garnier, exhibited at the Salon in 1800; see the comments by Jean Lacambre on a preparatory drawing in the Musée des Beaux-Arts, Quimper, in *Le néo-classicisme français* 1974, cat. 59, pp. 58–59.

29. "En général on peut reprocher à M. *Berthélemy* de trop s'abandonner à sa facilité"; anonymous critic of the *Journal de Paris*, September 15, 1785, p. 1064; Volle 1979, no. 81, pp. 91–93.

30. See Rosenberg and Sandt 1983, nos. 20–31, pp. 81–89. The drawing illustrated was unknown until its appearance at auction in 2018. The critic of the *Journal de Paris* dismissed the finished sketch exhibited in 1783 as being too closely based on Pajou's *The Roman Army under Camillus Assaulting the Temple of Juno at Veii* (see fig. 33 in this volume), an accusation of plagiarism that prompted Peyron to reply; Rosenberg and Sandt 1983, p. 83.

31. Ibid.

32. On the history and theory of this practice, see Pagliano 2019.

33. Haskell 1993, p. 222.

34. The siege of the city by the Carthaginians in 406 B.C. is distinct from the later siege by the Romans in 262 B.C., during the Battle of Agrigentum, by then a Carthaginian stronghold under the command of Hannibal Gisco. Neither he nor Hannibal Mago, who led the earlier siege, are to be mistaken for the more famous Hannibal Barca, the Carthaginian general who crossed the Alps with his army in 218 B.C. The source for the drawing by Desprez is Diodorus Siculus (Diodorus of Sicily), *Library of History*, bk. 13, chap. 86; the subject was identified by Régis Michel (2005).

35. David to Jean François Lesueur, July 1, 1804, with comments on his opera *Ossian, ou Les bardes*; see Bordes 2005b, pp. 184, 349 n. 7.

36. Volle 1979, pp. 119–25. In a letter of December 29, 1807, addressed to the director of the Académie Impériale de Musique, Berthélemy claims to have been in charge of costume design for more than twenty years and proposes as his successor François Guillaume Ménageot, whom he had replaced in 1786; ibid., p. 132.

37. Bordes 2005b, pp. 64–68.

38. On the decline of this doctrine during the Revolution, see Sandt 1989.

39. Lécosse 2019.

40. Bordes 2003.

41. See the thorough study with further bibliography by Jennifer Langworthy (2012, pp. 63–122, 215–31).

42. This drawing was sold by Ader, Paris, March 29, 2019, lot 37, and was with Galerie Terrades, Paris, in 2021; see Galerie Terrades, *Dessins 1530–1960: Salon du Dessins 2021* (Paris, 2021), cat. 14, pp. [54–57].

43. Girodet to Emmanuel Pastoret, ca. 1807: "C'est un tort pour les dessins de n'être que des dessins, et cependant ils exigent la même conception et presque les mêmes études qu'un tableau, lorsqu'on se pique d'y mettre du style et du caractère; il n'y a que le procédé d'exécution qui soit différent. L'artiste qui réussit dans ces sortes de dessins, ne peut être qu'un peintre d'histoire, ou un statuaire en droit d'attendre des succès dans ce qui constitue son genre proprement dit"; Coupin 1829, vol. 2, no. 27, p. 343. The manuscript draft, with minor differences, is in the Bibliothèque de l'Institut National d'Histoire de l'Art, Paris, Fonds Jacques Doucet, Manuscripts, Cartons Peintres 15, Girodet, folio annotated 5873.

44. A color print can result from the impression of several plates, each inked in a different color; from a single plate inked with multiple colors; or from the application of color onto the printed sheet; see Grasselli 2003.

45. Lichtenstein 1993, pp. 117–226. "Color . . . is the material in, or rather *of*, painting, the irreducible component of representation that escapes the hegemony of language, the pure expressivity of a silent visibility that constitutes the image as such; ibid., p. 4.

46. Cochin 1774, pp. 73–74.

47. Z. D., "Précis historique de la vie de Claude Rozet-St.-Genest," *Journal des arts, des sciences et de littérature*, no. 178 (20 Nivôse, Year X [January 10, 1802]), p. 75.

48. The term *chromoclasm* was invented in the 1990s by Michel Pastoureau to characterize an aspect of the iconoclasm of the Protestant Reformation; it is also employed in the study of medals. More recently, David Batchelor (2000) has explored the notion of resurgent chromophobia across time.

49. The website of Neil Jeffares devoted to pastellists before 1800 (http://www.pastellists.com/) includes a "Florilegium" of texts related to pastels. Among them is an extract from the "Notes on Crayon Painting" by Francis Cotes (*European Magazine*, February 1797, pp. 84–85).

50. Stendhal 2002, "Salon de 1824," p. 79. On Stendhal's fluctuating appreciation of David, see Berthier 1977, pp. 88–91.

51. "[David] ne veut pas entendre parler de dessins finis"; extracts from letters by Pierre Théodore Suau to his father, published in Mesplé 1969, p. 95. Suau also wrote: "M. David ne veut pas que l'on fasse des dessins finis d'après l'antique sur de grandes feuilles, il veut que l'on se serve de livres de croquis; par ce moyen, dit-il, on étudie sans se fatiguer" (M. David does not want us to produce finished drawings after the antique on large sheets, he wants us to use sketchbooks; in this way, he says, we study without tiring ourselves); ibid.

52. C. Michel 2004, p. 32. He cites a landmark lecture for royal academicians by the comte de Caylus in 1732 that praised the sketchiness of master drawings and argued, "l'oeil curieux, l'imagination animée se plaisent et sont flattés chacun d'achever ce qui souvent n'est qu'ébauche" (the curious eye and the spirited imagination are each pleased and flattered to finish what is only a rough sketch).

53. Chaussard 1806, p. 451: "le Dessin ne sera toujours que la partie froide et inanimée de la Peinture." Both drawings, *Bonaparte, First Consul Visits the Manufacture of the Brothers Sévène in Rouen, November 1802* (Salon of 1804) and *Napoleon 1st in Presence of the Empress Visits the Manufacture of Mr Oberkampf at Jouy, on June 20, 1806*, were recently restored but are unfortunately somewhat faded from exposure to light (both Musée du Louvre, on deposit at the Musée National des Châteaux de Versailles et de Trianon, Versailles).

54. Pushing legislation to reform the museum, David declared to the National Convention on January 16, 1794, that the institution was no "vain rassemblement d'objets de luxe ou de frivolité, qui ne doivent servir qu'à satisfaire la curiosité" (pointless assemblage of luxurious or frivolous objects that serve only to satisfy idle curiosity); *Convention nationale* 1794, p. 4.

55. Monbeig Goguel 1987.

56. Extracts from the inventory of David's main residence in Paris are published in D. Wildenstein and G. Wildenstein 1973, no. 2041, pp. 236–38.
57. "Si seulement j'avais fait cinq tableaux, mais je n'ai rien fait, absolument rien"; Bordes 1997, p. 132.

EARLY TRAINING (pages 68–71)
1. Schnapper and Sérullaz 1989, p. 41.
2. D. Wildenstein and G. Wildenstein 1973, no. 1368, p. 157.

CATS. 1–2
1. Annotated copy of David estate sale catalogue 1826, Institut National d'Histoire de l'Art, Paris (RES-W-1826).
2. The first of these appears on the verso of the large compositional study for *The Funeral of Patroclus* in the Musée du Louvre, Paris (RF 4004), illustrated here as fig. 1; see also Rosenberg and Prat 2002, vol. 1, no. 28, pp. 46–47. The other two *académies*, one in red chalk and the other in black chalk, are conjoined fragments and appear on the verso of another study for the *Patroclus*, in the Musée Eugène Boudin, Honfleur (37-1-62); see Rosenberg and Prat 2002, vol. 1, no. 29, p. 48.
3. Prat 2016a, pp. 290–91, fig. 1; sale, Thierry de Maigret, Drouot-Richelieu, Paris, March 27, 2009, lot 158.
4. The painted *académies* are listed as nos. 13 and 14 in the David estate sale catalogue 1826.
5. David estate sale catalogue 1826, pp. 2, 4; Institut National d'Histoire de l'Art (RES-W-1826).
6. J. L. J. David 1880, p. 651.
7. Rosenberg and Prat 2002, vol. 2, nos. R 33, R 63, pp. 1183, 1190–91.
8. Rosenberg and Prat 2002, vol. 2, no. R 186, p. 1209, might correspond to lot 106 of the sale held in the *grande salle* of the Hôtel Bullion, rue Plâtrière, Paris, January 21, 1788. See also Danielewicz and Guze 2009, cat. 25, pp. 202–3.
9. Régis Michel in *David e Roma* 1981, pp. 29–41.
10. "Comme il ne s'occupoit d'études qu'au moment de concourir pour les prix, il se passa plusieurs années avant qu'il pût obtenir le premier"; Chaussard 1806, p. 146.
11. Montaiglon 1875–92, vol. 8, p. 23.
12. Arlette Sérullaz in Schnapper and Sérullaz 1989, cat. 27, p. 85.
13. Ibid.
14. Rosenberg and Prat 2002, vol. 1, nos. 1, 2, p. 28.
15. See, for example, four *académies* now in the Ecole National Supérieure des Beaux-Arts, Paris, by François André Vincent, 1772 (EBA 3269; executed in Rome); Louis Joseph Hoyer, 1777 (EBA 2963); Anthelme François Lagrenée, 1789 (EBA 2988); and Jean-Baptiste Isabey, 1789 (EBA 2964). All are executed in black chalk, stumped, heightened with white.
16. Brugerolles 2009, p. 20.
17. I have been unable to discern a watermark on this sheet that might facilitate a more precise dating.

CATS. 3–4
1. Sérullaz 2000.
2. "[il] y étudia comme un commençant; il écrivait alors à ses amis qu'il ne s'occupait qu'à dessiner l'*Ecorché de Houdon*, qu'ensuite il passerait à celui de Michel-Ange"; Chaussard 1806, p. 148.

3. "honteux de [son] ignorance"; notes written by David about his childhood and his studies through his first Roman sojourn, Ecole Nationale Supérieure des Beaux-Arts, Paris (MS 316/54); see D. Wildenstein and G. Wildenstein 1973, no. 1368, p. 157.
4. "comme un jeune écolier, il se mit à dessiner, pendant une année entière, des yeux, des oreilles, des bouches, des pieds et des mains, et se contenta de faire des ensembles d'après les plus belles statues. L'anatomie fut aussi une de ses études de prédilection"; Lenoir 1835, p. 3.
5. The *académies* that David painted in Rome include: *Académie*, 1776 (signed and dated), paper laid down on canvas, Musée d'Art Moderne, Saint-Etienne (65-9-1); *Académie*, 1778, oil on canvas, Musée Fabre, Montpellier (851.1.1); and *Académie (Patroclus)*, 1780, oil on canvas, Musée Thomas Henry, Cherbourg (835.102).
6. Bassi 1959, pp. 33–34.
7. Brugerolles 2009, p. 32.
8. Musée du Louvre, Paris (RF 4004 verso; see fig. 53); and Musée Eugène Boudin, Honfleur (37-1-62). See Rosenberg and Prat 2002, vol. 1, nos. 28, 29, pp. 46–49. See also the discussion of cats. 1–2 in this volume.
9. The drawing was exhibited at the Galerie de Bayser, Paris, November 13–27, 2015.
10. Willk-Brocard and Gady 2015, pp. 4–5.
11. Brugerolles 2009, p. 40.
12. The drawing (fig. 54) was sold at the Clarac sale, Daguerre, Oudon, France, June 26, 2016, lot 71.
13. Illustrated in Motte Masselink 2016, p. 9, fig. 1.
14. Ibid., pp. 10, 16; see also Rosenberg and Prat 2002, vol. 1, no. 52, p. 71.
15. Brugerolles 2009, p. 47.
16. The *académies*, both in black chalk heightened with white, are by Auguste Moitte and François Laurent Chatelin; both are in the Ecole Nationale Supérieure des Beaux-Arts (EBA 3057, EBA 2804).

CAT. 5
1. See, for example, for Vleughels, Hercenberg 1975, cats. 123–28, pp. 103–5, figs. 135–41; for Barbault, Jacquot and Marcle 2010, pp. 83–120; and for Greuze, Munhall 2002, under cat. 4, pp. 44–49.
2. See Rosenberg 2006a, pp. 150–56; Stein 2016, cats. 58, 60, 63, pp. 184–85, 188–89, 194–95.
3. It is interesting in this regard that The Met's drawing was once owned by baron Roger Portalis, who collected works by Fragonard and authored a monograph on his life and work in 1889, and who generally favored the Rococo.
4. Sold at Sotheby's, New York, June 26, 2014, lot 42.
5. Bordes 2016.
6. Rosenberg and Prat 2002, vol. 1, nos. 9, 10, p. 35. The two drawings appeared together at auction at Christie's South Kensington, London, December 6, 2012, lot 135.
7. Bordes (2004, p. 124) connects the two drawings to no. R 139 in the "rejected" section, a pen-and-wash drawing done in Naples in 1778, given to Giovanni David, for which, see Newcome Schleier and Grasso 2003, cat. D11, pp. 34–35.
8. Jacquot and Marcle 2010, p. 89. No drawings by Barbault for this type of subject have been identified, although Jean de Julienne's sale catalogue (March 30–May 22, 1767) lists "two women in Italian costume; in black chalk on white paper, under glass"; see ibid., p. 84.

9. The drawing is described as framed in David's *inventaire après décès*, reprinted in D. Wildenstein and G. Wildenstein 1973, no. 2042, item 78, p. 238 ("un autre petit croquis aussi encadré représentant une paysanne des environs de Frascati").

CATS. 6–14

1. "Douze grands livres de croquis composés d'études d'après des bas-reliefs antiques, de figures d'après l'antique, de paysages, presque tous d'Italie, et de calques"; David estate sale catalogue 1826, lot 66.

2. "Douze grands livres contenant des dessins & des calques Etudes de M. David en Italie"; D. Wildenstein and G. Wildenstein 1973, no. 2071, p. 247.

3. For a history of David's Roman albums, see Rosenberg and Prat 2002, vol. 1, pp. 391–98, 407.

4. The surviving albums are: No. 1, Harvard Art Museums/Fogg Museum, Cambridge, Mass. (1943.1815.19). Seriously damaged: originally 22 leaves, to which were affixed 80 drawings and 8 tracings; now, 31 drawings, 6 of which are affixed to sheets not from the original album. No. 3, Nationalmuseum, Stockholm (NM 18/1969–NM 123/1969). Almost complete, but with some drawings detached: 22 leaves (of an original 23) and 106 drawings, 10 of which are on tracing paper. No. 4, National Gallery of Art, Washington, D.C. (1998.105.1; here, cat. 6). No. 5, Musée du Louvre, Paris (RF 54299-54394). Complete: 26 leaves and 97 attached drawings, 16 of which are on tracing paper. (This album resurfaced immediately after the publication of Rosenberg and Prat 2002; see Rosenberg and Peronnet 2003.) No. 6, dismembered and dispersed, but photographs predating its dismantlement exist. In 1826 it consisted of 24 leaves and 108 drawings, 11 of which were on tracing paper; in 1978, just before dismemberment, it consisted of 17 leaves and 61 drawings, 14 of which were on tracing paper. No. 7, Musée du Louvre, Paris (INV. 26083–INV. 26127). Complete: 21 leaves and 86 drawings, 13 of which are on tracing paper. No. 8, Morgan Library and Museum, New York (1998.1; here, cat. 7). No. 9, Musée du Louvre, Paris (INV. 26128–INV. 26181). Complete: 22 leaves and 97 drawings, 9 of which are on tracing paper. No. 10, dismembered and dispersed, but photographs predating its dismantlement exist. Originally, it consisted of 23 leaves and 89 drawings, 18 of which are on tracing paper; almost complete at the time of its dismemberment. No. 11, Getty Research Institute, Los Angeles (940049; here, cat. 8). According to the inventory of Mme David of June 27, 1826, the two lost albums are: No. 2, which consisted of 24 leaves and contained "quatre vingt un croquis et treize calques" (eighty-one sketches and thirteen tracings); and No. 12, which consisted of 22 leaves and "soixante sept dessins et quatorze qualques" (sixty-seven drawings and fourteen tracings).

5. To the fifty-seven "isolated drawings originally from the albums" catalogued in Rosenberg and Prat 2002 (vol. 2, nos. 1203–60, pp. 754–77) must now be added five drawings described in the first volume of the same catalogue (nos. 21–25, 45, pp. 42–44, 65) that were removed from the albums before the 1826 sale; eighteen drawings that have resurfaced since the publication of Rosenberg and Prat 2002 (for which, see Rosenberg 2017a); and two more drawings that appeared very recently: *Athena*, sale, Ader, Paris, May 29, 2020, lot 134b (illustrated here as fig. 63); and

*The Athenian Youths Delivered up to Minos*, sale, Bérard-Péron, Lyon, September 5, 2020, lot 10.

6. David estate sale catalogue 1826, lots 48–52, 64, 65. At present, it is impossible to say whether these roughly eighty drawings belong to albums now known but damaged (like nos. 1 and 6) or to the two albums that have not resurfaced (nos. 2 and 12). Alternatively, they may correspond to the aforementioned lots in the 1826 sale.

7. We are grateful to Reba Snyder, Paper Conservator, and Jennifer Tonkovich, Eugene and Clare Thaw Curator, of the Morgan Library and Museum, New York, for their collegial assistance with this research.

8. Sérullaz 1991, pp. 11–23.

9. On the possibility of a third "original" album, see Rosenberg and Prat 2002, vol. 1, p. 397.

10. According to the inventory of Mme David of June 27, 1826, the set of twelve albums then contained 280 leaves, which indicates that at least four leaves had been removed since the numbering of the original albums; see D. Wildenstein and G. Wildenstein 1973, no. 2071, p. 247.

11. For a reconstitution of the original albums that predates the reappearance of album no. 5, see Rosenberg and Prat 2002, vol. 2, pp. 778–830.

12. Care should be taken not to confuse the tracings *in* the Roman albums with the so-called Calques de Cahors (Cahors tracings), which are tracings *after* certain drawings in the albums; for the latter, see Rosenberg and Prat 2002, vol. 2, pp. 831–66.

13. For *The Death of General Dampierre*, see Rosenberg and Prat 2002, vol. 1, nos. 569–70, p. 467. For the *Sabines*, see ibid., vol. 1, nos. 572–81, pp. 469–73.

14. For more on this trip, see Rosenberg 2006b.

15. Note that a study for the same painting is drawn directly on leaf 218; see Rosenberg and Prat 2002, vol. 1, no. 559, p. 463.

16. Ibid., vol. 1, no. 729, p. 537.

17. Ibid., vol. 1, no. 1144, p. 727.

18. See note 13 above.

19. "la reliure de douze volumes de dessins, in folio"; Sérullaz 1991, p. 22, n.13.

20. See note 6 above.

21. For example, cat. 10 here represents a statue formerly in the Giustiniani collection (now Museo Torlonia, Rome; see Visconti 1885, no. 35, pp. 22–23); cat. 11 is a statue of a muse transformed into the figure of Anchyrroe from the Niobid Group, formerly in the Medici collection (now Gallerie degli Uffizi, Florence; see Mansuelli 1958–61, vol. 1, no. 95, pp. 31–32); and the head at left in cat. 12 represents a cameo of Augustus assimilated to Apollo, formerly in the Medici collection (now Museo Archeologico Nazionale, Florence [14521]). As it appears in the drawing in reverse, it was probably made after an engraving.

22. For instance, only two copies after Michelangelo are known, one after the marble *Pietà* in the Duomo in Florence (Rosenberg and Prat 2002, vol. 1, no. 934, p. 633), and another after *Adam and Eve Driven from Paradise* on the Sistine Chapel ceiling (Rosenberg and Peronnet 2003, no. 28, p. 62).

23. Rosenberg and Prat 2002, vol. 1, no. 641, p. 498.

24. Ibid., vol. 1, no. 1133, p. 724; vol. 2, no. 1226, p. 764.

25. In 2002 David's model had not yet been identified, and the drawing was described as an "Entombment"; see ibid., vol. 1, no. 826, p. 589.

26. Two drawings whose sources were previously unknown can now be identified as copies after two of Ricci's frescoes in San Marcello al Corso; see Rosenberg and Prat 2002, vol. 1, no. 924, p. 627; vol. 2, no. 1233, p. 767.

27. The Van Dyck painting in question is the *Portrait of Tommaso Francesco of Savoy*, now in the Galleria Sabauda, Turin (743); see Rosenberg and Prat 2002, vol. 1, no. 983, p. 657. For David's drawings after Rubens, see ibid., vol. 1, no. 522, p. 447; Rosenberg and Peronnet 2003, nos. 43, 44, 100, pp. 66–67, 83.

28. Rosenberg and Peronnet 2003, no. 44, pp. 66–67.

29. For the drawing after La Hyre, see Rosenberg and Prat 2002, vol. 1, no. 490, p. 430. Other seventeenth-century French artists whose works David copied include Poussin, Le Sueur (ibid., vol. 1, no. 783, p. 569), and Bourdon (ibid., vol. 2, no. 1235, p. 767). See also Rosenberg 2017a, pp. 49, 166 fig. 3. The drawing published in 2017 is a copy after the celebrated painting by Le Sueur, *Saint Gervasius and Saint Protasius Led before Astasius*; it is on the verso of a drawing of the Ares Borghese. In the case of the two drawings published in 2002 cited above, David drew details of some of the heads.

30. Rosenberg and Prat 2002, vol. 1, no. 1169, p. 734.

31. Now album no. 5, leaf 12; see Rosenberg and Peronnet 2003, no. 41, p. 66.

32. Rosenberg and Prat 2002, vol. 1, no. 634, p. 495.

33. Ibid., vol. 1, no. 523, p. 447.

34. Ibid., vol. 1, no. 924, p. 627. I am indebted to Tancredi Valeri for this observation.

35. For the landscape from album no. 4 that is here illustrated as fig. 60, see Rosenberg and Prat 2002, vol. 1, no. 633, p. 495. In other cases, David attempted to complete a drawing that had been cropped; see, for example, ibid., vol. 1, nos. 507, 674, 754, pp. 439, 512, 553.

36. For a similar but earlier watermark, see Heawood 1950, no. 161 (Rome, 1646).

37. Some drawings show the complete watermark, for example, a drawing now in album no. 11 representing three water buffalos (Rosenberg and Prat 2002, vol. 1, no. 1179, p. 737), and a copy of a grisaille in the Stanza della Segnatura, in the Vatican, executed by the Raphael studio, now in album no. 3 (ibid., vol. 1, no. 517, p. 445).

38. Rosenberg and Prat 2002, vol. 1, nos. 604, 1183, pp. 483, 738.

39. Provisional chronological sequence: Rosenberg and Prat 2002, vol. 1, nos. 1061, 603, 608, 642, 693, 692, 1127, 884, 820, 1117, 1030, 1108, 602, pp. 692, 483, 485, 499, 522, 721, 613, 586, 717, 681, 713, 482.

40. "la dernière étude de ce genre de croquis faite a Rome en 1780 le 17 juillet, et jetois [*sic*] parti le 18"; ibid., vol. 1, no. 620, p. 490.

41. "finie dans une auberge / en revenant de Rome. 1780"; ibid., vol. 1, no. 949, p. 640.

42. Ibid., vol. 1, nos. 494, 495, 509–11, 617, 647, 745, 748, 1123, 1125, pp. 432, 441–42, 489, 501, 547, 550, 719–20.

43. Ibid., vol. 1, nos. 538, 539, 598, 601, 1052, 1054, 1130, 1131, pp. 453–54, 481–82, 688–89, 723; vol. 2, nos. 1228–30, pp. 765–66.

44. Ibid., vol. 1, nos. 545, 546, 548, 880, 881, pp. 456–57, 611.

45. Ibid., vol. 1, no. 893, p. 616.

46. One such drawing, representing Athena (illustrated here as fig. 63), resurfaced quite recently; see note 5 above. See also

47. Rosenberg and Prat 2002, vol. 1, nos. 462, 746, 843, pp. 414, 548, 597; Rosenberg and Peronnet 2003, no. 24, p. 60.

47. Rosenberg and Prat 2002, vol. 1, no. 26, p. 45.

48. Ibid., vol. 1, nos. 898, 899, p. 618; vol. 2, no. 1254, p. 774. For more on the views of Gaeta and Palazzone, see notes 30 and 31 above.

49. Sketchbook (carnet) 2, in the Musée du Louvre (RF 4506); see Rosenberg and Prat 2002, vol. 2, nos. 1301, 1302, 1310 verso, 1325, 1354, 1356, pp. 897, 900, 905, 914–15. The fact that some of the landscape drawings from the second original album are on paper bearing the watermark of the Arnolfini arms cannot be used to date them, because the paper in the *Horatii* sketchbook has the same watermark.

50. Rosenberg and Prat 2002, vol. 1, pp. 402–3.

51. See, for example, two drawings (now in album no. 6) of a statue of Flora, then in the Giustiniani collection; and another (now in album no. 7) of a statue of a girl with a dove, then in the Albani collection (Rosenberg and Prat 2002, vol. 1, nos. 684, 685, 940, pp. 518, 636). See also Benjamin Peronnet in Radrizzani 2012, pp. 200–201.

52. See, for example, Rosenberg and Prat 2002, vol. 1, nos. 484, 488, 491, pp. 427, 429–30.

53. Ibid., vol. 1, no. 1171, p. 735; Rosenberg and Peronnet 2003, no. 49, p. 69.

54. For the *Virgil*, see Rosenberg and Prat 2002, vol. 1, no. 796, p. 574; and for the two studies for *Tatius*, see ibid., vol. 1, nos. 473, 474, p. 421.

55. Ibid., vol. 1, no. 28, pp. 46–47.

56. Ibid., vol. 1, nos. 498, 508, pp. 434, 440; see also ibid., vol. 2, pp. 781–82.

57. Ibid., vol. 1, nos. 729, 730, pp. 537–38; see also ibid., vol. 2, pp. 827–28.

58. Now album no. 11, leaf 1; Rosenberg and Prat 2002, vol. 1, no. 1103, p. 710.

59. Ibid., vol. 1, no. 50, p. 69.

60. Now album no. 9, leaf 13; Rosenberg and Prat 2002, vol. 1, no. 982, p. 656.

61. Ibid., vol. 1, no. 59, p. 79.

62. Now album no. 6, leaf 3; Rosenberg and Prat 2002, vol. 1, no. 677, p. 514.

63. Now album no. 9, leaf 16; Rosenberg and Prat 2002, vol. 1, no. 996, p. 663.

64. Now album no. 7, leaf 7; Rosenberg and Prat 2002, vol. 1, no. 761, p. 557.

65. Ibid., vol. 1, no. 65, p. 84.

66. Now album no. 3, leaf 17; Rosenberg and Prat 2002, vol. 1, no. 558, p. 462.

67. Ibid., vol. 1, no. 559, p. 463.

68. Now album no. 5, leaf 21 verso; Rosenberg and Peronnet 2003, no. 76, p. 76.

69. For the drawing now in the Pébereau collection, see Rosenberg and Prat 2002, vol. 1, no. 319 bis, pp. 302–3; for the two album drawings that inspired the bust in the background, see ibid., vol. 1, nos. 852, 854, pp. 602–3.

70. Now album no. 11, leaf 2; Rosenberg and Prat 2002, vol. 1, no. 1106, p. 712.

71. See ibid., vol. 2, p. 881.

CAT. 15

1. "par là, ils feront juger des progrès qu'ils font dans la partie du génie." For the full text of the regulations, see Montaiglon and Guiffrey 1887–1912, vol. 13, no. 6698, pp. 157–60, esp. p. 158.
2. See, for example, Rosenberg and Prat 2002, vol. 1, p. 37; Ekelhart 2017, cat. 68, pp. 166–67.
3. Rosenberg and Prat 2002, vol. 1, p. 37.
4. Perrin Stein in Stein and Holmes 1999, cat. 32, pp. 75–78.
5. Doyen's recent canvas, *Venus Wounded by Diomedes*, was exhibited at the Salon of 1761 and is today in the State Hermitage Museum, Saint Petersburg (ГЭ-5811). Deshays's recent painting, also exhibited in 1761, is known through a reproductive print by Pierre Alexandre Aveline; see Sandoz 1978, no. 70-5 Cc, p. 84, pl. VII.
6. Anne Claude Philippe Caylus, *Tableaux tirés de l'Iliade, de l'Odyssée d'Homere et de l'Eneide de Virgile; avec des observations générales sur le costume* (Paris: Tilliard, 1757). On the painting, see Colin B. Bailey in Bailey 1992, cat. 62, pp. 496–99.
7. The oldest inventories (*alte cahiers*) feature a very detailed description of the subject of David's drawing. It was likely written by François Lefèbvre, who looked after the ducal collection of drawings. The date of the inventory is not known, but the project was underway in 1795; see Dossi 1999, p. 56, n. 237.
8. Montaiglon and Guiffrey 1887–1912, vol. 13, pp. 195–98.
9. This theory is accepted by Pierre Rosenberg (2000, p. 162).

CAT. 16

1. For Peyron, see Rosenberg and Sandt 1983, nos. 43–51, pp. 92–96. For Vincent, see Cuzin 2013, nos. 307 P, 308 P, pp. 86–87, 415–16.
2. Palais des Beaux-Arts, Lille (Pl. 1193); see Rosenberg and Prat 2002, vol. 1, no. 33, p. 54.
3. The replica, in the same medium as cat. 16, but slightly smaller, measuring 11⁷/₈ × 9¼ in. (30 × 23.5 cm), is now in the Musée des Beaux-Arts, Dijon (CVA 854), having been donated by the great collector His de la Salle; see Rosenberg and Prat 2002, vol. 1, no. 32, p. 53. An anonymous copy was sold at Hôtel Drouot, Paris, December 12, 2003, lot 64.

CAT. 17

1. Musée du Louvre, Paris (RF 4004); see Rosenberg and Prat, 2002, vol. 1, no. 28, pp. 46–47.

CAT. 18

1. Perhaps the artist Louis Bouquet (1765–1814), an engraver specializing in natural history subjects.
2. Larrey's estate sale, which took place on December 6, 1842 (Lugt 16761), did not include this drawing.
3. According to J. L. J. David 1880, p. 653.
4. For the Sacramento sheet, see Rosenberg and Prat 2002, vol. 1, no. 34 (right part), pp. 55–57.
5. De Caso 1972.
6. That David had benefited from the study of Polidoro was noted in an anonymous review of the Salon of 1783, quoted in Kazerouni 2011, p. 203.
7. For more on this drawing, acquired by The Met in 2018, see https://www.metmuseum.org/art/collection/search/771456; Mayer-Michalon 2016, figs. 5–7, pp. 165–67. The left third of the composition (illustrated here as fig. 69), though depicting a battle between ancient warriors, focuses not on the gods but, rather, on the doctors helping the wounded, as befitting the fresco's setting in a medical school.
8. Christophe Leribault in Faroult, Leribault, and Scherf 2011, cat. 53, p. 112.
9. See de Caso 1972.
10. Johnson 1993, p. 52. In the *livret* of the Salon of 1783, the sheet is entitled "Dessin d'une Frise dans le genre antique"; see Schnapper and Sérullaz 1989, p. 568.
11. The improvisational character of the execution stands in marked contrast to the careful pen-and-ink drawing of a frieze in the Musée d'Art et d'Archéologie, Senlis; see Rosenberg and Prat 2002, vol. 1, no. 26, p. 45 (where it is catalogued as a copy after the antique, even though the inscription on the sheet reads, "J.L. David fecit et invenit Roma 1777"). In his review of Rosenberg and Prat 2002, Philippe Bordes (2004, p. 124) raised the prospect that it may be an original composition.
12. For David's submissions to the 1781 Salon, see Schnapper and Sérullaz 1989, p. 566.
13. The connection between the two works was pointed out in Rosenberg and Prat, 2002, vol. 1, p. 55.

BUILDING A REPUTATION (pages 110–13)

1. D. Wildenstein and G. Wildenstein 1973, no. 85, p. 11.
2. See Vidal 2003.
3. D. Wildenstein and G. Wildenstein 1973, no. 181, p. 23.
4. Crow 1985, pp. 211–54.
5. *Mercure de France*, June 7, 1788, p. 40.
6. Baetjer 2019, no. 107, pp. 317–24; Pullins et al. 2021.

CATS. 19–20

1. "Horace, vainqueur des trois Curiaces, condamné à mort pour le meurtre de Camille sa soeur, défendu par son père, au moment où les licteurs l'entraînent au supplice et absous par le peuple touché de ce spectacle et du grand service qu'il vient de rendre à sa Patrie"; Engerand 1897, pp. 13–14.
2. Rollin 1748, vol. 1, pp. 165–66.
3. Péron 1839, pp. 27–28.
4. Musée du Louvre, Paris (RF 1917); Rosenberg and Prat 2002, vol. 1, no. 50, p. 69. See also Calvet 1968.
5. Rosenberg and Prat 2002, vol. 1, no. 49, p. 68.
6. Tischbein 1861, vol. 1, p. 46.
7. *Catalogue des tableaux des trois écoles, dessins, gouaches, estampes, figures, bustes, vases de marbre, bronzes & autres objets curieux appartenans à M. de Wailly, architecte du Roi & member des académies royales de peinture, sculpture & architecture, dont la vente se fera le lundi 24 novembre 1788 & jours suivans de relevée, en son logis, rue de la Pépinière, faubourg Saint-Honoré,* lot 62: "Horace qui tue sa soeur, Esquisse peinte à Rome."
8. Calvet 1968.
9. Montaiglon 1875–92, vol. 9, p. 233; Rollin 1748, vol. 1, pp. 165–66.

CATS. 21–24

1. Régis Michel in *David e Roma* 1981, p. 136; Sérullaz 1987.
2. "Horace condamné à mort pour le meurtre de sa soeur et défendu par son père"; "Différents sujets proposés par MM. Les Artistes pour être exécutés au Sallon [*sic*] prochain 1785"; Archives Nationales, O1 1925 B; as cited in Sérullaz 1987, p. 91. See also Engerand 1897.

3. "Serment des Horaces, entre les mains de leur père"; *Explication des peintures* 1785, no. 103, p. 28.

4. "le moment qui a dû précéder le combat où Horace père, rassemblant ses fils dans son foyer domestique, leur fait prêter serment de vaincre ou de mourir"; Péron 1839, p. 29; Rosenberg and Prat 2002, vol. 2, carnet 2 (nos. 1285–1367), pp. 891–918.

5. The sketchbook (carnet 2) is preserved in the Musée du Louvre, Paris (RF 4506; hereafter, Louvre RF 4506); see Rosenberg and Prat 2002, vol. 2, carnet 2 (nos. 1285–1367), pp. 891–918.

6. Louvre RF 4506, fol. 9 recto; Rosenberg and Prat 2002, vol. 2, no. 1292, pp. 894–95.

7. *Study for "The Oath of the Horatii,"* Ecole Nationale Supérieure des Beaux-Arts, Paris (EBA 733), and *Study for "The Oath of the Horatii,"* Musée du Louvre (RF 29914); see Rosenberg and Prat 2002, vol. 1, nos. 67, 68, pp. 86–87.

8. Hazlehurst 1960; Rosenblum 1970; González-Palacios 1993.

9. Péron 1839, p. 31.

10. Hamilton's painting, *The Death of Lucretia* (1764), is now in the Yale Center for British Art, New Haven (B1981.25.318); see Rosenblum 1961. Beaufort's *Oath of Brutus over the Body of Lucretia* (1771) is in the Musée de la Faïence et des Beaux-Arts Frédéric-Blandin, Nevers (NP 205).

11. Lee 1969; Rosenblum 1970; Rosenberg and Prat 2002, vol. 2, carnet 3 (nos. 1368–1435), pp. 919–52.

12. See note 7 above.

13. *David e Roma* 1981, p. 136.

14. Antoine Schnapper in Schnapper and Sérullaz 1989, p. 164; Rosenberg and Prat 2002, vol. 1, no. 51, p. 70.

15. Louvre RF 4506, fol. 40 verso; Rosenberg and Prat 2002, vol. 2, no. 1323, p. 904.

16. Ibid., vol. 2, no. 1304 verso, p. 898.

17. Louvre RF 4506, fols. 21 verso, 58 verso, 80 verso; Rosenberg and Prat 2002, vol. 2, nos. 1304, 1341, 1363, pp. 898, 911, 917. See Calvet 1968.

18. Louvre RF 4506, fols. 58 verso, 80 verso; Rosenberg and Prat 2002, vol. 2, nos. 1341, 1363, pp. 911, 917.

19. "Son premier soin fut de mannequiner toutes ses draperies avec le goût tout particulier qu'il possédait à un si haut degré. Drouais les dessina sur le papier pour être transportées après sur toile"; Péron 1839, p. 33.

20. For the sheets not included in this exhibition, see Rosenberg and Prat 2002, vol. 1, nos. 69, 70, 73, pp. 88–90.

21. See ibid., vol. 1, cat. 69, p. 88.

22. Louvre RF 4506, fol. 84 recto, autograph notation in black chalk; Rosenberg and Prat 2002, vol. 2, no. 1367, p. 918.

CATS. 25–26

1. Biographical information on Flury-Hérard, a Parisian banker, was added to the website Frits Lugt, Les Marques de Collections de Dessins & d'Estampes in 2015; see http://www.marquesdecollections.fr/detail.cfm/marque/6997/total/1.

2. Ledbury 2005.

3. In addition to the two sheets exhibited here, see, for the three other versions of *Caracalla Killing His Brother Geta*, Rosenberg and Prat 2002, vol. 1, nos. 54, 56, 57, pp. 75, 77; for the second version of *The Ghost of Lucius Septimius Severus Appearing to Caracalla*, Arlette Sérullaz in Clark 1998, cat. 100, pp. 314–15.

4. Greuze's rejected painting is now in the Musée du Louvre, Paris (INV. 5031). For his failed academic aspirations, see Crow 1985, pp. 134–74.

5. Rosenberg 1999, cat. 41, pp. 108–9. Rosenberg had connected the two works as early as 1984; see Rosenberg 1984, p. 67.

6. According to Pahin de La Blancherie, "not only does [Véri's] munificence allow artists to congregate there whenever they wish, but he is very attentive to their every need"; quoted in Bailey 2002, pp. 127–28. For Véri's collection, see ibid., pp. 101–30.

7. Rosenberg and Prat 2002, vol. 1, no. 54, p. 75.

8. For the source for the statue of a woman holding a vessel, see Rosenberg and Peronnet 2003, pp. 56–57. For other possible identities of the figures represented in the statues, see Wood 2010, pp. 312–13.

9. Ledbury 2005, p. 176.

10. Rosenberg and Prat (2002, vol. 1, nos. 55–57, pp. 76–77) present them in the following order: Musée du Louvre, Ecole Nationale Supérieure des Beaux-Arts, New Orleans Museum of Art. Philippe Bordes (2004, p. 125) puts the New Orleans sheet first, followed by the Louvre sheet and then the one in the Ecole Nationale.

11. Bordes 2004, p. 125.

12. Wood 2010.

13. Rosenberg and Prat 2002, vol. 1, no. 65, p. 84; Bordes 2004, p. 125.

14. Rosenberg and Prat 2002, vol. 1, no. 54, p. 75. The antique furniture in *The Ghost of Septimius Severus* reflects prototypes from David's sketches made in Rome, for which see ibid., vol. 1, no. 980, p. 655.

15. Ledbury 2004.

16. One can see a reference to the ghostly corpse of Geta in Girodet's Ossianic illustration *Fingal before the Cadaver of Fillan*; see Bellenger 2006, cat. 27, p. 248. In a more general sense, many of the elements of the story of Caracalla and Septimius can be found, reconfigured, in Jean Germain Drouais's *Marius at Minturnae* (Musée du Louvre; see fig. 97 in this volume), painted in Rome in 1786. See also Korchane 2012, p. 97.

CATS. 27–28

1. See Rosenberg and Prat 2002, vol. 1, no. 60, p. 80.

2. D. Wildenstein and G. Wildenstein 1973, nos. 110–14, pp. 14–15. For what may be the sketch, see Schnapper and Sérullaz 1989, cat. 57, pp. 148–49.

3. For the influence of Racine, see Ledbury 2005, pp. 170–73. For the spike in admiration for Poussin around 1783, see Crow 1985, p. 211.

4. A number of these studies are listed in Rosenberg and Prat 2002, vol. 1, under no. 982, p. 656.

5. Stein 2005, cat. 64, pp. 158–59.

6. Rosenberg and Prat 2002, vol. 1, no. 982, p. 656, and no. 59, p. 79.

7. Rosenberg and Prat (2002, vol. 1, nos. 61, 62, p. 81) present these last two drawings in the opposite order.

8. It was perhaps the visibility of the pentimenti that prompted David to redraw a clean version of the composition, essentially unchanged; see Isabelle Mayer-Michalon in Clark 2017, under cat. 116, pp. 292–95.

9. Poussin's *Testament of Eudamidas* was no longer in France by the time David was working on Andromache, but he would have known the 1757 print by Antoine de Marcenay de Ghuy, an

impression of which is now in the British Museum, London (1840,0314.114); see Clark 2017, p. 531, n. 13.

10. The theme of fatherless sons as a key to the dynamics of David's career and his studio is the subject of Crow 2006.

11. Rosenblum 2006, p. 45.

12. See Isabelle Mayer-Michalon in Clark 2017, cat. 116, pp. 292–95.

13. Again, the pose may have been inspired by a study in his Roman albums; see, for instance, *Mother and Child*, Musée du Louvre, Paris (INV. 26154); Rosenberg and Prat 2002, vol. 1, no. 972, p. 651.

CATS. 29–30

1. The drawing owned by the London art dealer William Mayor was most likely not the Chicago sheet (cat. 29) but a lost compositional study for the same subject. It is described in the catalogues of his 1859 and 1863 sales as "Adieux de Regulus à sa famille."

2. According to Rosenberg and Prat 2002, vol. 1, no. 77, pp. 92–93.

3. For the exact wording of the commission, see Rosenberg and Prat 2002, vol. 1, p. 92.

4. For studies possibly related to Coriolanus, see Rosenberg and Prat 2002, vol. 1, nos. 79, 94 verso, pp. 96, 106. They also suggest no. 78, p. 96, as a possible sketch for *The Departure of Marcus Atilius Regulus*. As Antoine Schnapper (in Schnapper and Sérullaz 1989, p. 197) pointed out, the two subjects have strong parallels in theme—female family members trying to restrain a male warrior—making the identification of figures in individual studies (including, for him, the Chicago sheet) less than certain.

5. David estate sale catalogue 1826, lot 40, describes the technique of the study as chalk, partly traced in pen and ink. This drawing is likely the one owned by William Mayor (see Provenance and note 1 above).

6. Cantaloube 1860, p. 301.

7. Thévenin's and Lafitte's paintings depicting *Regulus Returning to Carthage* are now in the collection of the Ecole Nationale Superieure des Beaux-Arts, Paris (PRP 31, PRP 32).

8. This sheet and the associated references were brought to my attention by Benjamin Peronnet, who also suggested that it may have been a first idea for *The Departure of Marcus Atilius Regulus* composition. As described in Rosenberg and Prat 2002, vol. 2, p. 1229, the drawing was originally part of Roman album no. 3 and was described in annotations to a copy of the catalogue of David's estate sale in the British Library, London, as "César allant au Capitole." It was acquired at the sale by David's daughter Mme Meunier. Whether there was an error in identifying the subject at the time of the posthumous sale, or whether David carried over the poses while changing the subject, is uncertain.

9. She is identified as his daughter in David estate sale catalogue 1826, lot 53 ("Groupe de Regulus et de sa fille, sur papier de couleur").

10. See Stein 2005, cat. 65, pp. 160–61. Earlier studies, possibly after antique models, may also find an echo in the head of Regulus; see, for example, Rosenberg and Prat 2002, vol. 1, nos. 16, 17, pp. 39–40, especially the treatment of the brow and the lighting.

11. See Arlette Sérullaz in Schnapper and Sérullaz 1989, cat. 78, p. 182.

12. This connection was noted by Antoine Schnapper (1982, p. 90).

CATS. 31–35

1. In 1940, Klaus Holma described how he had been received by the vicomtesse Fleury, who in 1931 had sold the painting *The Death of Socrates* to The Metropolitan Museum of Art but still owned a preparatory drawing. He described it as "très poussé et très détaillé," leaving also, and perhaps most likely, the possibility that the drawing she owned was neither cat. 31 nor cat. 32, but a lost study closer to the final composition, of the type David made for his other history paintings of this period. See Holma 1940, p. 118, n. 47; this reference was cited in Rosenberg and Prat 2002, vol. 1, p. 71, under no. 52. The vicomtesse Fleury owned another painting by David, the portrait of *Madame David* today in the National Gallery of Art, Washington, D.C. (1961.9.14). Following her death in 1948, that painting passed through the Galerie Cailleux in Paris, but their (albeit incomplete) records for the period do not show any evidence that they also owned the drawing for *The Death of Socrates*. This information is courtesy of Claire Martin, Chargée d'Etudes Documentaire at the Petit Palais, Musée des Beaux-Arts de la Ville de Paris, where the archives of the Galerie Cailleux are held as part of the Documentation Marianne Roland Michel; email correspondence, September 23, 2019.

2. I am grateful to Philippe Bordes for this information, which derives from an annotated copy of the sale catalogue at the Bibliothèque Nationale de France, Paris.

3. Rosenberg and Prat 2002, vol. 1, no. 52, p. 71, associates both the 1889 and 1896 sales with a different version of the subject (cat. 31), but with the reappearance of this sheet in 2015, it is clear that they refer to The Met's drawing, both because of the description of the medium and the evidence of the Coutan-Hauguet collector's mark.

4. Based on her recent research for the 2019 catalogue of French paintings in The Metropolitan Museum of Art, Curator Emerita Katharine Baetjer believes that it was almost certainly the elder Trudaine brother who commissioned *The Death of Socrates*; conversation, September 9, 2019. See the updated entry for the painting at https://www.metmuseum.org/art/collection/search/436105. See also Join-Lambert and Leclair 2017, pp. 154, 259, under no. P.180.

5. The gestation of both David's and Peyron's versions of the painting was complex and intermittent, as explained by Pierre Rosenberg in Einecke 2001, pp. 5–15.

6. The question of whether the date on the drawing is in the artist's hand or a later addition was brought up by Philippe Bordes (1990, p. 154), and discussed at length in Rosenberg and Prat 2002, vol. 1, no. 52, pp. 71–72.

7. For a listing of the many painters who depicted the subject, see Pierre Rosenberg in Einecke 2001, p. 8. For a broader overview, see Lapatin 2009.

8. Etienne La Font de Saint-Yenne, *Sentimens sur quelques ouvrages de peinture, sculpture et gravure, écrits à un particulier en province* ([Paris?], 1754), p. 123.

9. Denis Diderot, *Œuvres de théatre de M. Diderot, avec un discours sur la poésie dramatique*, vol. 2 (Amsterdam, 1759), pp. 203–6. David's composition conflates elements from scenes 4 and 5.

10. The cupbearer is referred to as a slave in several contemporary critiques of the painting but could possibly be a servant, a functionary of the Athenian government, or one of Socrates's disciples. See Padiyar 2008, p. 51, n. 56.

11. Louis-Antoine Prat (2016b, pp. 115, 227 fig. 18) described it as "d'après Jacques-Louis David (?)." One of the two versions must have been the model for Jean-Baptiste Debret's lithograph made in 1844 as a gift for attendees of the annual reunion held by David's former students. In certain details (the flexed foot of Plato, the shorter length of the slave's tunic, the position of the chain), it relates closely to The Met's version, but in other details, it appears closer to cat. 31, and occasionally (as in the indications of the archway on the back wall), it departs from both; see Bordes 1981, pp. 181–83. For neither The Met's nor the private collection sheet do we have provenance information for that year.

12. A letter to Jean Félicissime Adry, mentioned later in this entry and cited in notes 15 and 16 below, suggests that David may have included a sketch of the composition with the letter, offering another possible explanation for the need for a repetition.

13. The flexed foot also appears in a study of a draped man drawn directly into one of the Roman albums, but as the drawing extends onto the backing sheet, it is difficult to judge the date of the study. The detail of the drapery covering the man's mouth would be taken up in David's later versions of *The Death of Socrates*; see Sérullaz and Prat 2005, no. 14, p. 73.

14. For further biography, see Crow 2006, pp. 93–95; Baetjer 2019, p. 314.

15. Bonnardet 1938.

16. "Mais j'irai contempler votre esquisse et vous dirai en toute franchise l'impression qu'elle produira sur moi"; ibid., p. 312.

17. As revealed by recent technical analysis, the semicircles of the near and far ends of the arched passageway were laid in using a compass, a process marked by stylus holes that correspond to the placement of stylus holes in the painting; see Hale and Centeno, Technical Examination Report (note 31 below).

18. The building may be a pared-down view of the courtyard of the Casa Sassi in Rome, an idea put forward by Arlette Sérullaz, quoted in Rosenberg and Prat 2002, vol. 2, no. 1330, p. 907.

19. While the figures on the stairs in the painting appear to be men, a pentimento revealed by technical imaging suggests that Socrates's wife, Xanthippe, had once been included in this group (see note 33 below). One might also read the figure slipping out through the doorway behind the foot of the bed in both the 1782 and 1786 drawings, shielding their gaze with their hand, as an earlier idea for her inclusion in the scene; see Padiyar 2008, p. 38.

20. See, for example, Baetjer 2019, pp. 307–8, fig. 106.2. Another version is the marble *Portrait of Socrates* from the 1st century A.D. in the Musée du Louvre, Paris (MR 652).

21. Plato's pose differs from the 1782 study in that his mouth is now covered by his drapery. This tweak may have made its first appearance in a small sketch inscribed "sur nature," presumably made after a live model sometime between 1782 and 1786. Sérullaz and Prat 2005, no. 14, p. 73.

22. A stylus hole just above the crown of Socrates's head can be noted in the painting in precisely the same spot; see Hale and Centeno, Technical Examination Report (note 31 below).

23. Plato 1924, vol. 2, pp. 197–98.

24. Ibid., vol. 2, p. 230.

25. For Thomas Crow (2006, p. 29, fig. 20), the power created by the gap between the hands of the principal figures—David's "distinctive compositional signature"—was anticipated by Drouais's Prix de Rome entry of 1784, *Christ and the Canaanite Woman* (Musée du Louvre). One could say, however, that David took the idea further by locating this "dramatic disruption" at the center of the canvas.

26. No. 13 in the "Inventaire des objets réservés pour la Nation" from the Trudaine residence (Archives Nationales, Paris, F17 1267 [T, No. 190]) is "La première pensée de la mort de Socrate. esquisse peinte composition de 9 figures. Sur toile, hauteur 11 pouces sur 18"; https://www.metmuseum.org/art/collection/search/436105, References. See Baetjer 2019, pp. 314, 315 n. 26; Bordes 1981, p. 183. For Holma's account, see note 1 above.

27. Often throughout his career, David made nude sketches of figures either before or under his drawings of clothed figures. In the study of Crito, for instance, one can see the light contour of his left calf below the drapery. A similar observation can be made of his study for the drapery of Plato in Dijon; see Rosenberg and Prat 2002, vol. 1, no. 81, p. 97.

28. David's drapery studies can be distinguished from Peyron's figure studies made about the same time in that they focus primarily on individuals, while Peyron's are more painterly and treat the figures and their drapery in a more unified fashion. See, for example, his *Study for the Death of Socrates*, ca. 1787, J. Paul Getty Museum, Los Angeles (2010.8); see fig. 26 in the present volume.

29. See ibid., vol. 1, p. 97, under no. 81, and no. 215, p. 226.

30. See https://www.metmuseum.org/art/collection/search/231010. For other versions of Chaudet's sculpture, including the terracotta exhibited in 1791 (location unknown), see Korchane 2016, pp. 116–17, 160–61, under cat. 23. The connection between Chaudet's Belisarius and The Met's Crito drawing was pointed out by James David Draper (2007).

31. Their examination used infrared reflectography, X-radiography, and macro X-ray fluorescence/MA-XRF. See Charlotte Hale and Silvia A. Centeno, Technical Examination Report, November 20, 2020, Departmental Files, Paintings Conservation and Scientific Research, The Metropolitan Museum of Art. See also Charlotte Hale, "A Condition Note on *The Death of Socrates*," in Baetjer 2019, p. 316. I would like to thank Charlotte Hale for the considerable time she spent explaining her findings and fielding questions, and Evan Read, Associate Manager of Technical Documentation in Paintings Conservation, for his work on the technical images.

32. The oculus window is clearly visible on the MA-XRF Fe, Mn, and Pb maps; see Hale and Centeno, Technical Examination Report (note 31 above).

33. These figures and the original form of the banister can both be seen in the MA-XRF Hg map. Charlotte Hale and Silvia A. Centeno (Technical Examination Report [note 31 above]) suggest that the figure painted out on the stairs likely depicted "Socrates's much younger wife, Xanthippe, and their third son, who, according to Platos's *Phaedo* 60a, was small enough to be held in his mother's arms at the time of his father's death."

34. A fact first observed by Daniella Berman; conversation, August 22, 2017. The buckle is clearly visible in the infrared reflectogram; see https://www.metmuseum.org/art/collection/search/436105, fig. 2.

35. See Padiyar 2008; Crow 2006, pp. 98–99. For Ewa Lajer-Burcharth (1999, pp. 57–58, 297–99), the tension point was Crito's grip on Socrates's thigh.

1. According to Rosenberg and Prat 2002, vol. 1, no. 730*, p. 538.
2. The appearance of this sheet in 2002 necessitated a reexamination of the provenance previously published for the Getty version (cat. 39). It is proposed here that the Flury-Herard and Dreux sales more likely included this private collection sheet (cat. 38), while the Coutan, Dubneville (or Denon), d'Esling, and Dumont provenance should, most logically, stay connected to the Getty drawing.
3. According to Rosenberg and Prat 2002, vol. 1, p. 102.
4. Ibid.
5. The Coutan, Dubneville (or Denon), and d'Esling sales all seem to feature the same drawing. They do not mention a date for it, nor do they give dimensions, saying only that the drawing was "small." It is possible, even probable, that the Getty drawing (cat. 39) was the one included in these three sales, but definitive proof is lacking.
6. According to Florisoone 1948, p. 52.
7. The twentieth-century provenance is according to Turquin (Duchemin 2008).
8. Pierre d'Hancarville, *Antiquités étrusques, grecques et romaines tirées du cabinet de M. Hamilton, envoyé extraordinaire et plénipotentiaire de S. M. Britannique en cours de Naples* (Naples: François Morelli, 1766–67), vol. 4, pl. 24. According to Rosenberg and Prat (2002, vol. 1, no. 730*, p. 538), the vase depicted in the print was not, in fact, from Hamilton's collection.
9. A second quick sketch, likewise done directly on an album page, switches Paris to a standing position and Helen to a seated one, adding a bed just behind them; see Rosenberg and Prat 2002, vol. 1, no. 508, p. 440.
10. Scholars have disagreed on this point. See Antoine Schnapper in Schnapper and Sérullaz 1989, pp. 185–86, under cat. 79; Bailey 2002, pp. 196, 298 n. 171; *Jacques-Louis David* 2005, p. 92, under cat. 31.
11. On May 9, 1782, "le frère du roi" (presumably the comte d'Artois) wrote to officials in Marseille to request further payment for David for his *Saint Roch* altarpiece; see D. Wildenstein and G. Wildenstein 1973, no. 102, p. 14.
12. For the dating of the commission, see Bailey 2002, p. 299, n. 173. For Vincent's untraced canvas, see Cuzin 2013, cat. *460 P, p. 457. For Ménageot's lost picture, see Willk-Brocard 1978, no. 79, pp. 85–86.
13. On the rarity of the subject, see Schnapper and Sérullaz 1989, p. 186; Bailey 1992, p. 512.
14. See Bailey 2002, pp. 194–200.
15. See Antoine Schnapper in Schnapper and Sérullaz 1989, pp. 185–86; Al-Douri 2005; Christophe Leribault in Faroult, Leribault, and Scherf 2011, p. 149, under cat. 77.
16. This connection is pointed out in Rosenberg and Prat 2002, vol. 1, no. 87, p. 101.
17. Ibid.
18. Both Pierre Rosenberg and Louis-Antoine Prat have called the inscription spurious, but neither discounts entirely the possibility that the date may be correct. See Rosenberg and Prat 2002, vol. 2, no. 87 bis, p. 1279; Prat 2016b, p. 111, fig. 7.
19. For the sources of the stool, see Rosenberg and Prat 2002, vol. 1, no. 637, p. 497; of the bed, ibid., vol. 1, no. 889, p. 615; of the zither, ibid, vol. 1, no. 977, p. 653; and of the candelabrum, ibid, vol. 1, no. 1176, p. 736. For a general discussion of the topic, see González-Palacios 1993.
20. West 1998, pp. 43–61.
21. Beugnot called the painting a "veritable diamant, l'aurore du bon gout, et frais, brillant, suave comme l'aurore elle même" (true diamond, the dawn of good taste, as fresh, brillant, and sweet as dawn itself). The letter, addressed to David and dated May 23, 1807, was published in Laveissière 2004, pp. 179–80.
22. Bailey 2002, p. 197.
23. Crow 1985, p. 246.

1. The drawing(s) sold in the D[emesse], Vauzelle, R[evil], and D[reux] sales could be either cat. 43 or cat. 44.
2. Lot 27 is described as "Etude pour son tableau: la Mort de Brutus, a la plume, lave d'encre de Chine"—presumably an error in describing the subject of the sheet, as it is further noted as a study for his painting. One cannot exclude the possibility that the cataloguer meant to write "la Mort de Socrate."
3. According to Rosenberg and Prat 2002, vol. 1, no. 95, p. 107.
4. According to *David et ses élèves* 1913, cat. 261, p. 67. This drawing could be either cat. 43 or cat. 44.
5. See note 1 above.
6. See note 3 above.
7. See note 4 above.
8. Rosenberg and Prat 2002, vol. 1, no. 96, p. 108, also lists as a possibility the van Os sale, Hôtel Drouot, Paris, December 2, 1861. That lot is described as "groupe de trois femmes dans l'attitude de suppliants; à la sepia."
9. See Stein 2005, cat. 65, pp. 160–61.
10. Bordes 1996, pp. 30–31.
11. The drawing stayed in the family after the artist's death and would have been known to Jules David, the author of the first catalogue of his grandfather's work, who described it as "composé vers 1787"; see J. L. J. David 1880, p. 655. Philippe Bordes (2004, p. 125), on the other hand, has raised the possibility that the Morgan drawing might have been done years later, during the Terror.
12. While David did not further pursue the subject of Brutus condemning his sons, he may have inspired others to do so; see Bordes 1996. The painting and drawing of the subject by Guillaume Guillon Lethière were recently acquired by the Sterling and Francine Clark Art Institute, Williamstown, Mass. (2018.1.1, .2).
13. Engerand 1901, p. 138. See also Schnapper and Sérullaz 1989, pp. 195–97.
14. "Contrairement à tous les usages [et] de sa seule autorité"; Engerand 1901, p. 138.
15. Herbert 1972, p. 18; Crow 1985, p. 247.
16. The letter, dated June 14, 1789, is quoted in D. Wildenstein and G. Wildenstein 1973, no. 207, p. 28.
17. Rosenberg and Prat 2002, vol. 1, no. 90, p. 104, appears to be the earliest version. Brutus sits at a table at left; his wife has collapsed into a chair at right, surrounded by a group of people. There is no indication of the architectural setting.
18. For a detailed discussion of the sequence of compositional studies for the *Brutus*, see Stein 2009.

19. Patrick de Bayser kindly brought the drawing to my attention.

20. The same strategy was also used about 1783 in *The Ghost of Septimius Severus Appearing to Caracalla* (cat. 26).

21. Specific precedents of ancient reliefs featuring Niobe protecting her children are cited and illustrated in Herbert 1972, pp. 32–33, figs. 18, 19; p. 134, n. 18.

22. See Rosenberg and Prat 2002, vol. 1, p. 107, under cat. 95. For the series of lithographs, see Bordes 1981.

23. Stein 2009, p. 228, fig. 14.

24. Reinach 1909–12, vol. 2, p. 278, fig. 1. This terracotta relief, known later as one of the Campana reliefs, was copied by Jean Germain Drouais, but David may himself have made a copy (now lost) during one of his Roman sojourns; see Ramade 1985, cat. 146, p. 94.

25. Debret's lithograph (see note 22 above) retains all the pentimenti.

26. Bordes 1996, p. 43.

27. Quoted in Crow 1995, p. 1.

28. See Stein 2009, p. 234; González-Palacios 1993.

29. Rosenberg and Prat 2002, vol. 1, no. 97, p. 109.

30. On the genesis of Drouais's painting and David's involvement, see Perrin Stein in Stein and Holmes 1999, cat. 89, pp. 204–7. Dorothy Johnson (1993, p. 661) describes Drouais's *Marius* as "an emblem of mesmerism," reflecting a belief, popular at the time, that powerful figures could act as conductors of a magnetic fluid and use the force to control others.

31. Sold, Ader Nordmann, Drouot Richelieu, Paris, November 18, 2016, lot 29. See Rosenberg 2017a, pp. 52, 174, fig. 23.

32. In black chalk, across the top of the sheet, "ne pas oublier de mettre un autel en avant de la statue de rome par lequel [il ecrit libertate (?)] et sur lequel [aussi (?)] il s'appuyait" (do not forget to put an altar in front of the statue of Rome by which . . . and on which . . . he was leaning).

33. Herbert 1972, pp. 123–24.

34. Quoted and translated in ibid., p. 124.

35. See ibid., pp. 126–29.

36. Quoted and translated in ibid., p. 123.

37. Quoted and translated in ibid., p. 68.

38. See Herbert 1972; Bordes 1996; Bordes 2002; Baxter 2006.

39. Stein 2009, pp. 225–28.

40. Stein 2005, cat. 65, pp. 160–61.

NAVIGATING THE REVOLUTION (pages 173–77)

1. Guillaume Faroult (2004, pp. 58–61) identifies a formula across David's revolutionary-era (commissioned) portraits, including representations of *Anne Marie Louise Thélusson, Countess of Sorcy* (Neue Pinakothek, Munich), *Robertine Tourteau, Marquise d'Orvilliers* (Musée du Louvre, Paris), *Madame de Pastoret* (Art Institute of Chicago), *Monsieur Philippe Laurent de Joubert* (Musée Fabre, Montpellier), and *Madame Trudaine* (Musée du Louvre). These date to between 1790 and 1792.

2. Berman forthcoming.

3. "l'auteur du *Brutus* et des *Horaces*, ce Français patriote dont le génie a devancé la Révolution"; proposition of Edmond Dubois-Crancé, October 28, 1790, as quoted in J. L. J. David 1880, p. 90.

4. D. Wildenstein and G. Wildenstein 1973, no. 330, p. 39. Sketches for this unrealized portrait can be found in sketchbook (carnet) 4

(Musée du Louvre, RF 36942), fols. 38, 39; Rosenberg and Prat 2002, vol. 2, nos. 1473, 1474, p. 969. Despite these preliminary sketches by David, the commission was actually given to the portraitist Adélaïde Labille-Guiard, though the painting was never realized and no preparatory works by Labille-Guiard are known. See Auricchio 2009, pp. 82–83.

5. The republican calendar (sometimes called the revolutionary calendar) was proposed by Charles Gilbert Romme. Designed to remove religious and royalist influence from the calendar, it reorganized time into new months of thirty days each organized into ten-day groups called *decadis*. Instituted on October 5, 1793, it began its count from the first session of the National Convention on September 21, 1792, corresponding to the autumnal equinox, in advance of the proclamation of the Republic the following day. Noteworthy, then, is the fact that the calendar was implemented in what was already Year II; Year I had not been lived as such but had been experienced only in hindsight.

6. David was one of the principal organizers of various festivals, including the pantheonization of Voltaire (July 1791), the Festival of the Republic One and Indivisible (July 1793), the Festival of the Supreme Being (Summer 1794), and the unrealized pantheonization of François Joseph Bara and Joseph Agricol Viala, the child martyrs.

7. "Le système des arts doit changer comme le système politique"; *Explication par ordre des numéros et jugements motivé des ouvrages de peinture, sculpture, architecture et gravure, exposés au Palais National des Arts* (Paris: Imprimerie de H. J. Jansen et comp., 1793), p. [3].

8. "ce qui prouve que la touche male [*sic*] et savant de l'artiste n'aurait pas seule suffi, et qu'il fallait encore cet ardent amour de la patrie dont il est enflammé [*sic*] quoique . . . le tableau de Marat. Il est effectivement difficile d'en soutenir longtemps la vue, tant l'effet en est terrible"; "Exposition dans la cour du vieux Louvre des tableaux de LePelletier et de Marat . . . par David," Collection Deloynes, vol. 54, item 1584, Académie de Peinture, Sculpture et Gravure, 1793–1807, Bibliothèque Nationale de France, Paris (EST. RESERVE YA3-27 [54, 1584]-8).

9. For a discussion of the relationship between the pantheonization ceremony and David's painting *The Death of Joseph Bara* (fig. 100), see Berman forthcoming; Foissy-Aufrère 1989.

10. David executed two drawings of Homer, both now in the collection of the Musée du Louvre (INV. 26079, RF 789); see Rosenberg and Prat 2002, vol.1, nos. 144, 145, pp. 158–60.

11. The reforms of the Revolution made divorce legally possible.

CAT. 49

1. In English, "an iron scepter in his hand / Despotism carried on a shield by Envy / Prejudice / Superstition fleeing at the sight of Reason / represented / by a single figure, she alone having / the attributes / of the 3 powers. Legislation by ta[bles] / of the law and a stylus. Executive power by a sword[.] Judic[ial] power by a balance scale."

2. See Mellinet 1836; Saunier 1903; Cosneau 1983.

3. Rosenberg and Prat 2002, vol. 1, nos. 103–5, pp. 116–17; vol. 2, nos. 1442–50, pp. 956–61.

4. The letter, in the Bibliothèque Nationale de Nantes (MS 2204 [Fr 2051], no. 49), is quoted in Cosneau 1983, p. 255.

5. See Rosenberg and Prat 2002, vol. 1, p. 116.

6. The two versions of the composition are in the Musée Carnavalet, Paris (D 4852; cat. 55), and the Musée du Louvre, Paris (RF 71; fig. 114); see Rosenberg and Prat 2002, vol. 1, nos. 128, 129, pp. 142–45.

7. Ibid., vol. 2, nos. 1436–89, pp. 953–75.

8. Ibid., vol. 2, no. 1444 recto, p. 958.

9. Ibid., vol. 2, no. 1444 verso, p. 958.

10. Ibid., vol. 2, no. 1442 recto, p. 957. The very sketchy figural group on the lower part of the page could be an initial idea for the woman carrying children and striding forward in the center of the Nantes composition.

11. Ibid., vol. 2, no. 1443 recto, p. 957.

12. Ibid., vol. 2, nos. 1445–47, p. 959.

13. Ibid., vol. 2, no. 1448, p. 960.

14. The loosely sketched young woman kneeling at his feet, reaching upward, recalls the mother-daughter figural group in the Getty and Metropolitan Museum versions of *The Lictors Bringing Brutus the Bodies of His Sons* (see cats. 43–44).

15. Rosenberg and Prat 2002, vol. 2, no. 1450 recto, p. 961.

16. Ibid., vol. 1, nos. 103, 104, pp. 116–17.

17. Ibid., vol. 2, no. 1441 recto, p. 956.

18. That project's vicissitudes are now well understood, thanks to the work of Philippe Bordes; see Bordes 1983.

CATS. 50–53

1. "Dans la composition de M. David . . . On croit assister et prendre part à cette scène immortelle qui a preparé le triomphe de la liberté française . . . ce tableau sera l'histoire de notre révolution, quoique le sujet paraisse circonscrit dans la première époque. . . . Tous les ouvrages de M. David ont été honorés des applaudissements du public; mais quelque célébrité que cet artiste ait acquise, celui-ci manquait à sa gloire, car il honore autant son patriotism que ses rares talents, et il peut servir de preuves que la passion de la liberté agrandit les facultés de l'âme et double les forces du génie"; *Supplément au Journal de Paris*, June 10, 1791, p. 1.

2. Philippe Bordes's 1983 publication remains the most thorough investigation of David's project. The drawing was on view in David's studio from late May until June 3, 1791.

3. André Chénier, *Jeu de Paume; à Louis David, peintre* (Paris: Imprimerie de Didot fils aîné, 1791), was published in February, well in advance of the drawing's display in either the official Salon in September or the "advanced viewing" in early June.

4. It is often repeated that the deputies were locked out of the chamber where they were supposed to gather and that the space was guarded by soldiers, sparking anxiety that a royal attack on the Estates General or just the Third Estate was imminent. Though little actual proof exists, such rumors speak to the general atmosphere of distrust of that moment.

5. Almost all of the drawings in this sketchbook pertain to *The Oath of the Tennis Court*. Two other sketchbooks—one at the Musée du Louvre, Paris (RF 36942), and another now lost but known from the artist's posthumous inventory—also contained drawings for this project. It is possible that David inscribed the March 20, 1790, annotation at a later date.

6. Philippe Bordes (1983, p. 39) discusses the letters between David's students François Gérard and Anne Louis Girodet. However, it is possible that Gérard and Girodet were referring to a different project, perhaps the *Allegory of the Revolution in Nantes* (cat. 49).

7. In the *livret* of the 1791 Salon (*Ouvrages* 1791, no. 132, p. 13), David claimed that his remit in the drawing was not to convey likeness, which would be his focus for the final painting, and he invited deputies present at the oath to come to his studio for portrait sittings. Nevertheless, a number of figures were recognizable to contemporaries, and a widely circulated engraving identified fifty figures in David's drawing.

8. Bertrand Barère de Vieuzac reported on the oath in his journal, *Le Point du Jour*. He would go on to be a prominent member of the National Convention.

9. See Mayer 2018.

10. Bordes (1983, pp. 39–40) and Rosenberg and Prat (2002, vol. 1, p. 122) claim that the Versailles drawing with fourteen studies (cat. 51) necessarily predates the compositional study in Cambridge (fig. 109). However, the figural groupings and their poses on the Versailles sheet are closer to those of the final composition than those that appear on the Cambridge sheet. Similarly, in both the Versailles sheet and the final drawing, the figures are lit from the left, further suggesting that David already had the full composition in mind—worked out on the Cambridge sheet or on another, unknown compositional sketch.

11. According to David's student and early biographer Etienne Jean Delécluze (1855, p. 138), the architect, and member of David's studio, Charles Moreau assisted David with the specifics of the interior space. On the other hand, David's grandson and biographer J. L. J. David (1880, p. 420) asserted that it was the Paris-based Italian painter and designer Ignace Eugène Marie Degotti who drew in the architecture for *The Oath of the Tennis Court* as well as for Napoleonic commissions.

12. Denon would execute an engraving based on David's *Oath of the Tennis Court* drawing in 1794, although it differs stylistically from its model. Prat (2016a, p. 302) posited that the two figures outlined in ink at right, and a register of black chalk heads added in the background, were later additions by Denon. While the graphic style of these two figures is distinct, it seems dubious that Denon would have drawn on David's sketch. It is more likely that these figures were added as David sought to work out the spatial relationship between the figures of Dubois-Crancé and Robespierre and others, including Michel Gérard, identifiable by his supplicating gesture, and Honoré Gabriel Riqueti, comte de Mirabeau, at far right. These figures' inclusion as placeholders, then, would account for their more cursory handling, whether by David or a member of his studio.

13. Bordes 2004, p. 122.

14. "figures [qui] respirent l'amour de la patrie, de la vertu et de la liberté"; Anonymous, *Explication et critique impartiale de toutes les peintures, gravures, dessins, &c. exposés au Louvre, d'après le décret de l'Assemblée nationale, au mois de septembre 1791, l'an IIIe de la Liberté* (Paris, 1791), p. 21.

15. While it is generally assumed that David stopped work on the large-scale canvas in 1792, it remained unrolled in his makeshift studio in the deconsecrated church of the Feuillants until 1803, when it was rolled and transferred to the Louvre. There is no indication as to whether or not David made any changes to the painting during this period, although archival evidence suggests

that he considered returning to this project intermittently during these intervening years.

## CAT. 54

1. Marat suffered from a skin condition for which a vinegar-soaked headwrap and medicated baths were treatments.
2. This plain but vibrating background recalls the *frottis* backgrounds of some of David's painted portraits from the revolutionary period, and that of *Marat at His Last Breath* (fig. 111).
3. Marat's first political publication, *L'offrande à la patrie*, was published in February 1789. It addressed the French people (itself a radical move) on considerations for the elections and reiterated the important duties of the people's representatives, which Marat felt were not being honored.
4. First published in September 1789, the publication's full title was *Le publiciste de la République française, ou Observations aux français par Marat, l'ami du peuple*. The final issue (no. 242) appeared on Sunday, July 14, 1793, the day after Marat's murder.
5. It should be noted that the concept of "the people" came to be understood anew through the Revolution.
6. As Vaughan and Weston (2000, p. 6) note, the deputy Audouin "begged David, 'Return Marat to us whole again'—which reveals an interesting faith in the power of the image to create a likeness so believable that the subject's actual presence might be felt." David had painted a large commemorative portrait of Le Peletier that was likely destroyed in 1826 by the deceased's daughter. It is known only through a fragmentary drawing by David's student Anatole Devosge (Musée des Beaux-Arts, Dijon) and an engraving after Devosge's drawing by Pierre Alexandre Tardieu (Bibliothèque Nationale de France, Paris). David also made a close-up drawing of Le Peletier's physiognomy, known to us through an etching by Dominique Vivant Denon, typically dated to 1794 (Bibliothèque Nationale de France). Similar to cat. 54, the four corners of Denon's print bear the epithet: "M. LEPELLETIER / PREMIER / MARTIR / DE LA LIBERTÉ," if read clockwise.
7. David announced the painting's completion to the National Convention on October 14, 1793, and requested permission to display it in the courtyard of the Louvre for two weeks prior to depositing it. He eventually presented it to the National Convention on November 14, 1793.
8. Tom Gretton (2000) remarks on an alternative order for reading this inscription, so as to implicate David, rather than Marat, as "l'ami du peuple." While Gretton presents a plausible exposition on why David would have happily taken on the sobriquet and mantle, it seems most likely that the "traditional" Z-pattern of reading the inscription was intended. Noteworthy, though, is Gretton's observation that the lettering's directionality differs from the manner in which it was executed in David's drawing of Le Peletier (see note 6 above).
9. Copia worked closely with the publisher Guillaume Jean Constantin, although it is challenging to discern the publisher's role and impact on the print's execution. Constantin presented the print to the Jacobin Club on February 17, 1794, by which time it was available for sale to the public. For more on Constantin, see Jacoby 2018. Copia's copperplate is at the British Museum, London (1898,0527.214).

10. Elizabeth Rudy (2017) notes that certain impressions of revolutionary-era prints have later interventions that change the connotation of the inscription, such as the one in the Harvard Art Museums/Fogg Museum, Cambridge, Mass. (R13046), that, by changing just a few letters, transposes the inscription from the first person into the third person, now reading "Unable to corrupt *him*, they killed *him*."
11. "dans une attitude qui me frappa"; David to the National Convention, July 15, 1793, J. L. J. David 1880, p.142.
12. One of the inks used was iron-gall ink which, due to chemical instability, has undergone a tonal shift over time, from black-brown to brown. The brown lines that appear to add depth and nuance around Marat's parted lips, for example, or in the creases of his neck would have originally appeared closer in color to the rest of the drawing than they do today.
13. Due to his skin condition and the July heat, both of which acted to hasten the decomposition of his body, Marat was embalmed quickly after his death. It is known that the future Mme Tussaud accompanied David to take a wax death mask of Marat. Some scholars have argued that the Versailles drawing might have been made after the mask, but that seems to have been an unnecessary intermediary for David, who had direct access to Marat's body. The sculptor Pierre Nicolas Beauvallet made a posthumous plaster cast of Marat's features at the behest of the National Convention.

## CAT. 55

1. "Je possède dans mon cabinet un grand et beau dessin de David, figurant une allégorie relative au système révolutionnaire de 1793." (I possess in my study a large and beautiful drawing by David representing an allegory related to the revolutionary system of 1793.); Lenoir 1835, p. 7. Lenoir is the earliest-known owner of this drawing, though it is unclear whether he purchased it or received it as a gift from David, whom he knew well. It does not appear in David's posthumous inventory.
2. Despite Lenoir's assertion, no records have been found to confirm this.
3. For a discussion of the drawing's possible relationship to a theatrical commission, see Rosenberg and Prat 2002, vol. 1, no. 128, pp. 142–44. The play *La Réunion du dix août, ou l'Inauguration de la République française*, by Gabriel Bouquier and Pierre Louis Moline, was performed regularly between 1794 and 1796.
4. Unrealized projects, abandoned by choice or by chance, were ubiquitous during the revolutionary period, often due to practical considerations or changes in what was considered the appropriate aesthetic language for the moment. See, for example, *Les architectes de la liberté* 1989; Berman forthcoming.
5. On November 7, 1793, David proposed to the National Convention that a statue to the glory of the French people be erected on the Place du Pont-Neuf, replacing the statue of Henri IV. The assembly provisionally accepted David's idea, which he outlined more thoroughly several days later, as recounted by various biographers, including A. Thomé (1826, pp. 67–69) and J. L. J. David (1880, p. 158), and recorded in the *Archives parlementaires de 1781 à 1860*, vol. 78 (Paris: Librairie Administrative Paul Dupont, 1911), p. 560. David proposed a fifteen-meter-tall bronze sculpture representing the people's triumph over tyranny and superstition. The sculpture was to consist of Hercules supporting personifications

of Liberty and Equality. The hero's forehead would be inscribed with the word *Lumière* (Light); his chest, *Nature* and *Vérité* (Nature and Truth); his arms, *Force* (Strength); and his hands, *Travail* (Work). Artists' proposals for such a monument were accepted as part of a competition in 1794, the so-called Concours de l'An II. Several artists attempted to visualize David's rhetorically laden concept, but the statue was never constructed.

6. The pose of these two figures is taken from a sixteenth-century Roman frieze, which was also copied by David's student Jean Germain Drouais and is preserved in an album at the Musée des Beaux-Arts, Rennes (74-73-17). See the essay by Philippe Bordes in this volume, pp. 35–65.

7. David undoubtedly knew Vien's drawing, which was submitted to the Concours de l'An II (see note 5 above), for which David was a member of the jury. For more on the competition, see Olander 1983. For more on allegory during the Revolution, see Berman forthcoming.

8. The liberty cap, often red, was typical of the sans-culottes throughout the Revolution. See Wrigley 2002.

9. The Brutus in the Carnavalet drawing differs from other treatments of this figure in David's oeuvre: we see here neither the stoic statue of the Louvre drawing nor the contemplative version David explored in his 1789 painting. On the revival of Voltaire's play *Brutus*, which originally premiered in 1730, during the revolutionary period, see Herbert 1972. André Grétry's opera *Guillaume Tell*, with text by David's mentor Michel Jean Sedaine, was first performed in 1791. In the drawing, Tell's son sits atop his shoulders, holding an apple and arrow.

10. Le Peletier holds his back to show where he was stabbed on January 20, 1793. Marat was murdered on July 13, 1793. Joseph Chalier holds the guillotine blade by which he was executed on July 15, 1793. Pierre Marie Baille (or Bayle) dramatically pulls his cravat, by which he was hanged (or, possibly, hanged himself) on September 1 or 2, 1793. Thomas Augustin de Gasparin holds the vial of poison that he was forced to drink on November 7, 1793. Claude Dominique Côme Fabre (Fabre de l'Hérault), depicted in a hat, shows the sword with which he was stabbed on December 20, 1793. Finally, Charles Beauvais de Préault displays the chains in which the British imprisoned him; he died on March 28, 1794 (although he was widely presumed dead earlier in the year). The inclusion of this last figure has been used by scholars to provide a post factum dating for the drawing, but it is possible that the sheet was cut off at the right, removing additional modern martyrs whose inclusion might suggest a later dating for the drawing. David executed preparatory drawings for many of these contemporary martyrs, including one of Baille and Beauvais (Harvard Art Museums/Fogg Museum, Cambridge, Mass.) and Marat (Musée de Grenoble). All are squared for transfer to the Carnavalet sheet.

CATS. 56–57

1. According to Rosenberg and Prat 2002, vol. 1, p. 152.
2. David estate sale catalogue 1826, lot 54, p. 14.
3. Rosenberg and Prat 2002, vol. 1, nos. 136–43, pp. 150–57.
4. David's design is untraced but documented by Jean-Baptiste Lesueur in a gouache annotated, "uniforme de la composition du peintre David"; see Harris 1981, p. 301, fig. 10.

5. See the remarks by Christophe Parent (2012).
6. Aulard 1889–1923, vol. 3 (April 1–May 5, 1793), pp. 63–64.
7. Détournelle 1794, pp. 271–72 (meeting of 16 Germinal, [Year II] [April 5, 1794]). The Société, whose members voted to drop "populaire" from its name on May 22, 1794, was the main association of artists at the time. The rival Club Révolutionnaire des Arts, a survival of the jury (with a mix of professions) that had judged the Prix de Rome competition in 1793, whose operations are also detailed in Détournelle's journal, was suspicious of the corporate spirit of the Société; see Hould 1991. For complements to Détournelle's account, see Lapauze 1903, pp. xlviii–lxxiii, 303–424.
8. Lapauze 1903, p. 308 (19 Prairial, Year II). The "Considérations sur les avantages de changer le costume français, par la Société Populaire et Républicaine des Arts" are published in Détournelle 1794, pp. 315–17; and in *Décade philosophique, littéraire et politique* 1 (Floréal–Messidor [Year II] [April–July 1794]), pp. 60–62.
9. "le costume destiné aux représentants du peuple près les armées de la République française"; Laharie 1999, p. 121. There is a misleading indication that David submitted several drawings on this occasion in the summary published in D. Wildenstein and G. Wildenstein 1973, no. 936, p. 94. On the politics of dress, see Hunt 1998.
10. See Rosenberg and Prat 2002, vol. 1, no. 143, p. 157 (drawing of the first version); vol. 2, no. G 4, p. 1213 (print of the second version).
11. "présenter ses vues et ses projets sur les moyens d'améliorer le costume national actuel et de l'approprier aux mœurs républicaines et au caractère de la Révolution"; Aulard 1889–1923, vol. 13 (April 27–May 24, 1794), p. 517; summary in D. Wildenstein and G. Wildenstein 1973, no. 1005, p. 102. David's contact on the committee was Bertrand Barère, who penned the motions relative to the costumes.
12. "les divers projets d'habillement national soit législatif, en fonction et dans les armées, ou judiciaire, soit civil ou militaire [*crossed out*: soit le costume des citoyennes]"; Laharie 1999, p. 92 (May 24, 1794).
13. See Détournelle 1794, pp. 255, 260, 316; Lapauze 1903, p. 270.
14. D. Wildenstein and G. Wildenstein 1973, no. 666, p. 70.
15. Ibid., no. 969, p. 99.
16. Laharie 1999, p. 92–94. Laharie reproduces thirty-six prints "illuminated" by Denon (now preserved in the Archives Nationales, Paris) that reveal a standard color scheme for officials and soldiers but free assemblages for the two civil costumes; ibid., pp. 93, 95, 97, 99.

CATS. 58–63

1. According to Rosenberg and Prat 2002, vol. 1, no. 148, p. 166.
2. Lajer-Burcharth 1999, p. 15.
3. Owing to poor health, David was released into the care of Marguerite Charlotte Pécoul on August 3, 1795, two months before amnesty was granted to the group.
4. See Arlette Sérullaz in Schnapper and Sérullaz 1989, cat. 138, p. 309.
5. See Lajer-Burcharth 1992, vol. 2, pp. 402–34; Lajer-Burcharth 1994, pp. 219–43; Lajer-Burcharth 1999, pp. 88–118. For an earlier, brief discussion, see Wisner 1990.
6. Slightly smaller than the works in the Prison series, the portrait of Lebas (fig. 117) was executed in pen and brown ink on a circular sheet of paper 6 inches (15.2 centimeters) in diameter, which

was later inserted into a larger piece of paper with a decorative surround drawn by another hand. According to an inscription on the back of the frame, it was made during a session of the National Convention. The sheet, along with a bronze medallion based on it by Pierre Jean David d'Angers, came up at auction at Sotheby's, Paris, June 25, 2015, lot 18; see Bordes 2016, pp. 104–5, 219 fig. 9. Another work, a profile portrait of an unidentified man in a top hat, significantly smaller and executed in graphite, has been proposed by the Galerie Ratton-Ladrière, Paris, as dating to the same period; see ibid., pp. 104, 219 fig. 8.

7. Ibid., p. 104.

8. *Portrait of a Revolutionary* (cat. 58) is the earliest, dated June 21, 1795, followed by *Portrait of Jeanbon Saint-André* (cat. 59), dated July 8, 1795. Eight days later, on July 16, David drew the dashing *Portrait of a Man* (cat. 60), and the *Portrait of Bernard de Saintes* (cat. 61) on July 24. See Rosenberg and Prat 2002, vol. 1, nos. 147–50, pp. 165–68.

9. See Lajer-Burcharth 1999, p. 94; Grasselli 2009, p. 262, under cat. 113.

10. For Jeanbon Saint-André's later career, see Mathy 2003. For more on Bernard de Saintes, see Julien 2012.

11. Rosenberg and Prat 2002, vol. 1, no. 135, p. 173. A resemblance to Jean Henri Vouland has been noted for the unknown *Revolutionary* (cat. 58). Various possible identifications have been put forward for the *Portrait of a Man* (cat. 60), including Honoré Gabriel Riqueti, comte de Mirabeau (although he died before David's imprisonment), Claude Alexandre Ysabeau, and Christophe Saliceti. A *Portrait of a Man* in the Louvre was once thought to represent Edmond Dubois-Crancé and, more recently, Jean-Baptiste Robert Lindet. The latter's name has also been proposed in relation to a portrait in Ottawa. See Rosenberg and Prat 2002, vol. 1, nos. 147, 149, 153–55, pp. 165, 167, 171–73.

12. See Lajer-Burcharth 1999, pp. 88–118; Bordes 2016.

13. See, for example, Perrin Stein in Stein and Holmes 1999, cat. 95, pp. 220–21.

14. Various scholars have dated works in the group to between 1785 and 1790; see Cuzin 2003, nos. 40–46, pp. 76–77.

15. The original support of *A Young Woman of Frascati* appears to have been round. For the society portraits, see Rosenberg and Prat 2002, vol. 1, no. 66, p. 85; Prat 2016a, pp. 295–96, fig. 5.

16. See Lajer-Burcharth 1992, vol. 2, pp. 413–15.

17. The device came into widespread use in the mid-1780s; see Bordes 2016, p. 105.

18. Bordes 2016.

19. The drawing is inscribed at lower left, in pen and black ink, "Lafitte f. à Rome 1793"; see https://www.metmuseum.org/art/collection/search/397670.

20. Robert was arrested on October 29, 1793, and released on August 4, 1794. For recent overviews of this period, see Bruson 2016; Catala 2016.

21. See Join-Lambert and Leclair 2017, nos. P.178–P.181, pp. 154–57, 258–59.

22. David had his fifty-one-page "response" printed and distributed in Paris: *Réponse de David, de Paris, représentant du peuple, aux dix-sept chefs d'accusation portés contre lui par les Commissaires de la section du Muséum* (n.p., [1795]); see https://gallica.bnf.fr/ark:/12148/bpt6k6222747p.

23. Lajer-Burcharth 1999, pp. 88–118.

24. The surviving mounts are all of a uniform design, suggesting that David had access to a mountmaker in prison, made them himself (?), or, perhaps, had them mounted after his release, before giving them away. See Prat 2011, p. 53.

25. "In vinculis" means, literally, "in chains" or, more figuratively, "in custody."

26. Perrin Stein in Stein and Holmes 1999, cat. 89, pp. 204–7.

27. For an exploration of the metaphorical associations of the word *chain* during this period, see Padiyar 2007a, esp. pp. 148–52.

28. "Les élèves de l'art que je professe, ces jeunes artistes, dans lesquels je me verrai revivre, ont signalé envers moi cette piété filiale qui lie l'élève à son maître par des chaines aussi fortes que les liens du sang, puisqu'elles se rattachent aux plus nobles sentimens du cœur humain"; *Réponse de David*, p. 49 (see note 22 above).

CATS. 64–66

1. In the brochure given to the paying visitors who came to see the painting, David cited Plutarch's *Lives* as his source for the story; see David 1799, p. 14.

2. In the words given to Hersilia by Plutarch, and quoted by David in his brochure explaining the painting, the combatants were "liées à eux par les chaînes les plus sacrées" (linked by the most sacred of chains); see David 1799, p. 13.

3. Delafontaine's account survives in manuscript form in the Bibliothèque de l'Institut de France, Paris (MS 3782–3784). For Delécluze's, see Delécluze 1855, pp. 178–79, 186–88. Both are cited in Schnapper and Sérullaz 1989, pp. 324–25.

4. Delafontaine says that David was brought "quelques livres"; see D. Wildenstein and G. Wildenstein 1973, no. 1131, p. 114.

5. Cuzin 2013, no. 380 P, p. 435. Commissioned by the king in 1779 and exhibited at the Salon of 1781, Vincent's painting was judged a suitable composition for tapestry in 1794 and was woven at the Gobelins during 1801–9.

6. The drawing was presented as a gift to the sculptor Jean Joseph Espercieux in January 1799, shortly before the painting went on public view.

7. See Lajer-Burcharth 1991, p. 403; Schnapper and Sérullaz 1989, p. 340; Rosenberg and Prat 2002, vol. 1, no. 146, pp. 161–63.

8. It was a working technique that he would continue to use in the Napoleonic era, as well. See, for example, Louis-Antoine Prat in Prat and Tonkovich 2011, cat. 5, pp. 30–31.

9. Mayer 2018.

10. According to Delécluze, there were two compositional studies in David's studio, one with the (presumably male) protagonists clothed and one with them nude, and David's pupils hotly debated the merits of each option. See Delécluze 1855, p. 188.

11. As noted in Rosenberg and Prat 2002, vol. 1, p. 162, under no. 146. A small sketch for the composition, perhaps predating the Louvre's study (fig. 122), was listed in the David estate sale catalogue 1826, lot 43.

12. Many can be found in sketchbook (carnet) 5 (Musée du Louvre, Paris, RF 9137); see Rosenberg and Prat 2002, vol. 2, nos. 1490–1551, pp. 976–1008.

13. Rosenberg and Prat 2002, vol. 1, no. 158, p. 176.

14. An intermediary drawing, between the Lille study (cat. 64) and the second Louvre composition drawing (fig. 123), has irregular

edges, but ones that suggest that the figures of Tatius and Romulus may have been cut out (to be pasted on a new sheet?). See Rosenberg and Prat 2002, vol. 1, no. 164 bis, p. 180, as "Paris art market."

15. "soit en décalquant des figures, soit en mettant quelques parties au trait toujours sous ses yeux"; quoted in Schnapper and Sérullaz 1989, p. 324.

16. Ibid., p. 592.

17. See ibid., p. 324; Delécluze 1855, p. 187.

18. The hypothesis of a lost late-stage compositional study is supported by Delécluze's testimony cited in note 10 above. In both surviving composition drawings (figs. 122 and 123), both Tatius and Romulus are clothed.

19. David 1799, pp. 13–14.

20. The albums comprise, for the most part, sketches made on his two Italian sojourns (see cats. 6–14), but on occasion one finds a sketch dating from much later, as here, where he seems to have drawn over, and in reverse orientation to, a faint sketch of a woman's head. The position of the rearing horse also contains an echo of one on the right side of Nicolas Poussin's *Abduction of the Sabine Women*, a precedent David (1799, p. 12) humbly referred to in his brochure (see note 1 above). According to the inventory of his estate, David had a framed print after Poussin's composition by Henri Laurent; see D. Wildenstein and G. Wildenstein 1973, no. 2041, item 43, p. 237.

21. David explained to his students that he was moving beyond the "Roman" style of the *Horatii* to a "pure Greek" style, as seen in his more linear and idealized male nudes; see Delécluze 1855, pp. 61–62, 71–72. He put his defense in writing in the final pages of his exhibition brochure (David 1799, pp. 15–16), expressing his goal of following the manner of classical artists who represented their heroes nude.

22. The question is sometimes raised as to whether David had assistance from his students in executing his drapery studies. For a discussion of the drapery studies for *The Oath of the Horatii*, see Bordes 2004, p. 125. In the case of the *Sabines*, there is a range of handling and style. Some are drier than others, and some have drapery that is more revealing of the underlying figure; see Rosenberg and Prat 2002, vol. 1, nos. 167–70, pp. 182–84.

23. See Grigsby 1998.

24. Arlette Sérullaz in Schnapper and Sérullaz 1989, p. 350, under cat. 154.

25. "Pendant le cours de la préparation laborieuse de son grand tableau, David ne cessa de tourner et de retourner, de serrer et de remanier chacun des groups, surtout des principaux"; Philippe de Chennevières, "Une collection de dessins d'artistes français," *L'Artiste*, December 1897, p. 419, quoted in Schnapper and Sérullaz 1989, p. 348.

THE NAPOLEONIC ERA (pages 215–19)

1. Chaussard (1800, p. 4) insisted, moreover, that he had discussed this equivalence between the divisive factions of modern-day France and the warring clans of the Sabines and Romans with David, who confirmed that it was his intention to convey such a message in his painting.

2. Laveissière 2004, pp. 83–86.

3. Schnapper and Sérullaz 1989, p. 362.

4. Louis-Antoine Prat in Prat and Tonkovich 2011, cat. 5, pp. 30–31.

5. Rosenberg and Prat 2002, vol. 1, no. 281, pp. 270–71.

6. See Grigsby 2007.

7. Bordes 2005b, cat. 27, pp. 205–11.

8. For *Alexander, Apelles, and Campaspe*, the compositional study is in the Pébereau collection, France (see Rosenberg and Prat 2002, vol. 1, no. 319 bis, pp. 302–3), and the painting is in the Palais des Beaux-Arts, Lille (P. 444).

9. Daru, whose title was intendant general of the emperor's household, oversaw all official patronage of the arts.

10. Bordes 2005b, cat. 12, pp. 113–21.

11. The account of this exchange, no doubt embellished, was relayed, long after the artist's death, by David's former student Etienne Jean Delécluze (1855, p. 231).

12. Bordes 2005b, p. 73.

CATS. 67–70

1. Rosenberg and Prat 2002, vol. 1, p. 209.

2. Sotheby's cataloguing of the sheet, when it appeared at auction in London, July 4, 2018, listed as the earliest provenance the Cottenet estate sale, Hôtel Drouot, Paris, May 16–18, 1881, lot 52, but the description of the sheet in that sale catalogue as "Prêtres italiens, crayon noir" makes it unlikely to be the present sheet, which is predominantly pen and wash.

3. Extensive research was conducted on the identities of the figures represented in the context of an exhibition organized around the painting in 2004–5. According to that analysis, there are 191 figures discernible on the canvas, of which 164 have features that are partially or largely visible. Of those, 75 have been identified. See Laveissière 2004, in which there is a labeled diagram inside the front cover and a key on pp. 138–43.

4. David described how a loge was built specifically to provide him an optimal vantage point: "J'y dessinai l'ensemble d'après nature et je fis séparément tous les groups principaux, je fis des notes pour ceux que je n'eus pas le temps de dessiner"; quoted in Laveissière 2004, p. 66. The manuscript of David's autobiography quoted by Laveissière is in the Bibliothèque de l'Ecole Nationale Supérieure des Beaux-Arts, Paris (MS 316, no. 13).

5. For the sketchbooks, see Rosenberg and Prat, 2002, vol. 2, carnet 6 (nos. 1552–95), pp. 1009–29; carnet 7 (nos. 1596–1640), pp. 1030–50; carnet 8 (nos. 1641–71), pp. 1051–67; carnet 9 (nos. 1672–1732), pp. 1068–91. For a discussion of the medieval sources consulted, see Laveissière 2004, pp. 66–67. Certain studies of individual heads, including a group of nineteen in Besançon, were done from memory years later, in Brussels, when David was working on his second version of the painting; see Rosenberg and Prat 2002, vol. 1, nos. 360–78, pp. 334–44.

6. See Laveissière 2004, p. 76. In his own words, Degotti described his role as "chargé de la partie scénographique de tous ces tableaux"; see Bordes 2005b, pp. 46, 342 n. 62.

7. Sylvain Laveissière (2004, p. 68) noted that a biography of Poussin discussing this practice was published in 1806. Little is known of these "dolls," but it seems likely, especially given their number, that they would have been made of paper, like paper dolls, perhaps colored with watercolor. The alternate possibility of Isabey's influence was kindly suggested to me by Philippe Bordes; email correspondence, April 6, 2020. An account of Isabey's

presentation can be found in Bausset-Roquefort 1828–29. vol. 1, pp. 4–5. I would also like to thank Cyril Lécosse for sharing his thoughts on this subject; email correspondence, May 13, 2020.

8. There is debate over the relative roles of different students. For a discussion of Georges Rouget's role in the execution of the painting, see Pougetoux 2004. In the opinion of Philippe Bordes (2005a, p. 201), a larger role may have been played by Albert Paul Bourgeois.

9. Rosenberg and Prat 2002, vol. 1, nos. 218, 219, pp. 228–29.

10. Laveissière 2004, p. 74. Per Rosenberg and Prat 2002, vol. 1, no. 200, p. 211, this drawing "probably" would have come after the Louvre sheet (cat. 67).

11. *Le sacre de S. M. l'Empereur Napoléon dans l'église métropolitaine de Paris, le XI frimaire an XIII dimanche 2 décembre 1804* (Paris: Imprimerie Impériale, 1807). For a hand-colored example in the Bibliothèque Nationale de France, Paris, see https://catalogue.bnf.fr/ark:/12148/cb403589353. Napoleon's personal copy, which featured a hand-written text and the drawings upon which the prints were based, is today in the Musée National du Château de Fontainebleau (GM Bibl. 3502); see Laveissière 2004, cat. 15, pp. 54–55.

12. David's student Etienne Jean Delécluze would comment on this arrangement decades later in his memoir of his time in David's studio, claiming that his master was ignorant of the laws of perspective. See Delécluze 1855, pp. 222–23.

13. It would appear that David gave Degotti the drawing along with a study of Napoleon crowning himself in front of the seated pope, as the two share a provenance. See Rosenberg and Prat 2002, vol. 1, no. 198, p. 208.

14. The careful perspective and evident use of a straightedge in the architectural elements of the Louvre sheet (cat. 67) contrast with the loose, impressionistic sketches of the interior of Notre-Dame that David drew, presumably, in the days just before the coronation. See Rosenberg and Prat 2002, vol. 1, nos. 192, 193, pp. 202–3. A study for *The Oath of the Tennis Court*, in the Harvard Art Museums/Fogg Museum, Cambridge, Mass. (1943.799), appears to be an earlier example of a collaboration with an architecture specialist (see fig. 109 in this volume). In both cases, David faced the challenge of presenting a large cast of characters in a known physical setting.

15. An 1824 account of David's life and work makes mention of an initial sketch of similar dimensions made by David immediately after the ceremony; see *Notice sur la vie et les ouvrages de M. J.-L. David* (Paris: Dondey-Dupré père et fils, 1824), p. 48. Usually considered lost, it is not impossible that the sheet described is the quick black chalk sketch that is the first layer of the Degotti sheet, if, in fact, the architectural details were superimposed at a later stage. Laveissière (2004, cat. 27, p. 94) rejects this association, dating the Louvre sheet to April 1805 or after, based on the apparent collaboration of Degotti. Arlette Sérullaz (1991, no. 207, pp. 166–67) described the ink portions of the drawing as coming after the chalk sketch and raised the possibility that the Louvre sheet is "perhaps" the one mentioned in the 1824 account.

16. Per Rosenberg and Prat (2002, vol. 1, no. 201, p. 212), following Sérullaz (1991, p. 278), they were by Corneille van Cleve and Claude Poirier. Per Laveissière (2004, p. 96), following Schnapper (in Schnapper and Sérullaz 1989, p. 407), they were by Claude Auguste Cayot. For studies of the statues, see Rosenberg and Prat 2002, vol. 2, no. 1572 recto, p. 1019.

17. Laveissière 2004, p. 96.

18. Quoted and translated in Bordes 2005b, p. 46.

19. The oil sketch on panel would be painted over by David, in 1808 or later, with a double portrait of Pope Pius VII and Cardinal Caprara, today in the Philadelphia Museum of Art (1971-265-1). For a technical study and infrared images, see Mark Tucker and John Zarobell in Laveissière 2004, pp. 75–80.

20. For a description of the process and references to the many letters that document the sittings, as well as arrangements made to borrow the clothing worn, see Laveissière 2004, pp. 81–83.

21. Ibid., cat. 28, p. 97. Other scholars have suggested that the Versailles sheet (cat. 69) may have been executed during the ceremony. For Louis-Antoine Prat (in Rosenberg and Prat 2002, vol. 1, no. 195, p. 204), the depiction is too unflattering to have been drawn in the presence of Josephine.

22. Bordes 2005b, p. 50. In the painting, the gold and floral embroideries of his chasuble glimmer like a Byzantine mosaic behind Josephine's head, a point made by Sylvain Laveissière (2004, p. 135), who compared the effect to the mosaic of Empress Theodora in the church of San Vitale in Ravenna (ca. A.D. 547).

23. For Rosenberg and Prat (2002, vol. 1, p. 218), all three were unidentified. Laveissière (2004, p. 142) tentatively proposed the figure on the left as Cardinal Antonelli.

24. Rosenberg and Prat 2002, vol. 2, no. 1565, p. 1016.

25. Laveissière 2004, p. 135.

26. Ibid., pp. 83–84; Bordes 2005a, p. 201.

27. These details are best appreciated in the series of detail photographs illustrated in Laveissière 2004, pp. 145–75.

28. "vous avez eu l'heureuse audace de plonger votre scène dans un océan de lumière"; the letter, dated May 23, 1807, is published in full in Laveissière 2004, pp. 179–80.

29. "Ce n'est pas une peinture; on marche dans ce tableau"; quoted in Laveissière 2004, p. 112.

CATS. 71–73

1. The detailed compositional study in the Musée du Louvre, Paris, is dated 1805, and by November of 1807, David described it in a letter to Pierre Antoine Daru as "déjà composé et dessiné sur la toile." See Rosenberg and Prat 2002, vol. 1, no. 203, pp. 214–15; Schnapper and Sérullaz 1989, p. 446.

2. David relayed this directive in a letter to Daru, dated October 25, 1808, of which the relevant passage is quoted and translated in Bordes 2005b, p. 56.

3. Each flagpole was topped by a bronze figure of an eagle cast after a prototype sculpted by David's friend Antoine Denis Chaudet, to whom he had given his study for Crito (see cat. 34).

4. David's absence has generally been surmised from the list of questions concerning details of the ceremony written in his hand in one of the sketchbooks (carnet 7), containing studies for the *Eagles* (Musée du Louvre, Paris, RF 23007); see Rosenberg and Prat 2002, vol. 2, no. 1640, p. 1050.

5. The sheet, formerly referred to as "la feuille Saunier," was acquired by Pierre-Jean Chalençon in 2016; sale, Audap & Mirabaud, Paris, June 14, 2016, lot 16. See also Rosenberg and Prat 2002, vol. 1, no. 204, p. 216.

6. Rosenberg and Prat 2002, vol. 2, no. 1631, p. 1046.

7. Ibid., vol. 1, no. 281, pp. 270–71.

8. See Schnapper and Sérullaz 1989, p. 450; Rosenberg and Prat 2002, vol. 1, p. 270.

9. For a detailed account of the nature and sequence of these physical changes, see Rosenberg and Prat 2002, vol. 2, nos. 1733–76, pp. 1092–1110.

10. David's idiosyncratic method of squaring, with the lowest horizontal line just below the figure's foot, and the highest grazing the top of the head, is described by Tamar Mayer (2017, p. 242).

11. See Bordes 2005b, p. 111. The sketch on the facing page, oriented in the opposite direction, shows a kneeling mother holding a child, their arms outstretched; see Rosenberg and Prat 2002, vol. 2, no. 1735 verso, p. 1094. Once associated by Arlette Sérullaz (cited in ibid.) with the *Sabines*, the sheet alternatively might be an unused study for a figure for an early version of *Napoleon and Josephine Arriving at the Hôtel de Ville*; see Rosenberg and Prat 2002, vol. 1, no. 203, pp. 214–15; vol. 2, no. 1439 recto, p. 955. That work was originally conceived with groups of citizen-suppliants welcoming their arrival with "hats and bonnets raised in the air, expressing the admiration with which they were animated" (Rosenberg and Prat 2002, vol. 1, p. 214), although a study for that work, abandoned in 1808, would also be unexpected in a sketchbook largely devoted to *The Distribution of the Eagles*.

12. See Philippe Bordes's essay in the present volume.

13. The earlier sketch, in which he is shown completely nude and holding the axe aloft, is still bound in the Chicago sketchbook; see Rosenberg and Prat 2002, vol. 2, no. 1747 recto, p. 1099.

14. "Tant il est vrai qu'avec David, les personnages possèdent l'étrange faculté de glisser d'une oeuvre à l'autre, comme le prouvent les nombreux folios de carnet concernant à la fois les *Aigles* et le *Léonidas*"; Rosenberg and Prat 2002, vol. 1, p. 270.

15. Schnapper and Sérullaz 1989, p. 450.

16. Bellenger 2006, pp. 308–21.

17. For a discussion of this debate, see Schnapper and Sérullaz 1989, pp. 448–49; Johnson 1993, pp. 209–13.

18. The inscription reads, "cette figure étoit destinée a entrer / dans le tableau ~~du Couronnement~~ des aigles, C'est / l'empereur qui ne la pas Voulu, on Voit / par l'attitude des maréchaux qu'elle étoit indispensable"; transcribed in Rosenberg and Prat 2002, vol. 2, no. 1608 verso, p. 1035.

19. See D. Wildenstein and G. Wildenstein 1973, nos. I 585–87, p. 185.

20. See Bajou 2007. She called *The Distribution of the Eagles* "a problematic, even a failed, painting" (p. 55).

21. D. Wildenstein and G. Wildenstein 1973, no. I 552, p. 181.

22. See note 15 above.

23. In its fusing of the colors of the Empire (red, green, and gold) with those of the Republic (blue, white, and red), the palette of the Versailles painting has been described by Philippe Bordes (2005b, p. 57) as a "celebration of the association of court culture and military ethos."

24. He is identified as Mohammed Said-Haled by Antoine Schnapper in Schnapper and Sérullaz 1989, p. 452.

25. The artist's estate sale did not feature any oil sketches, suggesting that the extant sketches were presented as gifts; see Schnapper and Sérullaz 1989, p. 451.

26. For Philippe Bordes (2005b, p. 264), the restrained technique of the *Horatii* and *Brutus* oil sketches was "a highly personal method meant to counter the formal libertinage associated with the oil sketch." By 1810, the oil sketch would have connoted something different, as it was embraced by many of David's students.

CAT. 74

1. "pour le rendre digne de la majesté du lieu; travail qui entraîne avec lui une grande quantité d'essais, de dessins, ou d'équisses avant d'arriver au terme qui réunit toutes les parties de l'ordonnanse générale d'une décoration aussi importante"; see D. Wildenstein and G. Wildenstein 1973, no. 1658, p. 192.

2. See Arlette Sérullaz in Schnapper and Sérullaz 1989, cat. 211, pp. 374, 482–83; Sérullaz 1991, no. 215, pp. 171–72.

3. Bordes 2005b, pp. 67–68, 212.

4. Laveissière 1993, p. 905.

5. The Jovian imagery, according to Thomas Crow (2001), would have been seen as a flattering reference to Napoleon, who, like Jupiter, was associated with the symbol of the eagle.

6. According to the British Museum's website, this print was one of five extra plates designed by Flaxman for the 1805 London edition of his *Iliad of Homer*, first published in Rome in 1793. Three of the extra plates were engraved by William Blake. See https://www.britishmuseum.org/collection/object/P_1973-U-1189-9.

7. Rosenberg and Prat 2002, vol. 1, nos. 305, 306, pp. 288–89.

CATS. 75–76

1. Bordes 2005b, p. 197.

2. "ils vont souper chez Pluton"; *Explication du tableau des Thermopyles* 1814, p. 8. David is not listed as author on the title page, but one assumes he was responsible for the text.

3. "Tant pis; vous avez tort, David, de vous fatiguer à peindre des vaincus"; Delécluze 1855, p. 231.

4. *Explication du tableau des Thermopyles* 1814, p. 8. In the painting the inscription in the rock would be changed to Greek, but the *Explication* (ibid., p. 7) supplied a French translation: "Étranger, va dire aux Lacédémoniens que nous sommes morts ici, en obéissant à leurs ordres" (Stranger, go tell the Lacedemonians that we died here, obeying their orders).

5. "A l'imitation des artistes de l'antiquité, qui ne manquaient jamais de choisir l'instant avant ou après la grande crise d'un sujet, je ferai Léonidas et ses soldats calmes et se promettant l'immortalité avant le combat"; Delécluze 1855, p. 226.

6. Schnapper and Sérullaz 1989, pp. 486–512.

7. Nash 1978, p. 111. For the series of letters Suau wrote to his father about David's work on *Leonidas*, see D. Wildenstein and G. Wildenstein 1973, nos. 1673, 1674, 1677–81, pp. 193–94.

8. Nash 1978, p. 109.

9. Mayer 2018.

10. It is interesting that Bordes (2005b, p. 198) used the word *collage*, in a figurative sense, to describe the compositional strategy, writing, "[f]rom the earliest sketches for *Leonidas* the scene was conceived as a foreground collage of male nudes striking a range of studied poses, and a jumble of more lively figures and groups behind."

11. Padiyar 2007a, pp. 9–49.

CAT. 77

1. According to J. L. J. David 1880, p. 663. Forbin was a former student of David's who succeeded Dominique Vivant Denon as

director-general of royal museums following the fall of Napoleon. David presumably sent the Cleveland drawing to him as a gift after the painting was completed in 1817.

2. Per Rosenberg and Prat 2002, vol. 1, no. 319, p. 301, all the twentieth-century provenance was according to Richard L. Feigen & Co., New York.

3. Schnapper and Sérullaz 1989, p. 518.

4. In 1880 David's grandson (J. L. J. David 1880, p. 663) noted that a second study for the picture, or at least of the same subject, was acquired by Alexis Nicolas Pérignon at the artist's estate sale.

5. For a detailed account of the picture's genesis, see Lampe 2007.

6. Sommavira was the former head of the Cisalpine Republic, a short-lived state created by Napoleon in Lombardy. He had long sought a work by David for his collection and presumably commissioned *Cupid and Psyche* in 1813. See Bordes 2005b, p. 232.

7. For an analysis of the figure of Psyche in David's work and in the broader cultural context of Paris during the Directory, see the chapter "Psyche in the Boudoir," in Lajer-Burcharth 1999, pp. 236–305.

8. The drawing, which has since appeared on the art market, was published in Rosenberg and Prat 2002, vol. 1, no. 1038, p. 683.

9. The painting is in a private collection. Guillaume Faroult (in Faroult, Leribault, and Scherf 2010, cat. 157, pp. 460–63) reviewed the literature on this painting and joined Ewa Lajer-Burcharth (1999, pp. 54–64) in supporting a date of about 1794–95. In Lajer-Burcharth's reading, *Abandoned Psyche* is a self-representation, expressing the artist's sense of loss and grief during his imprisonment at the Hôtel de Luxembourg. David's student François Gérard also treated the subject of Psyche abandoned in an illustration for Pierre Didot's 1797 luxury edition of La Fontaine's version of the fable; see Lajer-Burcharth 1999, pp. 279–81, fig. 143c.

10. The five sketches are on three sheets in a sketchbook today in the Musée du Louvre, Paris (RF 6071); see Rosenberg and Prat 2002, vol. 2, nos. 1824 verso, 1825 recto and verso, p. 1134.

11. "Il s'occupe dans ce moment d'un tableau d'histoire qui sera nouveau par le sujet qu'il représente. C'est l'amour et Psyché . . . le moment qu'il a choisi est neuf"; quoted in Mark Ledbury, introduction to Ledbury 2007, pp. xiii–xiv, xvi.

12. Lampe 2007.

13. Bordes 2005b, p. 232. A different model presumably posed for the figure in the Cleveland drawing. For a more detailed study of the head of the Cleveland Cupid, see Rosenberg and Prat 2002, vol. 1, no. 320, p. 304.

14. See Guilhem Scherf in Anne-Lise Desmas et al., *Bouchardon: Royal Artist of the Enlightenment*, exh. cat. (Los Angeles: J. Paul Getty Museum, 2016), pp. 350–68.

15. For contemporary critiques of the picture, including that of Gros, see Bordes 2005b, pp. 234–36. For modern-day derogatory descriptions of Cupid, see Johnson 1993, pp. 236–57.

16. The connection to the *Sleeping Ariadne* is discussed by Issa Lampe (2007, pp. 117), who sees in the reference to the tomb sculpture a mortuary symbol. Louis-Antoine Prat also notes the stylistic contrast between the figures, casting Cupid as "Caravaggesque" and Psyche as "Greuzian"; see Rosenberg and Prat 2002, vol. 1, no. 319, p. 301.

17. This rejection of the classical ideal was remarked upon even during David's lifetime. In 1824, in the words of the critic

P. A. Coupin, "While the crowds of artists, desperate to rank on a par with the masters, were searching for new ways to attract public attention, David himself was changing direction. We saw him abandon *le beau idéal* for a more realist type"; quoted and translated in Lampe 2007, pp. 118, 121 n. 19.

18. Marcia Steele, former Chief Conservator at the Cleveland Museum of Art, kindly shared the infrared images with me, October 5, 2020.

19. Lampe 2007, p. 120. This post-Empire reading aligns with the fact that David presented the Cleveland study as a gift to his former student Louis Nicolas Philippe Auguste de Forbin (see note 1 above).

REINVENTION IN EXILE (pages 247–49)

1. Unlike the absolutism of Louis XVI and his predecessors, against which David had rallied during the Revolution, the new Bourbon regime was a constitutional monarchy and left in place many of the reforms established between 1792 and 1814.

2. Rosenberg and Prat 2002, vol. 2, carnet 13 (nos. 1881–95), pp. 1155–58, 1280–87. For more on David's Swiss drawings, see Crow 2018, chap. 3.

3. J. L. J. David 1880, pp. 523–24.

4. "Madame, je n'ai point attend soixante dix ans pour souiller mes pinceaux, j'aimerais mieux me couper le poignet que de peindre un Anglais"; David to Mme de Hatzfeld, June 1816; as quoted in D. Wildenstein and G. Wildenstein 1973, no. 1786, p. 204. For more on the circumstances of these solicitations, see Crow 2018; Bordes 2005b.

5. Signed on November 20, 1815, the treaty reduced France's borders to their 1790 status, ordered it to pay 700 million francs in indemnities, and provided for its occupation by 1,200,000 foreign soldiers, although that number quickly dwindled.

6. Sieyès, a churchman, wrote the seminal pamphlet *Qu'est-ce que c'est le Tiers Etat?* (What is the Third Estate?) in January 1789, laying the foundation for the Third Estate's reassertion of its rights within the French nation and its representatives' efforts to draft a constitution. Like David, he voted for the execution of Louis XVI and held various roles throughout the Revolution. He also was instrumental in Napoleon's coup d'état of 1799. For more on his relationship to David and the latter's portrait of him, see Lajer-Burcharth 2007. Ramel, who participated in the Tennis Court Oath, was elected to the National Convention alongside David and served as finance minister during the Directory from 1796 to 1799. For David's portrait of him, see Bordes 2005b, cat. 52, p. 315.

7. "Nous jouissons d'une tranquillité qui depuis longtemps nous était inconnue"; Mme David to Mme Huin, February 12, 1822; as quoted in Bordes 2005b, pp. 187–88.

8. "David, parvenu à la vieillesse, n'existe plus que pour les arts"; petition to M. Decazes, minister of the Police General, February 1816; as quoted in D. Wildenstein and G. Wildenstein 1973, no. 1769, pp. 202–3.

9. "il n'y a que ceux-là qui sont à l'abri des passions des hommes"; David to Antoine Jean Gros, April 1, 1821; as quoted in D. Wildenstein and G. Wildenstein 1973, no. 1891, p. 221.

10. "Moi je travaille comme si j'avais que trente ans; j'aime mon art comme je l'aimais à seize ans, et je mourrai mon ami, en tenant le

pinceau à la main. Il n'y a pas de puissance, telle malveillante qu'elle soit, qui peut m'en priver; j'oublie toute la terre"; David to Gros, May 13, 1817; as quoted in Wildenstein 1973, no. 1799 bis, p. 206.

11. For example, Charles Meynier exhibited *The Departure of Telemachus* (Daniel Katz Ltd., London) in the Salon of 1800. See Mayer-Michalon 2019.

12. See Harkett 2007.

13. Pébereau collection, France; see Rosenberg and Prat 2002, vol. 1, no. 319 bis, pp. 302–3. The associated painting (1820–23) is now in the Palais des Beaux-Arts, Lille (P. 444).

14. Jérôme Martin Langlois, *Portrait of Jacques Louis David*, 1825, Musée du Louvre, Paris (RF 234).

15. Jean-Baptiste Isabey, *Portrait of the Painter David*, 1789, Musée du Louvre (RF 3819).

16. For more on David's engagement with classical tragedy and lyric opera in his late drawings, see Crow 2018, chap. 5. Both Thomas Crow (2007) and Helen Weston (2007) consider the influence of theater on David in Brussels. However, David's involvement with the theater began long before his exile; see, for example, Ledbury 2002, pp. 262–302.

17. This technique has often led to this painting being thought of as unfinished. For a consideration of David's "unfinished" style, see Berman forthcoming.

18. For example, at least one of the three versions of *Vie de David* by one A. Th***, published in 1826, each with slight variations, appears to have been dictated by David. Likewise, an anonymous *Notice sur la vie et les ouvrages de M. J.-L. David* (Paris: Dondey-Dupré père et fils, 1824) may have included input from the artist himself.

19. Joseph Denis Odevaere, *Portrait of Jacques-Louis David in His Studio*, 1820, Groeningemuseum, Bruges (2005.GRO0002.II). The drawing bears an inscription indicating that Odevaere's intention was to produce a large-scale painting ("portrait en pied"), which contradicts previous scholarship asserting that Odevaere's aim was an engraved portrait, but it is likely that both David and Odevaere had this possibility in mind. More recently, Nicolas Schwed has identified an earlier *première pensée* for the composition; see Nicolas Schwed, *Dessins anciens et du XIXe siècle* (Paris: Nicolas Schwed, 2020), no. 20, n.p.

20. Most painted portraits of David, whether self-portraits or those by his students, avoid depicting the well-known and identifying protrusion on his left cheek, either by minimizing it or by positioning the sitter with his head turned to the left.

21. David's renewed commitment to his former patron may have been linked to Napoleon's 1821 death in exile on the island of Saint Helena.

22. See Harkett 2007.

23. Years into his exile, David remained unwilling to renounce his previous actions, which would have allowed him to return to France, as many of his revolutionary compatriots had done. Following Louis XVIII's death and the ascension in 1824 of the more conservative Charles X, a pardon for the unrepentant regicide became increasingly unlikely.

CATS. 78–81

1. "J'ai fait depuis votre départ trente-deux dessins répartis en huit cadres contenant chacun quatre dessins; ce sont des croquis, des caprices j'ai commencé d'abord sans prétention, je jetois sur le papier les folies qui me passoient par la tête, comme vous en aves [*sic*] un de moi chez vous, ensuite l'amour propre s'en est mêlé et j'ai fait des dessins réellement, ma main s'étoit remise, enfin vous en jugerés à votre retour. Je crois cependant pouvoir dire sincèrement que cette collection tiendra son rang parmi mes ouvrages"; Fondation Custodia, Paris (2003-A.1234); as transcribed and translated by Mark Ledbury in Ledbury 2007, pp. xiv, xvi n. 26.

2. Johnson 2007.

3. Padiyar 2011, p. 8.

4. See, for example, the letter from David to Antoine Jean Gros, May 13, 1817, as quoted in D. Wildenstein and G. Wildenstein 1973, no. 1799 bis, p. 206.

5. Crow 2018, pp. 127–42.

6. Bordes 2005b, pp. 263–75.

7. David used the phrase "figures coupées" to designate half-length figures in a letter to his student François Joseph Navez, dated March 22, 1818; see D. Wildenstein and G. Wildenstein 1973, no. 1814, p. 210.

8. Rosenberg and Prat 2002, vol. 1, nos. 37, 38, 38 bis, 39, 41–44, 121 bis, 172, 177, pp. 60–64, 134, 185. Some of these drawings likely incorporate details from old master paintings yet to be identified. Another drawing that recently resurfaced on the art market can now be added to this group: *Heads of a Faun and a Reclining Woman*, sale, Oger-Blanchet, Paris, June 25, 2020, lot 15 (see fig. 24).

9. Rosenberg and Prat 2002, vol. 1, no. 36, p. 59.

10. Ibid., vol. 1, no. 37, p. 60.

11. For the 1821 sheet, see ibid., vol. 1, no. 434, p. 375. For that made in 1815, see ibid., vol. 1, no. 322, p. 305.

12. Ibid., vol. 1, nos. 762–68, pp. 558–61.

13. See, for example, three drawings in the Musée des Beaux-Arts in Orléans (Rosenberg and Prat 2002, vol. 1, nos. 397–99, pp. 354–55), executed on paper with the watermark of the Maison Malmenaide-Montmillan, "ancien fabricant de papiers d'Auvergne pour l'écriture et l'impression. Son dépôt est rue de la Sorbonne, no 4" (Oudiette 1812, p. 433). I would like to thank Olivier Fleygnac, conservator of graphic arts at the Orléans museum, for this information. In the catalogue raisonné, Rosenberg and Prat do not indicate the watermarks of the various papers used by David, so the study of such evidence is difficult.

14. For examples by Simon Julien, Claude Henri Watelet, Jean Jacques de Boissieu, and Louis Germain; see Stein 2013, pp. 133, 140, 162, 178.

15. See Lajer-Burcharth 1999, p. 324, n. 94.

16. Bordes 2005b, p. 288.

17. "sans faire auparavant un ensemble complet de movement général"; David to Navez, March 22, 1818 (see note 7 above).

18. See note 1 above.

19. Negotiations between David and the comte de Forbin, director of the Louvre, commenced in February 1817 and concluded two years later; see Agius d'Yvoire 1989, pp. 622–24.

20. "Dans les arts on appelle *caprice* toute invention, toute forme sans nécéssité, que la nature n'a point suggéré, que ne sauroit justifier le besoin, ou que la convenance désavoue; c'est le goût de toute production étrangère aux principes de l'art, et qui ne reposant sur aucune base solide, ne sauroit être de longue durée"; Millin 1806, vol. 1, p. 192.

1. "imprimer la resemblance" was the phrase used by David when, on August 20, 1806, he asked Cardinal Fesch to consent to a two-hour posing session; Département des Manuscrits, Bibliothèque Nationale de France, Paris (nouv. acq. fr. 6607, pièce 222); as quoted in Agius d'Yvoire 1989, p. 608. On the posing sessions for the *Coronation*, see Laveissière 2004, pp. 81–83.

2. For the portrait of Angélique Mongez (1806; Art Institute of Chicago), see Rosenberg and Prat 2002, vol. 2, no. 1762, p. 1105; Bordes 2005b, p. 112. For the profile portrait of the same sitter (private collection), see Rosenberg and Prat 2002, vol. 1, no. 212, p. 224; Bordes 2005b, cat. 16, pp. 156–57. For the portraits of Alexandre Lenoir and Adélaïde Binard, see Rosenberg and Prat 2002, vol. 1, no. 222, p. 232; Bordes 2005b, cat. 17, pp. 158–59.

3. Some of the seventeen drawings in question (Musée des Beaux-Arts et d'Archéólogie, Besançon) bear the autograph inscriptions "dessiné[e] de souvenir" or "fait de souvenir"; see Rosenberg and Prat 2002, vol. 1, pp. 334–44.

4. Sale, J. J. Mathias, Baron Ribeyre & Associés, E. Ferrando, Drouot Richelieu, Paris, July 1, 2015, lot 26; see Rosenberg and Prat 2002, vol. 1, no. 325, p. 306.

5. See Bordes 2005b, p. 138, and cats. 19, 20, 22, pp. 168–71, 175–77.

6. In 1806 Pauline married Jean-Baptiste Jeanin, an army lieutenant who had served in Italy and in the expedition to Egypt, and who was made a brigadier general in 1808, an officer of the Legion of Honor later the same year, and a baron of the Empire in 1809.

7. See the letter from David to Antoine Jean Gros, dated April 1, 1821, Bibliothèque des Beaux-Arts de Paris (MS 316, no. 43); cited in Agius d'Yvoire 1989, p. 627.

8. Bordes 2005b, cats. 54, 55, pp. 319–29.

9. Sérullaz 1991, p. 47. The history of the various datings of this sheet is reviewed in Rosenberg and Prat 2002, vol. 1, p. 387.

10. Bordes 2005b, p. 326.

11. "c'est le caractère d'Eugène il se lasse bientôt . . . il n'a pas d'applomb [*sic*] dans la tête" (it's Eugène's character, he loses interest quickly . . . his mind is unsteady); David to his chargé d'affaires Le Vol, June 17, 1824; as quoted in Agius d'Yvoire 1989, p. 632.

# Bibliography

**THE AGE OF NEOCLASSICISM 1972**
*The Age of Neoclassicism: The Fourteenth Exhibition of the Council of Europe, the Royal Academy and the Victoria & Albert Museum, London 9 September–19 November 1972.* London: Arts Council of Great Britain, 1972.

**AGIUS D'YVOIRE 1989**
Agius d'Yvoire, Elisabeth. "Chronologie." In Schnapper and Sérullaz 1989, pp. 559–637.

**AL-DOURI 2005**
Al-Douri, Taha. "Documents and Discussions: The Constitution of Pleasure: François-Joseph Belanger and the Château de Bagatelle." *Res*, no. 48 (Autumn 2005), pp. 155–62.

**L'AN V 1988**
*L'an V: Dessins des grands maîtres; 92e exposition du Cabinet des Dessins, Musée du Louvre, 23 juin–26 septembre 1988.* Paris: Ministère de la Culture et de la Communication, Editions de la Réunion des Musées Nationaux, 1988.

**ANGELIKA KAUFFMANN E ROMA 1998**
*Angelika Kauffmann e Roma.* Exh. cat., Accademia Nazionale di San Luca, Istituto Nazionale per la Grafica, Rome. Rome: De Luca, 1998.

**ANGELUCCI 2019**
Angelucci, Laura. *Inventaire général des dessins: École française: Antoine-Jean Gros (1771–1835).* Paris: Musée du Louvre, 2019.

**LES ARCHITECTES DE LA LIBERTÉ 1989**
*Les architectes de la liberté: 1789–1799.* Exh. cat. Paris: Ecole Nationale Supérieure des Beaux-Arts, 1989.

**ASSOCIATION DES ARTISTES 1884**
Association des artistes peintres, sculpteurs, architectes, graveurs et dessinateurs. *Catalogue des dessins de l'école moderne exposés à l'Ecole Nationale des Beaux-Arts au profit de la caisse de secours de l'Association.* Paris, 1884.

**AULARD 1889–1923**
Aulard, F.-A. *Recueil des actes du Comité de salut public: Avec la correspondance officielle des représentants en mission et le registre du Conseil exécutif provisoire.* 27 vols. Paris: Imprimerie Nationale, 1889–1923.

**AURICCHIO 2009**
Auricchio, Laura. *Adélaïde Labille-Guiard: Artist in the Age of Revolution.* Los Angeles: J. Paul Getty Museum, 2009.

**AUTOUR DE DAVID 1983**
*Autour de David: Dessins néo-classiques du Musée des Beaux-Arts de Lille.* Exh. cat., Musée des Beaux-Arts, Lille; Palazzo Braschi, Rome. Lille: Musée des Beaux-Arts, 1983.

**BAETJER 2019**
Baetjer, Katharine. *French Paintings in The Metropolitan Museum of Art from the Early Eighteenth Century through the Revolution.* New York: The Metropolitan Museum of Art, 2019.

**BAILEY 1992**
Bailey, Colin B., with Carrie A. Hamilton. *The Loves of the Gods: Mythological Painting from Watteau to David.* Exh. cat., Galeries Nationales du Grand Palais, Paris; Philadelphia Museum of Art; Kimbell Art Museum, Fort Worth. New York: Rizzoli; Fort Worth, Tex.: Kimbell Art Museum, 1992.

**BAILEY 2002**
Bailey, Colin B. *Patriotic Taste: Collecting Modern Art in Pre-Revolutionary Paris.* New Haven: Yale University Press, 2002.

**BAJOU 2007**
Bajou, Valérie. "Painting and Politics under the Empire: David's *Distribution of the Eagles.*" In Ledbury 2007, pp. 54–71.

**BANTEL 1981**
Bantel, Linda. *The Alice M. Kaplan Collection.* New York: Advisory Council of the Dept. of Art History and Archaeology, Columbia University, 1981.

**BASSANI PACHT ET AL. 2013**
Bassani Pacht, Paola, Sonja Brink, Dominique Cordellier, Annie Gilet, Laurent Hugues, Sophie Join-Lambert, Catherine Monbeig Goguel, Danielle Oger, and Guilhem Scherf. *En contrepoint de Disegno & Couleur: Dessins du Musée des Beaux-Arts de Tours: XVIe–XVIIIe siècles.* Exh. cat. Cinisello Balsamo, Milan: Silvana; Tours: Musée des Beaux-Arts, 2013.

**BASSI 1959**
Bassi, Elena, ed. *Antonio Canova: I quaderni di viaggio (1779–1780).* Venice, Rome: Istituto per la Collaborazione Culturale, 1959.

**BATCHELOR 2000**
Batchelor, David. *Chromophobia.* London: Reaktion Books, 2000.

**BAUSSET-ROQUEFORT 1828–29**
Bausset-Roquefort, Louis François Joseph, baron de. *Mémoires anecdotiques sur l'interieur de Palais de Napoléon, sur celui de Marie-Louise, et sur quelques evénemens de l'Empire, depuis 1805 jusqu'en 1816.* 3rd ed. 3 vols. Paris: A. Levavasseur, 1828–29.

**BAXTER 2006**
Baxter, Denise Amy. "Two Brutuses: Violence, Virtue, and Politics in the Visual Culture of the French Revolution." *Eighteenth-Century Life* 30, no. 3 (Summer 2006), pp. 51–77.

**BEAN 1986**
Bean, Jacob, with the assistance of Lawrence Turčić. *15th–18th Century French Drawings in The Metropolitan Museum of Art.* New York: The Metropolitan Museum of Art, 1986.

**BELL 2017**
Bell, Andrea. "Landscape Drawing beyond the Classical Ruin: David, Drouais and Percier." In *Wissenschaft, Sentiment und Geschäftssinn: Landschaft um 1800*, edited by Roger Fayer, Regula Krähenbühl, and Bernard von Waldkirch, pp. 56–74. Zurich: Scheidegger & Speiss, 2017.

BELLENGER 2006
Bellenger, Sylvain; essays by Marc Fumaroli et al. *Girodet, 1767–1824.* Exh. cat., Musée du Louvre, Paris; Art Institute of Chicago; The Metropolitan Museum of Art, New York; Musée des Beaux-Arts de Montréal. Paris: Galllimard; Musée du Louvre Editions, 2006.

BERMAN FORTHCOMING
Berman, Daniella. "The Aesthetics of Contingency: History and the Unrealized Paintings of the French Revolution." PhD diss., Institute of Fine Arts, New York University, forthcoming.

BERTHIER 1977
Berthier, Philippe. *Stendhal et ses peintres italiens.* Histoire des idées et critique littéraire 163. Geneva: Droz, 1977.

BOIME 1980
Boime, Albert. "Marmontel's *Bélisaire* and the Pre-Revolutionary Progressivism of David." *Art History* 3, no. 1 (March 1980), pp. 81–101.

BONNARDET 1938
Bonnardet, E. "Comment un oratorien vint en aide a un grand peintre." *Gazette des Beaux-Arts*, 6th ser., 19 (May–June 1938), pp. 311–15.

BORDES 1981
Bordes, Philippe. "Dessins perdus de David, dont un pour 'la Mort de Socrate,' lithographiés par Debret." *Bulletin de la Société de l'Histoire de l'Art Français*, année 1979 (1981), pp. 179–84.

BORDES 1983
Bordes, Philippe. *Le Serment du Jeu de Paume de Jacques-Louis David: Le peintre, son milieu et son temps de 1789 à 1792.* Notes et documents des musées de France 8. Paris: Ministère de Culture, Editions de la Réunion des Musées Nationaux, 1983.

BORDES 1990
Bordes, Philippe. "Exhibition Reviews: Paris and Versailles: David." *Burlington Magazine* 132, no. 1943 (February 1990), pp. 154–56.

BORDES 1996
Bordes, Philippe. *La mort de Brutus de Pierre-Narcise Guérin.* Exh. cat. Vizille: Musée de la Révolution Française, 1996.

BORDES 1997
Bordes, Philippe. "'L'écurie dont je ne sortirai que cousu d'or': Painters and Printmaking from David to Géricault." In *Théodore Géricault, the Alien Body: Tradition in Chaos*, edited by Serge Guilbaut, Maureen Ryan, and Scott Watson, pp. 116–35. Exh. cat. Vancouver: Morris and Helen Belkin Art Gallery, University of British Columbia, 1997.

BORDES 2002
Bordes, Philippe. "Autour du *Brutus* de David: Commentaires anciens et modernes." In *Bruto il Maggiore nella letteratura francese e dintorni: Atti del convegno internazionale, Verona, 3–5 maggio 2001*, edited by Franco Piva, pp. 247–61. Fasano: Schena, 2002.

BORDES 2003
Bordes, Philippe. "Jacques-Louis David et l'estampe." In *Delineavit et sculpsit: Dix-neuf contributions sur les rapports dessin-gravure du XVIe au XXe siècle: Mélanges offerts à Marie-Félicie Pérez-Pivot*, edited by François Fossier, pp. 171–79. Lyon: Presses Universitaires de Lyon, 2003.

BORDES 2004
Bordes, Philippe. "Le catalogue des dessins de David, par P. Rosenberg et L.-A. Prat." *Revue de l'Art*, no. 143 (2004), pp. 121–28.

BORDES 2005A
Bordes, Philippe. "Exhibition Reviews: David's 'Coronation of Napoleon,' Paris." *Burlington Magazine* 147, no. 1224 (March 2005), pp. 200–202.

BORDES 2005B
Bordes, Philippe. *Jacques-Louis David: Empire to Exile.* Exh. cat., J. Paul Getty Museum, Los Angeles; Sterling and Francine Clark Art Institute, Williamstown, Mass. New Haven: Yale University Press; Williamstown, Mass.: Sterling and Francine Clark Art Institute, 2005.

BORDES 2007
Bordes, Philippe. "After the Exhibition in Los Angeles and Williamstown." In Ledbury 2007, pp. 342–51.

BORDES 2010
Bordes, Philippe. *Représenter la Révolution: Les Dix-Août de Jacques Bertaux et de François Gérard.* Vizille: Musée de la Révolution Française, 2010.

BORDES 2016
Bordes, Philippe, "La vogue du portrait en médaillon à l'époque de la Révolution française." In Rosenberg and Prat 2016, pp. 99–108.

BORDES 2019
Bordes, Philippe. "La réforme de la peinture française au temps de Louis XVI: Bernis entre Mengs et Poussin." In *Le cardinal de Bernis: Le pouvoir de l'amitié*, edited by Gilles Montègre, pp. 399–412, 758–60. Paris: Tallandier, 2019.

BORDES 2020
Bordes, Philippe. "Reviews: Jean-Antoine Gros (1771–1835)." *Master Drawings* 58, no. 2, (Summer 2020), pp. 255–60.

BOUTET-LOYER 1983
Boutet-Loyer, Jacqueline. *Girodet: Dessins du Musée; Montargis, Musée Girodet.* Exh. cat. Montargis, France: Le Musée, 1983.

BRETTELL ET AL. 2002
Brettell, Richard R., and Françoise Foster-Hahn, Duncan Robinson, and Janis A. Tomlinson. *Nineteenth- and Twentieth-Century European Drawings.* The Robert Lehman Collection 9. New York: The Metropolitan Museum of Art, in association with Princeton University Press, Princeton, N.J., 2002.

BRUGEROLLES 2009
Brugerolles, Emmanuelle, ed. *L'Académie mise à nu: L'école du modèle à l'Académie Royale de Peinture et de Sculpture; Ecole Nationale Supérieure des Beaux-Arts, Paris 26 octobre 2009–29 janvier 2010.* Carnets d'études 15. Paris: Beaux-Arts de Paris, 2009.

BRUGEROLLES 2016
Brugerolles, Emmanuelle, ed. *De l'alcôve aux barricades: De Fragonard à David: Dessins de l'Ecole des Beaux-Arts.* Exh. cat., Fondation Custodia, Paris. Paris: Beaux-Arts de Paris Editions, 2016.

BRUSON 2016
Bruson, Jean-Marie, et al. "Des ruines et des prisons: Hubert Robert et la Révolution" and cats. 125–36. In *Hubert Robert, 1733–1808: Un peintre visionnaire,* edited by Guillaume Faroult, with the collaboration of Catherine Voiriot, pp. 388–415. Exh. cat., Musée du Louvre, Paris. Paris: Somogy Editions d'Art; Louvre Editions, 2016.

BÜCKLING AND MONGI-VOLLMER 2013
Bückling, Maraike, and Eva Mongi-Vollmer, eds. *Schönheit und Revolution: Klassizismus 1770–1820.* Exh. cat., Städel Museum, Liebieghaus Skulpturensammlung, Frankfurt am Main. Munich: Hirmer, 2013.

CALVET 1968
Calvet [Sérullaz], Arlette. "Unpublished Studies for 'The Oath of the Horatii' by Jacques-Louis David." *Master Drawings* 6, no. 1 (Spring 1968), pp. 37–42, 81–90.

CANTALOUBE 1860
Cantaloube, Amédée. "Les dessins de Louis David." *Gazette des Beaux-Arts* 7, no. 5 (September 1860), pp. 285–303.

CATALA 2016
Catala, Sarah. "'Carcer Socratis Domus Honoris': Les dessins d'Hubert Robert dans les prisons de la Terreur," In Rosenberg and Prat 2016, pp. 37–45.

CHAUSSARD 1800
Chaussard, P[ierre Jean-Baptiste]. *Sur le tableau des Sabines, par David.* Paris: Charles Pougens, 1800.

CHAUSSARD 1806
[Chaussard, Pierre Jean-Baptiste]. *Le Pausanias français: Etat des arts du dessin en France, à l'ouverture du XIXe siècle: Salon de 1806.* Paris: F. Buisson, 1806.

CHRISTIANSEN 2020
Christiansen, Keith. "Missing The Met." In "A Time of Crisis." Special issue, *The Metropolitan Museum of Art Bulletin* 78, no. 2 (Fall 2020), pp. 37–40.

CLARK 1998
Clark, Alvin L., Jr., ed. *Mastery & Elegance: Two Centuries of French Drawings from the Collection of Jeffrey E. Horvitz.* Exh. cat. Cambridge, Mass: Harvard University Art Museums, 1998.

CLARK 2017
Clark, Alvin L., Jr., ed. *Tradition & Transitions: Eighteenth-Century French Art from the Horvitz Collection.* Exh. cat., Petit Palais, Musée des Beaux-Arts de la Ville de Paris. Boston: Horvitz Collection, 2017.

COCHIN 1774
M. C. [Charles-Nicolas Cochin]. *Lettres à un jeune artiste peintre, pensionnaire de l'Académie Royale de France à Rome.* [Paris, 1774].

COEKELBERGHS AND LOZE 1985
Coekelberghs, Denis, and Pierre Loze. *1770–1830: Autour du néo-classicisme en Belgique.* Exh. cat., Musée Communal des Beaux-Arts d'Ixelles, Brussels. Brussels: Crédit Communal, 1985.

COMPIN AND ROQUEBERT 1986
Compin, Isabelle, and Anne Roquebert. *Ecole francaise, A–K.* Vol. 3 of *Catalogue sommaire illustré des peintures du Musée du Louvre et du Musée d'Orsay.* Paris: Editions de la Réunion des Musées Nationaux, 1986.

CONVENTION NATIONALE 1794
*Convention nationale: Second rapport sur la nécessité de la suppression de la commission du Museum, fait au nom des comités d'Instruction publique et des finances, par David, député du département de Paris, dans la séance du 27 Nivôse, l'an 2 de la République française.* Paris: Imprimerie Nationale, 1794.

COSNEAU 1983
Cosneau, Claude. "Un grand projet de J.-L. David (1789–1790): L'art et la Révolution à Nantes." *Revue du Louvre* 33, no. 4 (1983), pp. 255–63.

COUILLEAUX ET AL. 2019
Couilleaux, Benjamin, Michel Hilaire, and Florence Hudowicz. *Génération en Révolution: Dessins français du Musée Fabre, 1770–1815.* Exh. cat., Musée Cognacq-Jay, Paris. Paris: Paris Musées, 2019.

COUPIN 1829
Coupin, Pierre-Alexandre. *Œuvres posthumes de Girodet-Trioson, peintre d'histoire, suivies de sa correspondence.* 2 vols. Paris: Jules Renouard, 1829.

CROW 1985
Crow, Thomas E. *Painters and Public Life in Eighteenth-Century Paris.* New Haven: Yale University Press, 1985.

CROW 1995
Crow, Thomas. *Emulation: Making Artists for Revolutionary France.* New Haven: Yale University Press, 1995.

CROW 2001
Crow, Thomas. "Ingres and David." *Apollo* 153 (June 2001), pp. 11–17.

CROW 2006
Crow, Thomas. *Emulation: David, Drouais, and Girodet in the Art of Revolutionary France.* Rev. ed. New Haven: Yale University Press, in association with the Getty Research Institute, Los Angeles, 2006.

CROW 2007
Crow, Thomas. "The Imagination of Exile in Jacques-Louis David's *Anger of Achilles.*" In Ledbury 2007, pp. 122–37.

CROW 2018
Crow, Thomas. *Restoration: The Fall of Napoleon in the Course of European Art, 1812–1820.* Princeton, N.J.: Princeton University Press, 2018.

CUZIN 2003
Cuzin, Jean-Pierre. *Fragonard*. Drawing Gallery 3. Milan: 5 Continents; Paris: Musée du Louvre, 2003.

CUZIN 2013
Cuzin, Jean-Pierre, assisted by Isabelle Mayer-Michalon. *François-André Vincent, 1746–1816: Entre Fragonard et David*. Paris: Arthena, 2013.

DANIELEWICZ AND GUZE 2009
Danielewicz, Iwona, and Justyna Guze, *Le siècle français: Francuskie malarstow i rysunek, XVIII wieku ze zbiorow polskich*. Warsaw: Muzeum Narodowe, 2009.

DASSAS ET AL. 2002
Dassas, Frédéric, Dominique de Font-Réaulx, Berthélémy Jobert, and Philippe Bata. *L'invention du sentiment: Aux sources du romantisme; 2 avril–30 juin 2002, Musée de la Musique*. Exh. cat. Paris: Editions de la Réunion des Musées Nationaux, Cité de la musique, Musée de la Musique, 2002.

DAVID 1799
David, Jacques Louis. *Le tableau des Sabines, exposé publiquement au Palais National des Sciences et des Arts, salle de la ci-devant Académie d'Architecture, par le C^en David, membre de l'Institut National*. Paris: Imprimerie de P. Didot, 1799.

J. L. J. DAVID 1880
David[-Chassagnolle], J. L. Jules. *Le peintre Louis David, 1748–1825: Souvenirs et documents inédits*. Paris: Victor Havard, 1880.

DAVID E ROMA 1981
*David e Roma: Dicembre 1981–febbraio 1982*. Exh. cat., Académie de France. Rome: De Luca Editore, 1981.

DAVID ESTATE SALE CATALOGUE 1826
*Catalogue des tableaux de galerie et de chevalet, dessins, etudes, livres de croquis, de M. Louis David, peintre d'histoire, et d'estampes, tant anciennes que modernes, dont la vente publique et aux enchères aura lieu, par suite de son décès, les 17 avril 1826, et jours suivans. . . .* Compiled by Alexis Nicolas Pérignon. Paris, 1826.

DAVID ET SES ÉLÈVES 1913
*Exposition David et ses élèves*. Exh. cat., Palais des Beaux-Arts de la Ville de Paris. Paris: Imprimerie Georges Petit, 1913.

DE CASO 1972
De Caso, Jacques. "Jacques-Louis David and the Style 'All'antica'." *Burlington Magazine* 114, no. 835 (October 1972), pp. 686–90.

DELÉCLUZE 1855
Deléeluze, E. J. *Louis David: Son école et son temps: Souvenirs*. Paris: Didier, 1855.

DENISON 1995
Denison, Cara D. *Fantasy and Reality: Drawings from the Sonny Crawford von Bülow Collection*. Exh. cat. New York: Pierpont Morgan Library, 1995.

DESSEINS D'ARTISTES 2000
*Desseins d'artistes: Les plus beaux dessins français des Musées d'Angers*. Exh. cat., Musée des Beaux-Arts de Quimper; Musée Pincé, Angers. Paris: Somogy; Angers: Musées d'Angers; Quimper: Musée des Beaux-Arts de Quimper, 2000.

DESSINS ANCIENS 1991
*Dessins anciens des écoles du nord, françaises et italiennes*. Exh. cat. Paris, New York: Haboldt & Co., 1991.

DESSINS ORIGINAUX 1978
*Dessins originaux anciens et modernes*. Exh. cat. Paris: Paul Prouté, S.A., 1978.

DÉTOURNELLE 1794
Détournelle, Athanase, ed. *Aux armes et aux arts! Peinture, sculpture, architecture, gravure. Journal de la Société populaire et républicaine des arts, séant au Louvre, salle du Laocoon* 1 (1794).

DÉZALLIER D'ARGENVILLE 1762
Dézallier d'Argenville, Antoine Joseph. *Abrégé de la vie des plus fameux peintres*. Rev. and enl. ed. 4 vols. Paris: De Bure l'aîné, 1762.

DOSSI 1999
Dossi, Barbara. *Albertina: The History of the Collection and Its Masterpieces*. Munich: Prestel, 1999.

DRAPER 2007
Draper, James David. "Chaudet's Belisarius and a Borrowing from David." In *La sculpture en Occident: Etudes offertes à Jean-René Gaborit*, edited by Geneviève Bresc-Bautier, Françoise Baron, and Pierre-Yves Le Pogam, pp. 227–31. Dijon: Editions Faton, 2007.

DRAPER AND SCHERF 1997
Draper, James David, and Guilhem Scherf. *Augustin Pajou, Royal Sculptor, 1730–1809*. Exh. cat., Musée du Louvre, Paris; The Metropolitan Museum of Art, New York. New York: The Metropolitan Museum of Art; Paris: Réunion des Musées Nationaux, 1997.

DUCHEMIN 2008
Duchemin, Hubert. *Jacques Louis David: Trois tableaux redécouverts*. Exh. cat. Paris: Turquin experts en tableaux, 2008.

L'ECOLE POLYTECHNIQUE 1998
*L'Ecole Polytechnique: Un patrimoine inattendu*. Exh. cat. Palaiseau; Ecole Polytechnique; Paris: Mona Bismarck Foundation, 1998.

EINECKE 2001
Einecke, Claudia, with an essay by Pierre Rosenberg. *Final Moments: Peyron, David, and "The Death of Socrates."* Exh. cat. Omaha, Neb.: Joslyn Art Museum, 2001.

EKELHART 2007
Ekelhart, Christine, ed. *Die französischen Zeichnungen und Aquarelle des 19. und 20. Jahrhunderts der Albertina*. Beschreibender Katalog der Handzeichnungen in der Albertina 11. Vienna: Böhlau, 2007.

EKELHART 2017
Ekelhart, Christine, ed. *From Poussin to David: French Drawings in the Albertina*. Exh. cat., Albertina, Vienna. Munich: Hirmer Verlag GmbH, 2017.

ENGERAND 1897
Engerand, Fernand. "Les commandes officielles de tableaux au XVIIIe siècle: Louis David." *La Chronique des Arts et de la Curiosité; supplement à la Gazette des Beaux-Arts*, January 9, 1897, pp. 12–16.

ENGERAND 1901
Engerand, Fernand. *Inventaire des tableaux commandés et achetés par la direction des Bâtiments du Roi (1709–1792)*. Paris: Ernest Leroux, 1901.

EXPLICATION DU TABLEAU DES THERMOPYLES 1814
*Explication du tableau des Thermopyles, de M. David*. Paris: Imprimerie d'Hacquart, 1814.

FAHY 2005
Fahy, Everett, ed. *The Wrightsman Pictures*. New York: The Metropolitan Museum; New Haven: Yale University Press, 2005.

FAROULT 2004
Faroult, Guillaume. *David*. Pour la peinture 6. Paris: Editions Jean-Paul Gisserot, 2004.

FAROULT, LERIBAULT, AND SCHERF 2010
Faroult, Guillaume, Christophe Leribault, and Guilhem Scherf, eds. *L'antiquité rêvée: Innovations et résistances au XVIIIe siècle*. Exh. cat., Musée du Louvre, Paris; Museum of Fine Arts, Houston. Paris: Gallimard; Louvre Editions, 2010.

FAROULT, LERIBAULT, AND SCHERF 2011
Faroult, Guillaume, Christophe Leribault, and Guilhem Scherf, eds. *Antiquity Revived: Neoclassical Art in the Eighteenth Century*. Exh. cat., Musée du Louvre, Paris; Museum of Fine Arts, Houston. Paris: Gallimard, 2011.

FLORISOONE 1948
Florisoone, Michel. *David: Exposition en l'honneur du deuxième centenaire de sa naissance*. Exh. cat., Musée de l'Orangerie, Paris; Musée de Versailles. Paris: Editions des Musées Nationaux, 1948.

FOISSY-AUFRÈRE 1989
Foissy-Aufrère, Marie-Pierre. *La Mort de Bara: De l'événement au mythe; autour du tableau de Jacques-Louis David*. Exh. cat. Avignon: Fondation du Musée Calvet, 1989.

FONDS NICOLAS MIGNARD 1978
*Fonds Nicolas Mignard: Catalogue "centenaire" 1978, 2e partie—dessins*. Paris: Paul Prouté, 1978.

FRAGONARD ET LE DESSIN FRANÇAIS 1992
*Fragonard et le dessin français au XVIIIe siècle dans les dollections du Petit Palais*. Exh. cat., Musée du Petit Palais, Paris. Paris: Editions Paris-Musées, 1992.

FRENCH PAINTING 1774–1830 1975
*French Painting 1774–1830: The Age of Revolution*. Exh. cat., Grand Palais, Paris; Detroit Institute of Arts; The Metropolitan Museum of Art, New York. Detroit: Distributed by Wayne State University Press, 1975.

GERARD POWELL 2016
Gerard Powell, Véronique, ed. *Artistes, musées et collections: Un hommage à Antoine Schnapper*. Paris: Presses de l'Université Paris–Sorbonne, 2016.

GILET 2001
Gilet, Annie, ed. *Dessins XVe–XXe siècle, la collection du musée de Tours*. Exh. cat. Tours: Musée des Beaux-Arts de Tours, 2001.

GOLDNER 1988
Goldner, George R., with the assistance of Lee Hendrix and Gloria Williams. *European Drawings 1: Catalogue of the Collections*. Malibu, Calif.: J. Paul Getty Museum, 1988.

GONZÁLEZ-PALACIOS 1993
González-Palacios, Alvar. "Jacques-Louis David: Le décor de l'antiquité." In R. Michel 1993, vol. 2, pp. 927–63.

GRASSELLI 2003
Grasselli, Margaret Morgan, ed. *Colorful Impressions: The Printmaking Revolution in Eighteenth-Century France*. Exh. cat. Washington, D.C.: National Gallery of Art, 2003.

GRASSELLI 2009
Grasselli, Margaret Morgan, ed. *Renaissance to Revolution: French Drawings from the National Gallery of Art, 1500–1800*. Exh. cat. Washington, D.C.: National Gallery of Art, 2009.

GRETTON 2000
Gretton, Tom. "*Marat, l'Ami du Peuple*, David: Love and Discipline in the Summer of '93." In Vaughan and Weston 2000, pp. 34–55.

GRIGSBY 1998
Grigsby, Darcy Grimaldo. "Nudity *à la grecque* in 1799." *Art Bulletin* 80, no. 2 (June 1998), pp. 311–35.

GRIGSBY 2007
Grigsby, Darcy Grimaldo. "The First Painter and the Prix Décennaux of 1810." In Ledbury 2007, pp. 18–37.

HARKETT 2007
Harkett, Daniel. "Revelation, Narrative, Rupture: Viewing David in Restoration Paris." In Ledbury 2007, pp. 314–25.

HARRIS 1981
Harris, Jennifer. "The Red Cap of Liberty: A Study of Dress Worn by French Revolutionary Partisans 1789–94." *Eighteenth-Century Studies* 14, no. 3 (Spring 1981), pp. 283–312.

HASKELL 1993
Haskell, Francis. *History and Its Images: Art and the Interpretation of the Past*. New Haven: Yale University Press, 1993.

HAUTECOEUR 1954
Hautecoeur, Louis. *Louis David*. Paris: La Table Ronde, 1954.

HAZLEHURST 1960
Hazlehurst, F. Hamilton. "The Artistic Evolution of David's *Oath*." *Art Bulletin* 42, no. 1 (March 1960), pp. 59–63.

HEAWOOD 1950
Heawood, Edward. *Watermarks, Mainly of the 17th and 18th Centuries*. Hilversum, Netherlands: Paper Publications Society, 1950.

HEIM AND CHAMBADAL 1990
Heim, Jean-François, and Sylvie Chambadal, eds. *Peintures, aquarelles, dessins, 1755–1891: Exposition printemps 1990*. Exh. cat. Paris: Jean-François et Philippe Heim, 1990.

HERBERT 1972
Herbert, Robert L. *David, Voltaire, "Brutus," and the French Revolution: An Essay in Art and Politics*. Art in Context. London: Allen Lane, 1972; New York: Viking Press, 1973.

HERCENBERG 1975
Hercenberg, Bernard. *Nicolas Vleughels: Peintre et directeur de l'Académie de France à Rome, 1668–1737*. Paris: L. Laget, 1975.

HOFMANN 1958
Hofmann, Werner. "Un dessin inconnu de la première époque de J.-L. David." *Gazette des Beaux-Arts*, 6th ser., 51 (March 1958), pp. 157–68.

HOLMA 1940
Holma, Klaus. *David, son evolution et son style*. Paris: [P. Lejay], 1940.

HORACE DE CORNEILLE 1987
*Horace de Corneille: Voyage autour d'une œuvre: Maison des champs de Pierre Corneille, Le Petit-Couronne, mars–juin 1987*. Petit-Couronne, France: La Maison, 1987.

HOULD 1991
Hould, Claudette. "Aux armes et aux Arts! La société populaire et républicaine des arts et le Journal de Détournelle." *Man and Nature / L'homme et la nature* (Canadian Society for Eighteenth-Century Studies / Société canadienne d'étude du dix-huitième siècle) 10 (1991), pp. 47–56.

HOUT 2012
Hout, Nico van. *The Unfinished Painting*. Translated by Ted Alkins. Antwerp: Ludion; New York: Abrams, 2012.

HOWARD 1975
Howard, Seymour. *A Classical Frieze by Jacques Louis David: Sacrifice of the Hero: The Roman Years*. Monograph series—E. B. Crocker Art Gallery. Sacramento, Calif.: E. B. Crocker Art Gallery, 1975.

HUNT 1998
Hunt, Lynn. "Freedom of Dress in Revolutionary France." In *From the Royal to the Republican Body: Incorporating the Political in Seventeenth- and Eighteenth-Century France*, edited by Sara E. Melzer and Kathryn Norberg. pp. 224–51. Berkeley: University of California Press, 1998.

JACKALL ET AL. 2017
Jackall, Yuriko, Philippe Bordes, Jack Hinton, Melissa Hyde, Joseph J. Rishel, Pierre Rosenberg; with Joseph Baillio, Susan Earle, Christophe Leribault, Robert Schindler, and D. Dodge Thompson. *America Collects Eighteenth-Century French Painting*. Exh. cat. Washington, D.C.: National Gallery of Art, in association with Lund Humphries, London, 2017.

JACOBY 2018
Jacoby, Joachim. *Guillaume Jean Constantin, 1755–1816: A Drawings Dealer in Paris*. London: Ad Ilissum for the Fondation Custodia, 2018.

JACQUES-LOUIS DAVID 2005
*Jacques-Louis David (1748–1825)*. Exh. cat., Musée Jacquemart-André, Institut de France, Paris. Paris: Culturespaces, Nicolas Chaudin, 2005.

JACQUOT AND MARCLE 2010
Jacquot, Dominique, and Céline Marcle. *Jean Barbault, 1718–1762: Le théâtre de la vie italienne*. Exh. cat. Strasbourg: Musées de la Ville de Strasbourg, 2010.

JOHNSON 1993
Johnson, Dorothy. *Jacques-Louis David: Art in Metamorphosis*. Princeton Series in Nineteenth-Century Art, Culture, and Society. Princeton, N.J.: Princeton University Press, 1993.

JOHNSON 1997
Johnson, Dorothy. *Jacques-Louis David: The Farewell of Telemachus and Eucharis*. Getty Museum Studies on Art. Malibu, Calif.: J. Paul Getty Museum, 1997.

JOHNSON 2006
Johnson, Dorothy, ed. *Jacques-Louis David: New Perspectives*. Studies in Seventeenth- and Eighteenth-Century Art and Culture. Newark: University of Delaware Press, 2006.

JOHNSON 2007
Johnson, Dorothy. "Lines of Thought: David's Aporetic Late Drawings." In Ledbury 2007, pp. 152–69.

JOIN-LAMBERT AND LECLAIR 2017
Join-Lambert, Sophie, and Anne Leclair. *Joseph-Benoît Suvée, 1743–1807: Une artiste entre Bruges, Rome et Paris*. Paris: Arthena, Association pour la diffusion de l'histoire de l'art, 2017.

JULIEN 2012
Julien, Laurent. *Bernard de Saintes (1751–1819): La révolutionnaire Pioche-Fer de la conquête de Montbéliard*. Saintes, France: Le Croît Vif, 2012.

KAIRIS 2005
Kairis, Pierre-Yves. "Jacques-Louis David et Lambert Lombard." *Les Cahiers d'Histoire de l'Art*, no. 3 (2005), pp. 90–96.

KAZEROUNI 2011
Kazerouni, Guillaume, ed. *L'idée et la ligne: Dessins français du Musée de Grenoble, XVIe–XVIIIe siècle*. Exh. cat. Paris: Somogy; Grenoble: Musée de Grenoble, 2011.

KORCHANE 2012
Korchane, Mehdi. *La dernière nuit de Troie: Histoire et violence autour de La Mort de Priam de Pierre Guérin*. Exh. cat. Paris: Somogy; Angers: Musées d'Angers, 2012.

KORCHANE 2016
Korchane, Mehdi. *Figures de l'exil sous la Révolution: De Bélisaire à Marcus Sextus*. Exh. cat. Vizille, France: Musée de la Révolution Française, 2016.

LAHARIE 1999
Laharie, Patrick. "Les burins de la Terreur: A. Un costume pour chaque français; B. Une opération inaboutie de propagande par l'image sous la Révolution française; C. Le dossier du Comité de salut public." *Histoire & Archives*, no. 6 (July–December 1999), pp. 77–136.

LAJER-BURCHARTH 1991
Lajer-Burcharth, Ewa. "David's *Sabine Women*: Body, Gender and Republican Culture under the Directory." *Art History* 14, no. 3 (September 1991), pp. 397–430.

LAJER-BURCHARTH 1992
Lajer-Burcharth, Ewa. "Jacques-Louis David and Republican Culture
 in France after Thermidor, 1794–1795." PhD diss., City University
 of New York, 1992.

LAJER-BURCHARTH 1994
Lajer-Burcharth, Ewa. "The Aesthetics of Male Crisis: The Terror in
 the Republican Imaginary and in Jacques-Louis David's Work
 from Prison." In *Femininity and Masculinity in Eighteenth-Century Art
 and Culture*, edited by Gill Perry and Michael Rossington, pp. 219–
 43. Manchester, U.K.: Manchester University Press, 1994.

LAJER-BURCHARTH 1999
Lajer-Burcharth, Ewa. *Necklines: The Art of Jacques-Louis David after the
 Terror*. New Haven: Yale University Press, 1999.

LAJER-BURCHARTH 2007
Lajer-Burcharth, Ewa. "The Self in Exile: David's *Portrait of Emmanuel-
 Joseph Sieyès*." In Ledbury 2007, pp. 232–51.

LAMPE 2007
Lampe, Issa. "Repainting *Love Leaving Psyche*: David's Memorial to an
 Empire Past." In Ledbury 2007, pp. 108–21.

LANGWORTHY 2012
Langworthy, Jennifer. "On Shifting Ground: The Revolutionary
 Career of François Gérard." PhD diss., University of Illinois at
 Urbana-Champaign, 2012.

LAPATIN 2009
Lapatin, Kenneth. "Picturing Socrates." In *A Companion to Socrates*,
 edited by Sara Ahbel-Rappe and Rachana Kamtekar, pp. 110–55.
 Blackwell Companions to Philosophy 34. Pbk. ed., Chichester,
 West Sussex, U.K: Wiley-Blackwell, 2009.

LAPAUZE 1903
Lapauze, Henry, ed. *Procès-verbaux de la Commune générale des arts, de
 peinture, sculpture, architecture et gravure (18 juilllet 1783–tridi de la 1re
 décade du 2e moi de l'an II) et de la Société populaire et républicaine des arts
 (3 nivôse an II–28 floréal an III)*. Paris: Imprimerie Nationale, 1903.

LAVEISSIÈRE 1993
Laveissière, Sylvain. "*Date obolum Picturae*: Prud'hon, David du pauvre?"
 In R. Michel 1993, vol. 2, pp. 893–906.

LAVEISSIÈRE 2004
Laveissière, Sylvain. *Le Sacre de Napoléon, peint par David*. Exh. cat. Paris:
 Musée du Louvre; Milan: 5 Continents, 2004.

LÉCOSSE 2019
Lécosse, Cyril. "Portraits en série et reproduction mécanique des
 traits à l'âge des Lumières et sous la Révolution: Entre idéal
 démocratique et strategies commerciales." *Perspective* 2019, no. 2,
 pp. 203–16. https://doi.org/10.4000/perspective.15521.

LEDBURY 2002
Ledbury, Mark. *Sedaine, Greuze, and the Boundaries of Genre*. Studies
 on Voltaire and the Eighteenth Century 380. Oxford: Voltaire
 Foundation, 2002.

LEDBURY 2004
Ledbury, Mark, "Visions of Tragedy: Jean-François Ducis and Jacques-
 Louis David." *Eighteenth-Century Studies* 37, no. 4 (Summer 2004),
 pp. 553–80.

LEDBURY 2005
Ledbury, Mark. "Stages of Creation: History, Epic and Theatre in
 David's Early History Painting Projects." *Studiolo: Revue d'histoire de
 l'art de l'Académie de France à Rome* 3 (2005), pp. 169–90.

LEDBURY 2006
Ledbury, Mark. "Vingt ans de recherches sur la peinture française
 (1775–1825). *Perspective* 3 (2006), pp. 379–406. https://doi.org
 /10.4000/perspective.4237.

LEDBURY 2007
Ledbury, Mark, ed. *David after David: Essays on the Later Work*. Williams-
 town, Mass.: Sterling and Francine Clark Art Institute, 2007.

LEDBURY 2014
Ledbury, Mark. "Musical Mutualism: David, Degotti and Operatic
 Painting." In *Art, Theatre, and Opera in Paris, 1750–1850: Exchanges and
 Tensions*, edited by Sarah Hibberd and Richard Wrigley, pp. 53–71.
 Farnham, Surrey, U.K.: Ashgate Publishing, 2014.

LEE 1969
Lee, Virginia. "Jacques-Louis David: The Versailles Sketchbook."
 Pts. 1, 2. *Burlington Magazine* 111, no. 793 (April 1969), pp. 197–208;
 111, no. 795 (June 1969), pp. 360–69.

LENOIR 1835
Lenoir, Alexandre "Mémoires: David: Souvenirs historiques." *Journal
 de l'Institut historique* 3, no. 1 (1835), pp. 1–13.

LICHTENSTEIN 1993
Lichtenstein, Jacqueline. *The Eloquence of Color: Rhetoric and Painting in
 the French Classical Age*. Translated by Emily McVarish. Berkeley:
 University of California Press, 1993.

LOUIS DAVID 1979
*Louis David 1748–1825: Dessins du premier séjour romain 1775–1780*. Exh. cat.
 Paris: Galerie de Bayser, 1979.

LUGT
Lugt, Frits. *Les marques de collections de dessins et d'estampes*. Amsterdam:
 Vereenigde Drakkerijen, 1921. *Supplément*. The Hague: Martinus
 Nijhoff, 1956. http://www.marquesdecollections.fr.

MANSUELLI 1958–61
Mansuelli, Guido A. Mansuelli. *Galleria degli Uffizi: Le sculture*. 2 vols.
 Rome: Istituto Poligrafico dello Stato, Libreria dello Stato,
 1958–61.

MARSY 1746
Marsy, François-Marie de. *Dictionnaire abrégé de peinture et d'architecture,
 où l'on trouvera les principaux termes de ces deux arts avec leur explication,
 la vie abrégée des grands peintres & des architectes célèbres, & une description
 succincte des plus beaux ouvrages de peinture, d'architecture & de sculpture,
 soit antiques, soit modernes*. 2 vols. Paris: Nyon fils and Barrois, 1746.

MATHY 2003
Mathy, Helmut. "Jeanbon St. André—Der Präfekt Napoleons in Mainz und seine Entourage." In *Beutekunst unter Napoleon: Die "französische Schenkung" an Mainz 1803*, edited by Sigrun Paas and Sabine Mertens, pp. 90–95. Exh. cat., Landesmuseum Mainz. Mainz am Rhein: P. von Zabern, 2003.

MAYER 2017
Mayer, Tamar. "Drawing the Corporeal: Balance and Mirror Reversal in Jacques-Louis David's *Oath of Horatii*." *Studies in Eighteenth-Century Culture* 46 (2017), pp. 229–60.

MAYER 2018
Mayer, Tamar. "Collage and Process in Jacques-Louis David's Studies for the 'Intervention of the Sabine Women.'" *Master Drawings* 56, no. 2 (Summer 2018), pp. 233–48.

MAYER-MICHALON 2016
Mayer-Michalon, Isabelle. *Un dessin de Gibelin identifié dans le fonds Baderou. Le Temps des collections* (5e édition). Cinisello Balsamo, Milan: Silvana editoriale, 2016.

MAYER-MICHALON 2019
Mayer-Michalon, Isabelle. *Meynier's Masterpiece: The Farewell of Telemachus and Eucharis, an Important Rediscovery from the Salon of 1800*. London: Daniel Katz Ltd., 2019.

MCKEE 1995
McKee, George D. "L'art de dessiner l'art: Ingres, Bouillon, Dutertre et autres copistes au service de la gravure vers 1800." *Revue du Louvre et des Musées de France* 45, no. 5/6 (1995), pp. 73–90.

MELLINET 1836
Mellinet, Camille. "David à Nantes, en 1790." *Annales de la Société académique de Nantes, et du département de la Loire-Inférieure* 7 (1836), pp. 419–61.

MESPLÉ 1969
Mesplé, Paul. "David et ses élèves toulousains." *Archives de l'Art Français*, n.s. 24 (1969), pp. 91–105.

C. MICHEL 2004
Michel, Christian. "Le goût pour le dessin en France au XVIIe et XVIIIe siècles: De l'utilisation à l'étude désintéressée." *Revue de l'Art*, no. 143 (2004), pp. 27–34.

R. MICHEL 1993
Michel, Régis, ed. *David contre David: Actes du colloque organisé au Musée du Louvre par le Service Culturel du 6 au 10 décembre 1989*. Louvre conférences et colloques. 2 vols. Paris: Documentation française, 1993.

R. MICHEL 2005
Michel, Régis. "Desprez chimérique: La prise d'Agrigente; un dessin-frisson." *Bulletin Trimestriel des Amis du Louvre*, June 2005, p. 5. https://www.amisdulouvre.fr/sites/default/files/fichiers /publication/bulletin_trimestre3_2005.pdf.

MILLIN 1806
Millin, A. L. *Dictionnaire des beaux-arts*. 3 vols. Paris: Imprimerie de Crapelet, 1806.

MONBEIG GOGUEL 1987
Monbeig Goguel, Catherine. "Le dessin encadré." *Revue de l'Art*, no. 76 (1987), pp. 25–31.

MONTAIGLON 1875–92
Montaiglon, Anatole de, ed. *Procès-verbaux de l'Académie Royale de Peinture et de Sculpture 1648–1793; publiés pour la Société de l'Histoire de l'Art Français d'après les régistres originaux conservés à l'Ecole des Beaux-Arts*. 10 vols. Paris: J. Baur, 1875–92.

MONTAIGLON AND GUIFFREY 1887–1912
Montaiglon, Anatole de, and Jules Guiffrey, eds. *Correspondance des directeurs de l'Académie de France à Rome avec les surintendants des batiments*. 18 vols. Paris: Libraire de la Société de l'Histoire de l'Art Française, 1887–1912.

MOTTE MASSELINK 2016
Motte Masselink, Nathalie. *Académie d'homme en Hercule*. Paris: Galerie Nathalie Motte Masselink, 2016. https://www.mottemasselink .com/wp-content/uploads/2017/09/int.pdf.

MUNHALL 2002
Munhall, Edgar, with an essay by Irina Novosselskaya. *Greuze the Draftsman*. Exh. cat. London: Merrell, in association with the Frick Collection, New York, 2002.

LE MUSÉE FRANÇAIS 1803–9
*Le musée français: Recueil complet des tableaux, statues et bas-reliefs, qui composent la collection nationale; avec l'explication des sujets, et des discours historiques sur la peinture, la sculpture et la gravure . . . publié par Robillard-Péronville et Laurent*. 4 vols. Paris: Imprimerie de L.-E. Herhan, 1803–9.

NASH 1973
Nash, Steven A. *The Drawings of Jacques-Louis David: Selected Problems*. PhD diss., Stanford University, 1973. Ann Arbor, Mich: UMI Dissertation Services, 1973.

NASH 1978
Nash, Steven A. "The Compositional Evolution of David's 'Leonidas at Thermopylae.'" *Metropolitan Museum Journal* 13 (1978), pp. 101–12.

LE NÉO-CLASSICISME FRANÇAIS 1974
*Le néo-classicisme français: Dessins des musées de Province*. Exh. cat., Grand Palais, Paris. Paris: Editions des Musées Nationaux, 1974.

NEWCOME SCHLEIER AND GRASSO 2003
Newcome Schleier, Mary, and Giovanni Grasso. *Giovanni David: Pittore e incisore della famiglia Durazzo*. Turin: Artema, 2003.

NOTICE DES DESSINS 1797
*Notice des dessins originaux, cartons, gouaches, pastels, émaux et miniatures, du Musée Central des Arts, exposés pour la première fois dans la Galerie d'Apollon; le 28 Thermidor de l'an V de la République Française*. Paris: Imprimerie des Sciences et Arts, 1797.

OLANDER 1983
Olander, William. "Pour Transmettre à la Postérité: French Painting and Revolution, 1774–1795." PhD diss., Institute of Fine Arts, New York University, 1983.

**OTTANI CAVINA 2005**
Ottani Cavina, Anna. *Les paysages de la raison: La ville néo-classique de David à Humbert de Superville*. Translated by Maria Teresa Caracciolo. Arles: Actes Sud, 2005.

**OUDIETTE 1812**
Oudiette, Charles, ed. *Dictionnaire topographique des environs de Paris*. Paris: J. G. Dentu, 1812.

**OUVRAGES 1791**
*Ouvrages de peinture, sculpture, et architecture, gravures, dessins, modeles, &c. exposés au Louvre par ordre de l'Assemblée Nationale; au mois de Septembre 1791; l'an III.ᵉ de la liberté.* Paris: Imprimerie des Batime[n]s du Roi, 1791.

**PADIYAR 2007A**
Padiyar, Satish. *Chains: David, Canova, and the Fall of the Public Hero in Postrevolutionary France*. University Park, Pa.: Pennsylvania State University Press, 2007.

**PADIYAR 2007B**
Padiyar, Satish. "Dispossessed: On 'Late' David." In Ledbury 2007, pp. 302–13.

**PADIYAR 2008**
Padiyar, Satish. "Who Is Socrates? Desire and Subversion in David's *Death of Socrates* (1787)." *Representations* 102, no. 1 (Spring 2008), pp. 27–52.

**PADIYAR 2011**
Padiyar, Satish. "Last Words: David's *Mars Disarmed by Venus and the Graces* (1824): Subjectivity, Death, and Postrevolutionary Late Style," 0023. *RIHA Journal* 2011. https://doi.org/10.11588/riha.2011.0.69103.

**PAGLIANO 2019**
Pagliano, Eric. "'Drapé dans sa nudité': Les forms et les usages du nu dans la mise en place du drapé." In *Drapé: Degas, Christo, Michel-Ange, Rodin, Man Ray, Dürer . . .* , edited by Eric Pagliano and Sylvie Ramond, pp. 40–55. Exh. cat. Lyon: Musée des Beaux-Arts de Lyon; Paris: LienArt, 2019.

**PARENT 2012**
Parent, Christophe. "Histoire du costume parlementaire." *Revue du droit public et de la science politique en France et à l'étranger*, 2012, no. 2, pp. 379–418.

**PELLICER AND HILAIRE 2008**
Pellicer, Laure, and Michel Hilaire. *François-Xavier Fabre, 1766–1837: De Florence à Montpellier*. Exh. cat., Musée Fabre, Montpellier; Galleria d'Arte Moderna e Contemporanea, Turin. Paris: Somogy; Montpellier: Musée Fabre, 2008.

**PÉRON 1839**
Péron, Alexandre. *Examen du tableaux du Serment des Horaces peint par David*. Paris: Imprimerie de Ducessois, 1839.

**PLATO 1924**
*The Dialogues of Plato*. Translated by Benjamin Jowett. 5 vols. 3d ed., rev. and cor. London: Oxford University Press, H. Milford, 1924.

**POUGETOUX 2004**
Pougetoux, Alain. "L'exécution du Sacre: La part du Rouget." In Laveissière 2004, pp. 71–74.

**PRAT 2011**
Prat, Louis-Antoine. *Le dessin français au XIXe siècle*. Paris: Louvre Editions; Musée d'Orsay; Somogy, 2011.

**PRAT 2016A**
Prat, Louis-Antoine. "Additions au corpus dessiné de David: Feuilles isolées." In Gerard Powell 2016, pp. 289–312.

**PRAT 2016B**
Prat, Louis-Antoine. "Quelques nouveaux dessins de Jacques-Louis David (1748–1825)." In Rosenberg and Prat 2016, pp. 109–17.

**PRAT AND LHINARES 2007**
Prat, Louis-Antoine, with Laurence Lhinares. *La collection Chennevières: Quatre siècles de dessins français*. Histoire des collections du Musée du Louvre. Exh. cat., Musée du Louvre, Paris. Paris: Musée du Louvre Editions; Ecole Nationale Supérieure des Beaux-Arts, 2007.

**PRAT AND TONKOVICH 2011**
Prat, Louis-Antoine, and Jennifer Tonkovich. *David, Delacroix, and Revolutionary France: Drawings from the Louvre*. Exh. cat. New York: Morgan Library and Museum, 2011.

**PULLINS ET AL. 2021**
Pullins, David, Dorothy Mahon, and Silvia A. Centeno. "The Lavoisiers by David: Technical Findings on Portraiture at the Brink of Revolution." *Burlington Magazine* 163, no. 1422 (September 2021), pp. 780–91.

**RADRIZZANI 2012**
Radrizzani, Dominique. *La tentation du dessin: Une collection particulière*. Exh. cat. Paris: Noir sur Blanc; Vevey: Musée Jenisch, 2012.

**RAISSIS 2010**
Raissis, Peter. *David to Cézanne: Master Drawings from the Prat Collection*. Exh. cat. Sydney: Art Gallery of New South Wales, 2010.

**RAMADE 1985**
Ramade, Patrick, ed. *Jean-Germain Drouais, 1763–1788*. Exh. cat., Musée des Beaux-Arts de Rennes. Rennes: Le Musée, 1985.

**RAMADE 2016**
Ramade, Patrick. "L'Album Drouais de Rennes et les différents artistes qui le composent: Un exemple de *liber amicorum*." In Rosenberg and Prat 2016, pp. 119–35.

**REICHARDT AND KOHLE 2008**
Reichardt, Rolf, and Hubertus Kohle. *Visualizing the Revolution: Politics and Pictorial Arts in Late Eighteenth-century France*. London: Reaktion, 2008.

**REINACH 1909–12**
Reinach, Salomon. *Répertoire de reliefs grecs et romains*. 3 vols. Paris: Ernest Leroux, 1909–12.

**LA RÉVOLUTION FRANÇAISE 1983**
*La Révolution française, le Premier Empire: Dessins du Musée Carnavalet*. Exh. cat., Musée Carnavalet, Paris. Paris: Musées de la Ville de Paris, 1983.

ROLLIN 1748
Rollin, Charles. *Histoire romaine depuis la fondation de Rome jusqu'à la bataille d'Actium, c'est à dire jusqu'à la fin de la République.* 16 vols. Paris: Chez la Veuve Estienne & fils, 1748.

ROSENBERG 1984
Rosenberg, Pierre. "Reviews: Per Bjurström, *Drawings in Swedish Public Collections, IV: French Drawings Eighteenth Century.*" *Master Drawings* 22, no. 1 (Spring 1984), pp. 64–70.

ROSENBERG 1995
Rosenberg, Pierre. *Dessins français de la collection Prat, XVIIe, XVIIIe, XIXe siècles.* Exh. cat., Musée du Louvre, Paris; National Gallery of Scotland, Edinburgh; Ashmolean Museum, Oxford. Paris: Réunion des Musées Nationaux, 1995.

ROSENBERG 1997
Rosenberg, Pierre, ed. *Des mécènes par milliers: Un siècle de dons par les Amis du Louvre.* Exh. cat., Musée du Louvre, Paris. Paris: Réunion des Musées Nationaux, 1997.

ROSENBERG 1999
Rosenberg, Pierre. *Julien de Parme, 1736–1799.* Exh. cat., Pinacoteca Cantonale Giovanni Züst, Rancate; Fondazione Magnani-Rocca, Mamiano di Traversetolo. Milan: Skira, 1999.

ROSENBERG 2000
Rosenberg, Pierre. *From Drawing to Painting: Poussin, Watteau, Fragonard, David & Ingres.* A. W. Mellon Lectures in the Fine Arts 1996; Bollingen Series xxv, 47. Princeton, N.J.: Princeton University Press, 2000.

ROSENBERG 2004
Rosenberg, Pierre. *Passion for Drawing: Poussin to Cézanne, Works from the Prat Collection.* Exh. cat. Alexandria, Va.: Art Services International, 2004.

ROSENBERG 2006A
Rosenberg, Pierre, with Claudine Lebrun. *Les Fragonard de Besançon.* Exh. cat. Milan: 5 Continents; Besançon: Musée des Beaux-Arts et d'Archéologie, 2006.

ROSENBERG 2006B
Rosenberg, Pierre. "Le voyage de David dans les Pays-Bas méridionaux en 1781." *Revue Belge d'Archéologie et d'Histoire de l'Art* 75 (2006), pp. 117–28.

ROSENBERG 2017A
Rosenberg, Pierre. "David: Les nouveaux dessins depuis 2002." In Rosenberg and Prat 2017, pp. 47–54, 166–74.

ROSENBERG 2017B
Rosenberg, Pierre, ed. *De Poussin à Cézanne: Chefs-d'œuvre du dessin français dans la collection Prat.* Exh. cat., Museo Correr, Venice; Fondation Bemberg, Toulouse. Arezzo: Magonza, 2017.

ROSENBERG 2020
Rosenberg, Pierre. *La force du dessin: Chefs-d'oeuvre de la collection Prat.* Exh. cat., Petit Palais, Musée des Beaux-Arts de la Ville de Paris. Paris: Paris Musées, 2020.

ROSENBERG AND PERONNET 2003
Rosenberg, Pierre, and Benjamin Peronnet. "Un album inédit de David." *Revue de l'Art*, no. 142 (2003), pp. 45–83.

ROSENBERG AND PRAT 2002
Rosenberg, Pierre, and Louis-Antoine Prat. *Jacques-Louis David, 1748–1825: Catalogue raisonné des dessins.* 2 vols. Milan: Leonardo Arte, 2002.

ROSENBERG AND PRAT 2016
Rosenberg, Pierre, and Louis-Antoine Prat, eds. *De David à Delacroix: Du tableau au dessin.* Vol. 1, *Onzièmes rencontres internationales du Salon du Dessin, 30 et 31 mars 2016.* Dijon: L'Echelle de Jacob; Paris: Société du Salon du Dessin, 2016.

ROSENBERG AND PRAT 2017
Rosenberg, Pierre, and Louis-Antoine Prat, eds. *De David à Delacroix: Du tableau au dessin.* Vol. 2, *Douzièmes rencontres internationales du Salon du Dessin, 22 et 23 mars 2017.* Paris; Société du Salon du Dessin, 2017.

ROSENBERG AND SANDT 1983
Rosenberg, Pierre, and Udolpho van de Sandt. *Pierre Peyron, 1744–1814.* Neuilly-sur-Seine: Arthena, 1983.

ROSENBLUM 1961
Rosenblum, Robert. "Gavin Hamilton's 'Brutus' and Its Aftermath." *Burlington Magazine* 103, no. 694 (January 1961), pp. 8–16.

ROSENBLUM 1970
Rosenblum, Robert. "A Source for David's 'Horatii.'" *Burlington Magazine* 112, no. 806 (May 1970), pp. 269–73.

ROSENBLUM 2006
Rosenblum, Robert. "David and Vien: Master/Pupil, Father/Son." In Johnson 2006, pp. 45–57.

RUDY 2017
Rudy, Elizabeth M. "Reading Revolutionary Prints." *Art in Print* 7, no. 3 (September–October 2017), pp. 35–36.

SALON 1783
*Explication des peintures, sculptures et gravures, de messieurs de l'Académie Royale.* Paris: Imprimerie de la Veuve Herrisant, 1783.

SALON 1785
*Explication des peintures, sculptures et gravures, de messieurs de l'Académie Royale.* Paris: Imprimerie de la Veuve Hérissant, 1785.

SANDOZ 1978
Sandoz, Marc. *Jean-Baptiste Deshays 1729–1765.* Paris: Editart-Quatre Chemins, 1978.

SANDT 1989
Sandt, Udolpho van de. "'Grandissima opera del pittore sarà l'istoria': Notes sur la hiérarchie des genres sous la Révolution." *Revue de l'Art*, no. 83 (1989), pp. 71–76.

SANDT 1993
Sandt, Udolpho van de. "David pour David: 'Jamais on ne me fera rien faire au détriment de ma gloire.'" In R. Michel 1993, vol. 1, pp. 115–40.

SAUNIER 1903
Saunier, Charles. "Voyage de David à Nantes en 1790." *Revue de l'Art Ancien et Moderne* 14, no. 76 (July 1903), pp. 33–41.

SAVETTIERI 2007
Savettieri, Chiara. "La Galerie de Florence de Jean-Baptiste Wicar et Antoine Mongez: Tradition et originalité à l'époque de la Révolution." In *Jean-Baptiste Wicar et son temps 1762–1834*, edited by Maria Teresa Caracciolo and Gennaro Toscano, pp. 124–53. Villeneuve-d'Ascq, France: Presses Universitaires du Septentrion, 2007.

SCHNAPPER 1982
Schnapper, Antoine. *David*. Translated by Helga Harrison. New York: Alpine Fine Arts Collection, 1982.

SCHNAPPER AND SÉRULLAZ 1989
Schnapper, Antoine, and Arlette Sérullaz, eds. *Jacques-Louis David, 1748–1825: Musée du Louvre, Département des Peintures, Paris; Musée National du Château, Versailles, 26 octobre 1989–12 février 1990*. Exh. cat. Paris: Editions de la Réunion des Musées Nationaux, 1989.

SCHULZE 1994
Schulze, Sabine, ed. *Goethe und die Kunst*. Exh. cat., Schirn Kunsthalle, Frankfurt; Kunstsammlungen zu Weimar. Stuttgart: Hatje, 1994.

SÉRULLAZ 1987
Sérullaz, Arlette. "A propos du Serment des Horaces de Jacques Louis David." In *Horace de Corneille* 1987, pp. 88–96.

SÉRULLAZ 1991
Sérullaz, Arlette. *Dessins de Jacques-Louis David, 1748–1825*. Musée du Louvre, Cabinet des dessins, Inventaire général des dessins, Ecole française. Paris: Réunion des Musées Nationaux, 1991.

SÉRULLAZ 2000
Sérullaz, Arlette. "Jacques-Louis David: Le premier séjour à Rome." In *Antonio Canova et il suo ambiente artistico fra Venezia, Roma et Parigi*, edited by Giuseppe Pavanello, pp. 299–305. Venice: Istituto Veneto di Scienze, Lettere ed Arti, 2000.

SÉRULLAZ AND PRAT 2005
Sérullaz, Arlette, and Louis-Antoine Prat. *David*. Translated by Susan Wise. Cabinet des dessins 9. Milan: 5 Continents; Paris: Musée du Louvre, 2005.

SIEVERS, MUEHLIG, AND RICH 2000
Sievers, Ann H., with Linda D. Muehlig and Nancy Rich; with contributions by Kristen Erickson and Edward J. Nygren. *Master Drawings from the Smith College Museum of Art*. New York: Hudson Hills Press, in association with the Smith College Museum of Art, Northampton, Mass., 2000.

SPIRO 2005
S[piro], S[tephen B]. "Portrait of the Baroness Jeanin and Her Daughter, 1821." *Selected Works: Snite Museum of Art, University of Notre Dame*, p. 168. 2nd ed. Notre Dame, Ind.: Snite Museum of Art, 2005.

SPIRO AND COFFMAN 1993
Spiro, Stephen B., and Mary Frisk Coffman. *Drawings from the Reilly Collection*. Notre Dame, Ind.: Snite Museum of Art, University of Notre Dame, 1993.

STEIN 1999
Stein, Perrin. "Europe 1700–1900: Jacques-Louis David . . . *The Death of Camilla*." *Recent Acquisitions: A Selection 1998–1999. The Metropolitan Museum of Art Bulletin* 57, no. 2 (Fall 1999), pp. 38–39.

STEIN 2005
Stein, Perrin, with a contribution by Martin Royalton-Kisch. *French Drawings from the British Museum: Clouet to Seurat*. Exh. cat., The Metropolitan Museum of Art, New York; British Museum, London. London: British Museum Press; New York: The Metropolitan Museum of Art, 2005.

STEIN 2009
Stein, Perrin. "Crafting the Neoclassical: Two New Drawings for Jacques-Louis David's 'The Lictors Bringing Brutus the Bodies of His Sons.'" *Master Drawings* 47, no. 2 (Summer 2009), pp. 221–36.

STEIN 2013
Stein, Perrin. *Artists and Amateurs: Etching in 18th-Century France*. Exh. cat. New York: The Metropolitan Museum of Art, 2013.

STEIN 2016
Stein, Perrin, with contributions by Marie-Anne Dupuy-Vachey, Eunice Williams, and Kelsey Brosnan. *Fragonard: Drawing Triumphant; Works from New York Collections*. Exh. cat. New York: The Metropolitan Museum of Art, 2016.

STEIN AND HOLMES 1999
Stein, Perrin, and Mary Tavener Holmes. *Eighteenth-Century French Drawings in New York Collections*. Exh. cat. New York: The Metropolitan Museum of Art, 1999.

STENDHAL 2002
Stendhal [Marie Henri Beyle]. *Salons*. Edited by Stéphane Guégan and Martine Reid. Paris: Gallimard, Le Promeneur, 2002.

STERLING AND ADHÉMAR 1959
Sterling, Charles, and Hélène Adhémar. *Peintures: Ecole française XIXe siècle*. Vol. 2, *D–G*. La peinture au Musée du Louvre: Ecole française. Paris: Editions des Musées Nationaux, 1959.

TEDESCHI 1985
Tedeschi, Martha. *Great Drawings from the Art Institute of Chicago: The Harold Joachim Years, 1958–1983*. New York: Hudson Hills Press; Chicago: Art Institute of Chicago, 1985.

THOMÉ 1826
Th[omé], A. *Vie de David*. Paris: Les marchands de nouveautés, 1826.

TISCHBEIN 1861
Tischbein, Johann Heinrich Wilhelm. *Aus meinem Leben*. Edited by Carl G. W. Schiller. 2 vols. Brauchschweig: C. A. Schwetschke, 1861.

TRADITION AND REVOLUTION IN FRENCH ART 1993
*Tradition and Revolution in French Art, 1700–1880: Paintings and Drawings from Lille*. Exh. cat. London: National Gallery Publications, 1993.

TREY AND BAECQUE 2008
Trey, Juliette, and Antoine de Baecque. *Le Serment du Jeu de Paume: Quand David réécrit l'histoire*. Exh. cat., Musée National du Château, Versailles. Versailles: Artlys, 2008.

TRIOMPHE ET MORT DU HÉROS 1988
*Triomphe et mort du héros: La peinture d'histoire en Europe de Rubens à Manet*. Exh. cat., Musée des Beaux-Arts de Lyon; Wallraf-Richartz Museum, Cologne; Kunsthaus Zürich. Milan: Electa; Lyon: Musée des Beaux-Arts de Lyon, 1988.

TURNER 2001
Turner, Nicholas. *European Drawings 4: Catalogue of the Collections*. Los Angeles: J. Paul Getty Museum, 2001.

"UNE LETTRE DE LOUIS DAVID" 1907
"Une lettre de Louis David." *Archives de l'Art Français*, n.s. 1 (1907), pp. 324–26.

VAUGHAN AND WESTON 2000
Vaughan, William, and Helen Weston, eds. *Jacques-Louis David's Marat*. Masterpieces of Western painting. Cambridge: Cambridge University Press, 2000.

VIDAL 2003
Vidal, Mary. "The 'Other Atelier': Jacques-Louis David's Female Students." In *Women, Art and the Politics of Identity in Eighteenth-Century Europe*, edited by Melissa Lee Hyde and Jennifer Dawn Milam, pp. 237–62. Women and Gender in the Early Modern World. Aldershot, Hampshire, U.K.: Ashgate, 2003.

VIOLA 2012
Viola, Paolo. "Luttes pour l'hégémonie au printemps 1793." In *Girondins et Montagnards: Actes du Colloque, Sorbonne, 14 décembre 1975*, edited by Albert Soboul, pp. 121–48. Paris: Société des Etudes Robespierristes, 1980; reprint 2012.

VISCONTI 1885
Visconti, Carlo Lodovico. *I monumenti del Museo Torlonia*. Rome: Tipografia Tiberina di F. Setth, 1885.

VOLLE 1979
Volle, Nathalie. *Jean-Simon Berthélemy, 1743–1811: Peintre d'histoire*. Paris: Arthena, 1979.

WEST 1998
West, Alison. *From Pigalle to Préault: Neoclassicism and the Sublime in French Sculpture, 1760–1840*. New York: Cambridge University Press, 1998.

WESTON 2007
Weston, Helen. "Jacques-Louis David's *Alexander, Apelles, and Campaspe*." In Ledbury 2007, pp. 138–51.

D. WILDENSTEIN AND G. WILDENSTEIN 1973
Wildenstein, Daniel, and Guy Wildenstein. *Documents complémentaires au catalogue de l'œuvre de Louis David*. Paris: Fondation Wildenstein, 1973.

WILLK-BROCARD 1978
Willk-Brocard, Nicole. *François-Guillaume Ménageot (1744–1816): Peintre d'histoire, directeur de l'Académie de France à Rome*. Paris: Arthena, 1978.

WILLK-BROCARD AND GADY 2015
Willk-Brocard, Nicole, and Alexandre Gady. *Jean Augustin Renard (Paris 1744–Paris 1807): Dessins provenant du fonds familial de l'artiste*. Paris: De Bayser SARL, 2015.

WISNER 1990
Wisner, David A. "David en prison, 1794–95: l'image post-thermidorienne de la Revolution." In *L'image de la Révolution française: Communications présentées lors du congrès mondial pour le bicentenaire de la Révolution: Sorbonne, Paris, 6–12 juillet 1989*, edited by Michel Vovelle, vol. 3, pp. 2065–79. New York: Pergamon Press, 1990.

WOOD 2010
Wood, Susan. "Caracalla and the French Revolution: A Roman Tyrant in Eighteenth-Century Iconography." *Memoirs of the American Academy in Rome* 55 (2010), pp. 295–326.

WRIGLEY 2002
Wrigley, Richard. "Liberty Caps: from Roman Emblem to Radical Headgear." In *The Politics of Appearance: Representations of Dress in Revolutionary France*, pp. 135–86. Oxford: Berg, 2002.

ZAFRAN 1985
Zafran, Eric M. *Master Drawings from Titian to Picasso: The Curtis O. Baer Collection*. Exh. cat., National Gallery of Art, Washington, D.C.; Indianapolis Museum of Art; High Museum of Art, Atlanta; and three other institutions. Atlanta: High Museum of Art, 1985.

# Index

# Photography Credits

Courtesy of Ader auction house: fig. 63; © ADER: fig. 42; © ADER, Nordmann Dominique: fig. 99; Album/Alamy Stock Photo: fig. 86; © ArtDiscovery, 2018: cat. 73; Art Institute of Chicago/Art Resource, NY: figs. 50, 136, cats. 29, 59, 71; Art Digital Studio © Sotheby's: fig. 56; from James David Draper and Guilhem Scherf, *Augustin Pajou, Royal Sculptor, 1730–1809* (New York: The Metropolitan Museum of Art; Paris: Réunion des Musées Nationaux, 1997), p. 195: fig. 33; © Beaux-Arts de Paris, Dist. RMN–Grand Palais/Art Resource, NY: figs. 25, 29, 52, 79; Bibliothèque Nationale de France: figs. 40, 93, 112, 115, 128, 130, 142, 144; © The Trustees of the British Museum: figs. 28, 45, 81, 95, 138, 145; Image courtesy the Sterling and Francine Clark Art Institute: fig. 34; Cleveland Museum of Art: fig. 140, cats. 77, 80, 81; Columbus Museum of Art, Ohio: fig. 66; Crocker Art Museum: fig. 68; from *Château de Haute Roche: Collection de S. E. Claude Achille Clarac, Ambassadeur de France*, sale cat., Daguerre, Paris, June 26, 2016, p. 34 (lot 71): fig. 54; Courtesy of Valentine Dubard: fig. 19; Collections École Polytechnique, Palaiseau, France, photo by Delphine Gallot: cat. 16; © J. Faujour/ Musée Girodet: fig. 5; Digital image courtesy of J. Paul Getty Museum Open Content Program: figs. 26, 43, 57, 58, 59, 64, cats. 39, 43, 61; Getty Research Institute, Los Angeles: cat. 8; Ville de Grenoble/Musée de Grenoble, photo by Jean-Luc Lacroix: fig. 143, cat. 18; © President and Fellows of Harvard College: figs. 109, 129; HIP/Art Resource, NY: cat. 15; from Pierre Rosenberg and Louis-Antoine Prat, *Jacques-Louis David, 1748–1825: Catalogue raisonné des dessins* (Milan: Leonardo Arte, 2002), vol. 1, p. 81.: fig. 82, p. 101: fig. 94, p. 211: fig. 127; from *J. J. Mathias: Estampes, dessins, tableaux, Asia, céramique, émaux, meubles et objets d'art, tapisseries, tapis*, sale. cat., J. J. Mathias, Paris, July 1, 2015, p. 10 (lot 26): fig. 148; Kimbell Art Museum, Fort Worth, Texas/Art Resource, NY: fig. 146; F. Lauginie/Musée Girodet, Montargis: fig. 74; Erich Lessing/Art Resource, NY: fig. 111, cat. 20; Los Angeles County Museum of Art: fig. 38; Courtesy of the Maryland State Archives: fig. 147; Department of Scientific Research, The Metropolitan Museum of Art: figs. 89, 90, 91; Image © The Metropolitan Museum of Art: figs. 1, 2, 41, 47, 72, 118, 125, cats. 19, 32, 34, 35, 41, 44, 46, 70, 75; Image © The Metropolitan Museum of Art, photo by Erica Allen: figs. 7, 20, 87, 116, cats. 5, 82; Image © The Metropolitan Museum of Art, photo by Mark Morosse: figs. 13, 14, 65, 84, cats. 60, 62; Image © The Metropolitan Museum of Art, photo by Juan Trujillo: fig. 69; The Morgan Library & Museum, New York: figs. 8, 9, 21, 55, 96, cats. 7, 9; © Musée Calvet–Bibliothèque, Avignon: fig. 100; © Musée d'Arts de Nantes, photo by Cecile Clos: fig. 49; © Musée d'Arts de Nantes, photo by Pauline Betton: cat. 49; © Musée de la Chartreuse, Douai, France, photo by Image & son: cats. 1, 2, cat. 66; © Musée des Beaux-Arts d'Angers: cats. 23, 24; © Musée des Beaux-Arts de Tours, photo by Dominique Couineau: figs. 11, 48, 119, cat. 33; Musée Granet, Ville d'Aix-en-Provence: fig. 77; © Musée du Louvre, Dist. RMN–Grand Palais/Harry Bréjat/Art Resource, NY: fig. 39; © Musée du Louvre, Dist. RMN–Grand Palais/Martine Beck–Coppola/ Art Resource, NY: figs. 102, 103, 104, 105, 106, cat. 25; © Musée du Louvre, Dist. RMN–Grand Palais/Adrien Didierjean/Art Resource, NY: fig. 92; © Musée du Louvre, Dist. RMN–Grand Palais/Hervé Lewandowski/Art Resource, NY: fig. 141; © Musées d'Art et d'Histoire, Ville de Genève: fig. 4; © Musées d'Art et d'Histoire, Ville de Genève, photo by André Longchamp: fig. 23; Suzanne Nagy: cat. 45; © Fondation Napoléon/Patrice Maurin-Berthier: cat. 68; Courtesy National Gallery of Art, Washington, D.C.: cats. 6, 10, 11, 12, 60, 63; National Gallery of Victoria, Melbourne: fig. 37; Nationalmuseum, Stockholm, photo by Erik Cornelius: cats. 47, 65; New Orleans Museum of Art: fig. 78; Palais des Beaux-Arts de Lille, photo by Jean-Marie Dautel: cat. 21; Paris Musées/Musée Carnavalet–Histoire de Paris: fig. 12, cats. 55, 56; Picture Art Collection/ Alamy Stock Photo: fig. 149; Courtesy of Petit Palais, Musée des Beaux-Arts de la Ville de Paris: cat. 28; Véronique and Louis-Antoine Prat Collection, Paris, France: fig. 48, cats. 27, 30, 84; Private collection: cats. 26, 40; Private collection/Bridgeman Images: fig. 44; Private collection, courtesy of Galerie Talabardon & Gautier, Paris: fig. 35; Rennes Museum of Fine Arts, photo by Jean-Manuel Salingue: fig. 13; © RMN–Grand Palais/Art Resource, NY: figs. 10, 53, cats. 22, 51, 54, 69, 72; © RMN–Grand Palais/Art Resource, NY, photo by Michèle Bellot: figs. 32, 62, 113, 131; © RMN–Grand Palais/Art Resource, NY, photo by Jean-Gilles Berizzi: fig. 18, cat. 67; © RMN–Grand Palais/Art Resource, NY, photo by Philipp Bernard: fig. 67; © RMN–Grand Palais/ Art Resource, NY, photo by Gérard Blot: figs. 16, 51, 124, cats. 53, 74; © RMN–Grand Palais/Art Resource, NY, photo by Adrien Didierjean: figs. 36, 101, 137; © RMN–Grand Palais/Art Resource, NY, photo by Jacques Quecq d'Henripret: cat. 64; © RMN–Grand Palais/Art Resource, NY, photo by Philippe Fuzeau: fig. 88; © RMN–Grand Palais/Art Resource, NY, photo by Marc Jeanneteau: fig. 70; © RMN–Grand Palais/Art Resource, NY, photo by Thierry Le Mage: figs. 3, 61, 122; © RMN–Grand Palais/Art Resource, NY, photo by Hervé Lewandowski: figs. 114, 128; © RMN–Grand Palais/Art Resource, NY, photo by Jean-Marc Manaï: cat. 57; © RMN–Grand Palais/Art Resource, NY, photo by René-Gabriel Ojeda: figs. 30, 97;© RMN–Grand Palais/Art Resource, NY, photo by Thierry Ollivier: figs. 98, 139; © RMN–Grand Palais/Art Resource, NY, photo by Franck Raux: figs. 110, 123, 135, cat. 76; © RMN–Grand Palais/Art Resource, NY, photo by Benoît Touchard/Mathieu Rabeau: fig. 121; © RMN–Grand Palais/Art Resource, NY, photo by Michel Urtado: figs. 46, 71, 75, 76, 83, 120; Snite Museum of Art, University of Notre Dame: cat. 83; Statens Museum for Kunst, National Gallery of Denmark, photo by Jacob Schou-Hansen: fig. 22; Studio Sebert, Paris: cat. 42; Courtesy of Swann Auction Galleries: fig. 31; Charles White/JWPictures.com: cat. 17

This catalogue is published in conjunction with the exhibition
*Jacques Louis David: Radical Draftsman*, on view at
The Metropolitan Museum of Art, New York,
from February 17 to May 15, 2022.

The exhibition is made possible in part by the Eugene V. and Clare E. Thaw Charitable Trust.

Additional support is provided by the Margaret and Richard Riney Family Foundation and The Schiff Foundation.

The catalogue is made possible by the Drue E. Heinz Fund.

Additional support is provided by the Tavolozza Foundation and Mireille and Hubert Goldschmidt.

**Published by The Metropolitan Museum of Art, New York**
Mark Polizzotti, Publisher and Editor in Chief
Peter Antony, Associate Publisher for Production
Michael Sittenfeld, Associate Publisher for Editorial

Edited by Marcie M. Muscat
Production by Lauren Knighton
Design by Laura Lindgren
Bibliographic editing by Margaret Aspinwall
Image acquisitions and permissions by Josephine
    Rodriguez-Massop
Translations from the French by John Goodman

Typeset in Sedan and Saygon
Printed on Perigord 150 gsm
Color separations, printing, and binding by Trifolio S.r.l.,
    Verona, Italy

Jacket illustration: Jacques Louis David, *The Oath of the Tennis Court*, 1791 (cat. 53, detail). Additional illustrations: pp. 2–3: *The Lictors Bringing Brutus the Bodies of His Sons*, 1787 (cat. 44, detail); p. 4: *Portrait of a Man*, 1795 (cat. 60, detail); p. 6: *Napoleon Crowning Himself*, 1805 (cat. 68, detail); p. 12: *The Death of Socrates*, 1782 (cat. 31, detail); pp. 66–67: *Allegory of the Revolution in Nantes*, ca. 1789–90 (cat. 49, detail); pp. 264–65: *The Coronation*, ca. 1804–5 (cat. 67, detail); p. 266: *Sabina*, 1785 (cat. 24, detail)

The Metropolitan Museum of Art
1000 Fifth Avenue
New York, New York 10028
metmuseum.org

Distributed by Yale University Press, New Haven and London
yalebooks.com/art
yalebooks.co.uk

Cataloguing-in-Publication Data is available from the Library of Congress.
ISBN 978-1-58839-746-1